The Logos, Prai

T0243193

"Mark de Silva is high among the remnant few whose writing still justifies the writing of novels. He has earned this distinction by treating the novel not as a form but as a formative languaging of the world that spins and tilts beneath the reader."
—Joshua Cohen, author of *The Netanyahus*

"*The Logos* is an intellectual novel not subject to intellectual clichés; a psychological novel not determined by psychological theories; a complex novel of characters not restricted to characters' beliefs; and a masterful depiction of the search for an intellectual life not determined by intellectuality, in a time when the intellect has stopped being commonly understood as essential for social life—or even survival."
—Germán Sierra, author of *The Artifact*

"*The Logos* is a seance, a conjuring of unbodily plasmas, blackbox TV metaphysics for the word-made-without-commentary. Flaring outward from a collective dreamwork into the shape of things to come, *The Logos* is autoluminescent realism transacted at godspeed, in Panavision. Its truth is the obsequious banality of an infinite soap opera, reeling out the testaments, loop-ing and branching through countless subplots, ad-breaks, sales pitches, product placements, only to lead inevitably back to that perennial cave, Platonistic cinematheque—its resident mirror-gang armed with oxygen masks and image duplicators, waiting on the far side of the psychic screen for you, the literal voyeur, to summon them."
—Louis Armand, author of *The Combinations*

"Mark de Silva's *The Logos* stands with some of the best novels of the century: *The Known World*, *Middle C*, and *A Naked Singularity*. It's a dark mountain with vertiginous switchbacks-it quests to ask why we "love" those who use us, those who feast on our souls."
—Greg Gerke, author of *See What I See*

Square Wave, Praise

"Mark de Silva's *Square Wave* is the most extraordinary debut in fiction that I've encountered in many years. It's by no means an easy read, but I found it worthwhile to trust this brilliant writer as he took me places I've never been. His writing is always beautiful, even when I had to suspend comprehension and travel beyond my comfort zone."
—**Michael Silverblatt**

"De Silva emerges as a rare voice committed to mapping the many tones of a hostile world."
—**n + 1**

"Compelling and horrifying... the uneasy melding of the actual and the imagined gives the book its own peculiar rhythm."
—**Dmitry Samarov, *Chicago Tribune***

"*Square Wave* is an experimental paean to process, to our oscillations between extremes, to the revolutions that come and go and the worlds they leave behind in the ping-ponging between the poles that lie at the hinterlands of human experience."
—**Tyler Malone, *Los Angeles Times***

"An ambitious and wholly unique novel. The book feels hewn from the stuff of another literary age while at the same time feeling relevant in a way that will age gracefully. The multiple story lines are less intertwined than complementary, harmonious. They sometimes touch, but their direct connections are rarely the point... This is a writer doing what he pleases, and doing it well enough to deserve the permission. The expansive novels of Victor Hugo came to mind throughout my reading of this book... *Square Wave* is a stunning achievement."
—**David Nilsen, *Fourth & Sycamore***

"A novel that looks our technocratic, militarized present in the face, *Square Wave* tells the story of a night watchman who discovers weaponized weather modification technologies. It sounds crazy, but in de Silva's hands it all makes perfect (and terrifying) sense."
—**Flavorwire**

"Mark de Silva's truly accomplished *Square Wave* defies all categories. Provocative, fascinating, and edifying, *Square Wave* is a fiercely intelligent and thrillingly inventive novel."
—Dana Spiotta

"Beautifully written... de Silva's novel is refreshing in its belief that disparate ideas can, in some sense, be united, that experimental music has something to say to experimental meteorlogy. De Silva's ambition in creating a work that aspires to the heights of the visionary is commendable in itself. History, violence, music, science, human interaction—*Square Wave* treats these not just as facts to be reported, but as dots to be connected."
—Slant Magazine

"Brilliant."
—3:AM Magazine

"The descriptive writing and sense of place are excellent, with the historical passages about internecine conflict in Sri Lanka especially captivating. The novel's ambitious breadth makes for a reading experience that is somewhat challenging but ultimately meaningful."
—Library Journal

"[De Silva] explores history, chaotic weather, and life in an America where militarization has caused society to begin to curdle. With this wide-ranging novel, de Silva taps into a host of anxieties addressing the contemporary moment."
—Vol.1 Brooklyn

"Enticing and enthralling, [*Square Wave*] aims to hit all the literary neurons. This might be the closest we get to David Mitchell on LSD. *Square Wave* is the perfect concoction for the thirsty mind."
—Atticus Review

"A dystopian debut set in America with a leitmotif of imperial power struggles in Sri Lanka in the 17th century. Part mystery, part sci-fi thriller, the novel reportedly deals with "the psychological effects of a militarized state upon its citizenry"—highly topical for Americans today."
—The Millions

"The novel of ideas is alive and well in de Silva's high-minded debut, in which the pursuit of art, the exercise of power, and climate control are strangely entwined. Set against the backdrop of a crumbling America, this novel functions as a thriller where the confusions and obsessions of students are freighted with the dark reality they begin to uncover. De Silva isn't shy about his intelligence, and he shouldn't be; *Square Wave* is an intellectual tussle many readers will be happy to grapple with."
—*Publishers Weekly*

"Intriguing. A satisfying twist on more traditional dystopian fare... De Silva manages these varied plots skillfully."
—*Kirkus Reviews*

"A brilliant debut, ambitious with its ideas, extraordinary in their syntheses and execution, and its stylish prose lit up everywhere by a piercing intelligence."
—**Neel Mukherjee**

"Ideas run deep beneath the crackling surface of *Square Wave*. In this fascinating, provocative novel, Mark de Silva unearths the tensions of the past and follows them into a troubled future."
—**Joanna Scott**

"*Square Wave* is, above all, just excellent. Mark de Silva's prose is simultaneously uncompromising and unassailable. The resulting work is kinetic with an almost wistful erudition that relentlessly but organically plumbs the intersections between art, politics, and our baser human qualities. Ultimately, the novel's defiance of easy categorization or explication charges the story with a compelling mental resonance that somehow feels instructive."
—**Sergio De La Pava**

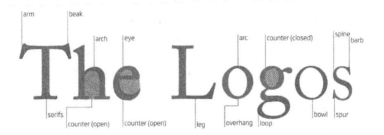

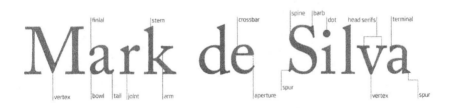

ISBN: 978-1-955904-22-3

Copyright © 2022 by Mark de Silva

Cover and typeset by Matthew Revert

CLASH Books
Troy, NY

For my father, S. P. de Silva (1943-2021)

Is painting done to be looked at?

—Edgar Degas

If a metaphysician could not draw,
what would he think?

—Gaston Bachelard

1

I have always thought of her face as a mistake. Always—even before I could see the world wouldn't turn out as we'd hoped. Where was it, though? The flaw. I suppose you could just as well ask, which of her faces did I mean?

There was, to start with, the one where she looked at you sidelong, her head tipped low and her eyes scrunched by a light pure enough to erase her. Claire was a whisper then, or only an echo of one, her face pulling away from you with a glance so slight you couldn't be sure you weren't imagining it. But how could you say there was anything to find fault with here? With blending into light. With admitting no edges. With looking askance even. I realized that.

There was another face of hers. It looked at you dead on and wasn't so far from guileless in the end. Yet something managed to spoil it, turn it feral. I suppose fear was drawn into it, the sort that has a way of inspiring the same. But how exactly? Was it the chalky skin, the way it made you feel as though merely being alive, and not some special exertion, had sent her blood into retreat? Or was it the tawny hair that went tumbling around her face, as if, moments before, something *had* happened, and ever since she'd been whipping her head back and forth, scanning the scene in terror? It might, though, for all anyone could know, have been as simple as the steep descent of her nose, which, even when she was stock-still, seemed to slash at the air in defiance.

But how could it have been the nose, really? Considered on its own, it was simply precise—exquisitely so. And her hair, however confused, fell only in mild curls, swathing her face just as though she'd woken from a long and fearless sleep, nothing like a nightmare. The apertures of her eyes, yes, perhaps they were a touch wide, at least for a genuinely settled mind; and against that pastel skin, the dark irises leapt out at you with frightening speed. But wasn't it a bit churlish to say eyes could be *too* open? And if they seemed to reach your own more quickly than you'd expected, well, shouldn't that rate as a gift for intimacy, something to be envied, not faulted or feared?

So, then, a third face. This time Claire had almost entirely untensed it, though somehow this didn't lend her the smooth and lucid neutrality you might have expected, and that I must have been seeking in her, in one way or another—from time to time, anyway—while sifting through an infinity of attitudes toward life and art. Instead, she seemed open and generous now, and so content she didn't even need to smile for you to know it.

How could there be any mistake here, you would ask? But this was precisely the issue. What you saw in her, you saw *everywhere* now. The floorboards of my ancient and once-grand townhouse apartment, so worn they looked by this point like some kind of pressed wood, the slabs dimpled by the unfinished feet of the aluminum stool she'd perched on, which was, by contrast, almost space-age in its polish; and then the window behind her gridded with grease pencil, putting you in mind of a prison as you looked out over what was in truth only a placeholder of a park, making bars, virtual or otherwise, wholly appropriate: all this appeared just as serene, as gilded, as she did. You'd never have imagined the raw feet of the stool stabbing into the floor, as if by merely sitting on it she was digging herself a hole. And you'd never imagine the true state of that park, all its steaming metal and concrete, with the trees giving cover to the dealers and muggers as they did their business with spun-out teens and, more recently, the homeless, who made their beds there when they couldn't tolerate the shelters any longer.

Nothing managed to mark Claire off from her surroundings. Instead she seemed to warp the room itself, and even what was to be found beyond it, in that park. That the distortion was rather pleasant, like Vaseline on the lens, didn't prevent this sense of unreality from vexing you, no less than any apocalyptic vision you might have projected onto the scene outside my window. In truth it was hardly that disturbing, if not quite banal either. There'd been a rather inventive killing carried out in the park in the summer. A runaway teen had her face collapsed by the fat edge of a laptop so hulking you would have had trouble conceiving how many product cycles back it must have come into being, before all its circuitry disintegrated through a life outdoors.

It was hardly a land of unmitigated cruelty or despond, the Bronx. Something as simple as the peculiarly heavy ice-cream truck traffic in the neighborhood told you that much. There were three or four trucks, all monocolored slabs of blue, various versions of the sky, and each considered the area its turf. The rivalries were often less than collegial. But then sometimes you could find all the trucks clustered by the rusting iron gate of the park in the afternoon, all doing brisk business, positively thriving. The neighborhood folk must have drawn a sizable portion of their sustenance from these carts, which were stationed along the streets at unusual hours, early in the morning, and often near midnight, times of day I hadn't imagined had much attraction for an ice-cream vendor, before moving here from Brooklyn. They sold a Mexican ice-cream of which I'd grown quite fond; I would pick it up on my many walks around the neighborhood, which was just north of the Patterson Houses and not so far east of Yankee Stadium—yet far enough, I suppose. It was by a large margin more ice than cream, with bright, artificial colors that misled you as to its flavor, which was extraordinarily mild, if not simply notional. The entire business was already so peculiar that one of the drivers had not long ago thought nothing of

selling tamales right alongside the ice cream—and why not? They were exceptional specimens. My days growing up across the country, in the Bay, equipped me to recognize this. The tamales came frequently to serve as my dinner, whenever I heard the driver's distinctive jingle in the street. It made a sort of tuneless ringing. The bell was broken. You couldn't miss it.

Even so, I thought, no world could be quite as charmed as *this* face. Perhaps it shouldn't be; there might be something slightly vulgar in that. These were matters on which my opinions had been shifting, after a long period of relative stability; but even now I tend to think of this look of Claire's as too pure for its own good.

One last face then. Perhaps the one that mattered most. There was nothing behind her when she'd made this one, so the background seemed empty (actually it was the palest blue, but you didn't notice this). What called out to you instead, as her gaze ever so slightly missed yours, confronting something that must have been just behind you, over your shoulder—almost on top of you, really, who knows just what it was—were the gentle symmetries of her ears and cheeks, her chin and brow. Her hairline, freshly visible now that her locks had been pulled back, described the upper bound of what was, structurally, a more or less ideal façade.

This time, unlike the third face, there was nothing unreal about it. Nothing utopian, I mean, the sort of thing that can get boring, that you sense must be masking complexities. For one, her expression wasn't quite placid; no, it was very much of *this* world: suitably, interestingly agitated. Whatever exactly it was that was over your shoulder, perhaps just some quotidian treachery, ensured that much.

Still, as your gaze traversed her face—as mine did then—it was hard not to notice your own loss of focus, as your eyes began to stray and other thoughts, almost any thoughts, would take her place. This was difficult to make sense of—it was a "great" face, full of story—until you accepted that an absence of error, including, this time, the error of ideality, the blankness of an unadulterated joy, could still amount to one. This, you might say, was a face too *real* for its own good. Truth, precision, no less than brazen fantasy, was not quite as profound as you would think, not until it was stained by its opposite.

As I began to dwell on this thought, or rather to dwell in it, to consider whether it was merely a compelling formulation for being koan-like, or whether it held some deeper integrity, and in this case the truth of the matter was genuinely elegant (if recondite), I was overcome by the intensity of our negotiations that day, which had been anything but elegant. I'd had to sit Claire down, roughly, on the high and shallow windowsill. She'd been wearing heels for no good reason other than that summer was halfway

through, and that was her way in summer. I coaxed her partway to her feet from there, and for an instant she seemed ungainly, in a manner I associated with beauty, or if not that, then with what was even more desirable than beauty, and here I don't mean truth, as nothing was less characteristic of her than ungainliness; it was its exceptionalness, rather, that brought it a kind of poignancy and weight. I'd taken her hands and wrapped them around the sill, leaning her shoulders against the pane, which was hot with summer sun, even without any light cascading through. From there I steered her frame against the glass until I was satisfied with the pressures, the pushes and pulls, the sense of rising action conjured through the slight strain of this posture.

After I'd located this interest, manipulating her person by going just past this point, into what I imagine was quite painful territory, shaping the arch of her back, the weight flowing down through her calves—you had to overrun things slightly, watch them fall, to know you'd found the peak—after I'd set her back in the strongest possible position, from my point of view and not hers, of course, though if she really were the artist I believed her to be, she must have known in some way that it was for the best, however much she ached, that is when the pleading began. My own, I mean: *Can you just stay as you are? I'll be fast, I promise.* I backed away from her, never leaving her with my eyes, toward the easel on which I'd pinned my paper. I started whittling down the black charcoal pencil, holding the knife at an angle just off parallel with the pencil itself to produce the longest possible point. I could see her track the shavings as they fluttered to the ground around my feet. I called to her then, seeing the burgeoning revolt of her entire body: *just a couple of minutes.* Hadn't I done the same for her, and more than once, as she'd molded clay in my image?

Once I'd gotten the pencil to a soft sort of sharpness, I held it by its base, with two fingers, upright, and stretched my arm out toward her till my elbow locked, as if I were trying, absurdly, to hand her the pencil from fifteen feet away. What I succeeded in doing was just to superimpose the plumb line onto her.

I held the pencil horizontally, too, staking out all the ways she took up space, and the way she, or rather the light leaving her, intersected the plane of the picture I was attempting to build. As I swiveled the pencil in the air, capturing proportions, marking her boundaries on a broad sheet of laid paper—the eleven segments of the so-called hinged I, the angle of her spine, the vectors defined by her arms as against her legs, which had a reddish hue to them from the Bronx light behind her; how the width of her sharp little nose compared to her mouth and eyes, and how exactly her earlobes aligned with her cheeks—I could feel her dissolve into these lines and curves and contiguous regions of color, all these interlocking planes that constituted her position in space. After a time, this is where a certain sort of perceptual attention,

rigorously pursued, invariably leads. I felt I could hardly see *her* at all anymore, not in any ordinary sense. All I could see, no less than Monet or Pissarro painting in open air, was the trace she left on me. When I wasn't feeling particularly jaded, this vanishing had always struck a note of despair in me, the remove it created from the tangible world I knew—or believed I did.

It was certainly still her I could *hear*, though, the occasional whines she made as I reconstructed her on paper: whines that were not without pathos, as I kept Claire posed this way for a remarkably long time, just as my method demanded. Long enough, in the end, to sketch her down to the knees, and fill in much of her face as well, those details I knew so well, and not just by sight. All the while my fingers took on a rich black shine from blending charcoal without my paper stump, smearing specks of carbon onto the heavy paper, the fineness of which tended to repel them without real pressure. It made my hands ache.

The several pencils I used collected on the lip of the easel. I switched between them for the line work, those and a few graded sticks of vine charcoal for the deep modeling. The softest of them laid down so rich and black it looked not only shiny but liquid, in the manner of other media entirely: ink or acrylic or even oil. I stopped re-sharpening with the knife after a while and let the line fatten naturally, the tip of the pencil simply melting away at even a delicate touch. To this I applied ink, with an old tarnished nib from a set I'd had since my Cal Arts days. I'd taken them off a favorite teacher, Sarah Arles; she'd been dear enough to me to have to steal from, just to keep something of hers when I left for New York. Firming up some of the contours this way, emboldening the hatching and then introducing white, dipping the same nib to achieve a marbled effect, these highlights wound their way around the basic tone, colonizing it like kudzu. The support itself, in that faded blue, paler than any sky I knew, had tiny ribs crossing it that hinted at a planar grid, along one axis anyway: the famous Grid we still hadn't managed to relinquish, so long after Constructivism, and even longer after the geometric abstraction defining all those rejected Salon pieces of Cézanne's. Yet the drawing atop it remained fluid, curvilinear, unorientable in Cartesian space.

Claire's face ended up quite finely finished, in high contrast, with great depth, the sort her body never had the chance to take on. For at some point, perhaps on the second day—or was it the third?—she mutinied. At the time, this was unprecedented. In hindsight I suppose it was the first glimpse of a greater abandonment to come.

Now, though, as my gaze drifted from her face, down to her shoulders and the windowsill, the whole of her world, the one I'd transferred to paper, grew increasingly vague, provisional, the very definition of space turned ghostly, its sense of volume dissipated. What she'd said later, I remember, in explaining her balking at my wishes,

which was a minor disappointment on its own perhaps, but something quite different when you realize it was the first refusal, really, and that refusals of all kinds would flow ever more freely thereafter, as if some sort of resolve had been permanently shattered by the act, never to reform with its original strength, in the manner of broken bones, was that her neck had gone stiff from having to turn toward me. It was true, the pose I'd asked her to hold could be excruciating over time: I'd wanted her body to hang between two of its prime postures, sitting and standing, maintaining a suspension in which relief was impossible to find, with reflex leading her ineluctably from one point to the other. But I have a hard time believing this was the deepest reason she'd found the position impossible to sustain. That was really a failure of the will, simultaneous with a failure of seeing the *point* of these sessions now. It's true that I had stopped showing any of these drawings; nor was I using them as preparatory works toward paintings, the very thing that might have shored up her resolve. Instead, I placed them with a few buyers I'd picked up through my dealer, Sandy Hinton. These were private collectors who'd stayed loyal to my biographical "studies," if that's what they were, even after I'd seceded from Sandy's louche Upper West Side gallery, his first space from twenty years back and still his headquarters, pleasantly distant from most other institutions of fine art. I demur at the word *studies* only because I can't say I was trying, at least in the end, to get to the bottom of anything, or to clarify something's nature, and it seems to me that's what studies are for. Investigation. Research. For me, these works, which were indeed closely attached to particular persons, sometimes fifty or sixty pieces all involving a single subject, you could see why someone would *think* they were studies, were more akin to pronouncements. I was concerned with surfaces, ultimately, with grafting onto each of these people new skin, new nerves, and in doing so, finding a new place for them in my mind.

Of course *these* collectors had remained interested, Claire said. That had nothing much to do with sympathetic understanding, and certainly not with loyalty, merely the fetish of completism and the whiff of profit, hoping to see out the last fizzles of this dying project, to seize it for resale or display, or else donation to some museum down the line that might help make their name. Weren't they all of that type? In the end, I think this was slightly too simple, and anyway I am sure Claire would acknowledge her remarks were driven by something else that had begun to simmer in her by then. Still, they were less off-base than I would have liked.

Whatever it was, there had never been an occasion on which she'd abandoned a pose once begun, as we considered modeling to be a kind of mutual duty. She'd also never criticized my work quite like this, insinuating that I wasn't genuinely try-ing anymore, that I'd capitulated in some way. In fact she would sit endlessly, most

times that I asked, however many sessions were involved, if she thought something of moment was taking shape. Sometimes, in the early days, I came to think she spontaneously took up poses in my peripheral vision, or repeated various motions or gestures, extending the time it took her to complete some mundane task like mixing paints, say, or watering the plants she'd brought with her when she'd first moved in, knowing that this is how ideas worked for me, surreptitiously, and that by performing thus she might provide, without a word, the precise stimulus I needed. These poses were often barely distinguishable from her merely carrying on with life as if entirely unseen, like a bather in a Degas. (She was going to water those plants regardless, after all.) She would do these things for me while I sat with a sketchpad and drank, or even just stared off into the distance, twirling a pencil in my fingers—anytime, really, an instrument was at hand.

That day, though, or the next, whichever it was, I can't remember, I believe it took place far from the easel—the moment, I mean, when she declined to pose any further, though she'd not done it noisily, instead gently pinning it on the irrefutable aches of her body. That must have been the turning point. These were *sketches* I was fussing over, she would have thought, unworthy of the months I spent bringing them polish and finality.

Drawing, *for her*—she drew all the time, had to—was something merely practical. She was a sculptor by training, an artist of literal space, and lately she was the kind who installed things—the favored sort of artist these days. The arts of figural space, painting foremost, had been mostly out of fashion for forty years and counting. Who ever thought icons like Schnabel or Prince to be level with Polke, Rothko, Richter, Keefer, and Hamilton? There was Hockney, I suppose, but his one note wasn't worth listening to very long. No, for most, painting as a medium hadn't been at the vanguard since the 1970s, maybe even the 1950s. It was actually *drawing* that had begun to have its advocates since the turn of the century, probably through the apotheosis of the sketch in all its forms: everything that was incomplete, unfinished, fragmentary—in short, epistemically infirm. Really it was moldy French thought, not terribly compelling the first time around, in the 1960s, given a second life by the internet, a medium effectively de- fined by its incompleteness, its indiscriminate if exhilarating admixture of knowledge and ignorance. Had digital culture actually sundered painting?

Claire's resistance to my drawings might have really come down to this: she didn't care for what she was beginning to see in them. She'd been in thrall to my paintings, and I knew this precisely not by what she said—how much can you know of someone from what they volunteer?—but rather by the way she would ferociously study them when she thought I was otherwise occupied, for instance, building frames, cutting

canvas, or grinding pigment, which I sometimes liked to do myself. There was *one* thing she'd actually said, I suppose, quite offhandedly: that it was my work that first convinced her she was a sculptor—something about the life I could fit, or find, in two dimensions, she didn't think she was going to catch me at that. There was also the suggestion, correct actually, that in three dimensions, the same dimensions in which we live our lives, I was rather hopeless next to her.

I don't really know how much to take from this. It could have been a simulated offhandedness, maybe only a kindness or encouragement to me. More likely it was a convenient way to cut ties with a medium that anyway had little momentum in modern life. Or perhaps the real meaning of the compliment, though this is not a generous thought, might have been less about my paintings, their character, and more about the sort of reception they were getting. It was *this* that she wasn't going to catch up to—which, to be fair, she might have been right about. I *had* been unusually well-received.

At the time we'd met in the city, four years earlier, I'd only been out of art school a short while, yet even then, as she liked to point out, I wasn't what you'd call an unknown. A *prospect* is what I was: my brother, Ty, our resident sports fanatic growing up, would put it exactly that way. Painting had been what I'd graduated in, a recently resurgent major, according to the mixed-media people and those of "new genres." But that it was in need of a resurgence said more than a little about its long-troubled state, as did the terms on which it was gaining re-entry. It was coming along with the return not merely of figuration but of outright narrative to art: graphic-novel, comic-book-panel narrative almost, where painting was claimed to outclass many other forms in its concentration, economy, and lucidity.

The actual sculptors in my graduating class were very few. Mallet-and-chisel sculptors, I mean, who treated the study of classical technique and hand fabrication not merely as dutiful tributes to the past while apprenticing as mixed-media workers of the conceptual or political variety. But Claire, who'd trained in Chicago, at SAIC, was just such a sculptor. She loved to cast bronzes, in particular, or anyway she had when I'd met her, and this is what I found most compelling about her. She was terribly fashionable in her person—well-liked and widely desired—yet not in her tastes. Where exactly she got them from was therefore something immediately intriguing about her. You wanted to unravel this.

I, though, I *was* a painter, and at just the right moment, apparently, ready to help bolster a true renaissance of the form, now that drawing was already in full flight. What's more, I was a painter of the figure, which no longer signaled something fusty and remote—as Claire's bronzes could—but now scanned as personal, vulnerable, authentic. The age made people hunger for these, the very qualities that would have been ridiculed in art circles as maudlin or naïve only a couple of decades ago.

In school, I would often include textual layovers with my figures and tableaus, whether in paintings or lithographic prints, even with some of the tenderer ones. Sometimes these works were typographically sophisticated, blending humanistic and transitional fonts so thoroughly, and without a hint of pastiche, that the origin or era of the founding idea became irrecoverable. Certainly it was difficult to call them modern. Although I was hardly a type designer myself, colleagues who'd gone far beyond *Thinking With Type* sometimes helped me complete one-off typefaces, usually slight bastardizations of ones they were already working on. More often, though, I achieved these syntheses myself, staring at musty type-specimen books and then hand-lettering in a kind of free improvisation on the standards, like a jazzman.

Photomontage, they'd sometimes call the results, a depersonalization of the personal or some such. Others thought of illustration first. Both were undercooked readings, based not so much on a fundamental lack of discernment as an inability to take youthful work with any real seriousness. There are some things that can only be believed or grasped when the messenger is right. Eventually, though, it began to be understood that my real models lay much further back, in Van Eyck and Steen and Saenredam, where phrases and proverbs are often wispily inscribed onto the canvas. Generally they are placed within pictorial space, although somehow they appear to overrun it; it's as if these bits of language are inscribed both *onto* the canvas, as an artist's signature is, and *into* the painted scene. Unlike certain paintings executed farther south, in Italy, where such words, when they do appear, are usually poetic or biblically aphoristic, these ones seem almost captions for the work, like internal title cards, making the ones on the gallery walls otiose. At the time, in college, I preferred to keep words and images more or less coeval, neither one symbolizing the other. Some were only fragments of text, three or four words at most, while others were as long as a paragraph. But I don't *really* want to discuss this, to tell the truth. The technique itself is now entirely a thing of the past for me. Not because it was unsophisticated. The best of those works, I believe, can stand with the works of more developed artists. The real reason for silence is simple: you would almost certainly misunderstand. That's why I abandoned the approach—people were taking these images and narratives a little *too* well. Context was betraying me. Words have this problem. It's why I left them behind once I got to New York. I haven't even titled a picture since college, never mind integrating text with it. People actually have to *look* now.

So what was it audiences saw in my figures, then mostly acrylic and oil, realistically depicted, contemporary? I relished their newfound uncertainty. These images, for one, weren't especially clever or ironical, having been studiously shorn of conceptual or post-conceptual suggestions. Nor, however, could they be called personal or earnest, that common point of retreat. Where else could you go? There

was always the realm of whimsy and nonsense; the entire twentieth century was peppered with works of this order. But I avoided any hint of irrationalism, as well as that other safe house, *kulturekritik*. How to describe them, then? What was it that my art *did*, exactly, if not illustrate ideas, divulge subjectivities, highlight iniquities? What is an art, a contemporary art, that isn't ingenious, confessional, indignant, or insouciant? I suppose I have left naïve art out of this catalog, but that's just because my own biography, the years of careful study—much of it undertaken in high school—and the technical fluency it had given me, ruled out any such interpretation. What else am I forgetting? There is the neoclassical, something that seemed to draw Claire. But no one sensible would be tempted to claim I was primarily after homage or replication, even if those Dutch painters had once given me ideas. The short of it was that my college work, though always centered on figure and narrative, befuddled all who looked on it. Despite this, a reverence persisted—I will get to why—one that gained me entry into the art circles of New York not long after I'd moved, and without much of the anxiety suffocating the more career-conscious of my peers. My professors, if they no longer claimed to understand my new, wordless direction, were apparently convinced that I, at the age of twenty-six, was on my way toward something "significant," even if what they imagined as significant seemed like nothing much to me.

Where, then, did this belief, this faith, stem from? *This* is what I think secretly infuriated Claire, though she herself owned the belief as well. Perhaps it came down to the sheer confidence of my line, which was irrefutable, or the speed with which I'd absorbed my lessons in methods and materials, in draftsmanship especially. Actually those kinds of measures are useless in gauging an artist's deeper gifts, but then, these were academic artists. What could you expect of them? There were other things they might have been reacting to, genuinely telling things: for instance, the uncommon shape, and depth, of my reading. In the years before and through college I might have read as much as I painted, owing to my father's deep library (a lawyer of rank should not only have one, he liked to say, but spend half his life in it) as well as my mother's curious notions about the needs of the developing artist. It meant that whenever my cohort would start to talk about art or criticism, I would end up drawing the discussion down paths that led beyond French and German theory, beyond art history, toward matters the others seemed only to have a passing acquaintance with: the logical form of agency, say, or the metaphysics of qualia, or else slightly unpredictable historical matters—the Commercial rather than the Industrial Revolution, or going back a bit further, the slow diffusion of hominids over the Earth's surface, millions of years ago, rather than European colonization of the New World. The trust I had in my intellect found its extension in my hands, as a creator of shadow, say, or of raking

light, or of projecting mass without line, or of shine without source; the way I could quickly and without fuss make a brass lamp's glow, that of the metal, overtake the brightness of its flame, as if this were routine.

Ultimately, I hadn't learned to think seriously only *after* I'd learned to draw and paint. With so many artists, including some brilliant ones, the thinking, even when it grew sophisticated, was retrofitted, so that it retained a trace of ornamentation. I, though, was relatively late to pick up a brush. My mother, herself a curator at several museums in Los Angeles, and more recently an arts administrator in San Francisco, was something of an aesthetician, with her own theories of artistic development. She thought it best to delay any focus on art until my high school years: it would be more valuable for an artist, or just a child, to split his time between books and brushes. I don't know what I think about her theories now. She would cite various psychologists when my father made gentle inquiries, but I never really looked up her references. And if they had all turned out to be just-so stories, it wouldn't have mattered in the least. She saved me from training in art before I was also poised to train my mind; hence I learned the two languages, of sense and thought, more or less simultaneously. I studied history and languages (German and Spanish) along with natural science with as much fervor as my studio courses in art, so that my competence in both grew at about the same rate and I experienced them from the first as seamlessly bound.

This is why my work, and even more, my measured hesitations, the diffidence I would evince toward ideas—and not merely my own—could leave others rattled. People in my presence seemed to lose confidence in the usual language surrounding art. Even professors, who would take the bombast out of their voices and talk to me in short little Anglo-Saxon words stripped of the cloak of high theory. By sophomore year, I was addressed with a certain generalized wariness, or else a pronounced irony that anticipated the unlikelihood of convincing me of very much. I can't say I didn't enjoy the spectacle of apprehension. It earned me the unusual privilege of never actually having to use gratuitous terms of art like *practice*, or nod eagerly and knowingly at the first mention of Lyotard or Rancière, or worse, draw up artist statements in their argot. But let me not paint the picture too brightly. There was a clear *weariness* in my cohort too, whenever I began to unspool my own thinking, as if I were willfully causing trouble, flouting the ground rules of art-school chatter, the ones we were all in some way aware of but had decided not to fiddle with, for fear of closing off the possibility of instruction.

So I can't say I was *liked*. Nevertheless, by the time of graduation, my teachers seemed to consider dealing with me salutary, in its way, or at least it gave them the impression that my almost violent insistence on independence in picture making would have to bear fruit. Although I didn't pursue graduate studies or

even seek grants—and perhaps, thinking back, I should have; it might have saved me from all that followed—I still had the feeling that they would have made personal efforts to place me.

I doubt, though, that anyone could have predicted what I ended up turning to after graduation, even while never actually moving away from figures and worldly forms. I began to make a subterranean reputation in New York through what Sandy would eventually call my longitudinal studies: paintings of the same person, with varying degrees of transparency, whether of the Dutch or Italian varieties, in various settings spread across ordinary time. The series were developed over years, and it would take at least several months to render even mild transformations of my sitters, the kind that can never be contained in a single image or moment. So it was really only after three years, just as I was beginning my work in earnest on the "Claire series," that a fuller awareness of what I was doing took hold in the city's art scene. What was it? The composition of visual biographies, mostly of unknowns: my previous superintendent, begun really only to win favor; the man, probably a procurer, who spent an inordinate amount of time in the street behind my house, working the stoop; my great friend from childhood, Immo; the eight-year-old son of a rising Bushwick gallerist; and so on. The individual paintings would sometimes appear in magazines, notably *Cosquer*, or be seen in people's homes, in the private collections of the friends I would sometimes give them to, or even in public showings of several pictures from distinct series. But really these projects could only be grasped or experienced in aggregate, in shows where the entire series to date might be laid out—shows of which there were increasing numbers, as time wore on and more pictures came into being.

It wasn't my handling of paint *per se*, or almost anything formal, that struck people first about these images. I'd made it a point not to draw the eye to the surface, where attention had for too long lingered in painting. It was rather what I was able to tease out of my subjects, good and bad, the flickering modulations I registered, the apparent identities I could show to be subtly non-identical. Formal and subjectual revelation emerged together always, and usually only across pictures, over time: in the particular patterning of my violation of power centers, say, or the rule of thirds, or my diversion of eye pathways, or simply my management of pictorial distance. I would sometimes depict the central subject as slightly too far off, for instance, making you want to view certain paintings, quite large format ones, from just inches away, however foolish you looked in doing so, as if this might help you approach the person herself. At first, of course, my close friends had wondered what I could possibly be *doing*, painting such apparently unambitious works; there was even the thought that I'd somehow given up, that all my doubts had led to an implosion.

Four years later, though, I could safely say I'd vindicated the sort of complicated confidence my professors and peers had in me, even if they'd all nearly lost it along the way, at one point or another.

The success of this project was predicated absolutely on its execution being non-mechanical, given how close, in other respects, the results of my work, the collections of images over time, were akin to personal photo albums, the modern variants being a matter of social media. What was mentioned again and again, though, was just how *un*photographic even my most scrupulously realistic pictures were. What were viewers reacting to, if not to the fact that compositionally, moment-to-moment, these paintings were channeled through my hand in a way that mechanical media like film, video, and photography cannot be? Whatever you do to them, using fisheye lenses or chemically burning the prints, photographic objects have a profoundly automatic dimension: the dull, thudding passage from input to output, when the image is truly set. They're stamps, im-*press*-ions of a kind, and although they can be tinkered with in all sorts of ways, this brute, mindless imprinting is at the center of it all. Everything leads up to it and away from it. Painting, on the other hand—at its center lies nothing like that. There is in fact no center. It simply goes on, permanently malleable, every revision being of the same nature as the original, and not something fundamentally auxiliary, as with photographs, which can be doctored, yes, but never reshot as one repaints or redraws.

Every stroke is mediated, formed by hand, which is also to say by the mind—seismographically. You don't simply set something in motion, the way you click a camera shutter or (if you ever do) pull the trigger on a pistol; you're present through the entire flight of the bullet, nudging it this way and that until it hits its target—or misses. Yet so many of my colleagues, I hesitate to call them friends, that's just what they do: click, arrange, shoot, collage. My hand, by contrast, is always in the mix—yet not in some expressionistic way, dripping with subjectivity or affect. No. These pictures are two-way mirrors, poised between the world and me, integrating one with the other.

What I'm keen to say is that there is, with my profiles, no going back to basics, to some simpler, pre-digital time. This is why I can't be lumped in with those who spearheaded the resurgence of drawing and narrative, which felt reactionary to me; iterations of this sort of movement come around metronomically, every few de- cades, this pang for the past—often a past that was, only a few generations earlier, rued for its forsaking of some more distant past. Far from longing for a return, I was interested in analog techniques precisely to make good on the promise

of machine utopianism, a promise made by Marinetti and the rest but never kept, despite all the vast mechanical and digital innovations since then, far exceeding what they could have imagined a century ago. Their dream, at its core, was to push us right to the heart of electric life—and I mean that literally, life since electricity's advent, this being the moment the modern artist had aimed to penetrate. But, in my view, the very one-wayness of mechanical reproduction has always been its irremediable limitation.

Photographic processes, cinema, television, have their charms. That can't sensibly be doubted. If they didn't, we wouldn't have the world we have, and those avant-garde manifestos would never have been written in the first place. Photographs are, in the bluntest sense, spectacular; it would be obstinacy to think otherwise. There's simply something alluring about the mechanical capture of surfaces. This goes back to the camera obscura, whose upside-down images were oohed and aahed at for centuries before the camera proper came onto the scene, even though its photo-esque images—images that are behind so many fine paintings of the past—now seem but distant echoes of the world. To our eyes they have too much of that strange liquid luster and peculiar lack of scaling we associate with the Dutch masters, like Steen and Van Eyck. These qualities did not go unnoticed by contemporaries like Constantijn Huygens, who observed in those images a peculiar sort of magic, the sheen of reality itself that elevated life to another plane, such that you could almost forget what was true and what was only glamor.

But actually, looked at long enough, longer than Huygens lived, it has taken an intergenerational memory to uncover this, we can hardly deny now that however spectacular they might appear, photographs are also (and probably consequently) the least incisive images; they tell us least about what *counts*. Painting, however, even highly realistic work—take those Dutch pictures themselves, like *View of Delft*— painting can't help but exist right at the nexus of mind and world. And that's true even when it dazzles—even when painterly properties are de-emphasized, in the manner of Close and other photorealists who used modular analysis to mathematize the construction of the picture plane. Painting, with the possible exception of flawless *trompe l'oeil* (and do any examples *really* exist?), interferes with immediate, unselfconscious interpretation, in a way that most photography, its brutishly causal cousin, does not, cannot. You have to confront a painting's slight irregularities, and through them the irregularities of its maker, just as much as you confront the world depicted by it. And these traces of the maker affect your sense of the image's significance, provide a kind of subjective map. You're forced to see that the world depicted before you issues from another world: two worlds side by side, or at least one as seen through the other, and you, perhaps, the viewer, forming a third world.

And drawing? Until recently I'd shorted it in the usual way of painters, as a medium for preparatory work and little more. Now I see it as more incisive than painting, more meditative, and more closely tied to the movements of the hand, even to writing—as the Chinese have long known—and through this channel to thought itself. It would be too easy to say that drawing carves things at the joints, cleaves form. But even if it doesn't quite represent form itself, it is certainly a way to *see* form. Drawing achieves this only by trading away some amount of spectacle for in-sight—although, not long ago, I discovered that pastels, with the purity of their pigments, especially the soft, crumbly kind, hardly mixed with a binder, these pigments with their concentrated brilliance could dazzle as well as anything, even outclassing oil. For proof, there are of course the pastels of Degas, which after the age of forty dominated his production, his subjects being mostly bathers, prostitutes, danseuses. Something as simple and startling as his rendering of gaslight proves the point. I always think of this light when I think of him, and the ballet and café concerts the lamps united in their ghastly glow.

In any case, it was just this quality of drawing, the way it could take you down to the bone, along with my gradual transition toward the medium, that Claire began to loathe. *What was wrong with the paintings?* she must have thought. Within two years of graduation, Sandy took me on and commemorated the occasion with a solo exhibition at one of his satellite galleries, lately among the most charmed on Bogart Street. Myself, I found that part of Brooklyn oppressive; the ubiquity of the arts community, transplanted from the art schools of America, unnerved me. I left as soon as I felt I could, which is to say, only after earning substantial write-ups in *Artforum* and *ARTnews*. A solo exhibit at the Serpentine followed, and I'd been given to understand a place in the Whitney biennale was forthcoming. It never materialized. I was told I'd run down the wrong artist with a woman on the judging committee. Apparently, after several drinks, I'd told her that his notions were simply *of no account*. That sounded *possible* to me, when I was reminded of the artist. None of it mattered. It cost me nothing among the few people who had judgment.

At the time I'd been composing the charcoal piece, though, a few months earlier, Claire had become open in her dislike of my switch to drawing and dry media. Once, not about this drawing but another done shortly after, she declared, with an exasperation I rarely heard in her genteel voice, *Sometimes I just hate the way you see*. It was uttered tentatively, without a trace of rhetorical snap, as if she'd only just found the words for the feeling—and even then the words weren't quite right. Really, I knew, she meant *more and more*, not *sometimes*. But I had to wonder, *did* I see any differently now? Was it a change in attitude, or just a change in medium, that was behind her change of heart?

She'd issued the same reproach many times before with the looks she gave me, even if she'd not been aware of it. There was an ongoing, low-grade panic in her ever since I'd tilted toward this new medium, as if I were now closing in on something that painting alone would never allow me to discover in her. She knew as well as I did that drawing was ruled by the line. It was fundamentally the geometer's business, a rationalist art, a reconstruction of volumes in space; whereas painting, with its colors and masses and secondary use of line, emphasized the surfaces of things, the dazzle of consciousness, at some expense to structure. This was true even of painters who *were* great draftsmen, whether Raphael or Rubens or Delacroix. And that was why one would have to say that many of Rubens' most *forceful* pieces were actually drawings; the same went for Rembrandt, in fact.

Painting, I came to realize, was almost an apology for the nakedness of drawing, a way of glossing over its conceptual blading of the world. It was a way of seeing blindly, so to speak, or passively, without the critical powers of the mind. Photography only heightened this tendency; that's why so many painters have been entranced by the lens, optics, the camera obscura, and the photograph. In contrast, drawing was incontrovertibly an analytical art: the mind's contribution was obvious, and there was no attempt at representing a sensory given—as if such a thing were possible. What one senses is as informed by what one believed as the reverse. Drawing simply owns up to this conceptuality, that is, the mindedness of seeing, rather than vainly questing after pure experience.

Drawing, then, began to feel like the intellectual *height* of the two-dimensional arts, its essence, its philosophy: not some rough-and-ready starting point toward rendering surfaces, as the pervasive notion of the sketch would suggest, but the ultimate product, fully distilled. This is why, for me, photography poses at least a *prima facie* problem for painting, in its competition for surfaces, whereas it offers no difficulty at all to drawing, properly understood.

The more I realized that painting shared in some of the empirical poverty of photography, the more tense my images grew. Fault lines glossed over in paint were now unmissable. The trouble in Claire, the mistake in her face I began with, which might not have been an intrinsic quality of hers but a relational one concerning *us*, her-to-me, started then to appear. My gaze sharpened; it began to *penetrate*. Even in my early sketches and studies, the problems manifest in the later drawings all seemed to be there, latent. That is the way I would come to think about it. Considering them then—those gesture drawings; the mass studies; the contour pieces made with one continuous stroke of the pen, circling for many minutes; the modular analyses, heir to Alberti's window; and the tonal studies in the same mold—I could see now, and I felt then, inchoately, the tension in all of them,

usually inhering in the face, or the face beneath the face, or in its interaction with her body or with pictorial space itself.

In fact, even when I wasn't painting Claire, many of her expressions troubled me, so that I had to consider whether something in me may have been chafing at her, ruining her even, inducing those appearances. That was what it meant to think there was a mistake somewhere in her face, or at least a problem, and not simply in the rendering—how could I have got it wrong so many times, with so many chances?—but living in the face itself, protean, resistant to isolation or extraction, constantly requiring a fresh attempt to trace its state but never, *never* disappearing.

Perhaps it was best she was gone.

By the time of this drawing, this incomplete charcoal portrait, I think Claire was already sensing the end, even if she didn't believe it just yet, and wouldn't have endorsed the thought if presented to her. And perhaps that distracted look I'd put on her face in the picture, that errant gaze that missed my own, was my way of registering this, too, though the thought, naturally, never entered my head when I'd drawn the picture.

Whatever it was, the fact remained that I'd left her transposed body unformed; it was more of a ghost, only hinting at a potential mass, and not, I thought, in a way that created much interest. But I'd refused to work from photographs and finish it, not without her standing just so in front of me. The entire thing had been composed by sight; to rely on facsimiles now, or to advert to memory, would have been to corrupt the work. The solution came to me quickly: I exacto-ed the support at her neck and kept the nearly finished head, leaving enough of the neck to give the face a sense of life, yet excising everything else so as to avoid suggesting that this truncated version wasn't the original idea, that in fact there had been more, much more, imagined below, visions that never reached completion. Claire's face, after the severe cropping, was far off to one side of the picture, beyond the natural focal centers of the rectangular field. I could have clipped the space on the other end to shift it toward a more classical spot, but I liked the scale it seemed to add, completely blank, and the tension the imbalance created, which well suited that trepid state of hers, late in our relationship. The proportions of her face were convincingly rendered, not in the mathematized manner of linear perspective—no, it was more convincing, more elastic than that, as experience actually is. Here I had indeed turned to that northern tradition of what is sometimes called optical perspective. In the right hands, such an approach to point of view could admit a trace of the original wildness of sight without losing touch with forms and meanings that lay beyond sense alone, that necessarily engaged the broader capacities of the mind. This was, to go by what others said, one of my primary talents: rendering space in a manner that would satisfy neither

a representational nor a formal approach. It was a kind of deep sight, I liked to say, the only kind worth cultivating. It cut through the surface to the objects themselves while remaining drenched in experience. I could mention Kant here. Or you could simply look at a Rembrandt.

Staring into Claire's charcoal face then, I couldn't help but think better of the third picture, the pastel one estranged from life only by the generosity it showed the inanimate. I'd done it months afterward, though the image recalled an even earlier time, in buttery ombré hues, almost impasto in their density, though soft pastel, not paint, was the medium, applied in heavy strokes to a bone-white vellum ground that had been brushed so that it would more easily take pigment. I'd forgotten the fixative; it had been shedding color ever since. Along the way I'd had to shore things up with gooey oil sticks.

The piece was a few months old now, and it dated to a period in which I'd already discarded my photographs of Claire and begun to draw by another instrument: memory. She'd been gone for at least a few months by the time I started. In the weeks after she left, I didn't paint or draw anything of significance, didn't really even try to. There were a few sketches I'd attempted without much feeling and soon aborted—mostly in rollerball—while I was occupied with more practical things, essential things, like compiling a list of bills that needed paying, and in what order, now that I wasn't selling paintings anymore. The drawings would bloom and die before I could ever regret beginning them there in the margin of a piece of recycled spiral notebook paper that bled heavily at the first drop of ink. They were done from phone snaps, which I relied on to bring her back to me, as if, remarkably, I couldn't quite conjure the woman who'd just been here. These days I could bring her to mind much more easily and richly, like seeing her in the reflection of a frozen pond, with a degree of tranquility that had been out of the question then.

But even in those days, when I couldn't summon the energy or build the momentum to finish any of the sketches, the photographic cues seem to steer me wrong. I would have done better to imagine a random woman than to try to use any of them as spurs. They seemed almost always to remember the wrong things. And it was only after turning away from the photos that calm finally came to me and I could return to her properly, in reminiscence.

If I were to do this piece again, I'd go for something even less painterly, something fully planar, materially, no impasto, no topography. I'd also expand the space, front to back, through greater contrast, or by depicting some object, it doesn't really matter what, looming right up close on one side of the picture, forcing the rest of it back. And perhaps, yes, I'd be a little more careful not to let what was in her, or what she was made of, torque her surroundings—even though this curious sense

of distortion was, in her best moments, the most remarkable aspect of actually being around her. What am I saying by this? She bent space. Without her presence to exert that pull, life certainly couldn't be like this anymore. But what about life *then*? Memory let me hew to the essence of those encounters with her in three dimensions, something at which my photos of her seemed always to fail. And not just photos. The eye itself, I realized, could fail in this. Painting from life, via plumb lines and the like, visually tracking proportions and curves and planes, could blind you to whatever it was that grounded, or better, gathered, all of that. Sight could present too many things indifferently, fracturing the world into near-autonomous shards, leading you toward an inchoate literalness that defeated the prime function of the organ of vision, which was to track the *consistency* of objects through time and space. There was, in fact, a touch of these problems in the charcoal face, which had after all been drawn from sight. The picture, my lines, failed to find the thing-ness of Claire—not in the subject-denying, derogatory sense of *thing*, but in the good sense: what it was that made her something more than a sweep of color upon the retina. My picture failed to see her unity, her integrity, and in turn, since it could locate no object, could hardly find a place for her subjectivity.

In my defense, at the moment I'd composed the charcoal piece, Claire might well have begun to falter subjectively, so that the flaw you saw in the picture was actually just a flaw in her. What made this drawing unsatisfying might then have been precisely what made her unsatisfying, even aggravating, though I couldn't name this in any more precise way. The drawing was the flaw's name, I suppose, or it showed the flaw, the fragmentation, in the manner of a demonstrative. *This.*

In the *pastel* face, though, the one I'd built only from memory, I'd fared much better in finding that ground, the unseen presences, the subject in the object, or perhaps more precisely, the subject of the object. Whatever my misgivings about the picture, I reveled in what the pastels had managed to corral, in what memory had managed to see that my eyes could not: the way space had been remade. Yet memory revealed a different flaw in her being: a smoldering intensity that in time would sear the world around her. Tellingly, the memory I'd pulled from for this one predated the charcoal moment by many months, extending back to a time when the problem with her had actually been an excess of inwardness rather than a shortage. *That* was to be preferred, I thought, at least conceptually, or maybe just romantically—a surfeit of human being, unshaped sense to formed emptiness—even if it was also a terrible portent of what had now already come to pass: the burning of bridges, I mean, and then the disappearance. How metaphysically clingy she had been back then. I'd felt a tremendous responsibility for guarding her being, preserving her feelings, which were so easily bruised, particularly around the matter of our work, the way she was being

punished, at least relative to me, for her good behavior, her politesse, everything her childhood had inculcated in her. And I was being rewarded for my truculence.

Both these drawings of her tracked a mutation in Claire's aspect over time, the changing impression she made, or really anyone makes, if one attends closely enough. This was something traceable through the earlier pictures I'd rendered in paint or graphite or ink, though at those times, whatever it was, if it was indeed *one* thing changing, it took different forms. It was this quality of these series of mine—there were now, all told, nearly a dozen of them; Claire's was merely the most recently launched, a launching she might well have taken as a declaration of war, knowing what had become of the other subjects, visually anyway—it was this quality that had gotten me attention, the way the pictures, however different they were from each other individually, seemed to hang together across time, without excessive self-consciousness or contrivance, without imposed narratives. They held together almost of themselves, as incomplete worlds, partaking of precisely the temporal dimension painting lacks, which has been overcome, in the history of the medium, by a rather strange means: I mean the manner in which, in certain medieval paintings, the background of the painting actually depicts the background of time, so that you can see the past life of all that occupies the foreground: the man as a boy, the tree as a sapling, and the like. As ingenious as this might have been, it was no general *solution* to the problem of time. As for my paintings, though, each one gestured forward and back, opening up further symbolic space with every new iteration. A professor of mine, not Sarah but the famed West Coast artist Paul Archer, had at first been a skeptic of my work but ultimately must have come around, judging by the frequency with which he kept in touch these days. He'd started referring to these pictures of mine as history paintings, although of a peculiarly private sort. It was a startling formulation, to bring to the fore the old hierarchy of genres that had come undone so long ago, halfway through the nineteenth century. But I knew what Archer meant. If you let yourself really settle into these profiles, to the worlds collectively disclosed by them, if you sought to live in them, as several of my most devout collectors did, and as I before any of them had done in composing the series, each image began to carry a symbolic charge that was not incomparable, at least structurally, with classical images, or *illustrations*, really, of the watershed moments of religion and myth. *Un pictura poeisa.*

What differed, of course, was the breadth of the network of significance represented. With the Greek gods, you had a system that could cover most of the Earth; in my pictures, the semiotic field was drastically curtailed. But both offered a point of view on something, or someone, which overran that of any individual picture. This excess of meaning, balanced against the complexity of the representations taken in total, the way each new image continued to disclose without apparent limit, must

have been the deepest reason history painting had been placed atop the hierarchy by those rigid academies: not for any of the compositional reasons frequently given, as if they had some independent standing, but because of the primitive, boundless charge of event, of significance, living within the paint.

2

Six months had passed since Claire had left, and a full year since I'd shown publicly, whether my visual profiles or any of the smaller things I'd been working on. There remained, as I say, only a few collectors to take my pieces, and at this point my livelihood was staked on them. I'd had a temporary position as an assistant programmer at the new Carrington Center, acquired through Claire's family connections—prominence in Boston meant influence in New York as well, though not always the reverse—but my contract hadn't been renewed. They simply let me know one day that the end of the month would be the end of me. I'd been surprised. I shouldn't have been. The Carrington staged a mix of high-profile art and academic events throughout the year, and my correspondence with various cultural celebrities, the very currency of a place like the Carrington, or Symphony Space, or the 92Y—well, my correspondence over the past year had been judged less than genial. I'd even positively ruined one event on the calendar. The keynote, Martha Nussbaum, wasn't able to make it in time because I'd not reported a change of schedule to her. Or, more to the point, because I was busy pining after Claire, repeatedly drawing her face on company stationery. Explaining the lapse to my manager, I'd posed the question of whether there wasn't something fundamentally forgettable about Nussbaum, which got me just as far as one would expect. Nowhere.

Without the job, I had no other means besides my holdover collectors, who numbered just four. I liked to think, of course, that what kept them in my thrall, and, more to the point, what would keep them that way, was the charge running through my work and the growing semiotic space it defined, a plenitude proven inexhaustible precisely by the shortcomings—the mistakes—of the individual pictures. Admittedly, they might have had other reasons for staying on with me. My withdrawal from the usual circles, just when I was beginning to attract real notice—and just before I was commanding serious prices—may well have *increased* the appeal of my pictures for the savviest collectors. They might have hoped my peculiarly private histories would gain in value as they grew more private still, with any additions to the series no longer finding their way into the light. Given the riches of Manhattan's buyers, this wouldn't be a bad bet to place, like buying up penny stocks just for the hell of it. But I tried not to second-guess motives. If you took it far enough, you could find reasons, good ones, for rupturing every bit of intercourse you had with the world. That was fine on an individual level, but globally it could feel catastrophic. One thing I knew, anyway, was that the collector

who'd been buying up the Claire series, the series I was most deeply invested in, and thus the one I guarded most carefully, was acquiring for the right reasons. I had no doubt. The man's name was Roger Whent, and, just as I'd done, he lived intimately with these pieces. I had so much conviction in his interest that, unlike the other buyers, I even let him have a hand in which pieces went into the series.

How many of them were there, officially? Forty, perhaps, even if Whent held only about half. But *which* forty? Wasn't the canon always shifting? There must have been two hundred pictures of Claire, at all stages of evolution, laying about my apartment now, never mind the ones Whent had bought or I'd destroyed, and the two or three which I had to assume were still with Claire, as I'd been unable to find them in the stacks scattered everywhere. For a time I produced pictures ever faster after she left, not only, I presume, as a matter of simple nostalgia and of penance, too, but also as a kind of denial, or a way of conjuring and nullifying her departure. It was only natural that some of them ended up as little more than effigies for the fire. Since the spring, you could say I'd found my way into a productive solitude—it would be the kindest way of describing my condition—though I was still unsure what sort of artistic returns I could expect from all these pictures of Claire. A good many, I suspected, would ultimately need to be destroyed, particularly the ones that were going to be of more interest to a psychiatrist than to a man looking to understand something about the world, and not just the sorry state of my mind.

If I'd had any regular visitors, or even the serious prospect of one, I might have already been driven to bring more order to the images, as they occupied not just the living room of the apartment, which had served as my studio since I'd moved in a year ago, but much of the rest of the place, too. As things stood, I'd not seen anyone here in two months but Immo, after a night of drinking. I doubt he could remember anything much about the place, and if he did, well, he was long familiar with my ways; there was nothing worth hiding from him. Even very good friends, though, especially any with a connection to art—John, Lindy, Rick—I'd not allowed here, never mind that my quarters were tantamount to a mansion for a young artist: I had rights to two of the three floors of a townhouse that loomed imperiously over the neighborhood from its position on a hill near the center. There was no way of having someone visit, though, without exposing the abject overgrowth of my art, which I was in no state to tame. The only picture anyone realistically could have come away with was one of psychosis.

For one thing, I'd transformed the massive, south-facing window into a kind of Albertian veil, cloaking it in a grid not of fabric but of grease, from the strokes of a pencil, at a quixotic moment when I'd thought to transfer, as Dürer depicts it, what could be observed through this mesh, in strict linear perspective. In Dürer's

case, there'd been a person on the other side of it. Mine, though, was closer to a landscape than to a portrait. There was the lonely little park beyond the glass, one thrust upon the neighborhood by an earlier generation of city planners hellbent on slum clearance. It was thought more or less uncrossable after dark, but three or four times I'd been intoxicated enough to make the trip—without event, so far as I can remember. How often had I stared out through this lattice thinking I should begin the transposition to canvas, square by square, of that iron gate fronting the greenery that seemed forged in another era? How impressively wrought it was, even if the metalwork had been painted over in a cheap black that flaked profusely, leaving the gate looking worse than if it had simply been left to rust. The foliage at least seemed just right for this park, shrubby and stunted; and cutting through it, just behind the gate, a wide gravel path ran onto an artificial lake in the distance, meeting it at its vanishing point. I'm not sure why I never actually rendered the scene. I did a tonal study of it once, filling in each cell of the paper with values of green. It had made for a pleasant afternoon, mostly in the mixing of paints, creating that abundance of greens. That much I can say. But I threw it out: no one needed bad Mondrian. Maybe staring through the veil was enough for me; nothing else had to come of it. In light of the rank violence of this warren of streets, or at any rate its chronic unruliness, I can't discount the sense of security those fine bars on my window gave me—even if they were merely grease.

Today, I was to see Whent. It's why I'd been going through all these images, reconsidering the faces of a now vanished woman. I slipped the two drawings, the pastel and the charcoal, flaws and all, into the leather portfolio I'd been using since art school. Either or both might find a place in the narrative I understood to run along Whent's walls; I'd yet to see this display myself, only heard of it from him and others who'd been to his tony triplex on the Upper East Side. What else, though? Sitting just beyond the pile of drawings I'd been examining in yellow-gray light given body by car exhaust was an overstuffed chair whose wrinkled blue vinyl skin stayed pleasingly chilly in all seasons. An apricot cloth sofa in the living room faced north, while a stool occupied the far corner. Generally I liked to stand and draw, at the easel, relying on a painter's muscle memory, or else sit back in the blue chair and draw in my lap, like a high schooler; but I never worked at the drawing table, which felt too much like abiding a desk job. Accordingly, the table ended up mostly a repository of artistic detritus: at best, after sweeping the debris away, I could examine work there, but never alter it.

Poking out from under the chair was a group portrait—gouache on frosted Mylar—of Claire and her two younger brothers, arms all locked, out on the roof of a gallery. They'd been at an early morning celebration of Claire's first solo exhibition,

which had taken place earlier that night just below, at the Crestle in Chelsea, a rival to Hinton, in fact, though Sandy didn't see it that way. I don't think he could quite fathom the idea of rivals; everyone he had any interest in working with, he *did* work with. He had unusual taste, which meant there weren't many competitors for his clients, at least in the early days. I missed Sandy sometimes. Not enough to take his calls, but still.

It was probably six in the morning, in the scene here portrayed; the last of the guests had cleared off an hour or two before. Three champagne flutes stood on the ledge behind the siblings at about the height of their chests, showing through the interspace almost symmetrically, as if arranged by a group portraitist. The light had just made its presence known, I recall, but hadn't had a chance to deepen, so that its main effect on the white rooftop concrete was to brighten it subtly, and then, as the minutes passed, to bring it an off-white note. At the same time, two of the glasses began to glow orange from the mimosas they'd made from bodega juice and last night's champagne. I stood apart, taking the scene in from the opposite side of the roof.

I remember first rendering the scene not on Mylar but on Bristol board I'd found lying around the gallery, probably from a previous show. I'd applied sanguine heightened with white chalk, all while they drank and talked and occasionally pointed toward me, though it was a common enough practice, my picking up a pen or chalk at social events, that their comments were few and mostly of the *once again* variety. I abstracted their movements, and their faces too—bleary, just as you'd expect—and I did this not as a workaround but rather because of what the rooftop had given me: perfectly square blocks of concrete, which formed, from where I sat cross-legged on the ground directly opposite the group, a radically foreshortened trapezoidal *pavimentum* leading back to a single vanishing point. This gridded floor, common in those days before Cimabue, became in my hands the plane of sibling fraternity.

I'd turned the original sketch, later that week, with better rest and stronger light, into the drawing now in front of me. I rubbed my fingers along the Mylar, which kept the undiluted gouache glistening right on the surface, like the page of an illuminated manuscript. The three of them existed there on that grid, in the still flat forms of Giotto, evincing in their geometry the symbolic relations holding between them, rather than the merely sensory relations of *perspectiva artificialis*, that seismic invention of Brunelleschi and Masaccio.

Originally I'd tried to single out Claire through the principles of yet another treatment of space, one I was especially fond of: aerial perspective. Intensity of contrast, sharpness, darkness of edge, all served to pull her forward in the white field of light reflecting off the gallery's roof. But the effect, even before I'd gotten three-quarters finished with the drawing, was unambiguously wrong. It separated her from her kin

in a manner uninterestingly at odds with that morning: Claire had been off to one side, as I remember it, with her head leaning lightly against her eldest brother's arm and with her right hand gripping him by the wrist, as if considering where to lead him. Her expression suggested only minor dissatisfactions, set against the backdrop of a general contentment that was the birthright of all three of these Beacon Hill brahmins and the broader Billings clan. Meanwhile, the two brothers wore a look of tipsy exhaustion. Jeremy, farthest from Claire, was some years younger than the other two. He was still in high school, in fact, yet already, I understood, a man of philosophy. Who could say what that would mean in later life, though? Everyone in his family had had the most catholic of educations. I'd gotten to know the youngest better than Ted over the years, as he was often around their Boston home when I'd gone up to see Claire's family. Here, in the curious angle of his haughty gaze—not just downward but inward, too—Jeremy showed signs of a burgeoning glumness generated by no one in particular, merely the fact that proceedings he'd relished just hours, even minutes ago, had carried on slightly too long. Ted, in the middle, was a newly minted lawyer I'd never really come to know. Not that there was much chance of that: though he lived in New York, his residence might as well have been the offices of Debevoise and Plimpton. He did tend to be more forward than Jeremy, and here he trained his eyes, the only pair unmarred by signs of disturbance, directly on me.

The salient feature of this picture was the curious indifference all three figures evinced, in different ways, toward appearances, false meanings, and missed signals—even simply toward me, as the visual transcriber. It was as if what I or anyone else understood of them now, together, was of no concern to them. It seemed like a congenital condition to me, but perhaps that's just what one assumes of the unimpeachably born. Tracing their represented bodies with my eyes, considering them as one linked form, the picture struck me as a sort of overlapping reverie, really, only in part about Claire's apparent success in the gallery. The show had been attended by a smattering of young and influential critics and artists, and they'd all seemed genuinely unsure of themselves in the face of her sculptures, struggling for words, even the silver-tongued among them, which was a bit of a first for her, and a quite reliable sign she was on to something. But the Billings reverie comprised more than this. It embraced exactly what they'd become over these past years: a single psychic body, just as their interlinked forms were conjoined by this moment. Seeing this, knowing this, it couldn't be right to separate them in space.

What I needed was to keep Claire just where she was, on the same plane formed by her brothers, but scale her up the tiniest bit, which would make her precisely the right size symbolically, that is, optically oversize, though by such a small margin you wouldn't necessarily notice unless you were a painter yourself. In the end, the picture I arrived at managed to lead the eye to centers of symbolic import without, I thought,

implying the wrong sorts of relations. The malleability of proportions, of course, was a known feature of children's drawings, art brut: empirical rather than linear perspective, which I always left myself open to, departing from Alberti on this point and admitting the Dutch tendency to allow certain sensorial irregularities grounded in the eye's natural susceptibility to illusion. But the conscious mind, unlike the camera, could afford this, as it had a means of thinking away aberrations. The eye didn't merely sense. It *perceived*.

That said, I suspected Whent wouldn't care for this drawing. Not so much because of its rejection of linear perspective, but because it might come off as pastiche to him. Neither of us had any patience for the glut of imagery squeezing contemporary figures into bombastic Renaissance and ancient molds. Painters like Kehinde Jones wasted whatever talent they had on these wry gags. They were clever for a moment until their work decayed into insufferable kitsch. Nothing could be less amusing. But their worst crime was that these pictures' mere circulation through the culture tainted the eye, which could lead one to shallow readings of the sort of picture I'd made here. I'd *not* grafted on or played up any historical features, as Jones and others did. No, the scene itself that day had been subtly built from them. I'd merely recognized as much. It had all come down to the faint light of a half-risen sun, which turned every form it touched abstract and volumeless.

I wasn't sure if I was interested in debating this with Whent today; I also wasn't sure I could avoid it. So I slipped the early morning memory into the portfolio, too, and left it for him to judge. There had anyway always been a divergence between my personal sense of the vital elements in the series and his. This had been true for all the series, actually, all my serial buyers, whether the individual pieces were six or forty in number. Perhaps that was to be expected, even indulged. Whent and the others had all politely declined some of my images, and I myself turned against more than a few of these rejects, shredding them or, when I felt less hostile, dropping them just inside the gates of the park to be dissolved by the elements or scavenged and incorporated into the "houses" of the homeless. But then there were some declined pictures I held in even higher regard than the ones my collectors had taken. This particular one, the illumination of the rooftop scene, might end up among that lot. Certainly it wouldn't end up in the park or on the fire if Whent didn't stake a claim to it. It would simply become a member of my shadow narrative of Claire, as it seemed to me to say something about her overlapping identities, filial ones, that the rest of the images I'd placed with Whent had not so much denied as simply passed over. Didn't that guarantee it a certain importance to anyone genuinely engaged with the woman in the pictures?

Yet even if he felt differently on this point, it wouldn't represent much of a problem for me. As far as I was concerned, he grasped only fragments of the world I'd

excavated around Claire. Still, I was eager to see his particular version of it, reconstructed as if from artifacts and then arrayed throughout his home, which, unlike my own, presumably couldn't have the character of a genuinely *private* environment. Surely, I thought, this technologist's triplex was kept in an antiseptic, quasi-modernist state, built to resemble (or even blankly quote) the very sort of venue I'd been backing away from for over a year now: the white cube of the museum, a space without a center or indeed a nature. But what I liked about Whent, why I continued to offer him pictures, was that, whatever I discovered about the condition of his abode—and perhaps he might surprise me on this score—he really did appear to dwell in these images, in the world they brought into being. Given the way I lived among my portion of the world of Claire that was shared out between us, how could I not feel some kinship for him, businessman or not?

Slowly I brought myself to my feet. My thighs ached from spending most of the morning crouched on the floor, crawling about. I took the forsythia pen off the drawing board, the one Claire had carved so carefully it became a sculpture in its own right, and approached the last of the pieces of her I'd started: a contour drawing I'd done in blue ink, dense with crosshatched lines, that I'd taped over a section of my northern window, where my fire-escape balcony was. Whenever my apartment seemed too filled with light, which was never a bother earlier on—only in the last months—when, passing so much time here alone that light itself felt like an intruder and my eyes craved a lower intensity, even while working—whenever things tended this way, I was in the habit of using drawings as blinds. I peeled it away and pinned the picture to the board on my rickety easel without any definite intentions, not yet, as light passed through the liberated pane, though like certain other of my windows, this one also bore the marks of a grease pencil. I struggled to recall when I'd made *these* marks, the glass had been covered over so long; but as I dabbed at the lines with my finger, it occurred to me that, shortly after signing the lease, I'd used this window for an old-fashioned technical exercise. It'd served as the picture plane onto which I'd traced the scene outside, while standing just in front of it. Looking down at my feet now, I could see the tape marks I'd made for precisely centering the viewer, fixing a point of view on the tire shop, slightly out of place, it had always seemed to me, flanked by soot-cloaked apartments with an underlying color of especially opaque dishwater, such that the soot was modesty-preserving and the best part of their appearance. In front, along the near curb, there was a line of cars that ought to have been bronzed, they lay so immobile. The street between these two planes was

subject to minor winds, often in the early hours, which would spin the city dust in circles, collecting cans and candy wrap- pers in their vortices. Little trees lined both sides of the street, trees that were easily mistaken for shrubs that blocked one's view of nothing. They leaned back on both sides, away from the street, as if in reaction to the choke of fumes thrown up by traffic, wilting rather delicately over the mineral side-walks shimmering in the summer so recently passed. My prospect was completed by countless hulking television sets that looked like long-discontinued models bought on clearance. More likely they'd actually been acquired in an earlier era and passed down like family heirlooms. It was still an earlier era here; time moved more slowly in the Bronx.

These cathode ray sets cut generous trapezoidal figures in my visual field, and they were all framed within the matrix of apartment windows of the private housing project across the street, lending the otherwise decrepit building such a pleasing ge-ometry, soothing in its uniformity, and imbuing it with a kind of order that raised its dignity, at least superficially, above that of the more arbitrary arrangements of shantytowns.

The notable property of this scene, and of the drawing it left on my window, if tracing could properly be called drawing, was its banality. The only thing elevating my marks above a student exercise concerning the manner in which light intersects a support, and the reason (perhaps) I hadn't yet wiped the grease pencil from the window, was that so little altered in my neighborhood, week to week and month to month, that even a season later this drawing continued to match the scene outside almost everywhere.

Almost. As I looked out the window I could see only one car just slightly not fitting its outline; a couple of televisions seemed to have been rotated, and a football that had sat on a low rooftop was missing. Months ago I'd watched a middle-aged man with sweat-soaked hair sidearm the ball up there in a rage; presumably it'd been retrieved later by the teen I'd seen on the street in a face-off with him. The man must have commanded some sort of respect in the neighborhood, as the teen and his friends just walked away after trading the usual abuses with him: he was old and stupid and a chink, apparently, while they were scumbags and druggies, by his reckoning.

These little changes, especially the way the seating was sometimes displaced in the windows through the vagaries of kitchen-table talk—residents would be slumped into chairs I'd outlined empty, in the early morning hours—this was all effectively proof of life in a neighborhood that otherwise might have been embalmed. And indeed it was that moribund state, and the depressed prices that followed in its wake, prices that hadn't changed in years, that gave everything here a certain glaze, as if all were trapped

in amber. Still, those prices were what had lured me in. For what I'd been paying in Bushwick to rent an apartment with a separate studio, the Bronx had furnished me with a palace of my own: two whole floors in an ornate Georgian townhouse curiously surrounded by tenements. The house, I understood, had once been the pride of an ambitious developer, and the apartments just across the way, as well as some to either side, also once belonged to him. There had been a couple of decades, back in the fifties and sixties, when his private housing project seemed to be working as intended. He'd certainly grown rich, and his high-rises looked half-decent at the time. He'd been so pleased with his work that he cleared some of the land and built himself a grand townhouse—on a hill he *also* built. At that point he became a lord, and his neighbors accepted him as such. Eventually, though, the slums came for his buildings and the lower-middle class fled, leaving only the poor with their crack cocaine and ice. For a while he carried on in the midst of a newly menacing ghetto, a proper slumlord now, if still relatively wealthy thanks to government subsidies for good works and the rents he extorted from his serfs. What finally brought him down, in the late 2000s, was simple tax fraud, which was only necessary to sustain his margins, his luxurious residence. Since then, the house had fallen into disrepair and the tenements had been sold off—to another slumlord, of course, who was clever enough not to live among his subjects.

My meticulous drawing, rendered directly on the window pane, was perhaps my only way of coming to grips with the slowdown of time around here, this map of a moment through which the few glacial changes that did occur could be gauged. The piece made a certain kind of infrastructural and economic abandonment visible, one that I was discovering to be less depressing than you might assume.

The picture vanished as I lifted up the window. Recently I'd begun to fresco the walls surrounding it with more and more of the view to be gotten from the iron escape, which I climbed out onto now to breathe some of the invigoratingly dirty air. It smelled faintly of frying oil from the deli below, grease that was almost black. I doubt the staff ever changed it, though the chicken fingers that emerged from the sludge were actually pretty good. I'd been making a similar fresco of the gridded window on the south side, facing the park, even though there was no escape there and I had to poke my head out the window periodically to get a sense of dimensions. Both of these parallel worlds, the tire shop to the north, the park below, slowly encroached on the whiteness of my walls and headed for a collision at some indeterminate future point—perhaps in the spring—on my nearly windowless western wall: oddly, there was just a slice of light coming in near the top, like a prison. What had the developer been avoiding back then?

The fresco, to my mind, was merely a complex doodle. If it came to nothing but patches of paint, separate scenes collaged together, as it probably would, fine.

And if it became something more? Maybe the unity just beginning to show itself here would emerge in full, and the image on my walls would come to depict not a series of discrete places, like maps of different towns, but rather a single continuous spatial field containing all these scenes, so that there was nothing arbitrary about the arrangement. On the contrary, it would become a kind of effacement of visual barriers via paint, transparency rendered through opacity. If, through this erasure, I succeeded in turning myself into a plain air painter like Monet, it would all be an unintended extra.

Unlike most of my work, there was no real way to fall short here. I picked away at it between other projects with clearer stakes, whether of a more rarefied sort, like my figurative paintings and drawings, or the more banal kind that was becoming a regular feature of my life in these days of unemployment: my dip into commercial art. The mural offered me a special place of peace, a place without hope, which is nicer than it sounds. My life with Claire might have been better, might still have existed, unbroken, had it been a bit more like this. The same could be said for all the drawings crumpled up in the trash bins around my apartment. I kept an unusual number of them, Immo had pointed out to me on one of his drunken visits. It was as if, he said, I needed the option of disposing of things within eyeshot at all times. He was being fanciful, as he liked to be around me, flaunting a kind of whimsy, or waywardness, though there was so much waywardness in his life already that whimsy might have been exactly it. Certainly nothing pernicious followed his little conceptual flights.

I'd ignored muraling at art school in favor of canvas and board. Now I ignored it, mostly, in favor of parchment and paper. Only parts of this piece—which I'd begun while Claire was just starting to flirt with exiting the Bronx, and my life—were rendered with any decisiveness of finish, and those only with guidance from John's friend Connell. That was his last name, but it was more attractive than his first, by his own admission, so that's what we called him. Because of his skill in frescoing, the priming of the surface, the mixing of paints for it, he was the only other person besides Immo to have come to the apartment these last few months. What Connell reported back to others I didn't much worry about. He had a sort of circumspection to him, the result of a strict upbringing, which made me feel he wouldn't enjoy gossiping about me; according to what I'd heard, he might have suffered acutely at the hands of gossip himself, questions about his mental health and the like. His mien was not quite affectless, but his being was steeped in anxiety, the kind that made him smile in an unhappy sort of way while his eyes darted around. He lent his talents to me mostly without comment, which is to say that he simply painted patches of the wall and expected me to take it the rest of the way. The softening of his manner over the weeks, the growing curvature of his mouth as he inspected my progress or touched

up things I'd done, was the only acknowledgment of my achievement he offered. And it was plenty. For his own part, Connell had given up art. If he found working with me on the mural worth his time, how could I not be honored? These days he mostly loafed, though he didn't call it that. He fancied himself a peripatetic philosopher and intensely guarded an old little notebook he carried around, as though whatever was in it, some secret solution to a problem we didn't yet know we had, would one day justify all his apparent idleness. His visits, and my gradual improvement in technique, meant that only the most recent bits of the mural, particularly the overgrown ash tree compromising my view of the park's gate, showed any verve. Parts of the piece had gone up in acrylic. I'd tried tempera, in a nostalgic moment, but I'd prepared the paint poorly and much of that portion of the picture had flaked away. Other areas were skeletal, mere underdrawing I'd abandoned, perhaps owing to some interruption in my life at the time, or a loss of faith or interest in that bit of the world I'd been trying to put before my eyes. Still others amounted to polished drawings, rendered in high detail, using powdered graphite—a favorite of mine—applied with stencils and a brush. Finally, in the shrinking white expanse between the two clusters of scenes, north and south, I had executed, on the western wall of my apartment, what was essentially one more drawing exercise. This was a sketch of the long, ragged roots of a tree—a tree upended, I imagined, by an eddy that had turned violent in the small yard behind my house, swirling not merely dust and urban detritus but also the larger structures of life.

Of course, I never actually *saw* those roots, their irregularly formed masses. And not just because the wall obstructed my view. From ground level, too, I knew there'd been no eddy, no uprooted tree. No, I saw these particular roots, the ones I'd been frescoing in fits and starts, only in my mind's eye. But where, I often wondered, was the analogy supposed to be between this kind of inner "sight" and ordinary vision, the one that showed them to be variants of a common phenomenon? No one, really, could give a definitive answer to this. Inner sight might well have been one of those linguistic maneuvers that served only to create a false understanding of the workings of the imagination. It would let you get on with things instead of being drawn into the riddle of the interior, the ways so-called mental imagery at times could seem, as when I was "examining" these roots, highly stable, controlled, regular in its behavior. When I attend to one of these tendrils, now represented on the wall, I can "see" the others in the background, in my peripheral—what? Peripheral *imagination*? For of course in truth there was something deeply groundless, or constructive, shall we say, about such imagery; there was a spontaneity to it, since there was no inner object that could plausibly regulate, through any relation of causation, the changing imagery given to me, in the way that physical roots, placed in front of my body, could regulate ordinary

vision, guiding my sensory states in a predictable way, and therefore answering to the geometry inscribed in *perspectiva artificialis*. What, though, was the *inner* geometry of the imagination? Was it specious to assume that the imagination so much as had a geometry, just as it was to think of one's head as the location of one's mind?

In any case, this purplish root on my wall was for now an island in a sea of white. If I ever bothered to finish the mural, to integrate the northern and southern faces through the imagery to the west, I might well paint over these glowing, outsize roots of a dead or dying tree and return to my pursuit of transparency, tethering the imagery to what existed directly behind those walls—what you would have seen if *they* didn't exist. Gazing at that in-between and undecided space inhabited only by the overturned tree with its roots exposed, wondering what direction I might take, somehow I arrived at a much more pressing and altogether different conclusion: to take two more drawings to Whent's place. Five pictures, I supposed, would make the trip worth the trouble.

A skull, I knew, had been peering at me for a while now, not from here but from my bedroom. I'd composed it in sanguine on black paper, where the chalk line rarely came up off the support, massing instead in various densities, thickening in circles, representing what I understood to be Claire's deep self. Peeling the skin off her face with my eyes: that's what it came down to. I'd done it so many times. But what had her opinion been of this particular picture? The image had been up on my wall for many months now, I knew. It was strange to me that I couldn't remember her reaction; perhaps she'd had no strong feelings about it, regarded it merely as a routine study, as she did so many of my other drawings, and not seen it as the probing of her spirit I intended almost every time I picked up a pencil or a crayon or a brush around her, whether I was drawing her or not. I held the drawing edgeways, as if searching for some secret in the skull, a reverse Holbein effect. Mostly I was examining the paper, the real star of the piece. Hand-pressed by Karen, it had the soft rainbow sheen of crude oil and was exceedingly loose in its weave, almost like a net or a nest for the skull, which, against expectations, had a lot of life in it. Maybe Claire had liked it.

And what about the picture in blue ink, with the forsythia pen, that stood on my easel now? It was almost phantasmagoric, this blue; traditional ultramarine appeared wan in comparison. The drawing was no more than half-finished, though weeks had gone by since I'd last touched it. Before I'd taped it to the window, I'd stood on a folding chair and pinned the sketch to the wall, I suppose as a deterrent to casual tinkering. It worked. I'd done nothing since then to change Claire's face, her expression, the words behind or subsumed in the look. What was the old saw about drawing? You're always finished sooner than you think?

I might also have kept her unfinished portrait mounted like that in the hope that her hard stare would wring a solution from me eventually—to no avail. She seemed

less pleased by the day, looking down at me. But finally I think I saw something. Not in the picture itself, which I'd just transferred to the easel. I think I saw something in *her*, my memory of her—something that felt like the intercession which could finally kill off the itch to re-enter this image. Naturally I'd had to think about Claire all afternoon, recalling her many forms, dwelling on her ways of being present to the eyes, as I sorted and selected which pictures to take with me to Whent's place; so it wasn't entirely surprising that a revelation like this might arrive just now. In fact this is how most of them came, through the sheer accretion of moments. On a dozen occasions at least, usually when I caught sight of her features described in blue, that sharp nose especially, I'd felt the impulse to add an ink wash to model her face more completely. Yet I'd never felt that *second* impulse, something I had learned to wait for. As I thumbed the edge of the drawing in slow circles, listening to the low scrape of skin against the grain while my gaze settled blankly upon those roots on the wall, the familiar restlessness descended on me. But when I regarded her face this time, just skimming its surface and not looking too closely, with my thumb still turning circles, my feelings finally precipitated into action. I swapped the pen for one with a metal nib and a heavier flow of ink and roughly laid in a handful of open contour lines, in a darker blue still quite far from black, just to tighten the drawing slightly, give form to her cheeks and depth to her eyes. I emboldened the left side of Claire's visage, strengthening the lines with pressure on the nib, and tucking some hatching along the curved plane of her face to suggest a more spatialized sense of incoming light, from the right, where I'd allowed none of these darker tones.

The movements of my hand quieted, my eyes slowed their dance. I let the pen hover over the drawing for some time. But my resolve disintegrated. No matter the angle at which I tipped the instrument, or the vectors along which I flicked my eyes, I felt no drive to deliver ink to the page. I'd done enough, nothing more was wanting. Perhaps Whent would feel the same.

I set the pen down. Claire had lost none of her angularity, perhaps her defining trait in this rendering, though not at all in real life—except for that nose. I'd not softened the angles as I'd imagined I might have, a month ago, when I'd noticed the drawing on the window, its edges diffused by the afternoon sun backlighting it. Instead, with the stronger illumination I'd shunted into the picture itself this time, through shading, her countenance was even starker than before, more severe. The image that had led me to start this picture hardly resembled what I was looking at. Turning over that memory again in my mind, whatever a memory *was* exactly, the metaphysical substance of my mental image of Claire, she struck me, even in that moment, as softer, less chilly, than she now appeared concretely before me. Well, not concretely, not really. She was only a collection of blue lines here, not the flesh and

blood I'd known so well. But I was yielding to the other images I carried of her, some of which I'd been recalling, or, to put it in its truer, passive form, which had visited me as I'd gone about selecting what to take with me.

Drawing and painting can accommodate this composite quality of faces, especially those of the faces we are deeply acquainted with, which always carry a trace of each of our previous encounters with them. It was a welcome enrichment, most of the time, to find second and third faces, or even seventh and eighth faces, buried within the one in front of you, like sedimentary layers through which one might reconstruct the past. Sometimes, in fact, even elements of the surroundings would be pulled in and then seem, once the impression had formed, to belong intrinsically to the person: a certain poverty of light on a warm moonless night that afflicts someone even when seen later, at noon; a face that seems bright even in the dark; and a mouth you thought could probably breathe underwater.

These five—the charcoal, the pastel, the rooftop gouache, the skull, and then the portrait in blue—these would do for Whent, I thought. For the time being I left the forsythia drawing to dry. There were still a couple of hours before I was to meet him, so I turned, with some reluctance, to the other images strewn about my home studio, none of them profiles or portraits. These ones increasingly took up my time, and in- deed yielded a growing portion of my rent, now that I'd quietly lost my job. Not that I was especially distraught by the loss. Although I'd started with thirty hours a week, they'd dwindled to ten, diminishing precisely in proportion to my enthusiasm for the position. What a perverse task: administering the arts, bureaucratizing beauty. Certainly my mother was never the same after entering those waters. I'd been warned, I suppose. But ever since Claire left, the working world in general had come to seem impracticable to me. Regimenting time in any serious way, regularly showing up at an office, it was starting to look unfeasible. So, when I was inevitably relieved of those last ten hours at the Carrington, not long after Claire herself had dismissed me—the timing was no accident—I couldn't help but feel a touch of relief amid my anxiety over this final confirmation of a new economic reality.

For the past months I'd been offsetting my shrinking wages with commercial commissions from Karen and Rick at Cosquer, the graphic design studio they ran. There on my drawing board was the album art for Joy Division's fortieth-anniversary edition of *Unknown Pleasures*, a straightforward pencil drawing I'd nearly finished, mostly with an eraser. Along with the brief from Rick had come an old Polaroid

of the band setting up in their original practice space, before they were much of anything, in the mid-seventies. I hadn't bothered to read the brief. I usually didn't. Karen and Rick never seemed to mind, or had anyway come to accept it as my way of working. I'd assumed I was meant to interpret the picture in some way. Sometimes Rick, the group's principal art director, the one of longest standing, certainly, and in truth one of the few people whose visual and compositional judgment I placed much trust in—he was a painter in the first instance—he would simply send me an email or a text with what he thought might be useful, given my unconventional working methods. A quote, say, or a circumstance.

What had made it possible for me to so much as consider entering the commercial realm was the uncommon latitude this particular studio had earned from its clients in executing its projects. And that was just because Cosquer was much more than a studio. Foremost it was a loose art collective that took its name not from the underground cave in France that housed those primordial paintings, tens of thousands of years old, like Lascaux, but rather from its replica, Cosquer 2—inspired of course by Lascaux 2—that had been built nearby. Far from offering Paleolithic proof of the artistic impulse, Cosquer 2 had been created not by ancient artists but by twentieth-century engineers with a rather workaday purpose: since the entrance to the cave was underwater, and the water was rising, they sought to give viewers—tourists—the mock experience of history being swallowed by the sea. In any case, to justify its long leash, Cosquer, the studio, traded on its designers' fine art bona fides, the unpredictability that attached to all genuine creation, and more than anything the pristine little art magazine the collective had been putting out in a variety of forms, often pamphlets, for almost four years now. It was here in the pages of this eponymous publication, which functioned as a kind of mutual exhibition space for work that would otherwise never be housed together, that the talents of the group were given a collective form.

Cosquer was Karen's brainchild, a curatorial project she'd begun on graduating with me. She had as much invested in it as I did in my profiles, perhaps more so, as she was planning to carry it forward while branching off in other directions, like the design work we now undertook. Five or six issues were released yearly, each representing an abrupt transmission: brief yet lushly—exactingly—produced, occasionally on paper Karen and the team had pressed themselves. There was no sense calling it a zine. These little chapbooks, that's what they most reminded me of, something from Les Figues maybe, covered matters not only in art but in heterodox literature and music. They even contained a few quasi-academic offerings, small rejoinders or interventions in specialized debates, the kind of thing that could put one in mind of *Tel Quel*, Sollers, Kristeva. The compactness of the issues ensured they got read and

were *seen* as much as devoured; an excess of material, no matter the quality, was an invitation to be ignored.

Quickly and naturally, *Cosquer* established itself as the *de facto* outlet for the print-bound endeavors of many of my Cal Arts friends. In fact, it could be said to have kept us together; some of us surely wouldn't be on speaking terms anymore without it. No doubt the venture would have died without Karen, who was a text artist mostly, and a typographer, and now the creative director (though she never *called* herself that) and prime mover (I *had* called her this) of the Cosquer collective. Rick, meanwhile, was an abstract-conceptualist painter of talent and growing reputation with very definite ideas about design; he'd played a vital role in defining the magazine's look and getting Karen's twin ambitions of large scope and small scale to mesh in the context of a publication. And so it'd taken hardly any time, really, for *Cosquer* to start mattering. That's how I remember it. Its circulation could never have exceeded three thousand copies at any point, and frequently it was much smaller than that, particularly in the early days, but the magazine had a way of landing in the right people's hands, sometimes several times over, as its elegant micro-editions were passed around both New York and L.A., and even found their way abroad to London and Copenhagen.

It was actually the writers of New York—and by that I *don't* mean the kinds reliably reviewed in the *Times*, or even in the *New York Review*, but those who were simply not digestible by the usual organs: writers of intractable prose, hybridists of all sorts whose protean output appeared in stranger, more ephemeral publications—it was *they* who'd been first to gravitate to *Cosquer*. Probably when they'd seen it in Greenlight or McNally next to their own preferred serials, they'd picked it up by accident. The sorts of papers used, the textures of rice and rag and much stranger plants, called out not merely to your eyes but also to your hands, the way papyrus does at the museum, and you find yourself having to resist the urge to touch the mottled fibers. And that tactility was just the start. As you opened an issue, you'd find a portfolio of a subterranean sculptor (one time this was literally true: a Syrian who now spent most of his days in a bomb shelter) who might even still use his bare hands to fashion things; a cluster of aphorisms of unknown authorship—possibly, probably, Karen's, or others who wanted the freedom to write in anonymity; some illustrations, occasionally mine, for an article ultimately abandoned or edited down to a paragraph or a single narrow column of text, or even just a caption, so the images now stood alone or almost so; and perhaps a short dialogue meant to be read in silence and not performed, if not a straight transcript of a conversation, with *um*'s and *ah*'s and typos included.

Even when the issues were dense with images, many were also inscribed with text. Karen's standing somewhere on the continuum between typographer and poet

had much to do with this. Some pages had little boxes containing mini-stories, or mini-arguments, or even mini-profiles, while others sported long stretches of fine print laid out with an intricacy it took a magnifying lens to appreciate. There were, throughout, the boldface names of the art-theoretic world, bold anyway if, having long been steeped in the scene, you knew that world as well as Karen Tally and her clan in Tribeca. It guaranteed the participation of the historians of Columbia and Yale, right there alongside the *avant-gard*ists of Cal Arts and Chicago.

The artists, the ones that actually picked up brushes and pencils, joined the party later, generally on the recommendation of the writers they knew. Only afterward came the men and women of commerce, the designers, the professional communicators, the ideas merchants, attracted initially by the buzz *Cosquer* generated among purer artists, though their interest was sustained by the magazine's striking design, which changed radically from issue to issue and for which Rick and Karen were most responsible. There was no website, just pamphlets grown dirty and dog-eared by the time latecomers got to them. Yet this was analog without a hint of nostalgia or primitivist lacquer. Like the replica Cosquer caves, it was analog only because it seemed like nothing else would do.

Once *Cosquer* got this far—eighteen months in, more or less—the commercial folk started circulating it beyond the hermetic worlds of advanced writing and art. I remember John exulting when Deerhoof, a band he'd thrilled to in his teens, asked the studio to design their reunion album. From there, opportunities bloomed, which not only funded a magazine we were all losing money on (Karen in particular had a certain amount of cash to play with, even if she didn't like to talk about it) but also began to help a number of the collective's members survive in the hyper-capitalized New York Bloomberg had bequeathed the world. I myself had abstained until a year ago, when I got my first taste of the financial pressures many of them had been coping with since school. This was more or less how Cosquer became two things: a magazine on the one hand and a design firm on the other, with both aspects carrying the shared name of that cave and its replica. So much did our profile grow, in fact, that institutions like the New Museum came looking for exhibition posters; as did the Whitechapel in London, where *Cosquer* found a devoted reader and viewership. Eventually, the large circulation magazines, the kind that *paid* their designers, made inquiries with Karen and Rick about the illustrators and photographers working for her, including me.

These days, sizable advertising agencies, as well as their corporate clients, political candidates, even cities themselves, came to us for help with their more forward-looking campaigns. Most recently, Cosquer had helped rebrand a transit department for what one would have to say was less, not more, visibility; the previous identity had

aged poorly—this was in Philadelphia—as it had been foolishly brash, too loud for the utilitarian service at hand.

Over the past two years, the roles within the organization firmed up and the collective arrived squarely at the intersection of art and commercial design: *Cosquer* and Cosquer. Given the cachet the latter drew from the former, the requests for work had a gratifying sheepishness about them, for asking for something so crass as marketing material from the makers of such a distinctive and convincing art publication. This usually meant we had *carte blanche* to offer what we wanted to offer, to refuse all conditions. The few who had quietly tried to impose requirements on us had been equally quietly dropped. While I didn't take much of an interest in design as such—plenty in *disegno*, of course, but that was something else—Karen conducted her project with a delicious disregard to the wants of *both* the commercial and art worlds. She catered instead only to a set of interests you would generally have had to acquire from her—from exposure to the magazine, from immersion in our design commissions—in order to hold at all. She was commercial without a trace of irony or self-deprecation; she was entirely willing to abrade the fine sentiments of the art school crowd and her own family. Naturally I adored her much more than I did Rick, who didn't thumb his nose at fine art in the same way. He was a believer, a traditionalist, and although he was gifted in design, it was always a sideline for him, a means of supporting his abstract canvases.

The leeway Rick and Karen garnered was frequently inherited by those who worked with them. It was rare that my offerings, even my roughs, were turned down, by clients anyway. A few times, all in the early days, when my contributions were more sporadic, there had been extended silences from Rick or Karen or even John, who would take a leadership role during his "good" periods, when his general deportment was less excessive than usual. My followups would be met with replies that conveniently failed to address the lone question I'd put to them. Karen in particular, for all her willingness to cross people, had an exquisite talent for politesse, and when she felt like deploying it on someone like me, whom she saw no point in irking, she did it without a false note. She might ask me about the work I'd like to see in *Cosquer*—my non-commercial work—never mind the business underway at Cosquer. Or she might send me an entirely different assignment, with the assurance that this one had my name written on it. What this meant was that not only had she not liked my rough; she'd rather I not try again. I liked to suppose that in doing so she was only heeding the advice of certain legends of design she'd told me about: people of the Carson school, for instance, who felt that if you had to instruct the artist much, the work probably wasn't worth pursuing. The results would never really sparkle.

Ordinarily, such evasions would have troubled me. And perhaps really they *did* trouble me. But whenever I got ready to take up the issue with the powers that be at Cosquer, and I was planning on being conspicuously unpleasant—I like to leave an impression—I would study my submission to construct the seemingly airtight case I knew myself to be capable of. (I am a lawyer's son; that sort of dialectical or sophistic skill is my birthright.) Yet each time I went about it, I found I simply couldn't summon the conviction to defend what I'd sent them—not in good faith, anyway. And when it came to brushes and pens, good faith was what I had. My work, on reflection, would turn out to be every bit as weak as they'd hinted it was: not merely off-target so much as aimed in the wrong direction. In truth, those three or four pieces weren't even worth their kill fees. It would have been ignoble of me to collect the cash, as my lack of effort and engagement was transparent. The very thought of such fees was idle, in any case, as I was never offered anything. Still, what one would do, even under circumstances that never arise, says something about who one is, or supposes oneself to be.

Whenever I went to Karen with a surliness corrupting my features, she simply looked at me expectantly, waiting for me to see the sense in her decision; she probably knew just what I meant to bring up, and in the end nothing would come from my lips. She would begin to smile, more and more, until finally I would laugh and she would lower her eyes and snicker, too.

I suppose they all thought of my output as deeply... volatile. *Mercurial* was Rick's friendly and rather cerebral epithet. Yet mercurial in a way that was worth working around, searching for a fix, owing partly to longstanding friendships and my connection with the magazine, but also to the fact that I did occasionally produce things with manifest commercial power—we as creatures of this civilization can all feel it in our bones—things that seemed to overwhelm the works of other artists who might also have taken a shot at the brief, but in too effortful a manner. Which is to say, sometimes you can only hit the target when you're barely aiming at all, and your mind is on other things. That was at the time when Sandy was selling my *real* work briskly. In those early years, I would only play at design, really more to stay close to Karen: a poster, a hand-lettered logo for some ultra-hip Ridgewood coffee franchise, and, just for fun, a brochure for a dying taxi firm that offered luxury rides in vintage cabs.

Now that my *pure* projects, my *personal, self-directed* pieces—as those who are planted on the commercial side of art call work not made-to-order—had slowed to a trickle, commerce was precisely where my interest lay. I was trying to take the assignments more seriously. I'm not sure whether my colleagues understood my comparatively chastened attitude, the noticeable dip in my... volatility. My focus stemmed

of course from my *need*, and presumably a deep-seated sort of grief. What else could explain my equanimity in pursuing such a course? They must have guessed as much, though they had the grace not to inquire. I do know that they began to take more of my work. Generally, too, I could expect an explanation for those pieces that were declined. They understood that the answers mattered more to me now—that I'd be refreshing my email until I got one.

None of this meant my efforts didn't continue to be oddly executed, and far more erratic than the output of others who had truly embraced the constraints of the marketplace. It didn't mean, say, that I didn't still ignore the briefs. After all, that was in some way what these clients were *seeking*, I reasoned: a certain artistic indifference to commerce that might, paradoxically, though no more paradoxically than prefabricated ripped jeans, help sell the product, by lending it a devil-may-care appeal. Certain types of self-sabotage had that effect, against all expectation. As with this Joy Division cover, I would often simply size up the client for myself, without forethought. I almost never accepted a job without having some personal impression of who had ordered it. This was what allowed me to proceed *sans* brief, triangulating who they were, whether it was an especially well-known curator, a masterful barista now running a small army of shops in a part of town I'd abandoned, or a band I had intended to see but could not—at the last moment—because my ears had acquired a peculiar sensitivity, one that seemed to track the flagging of my spirits.

So I sat at the drawing table and studied this little work, which I'd done in the stately, magniloquent tones of graphite, the medium which seemed to me to produce the most conceptually subtle qualities in art. I'd simply drawn the space and scene depicted in the battered Polaroid, pretty much as it appeared, but with a greater sense of plasticity, of structured, interacting volumes—the world-involving gestalt of lived experience—which returned to the interspace its permanent charge of possibility, of potential call and response.

I could have just put what I had in front of me in an envelope and sent it to Karen, let her bounce it back to me with the colored index cards she always included in the return package carrying her critique. I could also expect her to pass on any feedback she'd solicited from the band's representatives, or even from the living members themselves: at this point it was not out of the question for Cosquer to make that happen. Yet perhaps neither party would appreciate the concreteness of my take; they might rue having sent me the Polaroid. An extended back-and-forth might easily ensue over a piece like this, I knew.

I sat down and peered deeply into the four young men in graphite, the slightly unnatural postures, the open mouths of two of them that gave the scene a staged, illustrative appearance. Though the bandmates had nothing of the cartoon about

them in their details, you still longed for the thought bubbles I hadn't provided. Why? I suspected this wasn't so much an artifact of working from a photo. As I looked carefully at it, I felt it was the "photo session," if one could call it that, that induced the flattening of personality, of expressive action, in each of the figures. By contrast, owing to the sheer number of hours required to sit for a painting or drawing, a subject had time to settle back into his body, and this was true even if he didn't really want to settle back or be seen. Inexperienced models always broke after some amount of "posing" in this sense.

It occurred to me, as I continued to wait for the last of the drawings for Whent to dry, how I might move the dialectic with Karen and the clients two or three steps ahead, past its inevitable longueurs. I took up the kneaded eraser, full of my fingerprints in black on gray, and began to evacuate these men, these boys, one by one, into its doughy folds. Eventually all were absorbed. I tested myself for a change of impulse, but I felt not the slightest inclination to stop this holocaust. What was left behind, when the eraser was one shade darker for having consumed them, was a picture of that seminal basement marked only by four gaps, as if touched by flames that ate up all the living matter in the room. Why had I done this, exactly? What sort of improvement had I made, if I'd made one at all? Surely it wasn't a whim, what I'd just experienced. There'd been a steadiness and continuity to my action, of grave precision, as I'd lifted each figure from the scene.

Joy Division was a group I had once found so full, artistically, in high school, and that's why the band's commission was one of the few I felt truly pleased to have sent my way. I almost didn't require the excuses of poverty and grief to take it on, to reacquaint myself over the past week with all of the albums, and New Order's as well. The short-lived singer's vocals, which had the tenor of an even more depressed Jim Morrison, and the epic repetition involved in the band's best songs, seemed, with the brutish sonic palette that washed away so much nuance, to abide grizzled Platonic forms.

By nineteen or twenty, of course, I had spurned not only this music but all the lesser variants of it, or in truth simply forgotten about it. Its gravitational pull had waned, not because the band had changed, but because of the tiny gap that sat at the very center of rock and roll, and pop music in general, which you noticed from the beginning, when you were totally in its thrall. In that early moment, the abnegation it signaled was in fact the basis for attraction; over time, though, even from month to month, the void expanded, and indeed seemed to empty the music from the inside out. There was something exhaustible about the music, I felt, and those years between sixteen and twenty-five effectively transformed it into a nullity. That was its final state, its telos, its logos, too, this massless thing, so that even when

performed live, the music, in my ears, tended toward the Xeroxed, tinny quality of an mp3. At this rate, I thought, by forty the music would vanish altogether for me. I wouldn't hear a thing.

So, when I first opened the envelope from Rick, who was himself, I should say, a rock aficionado and a lover of sound in general, I found the photo of Joy Division inside, this band that had delivered to me a jarring lesson about evaporating art forms, and I recoiled. I read the top line of Rick's note. Something about a cover for the remaster of *Unknown Pleasures,* an album that was actually going to be a double album, including unreleased demos and early songs. I'd been hearing about this already from acolytes like Rick and John, even Hasan, my dapper friend who spent his days in a neurological lab, not a studio, but here was proof at last and it stoked something in me. Joy Division had at least this going for them: they were ideal in helping you understand the disappearing ink in which pop music was written. They *celebrated* nullity. And rightly so, as just before the whole enterprise slipped beyond the horizon into nonexistence, it was something absolutely worth witnessing.

Listening to the band again had shown me that emptiness even more sharply, though it no longer repelled me. It struck me as the perfection of a primitive form.

After I'd finished the drawing, my nostalgia passed, as it almost always did, and it was then, the very same day, that I felt the first tentative impulse toward erasure. I tried it out on the bass player standing just to the side of the dime-store instrument his mother had probably bought him for Christmas. His fingers were intertwined with the tuning pegs. I disappeared two-thirds of him, from the thighs up, though when I came to that fidgeting hand, I reversed course and reinstated the young man, line by line.

Today, though, I found I had no desire to stop erasing until they were all gone, leaving only their instruments as stand-ins for each of them. In Curtis's case, only a microphone lay on the ground, next to a yellow bucket on which the cord loosely hung. I was taking the band back to a scene before there was much of a band at all, just the hint of one, when the space the musicians occupied had been merely a basement with a bunch of gear awaiting them. Rock was anyway of such a nature that bands, after their vital early work, tended to get erased. Why not literalize a bit here, depict the void in embryo?

I was about to pick up the pencil and close up all those ghostly gaps I'd created in the piece—leaving them was never a thought; that would have been gauche—but a second wave of this negating impulse struck me. So I dabbed away the instruments, too, with the eraser molded into a point; or rather, it was as if I were redrawing them in white, against a white background, drawing them *out of* rather than *into* existence, which was the pleasure of working in white, of all negative drawing, and I stopped

only when all that remained was shelving, an oil stain from where a car might have usually been parked, a few fluorescent lights, and, against the back wall, near the door that swept your eye into the house, some tins of varnish or paint, a microwave oven, and a collection of saws of varying lengths hanging from the walls.

The picture was riddled with white gaps. I thought of Rauschenberg's erasure drawings, defined by *pentimenti* exclusively, and this gave my pencil an urgent purpose. I filled in all the holes with those portions of the basement that the figures and the instruments had obscured, or might have, as I invented what must have been behind them. I did this steadily but without fuss, certainly more quickly than I'd done the original drawing. When I finished, a trace of band-shaped *pentimenti* could be picked up, a subtle disjunction between the past and present of the piece, and also the past and future of the band, at least if you were looking for it. And if you weren't? Karen, with ignorant eyes, could tell me what she saw.

I brushed off the drawing, all the gray crumbs from the erasing, and held the image under the lamp's hard white light. "Unknown pleasures," I said aloud. It surprised me to think I hadn't even considered the title, nor even the songs, in any detail. But perhaps I'd taken out the instruments just because the pleasures *were* genuinely unknown, not only to Joy Division's fans but to the members as well. This was merely a garage now, a garage that would prove important to them as the site of discovery, though it didn't yet know its own future. Melancholy had always seemed to me to reside in graphite, so eminently erasable: a melancholy of impermanence that suggested just this sort of looping back, not merely to the beginning but to a time before the beginning. Which was, I considered, precisely what it would be for the band to undergo a renaissance in our amnesiac era of digitized and dispersed pop, where they were virtual unknowns. We might as well have *been* before the beginning, before anyone knew anything of Joy Division, in a world in which others somehow believed they'd invented the band's iconic palette themselves. I wondered whether I should add the album title, perhaps inscribe it right into the depicted scene, as in those Saenredam pictures, like the one with the memorial for his father, etched, inverted no less, on a foreground tile of a church. Perhaps *Unknown Pleasures* could go in the window of the dusty microwave, like a *wash me* sign. I would leave it for Karen to decide. I might even suggest she leave the title off the cover, perhaps just the band's name on the spine would do. It could definitely work, this picture: this could be the end of it. Or it could go through several more variations. *Or* the band, a group of old men now, might end up looking further afield, for someone a bit more serious about accounting for the album title, say.

In the end, it was only a sketch. At Cosquer we often sorted out many of the details later, as suited our less-than-professional ways. Beyond that, as I say, my

fondness for the rock idiom had faded, so the extra-monetary stakes were small. And in any case it wasn't very clear how much I was likely to make from this project, supposing we even won it. I'd known Karen and Rick a long time and they were not in the habit of shorting their illustrators and contributors. But this was a speculative project, and there was no way of knowing who else was working on it.

Even if the thing went nowhere, though, drawing this picture and then undrawing it just as carefully had given me something to do, now that I was doing less of everything else. There were certainly projects lying around my apartment I had a far greater investment in. I was midway through a set of illustrations of Edgar Allan Poe, for instance, for a new anthology that wasn't being executed on spec and would bring me some useful money, courtesy of all those dutiful high-school teachers who'd buy the book for their courses. There were also artistic motivations, obviously. Think of the precedents in book illustration, or just Poe illustration, which Manet had taken up with such skill. I'd spent the previous few weeks re-reading Poe's shorter works, including one that particularly gripped me, ever since I'd read it in junior high in a bowdlerized edition: 'The Gold Bug.' Over the past week I'd been rendering Jim, the doltish Negro, in all sorts of ways: up in the tree, at an extreme angle, where you could barely see him looking for the spider; standing at the base of the tree, bearing the narrator's scorn; and many besides. What sort of picture might convey the absolute violence of the unbowdlerized text, without papering over the incidental (though retrospectively essential) antagonisms of the work? I was still figuring this out. Beyond the Poe, there was also the cover art for the catalog of the fiftieth anniversary of a Dallas museum that had been bequeathed to that grotesque sprawl of a city by an energy baron. How frequently anniversaries drove the commissioned designs and redesigns we worked on, even when they failed to mark any sort of turning point in the development of the institution. A round number was all the reason you needed, apparently. This project was part of a larger initiative Cosquer had undertaken to reconstruct the museum's identity, including an updated logotype to be woven into the institution's physical and virtual presence; hand-lettered signage throughout the museum; and a series of limited-edition posters, with nods to Mucha and Chéret.

Now, though, all this would have to wait. Karen had texted me about Joy Division just yesterday, wanting something today or close to it. So here it was. My eraser had made it possible, and perhaps succeeded in conveying a little bit of my menace, too. Rick, being the music man among us—well, he might have a problem with this one. He might find it impertinent. He was generally coming to find me that way, I thought, just as I came to doubt his own direction. But we'd see, soon enough, and at all events, whatever money there was to be had from this piece was still quite a way off; the album wasn't due for release until June. My proximal financial hopes were

pinned, really, on Whent's attitude toward the pictures now tucked in my portfolio. It could mean three months of peace. It could mean even more, depending on how many of the drawings he took, and for how much. I lightly pressed my hand against the blue ink picture, stroking Claire's face, dabbing my fingers over her eyes and feeling only the tiniest damp. She was ready to leave.

3

It was twelve slim Bronx blocks from my duplex to the subway station. For the first six, the sidewalks were a shambles. They couldn't really be described as walkways. The concrete slabs rarely met flush. Some had crumbled along their edges, leaving heel-sized gaps. Others twisted away from each other, twisting ankles in turn, while still more rose at sharp angles driven by the unruly roots of dying trees, making it necessary to high-step their borders. In winter, when the ground powdered over with white that obscured rather than softened the jaggedness, my walk to the subway became more of an adventure than I cared for. Locals trudged right down the middle of the road, between cars parked tightly on either side of the matchstick streets, stilling traffic. Black ice made the roads treacherous even when they were clear, so that cars often maintained a pace hardly greater than that of pedestrians.

Now, though, in mid-September, that liminal zone between seasons, there wasn't a trace of snow to be found, even if one or two days recently had proved balefully cold. But the drivers had long ago lost their winter caution and whatever dribs of empathy came with it. They expected those of us on foot to keep to the disfigured sidewalks, and if they were no longer so dangerous as when they were laden with snow, you still had to be mindful of your footing in a way that made the walk seem far longer than it really was—particularly while carrying a portfolio full of drawings. To prevent my work from colliding with those gnarled slabs rising up like mountain ridges, from time to time I had to hold the oversize portfolio up in front of me by its handles, invariably attracting the attention of anyone nearby to something—art—that could only seem precious and out of keeping with the neighborhood. Loitering eyes at each intersection reinforced the oddness of my presence here, even those of people who recognized me well by now. It was as though, here, repetition lost its usual power to familiarize. Although they saw me week after week on these streets, sometimes even meeting my eyes, to judge by their visible surprise on seeing me the next time I must have appeared as strange and alien to them as on the day I'd moved in.

At least I could see there'd been an evolution in what *followed* this initial state of bewilderment. In my first few months here, their confused expressions would quickly betray a sort of curiosity that seemed to me fundamentally predatory. I'd seen it in my time on couches in Prospect-Lefferts Gardens and Sunset Park, right after graduation, and again in the stint I'd more recently done in Bushwick. Before coming to the

Bronx, I'd considered Midwood, a more tolerable part of Brooklyn, and not just because of Di Fara. In the end I opted for a change of borough, not only because of Midwood's sizable distance from Manhattan, but because even the far parts of Brooklyn were within semiotic reach of its status as an artists' haven. The place changed the way people looked at you. They were too ready to be observed—they understood their function for us—and you yourself, amidst that abundance of artists and writers, easily fell into familiar patterns not merely of doing but of seeing.

The Bronx had freed me from this constant presence of art, visible or not, which since my time at Cal Arts had struck me as anathema to real development. But here, too, there must have been something about my physical presence, perhaps the sense of preoccupation my features insisted on carrying even in repose (my self-portraits invariably confirmed as much, no matter the medium) which lent my face an intensity that suggested, I am told, that the very tenor of my mind must have been a bother to me. It was this that generally prevented my new neighbors' curiosity from developing into anything sincerely malign. My unease, I mean, soothed them. Happiness, should I have possessed any, could only have been a provocation under the circumstances, in the conditions of casual abjection that reigned in most of the South Bronx. The important thing, for them, was that no one like me who lived among them should feel at home, or settled, and apparently I didn't look it. Nor did I need any goosing from them to maintain the feeling.

After a time, there may have also have been an element of respect for my living in a neighborhood that had proved, somewhat famously, and to the pride of locals, resistant to even modest gentrification. No juice bars, no sushi, no yoga, no pet salons. I was more or less alone here. Mott Haven was the northern limit of artistic interest in the Bronx, and even there it wasn't especially strong. My cohort wouldn't follow me in numbers to the blocks beyond it, and even less would they migrate to Soundview, or Castle Hill, or Edenwald. No one was followed here. There was something positive in this for me: It meant I didn't represent the looming threat of a more general encroachment. I could be appreciated as a curiosity, an accident, a puzzle.

That my forlornness placated them, that this would be the lasting condition of our relationship, didn't trouble me much, nor did I attempt to alter it. Schadenfreude felt right, coming from them, since I did not, and simply could not, consider us as one. Nor could they. What they didn't understand—and did I myself, when I'd first moved here?—was that for me the chief virtue of the place was this sense of *not* belonging, of non-community, which had begun to me to seem, paradoxically, more humanistic than banding together with others in common misunderstanding. I was here to establish a nourishing distance, where there would be less wasted breath, more oxygen in the blood. I was here also, of course, for space. My townhouse. Some

days it felt as though my quest for space would lead me, after a series of intermediary moves, to some Kennedy-scale compound in East New York, which was technically Brooklyn, but utterly not Brooklyn. It was New York's sixth borough, with a proprietary form of desolation no other could seriously rival.

I continued at some pace walking south. No, there could be no true harmony between me and my neighbors. Our fortunes, if they were bound, as the fortunes of those inhabiting the same lands must be, were not bound in the right way. My relative poverty had been arrived at by a series of decisions made under conditions, positively Habermasian, they could never have experienced. If I felt inclined, there was another series of decisions that could lead me back to a kind of economic security they could never achieve. As my fortunes went, theirs incontrovertibly did not. I don't think this troubled them unduly. Their curiosity evolved, after only a few months, into casual dismissal, and more recently into something like amused derision. They perked up on seeing me; they enjoyed it. What did it matter if fellow feeling or kinship didn't figure in their pleasure, as long as I was giving it to them?

At the corner ahead, pulling on a cigarette and looking lonely, nothing like the same person without his minions, was literally the only man, very young, possibly teenaged, even prepubescent—the only boy, then—who had actually allowed his dark interest in me to tip over into a genuine threat of violence. The stage for this encounter had been a twenty-four-hour bagel-shop-bodega just a few avenues down. This combination was slightly strange on its face, but these sorts of commercial juxtapositions, almost experiments, undertaken in the least self-conscious possible way, generated by customer desire, existed throughout the outer boroughs. I might have stopped in now at this place, I had a small pang for a butter and jelly, if I hadn't told Whent I'd be over by noon.

My run-in with the boy had been at a very different time of day, in the hours just before dawn, when, in any part of the world, strictures of every kind loosened. I'd been reasonably stoned at the time, mostly on Claire's sleepers, the ones that took the fear out of her face and that she would allow me to indulge in from time to time. Now they were the only pleasure she gave me, these forgotten prescription bottles. I'd blended my laboratorial haze with weed tucked into an artisanal chocolate bar, the sort of thing that still struck me as laughable, even if others had almost immediately adjusted to marijuana's fall into complete mundanity. The boy came into the shop flicking a cigarette away and exhaling his last lungful of smoke directly in front of the counter. I was waiting on a jelly bagel, and all they'd had left at this hour was onion. I was undeterred by the combination; in my state of mind, it wasn't going to matter.

But the boy didn't know this. I'd first seen him through the window, ambling down the half-dozen steps to the door with a jitter in his gait that incarnated all

the drinking he'd done that night. Three or four others were in tow, and I distinctly remember all this having a mildly sobering effect on me. Despite their natty athletic wear, I couldn't shake the impression that they were, each of them, crudely formed. Though I was hardly someone impressed by omnivorous aestheticism, and though I kept myself from developing one of those tainted eyes that are constantly searching out "moments," as this was precisely the problem with Brooklyn that I was escaping, I have to admit that the *look* of a thing, its particular manner of being available to the eyes, generally gave me pause. Certainly it detained me longer than it did those who knew not a thing about grades of horsehair and vine charcoal. But there was little of the dissection board in my gaze now. I had carefully retrained myself, after art school, never to let my attention cleave away from the object seen, and to always ask why such a *thing* in the world should appear just that way. In this case, *just that way* meant *just that crude*. Anyone could have seen this, if they were genuinely open to their own experience, I thought, looking again at this boy from the bagel shop. He had yet to see me coming down the sidewalk, or anyway wanted to give me that impression. But I recognized his disfigurement immediately. His nose and mouth stretched across a skull that seemed to be wider than it was tall, like a football set on its side. The shape distorted his physiognomy, giving him the look of someone receding, even as I approached him on the corner. The skin itself, and this was true of several of the others from that night, refused all uniformity of shade or texture. Generally he appeared to suffer from some chronic dermal condition. They all did. Too much time outside in the acrid, exhaust-drenched air, burnished in summer by the sun? One good reason for staying in, I'd thought that night while studying the group.

He'd looked compressed from top to bottom, too. Actually all but one of them had. They widened just below the neck—evidently broad shoulders weren't always a virtue—and again below the hips, which gave them the squat profile of day laborers from a century ago, the kind who would have just spent twelve hours on the factory floor.

Most of this was down to fate, a function of natural endowments and caustic environs. What they could control, by contrast, was really quite delicately done. The cologne of the lead boy, first of all, was soft cedar, free of the abrasiveness of most commercial scents. Then, too, the curves of his close-cropped hair, which was more sculpted than cut, given his hair type. I could also see, even under the dead blue lights of the shop, that the raw denim of his jeans would have been costly; it looked inkier than anything mass market, with more variation in tone. Even the cotton of his wife-beater looked unusually substantial and refined.

The rich wouldn't be making haute-couture knockoffs of these garments, I thought, as they liked to do with so much style, because what these boys wore were already the low-market versions of those luxury proletarian imitations. Their tastes

at this point were entirely mediated by the rich, by Fashion Week. It was really their fathers' style, or even their grandfathers', given their accelerated generational rate, that had been appropriated decades ago, so that the present version they wore was merely a corporate imitation of a boutique imitation of a long-dead street original.

The disjunctions continued, though in the other direction. The boy's breath carried hops. As he approached the register, where I stood supervising the preparation of my bagel, I could see that his posture, though he must have been little more than fourteen or fifteen, had already turned vulgar, almost in anticipation of the troubles with women, with desire itself, that were certain to come. In the window behind him I could see his reflection. Stitched in black across the back of the loose gray shirt he wore over the beater, there was a very tall logotype, in a sans serif so distorted by condensation that I couldn't recover the original typeface that had been raided—it became almost abstract in effect. More important, I couldn't place the brand, as it was illegibly done in the same font near his front pocket. He was looking at me as if he recognized me, though I absolutely did not recognize him, not then. But, of course, it is the misfit who will be noticed and remembered, not one who bore so many of the signatures of the neighborhood, like this boy.

He hadn't been the first of the group to speak. As I listened to the R&B escaping from the headphones clasped around his stubby neck, another of the boys, the second tallest, dressed mostly in Nets paraphernalia—again, of the luxury variety—appeared on the other side of me. I must have missed him passing silently behind me. He stared downward now and tapped the face of my watch, which hung down near my thigh. He knew this brand of watch, he said, and the crown was supposed to stick out further from the case, on the *real* ones. The boys all chortled. I raised my wrist and inspected the crown. The proportions seemed fine to me, my expression must have conveyed. The group turned more serious again, inflamed by my indifference, and when one of them actually began to order something to eat, I took it as the right moment to make for the door, even though this involved shouldering past the rest. I would have left then, it would have been wisest, but I was still quite set on the jelly onion bagel. The chocolate bar had done it. So, outside, I lit a cigarette. The months of solitude had driven me back to smoking. But before I could take a drag, four of them came out of the shop. The leader, again the youngest of the group, which made his status all the more strange, didn't look directly at me. Instead, he sauntered up to me, just inches away—it would have been a frightening maneuver had he not been a child—and said only that he could *really* use a cigarette, mustering as much menace as a boy with such a tinny voice could. Then he looked at me, awaiting a response, while the other three were joined by the straggler who'd lingered to gather his food. As the young one stared at me through a trail of smoke that led back to my cigarette, the others began to make the indistinct

noises of agitation that presage trouble. I still hadn't taken that first pull, though, and I was desperate for it; so, even as the tumult grew louder and the curse words harsher, I felt myself blithely raising the cigarette to my lips. It was enough to make the boy regard me, though his eyes were empty of all import. He leaned in incomprehensibly close; I almost thought he might kiss me on the lips. In truth he was only setting his trap: if I exhaled without making special accommodations, I was going to do it right in his face. He *wanted* accommodations. The chorus of profanities rose to a wail as I held my breath for a beat and then two, just as a smile slowly corrupted my face. I could see he understood this smile wasn't a move in our face-off, but something involuntary and probably unfathomable, even to me.

I am sure this made all the difference to what followed. I watched doubt fall over him, I noticed his posture relax, so that even though he was still technically in the aggressor's position, brushing against my jaw, he appeared weak with second thoughts, wondering whether he was prepared to do what he would almost *have* to do as soon as I exhaled, with his friends' clamor growing only stronger. I was not exactly a small man. Especially compared to him. For a moment I could see him only in a womanly light. *I* almost kissed *him*; my cruelty was in bloom. Finally, though, my smile receded, and without shifting in the slightest, I shot out the smoke scalding my lungs.

I could feel his relief, his gratitude almost, as the smoke harmlessly clouded between our chests. I'd rifled it downward through my nose, saving us both the trouble. The others began to jeer, but they were mocking him, not me, I realized. I reached for my pack and pulled out not one but four cigarettes, filled the laughing-stock's hand with them. He was confused, I could see, but I had my reasons: I frequently gave away cigarettes simply to spare my health; the homeless outside my apartment and in the park had profited handsomely from this psychic tug of war. The boy must have been bewildered by my sudden capitulation, which occurred—and this is what would infuriate him later, when he'd made sense of events—without my losing any face at all: the very point of the exercise for him. It was *he* who ended up looking weak and indecisive. Indeed, he said nothing more as his friends grabbed the cigarettes from his open palm. Through the window of the shop, I saw my bagel sitting on the counter, jelly melting off the edges onto a Styrofoam plate. Yet it seemed apt, not for reasons of safety so much as of dramaturgy, that I walk away now, hungry as ever.

He looked different today as I passed him on my way to the subway. Or, rather, he looked *at me* differently. He was dressed more or less the same, though there was a fresh nerviness to his mien, which put his physical composure, his tamped-down form, in a new light. This was an alteration I didn't have time to puzzle out, although

I suppose if I felt inclined later in the day I could come back to this moment in my mind with a pencil in my hand. For all I knew his dealer or his buyer was running late today and there was nothing more to be made of it. He gave me only a passing look and the faintest of nods, the kind so subtle you would never have to own up to it later. He wanted to acknowledge me in some way, I felt, though his preoccupation failed to dissipate on my approach. A blankness remained in him, as if he wasn't attending to what his eyes were providing him. Probably only snippets of experience, intermingled with the fragments of memory they trigger, come through to us at moments like these. And I knew which memory was surfacing in him then, just before he looked me over with the quickest of glances, head to toe: his own moment of misjudgment from that night, one that had come to nothing in the end.

For my part, I nodded deeply in his direction as I passed, pleased to observe in him a form of absorption that didn't reek of the oblivious inwardness that troubled me in the artier sectors of Manhattan and Brooklyn. I'd noted this in his friends, too, and more generally in the social character of others in the neighborhood. They retained, under all conditions, a basic alertness to place, to bodies and not merely to the sensory forms that supervened on them; so that even when they were mulling other matters, as this boy quite clearly was, I wasn't in the least lost on him. My person was precisely inscribed in his consciousness, so that he would have adjusted instantaneously to any sudden movement or change of course from me.

It's not that I thought aesthetics *per se* were lost on anyone here, as opposed to Greenpoint or Ridgewood. It's just that in most of the Bronx, people tended to observe design or form directly *in* things, rather than abstracting it away from its place in life. Which meant that vision—the *faculty of beauty*, if you wanted to summon the link to Hutcheson and the eighteenth century—never lost its worldly grounding. The people *I* knew, however, the artists of New York, often seemed slightly *elsewhere* as they moved about the city; or, to the extent that they *were* actually *here*, it was as if the place registered only as a kind of playground, a movie set, and each thing in it became a prop, a servant to some ideal or form that gratified this sense of taste. Matters of life and death, thriving and perishing—the grubby practical significance of everything that was—receded at the same time that arresting, even ingenious notions of the beautiful in our time, idealisms of so many shades, came to the fore. Beauty, whether as form, idea, or virtue itself, remained the master. This is why artists and "creatives" were wonderful marks for locals. They were perpetually in one kind of fantasy or another, while the man-boy I passed, who'd hardly looked at me, never let the world out of his grip.

I'd like to think I was at least slightly less out of place over the next half-dozen blocks to the station. The sidewalk, for one, was quite suddenly sturdy and planar;

my stride took a second or two to adjust to the lack of obstacles. Not only was it less worn, as the city council had just recently redone it, but somehow the concrete slabs seemed more precisely laid, as if getting the angles right had mattered more. I had overheard talk that this renovation would be extended to the prior six blocks and beyond, where things, and not just physical things, only further eroded—it wasn't a direction I walked in much, for several reasons—but I got the feeling that no one much believed this. There were sound economic reasons for keeping the sidewalks in order in this area: it was a commercial space, even if this was somewhat notional, as the businesses, the laundries and pharmacies, the liquor stores and delis, were all clinging to bare existence. But even clinging counted for something. In comparison, the residential area from where I'd come, and in which I lived, appeared to exist only in the afterlife, there being no plausible excuse to get it into better shape.

The great oddity of the area in this respect was the vast community center, which appeared on the block on the opposite side of the street to me and was fronted by an equally grand and well-manicured plaza. It was built in something vaguely resembling the late International style, a sleek gray slab of a building, though its underpinnings traced back to the City Beautiful, with its notions of civic centralization. In fact, I knew, the ancestry of this sort of urban-paradise building went much further back, far past the Garden City and the Arts and Crafts Movement, and even past More's *Utopia* and the star-shaped planned town of Palmanova, established in 1593 in the spirit of that book, all the way to Pope Pius II, who had the city of Pienza constructed to his specifications in the mid-fifteenth-century.

The community center and its plaza appeared almost totally contrary to the ramshackle neighborhood in which it stood, like a foreign idea that hadn't taken, whatever the original redemptive meanings of these materials, this design. It seemed a part of some unrealized project, the rest of which had been either bulldozed or abandoned in the planning stages, perhaps when the city council's composition had shifted enough to take away its funding, leaving the job to be finished, as always, by the invisible hand. Still, even if it *looked* nothing like its surroundings, the center, all concrete and steel and plexiglass, sat in a kind of unintended conceptual congruence with the condemned spirit of the place: indeed, the grim and grand precision of this prisonlike structure could amount to a more rational (and better funded) model for captivity than the neighborhood itself, which was merely haphazardly moribund. In such conditions, even one's suffering became less predictable and hence more painful, like the punches you don't see coming.

The center was one of the first things I drew once I'd moved in: at least ten sketches of it, from all angles, this building which unlike almost everything else here was effectively unmarked, as the lettering on the frieze, engraved directly into the concrete without

any contrast, gray on gray, was too small to read from almost any distance. There was also—perhaps I shouldn't say *also*, because it is what struck the eyes hardest—a precise rectangle of tightly clipped grass at the center of the plaza that was almost hallucinatory in its saturation. I don't think I ever got the *trauma* of that green, in the midst of all that dull gray and yellow, quite right. It must have required zealous maintenance, like a golf course in Dubai, and it was the only living thing in the generally barren square.

I regarded the bow-shaped sculpture near the entrance as I passed and found it no more interesting than usual. Bronze and fuzzily modernist, it put me in mind of a giant Aboriginal boomerang. I hadn't bothered to sketch this in anything more than a perfunctory way, as that is just how it seemed to have been fabricated, so my haste felt like an appropriate homage to it. Behind the sculpture ran two long glass displays built into the center's façades, on either side of the entrance, with four tiers to each of them that all strangely remained empty. The cultural functions of the center were failing in plain sight. Often I would see employees—the slight formality of their clothes betrayed them instantly—passing briskly in and out through the automated doors that slid apart a tremendous distance, for what reason I don't know. I'd never once seen a crowd here that wasn't formed of employees. They may have been the only ones benefitting from the center; and I wouldn't have been surprised if they resided elsewhere in the city. Though it was easy enough to see that *I* would find no community here, I had a harder time understanding why the locals shouldn't either. But, from the effortlessly hostile way people navigated these streets, the sharpness in even their most pacific gazes, the gentle suspicion coloring them, which threw the preening and false bravado of others of them into relief, I had the feeling the social bonds they shared were no less tenuous than the ones linking them to me.

What bonds, though, did *anyone* have that were really any stronger? And I don't mean just the easy targets: the bankers and lawyers, the Hollywood parasites, the ones who we could assume, with justice, operated in something of a vacuum vis-à-vis the welfare of the people they packed themselves together with in the metropolises of the world. I mean, no less than any of these, my own apparent cohort, artists and intellectuals, the sorts of people who would have built, or anyway designed, this community center and would have contributed to its theorizing. On the face of it, they championed the vitality of communal bonds; they were keen to uncover injustice and falsehood, the very things apparently separating us from one another. Yet, before all of this, one was perpetually reminded of the sanctity of their private, autonomous aims—this building serving as a neat emblem, good only for the creators and the employees and their vanities—and then, barely beneath it all, an atomistic pessimism of the gravest sort, unknown even to themselves, but there all the same, pulsating in the shadow of their good intentions.

It had to remain subterranean, of course. It violated their professed commitments. They seemed unwilling to tinker with those principles, even if only to bring them into line with their actual manner of living in the world. In a way, you couldn't help but feel that the authentic and self-aware were those scorned men and women of commerce: the executives and stock-pickers, the salesmen and developers, and more generally those of the affluent professional classes, which included friends of mine like Immo, a pedigreed and promising physician. Mostly I mean the callow among them, who because of their youth still talked openly, without too much embarrassment, of their *desirousness*, their simple *ardor*; whereas the more mature ones, who had secured fine perches in society, learned to bury this honest crassness in humanitarianism, philanthropy, and art collections. These people might have been basically bad—they almost certainly were—but they were unsoiled by bad faith, which seemed in one vital respect to put them ahead of so many of those avowing a commitment to the life of the mind.

What sorts of things, I often wondered, actually went on in the community center? Was it making more headway than I thought in yoking together the peoples of this neighborhood? Or was its function at this point mostly symbolic, as if flesh and blood people were of only incidental importance next to the dream world the urban designers were ostensibly building? More and more, a contrary thought visited me: why exactly *shouldn't* dreams have an independent claim on us, however at odds with reality they were? Why is it no one could find their way to crediting that, at least sometimes, reality, first in the order of being, ran second to illusion in the order of value?

At what point would all these heirs to the Bauhaus finally stop pretending about the future, about where we were headed? Every decade or so, it seemed, some group resurrected a program—a project—of urban renewal, even if the members had to use a slightly knowing tone in discussing their efforts, which acknowledged the potentially indulgent, quixotic aspect, all the ignominious failures and the lessons of Jane Jacobs, to wit, that a city is not a work of art. What I wished, in certain moods, anyway, was that this tone wasn't only knowing but positively unabashed: that hopes, even impossible, delusional ones, might be avowed as dearer to us, more complete, than any reality.

As far as community went, it seemed to me that the threadbare businesses I was now coming upon, as the social center and its radiant grass receded, were doing a better job of fostering actual ties, a sense of a common enterprise, than any of the utopian plans for renewal. This town square of sorts, centered on a series of massive billboards off to the left, hovering above the ubiquitous signage of the smaller shops—it was here, if anywhere, that one could begin to see the soul of the fellowship,

the fount of its unity, where the personality of the whole, including its conflicts and incongruities, concentrated itself. Taking in all the hoardings and advertising, you felt as if you were staring it in the face. This was not an aspirational identity. No, it was a lived one, though one so many *outside* of this company seemed to be chagrined by.

I was always interested in the changing expressions of this face, in what new look it gave you as you passed. The larger signage altered every few weeks: fresh placards were posted in the bus shelters and abandoned telephone booths. But those two giant billboards might as well have been eyes, and when they shifted, the particular expression of *this* face would set the governing tone of the streets. It appeared that a new vision had emerged since last I'd walked this way. Was it two days in my apartment that I'd spent, not venturing beyond the pair of bodegas on my street? A monumental advertisement had gone up on the side of the ten-story apartment building just beyond the subway station, past the intersection. This façade wasn't blind: people lived and worked in these windows, theoretically at least, so there were holes cut out of the image to accommodate them—the windows, if not the people.

What went up around here really did matter, in a palpable, pre-theoretical sort of way; the wrong images could scramble the space, making it incoherent or worse. A few months earlier, I'd seen an especially ill-conceived advertisement plastered on this façade, for a televised psychological thriller in eight parts. People wanted their shows in parts now, segmented, and indefinitely extended: the idea of an ending, a finale, had taken on a newly tragic dimension. This show, *Connivance*, would go on to dominate the summer, for Netflix or HBO. But the central characters, pictured off to the lower left here, had been rendered indecipherable by the holes punched in the boarding. Worse, the blown-up face of the ostensible star, the man who was expected to get and keep people watching but who I only vaguely recognized, had not been placed along the edge, where there was more room to accommodate an image before all those windows began to break things up. Instead, his visage cut through at least three columns of apartments, such that even if you managed to recognize him from what remained, you certainly couldn't interpret his expression as he gazed across the frame at an encroaching conflagration. To know a face without also perceiving its expression is discomfiting in the extreme. It's like an outside without an inside, a window onto nothing. In this case, not only did one not know, immediately, for whom this television series was a vehicle—someone in a passing car would surely miss it—but, even more fundamentally, one also couldn't say what attitude he took toward the flames. It appeared he was smiling, but what sort of smile was it? Beatific? Contemptuous? Maniacal? Which one would have depended on precisely the information the windows redacted.

For precisely this reason, I assume, it was redone after only a few days. But the new image had no protagonist at all—or, if there was one, it must have been the holocaust itself, which cut more deeply into the foreground. The star's curious name, Merc Erringer, came just below it, in a poorly proportioned serif, almost as if it were naming the flames rather than a missing actor. I waited for this advertisement, even more jumbled than the original, to be taken down, but the costs must have been too great. It survived the month.

Today, as I stopped at the top of the steps leading down to the trains, this same façade was covered in thick red stripes slashing diagonally across a bright white support, with the Marlboro logotype along the bottom, in quite small lettering, so the colors themselves served as a metonym for the company. Nearer the intersection, there were the two billboards straddling the street and carrying, as they frequently did, a single ad between them. On the first, the larger one to my left, a blue can floated in white space while tipping right, with a plastic lid and an aluminum pull-tab flying above it, both halfway out of frame. A flurry of peanuts sprayed out toward the right edge of the billboard. Closer to the ground, on the shorter board on the opposite side of the road, there were more nuts, those that had completed the leap between the panels, cascading down into that same infinite white space:

The nuts with POP

This was the tagline, along the bottom, upon which the nuts fell. What I mean is that these were diegetic letters: the nuts were ricocheting off the letterforms themselves. At first, I assumed *pop* simply stood for especially good flavor. But looking more closely at the copy printed on the giant Planters can, and at the nuts themselves, more the size of basketballs and tinged a similar orange, I could see that these were *spiced* peanuts.

The fringe of the sign had already succumbed to graffiti; locals had added various taglines of their own, all of them endearingly obscene, laced with epithets and slurs and sexual references to nuts of all kinds. Theirs was no sterile rejection of the sign, the détournement of champagne socialists, but a genuine collaboration between the very people likely to consume this product. They weren't interfering with the marketer's message; instead, the graffiti resembled the commentary one found appended to online stories and Twitter posts, and, just as there, it only drew more attention to the sign, exerted a kind of communal possession over it, even in its soft contempt, which was, remember, the general tone of the entire neighborhood. Was there any other attitude that could have been more apt?

Marlboro and Planters, cigarettes and peanuts. Neighborhood staples. Taken together with a few other giant ads clustered on intersecting streets; the ads blanketing bus shelters and flying by on taxis; and the smaller shop signage, which itself seemed

to be reconfigured by the point-of-sales ads in the windows just below—you could say these comprised a kind of stage-set, but not one the actors recognized as such. It was simply their ecological niche.

The products and their distinctive designs and trademarks, the symbolic valences—the "personalities"—of the various brands to which they belonged, the latest line extensions of one company set against the classic reissues of another, jointly adumbrating the movement of history: all of this was luminously conjoined by nothing more than the physical constraints of that public space. It lent structure to buyers' lives, as market squares always have in every part of the world. It may not have been realized in quite the way one would have hoped, but it couldn't be said that genuinely public meanings weren't circulating here, that a common visual language didn't exist, nor that this language was any less binding than Christianity's iconography woven through the plazas and pews of days past. The parallels weren't merely visual. The adman's redemptive exhortations to consume, harnessed by turns of phrase meant to ring eternally in the ears and *move* men, in spirit and body, were simply an outgrowth of the minister's righteous entreaties. It could hardly be doubted that the representational powers of commerce were any less flexible, complex, or generous than any religious order's.

I trotted down the narrow, corrugated steps of the station. The entryway was especially deep; you descended three long flights of stairs, turning against one wall and stepping down sideways to make room for traffic in the other direction. Daylight gave way to greenish tones as blue electric light struck an aqua mosaic running down the inner wall and bleeding its colors onto the floor as well. Here was a queue of human figures, rendered at scale, extending at least thirty or forty yards, right up to the turnstiles—as if people were desperate to get on these trains, away from the borough above. But the bodies' forms were curious, indeed near-hieroglyphic, given not just their flatness but the discontinuous spatial relations linking one to another. That is to say, these bodies, recreated in miniature tiles of differing flesh tones, were *next* to one another without at all being *together*.

I didn't linger long over the mosaic, though, and the others passing didn't seem to see it at all. Underground, what really attracted their eyes, and mine, was the great variety of posters riddling the space. These bills were slapped across every surface that would bear one, whether the paid advertising spots in each station sold by the MTA or just any bare bit of wall, even sometimes a garbage bin or an elevator, where riders posted smaller notices for more local matters—performances, apartment rentals, protests—that, however regularly they were taken down by officials,

never seemed to stay down for long. As I slung my portfolio over the turnstile and swiped my way through, I could see them all together there, at various distances and in every size. Among the most polished were the large placards for bombastic silver-screen blockbusters, which were in truth almost indistinguishable in style and finish from the ads pitching the better television shows, of which a fair few were interleaved among all else here underground. In both cases—and curiously, just like the mosaic—they tended to flatten perspective and collage their elements in symbolic relations, however confusedly.

The ads for clothing, mostly mid-tier fashion brands employing mass-label designers, were cleverly calibrated to the traffic at this particular station, which was less generically laden with images than you might assume. Now that even the advertisements of public space could be almost as precision-guided as Facebook's and Google's online, these fashion appeals were pitched to locals as accessibly aspirational, not absurd or even mocking, as they would have been if the brands had been truly luxurious: Lobb or Creed, say, which you might well find closer to Fifth Avenue. As always, there was also a smattering of ads for abstract services like insurance or the issuing of credit, where the imagery had no clear significance at all: sometimes just a busy intersection or a large congregation, for instance, like the one in front of me presently streaming toward the platform, I suppose simply to signal a general sense of frenetic interaction, where Mastercard or Prudential could help in unspecified ways.

Typographically, the design consisted in a lot of knee-jerk, left-justified, lower-case sans serif: a careless, watered-down version of the already dulled Swiss style, which would have been too complex or jarring in its original asymmetric arrangements for today's consumers, who, experience proved, would settle for rather little, if any, art in their products, so long as they continued to confer the right sort of social stature upon their owners.

What I found genuinely appealing, though, was the continuity the posters and placards maintained with the world above: that overground space of bills. Not unlike the community center, the city-commissioned stairwell mosaic seemed distinctly misjudged, evincing a blindness to the real workings of the community by trying to provide what was already provided for. It was almost violent, the way public art here intruded into an ecology that had, without anyone's help, managed to generate its own order, however brash and abject you might find it.

Eventually I reached the platform of the five train. The summer was only just over and the station still held heat; within moments of entering I'd felt my shirt wilt against my body. On the streets above, the heavy air lent the refuse lying around a violent stench, far more commanding than the eyesore created by all those plastic bags. Down below, something similar went on, the heat amplifying the pungency of

beggars, like the one in army fatigues procumbent beside me. I toed the yellow safety line, inches away from the depths of the tracks and the little furry missiles, the truest natives, the rats, who probably felt the beggars to be squatters.

I'd seen this woman many times before. She was both emaciated (her arms and legs) and bloated (her face and neck). And she was always right here, on the Manhattan-bound platform of the five. We were almost intimates. Finding her brought me a sense of comfort, like seeing the mailman delivering letters, or watching the pigeons strut around Times Square. I believe her name was Helena, though it is possible, on the few occasions she used the word, that she'd actually been *asking* for Helena, or else simply declaring, through the slur of drunkenness, *hell-on-earth*, which would have made enough sense. We'd not really exchanged words, though we had both spoken or mumbled or muttered to ourselves within earshot of one another when there was no one else around. I considered her a confidante of sorts. Today she was rolled over on her belly, her marbled green-and-black trousers stained around the backs of the thighs—I could only imagine with what. Apparently she was trying to sleep on a bench that was itself specially commissioned, like the mosaic, but with less benevolent purposes in mind. It had been broken up with narrow, unusable armrests to make passing out on the bench unpleasant in the extreme, in the same way rows of gentle spikes—nothing that would create a liability, of course—were strategically placed in the plazas of grand corporate offices to discourage sitting or even leaning.

I regarded her warmly, without any of the pity of those who would take her fate in their hands and try to improve her life, say, with a five-dollar bill or half a Reuben sandwich, or even by sponsoring job training programs or drug rehab centers, as if they full well *knew* what a good life was and were going to help Helena achieve it. I admired her *as she was*, for the ancient archetype she instanced—the indigent nomad, carrying her sacred burden—and even more for her ingenuity in conquering the benches of the city planners, who were locked in an arms race with the homeless, perpetually extruding them from public space. Helena effected a number of contortions with her spine—her body undulated right along with the armrests—to turn this bench into a bed, as if it were no ordinary backbone she possessed but a jointed one, and multiply so at that, five joints to match the five rests, like some adaptation her line had evolved over the years to keep up with the treacheries of her steaming, sulfurous environs. In this regard she was no different than a bacterium clinging to life in one of those toxic Yellowstone springs.

Presumably Helena was sleeping off another hangover, which would spare her some of the pain induced by her tortuous posture, however well adapted she may have been. Alcohol was a second adaptation, or more likely the very first. I myself

knew, through dealing with Claire's departure, what alcohol could help reconcile you to. Whatever else you could say about it, it *had* magic in it.

The fermentation of beverages was the clearest component of the woman's odor—gin and beer were pronounced notes, and probably I would have detected other things had my nose been better, or had I been willing to risk getting any closer—along with what must have been weeks of perspiration that had worked itself into sloughing skin. The sweat had congealed into a crumbly tan paste around her neck. On days when she was down to a tank top, the same substance enrobed her armpits; I couldn't imagine how the situation could be any better around her crotch.

Her aroma commanded my attention, and that of several other would-be strap-hangers nearby: her own private *atmosphere*, a vile miasma, endowed Helena with her last bit of authority in the human race. How many times had I seen people sit, had I myself sat, shoulder-to-shoulder with tramps on the train while carrying on conversations with friends or even strangers that were of middling interest at best, yet whose continuity was entirely unthreatened by the plain sight of the beggars' stupefied heads lolling as the train rattled along. You could see, if you bothered to, that this stupor derived from drugs only in an ancillary sense. Mostly it traced to the sheer accumulation of desperation, which cleaved to them like sweat, this desolation induced simply by the relentlessness of living, the endless onrush that they, for what-ever reasons, and these reasons were far more diverse than we typically acknowledged, couldn't stay out of the way of—or just ahead of—like the rest of us. It left leaves and debris stuck in their hair, and crusting fluids staining their lips and shirts and trousers. And what exactly was it, anyway, this yellowish *stuff*, to be distributed so uniformly around their bodies?

Compare this invisibility to the way a vagrant, even one of the less tormented ones, if she'd not had access to a shelter's facilities recently, or want of them, could clear out half a compartment and still leave the other half dazed, staring at nothing, choking for air. The force of the odor was undiminished through familiarity. That you'd smelled fetid skin a hundred times before did nothing to assuage the pain you suffered the next time. Granted, the type of attention held this way usually was laced with contempt, exasperation, or irritation at the least. Stink was strictly a power to repel, not attract. Yet this *was* still power, the last bit these creatures possessed in the social world. Given how disoriented and diminished they seemed, it struck me as offering a kind of natural protection, as plants are protected by tannins, millipedes by quinine. Nature was clever about such things. And the power really wasn't all neg-ative. What I'd noticed, and I was noticing it again as I waited for the five train, was that the fragrance didn't just draw my attention: it *captured* it, refused to release it, so

that there was nothing left to do but engage its source. This is why the homeless were often taunted and occasionally beaten, even killed. More typically, matters unfolded like this: while my first feelings may have been, yes, exasperation and disgust, after thirty or forty or however many seconds, my mood would invariably soften as I began with my eyes to return the creature, till then hardly less alien to me or anyone else onboard than the rodents on the tracks, to a shared realm of humanity.

That didn't mean I took any action. Nor did it mean anyone else on the train did. But to see a creature as human is not to see her as a friend as such or, more fundamentally, to think you had an invitation to change the course of her life, as if something licensed you to select experiences for this person, decide which ones were worth having and which ones should go. Would I grant anyone a similar power over the course of my own life? Did I even grant it to myself? Did we really live only for pleasure and the cessation of pain? Maybe the rats did, but not us. It could be impossible to say what was best for any one of us, I thought. I couldn't even say with unassailable authority what ought to come to me. How many times had I not gotten what I wanted, what I *needed* even, and found that life had turned out larger for it? For all I knew, this is what the loss of Claire would amount to, though I hardly felt that in my bones, not yet. So what of Helena's pain and dereliction? Could it end up being the very deepest part of her life, even if it was also the darkest? I couldn't be responsible for taking that from her.

What I can say is that my regard, in those moments, could actually enchant its objects; it was as if someone were born before my eyes. If this capacity of mine had no material effects, well, I didn't think it needed to—though often enough I would later sketch whatever it was that had convinced my gaze of its higher possibilities.

Helena was sitting up now. My feet were starting to ache, the train was so late. I sat down in the last "seat" on the bench as she transferred herself to the ground, not far from me. My head filled with further ideas about what this odor was that had my being in its grip: rotting apricots came to mind, nauseatingly sweet, I don't know why. I almost wished I had my sketchbook with me; I sometimes felt able, like a synesthete, to render one sense into another. This lady crawling on all fours, I realized with some joy, was now more of an olfactory phenomenon than a proper object of sight. With the right instruments I could render the transposition, molding her visible form to match her defining scent. She stretched out and placed her head near my legs. For a moment I thought she might actually bite my feet. But she set her head down softly, put her face right on the concrete, satisfied that my loafer was neither a threat nor a source of nourishment.

A gentle breeze tickled my cheek, and soon after the train streamed into the station, carriage by carriage. I rose above Helena and lingered over her form for a

moment as the doors opened. No one got off, though the carriage was quite full; people must have still been going to work around this time, and my neighborhood was not much as a place of work. From one car down a pair of young black buskers did get off, rather noisily, but they boarded again through the far doors of the car I'd be riding in. One of them carried a portable stereo, a device more or less obsolete aboveground but put to good use here. I stepped over dear Helena's head and onto the train, my heel might have even brushed her hair, and slid the portfolio like a blade between several passengers, resigned to the musical performance to come. But as the train gathered speed, the stereo remained mute. The buskers simply stared through the windows into the black tunnel where nothing could be seen. They must have been off duty, which was just as well, for once again, as I stood with my portfolio balanced against my legs, my head tilted back to avoid incidental eye contact, I found myself face-to-face with the car cards, in this case a single advertisement running the full length of the carriage, like a multi-panel painting. They snaked their way down the far side and collectively addressed a rather heterodox theme: food delivery. In a skinny white lower-case typeface, set against pink and green pastel panels, and with no food or anything else actually depicted—this was the most interesting choice—these panels held forth on the virtues of the home-cooked meal, even when the home in question was one you would never visit. What mattered, rather, was that this home, its kitchen in particular, did in fact exist, and that a go-between did, too.

I fell to studying it, as I frequently did the city's vast and often incongruous signage; but it wasn't long before I turned to scan the cards on the facing side, as if I'd heard a voice over my shoulder, beckoning me. Here was a parallel set of ads from a different company, once again running from end to end: this was now the popular if expensive format. Once again they consisted solely of text, in all white, but the background tones were stark: black and gray with swatches of neon blue set vertically in stripes along the borders of each panel. Standing where I was, I could take in both sets of cards simultaneously, right above all the faces of the people I was avoiding. From this position it seemed as if the two advertisements were carrying on a dialogue, each panel speaking to the one directly across from it. But the darker panels spoke not at all about meals, home-cooked or otherwise, even if they were still enthusiastic about movement, transport, automobiles. Rather they spoke only of personal, not food, transport—car ride services and surge rates, to be exact—and this time they dared to speak comparatively, if not belligerently, naming the names of their chief rivals (there being but three players in this industry) yet maligning them only subtly, with a tonal simper.

The food delivery advertisements simpered, too, actually. Although they spoke past each other *substantively*, in language I cannot now recall and don't believe the marketers

had any interest nor expectation in my retaining, there was a deeper kind of conversation going on here: not a discussion of food and rides and food rides so much as a lesson in the best ways of speaking, and hence of thinking, *about* these things—to wit, hedged with parentheticals, laughing all the way. And it was diction, subtextual without being unconscious, that did the psychic work. Doubtless the marketers planned on making *this* message, rather than the language itself, unmistakable and eternal.

At this level, each ad said something parenthetical (the after-subtextual thought), although what was said under the breath, as it were, in each case differed greatly. The one touting the beauty of traditional home-cooked meals used invisible brackets to address the reader's misgivings: *What's past doesn't have to be past, you know. (Though let's not get carried away, it can't exactly be present either.)* The other series, however, framed the pitch itself as the afterthought, reserving the primary (invisible) copy for the ostensible virtues of the competition. It seemed to have no interest in lifestyle advocacy or nostalgia, playing instead to simple efficiency and the obviousness of its superiority: *You're getting one of those? Nice. (Seen this one?)*

The two voices rang out clearly in the subway, though both were defined by their keenness not to be seen as keen. The lower-case voice had been echoing, I knew through Karen's tutelage in the history of advertising, at least since the days of Bill Bernbach and those VW ads from the 1960s that people still couldn't stop trotting out as unsurpassed paragons: the ones where the clipped copy, the only ballast in a sea of white space, somehow turned the Bug's slightness, the fact that you could miss it altogether if you weren't paying attention, into its strength. This voice, which you couldn't escape no matter where you turned now—the Millennial and Gen Z versions were so many variations on a theme—had resignation as its eternal bass note, even when it was trilling with mirth. It spoke with a wry melancholy of and for a world buried in goods and services, in which the most one could do—or, rather, *would* do—given how little out of one's way, against the currents of ease, one was *truly* willing to go, even in the name of things one knew to be right, or anyway certainly not as wrong as this—the most one would do was *make the best of things*, which meant consuming with a touch of knowing regret.

More than one generation had tried to shake off this apparently terminal state of acquiescence, which advertising only reflected back to us. There'd been a flare of real indignation at the beginning, in the sixties, and here and there since then: the Frankfurt School art of the eighties and nineties—Cranbook art, we sometimes called it—and the waves of protest, like the anti-WTO demonstrations at the turn of the century; Zuccotti Park a decade later; and the more recent hashtag umbrage of Black Lives Matter and Me Too. But the emotional costs of fury, coupled with the unavoidable retrospective acknowledgement, in each case, that it had all been a retrenchment since

then, meant it petered out in one or another kind of moral fatigue—which of course led right back to resignation and gentle regret. In other people, the same emotional toll, and the same unyielding commercial realities, had led to the deliberate sucking of thumbs, a self-infantilization that spawned a childlike wonder at the starkness of twenty-first-century man's predicament; but this was really just a subspecies of surrender, defensively spiritualized through the assumption of the fetal position.

It seemed to me, as I rode the train with the buskers, that none of the voices clanging around us, whether of art or what passed for public philosophy, or even those of the admen on the billboards, had yet found a way through to a genuine rapprochement with the world as it was. A secular theodicy is what I'm talking about, more or less, or at least its possibility. I'd raised this notion I don't know how many times with Karen and John and Rick. They always got a certain look in their eyes when I did; an aloofness would overcome them. They were never going to help me explore this properly, as they were convinced that everything had to change, that *this*, the world that was ours, that was *us*, just couldn't be right. How much time had they actually spent trying to get a hold of what was, though, rather than trying from the start to refashion it into something they thought *had* to be superior? Did they even understand that something, either? They *thought* they did, of course—but *did* they?

The two buskers, black men dressed in homage to the 1980s, with satin jackets and tight black jeans, remained docile, biding their time as the train slowed at the next station without actually stopping. My gaze eventually landed on the people seated on the cool lavender benches, the ones addressed by the ads on the opposite side. Since I was standing at one end of the car, facing toward the rear, I had a vantage on nearly all the passengers, right along with the entire ecology of ads here that the MTA swapped out week to week—not just the cards above, but the posters near the doors and just over the seats. Half the people in the car must have had alternative forms of transport impressed upon them; the other half couldn't help but think about what lunch or dinner might look like, whether and from where it ought to be delivered. I myself was in some way considering both matters when, after a slowing of the train that wasn't a feint, we rolled to a stop at the next station. But before the doors could close again and we could restart our journey, 'Beat It' exploded from the boombox.

As passengers squeezed past the buskers onto the train, the one with Wayfarers clapped his slender ashy hands and swung his head low and wide, from side to side, in a way that suggested he was blind—which is to say full of life but utterly without vision. His timekeeping was abysmal: his claps went in and out of sync with the music and his swinging head did no better hewing to the beat. Everything about him was

wobbly, even his grunts and *come on*s and *oh yeah*s and *feel me now*s. So the hypeman's young partner, the dancer, had little choice but to carry the load. The boy was small yet his jeans were smaller, and evidently this wasn't an aesthetic decision but a matter of economics. The pants were meant for a child—probably the one he once was, who he was now compelled by circumstance to continue to dress as. I marveled at the degree of constriction the jeans enforced, the way they lent a geometric precision to the swings he took around the pole and the running wall jumps—the doors served for walls, he had such confidence in the train's integrity—that made him flare his legs in a manner somehow both mechanical and animal.

As Jackson's staccato vocals gave way to Van Halen's warbly solo, I let myself imagine the boys were brothers, or better, the subway children of Helena, making the daily rounds and collecting money to support her. They must have delayed their routine initially, I thought, in the hopes that by 125th Street there might be enough Harlem gentrifiers onboard from whom to scare up some pity and cash, the one leading to the other. This car's composition, though, had changed little from the time they'd gotten on; the crowd might well have suffered from greater material lack than the performers, who at least seemed unburdened by children and, who knows, might well be living on and off with relatives other than Helena. They had *style* to them, nothing mystical or in-dwelling, but also nothing that could be freely acquired. It was the kind one picked up only through just the right degree of exposure to hazard. It made certain others of us envious, the ones whose lives were simply too insulated from danger to furnish it. Most of the riders coming from the Bronx occupied that same reality, and so were probably no less formed by distress; but the weight of accumulated obligations, or just the recession of magical thinking that comes with age, had cost them their daring.

They seemed barely to register the performers right in front of them, and were in a state only removed by degrees from that of the homeless, who'd for their part been rendered almost catatonic by city life. Yet Jackson's song couldn't be so easily fended off. It must have led them back to memories from a time before their burdens had overwhelmed them so totally. At least two riders were openly mouthing the words, words I couldn't recall until I saw them on their lips; several others, almost despite themselves, could be seen quietly nodding along, as if they were resisting the impulse but failing to suppress it. I myself was accosted by shards of imagery from the classic music video: a corkscrew of glistening black hair down the forehead, virgin white suitings, eyes that seemed not to have aged with the rest of him. It had made Michael seem old when he was young and, later, young when he was old.

Jackson's words and odd ejaculations mingled with the ones from the ads, introducing another layer of text into the atmosphere as we descended further down the island

to a place where the young men's routine, nearly over, might still succeed. As the song entered its final bars, the dancer helicoptered dangerously close to riders' heads, but none of this could convince passengers to pay him any mind or protect themselves—which, I suppose, meant they believed in his skill. Or else they were genuinely oblivious to him, and not merely simulating preoccupation or lethargy, as was common in more prosperous neighborhoods, as a stratagem against verbal or physical assault. As the subway car emerged from the constriction of the tunnel, its volume seemed to expand many times over, precisely in proportion to the growth of our collective field of vision, which encompassed a good part of the overbright station. When the brakes clunked on to slow the train, the dancer, panting heavily, and the hypeman, putting the boombox back on his shoulder, held out their mesh baseball caps perfunctorily, guessing that from these uninterested riders no coins or bills were forthcoming. They brushed past me, with patchy moustaches and open mouths full of crooked brown teeth, at such a speed that even if I had wanted to drop a few coins in their hats—and had I been given slightly longer to consider it, I might have—there was no real chance.

This time they didn't even bother to hop out first and come around to the next compartment; they went straight through the interior doors linking cars, which from the start would have given them away to the next car as hustlers, rather than offering even the pretense of being ordinary passengers, perhaps inspired (it was absurd, but still) spontaneously to dance. I moved toward the windows of the doors they'd just passed through. I let go of the rails and leaned against the window, with the portfolio flat against the door, to get the best possible view of them, and indeed of the new adscape in which they'd be performing. I must have made a strange impression from the other side, clinging to the window like this, with my face pressed against it as if I were intoxicated. The older of the two buskers looked back and smiled, though I couldn't be sure he was looking *at* me exactly because of the sunglasses.

I could hear nothing from the car after the train began to roar and squeal through the tunnels: each section of track throughout the city seemed to make singular ululations, I wasn't sure why. I was curious to see how the buskers' performance played when framed through two windows and without the aid of iconic pop. My only indication that the music had begun was the swinging of the hypeman's head, which again made me think he could see nothing at all, and further that he couldn't have smiled at me just seconds before, only at the place from which he'd made his escape.

Observing his asynchronous sway repeated with such precision—perhaps he had more talent than I thought, though he was certainly deploying it oddly—as well as the boy beside him taking his first tentative steps with the same sense of experimentality, it was clear that their performance was more carefully choreographed than I'd thought. The program was quite strong: balanced, pregnantly paced, in a word,

shapely. And it closed fantastically, once again with those legs twirling above the young man's head as if he might just take flight, and the delicious hint of a disastrous collision with the face of an elderly white woman who looked as if life had brought her enough trouble already.

Yet the dancer was not yet a beautiful mover. The choreography outclassed him. Who'd come up with it? Perhaps the blind hypeman, in the days when he'd danced, which he might have outgrown not because of the onset of blindness, but for a reason similar to boys who quit singing soprano when their voices break and they're forced to move on to lower registers if they are to persist at all. I imagined that there were enough subway cars in the five boroughs, that someday this same boy would be something quite sublime—before he too grew too old for the part and turned into a sideman—supposing his station never changed and the underground remained his home.

His problem, once he got going, wasn't any kind of tentativeness, as one might have expected given the demands of this style of train dancing, and his youth as well. In fact, he was too brave, hurtling himself into positions he couldn't yet control. The blind man's claps seemed only to goad him to venture further beyond his skills. His ambition, though it was his primary charm, and I was delighted to witness it as I pressed against the glass, compromised his performance. I don't know that it would have been more satisfying, all told, if he'd respected his limits. It would just have been a performance with different merits. In any case, I doubted that the rawness of his maneuvers had much to do with why the riders remained indifferent, as they were for his latest performance, too. It was as if, side by side, two distinct modes of being prevailed, with no bridge between them. This was, to a lesser extent, the very condition of life in the city, a kind of open-air fragmentation of psychic space, a perpetual, and probably adaptive, blindness to what was right next to you.

The train stopped sharply and I nearly fell backward before catching the pole. The buskers got off this time without even going through the pantomime of seeking donations. They pushed their way out of the car with their hats back on their heads and disappeared into the station. Or they tried to. Through the car's windows I could see they were trailing an energy undimmed by their failure to transubstantiate it into cash, and this energy, demarcated by the emptiness of their wakes, the wide berth they were given underground, seemed to pulsate against the backdrop of all those anonymous passengers crisscrossing the station at what seemed like half-speed. I followed the boys quite a distance with my gaze, much further than ought to be possible if they were really no different from anyone else. I fancied their chances.

I took a newly vacated spot on the bench between two others who made no effort to make room; my portfolio crashed into their legs and I made no

apologies. I got off at the next stop, at a station I could only remember as *the one to get off at for the Met*. My last time at the museum would have been almost six months ago. Since then, I'd developed a startling and visceral aversion to such spaces, for whatever it was they did to my sight when I crossed their thresholds, ambling from room to room, with ceilings too high to concentrate the mind, passing from the listless supervision of one set of guards to the next, gazing alongside dozens, sometimes hundreds of others fanning themselves with the cleverly designed programs for the latest exhibitions or else trying to occupy understandably weary children with the programs' hot colors, and finally peering into the pristine glass houses of European paintings and sculptures. There was also the pivoting one did in the centers of rooms where recent work had been arrayed on all sides, intentionally haphazard, and throughout, the consultation of those blocks of texts stationed on the walls, in a self-serious humanistic font that needed kerning, though somehow this was missed in spectating like this, in an induced state of hushed, reflective repose, scanning a hundred cultures in a day: Etruscan pottery, the festive and cultic masks from Indonesia and Aboriginal Australia, not to mention Venice, alongside Mayan shields and stone tablets, inscribed with something like an alien calligraphy, and even a cracked spear from the Andamans, which I understood couldn't be reached, the islands, that is, but apparently not so, one could at least pluck the spear they hurled at invaders and tuck it away in a New York museum. Looking around in these ways, exercising my faculty of taste almost indiscriminately on all these uprooted artifacts presented as self-standing totems, representing only themselves, their looks: well, this is precisely how I had gone blind to it all.

Not to the displayed *forms*, of course. That's exactly what remained of them: shape, color, line, extension. But blind to whatever it was that might have made them, pre-reflectively, count for something; what might bond them, that is, to the world of their creation, to their original *users*, not merely their latter-day *appreciators*. Such an understanding was probably the historical reason they'd been gathered here at all, at least for the pre-modern work. The wall text was meant to situate me, but really it only redoubled the dissection-board-and-formaldehyde reek pervading the space. Modern museums invariably led one down the aestheticist path. No wonder people had been complaining about them for so many years.

Long before I'd developed this sickness, I'd studied museums quite carefully. Every artist did, of course, at some point, under the heading of *institutional critique*. So many of us had our intellectual doubts about the place, but that didn't seem to spill over into experience, the fundamental testing ground. Even for me, it hadn't happened until recently, and that only because, perhaps, the sheer length of time I'd

been considering all this, long before most, long before I'd ever arrived at college or even junior high. I was engaged with museums, and going to every last one of them, from my earliest days: all because of my mother. And I'd been thinking about them ever since. In what I learned of her self-exile from that industry were born, perhaps, some of my first doubts about its value, hearing her expound on how programming was created, and the sorts of people that went into this line of work, the particularities of their attitudes and educations. It was only a matter of time before my heart caught up with my mind.

What was the root of it? It started from all the history my mother had insisted I know, the books she wanted me to read, which she would even read to me before I ever became serious about making things to go in those spaces. Half of this stuff my brother and sister could tell you, too, though now they had no practical use for this knowledge. I knew very well, and for the longest time, that the modern Western museum's handling of objects traced most directly to the sixteenth century Kunstkammer and the *gentleman of taste* to whom it belonged. It amounted to a sort of proto-museum, this cabinet of curiosities, though it was private and permanently accessible only to its owner, being housed in his home, where he might experience it over long stretches, weeks, months, years, in solitude. It altered the equation, allowing for a sort of slow drift toward and through the objects so held that public museum-viewing simply precluded. It was here that the dispassionate manner of considering art began to take hold, where artifacts, frequently from far-flung parts of the earth, might be registered in the first instance not as objects of use, spiritual or otherwise, but as *curiosities* speaking to the diversity of mankind's endeavors, which was the first decisive step, really, toward formalism. It also had the hint of carnival, and novelty for its own sake, too: a tiger's paw, a Komodo skin, the tusk of some dinosaur, a medieval painting, an ancient bust, all crammed together. Of course, the remediating factor of the Kunstkammer, one which the museum didn't share, was that since the collection was private, it made it possible, should the nobleman spend enough time among his holdings, for his relationship to go far beyond mere curiosity and embrace more intimate functions.

This gentleman's most distinguished early theorist, my mother had first shown me, I believe as early as the seventh grade, which is extraordinary, was the Third Earl of Shaftesbury. It makes sense, I suppose, that it should have been an earl to have hit upon this, this somewhat remote and tranquil form of *appreciation* (does the word not already suggest a distance, something somehow *extra*?) long before Kant did. But it was a view I hadn't found agreeable for some time, if, in truth, I ever had. After all, hadn't I always preferred viewing prints of great and frequently esoteric works directly in my home, or else in an anonymous private carrel of a

library after getting the archivist to find them, rather than the original work in a public museum, which so many times I'd declined to view, or took only the most cursory peek at—say, Velázquez in the Prado? I could get far closer to a knock-off viewed in solitude than I could to original works of art in a museum, which managed to degrade and distance the signal, surely greater than my prints, of the originals they housed.

Saul Steinberg, the unplaceable metaphysician of the line, a line that ran straight through so many mundane venues, none more so than the pages of the *New Yorker*, had said he disliked museums precisely for *removing art from the flow of life*. I'm not sure I cared about dislocation as such, if it didn't have the effect of removing the art from art, too—though perhaps he would not have cared either, unabashed elitist that he was. What I did know was that it was no longer my goal to be in the permanent collections of New York's great museums, to be displayed in just the fashion that left me so cold. (This would have secretly thrilled my mother, given her own disappointments in the art world, though she would never *tell* me to throw away my career.) Crucially, that *doesn't* mean I was looking to create ephemeral art, or that I had gone in for participatory practices, relational aesthetics and the like, which had led to hardly anything of real import, once the novelty wore off. I was still keen on making *things*, concrete physical objects, not merely events or experiences. But it seemed to me far preferable that these things stay in private hands, and out of these glorified Kunstkammers. For was it not obvious that an artwork, any artwork, today was nothing more than a curiosity?

Of course, adequate prints of *everything* certainly didn't exist, so it remained the case that plenty of work could be seen nowhere else but in a museum. That was the state of the world; these endowed institutions had managed to stockpile great numbers of objects, as all those grand cabinets were donated by gentlemen of taste upon their death, for the sake of posthumous prestige, to the museums of the eighteenth and nineteenth centuries. When these artifacts existed in the hands of a private collector, though, they would have often carried real vigor in them: they would have made worlds present to their owners. Perhaps some of those collected items retained interest even after the relocation to the museum halls, just as one can occasionally find a happy bird or lizard in a zoo. Indeed, many of these objects, created in the centuries since Shaftesbury, were really bred in and for captivity, ideally for universities and museums to curate; they bore that lifelessness within them, in their origins. But the ones that had come from the age before the museum had seemed to me to have died behind bars, thought that didn't mean you couldn't still see some glint in their fossilized remains.

When I'd come to the Met last, there'd been an exhibition of manuscripts dating to the early Middle Ages, a period bound on one side by Boethius' *Consolation of Philosophy* and on the other by the rise of Charlemagne, the first great post-Roman European ruler. I had gone there, and indeed, climbed up these same station stairs, not with a portfolio but with a sketchpad. I'd come quite early in the morning, earlier than it was now, so that the Met would be as unpeopled as possible. The relevant exhibition was gloriously empty, as I'd hoped. I began to copy the specimen I'd come looking for, an illuminated manuscript of Lucian's *A True Story*. The original work dated to around 400 AD, and was full of alien life-forms; quite possibly it was the first science fiction text and therefore eminently suited to illustration. There was also a copy of *The Golden Ass*, which I was left somewhat unimpressed by, and then several of the five canonical ancient Greek novels, all written in the period of the Roman Empire. Perhaps because of the glass, I began my copying without much enthusiasm. But this couldn't be pinned on the museum's airlessness. I simply didn't know what I was seeing yet, the ancient delicacy that still clung to these artifacts expelled from the classical world. I could only see a nascent, underdeveloped form in them, something essentially transitional: the uncertainty of design, both of the images themselves and of their integration into the text, as well as the quality of the handwriting, which carried its own crudity, as I saw it, something that was only to be ironed out in the High Middle Ages.

I *did* know enough, from other cases involving other periods of art, to suspect that I might be, even must be, missing something, and that my view of things was likely embedding anachronisms. Only raw, extended exposure could loosen this view of things, the kind of exposure a Kunstkammer, or in my case, those books of prints I adored, could aid in. I was happy enough, then, simply to take things in at the Met, for future parsing, almost as if I were creating my own curiosities, through copying, that I might house in my apartment to simulate the effects of the cabinet, so that at some moment, I hoped, after sufficient steeping, I would begin to see them for what they were.

I sketched with great care, taking pains in penning the Latin to capture the evolution of the lower-case letterforms, alien to Roman antiquity, and the precise script in which these letters were rendered, their heavy angular strokes whose descendants would come to be known as blackletter, a calligraphic script developed by priests for the speedier copying of manuscripts. The slightest shifts of weight, I discovered, could mar the effect. The purpose of copying was twofold for me, though. I was always curious to see what effects copying would have on my original work, pushing my sensibility, which originated in my hand,

up against the world, and seeing what came of it, irrespective of what I *thought* might happen, or of what I could understand of it at the time, or even, indeed, in the future. There was a kind of blindness here that I actively sought. Today, though, with my portfolio in hand, I was headed east, away from the museum, and I was gripped, always as if for the first time, by the characteristic hush of the East Side. This and the intricate stone façades all around, clearly done at significant expense, and, just like my work in the museum, involving extensive copying of a sort, both of ancient and European specimens. Unfortunately, these weren't merely studies but finished products, which meant there was a dutiful, slavish quality to them. As I continued eastward across the pristine walkways and massively proportioned blocks, so unlike the spatial relations of the Bronx, what stood out was the hesitancy afflicting such pure copies, the lack of the wildness of creation.

All the same, there was no question, as I looked up at them now, that the architectural sophistication of the buildings was far ahead of my neighborhood, with the possible exception of my own aberrant home. Yet the primary point of difference was this: there were *only* buildings around here on most of the streets, and little public imagery—which is to say, the sparseness of advertisements, or more neutrally, in the language preferred by advertisers, of *communications*. What ads there were had been mounted low to the ground or done in muted styles, as if whispering.

This lack, this silence, or at least this quiet (shouting in public around here was not so much the norm as where I lived) was understood implicitly by all as a prime index of affluence. Still, as I listened to distant sirens and watched the city buses roar by, I could never really forget I was in the muck and mire of a metropolis. The lack of signage hadn't somehow managed to transform the area into the Cotswolds, despite its residents' attempts to cultivate such delusions. Neighboring Central Park, too, I thought, ultimately only reminded you of how grubby life was in the city, even elite life. There was nothing pastoral about it. It was grand as far as city parks go, if sheer size could make things grand—but compared with unbridled nature herself, which it couldn't help summoning by comparison, it was nothing, embarrassingly tiny, a curio next to the sublime, in short, a bad joke—but, perhaps, still a loving evocation of the fantasies of the bourgeoisie. I didn't know.

The lack of imagery among these giant façades, too tall, in my mind, to ring with real majesty, succeeded in marking a further absence of humanity, of man's activity, rendering it, if anything, less humane than my own neighborhood. Perhaps, though, it suited the kind of people who lived here, the bankers and old commercial

families who had never actually understood, even many generations back, anything of the true grace of nobility, but were instead the products of modernity's rising urban classes, who had managed, through sheer industry, to put gentlemen of taste into a permanent state of retrenchment. These massive stone structures, right up against the rot of Spanish Harlem, must have been a decent summation of their impoverished ideas of privilege.

4

Whent had told me modestly that his apartment was out toward the East River. It turned out to be fronting it. Yet I was pleased to find that the assemblage of buildings, whose modest curved forms seemed to float over the water, mostly left the past unmolested. It seemed to have unshackled itself from modernist severity without quite embracing the glibness that followed and still seemed to predominate in contemporary architectural circles. I had trouble dating the building, which was of course part of the postmodernist's delight, the confusion of time in the name of space. Was the buildings' design a recent rejection of Venturian insouciance, or did it embody an earlier, transitional style that simply hadn't mustered the necessary self-confidence to do so?

I stood gazing out over the river for a moment, its brilliance manufactured by sunlight that, seemingly sharpened by the water, threw wavy crystalline reflections onto my body and into my eyes. Turning away from the glare, I regarded the pale stone skin of Whent's towers, which shimmered in those same reflections. The entrance was restrained, if curious: a tall vaulted door made in black glass, with a man in a double-breasted suit standing by it. As soon as I passed within, I was swallowed up by a lobby of extravagant proportions, completely filled with light. It streamed in through glass inner walls which, I should have known, locked in *another* perfect square of grass, inscribed within a larger square of black pebbles and nothing else. A white-haired man came for me from the desk, moving at some speed, holding out his hand and giving me, from the start, a firm and purposeful smile. He took the portfolio and walked me to a glass box that was already open, as if my arrival were not merely expected but timed down to the minute. Inside the elevator, he stood with his back to the light. I stood opposite, though I avoided his face and attended to the green patch outside—or inside. I could see no way of accessing this space, so that it became for me a symbol of unreachable nature. Was that an improvement on the illusions of Central Park? Or was it tragic?

I watched the green patch shrink, and when the doors of the invisible elevator finally opened, which you knew to be occurring mostly by the whoosh of air—we must have been very high up—the green was not much more than an indistinct dot. The man by now was standing outside the elevator, with his hand in front of the door, preventing it from closing, and he was looking back at me with what I could see was a congenitally long face. Smiling must have cost him something. He

didn't offer a smile now—one was enough, apparently—and he didn't say anything either as he waited for me to lose interest in the grass. Eventually I joined him outside and tried to reclaim the portfolio, but he nodded me off and even patted my shoulder as he carried it on down the corridor. I followed behind on this poorly lit stretch, its thick champagne carpeting oddly dated; perhaps it was some whim of Whent's. Certainly it deadened our footsteps, so that I had little sense of how fast I was moving, only that the old man was moving faster. After a minute or so, I caught up to him at a set of large engraved doors. Here too, though, he wouldn't release the portfolio, instead merely raising his thin white eyebrows at me and, fighting appearances, making his face project some modicum of goodwill, which by this point I was willing to credit.

Yet before we could knock to announce our arrival, Whent was standing there in the gaping hole he'd just made by swinging both doors open, entirely silently. "Perfect," he said with a grin at me as he took the portfolio directly from the doorman's hands. His single word ricocheted around the foyer, which unlike the hall was dark hardwood. I hadn't spoken to him face-to-face in many months now; all our interactions had been via telephone and email, so I found myself momentarily reintegrating his voice with his body.

The doorman's bearing had shifted. He stood unnaturally upright, and his hangdog expression had stiffened with perplexity. I believe he had meant to have handed back the portfolio to me, the natural completion of the suspension he had earlier brought about. But when his tenant seemed so excited by the sight of it, he relented and turned smoothly for the elevator without so much as a look at me. I searched for his shoulder, to return the friendly tap from a minute ago, but he was already out of reach, on his way back to ground level, where that green dot would return to its true proportions.

"Come and see what you've done," Whent said as he led me across the vast living room, which the sun drenched through skylights that bore through the upper levels and illuminated the mezzanine and ground floor, as did the long windows on the far side of the apartment that opened onto the river. He was dressed far more casually than I had ever seen him in our previous meetings, which had never taken place at his home: loafers without socks, cloaked by a pair of linen trousers that were at least two inches too long and collecting unflatteringly on the floor. Either these had yet to be hemmed, or they had some sort of sentimental value. Their cut didn't quite seem adapted to his body, and this foreignness was only accentuated by his exquisite shirtsleeves, obviously bespoke, although he'd roughly rolled them back.

I was gratified by the abundant informality, here and everywhere about us: the cups and saucers stained with coffee at the bottom and in a thin line along the rim,

about an inch from the top, abandoned and orphaned on several surfaces; all of the international newspapers and magazines, some quite old, judging by the slightest of uneven yellowing across some of the sheets; and the many packets of stapled papers, reports of some kind, judging by the similarity of their design, the long legal-sheet dimensions, though mostly printed in landscape, carrying many graphics with tiny block capitals beneath them. Most of the places one might naturally sit in, not just the various chairs and ottomans and the seemingly endless sofa but also the little nooks and person-sized gaps the entire space seemed to abound in, were occupied by material of this sort, as if he spent a lot of time going from spot to spot. All this reminded me of my own apartment, of bachelorhood, even if he wasn't strictly a bachelor. But I could also see vacuum lines on a small carpeted space toward the windows, and nothing was dusty or dirty—contrary to my place—which suggested that the cleaning service he retained knew to leave his little stations just as they were, not even touching the coffee cups, for fear of disturbing whatever it was he had going on.

It wasn't antiseptic minimalism ruling here, nor the juvenile aesthetic that dominated Silicon Valley, but an almost arbitrary collaging of elements that appeared natural rather than designed. For all that, the apartment bowed to one sort of business fashion that seemed not to have a lifespan: it was done almost entirely in shades of white, which smoothed out the hodgepodge of furniture and lent the space the unfortunate neutrality of a gallery. That was one reason for the impression, anyway. For interrupting all that white were, and this really did cheer me as much as it dizzied me, dozens of my drawings and paintings of Claire. Mostly they were pinned up, without any formal mountings, in just the way I would have put them up in my apartment while they were being worked on. Strange that I hadn't noticed these as I'd entered. It was as if they came into focus all at once, after I'd crossed the living room and was standing closer to the windows overlooking the river.

"Amazing, right? I told you, I live with them."

I believed him.

"They've been up like this for a week now."

The ground floor walls were punctuated by them in most spots that offered a willing surface. He led me up to the mezzanine as his trousers dragged on the wide stone steps; now the Claires were in even greater concentration. He was still carrying the portfolio, and somewhat greedily, which pleased me. His hunger was real.

"I do most of my thinking up here. Just pacing. These ones must have been up for a month, I think."

We strolled along the inner perimeter of the half-floor, past various configurations of simple wooden tables and chairs carrying those same standardized reports, down to the last of the surfaces, quite large, with a bottle of whiskey and a couple of

glasses atop it. Passing each image—the tiny watercolor of Claire's toes; a cityscape in which she was only a small dot on the street (I'd drawn this one from the apartment, actually, as she talked with a neighborhood marijuana dealer outside our bodega); a set of tall sumi ink drawings in a *Japonisme* tone, with sweeps of ink elongating her form, so you couldn't say whether she'd been drawn or written like an immensely complex calligraphic character—a charge went off in me. And not because they brought back long-buried memories. In fact I recognized each of these moments instantly, as though the pictures themselves were still mine (weren't they?).

Whent told me nothing of how he'd organized them. I hadn't asked. I knew, though, that there was nothing random about the sequence. Despite the seeming chaos of the house, Whent was a storied computer programmer; in key respects, he was an impossibly meticulous man, and it was to this fastidiousness that he owed his wealth. The strangest thing was this: my *own* preferred ordering, evidenced by my felt prediction of which images would arrive next as I walked beside him, an order that correlated neither to chronology nor to the order of sale, tracked his own quite closely, so much so I sensed I could almost anticipate each image to come. It was a feeling like déjà vu, except that I was certain I'd never been here before. What principle, I wondered, lay beneath our shared preference?

Finally we came to the table with the whiskey and the two glasses I'd seen from the far end, shining under a strong and tightly focused lamp. Whent opened the bottle while I sat, though he didn't pour immediately, just stood above the bottle looking back on the paintings and drawings. He'd only met Claire once, and very briefly, at a show of mine, and then sat through a dinner afterward, which I think he slightly resented, and certainly regretted. This was actually a happy fact; it's what convinced me, and more important, convinced Claire, that there was nothing perverse in what Whent was doing, hoarding all these pictures of her, even if it was unquestionably odd. He'd liked her, I think, and she thought he was nice enough, if a bit abrasive, considering he was not an artist but a man of business, and of technology in particular, where manners, the real ones she knew so well, could rarely be found. She did accept, though, that his money was essential to us, given the listlessness (in which there was no small measure of pride) of our pursuit of gainful employment. She very much didn't want to call on her family to support her (or us) and although I might have been willing to call on mine, there probably wasn't enough of it. Money. Not for New York.

I remember that dinner, a celebration of a group exhibit in which several of Cosquer's members appeared. It was held at Minetta Tavern. Whent asked Claire not a single question, and in every moment when it wouldn't have been excruciatingly rude, he avoided her eyes. If she'd been less observant, she would have surely left with the

impression of surliness. But she suspected there was a more specific ground for his evasiveness, which didn't carry over to the rest of us at the table: Karen, for instance, with whom he made the kind of sanguine conversation I had come to expect from him.

Claire was right. He called me the next day to apologize for his poor form. He didn't want her, in her person, he explained, to *interfere* with the power he felt the images held. For him, they were something more or less independent of the rest of the world, including her. For me, of course, these pictures were *nothing* without Claire, the one of flesh and blood; they gave her to me, ratified her, though in ways the natural world might never consider. *Emanations*, or entanglements, you could call them; neither disembodied forms on canvas nor sensuously embodied truths, whether literal or the kind lying on metaphorical planes, upon which artists frequently assumed it was their business to unfurl higher truths.

Not so for Whent. If Claire had never existed at all, he might have found it all the more worthwhile, though of course—and this is what he didn't understand—I couldn't have created these images without her. Physical duplicates could be made of the canvases and surfaces, of course, but as far as I was concerned that would be the equivalent of *Lear* emerging from the typing of chimps. What my images were for Whent, what they managed to put him in touch with, if that is indeed what he expected from works of art, I didn't really know. He was, I suppose, surrounding himself only with an idea, or else with the products of my hand, with form, line, color, the constants running through my imagery; or perhaps what he envisioned were my feelings about this woman, which we had never personally discussed. I knew better than to disabuse him. Perhaps he used my imagery only to be put in touch with himself, something I neither sought for myself nor frankly thought possible. Selves were vanishing points, not for touching.

"These ones," Whent said, after a long silence, pointing out several simple images of Claire, fountain pen drawings coupled with ink wash that showed the influence, most clearly, of Delacroix; they were ethereal yet kinetic, as if an otherworldly force were making itself known, perhaps with the ironic touch of Daumier, each with one or two gestures intensified. "These you remember, I bet."

"From the winter."

"The last time you showed, correct? Sandy can't be thrilled." He was thumbing the top of the bottle now, somehow still not ready to pour. I was getting thirsty.

"It was, yeah."

"The last time you sold, too?" He placed one hand on the table and leaned forward, toward me. His wool tie, squared off at the end, somewhat frayed, and a rich blue and yellow—college colors—swept forward with his chest and continued to lead

straight down. Behind him, I was startled to see, was a small bar with no more than five or six bottles, in yet another bespoke nook. There were plenty of tumblers, too, all decoratively etched.

I gestured limply at the bar, ignoring his question. How many more of these were there, bars you had to come within feet of to recognize as such? I liked Whent more and more.

He looked back over his shoulder without really looking. "Anything you want in particular?" He brandished the bottle already on the table and began to pour a golden drink from it into one of the two tumblers. He sipped it, no more than that.

"How about that one?"

He examined the bottle as if he hadn't just poured from it, indeed, as if he hadn't even thought of it in a long time. "Cheapo Johnnie?"

He looked back at me flatly and waited a couple of beats, perhaps for some sign of protest, which didn't come. Johnnie Red was fine. He went back to grinning, as he had at the door. His teeth shone as he tipped the bottle toward the second glass. "Did you know I despise Blue?" he said with regrettable pride. Nothing could really erase the obscenity of his wealth, or the whole Upper East Side, except its donation or destruction.

He slid the dram toward me and started frowning in thought.

"I bet Alex still gets things from you."

I nodded. He stood up straight and held his glass in front of him, lowered it onto the palm of his other hand and turned it slowly, breaking the light that struck it into waves. I drank sharply from my own glass.

"And Don, too."

"He has, yeah."

"Not recently, though." He flicked the rim of his tumbler and we listened to it ring. He set it down on the table without drinking from it and sat across from me, with one leg folded over the other. "I didn't *really* want to ask you this, but why not. What the fuck is this 'no shows' thing about?"

I shook my head indistinctly, by this point having heard this question enough that I no longer feared it. It just tired me. Which doesn't mean I'd actually dealt with the matter in any way. Who was to blame for my exhaustion, then? I took another sip, a deeper one, right on the border of a swig.

"You're cooking up something else, beyond this series, right?" He uncrossed his legs and joined me in drinking this time. "I assume? How have you been? I mean, since *she...*"

I smiled absently while he squirmed with words. "You know," I said, "there's this poster for a Ty Segall show I'm working on." I think Whent thought this was a prelude to an answer, but actually that was all. "A *rock* band," I added. Here I

enunciated *rock* with just the same emphasis he'd given the word *she* just now, though the meaning of the inflection was that he couldn't be expected to understand such things. "What about Joy Division. I *know* you know Joy Division. Ian Curtis? The suicide?"

I could see this touch of belligerence didn't manage to push him off the idea that I wasn't quite thriving. But he looked aside finally, down at the grainy oxblood portfolio—for the first time, properly, I believe—which unsteadily leaned against the table. I thought it would slip to the floor at any moment. He was staring at it as if he could see what was inside already, but only with great concentration. Pity laced his words: "So who represents you now?"

"Sandy still, technically. He hasn't said he won't. His wife hasn't, anyway, if I decide to exhibit again. She's the one I still talk to now and then."

"Alice has great taste. Better than his, maybe. Of course she'd represent you. And of course you're going to show again. Soon."

I drained the whiskey; he refreshed my glass.

"But for now, right, it's about commercial things. For *now*. There is survival. I can still get that, you know." He laughed and drank.

"I haven't sorted it all out."

He shook his head and looked at the portfolio again. "How many are in here?"

"Five or six. All different things. I finished a couple of them this morning."

He swept the bottle to one side and set the portfolio on the tabletop. I waited for him to open it but he just studied me while ruffling his short brown hair, not far off black. The pity had spread from his voice to his gaze.

"The usual per, then?" he asked matter-of-factly, as if business were something to settle quickly and be done with, to save us both the embarrassment.

"You're not going to look at them?" I didn't wait for an answer. I understood and moved things back to money, where they belonged. "And *is* there a usual?"

"The high usual. Or why not a little more? These are going to have to be some of the last for me, probably. You can see I'm running out of room. You must be sick of making these by now, anyway." He scratched lightly at the grain of the portfolio's leather. "It just probably doesn't make sense anymore, does it? On a human level." That slow enunciation of *she* surfaced again. "For your sanity, I mean." The pity I dreaded was only growing bolder.

"Maybe you should actually look at these before you buy them, if you're so concerned about my state of mind."

"They're beautiful," he said without any defensiveness or retraction as he tapped on the sheath of drawings. "I can know something like that. But that doesn't mean you should be making them anymore. That it isn't time to find something else." He

frowned gently. "But look, these pictures, your art, they've treated me so well, you can't imagine. That's why I am really hoping you'll find something—"

"Business is good, then?"

He'd just picked up his drink again, but my insincerity made him sigh hard and set his glass down harder, finished now, it was clear, with my petulance. "Well, have you *ever* seen it fall off? Long term? Tech?" Now he sounded like a businessman, and he meant to offend, as retaliation. Much of what I knew of him, I knew through the internet, which seemed apt enough. He was the COO of a small but very profitable digital technologies firm, working mostly on problems in and around his abiding fascination and investment—the internet of things—which was something I understood at only the most superficial levels, even after all the talk of it through the last few years. Whent had told me about it once, over small plates and drinks, after perhaps my most successful show, where everything had sold, though not before I'd vanished with him into his white Giulia GTA—a beast of a car that still managed four doors, I suppose for the benefit of his longtime girlfriend's daughter, though he rarely mentioned either of them.

We ended up in the lounge bar on the thirty-fifth floor of the Mandarin Oriental, overlooking the car-lined spokes of Columbus Circle. There were plenty of more exclusive places in the city, of course; but he just liked it here, he said with a wink.

As far as he was concerned, he would slur later that night, after many rounds of drinks and nibbles that were never, to my knowledge, actually paid for—he must have had a tab—it was all about turning the many into one, on the largest conceivable scale. The world. We speak *as if* it's singular: *the* world. Why not really make it so, where every part of it is operating in concert with every other, relaying signals, like an enormous airport, a single unified functional organism? With the buttons being pushed by us, obviously.

He'd permitted himself more than a few cocktails that night, unusual stuff for him, mostly a man of neat spirits. Before him was some sort of decoction of pomegranate juice and liqueurs, three or four of them swirled together, definitely too many. He was also very clearly intoxicated by my paintings, especially, I think, by their being totally unmarked, not even with *Untitled*, or just the date of composition; nor was there anything at the show, online, or elsewhere about my *vision*, articulated in any manner other than through the pieces themselves. I had insisted on this with Alice, and Sandy made the exception. So even acquiring them became complicated, as the buyer had to resort to indicating some notable feature of the works: the one with the large feet, for instance. Whent's delirious delight in all of this, which was neither knowing nor clever, had made me feel that stealing away with him like this, from my own show, was all right, not an unforgivable *faux pas*. Something about his

peculiar status, too, made it acceptable, at least to me: I hadn't gone rogue with any of the artists, the ones who subscribed to a *Frieze* or *October* conception of art, nor with some naïve everyman, which might have been taken as a delicious stunt, but with a not especially well-known technology entrepreneur. Who also happened to be, as the stereotype would have it, a multimillionaire many times over.

Whent spoke at his most expansive that night, which was especially obvious to me given that, strangely, I'd had hardly anything to drink. Something about exhibiting put me off actual pleasure; I would drink later, I imagined, with Claire, whom I'd left in charge of the show in my stead. Integration was Whent's drunken leitmotif that night, *mechanical* integration. And while it was true that there'd been slumps, he said with fermented pomegranate on his breath, looking out over the darkened park and on toward the lights of the Plaza, while there had even been full-scale busts along the way, that was only to be expected. The trajectory was always, always the same, as far back as Babbage and Turing and even further back to Franklin and Edison and Bell and Morse.

"That's why I can do any of this," he said to me now before having another sip of cheapo Johnnie, presumably meaning the purchase of my art, or else all of this art; or even just buying in general: the limited-edition Alpha Romeo, the obsequious service at the Mandarin that night, the truly grand condominium I had not seen until today.

I was still very much an underground presence. The difference was that now I was an eccentric, too. He'd only come to know of me because his younger sister, Madeleine, a curator with leading-edge taste, had had a mild infatuation, years ago now, with me personally: one that Claire put an end to, politely, of course. My work was still cheap, really, only several thousand per piece, but since I'd stopped showing I'd already heard the pictures had begun their ascent, even if they'd not gone especially high yet. What I really had was youthful cachet, the promise of something important being afoot. Early buyers like Whent got a bigger buzz off of that than the actual cash value of the pieces they took. There was an irrefutable pleasure, as with music fandom, in *being there first*. Technologists were especially indulgent in this respect. Firstness, after all, was their life's guiding principle.

"It's why I'm going to do this," he said. He got up sharply and took the portfolio, still sealed, into a room just beyond us. Like the bar, it had seemed to appear all of a sudden, as it bore the white-on-white camouflage of the rest of the apartment. I hadn't noticed the door, since, in addition to the matching tones, the frame merged with the panel, leaving a gap that amounted only to the faintest of lines, so that Whent seemed to be opening the wall itself. He disappeared into that door-shaped darkness, which enveloped him so cleanly and quickly I felt it must be connecting him to another realm. He emerged just as abruptly. The only appreciable differences between the two legs of his journey were that on his way back to me the portfolio's

flap was wagging in the air, its contents disgorged, and that he seemed somehow to carry a more speculative air about him.

"You're in the same place uptown, right? That's where the check will go." Instead of stopping at the table, he went straight past me and perched on the railing that prevented one from spilling off the mezzanine, so that he could look over the ground floor dotted with my Claires, bathing in the reflected light of the East River. His trouser legs were finally off the floor.

He closed his eyes for a moment and sighed before turning back to me. "What I meant before, and you already understand this... You told me you do the same with your work before you sell it. After a while, when they're set out like this," he said as he waved his arm over the railing's edge, "you start to breathe through them, right? Isn't that what you feel? You do it all the time, I guess. That's just the life of an artist, in your studio, your home. But the rest of us get an entirely different experience, buying the work, putting it in gilt frames, worrying about whether the lighting system does justice to the textures. Or we set them in the lobbies of our offices, or even just archive them directly, without even looking at them. Isn't that what Saatchi does?

"But then I think, when you lay them out like this, scatter them around—*fuck* the lighting *per se*—I'm sort of living through you. What you see, I see. Not right away necessarily, but at some point. Or not what *you* see, really—who knows about that, not even you, maybe—but what you've cared enough to pay attention to, or to put down with paint or charcoal or whatever. About this girl, for instance."

He paused and folded his arms in dissatisfaction, seemingly exhausted by his own imprecisions. I felt no interest in helping him out, not out of cruelty, but because any intervention might narrow his meditations, lead him someplace I already knew too well. This way, through silence, he might take me somewhere I had no real notion of.

"I have no idea," he said, "even now, after all this time with them, what Claire must mean to you. Never mind what she actually is, you know, to herself. I'm not even trying to find that out, though, when I look at them. But I do see... or not *see*, but *sense*... currents?"

I nodded equivocally.

"Your concerns," he clarified, "the way they move, how every one of these pieces changes direction, speed. And it depends on which direction *I've* walked that day, from the kitchen to the living room up to here, and then on to the very top floor."

He pointed upward, through the wide aperture of the skylight that cut through the two full floors above us. The sheer height of his home was astonishing.

"I don't know where any of it begins and ends for you," he said. "But that doesn't mean I'm just looking at it as paint and ink and paper and cloth."

He looked at me as if I might validate his sentiments with a more decisive movement of my head. But again I only nodded in a way that suggested I didn't oppose his continuing, and kept looking up expectantly at the railing of the top floor that seemed miles above us. He was irked now.

"You know," said Whent, "you've known from the start that I don't have a *real* art background, or even a fake one, like most of the people in this city." He stood up again and swung around to me, no longer meditative, but declarative instead. I regretted not showing him a little more favor, but what inhibited me, ironically, wasn't a wish to withhold assent so much as my need to think through his reactions, which left me with no immediate answer for him. "At least, though, at least I actually *respond* to this stuff. It works on me."

"I do know that," I said with some sympathy, but it just seemed to annoy him, as if I could only be condescending to him.

"It's not always about knowledge. I mean, business is knowledge. And business, yes, is very good. But this, this is all beyond knowledge. A lot of people in my world don't get that. They don't get the way these things, each of these things, they don't stand for themselves, or by themselves."

I found myself wondering where his girlfriend, Eve, and her daughter were right now. I'd only once seen the three together, at a show of mine at 91st and Amsterdam—Hinton's gallery—and then I'd not even gotten a chance to speak with them. He'd made no effort to introduce us either. They lived near the gallery, that's really all he'd said. Eve probably found this apartment unlivable, strewn as it was with all these images of another woman. Who can even begin to speculate about what Jess, the little girl of just seven or eight with the crop of a boy, thought about it, as the daughter of another man?

Whent squeezed his eyes shut with great force. It seemed he'd gotten a bit too philosophical with me, embarrassed himself; or maybe he was only trying to recreate the sort of dark where he had emptied the portfolio, that room in the wall. He nodded me over and I got up and stood next to him at the railing overlooking the living room, sharing his vantage.

What he'd said was true. He wasn't really naïve. He knew his Velázquez from his El Greco, and he understood precisely why Forrest Best was an abomination. Yet he didn't purchase work because it was talked about, *au courant*, or expensive (usually these things went together). He also didn't merely appreciate art, revel in it; he was genuinely *struck* by it. I'd seen him at several of my shows, before I'd known anything about him; Madeleine had advised him to come, she was sure he would find something in my work. And I'd noticed him first precisely for the way in which he seemed, amid all the chatter, genuinely affected. If I was right about him,

contemplative pleasure was somewhat beside the point. He was instead seeking the *prospect of advantage*. The advantage he sought, though: what was it? His rich friends, those of his cohort, he told me, were looking for *notable* work. And this was how he stood out to me. He just wasn't. When he'd first been introduced to my stuff by Madeleine, he could hardly have known what my work meant to anyone, regardless of whatever she might have told him. Who knows how accurate what she'd said was, anyway, given that she was besotted with me then? Whent might even have thought my work was naïve, at least at first, before he'd spoken with me or Sandy, found out more about who I was, what I was said to represent.

I also knew, I should say, that Whent had one foot in the world of Kunstkammers, whether he understood their significance or not; and that this fact couldn't help but endear him to me, or at least arouse my curiosity, after I'd learned of it when Madeleine had formally introduced us at a group show I featured in. I was certain that upstairs, on that uppermost floor, was his *world of things*: his *cabinet*, as he'd called it. In fact it was my reason for agreeing to meet him here today. I couldn't help staring upward at the highest railing I could see, not far below the sun itself.

I think Whent came by his cabinet honestly, as an inveterate collector since childhood: comic books, baseball cards, and then, as his knowledge and wealth grew, grander things. It helped him think through technical problems, this microcosmos, and it stoked the same impulse that had interested him in the internet of things, which was really just another kind of cabinet, but writ large. He hoped it would one day cover the entire earth, and even space, the Hubble, the Apollo, all of it. The cabinet, he'd said, could help us figure out what sort of links we wanted in our world. Every symbolic bond could then be made digital, he believed that.

Again I looked up, and I could just make out, at the very edge of my view, what appeared to be a katana blade. "Should we go up?" I said with an enthusiasm I'd yet to evince today.

"Definitely." His charm had returned, in one word; it let us leave behind whatever unpleasantness had intruded on us. "That's why I wanted to do this here."

The mezzanine was like a half-floor, and the third floor took up about a half of that, which seemed to enhance the sense of its being cabinetlike, that all the things it might contain, of which only a blade now reached my eye, might comprise a single world.

We skipped the elevator for the resplendent stairway. I followed Whent up to the second floor, which revealed a high-ceilinged library curiously outfitted like a lounge; and indeed, the spines of the books were immaculate. As we climbed the next flight, twice as long since it carried us up a full floor, I marked our progress by the ancient katana blade's coming brilliantly into view directly beneath the sun. In fact, this floor gleamed under a plurality of skylights, some of which had screens covering them,

perhaps to protect the objects within from the intensity of their rays. A checkerboard of light on the hardwood resulted—and how much shinier his floors were than mine!

Quickly it became clear that, just like the human world and its disappointments, this Kunstkammer, which occupied a room I judged to represent a full half of the floor, was very much under construction. *Haphazard* might be the best word for it. Yet soon enough the curiosities arrived. Whent led me in reverential silence, letting me form my own sense of the place, as he must have done with my paintings at that first show, which were similarly unburdened of a surrounding discourse.

The first things to appear, including the blade, you would expect in any good cabinet of the past; they showed that Whent, however he may have begun his collection, was more aware of the history than I expected, and meant his Kunstkammer to be more than a metaphor for the originals. We began with taxidermy, natural history long being a mainstay of the form. Even now, every museum that aspired to true comprehensiveness, whether the Prado or the Tate or the Met, included mounted animals. First came the stuffed reptiles: two juvenile alligators—I didn't bother to ask whether they were crocodiles instead—and a colossal Komodo, army-camouflaged and ten feet long; several lesser lizards and speckled salamanders, some of them only half an inch; and a majestic giant tortoise that gave an impression of unfathomable heft, so that one felt quite sure that even in life this creature had been more or less immobile. There were no snakes, I noticed. But there were less recognizable creatures, whose scaly skin was manifestly natural and yet whose bodily forms seemed quite alien—soft, distorted, like the products of a child's hand, the kind of thing you could only imagine being dredged up by a submarine from the very bottom of the sea. A display running behind these creatures seemed to be some sort of chintzy kaleidoscopic backdrop one might find at one's local planetarium, until you realized its shimmering swatches of color were produced by ore blazing in the purest hues. I could only think of my chalks and pastels, and then the larger history of pigment, ground stone suspended in liquid; all the ancient minerals, since the days of Cosquer and before that, had been mined for no other purpose than to *depict*. There was one here of a very fine texture, like talc, but blisteringly yellow, and right next to it, in great heaps, a brutal blue that seemed to hang a vapor in the air above it, as in a cartoon. Although Whent managed to raise his eyebrows playfully now and then, tracking my interest, I was pleased to find that the cabinet had settled him and he held to his silence.

Not everything came at you from the ground up. Hanging from the twenty-five-foot ceiling (I couldn't see strings, but how else?) were birds which, in their perverse coloration, struck me as necessarily rare, even if they had once dominated the planet in the time before mankind, or at least before our twelve thousand years of

civilization. Whent extended his hands as if to fondle them, though they were out of reach, so the act had the quality of play about it.

The birds themselves, never mind their colors, were arranged as if flying in formation, like a single species with no phenotypic unity, so that they took on different forms: short-beaked, long-footed, multicolored, and so on. It also occurred to me, as Whent's eyes darted from one to the next with a kind of frenzy you might allow yourself when you were alone, that the formation they were in reminded me more of war planes than anything I remembered from nature; but then, I suppose many of those formations had been taken from birds. Tiny tusks of animals never seen alive by man lay on the ground in a loose pile, the outer edge of which seemed irremediably fuzzy, as if the heap had just been deposited and not finished settling; the same could be said of the other masses of even stranger creatures that seemed to pulse outward from where they sat, as if you could see the potential energy in them.

Natural history didn't change much, of course. It was in the matter of *artifacts*, the implicit anthropology they suggested, and more than anything the free hand Whent had taken with the notion of time itself, where things became truly interesting, and his cabinet turned boundlessly generative rather than amounting to a replica of a sixteenth-century object. Although it should be said, there *were* all the classic items: the ancient armor, the blades one finds at the Met, and the various bowls and pottery I assumed (with no real right) were even more ancient, or else from very different parts of the world—the early history of the Americas, perhaps.

Yet it was not just the legacy of wonder and curiosity, through natural history, ethnography, and the evolution of technology, that Whent represented here; he captured their futures, too, which is why his cabinet didn't simply take you up to the present—though that would have been interesting enough—but projected you into a future that was still being imagined, so that what was wondrous and curious *there* could still only be a point of conjecture. For Whent, there was no reason to think marvels ought not to exist as much in the time still to come as they had in the past, and if that was so, why shouldn't these speculative objects, the sites of a coming amazement, not find a place in a fully populated microcosm?

Some of Whent's more recent curiosities were no longer wondrous or particularly beautiful: a hard drive that appeared to date from the 1970s, judging by its ungainly design, the sure sign of an immature technology. Other wonders you might find at a technology show in San Jose: a stamp-sized phone that folded out, end-over-end, until it could straddle the space between mouth and ear. My host demonstrated this for me without my inquiring; clearly it had his attention. He held it out to my face and I spoke into it.

"It works."

My words broke the silence we'd been operating in, and from here on words would slowly return to us. Other curios expanded the concept of what could find a home in a Kunstkammer, and what sorts of linkages could be made between things, which was really to Whent's credit, and probably what made him good with the internet of things: a baseball, for instance, from the 1936 World Series that lore held had been struck 570 feet—that was its wonder. Or a small sheet of metal of a rose tone, whose conductive properties were still unconfirmed and only dimly understood: *its* wondrousness was still to be discovered, which was the most marvelous thing of all. Whent was sure that sheet would change the world; his own firm, Salient, would help make sure of that.

Next was a large cube, to which Whent almost skipped in excitement; I thought he'd trip over those dangling hems. He seemed to rediscover the pleasures of each item in introducing it to me, the way a teacher reacquaints himself with his subject by inculcating it in his students. He called the cube a graphene aerogel. It was nearly weightless: this was its mystery. I grasped it expecting the usual downward pull of things to greet my hand. Instead it felt like holding nothing at all. If it weren't for the hard edges of the cube, the way they repelled pressure when I closed my hand around the box and tightened my grip, I would have had no way of knowing, not by touch, anyway, that anything rested upon my palm.

I made to give it back to him, but he asked me to set it down on its display surface, which I scrutinized only now: a square of animal fur that had a color that didn't seem possible in the mammalian world, a soft blue. The fur itself was long, with filaments that were, taken individually, nearly invisible, like down. But the gel was so slight it could rest on these tips, seemingly suspended in air. In fact, Whent said, it was nine times lighter than air. As for the fur, it belonged, like the tusks, to a species that no longer roamed the earth, and I found it no less intriguing than the gel. Even more fascinating still, perhaps, was the way advanced experimental technologies were being juxtaposed with ancient natural ones in Whent's cabinet.

The microcosm he'd constructed for himself was undoubtedly strange. Judging by the gaps cutting through the various sub-collections, the many jarring transitions and incongruities we'd passed, it was in a nascent state and would be for a while. Although, historically, it should be remembered that many of the great European collections had the paradoxical blend of unfinishedness and overstuffedness about them. Like the cosmos itself, things were always defying organization and taking on unexpected shapes. I wondered how this conclusion, supposing Whent had come up against it already, figured in his thinking about his business life, the internet of things.

Many of the objects on display were simply too new to have taken on the enchanted feel of the curio, of something from an alien order that we nevertheless manage to comprehend in part, whether the order of the European past or the present state of another region. That said, of course, the world today is really a single place, partly because of Whent's technological ancestors, and surely this would only become more true in the future if he succeeded in his technological mission. We comprehend previous historical moments precisely because the past is a distance we *have* traversed, collectively; whereas the orders of the future lay in unknown territory, and so exist beyond an epistemic horizon, making their differences from the present unfathomed and thus eliminating the possibility of determinate wonder.

In Whent's budding Kunstkammer, obsolescent worldviews, worldviews we could safely regard with dramatic irony and take the measure of, merged by increments with the globalized world of the early twenty-first century. As the distance closed and we entered the frame of our own gaze, the defining contours disappeared from view. If the totems of those superseded orders were represented around us here—and that is precisely what made those artifacts *curious*, the distance of myth—then, by Whent's inclusion of objects from the present, the axioms of our own form of life must have been appearing alongside them, even if it wasn't yet possible to register them as the parochial curiosities they were. It would be left to some future generation to pick out just where our current convictions floated in the air, groundless, and what exactly it meant that at just these points we'd chosen to leave off and let our explanations come to an end, though not at others which might have served equally well. All that being said, there was no doubt, whether it was Whent's intention or not, that the simple gathering of these objects did give one uncanny intimations of our own *mythos*.

We strolled along, looking at the most modern of objects, until we seemed to reverse course slightly and come upon a battered leather chair from the eighties or nineties. Where was *its* wonder? Whent dropped into it with some theater, announcing to me that this was not a marvel, just a regular *thing*. Here alone was an area with seating that was free of those legal-pad-sized reports I'd seen sprinkled throughout the lower floors.

"I told you I do a lot of thinking out there, with the Claires, right?"

"You do some up here, too, I guess."

"More and more. *And* I rearrange things, draw up little maps like these." From a cabinet sitting astride the chair, he pulled out a stack of loose sheets with structural scribbles on them. "But I'm not sure it's helped me much. Like, where does *this* belong, exactly?" He bent down and touched the tarnished top of what looked to me like an elephantine bullet, on the far side of the chair. "What do I put it next to, summon it with and summon with *it*? I just haven't figured it out." He leaned back

into the crinkling grip of the chair and ran his hand over the monstrosity like a pet. "That goes for most of what's up here. But I guess that's the point, to figure out these unstated connections. To turn them over and over, creating them, snapping them, by tiny shifts." With that he leaned over the chair's arm and pushed the bullet forward with both hands. It was an unfilled B61 warhead, he explained. Nuclear.

"But then what about *that*?" he said before I could come to terms with the B61. He gestured at a long stick near the warhead, up against a stack of unopened boxes— presumably the latest shipment of additions to the cabinet. It was a spear of some sort, I could tell by the arrowhead: a large shard of purple mineral that might well appear in powdered form elsewhere in the space. It was bound with twine to the end of the tapered shaft and glittered wildly in the sunlight.

"Native American?" I asked.

"New Guinean. Should I find an American one, though? You should carve me a replica. While you're busy—how would you put it?—thinking about things."

"I might."

"You're really not working on something new? Because of her?"

I sat on the floor as there was nowhere else to sit. This place truly wasn't for show, just for Whent. I had to admire that. "A break's not so bad, really," I said. Until something comes to me, something worth making. But money's the thing no one's allowed to stop making, right? So I'm doing more commercial stuff."

"Album covers?"

"Illustrations, posters, all of it. All through Cosquer."

"The magazine?"

"It's a design firm, too, these days."

"And it pays well?"

"Well enough."

He shook his head incredulously and lifted himself up with the help of the fat armrests. "If commercial is all you're going for right now, you should really make it worth your while. So you don't have to do it for longer than you have to, right? This is the other reason I wanted to see you."

We started walking again, continuing our trek through a flock of low-flying marine birds racing over hills of ancient currencies no longer tendered, one of them a dull red, another yellow. I was tempted to ask him what was in the unopened boxes I'd seen, but the moment had passed, they were well behind us now. It didn't much matter. New things continually caught the eye here; it was hard to keep one's train of thought. But then this was the point, Whent had said: breaking patterns, finding new ones.

Just in front of us was a very early camera. I judged its vintage, as with the disk drive, mostly by its immensity. Probably mid-nineteenth century. It was partly

disassembled, its innards spilling out, but neatly, almost into the form of a flat-lay. Perhaps the entire Kunstkammer could be made into a giant flat-lay you walked within, I thought; perhaps that's what it was already beginning to resemble. But only a bird's-eye view, from a bird flying substantially higher than any of the specimens here, far higher than the roof itself, could confirm this.

Looking at the mechanics of the camera—Whent had slowed down here because of my apparent interest—looking at the parts of this picture machine, they really seemed, to a twenty-first century eye, oversized to the point of caricature, so much larger than necessary or useful. It lay in an open glass case, next to even more primitive optical equipment, perhaps Enlightenment era. Who assisted Whent in laying out things like this? Could he himself somehow know how to take these things apart? It might well be the thing he enjoyed most, I supposed, given his line of work.

Reluctantly we moved on past an enclosed, temperature-controlled rack of books that ran half the length of the room. Unlike those in his library below, these looked read, indeed, read a hundred times over through the centuries. I wanted badly to examine the titles, but this time Whent kept steadily moving forward with his lips pursed in thought. I relented and followed him to a spot beyond the books, where scores of idols, crucifixes, and other signets lay in heaps that were, like the camera, still being put into meaningful shapes.

"I had a friend, or really a colleague, over here at the house a few weeks back," Whent said. "He's the one who got me started on all this, actually. Cabinets of wonder, assemblages of things, integrating a cosmos. He was telling me about them a couple of years ago now. It got me thinking, this sort of thing could maybe clarify some things for me. Though there's a lot left to do. You can see it's still a mess, maybe it always will be. Now I don't think James, my friend, has a cabinet himself, but he's thought a lot about them—about lots of things off the beaten path."

He stopped at another stairway that led down again. He gestured back at all we'd crossed, including the rows of unmarked, utterly heterogeneous eggs just beside us, and—his fascination with the history of the electron was irrepressible—pieces of radio equipment that must have come in its early days, perhaps the 1910s.

"Most of this isn't that expensive. You can buy it in large lots at auction. But it all feels so *charged* to me. Just putting it all together in one room. Can you imagine a world in which all this stuff really *was* linked? Like we're linking everything electronic now, turning all things into conduits for electrical action, clothing to cars to kitchen appliances to medical equipment to musical instruments to traffic lights to nuclear arms?"

"Maybe they're already linked."

He laughed.

We went down to the mezzanine, to retrieve my portfolio, and then back to the living room, the realm covered in my hand, my drawings.

"Anyway, James was here a little while ago, and he called me again on Wednesday, you know what about? The pictures. He thought it was pretty bizarre, the way I had them up all over the place, but over the course of the evening, I think he felt something happen to him, maybe something like what happens to me. He's a very curious man. Garrett's his last name. A businessman, but in the most extended sense of the word. Definitely one up on me. He works in advanced materials, real laboratory stuff. He started in waste storage—well, in biohazard, nuclear. He's the guy who keeps us safe from all the toxic shit we make, you could put it like that. Ever heard of Antral?"

I had.

"That's his company. *Antral* means cavity. A hole-like thing, a place to put stuff, I guess. Makes enough sense for a storage company. Anyway, he's gone a long way beyond storage. Right now he's branching out into consumer products, fashion, too. Sports, eyewear, other things..."

I tried to listen as closely as I could but found myself profoundly distracted. So many incarnations of Claire, little portals across to the woman whom my life had been built *out of* for three years. With each step along the perimeter of the apartment, leading back to the front door, her presence accreted, breaching any particular image and taking on a kind of supersensible density anyone at all could recognize in their experience, even if there was no agreed name for it.

The pictures ran out and we were standing in front of the open door. Had he ever closed it? "The point is," Whent said, "Antral is changing, and I have to imagine that Garrett's going to need help making those changes, remaking it, extending it. And if I know him at all—I've known him since Berkeley—he's going to want to do it differently than most. He's an original, always has been. Trust me. I'm a hack next to him. And I assume, actually, that's why he wants to talk to you. Something about your drawings, he said." He smiled at me then with authentic warmth, it almost embarrassed me.

"Anyway, if he *does* have work for you, if he thinks you could be his guy, basically, I can tell you it would make whatever you're pulling in now totally irrelevant. Because it wouldn't be a one-off. Garrett doesn't do one-offs. It would be an engagement, a relationship, and it could, well, it could grow into who knows what with him, really. Everything has a way of growing, with him. And he won't let you get too bored while you're working together. He just won't. Or he'll disappear on you. That happens." He grabbed my arm softly. "To be honest, I hope you don't know him for *too* long. Long enough to get yourself straight, but not forever. Right now, though, looking at you, he really is your best bet—if you can keep him interested."

He waited for a response, but these days I declined to offer such things at once. I'd need time to get my head around what he'd told me, particularly as I found myself again drifting through the haze of my feelings for Claire. I closed up the empty portfolio, lashing it shut, and managed only a vague smile, not half as nice as the one he'd just given me, before turning for the glass box the doorman had long ago disappeared into. I moved slowly, so that there would be no suggestion of upset or offense, and for the second time today, before I was quite out of reach, I felt a hand on my shoulder that was meant to reassure me.

5

When I'd taken over the lease of the floor below me, Claire and I were still together, though I didn't understand then that our days were so severely numbered. We'd hoped to make it *her* floor, move her in more completely so she'd have every bit the space I had. Her studio would be here: we could both be done with Brooklyn and Queens. It had come open when the Becker family, the previous residents, got themselves violently evicted. Their stuff ended up all over the street, and the case against them had been made on the grounds of mild delinquency. That was part of it, anyway. Claire and I had also placed calls to the landlord, Mr. Kiver, and eventually, with his support, to the police, about chronic noise: on the one hand, the three or four angry mongrels crying below night and day—the family kept dogs in place of a security system; and, on the other, the televisions and radios that would play all day at remarkable volumes, which muffled the whimpers and grunts of children being whipped for their own good. The Beckers believed in the belt, even though they were black, which to my mind ought to have given them second thoughts about its virtues.

Now, without my job at the Carrington or any gallery sales, I really didn't have the funds to carry this extra floor we'd snapped up in a moment of delusion, when we thought it might keep us together. Claire left only six weeks after I'd signed for it for the year, insisting she could help me find someone to move in, but I told her no, I didn't want anyone else there: certainly no one she'd handpicked. I hadn't even managed to *enter* the floor since the eviction, so it remained in a state of disarray and decay, the state in which it'd been when the Beckers were removed. Kiver ordinarily would have cleaned it up to find a renter if I hadn't rushed in with a pre-emptive offer. I felt bad about it all, of course—I mean the role I played in the Beckers' fate—but I really believed it was going to fulfill a fantasy of domestic bliss for us, the one they themselves couldn't possibly live out. Neither could we, apparently. Now I didn't need the space; I needed the money.

A few days after my meeting with Whent, a check arrived in the mail, though it was much smaller than I was counting on and it wasn't from Whent at all. Karen had sent it. Surprisingly, she and Rick hadn't minded the Joy Division rough I'd given them in the intervening days, even though I'd left it in precisely the same state as on the morning I saw Whent. Karen probably suspected I'd done it—erased most of the thing, I mean, down to a stage with no actors, and nearly no props—on a lark. That

sort of thing certainly wasn't beneath me, she was right about that; but as it happens, it wasn't true, not this time.

Ian Curtis erased *himself*, didn't he, taking the band back, with one swipe—was it by knife, or some other way?—to the beginning, or before that, even, to an *Old Order*. Karen deadpanned as much in brilliant blue, her short upright strokes resembling type more than handwriting, extraordinarily legible even with the peculiarly small x-heights; you could read it, as I did, standing up while it lay on the couch cushion beneath me, this inscribed Smythson card I'd tossed to the side so that I might fondle this serviceable but hardly extravagant check. Smythson—she could be sentimental about a staple luxury like this, when in fact the cards Cosquer printed these days were better, materially and typographically. They were in fact set with fonts she and the team designed in-house. *But that watermark*, I could still hear her say. Karen liked to reach me this way, through handwritten notes sent via post, though I never once responded in kind, always switching our correspondence over to some simpler or more common medium, telephone or text or email. Her next communiqué, whenever it could wait, would arrive again by post. It's the same reason she insisted on paper checks, even though I'd been working with her long enough to have justified the arrangement of some simpler, electronic means of payment. Really she was teasing me. She knew I despised nostalgists who clung to print; that I thought it was, at best, the wrong reason for the right act. She liked to play with the idea that she was among nostalgia's casualties, banking on the intimacy of our friendship to give the lie to this.

As for my redacted version of the band photo, clearly there was something right in it. Rick thought so, too, she wrote. They'd sent my sketch to the band's management so the remaining members could consider it. Initial signs suggested that it would go through, perhaps with a little tinkering. Hence the advance. The reverse of the card had more for me: it would be nice if I came by the studio to talk over projects, ongoing and future. And actually, did I know that someone had phoned in specifically about my work for Cosquer? What did I think of that? I must be getting better at this commercial tripe. After I'd read these last words, I texted her in fragments: *thanks*, *yes*, *soon*, and also *really?*

I went downstairs to deposit the check at the short row of ATMs just down the street that locals preferred to keep in a liberated state, propping the doors with beer and soda cans or even the fallen branches of trees. It left me with the feeling, every time I punched in my PIN and someone or other loomed behind me with disagreeable curiosity, that I was about to lose my money and possibly much more. Today there was no one; it was too early in the day for that. But my relief didn't last long. Within minutes, the check's fungible substance disintegrated in the face of the many

outstanding bills I began to settle back in my apartment, each secure click on my computer taking my account closer to the void. I paid some of my back-rent—Kiver was gentler with me than he was with the Beckers, but he had his limits—most of the phone and internet bills, and the minimum payments on the credit cards, which were especially overburdened now with all the Uber fares from the summer months just passed, when the underground was an inferno and I, delicate as ever, desperately tried to keep to the surface.

The most significant addition to my bills was a cable television subscription with a luxury sports package, which guaranteed me a steady flow of athletics at all hours and on any day. It was a matter of importance, actually. I considered it a kind of medical expense, as I depended, without Claire, on its analgesic properties to carry me through days that were otherwise forlorn. The exact effect of athletics upon me depended on the sport and the season. With baseball, it was the gentle sedation its quiet rhythms afforded, which seemed perfectly to complement the haziness of summer months. With basketball, it was just the opposite, all the jittery, continuous thrills it gave through its endless reversals, in the deepening chill of late autumn. The time for it wasn't quite here yet, of course; nor was I yet prepared for it. What had just arrived, as fall was coming on, was football, which replaced the slow, methodical procession of the top of a baseball inning with the nuclear-level incident of the drive, leather flashing in the outfield transmogrified now into a discrete and wholly deliberate series of car wrecks, something that none of the other major American team sports could claim. Yes, hockey had plenty of violence to it, but it wasn't the very point of the game: to lay low the man with the ball before he could score. Nor, in any case, was hockey in the American bloodstream in the way of football. How could it be? Nothing that took place on skates could be properly barbaric.

I probably should have killed the cable. There was enough you could do with your laptop now, with streaming services of every variety, that it wasn't really necessary, and it was costing me over a hundred and seventy dollars a month, almost entirely for that extravagant sports package. Though I should admit that, for me, there was more to television than sports. There were the old sitcoms I liked to watch late into the night, taking shameful pride in anticipating every line of *Gidget* or *The Honeymooners* or *Bewitched*, a skill I'd won only at great cost, having seen every episode half-a-dozen times or more. And that's not to mention the cooking and antique shows, the obscure home decoration programming, and the foreign language channels beaming in incomprehensible imagery from Iran or Cambodia—all my various stays against inexistence.

Yet the most profound reason I had for giving up these expenditures was delinquency with my healthcare premium, which, if it weren't for several minor chronic

conditions, and now the matter of a firmly situational depression to deal with, I probably would have let expire months ago in favor of the austerities of catastrophic coverage. I had another two weeks until my contract would void, which meant I had a fortnight to find the money for it: a fortnight with cable. Yes, I was very late on my payment, but in a way now deeply familiar to me and many of my friends. We lived within grace periods. These reprieves—insisted on, of course, only by the law, without which there would be no grace at all in this country—are what made modern life possible, at least in the major cities. And my acute financial fears had now been neatly deferred by the knowledge that Whent's money would be coming to me in the next days.

What remained of my anxiety was mostly of a higher order, and at that level, it was growing swiftly. What *pattern* had my life fallen into, I wondered, especially since I'd stopped showing or selling any of my work? What would the flat-lay picture of my life look like *now*?

My coming to the Bronx at all, collapsing my studio directly into my living space in the process, at least partly traced to the diminishing income I knew to be imminent as I withdrew from Hinton Galleries. But the fall in sales had been made far more consequential through the loss of both Claire and my job. Yet the notion of finding relief—social and economic, that is—by taking on a roommate or even two, problematic enough when it was Claire herself, was genuinely unfathomable to me. Simply moving out of the place was equally complicated, particularly since there were almost six months left on the lease and Kiver was not the kind simply to waive his right to payment, given how extractive he'd been with the evictees on the floor below (though I suppose they *were* black, and that couldn't be entirely discounted in Kiver's calculations). This much was obvious: if I didn't make an adjustment *somewhere*, in a matter of months there were going to be real problems, of a kind I couldn't just shrug at.

Freelancing for Cosquer had helped curb the pain, but now I was always juggling assignments, which brought its own kind of despair. Individually, these jobs could be pleasant enough, and there was occasionally genuine artistry involved, given the flexible conditions the design firm operated under. But working to so many deadlines, which I'd never had to do before, and all the picking and choosing of projects, one by one, for suitability, were corrupting the rhythms of my life, which had formed early and depended on having vast allotments of time plotted out for myself, where the deadlines were only self-imposed, even if I did abide them more strenuously than one might expect. The virginal stretches of time I'd once known, even in college, where I was careful to keep my schedule dense with independent studies that were no more than sporadically supervised, had now been sullied by the endless deliberations of the design life. I was not and never had been a man for the committee, so it was

only natural that the deadlines and briefs and meetings Karen was encouraging me to involve myself in, which I now pretty much *had* to involve myself in, were coloring my days and spoiling my mood.

The final results of these projects, theoretically anyway, might have redeemed all of this, but even when the assignments weren't troublingly commercial or devoid of all life, they were almost always small-bore and disunified: some magazine or newspaper illustrations for a men's periodical, or identity construction for a software firm or a soft drink. They couldn't hold my attention for long; finishing them meant finishing *with* them. They didn't accumulate meaningfully, instead existing only while you were bringing them into being. At best they posed concrete technical problems for me to solve. But problem-solving, again, was so far from the way I thought about art, not just because art offered few solutions these days, but because it was generally unclear to me what the problem could be.

This was one way, only days into my program of abstention, I was beginning to miss my longitudinal studies, that sense of accretion they could be counted on to produce. I had, in fact, discontinued the last of them, the Claires, not just because Whent wasn't interested in more pictures but because, as he'd indicated in his halting way, that particular world had probably completed itself, and everything I produced from now on in that mold would represent not plenitude but surfeit. It would find no place *within* the volumes of that universe, but instead dribble away without effect.

Whent's check arrived the next week and it was handsome. Not handsome enough to put an end to my worries, but if I spent it sensibly it would reprieve me. I could finally pay off the back-rent in full, not to mention Blue Cross. It meant I could also forestall certain compromises I'd been contemplating with some dread, the first of which was asking for money from my family in San Francisco—from my mother in particular. I would probably have had to start with her, as I had in all my previous petitions. My father, forward in so many ways—he was a litigator, after all—lurked in the background of these discussions, which was especially odd given that he'd generated almost all of this money. Perhaps it was out of love for my mother that he entrusted this particular financial matter to her; or else he was using her as a shield, not wanting to enter into dialectic with the son he'd trained in its ways. Or maybe he just thought she was the best person for the job at hand. She was, it's true, very much practiced in the allocation of funds to artists, through museum administration work. But her expertise wasn't necessarily a boon for me. She was too wise about wastage and hot air, having seen it all about her for so many years.

Still, there was certainly money there to be discussed. I'd first called on it during school, to defray my various trips to Europe and Asia. Granted, they *were* artistically grounded journeys; but I would have undertaken them regardless. Since I didn't seek fellowships or a place in graduate school, my second appeal came when college had finished and I'd moved to New York. Now, my parents were closing in on retirement, and without their explicitly saying so, the notion had been made plain to me that there would be no way of making allowances much longer. Anyway they were both coming to think of it as a bit of an embarrassment to go around handing out money indefinitely to their oldest child, while the younger two pulled their own weight—or, in my sister Helena's case, had found someone to pull it for her. Where would all this lead? To my head lying on the platform, perilously close to the tracks like the *other* Helena in my life, sniffing someone's shoe for potential sustenance?

My brother and sister could be considered, at this stage, two independent sources of benefaction, though these reserves were unproven. The youngest, my sister, had married well only six months ago, just after her twenty-first birthday, and was now living a thoroughly Californian life in San Diego. I felt as though she might be able to do something for me if need be; her husband would have been regarded as landed gentry a couple of hundred years ago, and he seemed concerned to prove his worth to my family, which was richer in books than in cash. Our brother, Ty, just a year younger than I was, had trained as an engineer and became, briefly, a designer at Tesla specializing in aerodynamics. But now he was starting to see significant money as a management consultant in the Bay Area—how significant I didn't quite know—flying all over the country for three months at a time and disciplining all varieties of corporate economy, including, to his delight as a man of sports, that of the NFL's Houston Texans.

I had a hunch, and it was no more than that, really, that my siblings would be helpful in a pinch, particularly as it would entail an admission on my part that high-mindedness couldn't entirely be separated from folly. But they would help also because, as I say, our household tilted toward values most fully embodied in the life *I* led, not them. Which is to say, they believed in the life of the mind, even when they didn't live it. You couldn't have grown up in my house and believed otherwise. My mother, after all, had curated modern art at the Getty and the Hammer for years. And my father was an attorney of the most bookish variety, who, after a stint in corporate law paying off student loans, settled into a group practice in Los Angeles renowned for taking on cases of an esoteric, almost philosophical sort, where the jurisprudential stakes were highest, if not the financial rewards. Before yielding to the indignities of alms-seeking, lately I'd been considering the prospect of being less discriminate with my commercial projects, of taking whatever Cosquer put on the table, really, even while this seemed to me a recipe for a quick and fatal disenchantment with things far

larger than art. Perhaps now, though, with the check from Whent and the possibility of many more to come from his friend Garrett, I wouldn't need the work Karen said she'd wanted to discuss with me. Of course, the money wouldn't get me to cancel my meeting with her. It only made the prospect more pleasant, to meet her simply on the grounds of longstanding friendship—and perhaps for one other reason: she was a dear friend of Claire's; in fact, I'd met Karen through Claire. There might be information to be gleaned.

Ahead of the meeting, I was trying, these last days, to work out the kinks in the 'Gold Bug' illustrations, a project I really did care for, and which seemed to me a link to some future form of art I might try my hand at. These were executed in colored pencil, and all the blending was of the optical sort, in which strokes of red and white, say, packed closely enough together, produced a shimmering pink impression. It was an underused medium, colored pencil. It had neither the gravity of graphite nor the mineral vibrancy of chalk or pastel. Yet it was capable of enormous subtlety, a softness that was nevertheless tactile. Marco Mazzoni's pencil works; Martha Alf's just as much; Ernst Haeckel's perhaps most of all.

I also had some Yupo-based theater posters going, narrow ones, shiny and slick, hand-lettered in chalk and ink, with reverse lettering. These I'd mounted on white board, so you saw straight through the plastic support. It looked like a sort of frosted image, and it was perfectly suited, being waterproof, for the all-weather, outdoor deployment that Karen had reminded me about, for the Wooster Group. We were going to deck much of downtown with it, all around their space.

As a collective, we were working on banners for the Metrograph cinema. There was something fascinating about having a bearing on the way these institutions *met* the world, the forging of identities through something as simple and decisive as a choice of typeface or a background tone, or through subtle differences of medium: India versus sumi ink, say, as had been the choice confronting us with the Wooster posters; India won. Granted, there was probably less inspiration to this work than designers themselves would have you believe or would try to convince themselves of, and it was hard to begrudge them this vanity, these thwarted artists who'd lost their nerve to economic realities. But there were certainly profundities in play in what they did, never mind exactly *why* they did it.

The materials of all three projects surrounded me. I kept everything up here on the second floor, even though I had an entire floor beneath me to occupy. I still hadn't been able to bring myself to enter the space, to clear it for my own use or even to sublet it. I'd look into the windows occasionally when I came in through the side entrance leading directly to my floor, but you couldn't see very deeply into the place, the windows were so dirty. Perhaps I needed them that way.

I had sticks of chalk in each hand, for two different pieces, when the call from Garrett finally came. We didn't talk long. He didn't seem to want to, only enough to gauge my interest, which I made an effort to suppress. I didn't want to put my budding desperation on display.

What I took from our conversation, besides that I was to meet him tomorrow at his offices on Roosevelt Island, was the peculiar unresolvedness of his voice, especially for a man of business. It wasn't diffidence that he evinced, by any means, but there was a patent lack of finality attending his sentences, so much so that I could never be sure when it was my turn to speak, even after he'd been silent for some time. At the moment he hung up, even, I was convinced he was only pausing for breath. He had in fact said goodbye, yet there was nothing of parting in his tone—something that would be brought home to me in other ways later on.

The next morning was cooler than it had been for a while, a glimmer of the new season, and for the first time in my life, after nearly five years in the city, I found myself on the tram to Roosevelt Island. I'd never had a reason to go to before. Few people did, from my world. And even though the F train stops there, the natural choice was this form of sky travel I'd witnessed so many times while coming into the city from JFK, crossing the Queensboro Bridge in a hired car.

Predictably, many of the other passengers were tourists, and nearly all of them were focused on the island we'd just left, not the one we were headed to. Phone cameras clicked wildly, a few even with that sonic simulation of a closing shutter that the older generations often left activated, mostly because they didn't know how to change the default settings of their devices. They were creating ersatz replicas of the images of Manhattan they'd seen all their lives, on postcards, televisions, billboards, cinema screens, before they ever came to the city or even entertained the notion: helicopter imagery, a perspective that thrust the earthbound viewer somewhat dizzyingly into the sky, amidst all the iconic steel and glass spires of midtown, the topographical flattening that occurred further south, and then, just as the island disappeared into the water, that jagged spike of finance.

Many of these tourists wouldn't get off at Roosevelt but simply take the tram straight back for a second photo shoot. Their aim was only to gaze upon the island of which they'd already seen too much, the one that no one would ever need more images of; whereas Roosevelt and its dangling airborne transport was merely a point of view, not a state of mind. Having seen all I'd wanted of Manhattan, I was one of the few turned toward the more obscure island. In fairness to the others onboard,

there wasn't much to attract the eye, except, perhaps, the new university technology campus built of twisting glass panes, which repelled sunlight like water and seemed on the brink of shattering from torsion. At the southern end of the island I could see a colossal ruin, which I knew to be a state-of-the-art nineteenth-century hospital long ago abandoned to the elements. This might have been all I understood of the island—a place of stark growth and decay.

I was headed north, though. I took the shuttle from the tram stop and watched the East River come into view. A few moments passed before I realized what I was seeing, a building that had only just become familiar to me, though from this distance the vaulted door in black glass seemed reduced to nothing. Only the strong verticality of the structure and the pale yellow of its façade were clear; there was a slight taper toward the top, though that could just have been the effect of cascading light. This was the home of so many of my works: Whent's home. That sealed patch of grass, how electric it would be right now, if anyone bothered to look at it in the gargantuan lobby.

The shuttle stopped at a bright white hospital decidedly not in ruins, though it certainly it didn't look as if it were operating at its zenith. Rather it was one of those elemental structures that hadn't yet come into its own, and so it reveled in its own potential, which the passerby or guest invariably realized in his mind's eye. Garrett had said I should just walk north from there, along the water, to find Antral's head-quarters. So far Roosevelt seemed to me constructed almost wholly out of hospitals and business parks. Greenery interrupted by office buildings lay in all directions. Yet I kept to the water's edge as I traveled north, hoping this would steer me true, until I reached a complex of orange-toned, flat-roofed buildings, just three stories each and arranged in the shape of a closed parenthesis. Each building was connected to the others by sheltered walkways, and further paths led from each one to a central glass atrium fronting them—essentially a giant bubble. The back of the parenthesis pushed in on a wooded park, the trees of which, tall and crooked and mossy, appeared to be digesting the buildings, though in a happy sort of way that gave the offices the look of a visitor's center at a nature reserve, or a scientific facility designed for the study of endemic island wildlife.

Garrett had mentioned the buildings' soft orange tone. It was the only feature he'd noted, as in fact the color was so unusual that it often served as a marker ("that orange thing") in giving directions. This is how I would know I'd arrived, he said, as you could find the hue nowhere else on the island and possibly the world.

After taking the long concrete path through the center of Antral's shrubby yard, which resembled dense forest undergrowth, I entered the glass globe, whose true

size, IMAX-scaled, couldn't be appreciated until it consumed you. I wasn't asked to wait by reception, which I would have liked to, actually, simply to see what I could through the dome besides the taller trees of the park leaning over the buildings directly north. If I turned to the west, would I find Whent's apartment? Certainly there'd be the dangling tram, and the Queensboro Bridge. Would they seem changed through glass, as paintings in a museum did? I decided not to check.

My escort had arrived. She was clothed in the summer holdovers of a T-shirt and billowy cotton skirt and owned the softly anxious air of everyone I'd ever known in the basic sciences. Together we took the easternmost walkway leading out of the atrium and made our way to Garrett's office, which lay on the edge of that curve of buildings in the direction of Queens. The architectural lines of the atrium, the walkways, and the low-lying buildings felt straightforward enough, yet not so simple as to suggest functionalism. Here and there formal squiggles undermined the regular angles that held sway within these co-articulated spaces, whether in the strictly un-necessary depth of the atrium's threshold—deep enough that it amounted to some-thing more than a vestibule, almost a lobby within a lobby—or out in the walkways, which mildly undulated in width and height as you passed through them, for no obvious reason other than to express the varying properties of the sloping glass, which distended the trees and the clouds as we passed.

Subtle deviancy also attended the most curious feature of the complex, which remained the orange tint of the stone. At a distance it had an even, pastel quality that appeared to be the result of paint, but from closer up it was obviously natural and less even in intensity, with an irregular grain traveling outward in fractal whorls. It must be some rare form of marble, I thought, except that it seemed too matte for that.

Where this stone came from, I couldn't say; nor could I be certain I'd seen its kind before. But it had a mesmerizing translucence that only gradually made itself known to the eye. Again I had the impulse to stop and examine it, but each time I glanced hopefully at my chaperone, she tipped her head away from me with a preoccupied smile, acknowledging the reasonableness of my wish and denying it by the same gesture and thus saving time, which I gathered she held more precious than all else. So I kept moving, doing my best to take in the stone surrounding us in ribbons intercut with glass. Its color seemed not to exist on its surface, emanating instead from some deeper place, even somewhere behind it. The stone—or could it be some sort of synthetic material?—was merely the transmitting medium, one that ran totally uninterrupted every-where, as not a single mural, sculpture, or painting could be seen anywhere, the very things I presumed to find in force at the headquarters of an entrepreneur with an appetite for art.

We entered the eastern wing and the proportion of stone increased, along with the amount of metal and artificial light. We kept to the right side, speeding through several broad corridors and up two floors, and then finally crossing a shimmering showpiece walkway. Other than this architectural feature, the building's interior was analytical in design; even when you didn't see dials or instruments, you felt them lurking in this house of science. The office we arrived at seemed inappropriately modest for the chairman of Antral, a firm that would have been familiar to anyone who stayed abreast of the manufacturing industry, even if you didn't necessarily know just what they did. For some reason the office's ceiling was much lower than that of the airy hallway outside, and the varnished tan desk carrying neither paper nor electronics of any kind was of terrific dimensions, not at all in keeping with the modest proportions of the space. What's more, it'd been unnaturally centered in the room, leaving only a small band of space around the perimeter to move about in, which was made even narrower on one edge by an empty built-in bookcase and, alongside it, stacks of moving boxes and storage bins. A cheap metal chair with hardly any padding occupied a gap in front of the window, and the one item here of quality—a fine green leather desk chair, high-backed with a regal air—looked silly rather than grand in these conditions.

The crampedness was relieved only by an untrammeled view offered by the floor-to-ceiling window the desk faced, which overlooked the park and the East River beyond. Drawn straight to this transparency, in some manner seeking the illusion of open space, as one does from a subway car, I squeezed in front of the desk, leaving the woman behind in the hallway. She didn't stay long anyway, judging by the footfall. There were things to do.

I searched the forested land, as I did my own little Bronx park sometimes, for people and their traces, when the sound of boot heels came on. I whipped around to find a man—dark blonde, long-limbed, hazel-eyed, and probably in his early forties, going by the pliability you could see still inhabiting his rosy skin, which bore the finest creases. Besides dark boots he wore sky-blue shirtsleeves and black chinos. He arrived with a distracted air that dissipated almost as soon as we'd exchanged names—it was, indeed, James Garrett—after which we took seats on either side of his desk, though it was necessary for me to angle my little chair to one side to sit comfortably.

"Sorry it's so tight in here," he said. "My office isn't *my office* right now. There's a demo set up in there that's... well, anyway, didn't you bring anything with you?" He squinted at me and caught himself before I could answer. "I didn't ask you to, though, did I?"

"I don't remember it."

"Ah, but see, I don't think it matters. The studio you work with—I hope you don't mind—I told them I was curious about your work. They pointed me to some of the commissions you've done for them. Things with people, specifically. That illustration for the CRISPR op-ed, for one."

"Karen?"

"Right. And then this glorious cover, for a new novel?"

"The book is pretty bad, it turns out."

"But your design!" I felt as if he were about to stand. My directness buoyed him, made him more decisive than at any time on the phone.

"The sea of bodies."

"And how the title, the font, is just so delicate. It almost reaches you later. That's how I put it to Paul, my right hand. You'll meet him."

"Or it doesn't reach you at all. I don't know what they thought of that. That was for Penguin. Karen can sell these people on almost anything these days."

"Well, the magazine *is* terrific. It's well-earned. She sent me a few copies of the thing overnight. All paper, she wouldn't do PDFs."

"The place doesn't even have a website," I said, flexing my hands. "Anyway, the imprint that published the novel likes to see itself as forward-looking. So in a certain way, they *had* to swallow it."

He narrowed his eyes and shook his head with a silent laugh, just before tugging at the collar of his oxford. His face had grown ruddier. "But could it really have been any more *right* for that book?"

"You mean because of its ambitions?"

"Right. So the cover, in that case, really shouldn't be a slave to..."

"To information."

"To function, is how I would say it. And you haven't been cute with it, either: scrappy or frilly or know-it-all. That would have ruined it, for me."

"What I came up with was basically what I thought the book *could* have been."

"If the writer had been any good, you mean."

I smiled a little, no teeth. "Up to his own material, yeah."

"The execution. Exactly."

"But the cover *is* based on the book. I read it, absorbed it."

"But you didn't, I don't know..." He looked past me, out the window. His gaze softened. "You didn't *draw down* to the book."

"That's true," I said with a long nod.

He chuckled like a boy at this. "And why exactly should you be expected to draw down, by anyone, least of all by the client?"

"The book had already let itself down. That was my thought."

"So why should you?" He stood up and walked to the window, briefly positioning himself beside me as he looked out over the wood and water. "Did you know you can see Rog's place out there? It's where I first came across your pictures."

He started pacing slowly in front of the window, head thrown back rather than bowed; the sun was right there in his eyes but he didn't seem to mind. I could think of nothing to say, nothing that was more interesting to me now than watching him gather his thoughts in the light until, finally, after some time like this, he spoke again. Between long and thoughtful pauses, he began to tell me about himself and Roger Whent—or Rog, as he called him. He'd known Rog for a long time now, apparently, since their days at Cal together. They were chemical engineers as freshmen, though Rog switched over in his junior year to his true love, computers. From there he went on to the Media Lab at MIT for a few years before returning to the Bay Area, to work in a fledgling company's wireless operations, creating ultra-fast radio-wave WANs in which whole cities became efficient hotspots. Only later, Garrett explained, did Rog move east, to New York, to found his own company, Salient Technologies, focused on making action at a distance—that's the way Rog liked to describe his core interest—the norm. Where every element of life could be put in mutual touch.

Garrett, though: he'd gone straight from Berkeley to New York. The only other place he'd ever lived was the Chicago exurb he'd grown up in, where his mother still resided. His father, Terry, a landowner and semi-industrial farmer, was now dead, but he'd left behind a lot of everything to his wife and his only child, including seed money for Antral.

Garrett's and Whent's companies had gone through the usual growing pains in parallel in the city. It really wasn't worth recounting, he said with a grin that acknowledged anxieties now long since passed. Although they were never in exactly the same industry, when it came to technology they both hoped for crossover down the line between their interests. That was an article of faith among technologists, really. The whole thing—here he tapped the window for emphasis—the whole thing was predicated on just this: the possibility of extension, indefinitely, even when it seemed you would need some sort of magic to bring it off. Magic, after all, could be invented like anything else.

"So just a few weeks ago," Garrett said, sitting down in front of me on top of the desk, with his boots dangling, "I went over to Rog's place for a little party in honor of a mutual pal." Lucas, he was an engineer and programmer, based in Denmark, actually, who spent all of his time on 3D printing. Apparently he'd constructed a prototype that was a quarter of the cost of its closest rivals, yet still somehow twice as versatile in the jobs it could handle. The machine had just made the rounds at campuses and technology forums throughout Europe, in Munich and Oslo and Manchester. Rog

was fêting Lucas upon his arrival in the United States, ahead of a show, celebrating this machine's potential, which couldn't be totally known yet. Much of the intrigue surrounded just how widely its low price point would allow it to be distributed. What kind of sea change could it induce, if the fabrication process could be brought to heel, cost-wise, in the way their Danish friend claimed to have done?

The drinks were flowing that night, exotic cocktails mixed by the caterers, and the things they drunkenly printed out were getting progressively sillier. "It was all pretty amusing," said Garrett, "until I noticed the drawings on Rog's walls, the ones I must have been looking at, hardly thinking about it, the whole time, while I was caught up in the novelties coming out of the printer, and the booze." For all their differences of technique and material, he suddenly realized the pictures were all about one thing, one woman: my Claire. "So I started making my way around his place, just looking at these things. I went around like that three or four times, upstairs too, picking up another slug of whiskey from Rog's private cabinet, forget the fancy cocktails, every time I came around past the kitchen." Here was a universe built from a single person—that's what Garrett remembered feeling. "It was an epic, sort of." He'd once had a classics professor, he told me, a brilliant man at Berkeley who'd made everyone read *The Iliad* aloud in class, day by day. "Best class I took, I'd say." The engineering courses were just information you took in, but here was an experience. Yet there was a problem, and not a small one, Garrett thought: "It wasn't *my* universe, or *our* universe either." He paused without elaborating, began tapping once again with his fingernails, brow furrowed, but this time on the desk beneath him. I gathered, from what he would go on to tell me, in fits and starts I patiently waited through without moving from my chair—unlike Whent, he seemed to appreciate my silence—that he thought that Homer's poem stood in a world that was long ago lost to us, severed from modern life. You could only grasp it limply from a distance now, as a specimen text from another era, a cadaver almost, and always with the help of a professor.

Unfortunately this wasn't the end of Garrett's disappointment. His complaints grew more blunt, and as they did, his tone darkened. "Your drawings, too," he said, "as much as I couldn't stop looking at them." He eyed me for the first time in a while. "I felt sealed off from them." Even though the world I depicted was contemporary, he said, there was just so little of it beyond Claire, and beyond my particular way of seeing her. It was mostly a private world: hers, and mine just as much.

What this meant to Garrett, what I surmised he meant, anyway, was that the meanings, the stories that circulated through the body of pictures, couldn't really be inhabited by him. He could make inferences about the significance of what I'd produced, he could study it like an object of science, observing it patiently and in-terpreting it, but that was actually the very opposite of habitation. "It wouldn't be at

all like coming face to face with yourself in the work," he said, "or finding a home in it"—not in good faith anyway, without simply foisting your thoughts onto it, bending it to make room for yourself in its lines and washes and colors.

What was *worse*, he said, getting up to stand at the window again, but now with firmer resolve, was that whatever meaning you did pull out of the piece, there was no reason others wouldn't extract something entirely different. Which again left you feeling distanced from the thing itself, and from everyone else who'd looked at it, too.

Finally he returned to his throne of a chair. "It made me a little sad to see that, how lonely it all was in the end. And maybe Rog and everyone else is fine with that. But that's what I was thinking about on my way home that night." He rapped on the desk with his knuckles and perked up, looking almost apologetic. "It gave me a lot of ideas, too, though. That's why I wanted to see you here."

I smiled faintly but turned away from him toward the trees outside. All his talk, mostly critical of what I'd achieved, had driven me into my own thoughts. Even if strictly speaking he knew rather little about me, I was impressed by what he'd managed to deduce. Whent was right: Garrett *was* curious. For one thing, he was correct in saying that I, though quite capable of the outer gesture, the social dance, naturally tended toward inwardness, which I evinced even in the very of having this thought, with him giving me some time to compose myself by kneeling down near the shelves and riffling through the boxes stacked against them.

I say naturally inward, though whether this bent was merely a contingent matter, owing to the present shape of the world, I didn't know, given that I had experienced no other. The very fact of my discomfort with an entirely private life—why become an artist, after all, if you had no interest in public space?—gave me hope that, indeed, my withdrawal now was hardly fated, even if I wore it well.

It's always nicer to imagine that if the world had been just a little different, or one had been born in another age, including the future, peace and joy would be in touching distance, rather than have to admit the aptness of our existing relationship, if *fit* isn't quite the right word, with the world just as we find it: even when that relationship is rude and fractious. For me, there *had* been, and continued to be, opportunities to make other choices, to live different sorts of lives, that much was obvious. So what else but a genuine preference for psychic distance could explain why I'd voluntarily moved to the Bronx from a place like Sunnyside? That's where I'd gone after I'd decamped from the milieu of artists occupying Bushwick and Ridgewood, at the border of Queens, a milieu I'd been told was my own. I'd left because it wasn't distant *enough*; I could still hear them breathing. Had they had different natures, though, how could I know whether I would have sought out their company or been even *more* repulsed, this time for completely different reasons?

In any case, I suppose it made a certain sense that my pictures would feel hermetic, inscrutable. They may have occupied the space of myth, but it was undoubtedly private myth. What I didn't fully realize, as I turned away from the brightness of the glass and watched Garrett down on his knees, rearranging storage bins, was quite the way that this privacy, the particular sort of mystery it induced, much as it might liberate the viewer from a straitjacket of meanings, did so at the cost of leaving him estranged, without orientation. Some viewers, like Whent, didn't mind that. Considering his relations with his girlfriend, and with other women, too, he probably even sought it. Indeed, this divorce between creation and perception, poiesis and aisthesis, is the signature trend of modern art, particularly in its irrationalist and abstractionist guises. Artworks that brook no recognized links between expressive means and subject matter are like maps without a legend: being more or less indecipherable to the gallery-goer, such imagery can be freely absorbed into any fantasia that appeals to the viewer. Meanings can be projected onto canvases quite heedlessly. These works don't draw you out of yourself and force you to meet the artist and the culture on common ground, so much as provide material to be used in any way you choose. Discovery, communion—in some sense these just aren't consistent with the ubiquity of personal interpretation that so many theorists and artists have helped bring about.

Other people, though, people like Garrett, appeared to seek something besides a space for the free play of meanings that had dominated visual art for well over a century. I myself wondered more and more about this: whether Descartes really was wrong and meaning was public in the first instance, so that all else could only be derivative, a retreat or debasement or perversion. And it was the *Lebenswelt* of the Bronx, of all places, that seemed to raise the question most insistently for me.

Garrett returned to his feet with an armful of books with blank bindings and set them out on the highest shelf, one by one. Satisfied, he came back and stood just in front of me, going over his knees roughly with his hands to knock off the dust. He might have told me what the books were about, or why exactly we were meeting in a room that he hadn't even moved into properly, but he offered me a brisk nod instead, as if to say he'd finished whatever it was he'd meant to do with the boxes, even though almost all the materials remained unpacked and the bookshelf had only a half-dozen volumes on it. It didn't matter to him, not now, when there was so much else on his mind. He pressed his palms together lightly, leaned against the desk, and picked up his story. The day after Rog's party, he said, he couldn't be quite sure how much he'd had to drink, nor how much his feelings had been provoked by the pictures themselves.

So he called Whent and got put onto Cosquer, which he'd never heard of before. He looked over what Karen sent him, some of my projects, and some copies of the magazine itself, and he was heartened to find that what he'd felt that intoxicating night was in fact quite real.

Garrett pointed out the window now, his cheeks plumping and a smile breaking over his lips. "Rog and I, we were neighbors over there for a while, until I moved to the island." His arms were folded and his eyes nearly closed from the intense sun in our faces. "Partly to be closer to work. But also just because." He opened his eyes a little. "You know what it is we do here, right? Rog told you?"

"He mentioned materials. Storage." Toxic waste, I thought, might not be worth mentioning just now.

"*Really*? That's all—*storage*?" He went back around his desk and sunk into the arms of his commodious chair, breathing in deeply and exhaling through his teeth as he leaned all the way back, so that with a downward gaze his eyes narrowed on me. I don't think he believed I knew so little. He recognized politesse.

"And that you're branching out," I added. He waited for more, calling my bluff. Finally I admitted, "Roger was vague." This was a lie, too. Whent had said enough.

Garrett smiled wearily, stood up, and sighed. "Well, materials is *true*. Storage, yes, that's how I got my start. Anything else he mentioned? You really don't know much about this?"

I shook my head.

"It's just, none of it is necessarily relevant, from where you're standing. That's what I would say. I hope Rog might have made that clear to you, too." He edged toward the door before looking back at me. Now his wide red face altered: he was excited, the definition of outward-looking. "But why not have a tiny peek, since you're here?"

I followed him down the narrow corridor. His body seemed barely able to contain the force that ran through him, the time for reverie was past. I almost had to trot in places to keep up with his shrinking form as he wended his way ahead of me. Eventually we reached a room that reminded me most of my doctor's office at New York-Presbyterian, an internist who'd remained there through my years in the city, though I'd only briefly lived nearby, at a family friend's when I'd first arrived. But here in Garrett's compound, among all the mirrors and glass and chrome, in the place on the examination table where a patient might have sat, there was instead a body-sized swatch of material, perhaps cloth or plastic, so startlingly black that it reflected

almost no light. It was secured in place as if it might escape otherwise. Silver pincers clamped its edges like a trampoline, and everything was enclosed in a transparent plastic frame. Less than a yard from it, within this chamber, a gunmetal blue nozzle fed by a hose blasted it at regular intervals and varying intensities with a purplish gas. Garrett, his demeanor entirely changed, said it was merely compressed air, so its lilac tones might have only spoken to the peculiarity of the lighting within the chamber, which was overwhelmingly intense, designed, I assumed, to reveal qualities of the cloth or the gas or their combination.

The heaviest shots from the nozzle met the ears like pistons pumping, or industrial doors closing. Garrett slid his fingers onto a control panel just inside the doorway and piercing jets of water replaced the gas; the material ballooned outward now at the point of impact and glimmered as it soaked through. Yet even before the next blast could come, the distended span of black somehow reclaimed its original flatness; it dried at startling speed, too, glitter replaced by bottomless black as water drained out of the base of the chamber in rivulets. The cycle repeated several times: deluge, distension, recovery.

"This is still at the core of Antral, for sure," Garrett said while we stood back, observing from the hall. "Chemical engineering is what I *know*, and I still manage to supervise almost everything around here, through testing and the rest. But we don't exactly sell this stuff to the public. It's for industrial applications, construction, storage. Scientific and, well, government purposes, too. I've been lucky, it's been mostly profitable—once we got settled in, anyway, made a few key discoveries. And there just hasn't been any need for promotion. It's all so clearly necessary for our clients." He spoke at a more rapid clip now, his voice carrying the same energy that had crackled through his body down the hall.

I was tempted to enter the room properly and inspect the black specimen more closely; this temptation to search I felt everywhere in this building, radiating through its walls. I wanted to steep myself in the peculiar rhythms of the fabric's transformation, the graceful manner in which it re-established its shape and shed moisture from the outside edge of the depression inward, in waves, like ripples in a pond running in reverse. But Garrett swept decisively out of the doorway and down the hall, leaving me to trail behind his sturdy black work-boots as they clopped like hooves.

"What we *could* use help with," he said over his shoulder, in a voice amplified by the great height of the corridor, "are the new branches of the business. Things that don't have complete economic necessity baked right in. You've heard of Arête?"

The distance between us allowed me to pretend I hadn't made out what he'd said, while in fact I was searching my mind. He slowed down and repeated the question. Finally something came to me.

"It's like a sharp ridge, right?"

"A mountain ridge." My uncertainty prompted him to turn around and let me catch up, as if physical proximity might somehow also narrow the gap in understanding, which was still wide, as it wasn't a mountain ridge he had in mind: "Actually I mean the sports brand—capital-A Arête—although it is named after a ridge. It's a lot smaller concern than Antral, obviously. But then, the fact that this explanation is necessary"—he gestured at me and back at himself, now side-by-side, as we continued down a ramp to the ground floor, though the narrow passage we took, off the main one, barely allowed for this—"the fact that you *haven't* heard of the brand, I mean, tells me Paul and I aren't getting the job done."

"I think I know of it." This wasn't a lie, exactly, but my grounds for saying so came down to my recent sports television marathoning. How was it possible I *hadn't* heard of it, given all the commercials that passed before me?

Garrett chuckled kind-heartedly. "It's really only getting started, so it's okay, for now, if you don't know it. But that's got to change. With your help, I hope."

We stepped out onto a landing and here the ethereal orange of the building fell away for space-age white. "We launched Arête because once things started moving with the industrial stuff, we thought, how can we use these techy materials, all the profits from the other side of the business that were just accumulating? I don't live a gaudy life. So how to reinvest to create more public things, universal things, that can matter not just to labs and governments and industry?"

His was the sort of longing, I thought, by which every culturally invisible behemoth must be gripped: Qualcomm, Oracle, Sun. That's why they sponsored stadiums and arenas around the world, desperate as they were for any measure of public recognition. I wasn't sure Garrett was after exactly that variety of glory, though. Just looking at the man, the way he carried himself, he might be up to something a little fresher, even if they *all* felt they were ahead of the curve.

"So the thing that came immediately to mind, when I was first thinking about expanding Antral, was *sports*. It's such a natural crossover for a materials firm, right? Fabrics, like the one we were just looking at. There are others we've got around here that can hold body temperature down, or absorb moisture, at phenomenal rates; shoes and braces designed for ideal support and flexibility *at the same time*, without the trade-offs of rate-activated tethers."

"Stuff Nike can only dream of."

"You don't believe me. But actually, yeah. This is stuff we…" He was on the verge of elaborating, then thought better of it, smiled. "It's genuinely cutting edge, not stuff that shows up twenty years later in Reeboks." He winked at me. I don't believe I ever saw him wink again, not like this. There was something unabashed about it. Did it stand for the thing he'd just suppressed?

We came to a freight elevator oddly bereft of buttons. There was just a gash in the panel, into which Garrett twisted a key, leading us further down beneath the facility. Apparently large parts of the place existed underground, which explained why such a robust business had risen only three stories. How many stories did it sink? We were underground. "Right now, Arête's gear—the firm's only a couple of years old—is used by a few football and basketball teams, and that's about it. A couple of college programs, too. The costs are coming down a little, but this was always going to be niche stuff. The research hasn't been cheap, and the fabrication isn't either."

We twisted sharply into another space that lacked a door; this seemed to be a feature of Garrett's headquarters, doorways without doors. Before us stood a trove of clear glass disks, some as large as dinner plates, others as small as pocket change, all of them glinting. "We're about to launch an optical division: sunglasses for baseball, visors for football helmets. Oakley's got their Prizm lenses, right? They're nothing next to these. Eventually they'll go on the broader market."

I left him to walk among the lenses, determined this time to linger.

"Pick it up," he said, referring to a lens that had caught my fancy, rainbowing in the light from some sort of coating or treatment. Looping my thumb and index around its circumference, I held it up to my eye like a monocle and regarded Garrett, which drew a wry face from him. "Some of the things these lenses can get you to distinguish, they're going to have uses way off the field or court."

I continued inspecting him. He'd turned a shade of blue, as though underwater; and remarkably, his structure leapt out. The less-than-ovoid shape of his head, for instance, and the length of his stout jaw, the compactness of which contributed markedly to the breadth of his visage. It was a lens keyed to proportions, I thought, to judging weighted masses and their interrelations. I studied Garrett brazenly, descending from the sturdy trunk to the sinuous hands to the hips and legs that surprised me with their litheness. Invading him with my gaze with such impunity, of course, would have been impossible without the pretext of testing the lens.

"The whole project is going to straddle sports and fashion, too, in some way. Arête technically already *was* a fashion label, an obscenely niche Swiss one that my wife was a fan of. She'd seen it first at Roland Garros. So I bought it, renamed it, and merged its original design team with one I'd more or less poached from a rival company, a French start-up."

I let the lens fall into my hand, the way monocles fall in old films when the count is surprised by something. Exploring my vision through the lens had also given me cover for puerilities like this. Who had time for sober reactions when endowed with a new consciousness?

I'd meant nothing by dropping the lens, of course. I was only playacting. I don't know whether *he* thought I'd meant something by it, though, since I'd done it just after he described gutting another company. Whatever it was, he was beaming at me now. If only he would cap it with the wink he'd given me earlier, I would have known for sure.

Garrett turned and took a set of stairs up past the display of lenses without saying anything, and I followed him a very long way back to the surface, eighty or a hundred steps on a continuous flight. How many floors down had we been? When we reached the top, he was breathing no more quickly than before, though his chest heaved, as if his lungs had doubled in size. My own breaths were shallow and rapid. He swung a small door open and everything before us turned green. Here was a garden, slightly overgrown, outside those enclosed walkways I'd come in through with his lab assistant. People were marching through the tubes like denizens of a space station deposited into a pasture. They stared at us as though we were ghosts, as if they knew for a fact that the place we occupied could not in fact be occupied. Garrett happily trudged through the yard. His boots made more sense here. I could see prints in the dirt that matched the ones he was making.

Through the transparent atrium just in front of us I could see a wobbly Queensboro bridge, twice refracted through both sides of the dome. Once we were back within the bubble, through a transparent door you could barely see the hinges of—it was as if we were being directly absorbed into the innards of the place—the bridge stabilized above us. Through a single pane of the bubble, it was brighter, sharper; the material seemed to gild the light passing through it, lend it a glow.

Garrett strode through the atrium, blind to the support staff and researchers milling about now, far more than when I'd first entered. None made an effort to hail him, and I could very well imagine him contractually insisting on their silence. He was exactly the right eccentric for this unfathomable order. I thought he was going to deposit me near the entrance, but instead he accompanied me past a group of men in casual suits within that extended vestibule. I took them for venture capitalists, I don't know why. They were the first to look directly at Garrett; perhaps they'd not been informed of his preferences, or they only obeyed it with regard to me. He paid them no mind, though, and walked me outside, all the way onto the path along which I'd first arrived that led down to the water from the slight incline Antral's headquarters sat on.

"Why don't I just walk you to the shuttle?" he asked, as if this process were not already well underway. "I've been inside too long, since last night actually. That jaunt through the green back there was a treat." The path cut toward the water at an aggressive angle before straightening out in parallel to it. The wakes of small powerboats

rippled the surface of the river, but the greatest swells came from an incoming ferry charging toward the shore with such abandon I felt sure it was headed for trouble.

Garrett was again examining Whent's spire, and soon I was, too, never mind the ferry and its fate upon the rocks. "Can you see that reddish one?" His finger extended on a line that just missed Whent's building, intersecting instead with one a few blocks north that was indeed a dark crimson. "I liked it there, for a while."

"Do you live near here?"

"Other side of the island, actually. I want to be close, but not too close." He chortled at this, his eyes roamed. Yet in a couple of strides he was back to business, as though the laugh had helped him clear away pointless thoughts. "The thing is, we are pretty much always working on new extensions with Arête."

I nodded without understanding.

"New shoots, they're always sprouting. Drinks, for instance."

"Gatorade or something?"

"In a way, maybe. Body Armor, Bolt24, they're fun, they're hydrating. But we want real *efficacy*." He slowed me by grasping me by the forearm and squeezed. "And maybe not just for sports." He released me and we carried on along the path, which slightly veered away from the water. "I think what we're working on could be the next step in that market."

The ferry neared a dead stop in front of us; it turned out there'd been time after all. I searched and found the shuttle in the distance, at the bright red bus shelter enrobed in tramway posters, all carelessly designed and the evident result of desktop solutions. Much of city design had this problem. There was simply *too much* to do; the best people could only take on so many projects. Hence much of the work fell to lesser lights, with gaudy consequences. Still, to the credit of the small fish who'd thrown this one together, even from here it was legible, its blocky rendering of the Roosevelt Island tram reaching us at a quarter mile's distance.

"And if that's not enough for you, there's another drink we're working on, too," Garrett continued. "It's not even under Arête. I don't totally know where it fits with the rest of my business." He sighed and paused and let me take that in. "It's its own thing. My dad's whiskey. Or our neighbors', the Whites. But he picked it up from them."

I slowed down, working this swerve over in my mind. He was pleased to have surprised me, I could see. "My father bought this old distillery back home, in Illinois, decades ago. He was a big, big farmer, so his life, our life, didn't look very farm-like, if you can understand that." His accent seemed to modulate into something more Midwestern, and more circumspect, too—the voice, perhaps, he'd used around the dinner table, growing up. "But *this* was still something small and

quaint, a distillery. It worked with unusual grains. Way past corn. Designer whiskey, we'd call it now, I guess. Wheat was probably the most normal of them. Maybe that's why it didn't do so well. Not then, anyway. He always thought of that buy as a failure, a moment of weakness or plain old nostalgia, something he never wanted to allow himself. But then I think how he specifically left the distillery to me, not to my mother. That must mean something. And I'd like to see what I can do with it. Again, with your help."

The word rang in my head—*help*—and as we reached the shuttle stop it metastasized into a cluster of doubts. I realized, even at this stage, that it was not at all clear what sort of help Garrett wanted from me. What had been achieved by this meeting, for either of us? We sat on the low bench, I on one end, Garrett beside me, and, a few places beyond him, a man in a red and white sweatsuit and a black bandana worn more like a headband. He was in his early thirties and quietly gasping, with one leg splayed over the end of the bench. He must have been out jogging, though from his sweat-beaded state, he might have been all-out sprinting. His anguish hurt me.

There was a water fountain about twenty feet from us. Maybe he'd doused himself to cool down before we'd arrived. By his twisted expression and closed eyes, it looked like he needed to. His body corkscrewed, too. He straightened out now and then and hunched over for a bit, and his face would arrive in his hands, his head weighing a little more each time, it seemed, as it fell ever lower. This run he'd taken, it had to have been epic; it was clearly too much for him. But then I noticed that I was beginning to trickle with sweat as well. It'd grown muggy since I'd left home, probably ten degrees warmer than expected this time in September. Certainly his sweatsuit, even with the sleeves pushed back, was out of place, possibly even dangerous. The shuttle idling before us would be his salvation, I considered, taking him back home in air-conditioned comfort. But its doors remained sealed, and the driver, who I could see through the tinted windows fiddling with his phone, wasn't going to open the doors before departure was close at hand.

"So how does this all sound so far? Just in general. *Boring?*" Garrett wasn't especially concerned with the jogger's distress, though I could still hear the man panting.

"It's not how it sounds," I said dubiously, still eyeing our companion. "I just think I'd need to know more about what specifically you—"

"Did you know that people have sent me to *hack* after *hack*," he said with a stridency and impatience that surprised me. He shook his head tensely. "But I saw it, at old Rog's, the genuine article. And that's what I need. Because, well, maybe there's a way for us to do this that we'll *both* find interesting." He broke off and cocked his head slightly without turning. "You need some water, friend?" He pointed at the fountain

but I could see the jogger's eyes were closed tight. "Are you going to be all right?" he said as he turned to him.

The jogger nodded vigorously; I had underestimated his strength. Just then the shuttle opened its doors with an extended hiss. Garrett turned back to me and stood up. "Now, let me ask you something completely different, before you go. You know very much about football?" I must have looked even more perplexed this time. "A tiny bit, even?" Yet before I could answer, and without a word, he turned around and began helping the would-be athlete to his feet.

"As a casual fan, I guess," I said as I rose. My recent immersion in sports television had equipped me with a greater acquaintance than this, actually, though I couldn't say just how great, given the profound inattentiveness with which I watched.

"Okay, perfect. And what about the theater?"

"The what?" Had he actually said *theater* now?

"My last surprise, I promise." He spun back toward me, having finished assisting the jogger and wiping off his hands on his trousers. "I'm talking about off-Broadway stuff. *Off*-off Broadway even. And indie films as well. I don't know a lot about them myself."

I started sinking back into the confusion from which I'd just felt myself to have emerged. The jogger, meanwhile, was limping toward the open doors of the shuttle.

"A little?"

"A little is great," Garrett said. "Better than a lot, sometimes." He took my right hand between both of his, which were free of obvious signs of the jogger's sweat, though I knew in fact I'd been branded with it. Any lab could tell you that, including Garrett's. Worse, he held on to me for a while and squeezed. "Let me get a few things together, then. I'll talk with Karen."

Now the shaking started: our hands bobbed up and down together, but curiously it wasn't entirely clear who was responsible for the movement.

"This really is not as crazy as it seems. I mean that." His words lent our handshake another sense, brought it a purpose that wasn't purely otherworldly.

I freed myself of his grasp and hopped onto the shuttle. The perspiring man unfolded himself on the seat across from mine and basked in air conditioning that was disappointingly weak. As he and I headed back down the island toward the tram, he kept his eyes closed. For reasons of pleasure or pain? I didn't know.

6

I'd never really taken sketchpads into the world before. There'd been a few art school exercises dutifully carried out: walking into the town square, more or less, pen in hand, surveying the scene, usually in some particular register. I'd be looking for masses, or gestures, or contours, depending on the day. Whatever our professor asked for. Since that time, I'd done nearly all my drawing under controlled conditions, whether those of a studio, or my apartment, or indeed my bed.

There's something slightly embarrassing about the artist in public, I think, never mind *en plein air*, even something a bit tacky. Our stature has fallen to depths unknown in the time before mass culture's ascendancy; but in the few days after my meeting with Garrett, I came to find it the most natural way to proceed—perhaps the only way. That I was no longer exercised by any substantial artistic project explained some of this. But so did Garrett's thoughts about the mystery in so much art today, apparently even my own, the separation it created, diminishing one's feeling for (or with) the world. These notions only reinforced Whent's, what he'd said about lost causes, lost worlds.

If there's one virtue to finding yourself in a cul-de-sac, it's in knowing there is nothing to do but turn around. And so I did, leaving behind a personal world for a broad and nameless public. I started rendering patrons in bars and diners in the Bronx near my apartment. To offset my professional embarrassment—partly stemming from my training, which didn't smile on the imitation of life, and partly from doing anything as conspicuously aesthetic as drawing in this sort of neighborhood—I used an exceedingly small pad, no larger than an appointment book, so that anyone observing me from a distance would think I was merely working out my schedule for the week, or even lining up my picks for the races, just as they were. I was learning how to compose *in medias res*, truly, and how to do it without being noticed.

My first efforts were spoiled from the start, congenitally, you could say, simply and directly by the unfamiliar scale. All sorts of tableaux presented themselves to me. There were young families crammed into booths, one too many on either side, so that legs dangled and postures were made curious by the crush. There were stabs of almost abandoned property: long, narrow bars standing virtually empty, except for the bartender and me, deep in the recesses, far from the door-shaped panel of light, the only light, as the windows often had their blinds drawn even during the

day, to keep out the heat. And there were what I hesitate to call outdoor cafés, as they had none of the charm that the term would lead you to expect, just dirty plastic chairs which for all their volume seemed to weigh nothing at all, or crooked wire ones that unintentionally rocked. There were also those tableaus I transcribed in the park, the venue least debased, since photosynthesis guaranteed some modicum of upkeep and regeneration.

All these scenes, tiny in the way I got them down, seemed to explode past the borders of the little jotter, and not happily. I was left with images that appeared arbitrarily, fatally, cropped, with the central point of interest left out of frame, or else the frame sliced right through it and forced some other element into the natural position of interest. In this way my true subjects emerged almost of their own accord: a torn packet of sugar next to the sleeve of the young man whose pockmarked face was only implied by his stained and fraying cuff; or the beads of condensation on a glass of water carrying wobbly fingerprints, a glass meant to sit, in the image, beneath the bartender's face—it was his drink—until it had consumed most of the picture plane, inadvertently putting one in mind of a crime scene.

All these are hallmarks, of course, of the photographic snapshot, effects the realists and impressionists played at long ago, though with ingenuity and verve. So did Velázquez, for that matter. What I'd achieved, well, it was nothing at all. My troubles with scaling meant that much of what belonged to the moment of composition, to what I had in fact seen, became irrecoverable from what I'd drawn, which accounted for only a fraction of my visual field. I overcorrected at first, desperate to preserve reality, to make things now vanished somehow *fit*. But now my figures found themselves positively crushed by my encroaching strokes piling up and shrinking what little space was available to me in the pad. Even my vanishing points got compressed. Most of these drawings were done at an angle to the subject, in two-point or even three-point perspective, if I sat at one of the barstools and drew someone down low. In one sketch, a child in diapers raised his hand to a molded table surrounded by his three brothers and father, and his father's girlfriend, to judge the relationship by the distance between the children and the woman. My misplaced points, naturally too close together—a common problem—warped space itself and tortured these children more than they knew. You could say there was something apt about this, even mimetic, but that would be making excuses.

My judgment here wasn't exactly helped by the drinking I did at the establishments I visited: sometimes four or five whiskeys in a session, a Michter's one cube, a Sazerac neat, or a house scotch and soda when my throat began to burn. Nor was it aided by my subjects often departing right in the middle of conversations or table service, or taking up new positions in the venue that were inassimilable to the ones

they'd first occupied in my picture. These movements fractured perspective. That was Bronx culture to a tee, though, I was learning: a life without segues.

The problems ran deeper than this, actually, down to the substance of my ground, which was stone: limestone dust mixed with some sort of emulsion. Beyond the novelty of these notebook pages, which is what made me buy them in the first place, at a stationery shop selling all sorts of gratuitous materials, they were best adapted to notes of the linguistic variety: script laid down fat and bright. They felt pleasingly spongy as I drove the nib across them. But language was not my concern now. Nor were *notes* of any kind, linguistic or visual. What I was attempting to draw transcended mere sketch-work; instead it approached portraiture, which turned on a much finer control of space, and on plasticity, which required a delicacy of line and a variation in pressure and angle of attack that stone, even powdered stone, evidently couldn't accommodate.

The first thing I did to improve my results was switch to a paper that *wasn't* mineral—that was actually paper, I mean—though the size of the notebook remained the same, not just for the sake of discretion but because I knew that these peculiar dimensions might force something fresh from me; in fact they had already begun to do that. Slowly I gained facility composing on my replacement support—heavy cotton rag but with a very fine tooth, fine enough for the most minute details to be registered—and with a new instrument to boot: a Nayaka pen with nibs of a suppleness not fabricated in any other country. As the clarity of my forms sharpened and my feel for the miniature scale grew strong, I felt my moroseness lift in some way I cannot yet wholly account for. Alcohol became less necessary for me to work amidst the din of the rabble, who would sometimes, in their mistrust, offer a hard stare back at me, though occasionally the look would soften, if they happened to take pleasure in being seen. (You couldn't predict which people would.)

By the time I met Karen at Cosquer's headquarters in Queens, my pictures, assembled briskly yet not without a certain diligence, had the proportional grace of bonsai trees. What was most apparent to me, as I paged through the drawings in a slick café-bar in Long Island City, waiting on my bourbon, was that my Bronx subjects, and by that I mean not just the many customers and bartenders I'd drawn inside those establishments, but equally the neighborhood folk loitering outside in heavy heat, whose movements and even deliberations seem to have been slowed by the mid-afternoon bloom of the sun; folks who were involved in conversations that were often less than benign, and deliberately vague; folks I'd transcribed from indoors in all their brilliant obscurity, whose bodies were partly obscured by the glare—all of these people, indoors and out, never mind the variations, were cut from the same crumpled cloth. How to put it? They gave the distinct impression of freedom; that's the best I can do.

Yes, there were a few empty and darkened bars I'd drawn in, which I sought out for the peace they offered me. But mostly the places I sketched were teeming right through the afternoon, and with the same customers, day after day throughout the workweek, even if they weren't buying much. This was one of the first things I'd noticed after I'd moved in. *I*, of course, was naturally free, not seeking steady employment beyond my art. Otherwise I would never have been in a position to notice them.

In fact, the Bronx seemed to be home to lots of self-employed people: inveterate, unwilling freelancers, you could say, though without the consolations of art. Around here freedom was a disease, an implacable condition foisted upon residents out of a broader social neglect, rather than something won or cherished. Nevertheless, it *was* freedom; from whatever it issued, and however much it was debased, it could never lose some hint of value, of possibility. This is what brought the people's patent distress, cultural as much as economic, some element of unity—these invisible whites, Latinos, and blacks—even if they spent much of their time at each other's throats. And it was really only from my drawings that this became apparent to me. A form of life emerged as my picture-making matured. It wasn't exactly ballet, as Jacobs had thought. More like MMA.

Equally clear, though, was how much I was still missing, particularly of my subjects' inner lives, which remained a blur, no matter the focus and empirical richness of the later pictures in my notebook. Or else, if not always quite a blur, in some subjects there was an imposed, false pathos, the kind one sees too often in Rockwell. In other drawings there was a simple blankness, no hint of an inside at all, just Cartesian fauna, black boxes of the heart. Frankly, I was pleased that my pictures at least brought this *lack* of sight to the surface: a sure sign of a well-functioning instrument. Only more study would let me see just what I was seeing.

I set the sketchbook down and surveyed the bar with an imperiousness I wouldn't dare in my own borough. This was enough to get the bartender back on his job, pouring my drink. The patrons here were nothing like those in my local drinking spots; nor were they even representative of their own borough of Queens. Long Island City was in fact home of Manhattanites in exile, urbanites who had migrated directly east, whereas most of their kind had headed farther south to Brooklyn. I glanced across the East River from this unfamiliar vantage, and before my eyes could meet midtown's phalanx of high-rises, the tallest of which were still under construction right around Central Park—as always, for the Chinese, the Russians, and the Arabs—my gaze struck the southern tip of that other island that was only just becoming properly visible to me: Roosevelt. It was in this region that Garrett had said he lived, not far from the crumbling slate-gray hospital grounds that dominated the topography. I'd

briefly looked into it since my first encounter from the tramway. Apparently it was now more or less a museum—an archeological site with heritage status—though what sort of people stop in at derelict hospitals on not-exactly-famous islands? You would need to have booked a rather long trip to New York to have time for it, or you'd have to have a medical bent, and perhaps some resident morbidity as well.

Two condominium complexes had been erected on the edge of the island. As if in deference to the defunct hospital, their tones were dimmer than one might have expected, tipping toward the same stoic shade of blue. Structurally they were wide rather than tall, mimicking their neighbor, though one wondered if the hospital had suffered some kind of collapse to have ended up this way. The condos had no need of height anyway: there was nothing to obstruct the view of Manhattan, which their residents would gaze upon with the longing common to refugees, although these were the economic kind. Like most of Long Island City's luxury accommodations, these towers had only recently been constructed, now that the pace of Brooklyn's growth had slowed and Queens was finally, grudgingly, being colonized. Probably the emigrants had even convinced themselves that Manhattan was actually better from a distance, that living within the city was akin to taking front row seats at the cinema: it burned your eyes and stiffened your neck. And while I still knew little about Garrett, I felt certain he wouldn't accept this sort of rationalization. Nor would he offer another. His concerns were bigger than his place in New York, which is only to say, whatever it is he might have been exiled from, it had to be greater than a mere city.

I'd seen Contra's white neon sign more than a few times before, dangling low over the bar's entrance; I nearly clipped my head on it as I came in. The lettering was unusually serifed—something transitional, a Baskerville knockoff—which cut against whatever vintage fussiness neon conjures. I'd only ever regarded the bar's signage in the evening, when it made sense for it to be illuminated, punching a hole in the thick industrial dark of Queens. This time, though, it was just past noon, yet the neon was still flaring. It must have never gone out.

I'd already stepped off the seven train at Vernon Boulevard when Karen called to say she'd be late meeting me. My trips to LIC always had a single purpose: to connect with Cosquer, generally at the collective's headquarters a few blocks from Contra. But her delay had given me the chance to visit this bar marked in my memory, not to mention scan through my work of the past week. My iced bourbon finally landed beside me with apologies. I downed it in one go: why shouldn't my form have been as poor as the barman's? Fashionable venues anyway tended to bring out the boor

in me. My eyes searched the room for someone to disassemble and reconstruct in the sketchbook's last blank pages, just where my Bronx pictures left off. Eventually I found a thirtyish woman sitting in the wide bay window, dressed in jeans and a wispy pink slub T-shirt, the everydayness of which offset the bits of jewelry subtly dotting her body. Her ears twinkled, just barely, with studs of false modesty: though the diamonds themselves were slight, they glowed with the purity of only the best stones. (Without at all trying, Karen and Claire had trained my eye for this sort of thing.) The woman's chest carried an abstract slither of a pendant in rose gold, and her hand sported both a single sapphire and what I would have called a wedding band, except that she wore it on her middle finger. Her sandals, which I could see just beneath the table, with their baroque yellow straps and exaggerated arches, were nothing that could really have been bred in Queens. They would have come in right along with the luxury towers now dominating Hunters Point and increasingly much of the territory stretching north up to Dutch Kills, which had once been a purely industrial land of metal reclamation centers and taxi garages.

A heavily bearded waiter who was jaunty all the same had just brought the woman sangria in a silver server. He poured the drink from a rising height, and in the shadows created by the puffy awning outside, the liquid looked almost black, or the color of burnt cherries, as it descended from the lip of the jug. Closer to the glass below, it turned rust-red as it fell into the field of sunlight reaching through the window, a light that also made the lime green tablecloth dazzle. The woman took up the glass, swept it out of this field; the drink turned near-black again by the time it reached her lips. Just before she drank, though, she tipped it slightly away from her, in an air-clink.

She wasn't alone: a girl at least a decade younger, with only water for a drink, sat across from her, in the corner where the window didn't reach, and hence in deeper shadow than even the drink. It had taken me a minute to see her, actually, the place was kept quite dark, and what I noticed first were her hands gesticulating over the table, cutting into the light. Although I couldn't make out her words, the younger one did most of the talking, while the sunlit woman mostly emoted: a soft sigh audible just beneath the clatter of cutlery; an eye roll that was anything but dismissive; a smile that appeared all at once, reaching its peak curvature instantly, with no intermediary stages; and a benevolent look that came over her now and then yet seemed to have nothing to do with anything going on around her.

Her midday freedom, I thought, differed in kind from the one found in the bars of my adopted neighborhood. It flowed from wealth, not poverty. Not unfathomable wealth, otherwise the flight from Manhattan wouldn't have been necessary, however nice the view might be from here. She could, of course, have had some

connection to the arts. It might have been worth something to her to live near MoMA PS1 and the slew of graffiti artists who continually repainted these streets. Yet whatever its precise extent and origin, her freedom had a quality of enforcedness, too. The money that fed it felt extrinsic. She wasn't the source. It flowed from higher country, from a spouse, or a former one; perhaps this was what displaced the wedding band. Or it was family money, and the girl sitting across from her might well have been a part of it. A not-quite-next generation. Their inner lives appeared easily within my reach, not as in the South Bronx, where they were only smudges or smears on the horizon, mere theoretical spaces that might variously be filled in. And this, I suppose, was simply down to what I was: a bourgeois. However unpleasant the thought, the distance between these two women and me was not very great in the end.

I turned the sketchbook sideways and brought the older one's face into view across two sheets, with quick, jabbing strokes, leaving the contours open and natural, before I got into the details with the finer hatching, little *x*s conjuring light and volume, trading the outline drawings of cartoons for the volumetric ambiguity of life itself. I kept at this right until the point she reconvened with the waiter and committed to more sangria (she didn't take much persuading). I got myself another drink, capped my pen, and studied the picture in progress before looking back at her. Though she was drinking more and listening less than someone genuinely happy in her own skin, she seemed already less foolish, or risible, or trivial, than I'd originally assumed, as a function of my own background: the intellectually minded artist examining the unrepentant bourgeoise. In fact, my picture, to which I returned my eyes, *showed* that she carried something more than mere vice, qualities I would have passed over if someone had asked me to put this woman into words. The image, though, effortlessly gave the lie to any such verbal reconstruction. That was a brute difference between the modalities of vision and speech. You could choose what you said, but rather less what you saw.

Examining her again in the flesh, I could see the care with which her nails and makeup were done; and it may only have been my depiction of her that was able to alert me to this quality. Not because I'd rendered it in terrific detail. I hadn't. Yet even in embryo, the drawing illuminated certain of her facets: the articulacy of her clasped hands, the delicate tilt of her head, the unforced expression, the gleaming heft of her hair, worn at just less than shoulder length. All of it pointed toward other facts of the same nature. Looking again at her, you could see, without too much contemplation, that all this was a mark of a certain sort of virtue, even if it sounded slightly ridiculous to say so of this particular woman. Partly this stemmed from her *not* being made-up in a way that smacked of the salon. There was always a fulsome sheen to that kind

of work, an overstatement of life and body. Hers was DIY work of the highest order, the nails finished in a discreet lavender, but with a thick, gel-like polish that gave them a plasticity and shape without undue gloss. Similarly, her face, which you could easily mistake for being free of cosmetics, participated in the most gentle illusionism, the sort that intensifies, by a degree or two, no more, what is already there in plain sight—the sharp cheeks, the whisper of a nose, the extravagant eyes that, I believe, had been left entirely alone—without introducing foreign elements or entering into the sweeping exaggerations, the almost masklike quality, that judging by any stroll down a Manhattan street, so many women, even the ones in Margiela dresses, believed was the essence of being made-up.

There was a sort of quiet bypass of the spectacle in this woman that you had to credit her with, even if it stood in a context that was less than saintly. It wasn't mere empty-headedness that she signaled with her unfocused gaze, as I'd thought on observing her exchange with the girl—before, that is, I'd actually been moved to compose my picture. I turned from her to the drawing and back again, ricocheting between my representation of her and *her* representation of her, studying her face in the light of my rendering, as if she were merely a sculpture assembled from my sketch, her neck touched by light and sky, and framed by those industrial buildings beyond the window. Her detached expression struck me as self-protective, a sign that if she were to peer at things any more closely—the blight she saw around her, as this neighborhood had scaled up in cost and people like her had arrived—well, it might hurt her heart.

Escapism didn't make her *good*, of course. But it did suggest she was *capable* of feeling. Why would escape be attractive otherwise? There was a life within her that wasn't dead yet; there were things she still couldn't bear to confront in the world. Whereas with many others I knew—well-educated others; they dominated the city now—they'd simply stopped averting their eyes. Not because they were artists who *had* to look, to do their job; not because they declined bad faith, whatever the difficulties incurred; not even because they were possessed of a compassion that demanded being in touch with others' pain, but simply because *they'd* stopped hurting. The sufferings of strangers no longer terrorized or unnerved them. Wasn't my dear Immo among this sort? Was he obviously superior to her, however much sharper he may have been?

That is what fifteen minutes of sketching gave me of this woman. We would never speak, she and I. But I'd had enough experience of rendering figures, even of people I barely knew, to know that dialogue, while it could certainly embroider my understanding, could never refute what manifested directly in appearances. They weren't inferences, I mean, the things I perceived, deductions from something outer

and visible to something inner and therefore only indirectly known. There was no ghost in this machine. It was possible for me, for anyone, to see the one in the other, without mediation.

Now, doubtless what I saw could be refuted. It was always possible to be wrong; it had to be so, if there was something called being right. But if anything was going to overturn my impressions, only *further* probing with the eyes, rendering with the hand, would identify it. You would be seeing, then, that you hadn't really seen—that you'd missed details that set the others in a fresh light—rather than discovering that what was available to vision was somehow insufficient, that appearances were *mere* appearances. No, I knew it to be true, not *a priori* but through the act of drawing itself: looking was primitive, unanalyzable, followed its own logic; it yielded a proprietary knowledge, one that couldn't be reduced to, nor made wholly answerable to, the deliverances of any other faculty of the mind. Any artist knows this, though only some know they do.

The kiss suddenly fell on my cheek, from above. Not the woman's—Karen's. I'd been lost in pictures, in the scene, the lines of force between me, the woman in the window, and my drawing. I looked not to Karen first but to my subject. Three drinks in, she was doubled over in her chair, groping the floor for her handbag, her face hovering just above her table, at the height of a now empty glass of sangria, while her young friend finally raised her glass of water after concluding a long soliloquy, looking more content than at any time while delivering it. "Shall we?" Karen's soft grayish eyes shone as she gestured to the door she'd come through that was still creeping shut, just before she finished off the last of my second drink, a scotch and soda turned to water now that the ice had melted. "Something came for you, actually," she said, flashing a half-smile, the smile she gave when she wasn't trying to, or didn't even want to—the kind she wore best. She headed back toward the door before I could reply. The woman I'd drawn went out just before Karen did. For a moment I imagined them speaking furtively outside, though I struggled to conceive of just what they would say to one another.

I settled up, and when I finished I found Karen back inside, waiting near the exit. Now she had sunglasses on, clear frames with bug-eyed mirror lenses. Together with the thick dark hair framing her face, the glasses masked her fine-boned features, ensuring that when you looked at her you invariably saw yourself; they played against her delicate build and almost congenital art-prep sense of dress: the pleated skirt, the tights, and the close-fitting top, all in remarkably deep greens.

Perhaps, I thought, she was back inside because it was too balmy out on the sidewalk; or I'd taken too long for her liking; or the woman really had delivered a piece of pernicious gossip. After all, as I came to meet her at the door, Karen *was*

staring intently at the young girl in the corner. At least I thought she was, though of course I couldn't see her eyes.

The street outside had warmed and brightened. The road was unusually broad for this neighborhood, which was crisscrossed by narrow avenues closer to alleys vexed by bits of dirt and the shrapnel of manufacture: plastic, rubber, wood. This silted air I associated more closely with Dutch Kills to the north—the direction in which we began to stroll—where those gusts of industrial detritus were strongest and you found something close to dust storms throwing about the residue of ethnic enclaves, mostly South American. I'd eaten a few times in the area. It was the only thing I'd done there, always at the request of the sort of people who considered it worthwhile crossing boroughs over food. The meals themselves had been compelling enough, especially the raw aggression of their flavors, which more august establishments tamed, assimilating them to the relatively muted palate of Europeans. But these forlorn environs, coupled with the picture, just across the East River, of the sun-dappled glass towers of Manhattan, coldly throwing Queens' own reflection back at the borough in the way Karen's mirrored sunglasses threw mine at me every time she looked over and smiled more fully now, for no discernible reason, tended to compromise those meals for me. Every star needs its dark partner, I suppose.

A sharp breeze threw grit in our faces. I shielded myself with my hands when it was strongest, turning my head away from the wind. Walking close beside her, I could see the furrows at Karen's temple and narrowed eye beyond it as she squinted behind her sunglasses, dust filtering in the sides, with an expression that was almost wicked. We made our way past taxi depots and warehouses teeming with delivery trucks and uniformed men to Cosquer's ghetto-chic offices, which were adjacent to Karen's own personal studio. All of this I associated, correctly, I think, with the general maintenance of Manhattan. Across the midtown tunnel and the Queensboro bridge was where most of these people traveled each day, and it was only their shine boxes that kept Manhattan glowing, head to toe, as it was right now, in broad daylight—hurting my eyes. To the north, in Astoria, the particle-borne abjection would have dissipated, but here in the south, in Long Island City, you could still feel it, notwithstanding the luxury condominiums that had materialized these last few years and glittered now in a kind of mimicry of the city across the river. But imitation only reinforced the gulf between the two locales, particularly with that giant neon-red Pepsi sign fronting those condos. It signaled retail commerce, finance in its most modest form, and even then with a product that was only second-best.

For a few minutes Karen and I didn't speak; we just winced our way north, until eventually we turned down a side street and the wind vanished, so we could stop furrowing our brows. Along with the usual spray-can tags along the brick

walls, frequently at heights that made you wonder about the circumstances of their creation, there were two bona fide murals here, executed, like the rest, in the medium of aerosol paint, on opposite sides of the road. They must have been done in just the last month or two, since my most recent visit to Cosquer. Karen paid them no mind. She'd seen them too many times by now. Graffiti art had become so ensconced in LIC it no longer sparked even a hint of protest from anyone. It was implicitly state-sponsored at this point, which took away much of its barbarous charm. Yet now that I was playing at my own mural, I was more alert to the presence of others in the streets. I would mine them for their secrets, wherever I passed them. So I held both of us up, letting my eyes shoot back and forth across the street. On one side was a mouse that looked to be a cousin of Mickey's. He pivoted away from us out of discretion, for in his famously four-fingered hands was a sizable bong on which he pulled with a wink. On the other side of the street was this same mouse, his eyes twinkling but half-closed, diving into an above-ground pool. Although I say diving, he seemed to be hovering above it, like that woman's head had hovered above the table in the bar. On looking more closely I could see that his body carried a faint upward thrust, as if, instead of falling into a poor man's pool, he might well be taking flight into a sea of blue: the blue of the upper portions of the wall, and then, even higher up, the purer, grander blue of the sky.

The metal door to Cosquer's offices lay just beyond the diving board. Perfect brown circles marked it in such a geometrically regular way—long rows and columns—they could have been mistaken for stencil work. In fact each dot was a tiny rivet, rusted without being rust colored. It was the kind of aestheticized rot that people who enjoyed generally better conditions in their daily life found not only inoffensive but positively *interesting*, when in truth it was a prime index of the degradation and neglect facing the people who'd worked and lived here before, out of simple necessity.

Earlier, the dust blowing around had made us keep our mouths closed. Yet even after the wind had gone, we kept them shut. There wasn't anything odd about this. Between me and Karen, it signified nothing. Or perhaps just one thing: how we'd first known, back in college, that we would end up comrades in some way, this heavy silence in which we could wrap ourselves with ease, in a place where people loved to talk and talk. The quiet was inhabitable for us, a refuge, as it is by the end of the *Tractatus*—something to be sought out, most of all among one's peers.

Inside the door, which swung open with a prolonged squeak, there were, quickly, five more doors, built from the same gray metal and tiny rivets, but this time free of rust. Two of these doors stood to our left, with another two on the right. One was Karen's. Two belonged to other members of Cosquer: John and Lindy. The fourth

had once been Rick's, though he'd since moved his studio closer to his residence. Now it belonged to Brady, a man who didn't look much like an artist, or anyway not one of this generation. Often he arrived in a suit and tie, entirely without brushes or other paraphernalia. Karen had said his studio was mostly bereft of artistic tools; it was more like a small library. All anyone could say for sure about him was that he was older and evidently conceptual in his approach—if he had an approach at all, and wasn't actually an imposter.

When Brady was in, he could usually be found with the door flung open, sitting on a blocky sofa not far inside with his fingers on his forehead, studying the thick, austerely bound volumes of a very large set, possibly legal or encyclopedic in nature. No one had seen him make or perform anything, supposing "making" and "performing" weren't too passé for him. And since he had no pen or pad in his hands for notes of any kind, we could only wonder what he was looking for in these books, where he was going artistically. He didn't talk much when anyone drew near to his door, and the few things he said mostly concerned the weather or subway delays, not the books that filled the space, nor what he was doing here exactly; certainly he had no questions for anyone else, and his manner didn't encourage free exchange. What was clear was that he very much liked to remain in sight of anyone exiting or entering the building. Whole issues of the magazine had been closed with him sitting there in contemplative repose through the early morning hours, reading or just mulling with a tight and thoughtful squint, always avoiding all eye contact with the editors and designers scrambling to finish.

In the last few weeks Karen and the others had begun to wonder whether Brady's project was a kind of artworld analogue of the Sokal affair, and he was simply waiting to see how long it took the artists working around him to realize he *was* just a lawyer using the space as a reading den. But they were fearful of saying anything. If it wasn't true, who could say what sort of offense a man this curious would take? He might have been patiently awaiting a conceptual breakthrough none of us would be able to fathom.

Today, his door was firmly closed. Directly in front of me, a set of double doors led on to the fifth and largest room: Cosquer's headquarters, which was nearly the size of the four studios combined. The doors were already open; Karen had stopped in before coming to find me. Toward the back of the open plan space, leaning against a printing press I didn't recognize, one they hadn't yet finished restoring, apparently, stood a poster-sized version of the album cover I'd drawn. It startled me, to see it in this way, at this scale. Perhaps Karen had wanted to gauge my reaction to its newest embodiment. Printed in cherry red on a mottled cream stock that had the look, as I suppose she knew, of my preferred support, vellum, it was also lettered by hand with

Joy Division, superimposed in a darker red, closer to the red of the sangria of the woman in the bar, just along the bottom, in a script redolent of teardrops, evidently a hybrid of blackletter and Antiqua.

"It's an offset," Karen said pre-emptively. "I did the lettering myself, just as a trial."

I looked at it for a while, probing for problems, especially in those letters. I found none.

"Yeah," I said.

She raised her eyebrows and turned from me, toward the drawing. "But the color?" She faced me again; her mien had softened.

"It looks okay to me."

Mild words could count as significant praise between us, particularly when it came to the assessment of work. She warmed. I could feel her satisfaction.

"You're pretty much the only one whose sketches end up almost-finals," she said. "I think they like it as-is. We should still tinker, though, in case."

"And what do *you* think of it?" This was my overture toward a greater openness between us. I often felt Karen preferred a more distant attitude from me, especially lately, after what had happened between me and Claire, her best friend. But there was more to it than this, something more general about my person, which, when exposed, could—what's the word? She wasn't the only one to think that I was best left weakly grasped. It might have been the signal difficulty of my life.

She laughed and planted her nails in my forearm, and not so gently. "Does the fine artist care?"

I shook her off and examined the claw marks.

"Oh, don't pretend it hurt."

I strode through the office toward the print. I liked to take in pictures from many vantages. I didn't believe in ideal viewing distances or entirely fixed points of view, whatever an artist's aims in constructing them. There was a lot to be gained from examining a picture from too close, to see the whole of it clearly. The intensity of color, for instance. I drew back from the picture and considered how well the rich red Karen had chosen counterbalanced the evanescence written into all the ghostly erasures and uncertain linework of that English garage.

"As if I would have sent it to the band's management, if I didn't think there was something here." This was probably as far as Karen would go.

"Something."

"It's good," she said, almost curtly. "And fuck you, okay?"

I flicked the poster with a heavy thud and delivered a vague smile.

"It doesn't mean you couldn't see, I don't know, how cleaning up the contours here with the shelved items might help. What is this, a paint can?" She was pointing

at something in the print but I'd already moved on, my gaze drifting up toward the high-set windows, the office's signal feature.

"It could, yeah." I was in a concessive mood now. I'd gotten what I'd wanted.

"And I'm thinking about whether the lettering I've done is too playful for this particular band."

"Have you ever actually listened to them, Karen?"

She scowled.

"Black Flag, then?" Whenever I thought about album covers, I couldn't help but think of Pettibon's designs. "The Misfits?" How nice it would have been to do something for Danzig now. "Anyway, it's not that playful."

Karen's frown lifted slightly.

"Maybe for a type designer," she said. "Not really for, well, normal people."

"People like you?" She squinted her eyes at the drawing, though not quite as tightly as she had in the dusty wind, and nodded slowly, weighing up the picture, the point about playfulness, and the compliment all at once. Then she seemed to clear it all away—I'd no sense of what she'd concluded on any of those scores—and gripped my arm more gently this time: "Thirsty at all?"

"Weren't we just at—"

"There's no way they have *this*, though." She held out her index finger, the nail a deep orange, pointing at something behind me.

Bottles stretched across a narrow pine table just inside the double doors, all of them molded from thick glass. Eight of the same size, perhaps twelve-ouncers, carried a blue-green tint. Beside them was a single taller bottle, stopped with a cork and shaped like a Chinese vase, filled with what looked like water struck by sun, even though the four columns of light descending from those large windows didn't actually meet it. Nothing had a label.

I turned back to Karen.

"All from your Garrett," she said, as if deflecting responsibility.

These were the things he'd described to me at his offices. We'd come to no agreement as such, but here it was: a whiskey, what was it, of wheat? And then... some sort of next-gen energy drink, if I'd understood Garrett correctly.

She steered me toward the bottles, away from the Joy Division print. "I was going to talk to you about a *lot* of things today, things you might like working on, stuff we could use you for. But then this came in the morning." She lifted up the large vase of a bottle, held it with precisely the delicacy one might use with an ancient artifact only recently recovered. Below on the table was a long blue envelope. "Open it."

"Looks like you already have." The edges were torn.

"It was addressed to me."

Instead of picking up the envelope—she could tell me about its contents when she was ready—I took the whiskey from her hand. I rotated it at an angle, watching the golden syrup reach up to the stopper as I tilted it further back, until it was nearly flat.

"And there's a check already." She picked up the letter herself with one hand, tapped it on its edge against the table. "Just for *thinking* about it."

"I met with him," I said, still gazing at the bottle, or through it.

"He mentions that. He's just so vague about what he wants." She tapped the note again, though less insistently, and left it closed.

"He was vague with me, too." Finally I set the whiskey down and picked up the envelope. "Not necessarily a bad thing, right?" I nodded toward the blown-up album cover.

"All that freedom, I guess."

"It could be a nice account."

"For you especially. He's really taken with your work, isn't he?"

"That's what it sounds like."

"I think he wants us—you—to figure out what to do with this stuff."

"Like... a logo? Or what?"

"Probably." She waved at the letter in my hand. "That's me guessing, though. He wants you just to play around for now, is what it says."

"Sample it."

"And see what comes to mind, yeah." She rocked the bottle's stopper back and forth and coyly asked, "Want to try it now?"

I was always charmed by her glee, the way she could go from being so poised and formidable—she didn't lack for self-belief—to something in the vicinity of girlish. I suppose she felt she could allow herself this luxury, and that's exactly how she treated it: a frill to be indulged sparingly, in the right company, but only because she knew she had the claws to make you pay. The more brilliant you were—this was just a truth of the metropolis, its logic—the more you could take liberties and license. The most fearsome gesture you could make was to throw your shield to the floor. I can't say I didn't employ the same tactic from time to time. We were kin in this respect.

"I've had too much already," I said, though I was a little sorry to disappoint the girl, now that she'd shown herself. "I won't know what I'm drinking, really."

"Then what about the other one? What is it, a 'smart' drink or something?" She wrapped her hands around the necks of two of the smaller bottles as if she might hurl them like Molotov cocktails.

Smart drink sounded fine to me, though she must have known that no one used that term anymore. *Nootropic* was the favored word for a cognitive enhancer. But was that even what this was? The liquid's origins at Arête made it a sports drink, even

though Garrett did say he had hopes its use would spread far beyond athletic circles. Still, if it was meant to help ballplayers in the first instance, wouldn't its effects need to be more bodily than mental? Or was I underestimating the cerebral aspect of sports?

As for sampling it right now, though, I could only shake my head. The moment I did, the two bottles came crashing together like cymbals; I thought they might shatter. Karen's face briefly reddened with anger and annoyance, obviously, but also embarrassment. She herself was surprised by the force she'd applied, I think, and hadn't meant to make quite that impression. She set the bottles down quietly yet appeared no less upset; my recalcitrance, it seemed, had driven her to make a scene, which cost her any leverage with me in persuading me to drink. I just *had* to make things difficult, she would have thought.

In fact my reasoning was simple and sure. I wanted to explore both drinks first in solitude, my habitual testing ground; there'd be time to sample them with her later. Really she should be pleased, I thought, that I was taking an assignment with a modicum of seriousness, to want to explore it. But before I could convey any of this to her, she lit up with a different idea.

"John's here, though! Isn't he?"

I shrugged.

"I think his door had a light on under it. *He'll* try these with me." She left to get him, carrying two of the bluish bottles with her.

I was still holding the envelope. I plucked the letter from it and the check fell out, sweeping through the air in descending arcs until it settled at my feet. It was hard to think of the note, though, after crouching down and seeing the size of the number scrawled across the check. Sadly, but not unjustly, it was made out to Cosquer, not to me, so I snatched it up and left it on the large desk against the wall in the corner. Karen's. It had been a long time since I'd been alone in here, just me among these great heaps of machinery. They'd stood out to me the very first time I'd visited, when Karen showed off the new space to Claire and me—back when the two of us had been deepest in love. Naturally we had other things on our mind; just before Karen's tour, I'd touched Claire in the industrial unisex bathroom, her little yelps reverberating around us and possibly beyond, I didn't know or care then. Now there were new machines. There were always new ones. Nothing ever seemed to disappear; a fresh use could be found for anything. The place was always becoming.

The device that had been there from the start, on that first day, and indeed, amidst all the other encroachments, continued to dominate the room, if only barely, like a fading superpower, was the vintage letterpress Cosquer had acquired from another studio. Sitting right at the center of those four corridors of light, it managed,

improbably, to reside entirely in shadow. The press was finished in flaking yellow paint, and it remained Cosquer's prized possession. It functioned with just the range of variation one wanted in an analog instrument: enough to mark each print as an unrepeatable original, allowing its mechanical capacities to preserve rather than dispel auras; but not so much as to damage the sense of uniformity and precision of the letterforms. One couldn't escape the feeling that each image it produced, though it may have been an original in some sense, was, in another, entirely universal, as the Purists and Suprematists would have it, and therefore part of a broader reproductive system that only increased its power. To both confer and not confer an aura was the feat a device like this accomplished. No one knew exactly how to replicate its effects on any other machine, even a structurally identical machine from the same manufacturer, which meant that the very same aura that hung over the prints attended the press itself. This one had never been restored, and in a sense it couldn't be, not without shattering its distinctive qualities. It had come with John, as I recall, in a sort of package deal, as he'd joined Cosquer from another shop that was disintegrating, the usual fate in the design business and not necessarily an inglorious one.

Since there was still no sign of Karen, I wandered deeper into the undivided space, toward the group's intaglio press, which bathed in the light falling just beyond the letterpress. Its giant rolling wheel seemed to belong to some ancient whaling vessel. It was used for reproducing the engravings and etchings we produced in small batches, and some of us used it for our personal projects, too. I myself never gained much facility with any of the presses, which is why I hesitate to include myself in Cosquer properly: all the core members knew how to use these sorts of things. The rest of us, the illustrators and photographers and copywriters, occupied a peripheral space, though Karen and Rick would dismiss that idea whenever I brought it up.

The light stretched toward the opposite side of the office, which was windowless and lined with state-of-the-art digital printers; despite naming the collective after an underground cave of ancient paintings, no one here was hostile to the latest technologies. Nearby a small sealed room housed the photographic equipment needed to prepare the various plates: relief, intaglio, lithographic. The litho press, actually—one of the newer additions, which Karen would have used for my album cover—was tucked away in the back, in the murk, and was itself close to a work of sculpture. I'd not bothered to turn on the lights, so that, to appreciate it now, I could only run my hands over those clean edges and decisive slopes of metal, far from the usual collection of cubic forms common to modern versions. I had used it previously to make a number of prints of my own work. Or, rather, I'd had someone use it under my direction—Karen, mostly, but sometimes also Claire, late at night, when the two of us had the studio to ourselves, between other activities I

could once tempt her into. I leaned against the machine, tucked myself into it as if playing hide and seek.

These days the magazine's printing was outsourced, though its design was done from here, mostly from this office and the adjacent studios. Oversize proofs from the most recent issue, marked up in sharpie, some replete with the proprietary logographs of copyeditors, sat in unruly piles on nearly all the white wooden desks, their pages spilling onto the floor. The very tallest stack, naturally, sat on Karen's desk, as she gave everything the final read and signed off on last-minute changes.

I made my way back to her desk, where I'd placed the check on the pages. My own proof was the one on top. This was my main editorial contribution to the magazine: showing up to mark proofs just as production was closing on the latest issue. Karen liked it, and nearly always insisted I come. That was about the only time anyone could reliably find me here, and indeed, these days it gave me an excuse to see people in an ambient sort of way, without having to talk, only work, whenever my droning television set seemed too slight a source of human nourishment. I suppose this means that however peripheral I fancied myself, my output *did* occupy a significant portion of the pages of the magazine over its four-year history, particularly at the start. In the very first issues I was even listed as one of two senior editors, although these days I held that most nebulous of titles without official responsibilities: editor-at-large.

I sat at Karen's desk and put my feet up, right next to the proofs, where she would never have put her own, and I looked back at the bottles near the doorway, arranged like a brigade, the golden general towering on horseback above his sapphire men. Voices began to reach me from the vestibule, John's and Karen's, and two or three others as well. Soon they'd arrive in person and spoil my tranquility, which I'd found in combing through the recent past under the mellow influence of alcohol from my time at the bar. So I closed my eyes, awaited the inevitable end, and considered, in the time left to me, just what we'd all achieved here, together, in this room.

In the *very* early days, before there were any actual plans for a magazine, I'd had a conceptual influence on *Cosquer*. Shortly after college, there'd been many discussions among our group about the sort of artistic progress that refused to sever or mask its connection with the hand, that insisted on it in the face of digital technologies—but, and this was crucial to all of us, *without* stooping to unredeemed irregularities and eccentricities or the one-note trumpeting of illegibility that poisoned the eighties and nineties, whether it was Chantry or Carson or Brody or Glaser. Even more obviously, there could be no truck with nostalgia and empty relativities.

This is how *Cosquer's* editorial ethos was forged: a precise, careful grounding in the analog that avoided every ideological pitfall we could think of. So, on the one

hand, the magazine had no website; on the other, its appearance could not have less resembled a DIY production, given just how crisply constructed it was, in both the *what* and the *how* of it. That's why we could give prominence to certain kinds of painting and drawing over photography without any spurious anti-technological stance. What did it mean, after all, to be against technology *per se*? A life without fire, and not just metaphorically? A life without wheels? A life, indeed, without language, one of our earliest technologies? No, the question was rather which technologies you picked, and how exactly you chose to deploy them. That was still true. What did you choose to *burn*?

Our criterion was simple, and general, and probably impossible to apply definitively. Nothing, anyway, was let into the magazine that anesthetized the mind, or distanced us from the world, which is to say, ourselves. It just so happened, really, that these were the common ailments of so much that was mechanically produced. In the beginning, it had been hoped that just the opposite might result. Malevich, Rodchenko, Marinetti, all of them. Avoiding anesthesia: this is what made our issues so short. Readers assumed the brevity stemmed from design and deliberation, but no. It was, in the beginning, simply a matter of not being able to find enough art that could avoid Scylla and Charybdis.

In the first years, my art featured nearly continuously in *Cosquer*, every couple of months or so. Sometimes it was just a quarter-page painting, sometimes only sketches for work I'd yet to execute in a more finished form. A bit later on, as the magazine began to contemplate advertisements to sustain itself, and indeed began to grow in length—Karen had started the operation out of her own deep pockets, but to keep things running depended on the largesse of printers who were actually family and fellow artists—we, or really I, started to construct advertisements for brands that didn't exist. First came a logotype for Perilex—what it was exactly didn't matter; perhaps some sort of drug and probably a dangerous one by the sound of it—followed by The Avocado, a vast emporium dedicated to the sale of the many varieties of the fruit, and then, of course, Prophets, water-walkers for weekend hire.

These were trial runs, provisional answers to the question of what our pages might look like when intercut with ads. With enough ingenuity, we wondered, could we prevent ads from damaging the magazine? Might they even enhance it? The experiment served the marketers, too, letting them see how well their products could be laced through an issue of *Cosquer*. I, naturally, had no thought of making the magazine financially sustainable, even if I had contributed a few dollars here and there, and more than that, offered my work for free to Karen. Making mock advertisements remained strictly an artistic and social investigation for me, driven mostly by the pleasure of toying with *Cosquer*'s growing commercial audience.

Since the spots were fake, they didn't have to resemble legitimate examples of the form—the sort intended to *increase* sales—but, then, they couldn't be of an entirely different order, either. There were useful limits here, a vocabulary, a grammar, just as there was in painting or in poetry, that had to be respected if you were to be understood at all. Still, I was free to summon associations no modern advertiser would or could want these days: historical allusions, things like the Gold Bond Twins (the company, still going strong, long ago dropped the black babies as their mascot) or Aunt Jemima, or those colonial-era propaganda posters, in bright yellows and reds with the flattened, sketchy figures mostly in outline, like cartoons, illustrating how the European colonies throughout Africa and Asia, while yielding profits for the motherland, also *civilized the natives*. And they, too—the natives—were products of a sort: glossy, shiny, far more valuable than the raw material used in their construction, just as fine furniture was so much more precious than imported timber. I did a whole series of these ads for *Cosquer*, actually, using the same colonial visual palette, but in slightly less malignant ways: pitching realty firms, winter coats, and free-range frankfurters.

Given my interests, these pictures were more art than commerce, selling their hypothetical goods and services in the softest ways. So it remained unclear whether *effective* ads, the kind someone would actually pay to place, could ever mesh with the magazine's prickly contents. Until, that is, forward-thinking marketers started calling, not only inquiring about placing ads with us, but commissioning us to design them precisely in the manner of our fakes. We were a little stunned, and I might have been disappointed, too, though I shouldn't have been: it would be some time before I understood what sales ultimately depended on.

The creation of this original batch of ads inaugurated the unitalicized version of Cosquer, the design studio, that is. The first pieces appeared only in our pages, of course, but it wasn't long before selected art publications and the more adventurous zones of the commercial sphere started to solicit our talents, particularly John's, as I myself lost interest in the project almost as soon as the ads were built around real companies rather than the creatures of my imagination. In the last year or so, my own artwork had featured less and less in the magazine because, frankly, I was making less and less of it, of any kind. But as my output dwindled, Karen and Rick had taken to consulting me about the overall look of the magazine, which had been decisively re-inflected by the creation of those pseudo-ads. I was inexpert in matters of typography, but Karen thought my general compositional instincts would transpose well enough for me to help with the magazine's redesign. We'd started, for instance, on my recommendation, if you can call it that, with the inclusion of a quite complex table of contents. It was turning out to be about a quarter of the book now, with

lengthy exegeses and annotations of the subheads, mini-essays that sometimes made you think it might not be necessary to read the actual text of our features. Karen would allow editors to undercut each other in this way. The sort of reader who'd be flummoxed or turned off by our free play—well, we didn't have many of those.

Perhaps my greatest influence on *Cosquer* now came at the proof stage. I would show up late at night and invariably find the others working in profound silence, which always struck me as odd for such a collaborative endeavor, but gratifying all the same. I'd come in and sit at my desk, right next to that airtight prep chamber, and, using a set of colored pencils, begin to carve up the proofs that would be lying there waiting for me. My marks were primitive and free-form, unlike those of the others, who had, over time, internalized Chicago's guidelines for these things, with selected aberrations adapted to the particularities of the magazine. Together they'd built a common language, and all I could understand of it was the delete sign (that little bow) and the carrots of insertion (those little birds). But my marks? Anyone could decipher them. They came from a place of ignorance, which gave them a certain universality. No symbols to be decoded at all, really, just distinctly inelegant pencil lines yoked around anything that seemed off, leashed to a suggested fix in the margins. Other times I could be far harder to parse, especially when I was singling out things that weren't strictly mistakes. I might just offer a cryptic assertion between the lines, or a philosophical question that would prove unanswerable in the context of closing a magazine. Generally I provided no alternative in these cases. On some occasions I would do without words and simply circle things—portions of images, the rules used on a page, the column width—or cut up words into their constituent letters with slashes; or else bracket items into unfamiliar groupings. Often, it was unclear what exactly I'd meant to point out—even to me. My edits, in these cases, could only signify, on the most general level, something like *Sure about this?*—where even the referent of *this* was ambiguous. Was I trying to draw attention to the heaviness of the rule, or its length? The kerning of a word, or its tracking? I was merely following an impulse to mark, probably, with results that someone else would have to decipher later on, or conclude were more or less meaningless—the fruit of an errant instinct.

I suppose I meant only to raise eyebrows, Karen's in particular, to see if she saw both a problem and a solution. When I'd first begun proofing, I was sure she'd be annoyed by the vagueness of my approach. And maybe she had been. But she took to it soon enough, and eventually insisted that I mark up the proofs at the close of every issue. This routine had brought us closer than we'd been at any time after art school, those years of stymied flirtations, though there was, of course, the complication of Claire.

And so, these days, looking through the magazine, I'd find that some change or other had been made to most of the things I'd flagged, although often enough something different from what I'd inchoately had in mind. Finding out how Karen had responded to my undefined doubts became one of the central pleasures I took in going through finished copies.

Laughter startled me from my thoughts. It was fast replacing the talking I'd been hearing in the distance. I stood up and tentatively approached the doors, which were flanked on one side, opposite the table laden with Garrett's bottles, by a drawing board. Clipped to it was an ethereal silverpoint on wove paper, one of Karen's. She herself had produced the last cover of the magazine like this, a delicate abstract with what seemed like thousands of strokes, which made me think of iron filings being torqued by a magnet held out of frame or behind the picture. This one, on the board, was figurative, though it was so unfinished—barely begun, in fact—that I couldn't be certain even of that.

I swiveled about in the light, still tipsy from the bartender's heavy pours and my empty stomach. I could hear nothing now, no laughter, no voices. Maybe they'd all left with Brady, shared the nootropic between them and lost interest in design once the beverage had taken effect. I continued to turn slowly, surveying the space, its total effect. There was markedly less paint and ink splattered about this studio than most. This was Karen's doing. She didn't like things going to hell, nor did she indulge certain eighteenth-century fantasies about the artist's temperament, the organic state of filth in which he must operate to thrive—fantasies of a bent that I did occasionally toy with, in an *ad hoc* way, or sheepishly reach for when feeling in need of some explanation for the unshapeliness of my life. For Karen, a magazine's being produced here, the precision and teamwork involved in the process, simply wasn't compatible with a space that had fallen under the sway of waywardness, even if—or, more likely, *because*—some of Cosquer's members' chosen means of printmaking were given to chaos, and not always experimentally.

Whatever chaos there was concentrated itself in the far-right corner of the office, just beyond the workstations. John's corner. He couldn't be expected to abide Karen's prerogatives, and silk-screening, which occupied this part of the space, was mostly his domain. No one among us did better work in the form. John's talent, insouciant though he was, earned him a pass, as it always had, as did client demand for his peculiarly slanted style. Dirty screens abounded in loose stacks, seeming always on the cusp of avalanching into nearby territories. Intense streaks and splatters of color from the rollers stained the gray floors, but that was only one source of the bright mess in his corner. He liked to touch up and deface his silkscreens by hand, as evidenced by

the many easel and palette knives and tubes of acrylic and oil paint, not to mention the squares of sandpaper and bottles of paint thinner. I couldn't help but smile a little at this corruption of Karen's ideal.

"So I guess now you want to screen something," a voice boomed from behind me. I turned back sharply and there he was, standing in the doorway.

7

John approached me carrying not the sports drink but the bottle of whiskey, uncorking it with a muffled pop and handing the stopper to Karen, who began squeezing it steadily like a stress-relief toy. Unusually, John was clear of paint, and in fact free of color altogether, just crisp black trousers (wool, by the looks of it) and an exceedingly cheap white T-shirt riven with grainy, grayish striations, as if to make some sort of point by way of the disjunction. From his neatness, I knew that today was one of his thinking days, as he liked to call them. He might, I thought, get along after all with Brady, for whom every day was just so. A day for strategy—that would be another way to put it. I can't exactly say that John was a friend of mine anymore, not without elaborate qualification. He was certainly a *figure* in my life, though, and I in his. He was the first person in college I came to respect, even before Karen—indeed, the first I came to admire, and perhaps to envy, if I permitted myself that feeling. So many other artists, then and now, seemed to me not worth attending to very seriously; there was nothing to be had from such scrutiny. But John, who tended to induce a mild and not infrequently agreeable state of confoundment in those who fell into his orbit, seemed always worth the trouble (and he could be plenty). Not that you got progressively closer to him over time, necessarily, or came to some firmer, even approbative sense of his compass. But you couldn't say you didn't get anything out of the looking. There is an instinct in all of us, I think, to sift out such people from the rest when entering social milieus, for the value we implicitly know them to carry, which we may wring simply by *involving* ourselves—whatever we finally think of them. John and I quickly figured each other to be just this sort of person. It was a kinship that brought us together swiftly and naturally; it also prevented us from remaining close for long.

"I was just looking your silkscreens over," I said.

"The mess." He rushed past me, deeper into the space, as if he were merely talking to me on the phone, bottle still in hand. His gait had a deliberate urgency to it, and he made his eyes slightly wild, as distinct from their being made wild by circumstances. Always the actor. His gifts, it had to be said, were the least assailable of anyone's in our year, even my own. He was an out-and-out prodigy, really, with the tightest grip on light that I'd seen then or since: Titian to my Raphael, he liked to joke. I'd never seen even a quick watercolor or pastel of his that faltered tonally, and it wasn't uncommon for him to work just two or three colors together—a few sticks of chalk, that's all it came down to—with such casual grace that you imagined

you were seeing more than a dozen. Even in his prints, the format he concentrated on these days, the way he welded tones together could startle you, no matter that the lineation of the print was routine. As for his compositional sense, he seemed to find, time and again, unconventional pathways for the eye which nevertheless remained convincing. And then his brushwork: his strokes carried a preternatural decisiveness, even when they only amounted to vague dabs, or when they were so finely applied they seemed to paint themselves out of existence.

John went straight for the clean-up sink adjoining his masses of silkscreens and scratchboards (a slightly newer medium, for him—but even in black and white, he was proving himself effective) while Karen followed behind him. He flipped over three of the cheap little glasses that he used to clean his brushes. He'd discovered this secondary function for them, as makeshift tumblers, during the regular gatherings he'd introduced to Cosquer headquarters, somewhat against Karen's wishes, and often when she wasn't around. Lately he enjoyed toggling between the glasses' functions with only a careless rinse, whenever we needed to reinvigorate ourselves after a day of unprofitable work. You could taste the thinner in them then, but we were usually too weary to protest. I could see flecks of paint clinging to three of the glasses now as John set them onto the rolling side-table, one after the other, each one landing with a tiny thud.

"But not too much," Karen said. "It's really for him." She was gesturing indistinctly at me with a fist that had closed around the cork. John brandished the bottle with two hands, hovering over the dirty vessels, his knees and elbows bent like an athlete's. An aggressive mirth radiated from him; any demurral from me might make him flood the glasses, if that's the way it had to be.

He was decisive, shall we say. We were used to this. Only a semester or two of art school had passed before he'd drawn conclusions and settled on a representational direction: total abstraction was "frictionless" (I got that word from him). He liked to say this especially to abstractionists like Rick, who became our common scapegoat. He and Lindy both. But John's mimetic bent—here was the rub—was of a studiously inhuman variety, as in non-human, or human only by careful and complex abduction. He redacted the purposive aspect from each depicted thing, an engine, a bullhorn, a chain-link fence, the way Diderot's *Encyclopédie* did in its own manner, each of its diagrammatic pages isolating objects of interest from their broader context and finally exploding them into their components, all in the name of understanding. Much of John's work from school formed a sort of addendum to that book, except that his images—not multi-stage diagrams or illustrations but fully rendered paintings—operated in reverse, so that they suggested not how artifacts and objects could be made intelligible by their place in human life or the world at large, but how we

could understand ourselves through *our* place in the lives of objects, or technologies, the way each generation molded itself from the materials and inventions provided by the last one. He was blasé about the decades-long resurgence of figuration and narrative in painting. This was merely an "unproductive retaliation," he would tell me while we worked side-by-side in our third year, in adjoining open-plan studio spaces in a converted parking garage not far from the apartment we shared. I relished those times, even now. The presence of other artists generally diminished my capacity to work; often I found it impossible to proceed, and when I managed to get something done, the results could be timid. John, though, was never a dissipating force. The manner in which he worked on a canvas or a print somehow managed to be both reckless and fastidious; every glimpse I caught of him at work re-established in my mind the possibility of this combination. It propelled me, seeing that.

"Is it really just for him?" John asked, throwing a glance my way.

"Not *just*," said Karen.

"So then!" As he laughed, his brown curls, just short of unruly, bounced around his bearded face. He was pouring the third slug before Karen could tell him I wasn't having any.

"I don't believe that," he said, looking up at me and raising his eyebrows improbably high.

I nodded ruefully to confirm his fears. He froze for a moment, and not for effect. The whiskey ran halfway up the tumbler before his face dropped and his hair came down like a plush curtain. He'd been so much more clean-cut in school, with none of the beard or lazy curls about him. But after graduation he'd gone abroad, to Ningxia and Outer Mongolia, rough-and-tumble places in keeping with his "frontier" childhood in Rapid City, studying forms of art he'd only scratched the surface of in our classes. Twenty months later he came back to the States with a lot more hair and Constructivist leanings, not of the International variety, when the spirit of the movement had died and all that was left was a form, a style, but something closer to Malevich's and Rodchenko's original sense of it. Suprematism. Is this what exposure to Communism, even the bastardized form it took in modern China, inevitably produced?

The human body finally began appearing in his work. But by this point, he'd lost whatever interest he'd had in being a gallery artist. (You could say I was only following his lead out of the museums; he'd been the pioneer.) Which meant that the figures in his canvases were going to be public figures, the kind that sat on billboards and transit posters and magazine pages. Figures of consumption.

"Well, then, we'll just have to make do," John continued with an air of pragmatism. Still holding the whiskey bottle in one hand—he seemed unwilling to separate

from it, even for a moment—he gulped down a finger of whiskey from the first glass and slapped the empty tumbler on the side-table, which sent it rolling into Karen's hip. The dram didn't make him flinch, not even a tiny bit, no tensing of the mouth or cheeks at all, which was curious for a whiskey of any proof. It also showed the slamming of the tumbler to be mere theater, not an expression of any sort of distress. He was, always and still, an *awareness* artist, even when he wasn't making art. What I mean is that he was always *sending a message*. There were particular notions he wanted to project in any exchange and any artwork. Things he wanted you to *know*, or at least questions he wanted you to ask: a state of being that his work, or simply his behavior, as now, implored you to inhabit. He needed to change your mind; that was the whole point.

"*Why* do you have to drink it like that?" Karen pushed the table away from her. "What are you going to find out about it that way?" How quickly her voice could relapse into the chiding tones of the exceptionally well-off. I heard her aunts and her mother in her now. I heard all of Claire's relations, too, and everyone else in the city brought up far above the fray, who therefore couldn't help but register small breaches that the rest of us either never noticed to begin with, or more typically had long ago accepted as par for the course. Something in them instinctively resisted.

John skipped over her question and went straight to the verdict: "Phenomenal." He was going to make this declaration, this decree, almost, no matter what it tasted like, of course. He circled back to Karen's concern: *What could he learn about the drink by bolting it down?* "Everything, really. Most of this stuff gets drunk like that—in field conditions."

I watched his face as closely as I might a sitter's, looking for the slightest modulations. And slowly I could see that the drink, whatever its nature, began to work on him, breaking up his routine and wringing sincerity from his glib appraisal. He gave a little scowl, puckered his lips; his forehead turned into four wavy lines as the drink defied his expectations. He picked up the other two glasses, this time more respectfully—apparently the whiskey had taught him it wasn't to be trifled with—and gave one to Karen. He reached to touch glasses but she'd already taken hers to her mouth. He shook the remaining glass, the one he'd overfilled, vaguely at me; this was, after all, to have been mine. Finding no change in my inclinations, he followed suit and drank, but delicately this time, just a sip, taken with enough concentration to get him to set the bottle down.

The drinkers' faces mirrored one another's. Both were lightly tensed, with their eyes narrowed, in that peculiar form of dispassionate concentration that wouldn't go away, however discredited it might officially have been in artistic circles: *appreciation*. This is how the aesthetic attitude got worn, willingly or not. Had people

made this face in the tenth century? The fifteenth? Or did the sort of enchantment, the rapture, that Renaissance aristocrats like Alberti wrote of involve a different quality of attention, one in which self-awareness didn't feature so prominently, if at all, and one didn't study the work so much as put oneself in its hands, the response then either following or not, of its own accord, without intense contemplation or scrutiny? Distinct as the two of them might have been, one the reluctant lady, the other the joyous raff, their reactions began from this same point of aesthetic submergence, although they did follow separate paths back to the surface. Karen's eyes closed fully and her lips twisted to the side. She made a soft fist with one hand before stretching her fingers widely and puffing out her cheeks, which glowed with a touch of pink to them, almost hiding her freckles. She nodded several times and ran her hand through her hair before finally reopening her eyes, though even then they were downcast.

John's eyes never closed; they only seemed to narrow infinitely as his gaze bore into the drink from above. He held the glass with both hands and tapped it rhythmically with a middle finger, as if isolating the liquid's pulse, its frequency of vibration. He smacked his lips quietly, introducing air into his mouth, before his expression turned grave, almost bitter. It was a look he'd never worn before China. His laughter, ever since, was forever mixed with something darker, his mood never quite the same. From it, you would have thought he'd served in some theater of operations out there, and not been freely traveling. Yet at least three or four times during his travels East, he'd faced censorship of his projects, partly because they took place outside gallery doors. In one case, the last of them, when he began to produce replica money with minute alterations he assumed would be taken harmlessly, he was deemed to have attempted not quite a criminal act, but probably a trial run of one. There was a period of detention, but the investigation didn't take long. Soon after, he was given a ticket back to the United States. He was lucky to have got off so easy, I thought, given it was his fourth indiscretion in the country. He didn't see it that way. He had plans for a more extensive trip abroad, but these depended on using China as a base camp, which was now impossible. He returned an angrier, more critical artist. At least he had real reasons, unlike the rest of us who only had to deal with the lesser oppressions of liberal democratic life.

It was natural enough, I suppose, that ever since then he'd wanted to inculcate the sort of communal awareness that might, for instance, persuade the reigning powers *not* to throw a person out for creating manifestly phony money, particularly when the intentions had hardly been hostile. He was too smart to think his work might have exactly determinable effects, that it could function as a *specifiable* corrective, but he did believe some sort of definite improvement was in the offing, which was

something new for him. It was a path I didn't follow him down; I'd never had time for self-conscious interrogation.

"I like it," John re-affirmed. "I don't know much about whiskey, though. Think that's a problem?"

Having surfaced from their reveries, one after the other, Karen and John approached me slowly, unsteadily, as if reacclimating to ordinary consciousness. He was fibbing about his ignorance. Karen may have been less aware of his intimacy with such things—with American spirits in particular. Or else the charade was just his way of acknowledging that Garrett's spirit had so far left him mystified. "Good thing this is *your* project," he said to me.

"It comes on so slowly, doesn't it?" she said. "It's still coming on. And it gets..."

"Difficult," John said.

"But really quietly, right? I don't know what it's like."

"What proof is it?"

Karen and I shrugged at the question. Garrett had kept this information to himself.

"So please," he implored, looking sharply at me, "will you try it *now*?" He rocked the glass that was still in hand, and still quite full. "We need a finer sensibility, a real artist's sensibility, you know?"

"I will, yeah. Tonight."

"Oh, will you ever just let us have a fucking *moment*? Jesus." He winked and laughed, which softened his words just enough.

"Never," she giggled. "He's so good at that."

"I can't even think about booze right now. I put in time at Contra today."

"But you didn't even finish your drink then," she said. "*I* had to."

"Did you think it was my first? You kept me waiting a while."

She didn't apologize.

John sipped a little more whiskey as he walked to the table near the doors. He set the glass down and sucked in his lips "Well, then, what about this one?" he called to us. He picked up two of the smaller bottles, one in each hand, and held them out in front of him by their necks. "No alcohol here?" He pulled one of the bottles back toward him and inspected the bluish fluid. "What *is* it, though?"

We crossed the room and joined him. Karen gazed into one of the bottles on the table, but less intensely than he did, because of what Garrett's letter failed to disclose, and what she therefore knew could not yet be known.

"In the letter, Garrett only calls it 'the reviver.'"

John's head snapped toward me the moment the word came from Karen's lips. "Like a skincare product," he whispered while looking at me significantly.

Karen sipped the whiskey again. "This is good, though, right? It doesn't have the burn you expect. Maybe that's all that's strange about it." Although her reasons might have been different, she, like John, was quite attuned to qualities of fine drink—to a fault, actually. After all the downtown soirées of her childhood, where she casually met artists of the moment mixing with the vanguard of her father's generation, all mingling together in her family's townhouse, she could be unpleasantly fussy about wine or cocktails when she was in the mood to be a connoisseur or just a thorn in your side, wallowing in the mode of rejection. At other times, always funny to see, she could quickly down a drink without the least fanfare, as she had with what had remained of my scotch and soda at the bar. She didn't drink much straight liquor, naturally enough, so I wasn't sure how useful she could be to me parsing this one. There were, of course, whiskies that didn't bite, but she wouldn't necessarily know that. She *would*, I imagined, be valuable as a representative of the clientele Garrett was hoping to secure for his product: well-educated, well-heeled, cocooned from life's gross pains. Just the sort prepared to explore something as minor as a boutique spirit.

John was trying to hold my attention with his eyes, and I could see he was no less nonplussed. The word *reviver* ought to have triggered some response from me, he appeared to think. At least a derisory laugh at Garrett's nomenclature. "I think it would properly be called a revi*vifi*er, though."

"Maybe, yeah," Karen said. "Or *revitalizer*. But then that would be cosmetic—"

"Do you actually care about this?" I said, more sharply than I'd meant to, though I found myself shaking my head as well. It might have been my first unkindness of the day.

They shot a look at each other that seemed private and incredulous. I suppose *qua* collective rather than art publication, we were now in the business of framing products, which in part meant *naming* products, and naming them aptly. John and Karen's mute exchange was the first hint, though, of another *Weltanschauung* that excluded me, in which I featured only as an object of talk, not a party to it. Perhaps it was the look that separated authentic members of the group from interlopers—or simply remnants of the past. It was a goad.

"You truly give a shit about the name?" I pressed. "This minute, I mean." I was actually queasy now from what I'd drunk on an empty stomach; inebriation, or nausea, its close cousin, had gone from a convenient excuse to something like the truth. I was beginning to grow into the sharpness I'd shown them. My impatience with so much as being here, away from my apartment, was now in full flower.

There was a beat or two of silence before John turned to me.

"So how exactly is the whole *drawing* thing going for you?"

Karen blanched, proving the punch in his words. I hadn't addressed the matter of

my change of direction directly with John over the months, as I hadn't spoken to any Cosquer people much about my personal work. Immo probably knew more about it than them. Except for Karen: she knew. I wonder how she'd described matters. Or was it Claire who'd poisoned things?

"I don't think I've seen anything come of the new phase besides these pissy moods. Have you, Karen?"

I regarded them both and began to pace, letting the moment of confrontation open up before us, stretching it however much I chose, a full minute if I cared to. It wouldn't be so unusual. Once I'd been provoked, I could be a demon. They both knew that much. While my contempt for John built in my blood, with each step I took, back and forth, back and forth, I found that what came to me, quite unhelpfully, were the likenesses between us. He and I were, after all, the finest draftsmen to graduate our class. But the affinities that rose before my mind extended far beyond our skill with a pencil and our exit from the galleries, which may, for all I knew, have nourished my disgust with him now.

Did we not, for one, both reject détournement in its many guises? The conclusion that had emerged from our drunken discussions over the years—we could both get on a tear with our drinking, at a pace that others couldn't follow, we'd be screaming over our group by the end—the conclusion we'd arrived at was that there was simply no way you could commandeer consumer images or tropes *after* they'd already made their way into the world. Whatever defacement or redirection you attempted would be welcomed by ad execs and actually written into follow-up campaigns. You were essentially working *for* Coke when you defaced their ads, serving up new possibilities for monetization. Hadn't the lucrative sales of products like baggy, faux hand-me-down designer trousers proven this point a long while back? Hadn't Bernbach's cheekiness, the occasional grace note of self-hate that flared in his indelible copy, done the same even earlier, in the fifties? Holzer's typographical signature now moved fashionable merchandise. Graffiti art was the same. Recuperation always triumphed.

John had found hope in bypassing the impotence of Situationism for Constructivism. You could create something durably radical, like the old Bolshevik signage, advertisements, and indeed propaganda posters, if you actually produced the original image or consumer object, and built in whatever misgivings you had right from the start, when there was still a chance of shaping first impressions, guiding the formation of meaning. Not that he didn't have his misgivings about the legacy of Constructivism. Those tropes, the foundation of the Swiss style, couldn't have been more exhausted for him. Typographically, he preferred symmetry and blackletter whenever advertisers would tolerate the diminishment in legibility, and otherwise classical serifs, especially the all-caps style of the Roman alphabet. The Romans could

never have known their elegant script would come be understood as the equivalent of SCREAMING, whether on street corner hoardings, hailing you as you walked and imploring you to buy something, *anything*, or more recently in the overheated language of social media, shrill in the extreme.

Spiritually, though, John *was* basically Bolshevist, a would-be social engineer more than an artificer. His output now had pretty much nothing to do with the galleries, except for *Cosquer* itself. Unlike Rick, who was still wrapped up in painting canvases and saw his work for the magazine only as a side project, even though it was taking the lion's share of his time, John had come to understand his commercial projects for Cosquer as his primary mode of artistic activity. He wasn't especially worried about how much money they brought in, so long as they could serve as a vehicle for his art; whereas for Rick the whole point *was* the money. The *possibilities* of ambivalent advertising fascinated John, the kind of graphic work that won its place in the public square through its connection with commerce, yet performed this function with a double edge, raising in viewers profound and legible doubts, perhaps stronger than any that Rodchenko and the photomontagists could have imagined. For instance: far behind them both now—Karen and John had their eyes lowered and were mumbling unintelligibly to each other; it was as if they were outside in the foyer again, separated from me by a concrete wall—back behind them, by the desk in John's corner, there were a few scratchboards he'd just finished, lying near the silkscreens. They'd been designed for a major cable news program and podcast, set to début this fall, in which the two irreverent hosts—a respected political-scientist-turned-pundit, along with a "pure" media personality whose credentials for weighing in on the news were unclear, except that he had a lot of opinions and business interests—were depicted as a pair of grotesques, rendered with John's prodigious imagination into a composition that was viscerally discomfiting. One appeared as white on black, the other the reverse, and the "pure" media persona as a beautiful ghoul. The copy for the ad was still in the works. Karen hadn't settled on anything yet. All I knew was that it was destined to go up on a forty-foot billboard off of Bryant Park. It was worth a lot of money to the firm, which met Rick's goals of generating income, and Karen's of funding the magazine. But this was John's baby—his *art*. What was he actually achieving on this front? John's original proposal had been flat and simple: *Your Dream Team*. Jaded, aggressive marketing for a news program, of course; but since the media itself had changed so much from the time when news readers like Cronkite or Rather incarnated the transmission of knowledge, we were growing more comfortable in acknowledging the news' bedevilment by bias and even bad faith. This was Bernbach times ten. Increasingly, advertisers realized campaigns with this sort of internal contradiction at

their heart were actually desirable, since it was authenticity that appeared to be most valued among consumers—even honest fakery—and because ads that held instabilities at their core, that refused to resolve, to fully make sense even, tended to be more memorable. I couldn't help wondering: if John was an engineer, was *this* the kind of engineer he was? What sort of amelioration could be achieved by this sort of work, if as a society we'd already abandoned the euphemisms and were positively reveling in subjectivity these days, whether of the Antifa or Breitbart varieties? The darkness John was trying to conjure was *part* of the product—even a news product.

In the last few minutes, as I'd paced back and forth, more or less meditating, Karen had come to the edge of interjecting. I could see her chewing on words, silently moving her lips. But in the end she said nothing. She was shaking her head in real distress, distress over the stalemate, the way things had quickly unraveled. The way I was allowing them to. John, though, was entirely game, patiently awaiting my rejoinder.

"How *is* Claire these days, John?" I was betting she'd been the one to relay my artistic woes to John, not Karen.

He stared at me a long while, with blue irises of unusual ferocity, manufacturing his own pregnant pause, as I had just done. I was giving him every chance to up the stakes here, if that's what he wanted. He could tell me he'd just fucked Claire this morning; that would be good. The seconds dragged on. Karen seemed near tears now, though I'd hoped my words would bring her some calm. It had been a long while since I'd seen her cry, and back then it had been for personal reasons. Perhaps this was personal, too, more than I knew. Such things were all that could threaten her usual pragmatism. Fifteen seconds of silence had passed, really a very long time, though only half as long as I'd left it, it felt like. Finally John broke the stare we were locked in, rubbed his eyes, scratched his beard with two hands. He smiled softly, not with mockery, except maybe of the self-directed sort. Karen was wiping her eyes with the palm of her hand, though only pre-emptively. I could see no tears.

He'd folded. John was a contentious man, deeply untroubled by the prospect of conflict—one of his most admirable traits. That he decided to abort this escalating scrimmage was a mark of friendship. I felt sorry, and I tried to honor the friendship too, now, by bringing us back to the matter at hand.

"I don't think Garrett wants us to know what's in the drink, not at this point. We're supposed to just drink blind."

"Well, then," said Karen, "why don't we?" Her voice, ordinarily clear and bell-like, had thickened with resentment. She finished off her whiskey. John pinned the top of a bottle of the "reviver" to the edge of the table and brought his other hand, the open palm of it, down with a force that rattled the table and launched the bottlecap toward me. His Midwestern graces still being with him, he leaned over to fill Karen's

glass but she covered it with her hand. "It'll mix with the whiskey," she said. She held up the tumbler and rocked it to show the trace of whiskey left, a little splash that washed up on the side of the glass.

John could only shake his head, probably at the entire scene, the whole day. He mouthed something to himself, I think it wasn't nice, and pulled the bottle back to guzzle from it as though he were brutally thirsty. For several seconds he looked up out of those high windows, searching for what to say, to think.

"Sour"—that was all, the violence was gone from him.

"In a good way?" Karen asked.

He was still looking up. "Sour like... buttermilk."

"No!"

"Do you not enjoy fresh buttermilk?"

She hesitated as he played at the line between them, town and country.

"Okay, it's *not* like buttermilk. But definitely—"

Before he could continue his game, she took the bottle and swigged from it, just as he had, except that she spilled the drink on herself, down her shirt. She hadn't spent a lot of time swigging in her life; it wouldn't have gone over well at home. But John brought this out of her, out of almost everyone but me.

Once the drink met her lips, she looked skeptically at John. "Oh, it's not sour. It's got an edge, but that's different. What's the right word for it? Salty? Is that possible?"

"But do you like it?" I said.

"Will you please try the fucking thing?" John said. Our truce was coming undone already, though the scream was less angry than deranged. Who knows what had gone on in his life, or earlier that day or that week? He could be hugely sensitive to the minor vicissitudes of life. He reclaimed the bottle from her, walked the few steps left to me, and thrust it in my face. The motion threw a long lash of liquid onto my shirt and neck. I didn't flinch. He didn't apologize.

Karen didn't see us approaching the precipice. She had turned around and was still weighing my question. "I don't know if I like it, exactly. I think I *could* like it. Same with the other one, the whiskey. They're nothing alike, except for that."

"It's going to take something pretty special to sell this one, I'll tell you that." John stole another swig and again formed that exhilarated grimace.

"You seem to like it just fine," I said.

"But I like *everything*." He drank a little more. "And what am I supposed to be *feeling*, anyway?" he snarled. "What's this stuff supposed to *do*, besides be pretty and blue? Do you have any idea?"

"It's not just his problem, John, really," she said. "It could be the sort of project that carries the entire shop. We could just be thinking about this and the magazine

for a while, if things work out."

"I think Garrett's going to give us a lot of space with this, John," I added. "I wouldn't worry—"

"From the guy who won't touch the stuff. Just forget it."

I set less kindly eyes on him. I was going to have to test his seriousness.

"Don't look at me like that," he barked. I wouldn't be surprised if he were inebriated, there was so much substance to his life. Another pause ensued. This is how so many conversations unfolded between us: silence broke them to pieces. As Karen twisted her hair around her fingers, John took several gulps from the bottle and nearly finished it off. Eventually, ultimately, he cracked the grin I'd long known. "Like I can't fuck with you."

"John's only jealous this commission isn't his," said Karen, as if I needed consoling, and as if he weren't even there. She let go of her hair and grabbed my hand as I regarded him, though more gently now, more quizzically. I felt drunk, the more since seeing him. He had that sort of effect on anyone he crossed paths with, and only occasionally in a good way.

I had to remind myself that there was no deep rift here between us. He leaned toward me, very close, for reasons only he understood, and I slapped his face sharply. It had to have stung. Like a baseball player hit by a pitch, he didn't rub out the pain. We laughed a little, even Karen. This was all it took to put us back together.

"Rick should try these, too," she said. "Before we really talk about it, anyway."

John rummaged around at his desk and found a plastic grocery bag still lined with a brown paper one. He settled the whiskey and the other bottles in it and carefully crimped the paper to hold them in place. Then he held the plastic handles out to me and nodded. This was a small form of penance for the trouble he'd given me—today's or any other day's, I couldn't tell.

"And are you done with the design for the taxi ads?" Karen asked him. Her tone was flat and no longer sociable. Before I'd even gone, she'd returned to business. There was only so long she could hold out.

"That's what today's about," he said, reconnecting with their common enterprise, what went on here in all the hours I wasn't around. I took the bag from him, heavy with bottles that managed to peal despite his best efforts. Clanking glass and crinkling plastic—this would be my inevitable accompaniment on the long ride home by way of several trains.

"I'm trying to figure out where the copy will go," John said. "Or if we even need any. I think we're using too much of it these days. In the magazine, too."

Karen had drifted toward her desk and had already displaced the stack of proofs, but these words turned her around.

"You can't mean that."

"You want words everywhere, Karen."

"They *are* everywhere."

He wasn't wrong. The proliferation of copy, of prose, in everything relating to *Cosquer*, was stark. Ever more pages had turned to text, including some penned by Karen, so that every month the magazine seemed to get less visual, less poetic. She was, I thought, inexorably turning from text artist to poet to prose writer. That's the arc I'd noticed in her since we'd all moved to the city. She was a writer at this point, though she wouldn't admit it. What visual art had she put together in the last year? What she did, besides write, was edit the magazine and run the design firm. It's why she was okay with her own trajectory, in fact, because unlike the typical designer, who quietly set aside the matter of fine art, she was only relinquishing one art to segue into another.

John turned back to me. He looked pleased now; his blue eyes shined. "You're going to see this thing all over the city in a few months. HBO's paying for it, for that new series about rural life, which—did you see the screener?—it's just obscene. They understand nothing." He'd been born in South Dakota, in a town even smaller than Rapid City, and knew more than a little about life between the coasts. This only added to his authority and allure, this zone of experience that was his possession alone, unknown to the rest of us, who hailed from the usual cosmopolises: Los Angeles, San Francisco, Chicago, New York. This proprietary history was his to mold and use as he wished, including running down others who made any claim to speak of flyover country. (Garrett, I thought, benefitted from something like this, too.) One thing I appreciated about John, for instance, was something he'd told me was a regional trait: seething at will. Apparently his mother had it in spades (she was also bad with alcohol, which wouldn't have helped). But he'd said this quality could also be found all over the Dakotas. Someday I wanted to go there and find out how much slander, or anyway myth, there was to his tales of home, how much perversity he cast the entire region with only to explain away his own deficits. "Basically," he said, "I've done these Rockwellish portraits of the leads of the show—corn-fed American virtue and all that. But they look sort of sinister: KKK types rendered, well, phantasmagorically, I guess. It's hard to explain, the effect isn't obvious. But it's powerful. I really don't think we need *any* copy, Karen," he said over his shoulder. She'd already heard this speech, I could see. "*Actually*," he started up with new intensity, "the pieces are in my studio right now." He went to retrieve them; I think he was trying to prove a point to Karen with my backing, if I did indeed approve of what he showed me. My judgment, though not deriving from a deep grounding in the world of commerce, appeared to carry some clout around here. But it was more than that. He simply wanted to see what I thought of the pieces, never mind their value to Cosquer. There weren't many people whose opinion he cared about.

Really, I should have shown more interest in his work. I *was* a part of this group, if not quite as wholeheartedly as he was. It was this partial remove that excluded me from that conspiratorial look he'd earlier shared with Karen. In truth, I *was* interested in his work, in anything he did. It was all worth knowing about. I'd lost interest in plenty of artists, but not in him.

My nausea seemed unbounded. It had already peaked, I thought, but now I found it building again; presumably it wouldn't relent without the aid of sleep or food. I'd missed not just lunch but breakfast, which I was anyway in the habit of skipping. It took me several hours each morning, after waking, to find the prospect of pushing plant and animal matter into my mouth less than repellant. It would be best, I knew, to head home now, take some air; to eat and nap, or vice versa; and then, finally, to turn to these bottles, or even just stare at them a while in the light, before imbibing as John had been imploring me to do. I'd had as much continuous social contact as I could comfortably handle. My sociability had always been less than typical, when measured in minutes and hours, at least since the early years of high school. I've always preferred concentrated stretches of communion, exchanges that taxed all parties owing to their stakes, to the lighter, longer interactions that life serves up in far greater abundance, and which I quietly ride out, seeing whether something worth mulling might be pulled from them so that the time is not entirely lost. Still, there was no question that my tolerance for *any* form of contact, rich or poor, had been far greater before Claire had gone—before silent appraisal became my natural modality. In the last months, most of the time I felt, whenever I thought back to her, those two-and-a-half years together, that she was a burden well-shed, an obstacle finally cleared from my path. A path to where, though? And if I couldn't say, in what sense did I know her to be in my way?

John hadn't committed a real transgression today. Yet I was within my rights to be mildly offended, even if I didn't actually feel so (there is, in fact, an ethics of feeling), particularly if I were as drunk as I'd let on (though I think I might have been), because it would have been only too easy for someone to misread his playfulness—if that's what it was—as a slantwise affront. All the more so given my reputation, mostly justified, as a belligerent drinker, someone quick to anger, to destroy things, even to dare other people to destroy things: especially connections. So I capitalized, grabbed his arm, and said simply, "I've got to get home," with a touch of a scowl, as though, even if I were not exactly angry with him, I'd been distressed enough by his actions that I couldn't be expected to be in a mood to indulge him further.

For an instant, he seemed to be poised between several responses. Karen and I could both see this, by the way his face turned protean, almost liquid. More than an

instant: it must have been a full three seconds, four, five—which, when it comes to the effects our words wring from the people around us, especially when what we have to say is not what they would like to hear, can be a very long time. This was doubly true for John, for whom words like *irascible* and *mercurial* were invented.

But my gambit, which came down to the precise way I held my face, the sense of both friendship and duress I signaled with it, won the day. He grabbed me by my arm in return. "Okay, yeah," he said. "I'll scan it and you can tell me about it later. But," he added, "sober up and try this stuff."

"Yes, please," Karen called out plaintively from her desk, though without looking up. She was leaning closely over the papers on the desk and had pulled her hair back, which she did, I knew, when the problem she faced was difficult. John joined her and huddled over her shoulder, inspecting the cause of distress, whatever it was.

"When you finish yours," I said, pointing at the open bottle on the table with blue at the bottom, though no one was attending to me any longer, "you'll tell me how you feel?"

8

On the train home, in the late afternoon, with my head too light and the bottles nestled at my feet, I reached into the shopping bag to find the long blue envelope. I unsheathed the note, felt the paper dense and rough on the tips of my fingers as I unfolded it in thirds. It was green or greenish, the train's light made it hard to tell, and it was flecked with gray. Its edges, all of them, were uncut. The message, in a heavily condensed hand, began at the very top left, where you might start a grocery list: first the salutation, then my name and Karen's, then straight into the text, all on the same line—thin, quick, maroon strokes made with a plastic-tip pen. Garrett's letterforms were precise, rectilinear, and showed almost no variation, regardless of their position in a word, like a typeface. They looked as if they would be more at home on graph paper, one glyph per box, not on hand-pressed rag. Probably Antral had only recently made the switch from one to the other, as they'd expanded from hard-edged science into less defined areas. Still, as I read the letter through, I could almost see a vestigial grid overhanging the page.

Form aside, there was, surprisingly, nothing much left to glean from it. I'd assumed Karen was radically paraphrasing before, she conveyed so little about it to me at the office, but she'd in fact shared nearly the totality of its contents. Nearly. In a tiny postscript on the back of the note, Garrett had, *pace* Karen, actually mentioned a provisional name for the drink, which was Paul's idea: *Theria*. She must have missed this tidbit, which was a shame, as it might have forestalled tensions back at the office; it suggested that Garrett's description of the drink as a reviver was offhand, nothing to make too much of, as John most certainly had. In any case, beyond this detail of a name, the letter really did say very little: more or less, *Here are some of the items to be sold. Sample them...* and what, exactly? There was no mention of, say, making sketches based on the bottles, or composing logotypes or trademarks. Garrett simply said he'd be in touch very soon. Then he signed off, or really, printed his name in that same geometric script. Conspicuously, he offered no valediction.

Come to grips with these drinks—I suppose that's all there was to infer from his words. Garrett had a habit of underexplaining things. I'd already noticed the pattern on the telephone and in person. Here it was again in letters. It didn't matter, though. I wasn't irked. It seemed to emanate from his nature, rather than being a play at obscurantism, or a way of avoiding responsibility for his own thoughts by making them yours. The most natural explanation, given his wealth and stature—he was someone who by right might

have dealt with people in blunter ways—was that this was actually a sign of his generosity: working with people without merely giving them instructions, without treating them as a means to an end. By refusing to finish half his own sentences, he could see what leaps others would take in concluding his thoughts. They might well stumble on ideas that he liked more than his originals; although I'm sure there were occasions on which he had no complete thought in mind, and his meaning remained only partly formed, a mere stem waiting for the right interlocutor to bring sense to it.

After a couple of line changes, I emerged at my usual station, past the multi-racial mosaic, and my nausea reawakened. I was thinking I'd stop in at one of the two diners I frequented, but within a few blocks, walking in the September breeze, I found there wasn't much need. My unwellness had mostly lifted; little of my hunger remained. The simple passage of time, the cool air, and perhaps most of all my withdrawal from company into anonymous circumstances, had calmed me, if not healed me altogether.

I climbed the stairs to my apartment, past that vacant first floor, the Becker floor, that I hadn't dared to enter properly. It was a problem still waiting for a solution. But the closer I got to its dirty door and those cracked windows, to the scene of the family's eviction, which had begun with repo men and ended with police, the less I felt able to solve it. A tinge of the sickness seemed to return. The feeling impelled me onward, upstairs.

By the time I'd gotten my own door open, one floor above, I no longer felt any need for a nap. Before doing anything else, before even taking the key out of the lock, I pulled the bottles from the bag, two by two, and lined them up on the sill of my window wearing that veil of grease—the one I'd sat Claire on for the charcoal portrait. Seven bottles of Theria—and if this word was *not* arbitrarily generated like most brand-name pharmaceuticals, but actually borrowed from the Greek, would we then be talking of, well, *wild animals?*—and the fifth of a gallon of whiskey, minus what Karen and John had drunk from it. The sun filtered through the glass and gave me my first proper look at these liquids. The Theria had a transfixing blue-green to it, more saturated than water but of the same general tint. It looked like water as we sometimes imagine it or represent it in art: intensified, concentrated. The wheat whiskey, which sat at one end of the line-up, shone a diaphanous straw hue, with none of the reddish shades of scotch or bourbon. The daylight passing through it only amplified the brilliance I'd briefly seen in it at the office, blending an atmospheric gold with the drink's more localized variety. I tipped the bottle on its edge and swirled it a bit. The surface, still quite high in the vessel, despite John's depredations, rippled sluggishly, as if it were the molten form of a solid. I did the same to the Theria and it jittered with the immediacy, yes, of water.

A dusty tumbler sat next to the easel. For how long? Weeks at least, to judge from the grime in it. I washed it out in the sink, then returned to the window and poured myself a measure of whiskey. I held it just beneath my lips and drew in the vapors. It felt like our second encounter, this wheat spirit and I, given how closely I'd observed my colleagues partaking in Queens. The nose, it was apparent once I'd uncorked the bottle, was profoundly gentle, without a trace of pungency, yet with no sacrifice of complexity. Baking bread, that's what occurred to me. Each of its visible traits was recapitulated on the tongue: the peculiarly lambent flavor that never threatened to blind, only clarify, an ethereal pianissimo of a grain so utterly familiar from other contexts, but not in a whiskey; the contrasting tactility, a light stickiness in the mouth, just as those slow ripples lapping against the walls of the bottle had presaged. It was this body, almost universally lacking in young spirits, that promised more.

Just as I was about to finish off what I'd poured, a dispute convulsed the street, acrimonious enough to reach me through closed windows. I couldn't see the participants below, but the voices, male, female, even infant, were all gilded with the spontaneous anger I'd grown used to on this block. Remarkably, the argument turned out to be over a parking space, an objectively improbable dispute, given how few of my neighbors had operational cars. As I listened more closely, I realized that the clash issued merely from hypotheticals—apparently the belligerents were philosophers—conjectures concerning the *entitlement* to park rather than about *actually* parking a vehicle. But abstraction only intensified the discord, through a purification of all real-world complications, the things that make for gray areas, compromises. Strangely, I'd discovered that conflict wasn't just a means toward the resolution of disagreements around here; instead it seemed to hold intrinsic value, often more value than conciliation could deliver. Hence disputes tended to conclude only when people had spent themselves and not before. For this reason I finished my drink in some equanimity, the heated words scudding outside bringing an innocuous piquancy—innocuous for me, anyway—to the occasion.

The first few times this sort of thing had happened, of course, I'd reacted differently. I'd felt something akin to terror, in fact, and I would have trouble working or sleeping for hours afterward, fearing all sorts of potential outcomes from the incident. By now, though, having found that usually there was no upshot, just a flaring scrap in the manner of angry dogs, the disturbances began to hold for me the pleasant terror of horror movies. Although punches were sometimes thrown, knives pulled, blood spilled, cops summoned, I in my person had come to accept my total and complete safety. I was a pure spectator, as removed from what was occurring as anyone watching a police procedural, except that I had a better seat,

so I could see the real color of things. Even though I was stationed only on the second floor, the artificial hill the slumlord had built beneath the house meant I always held the high ground, the same ground that necessitated the abnormally long stoop I had to climb each time I returned to my place, as if I were approaching the monuments of Lincoln or Jefferson and not that of a simple profiteer. I was always slightly winded when I made it to the door.

A few incidents, I should say, were so intense they managed to shatter all sense of remove. Not even a month ago, I'd heard an outburst at three in the morning, an hour that increased the odds of consequential violence. But this drama sprang from a single voice, which in fact only ratcheted up the tension. I could have stayed in bed. I was actually terribly tired that night, having fought with Claire in my dreams, but the sheer force of the man's voice, which arrived like a conflagration, drew me to my feet. I delicately tiptoed ahead, with exaggerated high-steps. For me, the man owning this voice had to be something more than mortal; he would hear footfall any heavier from the street itself. I slowly headed for my northern window, which faced onto the tenements, the source of all this bile. But I left all the lights off. I drifted through my kitchen and living room from memory alone, experimentally, trying to recall what I'd left lying around, so as not to stumble and alert him to my approach. Once I'd drawn close to the window, I crouched down as low as I could, inching the last few steps on all fours so that my head just peeked up above the bottom lip of the frame. There below me, under the high-pressure sodium lamps, was a black man of less than twenty draped in *giallo*-film red. The T-shirt was so large, its sleeves ran to his forearms and its hem fell to his knees, just where white enveloped him down to his sneakers. He blurred phantasmagorically under the lamps as he skipped and twirled up and down the street; it gave his rant an unmistakably ecstatic dimension, I thought. This went on for a full eight minutes, too—I timed it on my kitchen clock, whose glow-in-the-dark hands cut easily through the black—this soliloquy of purest contempt, somehow shunted into a single phrase, all of this menace and pain. And not even a threatening phrase, but a couple of numbers: *Six two.* What his tongue was able to do with this little incantation, I cannot fully account for. Dozens of times, though, there was *six two*, in every possible inflection, sometimes in one breath, sometimes in two. Some of these soundings betrayed real despair, fear, self-pity, though the varieties of menace with which he was able to charge the numbers far outnumbered them. I'd not known so much life could be extracted from a pair of syllables, from such a mundane utterance hitched to that little dance, up and down and back again. For all I knew, this was it, the whole of what he was offering, and in its own unfathomable way, it was probably plenty. Yet eventually, like any actor, he couldn't resist bringing a touch of sense to proceedings. I stared into his face as he screamed out the kicker: *Right here.*

The six two. Who wants it? I'm right here. Because every bit of this is mine. There was only a cavernous silence as he held his face aloft for the first time, staring up into the windows all around him.

This was enough for me to work out the significance of his chosen number. He meant 162nd Street, and he was laying claim to the entire block, to exclusive dealing rights, I presumed, if not other illicit enterprises as well. Indeed, I realized, as he peered into the apartments, seeking some rejoinder, that I had seen him around before; I circulated so much through these blocks, everyone and everything fell under my gaze eventually. He always wore a bug-eyed look, I recalled, as if he'd been awake for days; and his short dreadlocks were perpetually blown back by some phantom headwind that never stopped fronting him, whichever way he turned.

He wasn't done, apparently: *I'm telling you—I am. This mine. This the six two. Ain't nothing none of y'all can do. See that? I see you.*

He whipped his head my way and I thought his eyes met mine.

So see this.

I ducked beneath the window and leaned my head against the wall, wondering if he'd just pulled out a pistol. How could he have seen me in the dark? And when was all this bluster going to draw a response from someone, on a block this hardened? Not necessarily a retaliation, but *something*: maybe just an old man screaming out, *I can't sleep like this. I will not do it,* son! And then what would this kid's response be, if not some higher violence than mere words can conjure? My legs were shaking.

But the street stayed quiet. Not that the challenger had gone unnoticed. Not at all, to my chagrin. Looking around at all the neighboring buildings, I was made ashamed by the sight of people, whole families, including young children, filling at least a dozen *lighted* windows of the high-rises. They had the courage—though only a coward would describe it that way, I knew—they had the mettle for high-stakes guerrilla theater without any need for a cloak of darkness, something that was simply out of the question for me. Worse still, as far as my pride went, as their eyes met the young man's squarely—eyes I avoided even while I returned to his face through the dark—not one of them flicked out his light.

Eventually his voice frayed, he shook his head at the onlookers, his dreadlocks flew. Then he reared back to declaim one last thing, I sensed, with arms operatically stretched toward either side of the street. What followed was just the slow flexion of his fingers around what could only be the necks of two rather tall ghosts. He wrung them thoroughly, face held low, before shoving those murderous fists into his pockets and shuffling off, barking something to himself like a lost dog.

I don't know if he actually flashed a gun at any point during his monologue, though he *had* brought his hands down to his waistband several times while prancing

to suggest as much. And his tone certainly implied the presence of arms. But now I think it might all have been wild bluff, and my neighbors had somehow sniffed this out, though I don't know how. To me, it seemed foolhardy to press so hard *without* a gun. I almost wanted him to have one, for his own sake. But this might have just been the logic of a foreigner.

Today, though, was different. As I sipped Garrett's whiskey, an atonal polyphony wafted up from the street, and far from discomfiting me, I found my nerves positively soothed. Communion took many forms, I was learning. Here it could come through fractiousness and contempt, even if no one understood this to be a kind of fellowship. Yet what did *that* matter, knowledge, I mean, so long as fellowship existed? I drained the tumbler and pushed off from the stool, where I posed people like dolls, to the formless couch where no one sat but me these days, to lie down and savor the fading screams and the drink's decay.

The braying had lost its edge. The women involved decided the space belonged to one of them, Darla. But if it was open—as it always was, since Darla hadn't owned a car in years—then Macy, or rather Macy's relatives, might use it when they visited town. She herself, of course, was as carless as Darla. A few snorts and mutterings concluded things, and with that my full attention returned to the whiskey, the flavor of which had expanded tenfold in the finish, both in size and import. It no longer seemed to reside within me—in my mouth, my belly, or even my head—but rather cocooned me. Never had I experienced such a long tail to a drink, one that reached its peak intensity, as with certain peppers, well after it had landed on the tongue. I rose, poured again, and tested my hypothesis. Each sip seemed to overlay the previous ones, so that a sort of round or fugue of flavor was produced: a series of overlapping crescendos that remained distinct from one another, like ripples in a pond. As for the fermented wheat, it manifested itself as the staple it was, in a way corn or barley didn't manage.

I wasn't a connoisseur like John, nor did I seek to be. I abhorred wine (literally sour grapes) except as a way of getting drunk, particularly at openings, where often little else was available; and although I'd had my share of liquor, I'd always found something faintly ludicrous in the language around it. Speaking about taste, the gustatory phenomenon, seems hopelessly impressionistic in ways that don't afflict other modalities, especially sight. The only way you can do it at any length is to name all the things something tastes *like*: ripe fruit, say, or toffee, but also things you will never put in your mouth—granite, leather. This isn't wrongheaded, a category mistake, say, so much as pointless. Demonstrative definition—*this* is what it's like—seems the only serious choice when it comes to grasping the properties of taste. Why pretend you can understand such character through description? Better to keep one's comparative talk

to a minimum, and push forward on factual grounds, as one might do with the look of a drink, with no pretense to conveying the experience itself.

In any event, all the sampling I carried on with through the afternoon had more practical consequences. Though I didn't feel drunk as such—my head grew exceptionally clear, pervaded by a kind of mentholated coolness—my coordination began to fail me in small and telling ways. I managed to shatter the tumbler, for one thing, dropping it while feeling myself to have a perfectly adequate grip on it. (Thereafter I had to work straight from the bottle.) More agonizingly, when I eventually turned to drawing, my line lost all its shape. I finished by throwing out not only the papers on which I'd sketched, but the pen, too, never mind that the defect lay elsewhere. After this fit of pique, I started to feel a strong pull toward sleep, of a different magnitude from the one that had plagued me earlier at Cosquer's offices, even if it was not yet six o'clock and there was nothing natural about the need for unconsciousness just eight hours after rising.

I did nothing to resist, though. I didn't move to my bedroom either, preferring the broad volume of light I found myself encased in on the sofa. I let myself drift off into the drink and I didn't even bother dreaming—not memorably, anyway. I woke many hours later, around ten in the evening, yet with hardly a hangover. Sitting up and checking the low waterline of the bottle, the absence of after-effects was remarkable. I didn't recall having drunk anywhere near as much as I must have, but in the throes of experimentation, who can possibly keep track?

Usually after sleep, the taste of scotch and especially bourbon would have been sour and somewhat vile on the tongue—unlike, say, vodka—as if the grain had undergone a second fermentation in my mouth. But for all its sneaky intensity, Garrett's whiskey didn't offend in the ways of other brown liquors. It was almost its own kind, neither a brown nor a clear. I could taste it, yes, but it wasn't at all unpleasant.

Now the apartment was black except for the faint light coming from the street and the lamp I'd left on near the easel and windowsill. Too late, I thought, to do anything useful with such a small slice of night remaining. Anyway, I preferred to work in the late morning and through the afternoon: so, though I wasn't tired, I got myself up from the couch—my coordination had returned—and took myself to bed.

Sometimes it was possible for me to get a full night's sleep just after having napped profligately. But it took real concentration. I would lay in the dark and consider all the things I *might* do in a wakeful state, that is, all the worthwhile mobilizations of consciousness I could think up; and, just as with window shopping, merely contemplating these possibilities was often enough to satisfy any urge to realize them. When it wasn't, and ideas continued to tantalize me, I turned to rationalizing how each one of them might most profitably be put off until later, which would of course sap their urgency

and all capacity to keep me awake. I'd grown very good at rationalizing, so that once I'd delegitimized all my plans, and my head was empty, that was generally it.

Tonight, I didn't have to exercise myself in this way. There really *was* nothing I needed to do right now. My personal projects were on hold. I did need to investigate the energy drink, of course, but that could wait for morning. Garrett had given me no time frame, no deadline. Probably it *should* wait, until the whiskey had fully cleared my body. Curiously, my mind refused this relief, and what crept into it might well have been the forgotten substance of my dreams, so familiar did it seem. Colors without shape: that's what I saw. They filled my entire visual field, despite my closed eyes. For even then, we know the field remains, as when one sees a wide hazy yellow-red expanse through one's eyelids while dozing in the sun, or electric green when rubbing one's eyeballs in the dark. This time the shades were different, and different in a way that seemed right: non-arbitrary, though not exactly explicable. Cyan and ochre. Were these not shades that always found favor with Claire, that flecked her wardrobe, that had indeed once draped the apartment itself in the days she would fill with fabric and fiber projects? But wasn't there more still to these colors? There must have been, I felt. I opened my eyes, hoping to vanish the tones and the forlornness they brought me. In the pitch dark, though, they continued to strike at me, like those flickering frames at the end of a film reel. I sat up and rubbed my eyes but nothing changed. I knew nothing would, somehow; the flashes of blue and yellow kept coming. I was seeing without seeing, the illusions were pouring out of me. I had to be the source, right? I turned on the light and the sparks dimmed, as I knew they would. I switched off the light and there they were. I had known this, too.

Through my growing bewilderment rose the odd and inescapable feeling that I might be living with these two luminous shades for a while. Sensing no change in my state, even after some minutes in bed watching these fireworks, I decided there was nothing to do but get them down in front of me, properly, then and there. With the lights back on, I dug out a sleeve of pastels from my nightstand, which was piled with the modernist tomes I'd been prone to reading in the last months, predictable things, the natural companions of recent estrangement: *The Notebooks of Malte Laurids Brigge*; *The Sleepwalkers*; *Auto-da-Fé*; and that ultimate bourgeois saga of bemusement, *In Search of Lost Time*. The pastels looked chalkier than they should have; perhaps they'd dried out a bit. I smeared a couple of sticks onto the sketchbook I'd been keeping on the other half of my bed, but the colors didn't align with what I'd seen or imagined. I made a few more tries, colors in combination, but there was a bigger problem than tone. They were more matte than what I needed, which was the rarefied shine I no longer worked with, the kind that only found a place, here and there, in my imagination, or my night terrors, or whatever

this whiskey-bred state was. No, try as you might, you couldn't summon this *glow* without the help of linseed. As there were no tubes of paint in my bedroom, I went out into the living room that served now as my studio. There on the broad table of unvarnished pine I kept just off the kitchen was an unopened set of oils. Rick had brought them by on his one and only visit here. I'd not invited him; he'd just come with Karen, to remind me, I suppose, of his own art, the one I used to practice: painting. Since I'd not paid for the paints myself, and since I'd felt less close to Rick than I had in a long time, I handled them wastefully now, squeezing gobs of green and red and orange and yellow, and half the tube of white, onto my long-neglected palette. This was a part of painting I missed: the preparation. This and the manner in which one *built up* an oil painting, layer by layer. The length of time it took, all that drying, as compared to any other medium. It's what kept it fungible, responsive to a creative act that might extend in time over months. Pastels and chalk generally blended best optically; they rarely mixed deeply when you combined physical strokes. Watercolors could be mixed to very good effect, and acrylic, too, though they both dried far more quickly than oil, so you couldn't keep them growing, developing, the way an oil painting was almost an organism. But then, I was also using less of *those* paints. And given the unrelieved shimmer I was seeing in my mind tonight whenever the lights went out, there was no question that those media would pale next to oil, *a priori*. Really, when you're looking for the purest liquid intensity, you don't have a choice.

I stirred the paints with a narrow kolinsky-sable brush, a prized instrument of John's which I'd stolen from him in school and always hid whenever he came around. It hadn't seen water in a long time now, hadn't even been cleaned properly since I'd given up painting. It was more or less ruined, the bristles didn't give. I used it like a reedy stick now, stirring the paints so that the oils remained rich and globular, even as they metamorphosed in color. Eventually I smeared each onto a sheet of Bristol board with my finger, and after myriad trials over multiple sheets, each of which became covered in swatches of near identical colors, I approached something like what I'd imagined, or what my imagination had forced on me, in the dark.

The ones that worked best, it turned out, were the ones I'd blended incompletely. The paint had marbled rather than blended, so that the smears appeared unified in color from a distance, even if, on inspection, you could see the traces of white I'd mixed in to give them their light-raked appearance. Around one in the morning, I arrived at two perfect, irregular swatches. I say this because I could turn away from the lamp and close my eyes tight and find those peculiar afterimages alive and lustrous as ever; but I could open them up now, too, look directly down at the paper, and experience something of the same order, in tone if not in rhythm. Tomorrow I would

really know what I had, of course, when I checked the patches in daylight, which gave everything away. Maybe some of that rhythm would even appear.

I crawled off to bed with my eyes on fire and laid down over the covers, feeling too clammy to be swaddled in them. I didn't bother turning the lights out. What would be the point, with those shimmering blues and golds hounding me through the dark, who knows for how long? Probably just as long as this not-quite-hangover lasted. So I closed my eyes and basked in the rust glow penetrating my eyelids, masking all other sensations, as if I were sunbathing on some remote island beach. Which is to say, even then, my mind couldn't expel those stubborn tones. They merely shifted ground, fleeing sensibility and finding refuge in my thoughts.

9

At sunrise light collected quickly in my bedroom, as it always did. I didn't have blinds. Claire hadn't wanted any. Even at night, she liked to see lamplights flaring in the street, and she slept best knowing that if she were to wake, as she often did, for many reasons, the world at large would be there to meet her gaze. A window, for her, was an inviolable channel uniting spaces, and thus a core architectural feature of a building, which was not to be interfered with whenever it happened to suit one's purposes. I'd had to take down the cheap orange cloth that had been hanging from the curtain rods when we'd moved in, so that now they sat on the floor of the closet like the discarded robes of monks.

In half an hour sunlight overcame the bulb that had burned above me through my brief night. The beams falling on my eyelids reignited earlier concerns in me, groggy as I was, and it wasn't long until curiosity drove me out of bed. I passed by the kitchen into the living room through the heavily built doorway, which was retrofitted with some sort of bracing around the frame, as were all the others. They gave me the impression, or did until recently, that the whole place might come tumbling down without them. Lately, though, each time I passed through them, I thought only of the Beckers' doorways underfoot—did they even have the benefit of these curious bolsters?—and the general state of decrepitude that could only be strengthening its hold while I neglected the place. *My* place.

I squinted my way to the window and crouched down for my first daylight glimpse of the two paint swatches laying on the floor. As my gaze shuttled between them, finding a new rudeness in the gold and blue patches, I slowly looked up to the window, toward the source of this vigor, which penetrated the glass and gilded all the world. Before I could turn back to the paint, I was thrown violently into wakefulness by the realization of what I'd been doing in those manic hours only just past, all without knowing it: the bottles there on the windowsill actually recapitulated the colors at my feet. They weren't quite the same, of course, given that one pair existed in a fluid medium, and the other on paper. But that was unimportant. They were definitive analogues, effortlessly radiating metonymic force.

Last night's labor *would* count as work, I considered while rising to my feet, wide awake—the sort Garrett may well have been hoping for. Who could say? He'd said so little. I rounded up my phone and corralled the patches of paint within the viewfinder, snapping a shot for our new client. I was going to take his project seriously from

the start, mainly to keep him writing checks, perhaps eventually addressed to me alone. Which would certainly help. My apartment, after all, was only cheap for what it was. Cheap *considering*. Considering what? This tatterdemalion ward, where only the police precinct bustled and hummed, and then only with arrests and stakeouts and raids, and a mushrooming staff to match. Not long ago, the borough's top man had called for a law-and-order clean-up, effectively a civilizing effort, as the *Post* put it, and if the city's mayor had any misgivings about it, the governor and the president did not. The upside to all this, at least for me? For the cost of a two-bedroom in Fort Greene or Williamsburg, I was able to rent out two entire floors here, even if I had yet to exploit one of them. The level I occupied was, by itself, a three-bedroom, two-bath apartment. The master bedroom was vast, in principle, anyway. Claire and I were forced to abandon it after my columns of books overran it (she'd kept her own in the living room). My collection had been accreting since junior high, and I'd lugged these volumes all over the country ever since, with every month seeming to bring another ten or twenty into the fold. I suppose what I'd amassed was large enough to be referred to without pretension as a library—a couple of thousand volumes, all told, though I was no collector or general bibliophile, and this could be shown easily by how few of the texts I possessed I *hadn't* actually read.

In college, gorging on books had made me quick to speak. Now I'd read enough to prefer silence to the hours-long scene-setting it could take merely to prepare the ground for a profitable discussion. Perhaps I expected too much. However it was, I'd found knowledge to be, except in its early stages, not a bridge between people but a wall hiving off the benighted from the lettered. Which camp lost more through this estrangement, though, given the capaciousness of the former? It's a question I never would have thought to raise back then.

In the circles I moved in—less and less now, but still—this library was quite well-known, not least for its accidental formation: it was once not much more than a bibliography of my reading life. In time, though, friends began donating their own surplus to the lot, mostly out of guilt, I think, so that they could maintain some personal relation to their abandoned volumes rather than leave them in boxes on their stoops to be disappeared by the hands of strangers.

Guilt couldn't account for Immo's charity, though no one had contributed more, something on the order of one hundred volumes, nearly all of them of a medical nature. They'd come in two batches and never again: the first just after he took his M.D., and the second once he'd finished his residency. He knew I'd get something out of them, given my trade, just as he knew he needed to divest himself of these assets as quickly as possible after they'd served his purposes. He was clever, perhaps as naturally keen as anyone I'd met, but he had no wish to be a custodian of knowledge.

Quite the reverse: he proudly declaimed that in his apartment you couldn't find a book if you tried. Why bother? He kept nearly everything he knew in his head, for better or worse. I went on to read most of my friends' contributions, including at least half of Immo's archive in anatomy and physiology, far beyond what draftsmen usually troubled to imbibe. But this kind of empirical excess has a way of making itself felt in the work. Immo himself had noted how, even when a picture of mine turned quite abstract, there remained telltale signs of bona fide biological insight, which generally resided in depictions of those peculiarities of the body that cannot be explained by present function or aesthetic unity, only the vagaries of evolution.

Before my books had entirely appropriated the master bedroom, Claire and I even slept next to them, almost *within* them, shoving them behind the headboard and ceding to them the far reaches of the mattress. No concession ever proved adequate, and eventually we had to evacuate to a bedroom small enough to call a bunker, a place where we could finally be free, or freer anyway. For even in our humbler quarters, it wasn't long until books began making incursions. Our final bedroom, the middle-sized one, had served as Claire's workspace, when she wasn't working from the shared studio she'd retained in East Williamsburg—the very space to which she'd now migrated permanently, of course, so that her spell in the Bronx appeared only a mere detour, a curious aberration, along her path through New York. Before she'd actually moved in, I'd insisted the room be hers, so that she might be inclined to spend more time here, without having to commute to Brooklyn, a gesture that had been received with tenderness and facilitated her ill-fated stay here. Now that those days were past, I ought to have occupied the space to relieve the crampedness of my present arrangements. But all thoughts of doing so were delayed by the role the room now played in my life: it was my home theater—fitting enough, I suppose, in a Bronx palace like this one. Blocking much of the room's east-facing window was a 102-inch plasma screen that produced overpowering analog blacks, blacks that registered as zero signal, the perfect absence of light. Claire had acquired it secondhand and used it as the centerpiece of an installation in the days before I knew her well. She'd only described the original project in the sketchiest terms: the screen had been used mostly to display, of all things, a video still—cheap and grainy and entirely below the screen's performance thresholds—of the IMF chief in the minutes after enforcing a minor clause of the Washington Consensus on a nascent African kleptocracy (Burundi, if I recall).

That's as much as I ever learned. Claire stopped discussing it with me after realizing I generally took a dim view of art-as-kulturekritik. Perhaps she'd even had the feeling herself, and maybe I'd only helped her see this, that the piece belonged to an earlier phase of her artistic development, when she was just branching out

from classical sculpture. This thought might have been too convenient to be true. For even now, when I tried to fathom those elements of her psyche that resisted integration with my own ethos, I couldn't help but wonder what *exactly* had appeared on the screen, besides that IMF head. There must have been more than that. Might those pictures have prefigured our parting in some way, had I only known of them in time? But they were gone, and what remained was only this great black face. In her Williamsburg studio, Claire had kept this face hidden against the back wall, storing the screen like this since she had nowhere else to put it. Once she'd moved in here, it was quickly granted a second life: after long days working together in the apartment, separated only by a door, we would screen films on it with gin and tonics or a bottle of red, on a crusted couch I'd inherited from the previous tenants, who may well have gone the same way as the Beckers. Claire took as much warped pride in retaining this bit of furniture—forensics would almost certainly have revealed ghastly deeds committed on it—as any recalcitrant blue blood would. There was no disposing of it, not then.

Whatever knowledge I had of recent cinema, particularly feature-length material, I owed to Claire. I myself had moved directly from a close study of Anger and Brakhage and Thornton in my youth, treating them more or less like painters and poets, directly to cop-buddy movies, so slight was my impression of the narrative worth of cinema. She was a film aficionado, as one, in some sense, was expected to be today, if one was an artist. Half of *Artforum* was now dedicated to film. I watched Haneke and Dumont and Costa with a skeptical sort of interest, and Claire, to her credit, managed to find a way, often a drunken way, but a way, through the Bill Pullman or Chris Tucker vehicles I favored. After things soured between us—and these radical gaps in pleasure-taking, funny enough on the surface, must play a quietly corrosive role in such eventualities—Claire was supposed to pick up the screen, return it to its home in North Brooklyn. But at some point, probably months ago, or really even earlier, on the day she cleared this room of everything she truly valued, she must have just decided to let go of it.

I had no interest in revisiting the issue by, say, delivering the screen to her. She could only see my efforts as a pathetic pretext to get back in touch, particularly given the low profile she'd kept in the last half-year, how studiously she'd managed to stay out of my sight, even when I was drawn reluctantly into her parts of the city, or into contact with her friends, especially Karen. Claire had become my shadow, the dark matter of my world, unseen but not unfelt. Perhaps she left the screen to me only because she didn't regard it as hers anymore; memories and eras she meant to shake off might have clung to it, like the IMF project, and me. However difficult I found it to credit, her motives might well have been benevolent. It *had* been my idea to

bring the screen to the Bronx, after all, to watch film with her even though I'd shown so little interest in cinema before. Maybe she thought I'd regained an interest in the medium through the monitor, and she'd rather not disrupt that.

This was the sort of conjecture that could do some good, I knew. So I continued my screening sessions long after she'd gone, often turning to films she would have wanted to show me, the kind she'd dilate on afterward while I would simply listen: features from Slovakia and Iraq and Benin which, for all their craft and color and invention, I had trouble bringing sharply into focus in my mind now. To the global eclecticism she favored, or fell into, depending on how you looked at it, I had from the start of our movie-watching added various American classics, films that seemed to stick with me more easily, if only for being in English, which eliminated the perpetual distraction of subtitles: *Double Indemnity, Night Moves, Bigger than Life.* These, I knew, were pictures Claire instinctively scanned for buried signals, and therefore always held mixed feelings for, all the more, I suspect, because they were proffered by their makers as *critiques* of American culture. I received them rather differently, though I agreed that they failed in creating much critical distance from their objects. Instead, they were of the same nature as that which they represented, and so could be valued and enjoyed as such. Given the global stature of America at the time they were produced, during the country's socio-political zenith, you could say they were quite inadvertently forged in the shape of the entire world, in just the way bits of Habsburg or Mongol or Roman or Mughal culture were, if they were taken from the eras in which those lifeworlds had managed to draw the entire planet into their orbit. This *tenor* is what I responded to in those films. Their critical aspects interested me mostly for the way they reverberated with what was ultimately a parochial spirit—the American spirit—no matter that it had managed to infect all the world. The world has endured many such infections.

After watching *those* films, of course, I was the one who had to do most of the talking. Claire would listen skeptically, eventually realizing, once and for all, that explorations of American vice, or imperial vice generally, even when they were absolutely accurate, simply couldn't engage me, not unless some further conclusion was drawn, something more surprising than that the powerful are prone to misbehave, and that the weak are likely to bear the brunt of this. That's a lesson at least as old as recorded history, and almost certainly a lot older than that; indeed, the word *lesson* is too grand for something so prosaic. On the other hand, coming to appreciate the exact *manner* in which the powerful misbehave in a certain place and time, the specific liberties they thought most worth taking in life? Well, *that* could be exhilarating. Claire came to despise this in me, I believe, this taste for mishappen particulars over smooth principles.

Things changed for me once she had gone. Boredom crept into my viewing. Most feature cinema came to seem to me psychologically risible, and frequently insufferable, at least for more than half an hour or so. I quickly upped the anesthetics in my nightly routine, switching back from Coen to Owen brothers films, and other debased products in which one could catch a glimpse of oneself, not on the screen *per se*—the characters and plots were frequently ludicrous—but in the affect that came over you as you watched: the sense of feelings dissipating like storm clouds, an apprehension of selfhood at one's least mindful. Inevitably, as these films showed me just how flimsy *we* were—that was their magic—they started to succeed slightly too well. After a while, the screen might as well have gone black, the speakers silent, for all the effect they had on me. Something had to be done. And so I moved on from cinema to the deluxe package: first, to pump the dronelike, allover quality of sports television into my life—ESPN1 and 2 and 3 and 4, FSN 1 and 2, the Tennis Channel, MLB Network, and on and on—and second, to interleave my days and nights with reruns of the sitcoms from someone else's childhood: *The King of Queens, Just Shoot Me!, Everybody Loves Raymond*, shows I'd never had the chance or misfortune to see the first time around. Today, though, would mark my return to film, for the first time in months.

10

I signed on to email, ready to relay photos of last night's work to my new employer, only to find that Garrett had already delivered a message of his own around five in the morning. There was no subject heading and the text was brusque, without greetings or names, his or mine, just two hyperlinks—onion links—accompanied by telegraphic annotations.

Follow #32, he'd written beneath one URL, in a miniaturized point size that nearly obscured the injunction. *And the redhead* came after the other link, but in a different typeface, as though the note wasn't dashed off but assembled through cut-and-paste. The phrase *PASS:PASS* concluded things.

I hadn't used Tor in a long while, not since streaming a clutch of Salafi dismemberments that represented speech "of the most radical kind," in the words of an artist I'd known years back who I was in no particular hurry to reconnect with. Since then, though, I always kept the military-grade browser on my computers; that was his lasting impression on my life. I opened up a Tor window, dropped in the first link, and went bouncing blindly around the world through the network's encrypted relays. Eventually I arrived at Antral's servers. A password field hovered over a grayed-out archive of mpeg files, each one named only by its length. After supplying Garrett's four-letter word—what was the point of using an onion domain if your password was this primitive?—*195minutes.mpeg* became mine. The same letters unlocked the other file, *131minutes.mpeg*.

Strange to say, but these inscrutable titles prompted little curiosity in me about the contents of the videos. Instead I basked in the prospective pleasure of duration. Specifically, the professional obligation to spend *five hours* gazing into my titanic plasma. An actual workday was in the offing; it would even divide neatly into two sessions, morning and afternoon. Here was my riposte to my dismissal from the Carrington, I realized with defiant glee. Who *wouldn't* prefer my new job to the last? Yesterday I'd been able to do it downing half a bottle of whiskey, and today my labors would in all likelihood take place prone on my couch. The perks of organizing arts events were nowhere near as seductive.

Through this film session, Garrett had created ideal conditions for sampling the sports drink—passive, spectatorial conditions, I mean. It would be like sipping soda at a double-feature matinee. There was something redemptive about a day with a shape to it I wasn't responsible for imposing.

I put several bottles of Theria in my freezer, which was empty but for the chalky ice-cream sandwiches, imported from Central America and bought at the local bodega, that from time to time *I* depended on for sustenance. I took two bottles with me into my little theater. Lying on the floor against the far wall was a dusty silver laptop, permanently linked to the screen through thick legacy cables. I knelt at the keyboard and felt the sticky, familiar alloy of dust and oil, plaster and paint, on the pads of my fingers. This same detritus suffused the entire room; it's why I declined to make myself any more comfortable there on the floor. I jabbed awkwardly at the keys, which wobbled and squeaked owing to their cartoonish degree of travel. This had once been a desirable ergonomic quality, travel, but recent laptops had forsaken it for the flatness of calculator buttons. This machine was not five years old and already felt like the product of another era, a Remington or an Olivetti, though not nearly so distinguished. It had until recently been my primary unit, but by the time I'd retired it from frontline service, maxing out its RAM no longer offset the incapacities of its motherboard, which suffered mostly from our apparently limitless demands on computing power. I picked up the laptop, leaving a crisp brown square in the dust on the floor, and slouched onto the yellowed couch while the first video slowly loaded.

Finally, I poured the drink, and somehow found this aqueous substance to have hardly any aroma. Pushing my nose deeper into the glass I managed to pick up a medicinal note. Juniper? Elderflower? Elder*berry*? Blind guesses, really. I wasn't on intimate enough terms with any of these fragrances to draw distinctions. No matter: I shut my eyes, inhaled deeply once more, and meditated on the question anyway. Nothing came to me, of course—except the low rumble of marching drums. A fight song. My eyes opened onto a field of green.

Amid that vast expanse, a stream of blue, white, and yellow swept toward the center and struck me hard. These were Cal men, in Cal colors; I knew them too well. As a boy in Berkeley I'd never gone to a game, but I remember big-game weekends, especially against archrivals. Soon, a whooping, leaping red and yellow train emerged from the opposite tunnel: Trojans barreling into the Coliseum. Here was a Pac-12 grudge match, any native Californian could tell you this. The camera panned back toward mid-field as the red jerseys gathered along the thirty-five-yard line, preparing to surge forward behind the kicker, who would lead the way with his one bare foot and his single-bar helmet that always put me in mind of earlier eras, where each player, not just the kicker, wore so little facial protection that his identity might be known to all at a glance. Today, of course, a football player was nearly an android, a veiled homunculus buried deep within a raft of high-tech gear, seeing only through the chinks in the metal grating encasing his visage, which was

further shielded by a polymer visor, the kind Garrett was beginning to manufacture. Probably some of the players onscreen were wearing his prototypes.

The commentators had already begun to blather, using those peculiarly torqued voices that abound on television and radio. I was tempted to mute the screen, as it so often was in my childhood: a preference of my father's. You could barely see the game, he'd say, or hear yourself think, with all these media personalities manhandling your attention. As if you couldn't find your way around on your own. For the moment, though, I let these voices have their say, in case they were relevant to Garrett's purposes. Just before kickoff, the camera cut to the booth and the two men made chummy introductions. The color commentator was a washed-up quarterback, I knew, a mere game-manager whose acquisition of a Super Bowl ring had been serendipitous in the extreme, in that *anyone* quarterbacking the Ravens that year would have got one, and not just the ring but all the spoils that flowed from winning a title, including media gigs like this. All I could wonder as he rambled on was just how he'd gotten this fat so soon after retiring. Nestled beside him in that cramped space was a journalist of an altogether different rank, a storied California play-by-play man I didn't even need to see to recognize. His cadences were so distinctive, indeed so instinctively pleasing, they managed temporarily to expel his underachieving partner from my mind.

Back on the field, slanted amber rays collected in the stadium like felled pillars, one on top of the other, turning Pasadena red-gold as their kicker launched the ball deep into the sky. Cal's returner dropped back from the goal line into the end zone, sensing the cleanness of the strike, but the ball sailed over his head just the same. The whistle trilled and the Trojan gunners shortened their strides like sprinters just past the line, while the returner trotted toward the sideline with a strangely gloating air, as if he'd furthered Cal's cause without even getting a finger to the ball. The camera cut to an aerial shot of the field, an aggressive hard-rock riff buzz-sawed beneath it, and the everything faded abruptly into a Pontiac commercial with an unlikely operatic score. Schumann, possibly. Garrett's staff must not have bothered to take the commercials out, I thought, even though it would have been simple enough to do.

This must be why he'd asked me about football at Antral's headquarters. This video. It was true, what I'd told Garrett. My knowledge was rudimentary. I never really *watched* football, not properly. Generally the games remained at the edge of consciousness, even when I was staring directly into the screen, as I had over these last months, doing little else but dwelling and drifting in thought. Sports were more or less like background music to me, with one difference: I strongly preferred *live* matches, for the close companionship real time uniquely produced—the kind you may have with, say, an upstairs neighbor you never meet face-to-face but still hear regularly through the ceiling, day and night. With live television, the screen

effectively becomes a window between two coordinated spaces, not something you look *at* so much as *through*, giving access to whatever is there, in the studio or the stadium, at the very moment you are looking. Really, I suppose the screen is more like a telescope than a window, an instrument that positively enhances the powers of the eye, collapsing space but not time.

In any case, through all these hours of observation, careless as they were, I must have picked up quite a lot about football. No other hypothesis was tenable. Yet it was knowledge of a sort that always had to be jogged, that is, called forth by other experiences. If, in a bar, I overheard patrons discussing a particular player, a dossier's worth of details about him would spontaneously assemble in my mind. And if no one had mentioned the athlete's name? I would have had no hope of recovering that information, intricate as it was. How much of anyone's understanding took this fugitive form? How ignorant might we appear, to others and ourselves—how ignorant might we in fact *be*—if not for these chance spurs to memory the world routinely offers up?

Up until the last few months, my knowledge of football had been acquired almost entirely by osmosis, through chronic exposure. The game had graced our television often enough, growing up, for me to have absorbed the essentials, even if the deepest, tactical elements eluded me. Ty of course was a bona fide fan, he *watched* the game, whereas the rest of the family merely heard it through bedroom walls, or saw it while passing by the living room sofa, catching it only in snatches. For my part, I found real pleasure not in the game but in watching Ty watch it. Usually I would be sitting in the breakfast nook, a few yards behind him, observing his head in quarter-profile while his eyes tracked movements on the screen. Whenever he stirred from that affectless trance common to spectators, I would follow his line of sight and share in whatever it was that had triggered the disturbance in his aspect, whether a grimace, an exclamation, or even a laugh.

My mother would play this game with me, too. Any excuse to gaze at her two boys, and to understand their respective pastimes. At first Ty would react self-consciously to the careful study we were making of him, unsettled by the meaningful looks I exchanged with our mother, but after a time he seemed to resign himself to our scrutiny. Which was important, actually: much of what I know now about the human face, its fluidity and fungibility, came to me first through observing my brother in this recurring scene, though somehow I never once thought to draw or paint it. There'd been no need.

I found his fandom puzzling, really. He couldn't have picked it up from our father, who quietly derided all serious interest in the playing of children's games by adults who'd failed to outgrow the habit, and moreover were magnificently reward-ed for this failure. It was the fans who arrested the players' development, with real

human consequences, he thought, given how poorly the bulk of players did in their retirements, losing their fortunes on half-baked business ventures or obliterating their minds with high-grade pharmaceuticals. They were thirteen-year-olds suddenly expected, at thirty or thirty-five, whenever the end came, to act their age. Anyone would flounder, my father pronounced.

Even in a sports-hostile environment, with all my parents' talk of Parkinsonism and traumatic brain injury, Ty developed a lasting attachment to football. Given his logical, linear bent—strong enough to take him through an engineering degree at Caltech (which my father, normally quite restrained, couldn't help but gloat about sometimes, that he'd had a son *that* smart) and on to a consulting position at Bain— Ty thrived down in the thickets of the game, where my appreciation didn't extend. He took me for a philistine on this front. Whatever it was I was seeing in the game, he'd say, the surface stuff, the crashing helmets, the broken bones, it hardly mattered at all; the real interest lay far deeper, at the nexus of calculation and chaos. It was in working to distinguish these two factors in the game, what could be controlled and what could only be observed in awe or terror, once the ball was snapped and the men were in motion, that the devotee's pleasure was to be found. I'd never tasted this, though. Maybe in paintings, but not here.

On Sunday afternoons and especially Monday nights, football played out on the television while life carried on in the rest of the house. Usually my father would be occupied with intellectual property, his legal briefs. Doubtless he spent some of this time pining for the downtown offices of his firm, and not just for their conducive-ness to work. No, I suspect he also longed for breathing room, some refuge from the household, and particularly from my mother, who could be more than a little unpleasant while preparing lectures for her University of San Francisco classes. You couldn't help but pick up the resentment. Professing reminded her that she was no longer a proper participant in the art world, a shaper of its substance, only one more teacher of unimpeachable pedigree standing on the sidelines. She'd had to step back from her curatorial practice because my father's career in law had required it, at least in her mind, though I think we all knew the deeper obstacle was her disillusionment with professional art circles, her difficulty in rising through the ranks at the Getty. No one dared remind her of it, though, out of both fear and tenderness. She'd learned about my withdrawal from Hinton, my unhappiness with most existing places of exhibition. Yet she had no real response to it, which I found odd, and telling, too. She must have seen a part of herself in me. But did she see a part she was *proud* of? And was she rooting for me to succeed, or simply to turn away and become, say, an administrator at the Carrington? She was inscrutable on these matters, distressingly so. But then, I generated complications for her that Helena and Ty never could.

So what exactly was I doing in those early days? While Ty watched endless games on the set, I was mostly sketching my way through reams of paper. Most of these pictures went straight into the garbage. For even then I realized that my work, like my mother's, was merely prep, though for a day that was still years away. I have retained almost nothing from that time. No juvenilia survives, I destroyed it all so quickly. I suppose I was already thinking of the record.

After spending a decade in Los Angeles, when I was still just five or six and only beginning to come into my own, we moved to a nice house with a small yard just outside San Francisco. My father was relocated there by his firm, and not exactly with his blessing, though the position he took up was a plum one. Still, it mattered that it wasn't his choice. It's why my mother couldn't properly resent him, only fate, the larger patterns of life that no one can govern. And if it had been up to him? I'm not sure what he might have done. Easy to say now, of course, that he would have remained in Los Angeles, supporting my mother's stalling career. In fact I think he might have still pushed for a move, for *her* sake, to get her away from an established order of art in the habit of humiliating its own.

When I was a bit older, we moved to the outskirts of Berkeley, which not only granted us a more expansive home (and yard) but satisfied my father's need to be closer to a serious law library and intellectual hub, away from the crass tech overrun of San Francisco, which he seemed genuinely to despise—the personalities of that culture, specifically—even if much of his business involved the patents and copy-rights surrounding digital technologies. This migration within the Bay serendipi-tously conferred on Ty and I the right to root for either of the area's two NFL teams of that time, the Raiders (then in Oakland) or the 49ers (still in San Francisco). The latter squad surged to the forefront of my mind now as I studied USC's colors on the plasma, colors that differed in shade but not hue. Given our earlier residence in Los Angeles, I suppose I might have had a right to root for them, too, if only they weren't playing against Cal.

These days another professional California team, the Los Angeles Rams, bore Cal's blue and gold. Even my father watched the Rams, from time to time anyway. Generally speaking, he could put aside his broader misgivings about football—he was strangely coy about their full extent—plunk down next to Ty on the sofa, brief usually still in hand, to take in the fourth quarter of almost any close match, just so long as it involved at least one team from Los Angeles, the city where his life first took flight—his career, his wife, his kids. The Bay would never compete: he'd already established his fundamental arc by the time he arrived there, which meant, given the bond between memory and adversity, that his richest recollections would always be tied to the city of angels, where everything had still been uncertain. He and Ty parsed

the game with the same analytical cool. I could see this in the steadiness of their gaze, discreetly sizing up goings-on. It was this gift for objective appraisal, surely inherited from our father, that made Ty more of a football aficionado than a fan. Fans, after all, were almost definitionally partisan. But Ty followed the Raiders *and* the Niners with equal avidity. He was loyal only to great football, whichever team—it needn't have been a Californian one—happened to produce it on a given day.

By now I was profoundly familiar with intrastate rivalries like USC-Cal. No one could grow up in America innocent of football, even if you never actually watched it yourself, no more than a Brit could be oblivious to soccer. It ran too deep in the culture not to reverberate through it. But my early steeping in football put me, unlike many of my art school friends, in a position to draw pleasure from the game whenever I found it playing out in front of me; whereas any enjoyment they took in it came freighted with self-consciousness, which invariably contaminated the experience. Often enough their appreciation had an anthropological quality to it; yet from an outsider's standpoint, I knew, the substance of the game was effectively invisible.

Luckily, I was primed to experience football in an easy, half-conscious sort of way, which was the very way most fans took in these three-and-a-half-hour spectacles: with a domestic beer or five. Football seems more or less reverse-engineered with beer in mind. The tenor of alcohol—every substance has its own—meshes with the game on a constitutive level, particularly the creeping drunkenness brought on by low-point drinks. It's no accident that football began to displace baseball as America's pastime not long after the country rose to superpower status. As a cousin of cricket, baseball was essentially a gentleman's sport, a poor fit with the tough's role.

Today it was going to be up to a sports drink, not alcohol, to get me through the entirety of a game, which was back in my sights after Pontiac and Chevy and All-State and Raid and Nabisco all put in appearances during the break. Who was I supposed to be looking for, again? I checked the note from Garrett on my phone. Number thirty-two. Bear or Trojan, though?

The first huddle broke with a clap and Cal's offense began arranging itself along the line of scrimmage. Immediately I could see *a* number thirty-two. Briar was the name, stitched in blue right above his number. I was sure I'd heard of him on SportsCenter, having watched so much of the program these last months that even minor subplots in college football had little chance of escaping my eyes and ears. Briar trotted languidly to the far side of the field, right near the sideline, lining up at receiver. *An undrafted wide-out in search of a contract*—that was his story, wasn't it? I could see he wasn't much bigger than his defender, strong evidence of a modest stature, given that cornerbacks are nearly always diminutive. It's *why* they're cornerbacks and not receivers themselves. That and a lack of the soft hands needed

to reel in the ball. No wonder, then, that the antipathy between pass-catcher and coverman runs so deep, why so many fights break out between these counterparts and not, say, between linemen, where there is no implicit disparity in talent, no second-class citizenship.

The Trojans nudged their safeties up close to the line, threatening to blitz, but Cal's quarterback, Henderson, audibled out of the play-call and reset a few steps back, in the pistol formation. They ran a simple power draw to the left side, the running back, Fonseca, crashing through the line after the shortest hesitation, straight into the arms of Cal's middle linebacker, who casually spun him to the ground. A three-yard pick up, on one of those archetypal plays executed a couple of dozen times a game. You'd have to know the sport uncommonly well to differentiate this particular run from all its relatives, the way the commentators tried to. How many fans could actually do this? Could understand what was meant by *A-gaps*, or *overloads*, or *stunts*? And did it even matter? I'm not at all sure the intensity of your fandom had much to do with such minutiae. Mostly you just skipped over this sort of sporty technical talk, even while being reassured by it, to wit, that the events transpiring were more controlled, more skill-driven, than they appeared to the untrained eye. What you were watching, it appeared, was more than simple violence: it was *organized* violence, pain with a point, which made all the difference. You were witnessing strategy, not savagery, even if it was the latter that was responsible for your tuning in.

Second and seven. This time Briar was the man in motion, jogging down my screen toward me. Henderson, a moderate talent who'd had to wait till the third day of this year's pro draft to have his number called, took the snap out of the shotgun, but the Trojan nose-tackle immediately bulldozed his center, forcing the quarterback to fling the ball toward the sideline. His target, if he'd had one and wasn't merely avoiding the sack, had to be the back shoulder of forty-four, Hilliard. Here was a wideout of more conventional proportions, not undersized like Briar. The first thing I noticed about him were his exceptionally long arms, arms so long his hands nearly reached his knees when he'd lined up in formation, waiting for the snap. He slanted out farther toward the sideline now and used every inch of that reach to corral the errant ball, right on his fingertips. I'm not sure how he managed to decelerate so sharply then, keep himself from crashing out of bounds, which is exactly where his counterpart ended up, spilling past the sideline having only barely grazed the receiver's helmet.

For a moment, forty-four seemed to freeze in place on screen, studying the fallen man. Then he was moving at full speed again, racing toward the goal. Another defender—number twenty, Khaleel Barker, free safety, the commentators would later elaborate—had good position and rapidly closed on him. Barker seemed certain to

force Hilliard out of bounds, if the receiver expected to avoid a brutal shot. Hilliard slowed, as if recognizing the choice facing him and considering the matter. The safety adjusted his angle of attack, but Hilliard kept jogging forward, refusing to step off the field and save himself from the blast.

Barker was almost on top of him now, Hilliard's fate looked to be sealed, when a blur of yellow and gold broke in from left of frame, directly into the Trojan's chest. Barker crumpled on impact; forty-four, proceeding untouched down the sideline, couldn't help rubbernecking. No one could blame him. It was one of those collisions—cataclysms, really—that happens two or three times a game, where you have no idea which of the parties involved will come out worse for it, the impact is so severe. Moments later, with Trojans distantly trailing him, Hilliard arrived in the end zone. Fourteen minutes left in the quarter and the score was already six-nothing.

This is just how college football goes. Big plays rule, plays that depend less on brilliance than incompetence. It's why I prefer the pro game. The missed tackle on Hilliard, just after the catch, where he might have been stopped for a two-yard gain, was the first of several blunders. Hilliard had applied only a perfunctory stiff-arm to the cornerback; nevertheless the Trojan sailed past him—past the sideline, too—and sprawled violently to the ground. Then there were the lapses of the other defensive backs in the vicinity, who'd been far too slow to react to the catch, or probably just assumed the tackle would be made by someone, anyone, other than themselves. Finally, there was the misjudgment of the safety, Barker, who should have met Hilliard at the sideline and channeled him out of bounds or forced him back into the interior, where he would have been easily brought down by the rest of the defense. Instead, Barker opted for the straightest line of attack on the receiver, who baited him with that insouciant little jog, buying time for his blocker to arrive. Smelling blood, the safety fell right into the trap, and got buried by the Bear he saw too late.

It *was* a phenomenal block, a brilliant bit of improvisation. The broadcast lavished attention on the end-zone celebration, the Cal players cracking their helmets together and tugging on Hilliard's face-mask with worrying force. Only later did the camera bother with Barker, who remained prone on the field at the site of the collision. By this point, several players from both teams were leaning down over him, patting his shoulder pads in pro-forma consolation. Medical personnel knelt beside the safety—the resonances with classical art were unavoidable—and in the end Barker managed rather dutifully to wiggle his fingers, even lift one of his legs a few inches off the ground.

The feed kept cutting away from this poignant scene, almost shame-facedly. But the lens couldn't help being seduced—rather obscenely, though what is football if not

sublimated obscenity?—by the instigator of this medical emergency: thirty-two. *That was Duke Briar's touchdown, really*, said the aged quarterback confined to the booth. Since USC tradition dictated never using names on the backs of the jerseys, it would have made more sense for Garrett to single out a Trojan solely by number, not a Bear. But after that block, all else was far from equal. It was Duke I was meant to see.

While his teammates had sprinted to the end zone to join Hilliard in celebration, Duke had apparently gone straight to the side-line. The camera framed him on the bench, a towel wrapped around his head like a hijab, with his helmet by his side. On his other side were three pylon-orange kegs of Gatorade, in front of which a procession of teammates formed. Each detained Duke only briefly with a fist-bump or sharp slap of the head or shoulder, all to salute this block to end all blocks.

The celebrated man was not especially handsome. His features were sharp if somewhat unhappily delicate, given his vocation, especially those liquid almond eyes that carried the quality, anyone could recognize this straight off, of the quickened mind. A calm one, too. Calm, indeed, *because* it was quick. Duke could see, as Barker could not, just what was coming, I speculated, including perhaps these very congratulations, which he accepted politely but without the usual vim of a football player who'd just made a defining play, offering only shallow nods and the weakest slaps of hands. By this I mean he merely extended his hand, palm up, and left his teammates to do the slapping (many obliging, to be sure, with magnificent force). He didn't need to run hot to get through a game, not like the other players. *They* were manic, and always on the edge of violence, so that exultation couldn't be prevented from descending into mild forms of mutual battery.

As the play-by-play man noted, Duke was also a native son, an Angelino returned home, which explained the ovation he got from the crowd when he'd gone up on the jumbotron, despite his just having demolished one of their Trojans. There were boos amid the cheers, of course, it would have been unseemly otherwise, but the jeering simply confirmed the fans' attachment to him.

Hilliard, the one who'd actually spiked the ball and scored the points, finally dropped onto the bench beside Duke, or rather Duke's helmet, which sat stolidly between them. Forty-four said nothing, he just looked out ahead into space aloofly, drawing from Duke the intended response: a soft smile—his first definitive reaction since laying the block. Yet the smile seemed otherworldly, its meaning only incidentally related to the game.

I thought I saw the two players' lips subtly moving then. I wondered about the backstory that made possible such a muted exchange, so uncharacteristic of football. I wondered, too, who was the true star receiver between them, or if the pair were, as occasionally happens, genuine equals. One thing I was sure of: at well over six-feet

tall, and with that long galloping stride he'd shown on his way to the end zone, the kind greats like Randy Moss and Calvin Johnson had flaunted, Hilliard had the look of an alpha, one who'd go on to deliver an NFL team a thousand-plus yards a season on a regular basis—if of course he didn't suffer the sort of catastrophic injury Barker had intended to inflict on him. Somehow, though, even this stud receiver evinced a circumspection bordering on reverence toward Duke.

The fans crowed, no hisses at all this time, and the camera cut away to its cause: Barker finally found his feet. He used a pair of white medical staffers like crutches, one small man lodged under each of his arms, to cover the first half of his trek to the sideline, before going the rest of the way on his own, even galloping a little toward the end, not out of jubilation, I thought, but simply to get the feeling back into his lower body. He shook his head widely and wildly, as if offering a vehement *no* meant to be visible at one-hundred yards, though really he was stretching his neck to confirm that it hadn't been broken. Just minutes before, when he'd first been knocked to the ground, there'd been reasonable fears of paraplegia. Now it looked as if he wouldn't miss a snap. What a picture he made, dancing to the sideline, shaking off fate. It had missed him by a hair's breadth, this fate several players suffered each decade: to walk no more, much less to run.

Commercials intervened again. If football seemed reverse-engineered for the consumption of beer, I thought, it was even more perfectly designed as a vehicle for marketing, frequently heavy with the same digitally generated imagery that Fox and ESPN used during their broadcasts, all those abstract metallic backgrounds shifting and glinting in tribute to some sort of masculine futurity, while the announcers confidently strode in front of them in their light brown shoes and procurers' suits. Full-body shots prevailed these days, with not even a desk between viewer and presenter; the on-screen talent seemed almost to float in virtual space, as meteorologists had for decades. Fox, perhaps unsurprisingly, pushed things furthest in this direction with their android football-player avatar. This machined man looked very much like a Transformer, a version of Megatron perhaps, given the sullen menace he radiated as he bent and stretched his limbs, warming up for some cybernetic football game whose kickoff was scheduled for next century. Sometimes, particularly during intro and outro segments, this football-Megatron with glowing red eyes would pound his fist in his hand, looking ready to hurt something. And since he was staring directly out at the viewer, the only conclusion you could draw was that, whatever it was he had planned exactly, it was *you* who would be on the receiving end of it. In the presence of this android—or was there still some trace of wetware within?—I always felt as if I were being implored to drink, that intoxication would ease the pain of the beating I was about to take, the spectacle I was going to join, and smooth over

the disjunctions emanating from all that CGI: those textureless digital interludes, backgrounds, and superimpositions that seemed to bleed into the live footage of the game itself.

Before the match returned, I held up the bottle of Theria by the neck and peered through its marine tones, tones that made me imagine this liquid might have been siphoned out of some remote lake in the wilds of Alaska. With their saturated chemical hues, Powerade, Body Armor, and Gatorade made a very different impression, even if they aptly symbolized what athletics had become: a biotechnological affair, a physics experiment. I took a good gulp and, happily, the sense of wildness persisted. There was, again, the medicinal, jammy note I'd smelled, and my confidence grew that elderberry was indeed responsible for it when I realized that Burleighs, a favorite gin of Claire's, used the same fruit to great effect. But in Theria this was coupled to an edge, just as Karen had suggested. It wasn't a matter of simple tartness or sourness. John was wrong about that, though I don't know how seriously he was taking any of it anyway, at the point of his first sip. He'd seemed keener on irritating me with his bluster. Whatever it was, the drink certainly owned a sharp, pungent, not unpleasant bitterness.

Just as I said this to myself, though, I took another drink and rather sheepishly had to concede something to John's description. Perhaps it really *was* just a sourness here, pure elderberry, nothing more. That's what the second swig suggested, anyway, contradicting the first. I held up the bottle in front of me again—something I'd end up doing frequently with this bewitching drink—as if holding it so might help me penetrate its mystery. The sum of the two swigs, taken so many seconds apart, had seemed to result in an unalloyed tartness, whereas one swig alone registered as bitter. It clearly *had* been bitter, hadn't it? And had John deemed it sour after his first or second taste?

Though the game had returned to the screen a little while ago, only now did it come to the fore of my awareness. Lost in the puzzles of the drink, I'd effectively missed the Cal kickoff. A mirror image of what had come before unfolded in front of me now, with red not white holding the ball on their twenty. From here the déjà vu ceased: the Trojans bypassed a simple draw for something exotic, tricksy, even effeminate by the reckoning of diehards (cleverness wasn't smiled on in the game). Besides a faked kick, it might have been the only gimmick play I knew by name and could recognize on sight: the flea-flicker.

O'Leary was under center for USC. Unlike Henderson, he was an elite prospect—USC had long been a quarterback finishing school—destined to go in the top five of the draft. He took the snap and tossed the ball to a running back. Just before reaching the line of scrimmage on the right side, the runner pitched the ball back to O'Leary, who, however, had two defenders harrying him by this point. The

line had crumbled, so that as soon as the QB caught the ball and began searching upfield for a receiver—and there was one streaking down the sideline unattended, just as he'd hoped—a Cal blitzer swept O'Leary's legs out from under him on a play you suspected was designed to snap ligaments. What's a roughing penalty next to knocking a quarterback out of the game, or even the season? O'Leary's teammates seemed to be pondering this question. Naturally a scuffle broke out.

I returned to the drink as the referees separated the players, all deeply engaged in the elaborate pantomime of a fight that was nearly always a bluff on both sides. In the finish I discerned a burgeoning sweetness. Vanilla? I took a third taste, several contiguous gulps really, though they were so closely spaced you could have called them one. The sting came out of the sourness as the vanilla bloomed.

When I talk of vanilla or elderberry, I should say I am speculating on the actual composition of the drink, not what the drink's taste might resemble, which was the connoisseur's modus operandi: reaching for metaphors, that is, not facts. But was my way, finally, any more sensible? I was no more an epicure than I was a chemist. And in any case it wasn't my *job* to distinguish the drink's elements so much as grasp it as it was and transpose the whole into a visual register. That the substance had to be broken down before the transposition could be effected was mere analytical presumption. Ultimately, finding analogues doesn't depend on being able to take things apart; it might well get in the way.

It was becoming plain to me that Garrett's brew was truly protean, refusing to resolve into any one flavor or arrangement of intensities on the palette: even to the nose it seemed kaleidoscopic. I sipped the drink and gazed into the screen abstractly—as one was meant to, really. A football game is too long, too full of incident, to really sustain attention, except perhaps the last half-quarter of a close game, which anyone knows can be ecstasy. USC picked up two first downs before the drive stalled and the special-teams units trotted out onto the field. They were set to punt, and who should have come back to return but my thirty-two. He was emerging as an all-purpose player, a Percy Harvin, Tyreek Hill type, though Duke blocked more like another receiver I'd always held dear as a child, for his venom: Hines Ward. There'd even been a special rule, hadn't there, implemented to protect players against his predatory tactics? I could have texted Ty about it, he would have known.

Hoping to pin Duke back with his kick, the punter put a lot of air under the ball, so much that it disappeared into the lights and soared off-camera, above the stadium. When it reappeared in the sky it was coming almost straight down on Duke, who was planted just inside the ten-yard line. The ball had nearly made it down to him when the defense arrived. At just that moment, he offered something like a low, truncated wave of the hand, I couldn't quite tell if he meant anything by it. It was as if he were

unsure whether to bail out of the play with a fair catch—the sensible choice—or grab the ball and try to spin away from his pursuers just before impact. In the event, the ball reached him in the same instant two Trojan gunners did, the catch and the tackle coming so close together that I experienced them as a single event.

The hit was so crisp, so sharp, it jarred me, straight through the screen, the crunch of those helmets deep in Duke's chest. Why no targeting penalty was called, no one understood. Then, for once, the commentators fell silent. What was there to say, other than a prayer for Duke? A freeze-frame of the three players in a pile would have given you a good idea of mortality. Slowly, the Trojans got to their knees, revealing the Bear beneath. Evidently the two of them had paid a steep price for the hit, crawling around on all fours and grasping the backs of their necks rather than celebrating their work. It was no ordinary hit, of course. This was revenge—for Duke's block on Barker, a play that quite naturally put a target on his back for the rest of the day, and therefore made it genuinely perplexing as to why he didn't take the fair catch and save himself the trouble. Even the two gunners would have thought he'd never give them such a sublime opportunity for vengeance. I suppose Duke might have assumed mere rules weren't going to stop them from retaliating. Best, then, to take a shot at the punt return, even if it was only a most fanciful one, the kind you'd need to be able to freeze time to bring off.

After the two Trojans hauled themselves to their feet, they stood over Duke and peered down at him. With menace or glee? The helmets made it impossible to say. But when Duke didn't move, not even a little, the Trojans were right back on their knees, checking on him. You wanted to anguish your opponents, absolutely. You wanted them to feel the psychic force of physical pain, the inner burden that carrying it the rest of the game involved. You wanted, in short, to torture them. But you *never* wanted to injure them, not if you had the spirit of the game in you, anyway, which was sometimes a question you had to ask yourself, after plays like this: what *were* you trying to do exactly, what were your hopes here?

Medics raced once more from the sideline—their job seemed to center on this little sprint—though this time they were Cal's. Long before they could sweep the Trojans out of the way and give succor to Duke, and long before other players could begin to put down one knee in tribute, with their helmets in their hands, the victim's eyes flared so brightly you could see it through his mask. His revival got the gunners back to their feet, all their solemnity converted back into the gentle scorn inherent to competition. Duke raised his already splayed arms from their places on the ground, up toward the Trojans, and the crowd rumbled.

A moment's hesitation and the rumble turned threatening; the Trojans were being shamed into action; they grudgingly clutched Duke by the forearms and ratcheted him up to his feet. As soon as his arms were free he slapped one of them on the

helmet and banged heads with the other. All was forgiven. The arriving medics want-ed Duke to hold still while they assessed him. Too late: he was already jogging to the sideline—a bit gingerly, of course, but surprisingly well for someone who'd just gone through what he had. Meanwhile the rest of Cal's offense strode onto the field to start the drive from the eight-yard line.

I polished off the bottle of Theria, relishing the puzzle of its flavor, the way it held in suspension the classical dimensions of taste—salt, bitter, sweet, sour—so much so that I was overlooking the real breakthrough Garrett said the drink had made, which had little or nothing to do with its taste. Still, might its action on the tongue carry some clue to its bodily effects? Garrett hadn't said otherwise. Which left me to wonder.

Third and ten and the Bears sent in Duke, who'd just finished having flashlights shone in his eyes and fingers waved in his face by the medical staff. The offense ran an option to the near sideline, with Duke attracting what looked like a *triple* team on the other one. Henderson found a seam and hit a wide-open Fonseca out of the backfield for twelve yards. This was the beginning of a succession of first downs, the yards com-ing off screen passes and check downs and crossing routes, short- and medium-yard plays the Trojans ceded to seal off the deep threat posed by forty-four and thirty-two. Finally, the defense loaded the box, eight men on their own thirty. Duke ran a go route—a foot race with the corner, effectively. The coverage was tight, the corner was quick, and Duke's straight-line speed was manifestly modest, his short strides failing to create separation from his defender; worse, the safety came in over the top to give help. None of this deterred Henderson. But as the ball came out of his hand, you could see from the start that it was underthrown, with too much loft. It might even have been deflected from behind by the defensive end who got to the quarterback just after he delivered the throw. The result: a jump-ball scrum between the safety, cornerback, and receiver, just in front of the end zone. It was strange to see—I wondered if the drink was affecting me then—but Duke, though no taller than the other two, seemed to me to rise at least half a head higher; not only that, as with all great leapers, he held his apex longer: while the Trojans were already headed back down, he somehow floated there, clasping the ball and tucking it just beneath his chin. Only then did he drift earthward and crash upon the bodies of the other two.

I sat, mesmerized.

The rest of the tape would show this soft rainbow throw of Henderson's to be no mistake: there hadn't been any deflection. No, this was actual team strategy when it came to thirty-two: Duke may have lacked elite speed, but his capacity for *vertical* separation was simply eerie; it made me doubt my eyes and, naturally, wonder what exactly was in the bottle in my hand. For on any play whose success depended on the

leap or the quick cut—the diving catch, the crushing block—Duke was visibly the best on the field. Even double-teamed, if the ball was lofted high enough, or thrown off to one side far enough, back-shoulder, near-shoulder, Duke would get there first. Yet the quality of his leap was only part of his gift. There was also his aptitude for the airborne scrum, the same skill the great rebounders have in basketball, this nose for where the ball will ricochet through all the limbs in the air.

Duke rose now from the pile with the ball's tip planted in his palm and quietly placed it on the hash mark where he'd landed. A twenty-eight-yard catch. Bears were crashing downfield in a rising wave of celebration. Yet Duke shrugged them off on his way back to the huddle. They took the rebuff well, I thought, contenting themselves with congratulating each other while their receiver thought only of the next play.

I, like them, was still lost in what he'd just done.

First and goal from the two. The Trojans played the run but Cal swung the ball out to Ellesnic, a scrawny tight end with bony hands that looked like they might shatter when Henderson's firm ball found them. But Ellesnic held on, and after tip-toeing into the end zone over the bodies of fallen Trojans, he merged into a frenzy of Bears. Duke, who decoyed on the play, drawing two defenders away from the action, stood patiently to one side, helmet in hand, looking almost philosophical, or just bored: who could tell? He checked the jumbotron several times, but that might have been a way of discreetly gauging whether the party was over yet. Eventually Ellesnic freed himself from the chaos and Duke took him on a quiet amble to the sideline. As the camera zoomed in on them, I could see Duke mouthing something as they went. He seemed to have a lot to say, actually; he was almost delivering a talk, without obvious affect or inflection, positive, negative, as if nothing of gut-level significance had just occurred, as if it were all merely an occasion for reflection. Ellesnic's face, though, was very much animated, and mostly by violent bemusement. Not the kind of thing one usually sees after a touchdown drive, the commentators noted with a nervous chuckle.

As they reached the sideline Duke split off from Ellesnic, taking up his familiar place on the bench near the kegs and settling his helmet next to him with as much care as he'd offer an old friend. Coaches approached. But before any could reach him, he wrapped his head in a towel—not the usual drape over the back of the head and neck but an eccentric sealing of the face, as though total sensory deprivation were his aim. A couple of coaches shook their heads and smirked. Another pursed his lips. All of them kept their distance.

With Duke on the bench and Cal up fourteen-nothing after the extra-point try, I turned back to the drink. What *had* I noticed about it so far? What did I notice about *myself*? Only fifteen minutes had passed since I'd taken my first sip—four minutes, if you

went by the game clock. Searching my mind I discovered little of significance besides the general sense of quiet exhilaration induced by Duke's play. Maybe I was looking for the wrong things. What mattered, perhaps, was not what the drink did to *me* so much as what it did to *the world in my eyes*. That world, the world of the game, well, so far it had been... odd. Might the drink enhance this sense somehow, bringing curiosities to the surface? Or could it well have the opposite influence, and make the game seem *more* intelligible than it otherwise would—by which I mean, could it accelerate my uptake of its patterns, which would give one the feeling of the world slowing down? Yet wasn't this a question of response times, an empirical matter, not something introspection was specially equipped to detect? Enhanced rates of reaction: that would be a quality of real use to an athlete, the prime customer base for Theria. Really, though—and I knew this was important to Garrett and the drink's wider prospects—seeing things at immense speed, comprehending the world's complexities all in one go rather than serially, could be of use to anyone. How far could things be taken in this direction? Could one's attentive capacities be so greatly amplified as to bring the world nearly to a halt? Would this even be a *desirable* quality, outside the context of a sporting match?

The more of Garrett's video file I watched, the stranger things got. But everything fanciful, everything grotesque, too, appeared to spring not from the recesses of my drugged mind so much as from the object of my consciousness, this taped football game, which was to my reckoning blatantly over-rich with extraordinary moments. In the first half alone, there were, by my count, five interceptions (two pick-sixes), a kickoff returned for a touchdown, a blocked field goal *and* a blocked punt, not one but *two* safeties, and four scores of over fifty yards. Even for college football, this was freakish eventfulness.

Two of those scores were Duke's, including one just before half-time, with Cal up twenty-one to ten. Duke caught a lateral from Henderson and managed to shake three separate tackles, using that unreal burst, raw strength, and the fabled and unanalyzable quality of elusiveness every scout dreams of. He took it nearly seventy yards down the sideline for the score, flanked by a convoy of blockers who saw off all threats. Even then, with such total security, there were no celebratory antics from him along the way: no goose-stepping or turning back toward chasing defenders, no deceleration even as he crossed the goal-line. His way just seemed so out of character for the game I knew—so *measured*.

He also scored on an eye-watering ninety-eight yarder, a kickoff he took all the way back that must have felt to him like recompense for the punt return that had left him unconscious. This time, he had more space to operate with, and wending his way down the field he must have juked a half-dozen players, putting me in mind of Maradona more than any American footballer.

In between these touchdowns, and this is where things became especially strange, he was penalized for taunting a defensive lineman, though it was done in a manner so genteel—invisible to the cameras even after multiple replays—that it left the broadcast booth perplexed as to what the referee might have seen or heard. Duke hadn't touched anyone when the flag came flying out of the referee's pocket, and his lips had barely moved after he'd pulled out his mouthpiece. Perhaps his jaw had shifted slightly, or he'd ground his teeth, that's the extent of what replay established. All you saw for sure was Duke, right after throwing a low but legal block on USC's middle linebacker, brushing past the lineman on his way back to the huddle. Maybe he'd also mouthed a couple of choice words, though without even looking at him; the lineman's sharp surprise implied as much. Duke didn't protest the call against him. Perhaps he had history with the lineman—this was the play-by-play man's proposal—and knew he was already on a short leash with the referees. He merely stared at the twist of yellow cloth not far from his feet, negating an eight-yard run for a first down, this phantom affront, which almost certainly cost the team points by pushing them out of field-goal range.

All of this is to say, if there were a single origin to the aberrations riving this game so far, it had to be Duke. He was behind, or anyway hovering around, most of the bizarre or transcendent or bizarrely transcendent moments of the first half, the terrible blunders as well as the demonstrations of consummate skill. And his involvement didn't actually end with the Cal offense. I noticed partway through the second quarter, when I wasn't much paying attention, since the Trojans had the ball, that Duke was somehow *still* on the field, on defense, lining up at cornerback. I don't know exactly how many snaps he took like this, maybe half-a-dozen, possibly more, since I must have missed some before grasping his dual assignment (triple, really, given his return duties on special teams). Cal was cycling him in to cover one particular receiver, Creighley: the two were always lined up opposite each other, out wide, on the edge, or else in the slot. Duke played corner brutishly, grappling with Creighley, his taller, slenderer opponent, bumping him off the line in those first few yards from scrimmage, one time with such force it actually knocked Creighley to the ground. On some plays, Duke appeared badly beaten, overmatched. But thirty-two had a way of launching himself toward the ball at the last moment, just in time to slap it away from his counterpart. The first few times you saw it, it looked like an emergency maneuver; the results must have been lucky. Yet over time it emerged as a skill, and what it meant for opposing quarterbacks was ominous: you didn't have him beat quite when you thought you did.

The second half of the game played out faster than the first, giving the lie to all speculation that Theria, which I continued to swig with increasing frequency, slowed down the experience of time. Perhaps just as its flavor refused to settle, it could both

stretch and condense time, depending. The game came down to its final few minutes. Cal recovered a Trojan fumble at their own five-yard line, off a strip-sack of O'Leary: by this point such plays, usually destined for highlight reels, registered to me as entirely mundane. Leading 44-41 with three minutes to go, Cal had a chance to ice the game. The Trojans' defensive front had worn down a while ago, as Cal moved away from the passing game and, relying on Fonseca, gashed the defense for six and seven yards a play, all while burning up the clock. It was third and two on the Cal twenty-three and everything said *run*. But the coach gambled, as college teams will. Duke split off the end and found himself deep over the middle on a slant. The safety—Barker had rather remarkably been revived and returned to the game by his team—had tripped on no one in particular in getting back to defend Duke's route, tripped out of sheer anxiety or a lingering wooziness from his first run-in with him. Having already shed the cornerback, this left Duke to make a simple enough catch and gallop the rest of the way to the goal.

Barker's blunder was catastrophic, or should have been; somehow he was redeemed by another error that was truly unfathomable. Just as Duke was crossing the goal line, untouched, holding the ball aloft in one hand in celebration, it squirted away from him out of the end zone for a touchback, along with the six points it represented. The crowd, muzzled so far by Cal's success and the growing inevitability of defeat, came back to life. Duke looked shaken, getting back to the sideline. USC took possession, with fifty-one seconds to get into field-goal range and tie the game.

Yet when Cal's defense came onto the field, there again was Duke—with a growing intensity, a new sharpness to his movements. I'm not sure what sort of deal he'd made with his coaches, but this time he was lining up not against Creighley but LeCroy, the Trojans' star wideout. It was remarkable to see: Duke played LeCroy so tightly and effectively, like a bona fide shutdown corner, that O'Leary never even dared to throw his way. Four plays later, on fourth and eight, with LeCroy and Creighley blanketed, the Trojan quarterback's check-down pass fell harmlessly to the ground. One kneel-down in the victory formation for Henderson and this strange game, three and a quarter hours after it had begun, finally ended, with Duke absolved. In the span of the game I'd gone through almost four bottles of Theria—although, from about the end of the first half, I'd hardly thought of the drink again, or any of the questions about its effects that I'd meant to ponder. After I'd downed the first bottle-and-a-half, I'd been drinking the stuff like beer, in that mindless sort of way, partly because it wasn't laden with any of the sickly sweetness of the typical energy drink, which was invariably nauseating in large amounts, like a bag of candy corn.

The longueurs of a football game always distressed me, no matter how happily I'd begun watching it. Two or three quarters in and I would have to give up, sometimes even quite close to the end, when the game was still in the balance. And this was *with*

the aid of beer. But alcohol takes you away from the game. The niceties of it are re-placed by gross facts visible without much concentration: interceptions, touchdowns, and only blurs of movement in between, men crashing into other men in a mad scramble for the ball. Under Theria's influence, though, so many of the game's quieter dynamics, matters of momentum, and all sorts of strategic considerations, the kind Ty savored, opened up to me. Everything appeared hyper-vivid and pre-parsed, too: the technical game-talk of the commentators lost its ring of higher gibberish. Most of all, my *desire* to understand, to see, seemed unnaturally stoked.

I was left with the question: Could the eccentricities of this particular match be the real explanation of my reaction? Or could Theria make *anything* singular, cutting through the generic surface to reveal the variegations below? I finished the bottle in my hand and let the liquid roll around my mouth, searching for further indications with my tongue, as if something in its flavor—that medicinal bitterness perhaps, which competed against salt and brine, not just vanilla—could speak to my questions. Yet for hours now I hadn't really been able to con-centrate on taste; the game had turned out too fantastical for that, too *unlikely*, and nothing is so consuming as unlikelihood, those things that by all rights shouldn't happen but do. Events—recorded, televised events—had occupied me. Really, number thirty-two had. You couldn't bring any semblance of sense to this game without grasping his role in it. He *was* its meaning: its ebbs and flows, its textures and tones, its strategy, its substance. The only word for it was *spectacle*, though not in an unbecoming sense.

The oddest part, I considered, was how this spectacle's polarity had reversed itself throughout the game, in a way Duke couldn't control. You would be admiring a razor cut, a beautiful break on the ball, an aerial maneuver whose grace was such that even casual observers could sense something extraordinary in it, and what followed was some abomination, the purest manifestation of athletic incompetence—incompre-hensible given the heights he'd just reached. It was as if he were in possession of his talents only three-quarters of the time, and, for the balance, he wasn't merely ordinary but inferior, the sort of player who costs his team points (and games) in egregious ways. While I watched, I'd found myself trying to predict the net result of his on-field schizophrenia. Here was something every Cal fan, and certainly the coaches, would be asking themselves: is he costing us more points than he's helping us score? I could certainly imagine him being pulled in games when the ratio was off, like a streak shooter in basketball having to ride the pine on a cold night. Such players invite questions. Would time expire before he had a chance to redeem his lapses? Or would a lapse turn up just before victory could be sealed, undoing the team's good work? I had an itch to draw now and it was nothing like a visitation from the Muse. No, it

was almost literally *an itch*, a particular spot on the page that needed scratching out with a pen. This is how I usually got my hand in with a new subject, acquainting myself with it tactilely even in its absence. I plucked one of the dusty sketchbooks lying near the window from a stack that managed to stand only with the wall's assistance, it was so tall. I backed up the video, and after hopscotching through a series of low-res stills, I arrived at one of the last images of Duke. He was out on the field, post-game, along with hundreds of others, and for the first time he was genuinely divorced from his helmet, which sat on the ground, at his feet, no longer looking like much of an equal. Remarkably—this was why I picked the image—he was peeling off his jersey for a swap with none other than Barker. The Trojan, for his part, was removing his own shirt rather gingerly, as if his chest were cracked.

I wiped my hand down the face of the sketchbook's plastic cover and a hazy residue collected in a mossy line along the edge of my palm; the notebook itself reclaimed its true hue, lipstick red. The cream stock felt almost brittle under my fingers. It was heavy paper, it ought to have aged better, but its color seemed to be fading. With my fingernail, I poked a Bic out of the spiral binding it was jammed in and searched for the first empty sheet. This was Claire's notebook; all of them were, a whole tower of them. This room was *her* space; sometimes I forgot that, surprising as it sounds. These books, none of which was ever filled up—that's why I'd reached for one in the first place, knowing I'd find large tracts of blankness, though how much depended on when exactly an idea had proved itself empty, an illusion—these books were how Claire made new starts. With crude ballpoint drawings she remolded shapes pulled from the imagination rather than from life. Generally, there were conceptual origins to her projects, though the work went best, I thought, once it'd freed itself from those moorings and her instincts took charge. She hated hearing this, she found it condescending and misogynistic. Perhaps it was, but it was also true. Even she knew that. This was really a graveyard, this stack of sketchbooks cobwebbed at the base. That's why Claire had left them behind. The forms that *had* taken flight, that had managed to consume full notebooks, perhaps two or three even, would still be with her, as would the children of those books, the sculptures themselves.

This pad began aggressively, with a series of overlapping, irregular shapes, inked in a heavy blue line—Bic blue, Claire called it—which looked as though it had been retraced many times. Most of these figures fanned out from a horizontal line bisecting the lower half of the long rectangular sheets. The first few pages were thickets of line work, extraordinarily intricate and hard to interpret. Flipping through the first fifth of the book, the chaotic density began to wane and a single form, in so many variations, emerged from that swamp of ink. This, more or less, was a transcript of Claire's

imagination at work, extracting shape from a blank page like a sculptor hewing stone. Her mind worked this way in all domains, actually; it marked a fundamental divide between us, as I tended to operate constructively, slowly filling a primordial emptiness with the world. Which meant the first pages of her sketchbooks might be the last pages in mine. Although it was a question without an answer, or rather too many answers, I did sometimes wonder, when my hours turned idle, how our time together had been prefigured by this difference, and how it might have quashed our prospects from the start.

By about the halfway point, Claire's chosen shape in the book transformed into a proper *form*, by which I mean a representation to which one can imagine some correlate in the world: a carefully proportioned wooden chest, in this case, or else a steamer trunk. What had been on her mind at this point? Travel? Escape? What *was* this unrealized thing? Her old sketchbooks always raised these sorts of questions for me, often pleasantly so, in the early days, when they weren't yet pregnant with the sort of meaning that blooms only when everything is finished. Yet paging through the book I observed the classic symptoms of one of her doomed gambits. The subtraction of linework turned so severe that the chest began to lose all plasticity, disintegrating until it was no longer a chest at all, just a collection of interlocking shapes, and then not even that; the contours became so open that nothing remained but slants and angles meeting in increasingly untenable ways, until they didn't even meet, leaving simply two parallel lines. On the next page, at the two-thirds mark in the book, there was only the original axis, a horizon marking eye level, about a quarter of the way up the page. The idea had entirely disappeared. That was the way with her failures. I flipped to the next page and found what I was looking for. The axis was gone. Blankness had entirely reclaimed the book, just as it had prevailed on the very first page; that one was always left empty, reserved for some unknown purpose. I ran my fingers over this void hidden deep within the interior of the book, this page that seemed less aged, with nothing brittle about it.

Having readied both paper and pen, I turned back to the still displayed on the screen. Duke and Barker were stripping off their jerseys just before the moment of ritual exchange. I drew blind, without much thought, simply letting my hand wander, tracing what I took to be the edges of the men's forms, the places where insides became outsides. This went on for three or four minutes. I barely allowed the pen to come up off the paper. Instead I went around and around the shapes, not just the shapes of the men but the ghost shapes of the empty jerseys they held up, so that it looked as if four men held the field, not two. I kept working over the paper, incising it with what seemed like a very dull blade, this scratchy, dried-up Bic whose line you didn't have to scrutinize to know was worthless.

Eventually my hand slowed, and at just that moment I felt like closing the sketch-pad without ever turning my eyes to it. Whatever was there on the paper, in some significant sense, wasn't a drawing at all. No particular result, I mean, could have undone the preparatory value of this movement of my hand, the familiarity I was cultivating with my subject. Yet no one, certainly not I, was beyond vanity. I briefly studied the page, wanting to know whether my blind drawing with this terrible instrument, on falsely attractive paper that would age awfully, was nevertheless a match for artists who were actually looking at what they were drawing.

The two silhouettes, or four silhouettes, including the two torsos they dangled in front of them, held my eye. My tracing and retracing had been unusually accurate, notwithstanding my long practice at this sort of blind mass-drawing, so that it seemed as if I'd done only two or three passes with the pen rather than ten or more. The two faces themselves were mostly undefined. Besides the relative clarity of the contours, I'd kept internal definition to a minimum—this being guesswork in the extreme when one's eyes are diverted. Yet even then, something of Duke's peculiarity came across: the slant of his lips, his aloof smile, the mild squint of incredulity he gave Barker. Something of the various permanent possibilities of appearance, to pervert a phrase, that lived in the face of each man came through in the sketch. This resided in a small set of features, in the tensed deference and proffered absolution of the safety, most definitely a casualty of this game, not a star. He held out his jersey quite firmly, gripped it almost with closed fists, but this somehow only confirmed his weakness. Duke held his by the neck, while supporting the jersey's back with his other hand, as if presenting a Christmas gift to a child. Much of Duke's nature I may have simply been dreaming up here, of course; much, too, of the world as he saw it. That this developing picture of him demanded *consideration*, however, was beyond doubt.

11

My body was stiff from having sat so long, rapt and motionless and remarkably low to the ground: the springs of the old couch had wilted and become permanently depressed, so that lounging upon it at length was akin to settling into the bucket seats of a coupe for a country drive. I weighed emailing Garrett with early impressions of the football game, or else a gloss of the swatches—he'd not written back about them yet, perhaps he was more easily thrown than I'd guessed—as these were among the few things I could do from exactly where I was, with my phone, without first having to negotiate a way out of the hole I was at the bottom of. I made it only as far as the salutation before drawing a blank.

It was noon already, I considered, and I'd had nothing to eat yet. I didn't *feel* hungry, even if I should have been. I would need to have something small then, something you didn't really need to be hungry to get down. I rocked my way out of the sofa and in the kitchen discovered a lone egg, its terracotta shell speckled lightly at one end. Smashing it into an oily pan already on the burner, I twisted the dial sharply and the metronomic clicks of the igniter sounded over the invisible rush of gas until an anemic blue flame appeared.

The meals I prepared at home were uncommonly limited for someone five years removed from college. There were eggs, and toast, and penne served without even jarred sauce, just butter and salt. Thinking of my various acquaintances, perhaps this wasn't *so* unusual, given how dependent anyone living in the city becomes on takeout and delivery, services that induce the sort of deskilling the cellphone does vis-à-vis our capacity to find our way around (through its GPS), or even to count (with its calculator). What made my case unusual was only that my kitchen skills were in fact quite developed, and that my reasons for leaving them unexploited had not even a little to do with the shrewd management of time.

Not long after arriving in New York, while I was living alone in Bushwick, I spent nearly six months giving myself a course in the preparation of grains, after thumbing through some ancient cookery guides at the bookstore on my block. My initial interest flowed mostly from the mathematics of the enterprise, I think, the way that the various doughs and batters and puddings were defined largely by the application of distinct ratios to a few common ingredients, which functioned almost like the colors of a palette: eggs, milk, sugar, salt, flour, yeast. Breads, not crepes or cakes, quickly became my focus. I started in earnest with a spiced Moroccan loaf, big and round with a

yellow-green crumb, prepared to accompany the tagines John had taught me to cook in college; for a Dakota roughneck, he could be rather refined in private. Irish soda bread came next. I'd go on to make it regularly for Claire, who was charmed by my baking habit, the one bit of domesticity she could depend on from me, even if my take on this particular bread was too austere for her, too rough on the palate. Then there was the bread I'd been most proud of, and most ravenous for. If I ever started baking again, if *taste* could once more stoke my interest, it's what I'd make first: a chocolate boule that didn't smack of chocolate, not in any ordinary sense. It was almost savory, like a distant cousin of the Moroccan. It could go proxy for breads as robust as rye, though with a pad of butter it sweetened and offered up little glints of cocoa. Cut into points, with ham or raclette, it couldn't have been more at home.

Baking wasn't the end of my culinary forays. Stews interested me, too, all kinds, not just tagines, whether bouillabaisse or gumbo or more exotic things, say, a mango kadhi made with uncultured buttermilk. I always enjoyed returning to classics like English stew, which was hardly more than meat and potatoes, carrots and onions, conjoined through a forever-simmer. Barbeque held a privileged place in my diet, particularly ribs. I'd spent some time mastering the complexities of dry rubs and the proper use of a smoker, with more than a few fires along the way to show for it. What else? Coffee and the niceties of its preparation had briefly obsessed me, though it wasn't until meeting Garrett that I'd found an occasion to concern myself with the nuances of whiskey or wine, probably owing to the way I took them, the inevitable unpleasantness to which it led.

For all that the metropolis crippled you through its conveniences, then, it had a countervailing tendency, at least in New York, a place in which headlong engagement was the only kind that seemed to make sense to anyone, of encouraging productive infatuations. Cooking, furniture making, surfing—Half Moon Bay had planted that last seed in me, though it needed the rather poor soil of the East, the pathetic ripples of the Rockaways, to make it sprout—in the city I undertook each of these with sufficient zeal that, after just three- or six-month excursuses, I grasped enough to make such avocations a permanent part of my repertoire, if not quite my lived life. Which of these skills I actually deployed depended almost entirely on circumstance. Claire, really. Perhaps this was the great favor she'd done for me: she was exceptionally clever at engineering contexts in which the full range of my abilities might be activated. If I had the idea to paint outdoors, she'd make sure the session occurred near a beach, so that later, as I was packing my brushes away, I could be drawn into renting boards and perhaps giving her lessons, too, though all of that would appear to me entirely by the by. If a friend of hers was putting on a dinner party, my competence in braising duck would somehow, in her telling, become essential to the evening, the

very thing needed to *make* the night. Part of this, I know, must have been about me. She thought I might be happier this way, if I were spread a little thinner, and not quite so concentrated. But part of it—and as time went on, I suspected this factor was growing—had to be that it made *her* happier, this version of me, in which something more than my artistic bent was manifest. For myself, I don't know which version I preferred.

These days, without Claire's delicate string-pulling, I was in purer artistic air. Michelangelo may have had his stale crusts of bread, but I had my ageless pastes: peanut butter, Nutella, lemon curd, rhubarb jam, and, sometimes, pâté. I had cheeses, too; I used to have exquisite ones. This was another pastime I'd plunged into, two summers after college, curating gorgeous cheeseboards, mostly for myself. But the story had changed since, especially after Claire's departure. My selections were careless now, or else governed by the wrong criteria. I'd go to Whole Foods and buy mostly with longevity in mind, knowing I wouldn't be making another trip—couldn't, really—for a while. Most blues can last forever: you'd have a hard time distinguishing the mold in the caves of France from the mold in the fridge, especially if you had an interest in not knowing the difference. Firm goat cheeses, like Village Green, also do well in the long haul, I can attest. And so it was these, and even barbarities like American cheese, that came home with me

If the cheeses and pastes I consumed these days were nearly imperishable, for the sake of bulk I paired them with a staple that had a much shorter shelf life and thus needed to be sourced locally, usually from the bodega. Yet what *kind* of bread would suffice? One way to guarantee a certain standard of quality, even a poor one, is to buy the most visible brand. Any consumer knows this. In the case of bread, that's Wonder Bread, the starch with the most recognizable logo in the business—that luminous cluster of polka dots—and, more important, an other-worldly resistance to mold, staling, or decay of any kind. I imagine the precise medley of preservatives is no less carefully guarded than the formula for Coca-Cola.

In the last half year or so, it seemed I might have exceeded even Michelangelo in my devotion to draftsmanship, inasmuch as I could only occasionally be bothered with the bread, crusts or no; indeed, recognizable food products had come to seem optional. So it was on to powdered shakes and protein bars, stocked away by the carton from Walgreens. Whenever I managed to summon the patience to face people before meal time, and I found myself able to organize delivery, which meant, first, clothing myself in a manner that didn't risk giving offense as I opened the door for the driver, lunch or dinner generally was a matter of Thai or Mexican food. If I didn't mind adding shoelace-tying to my trials, something from the deli across the street could make the menu. The place was run by a rotating cast of Chinese, an extended

family whose outermost branches grew, over the course of a decade, from Guangzhou to New York. I counted on them mostly for carnival fare—freezer-burned chicken tenders and burgers that bled grease—though once they got used to me shuffling in several times a day, I was quietly granted the right to purchase whatever Cantonese finger foods were sustaining the staff that shift.

Some days, though, I couldn't help wanting my simple cheese and bread restored to me, but with someone else doing the work, even transforming it. Baking it, say. For those times, there was a pizza joint up the street. It had a narrow counter and just four tables crammed in front of it, and overhanging two of them was a beefy CRT on a flimsy metal arm I had no faith in. Setting eyes upon it filled me with dread, but then so did the clientele, with their sweat-stained bandanas and shiny oversize jackets worn in all seasons. No matter where you sat in there, you were going to be on edge.

The egg hadn't yet come together in the pan when I gave up and I dribbled it onto a plate. Only then did I realize, with more disappointment than anyone has a right to, that the Wonder Bread was finished. I did have stone wheat crackers and a small jar of spicy relish. I *always* had these two. They'd been sitting on my counter for almost a year, remnants of a gift basket I'd been sent by my mother shortly after I'd moved in (an in-person visit wasn't in the cards). I pulled the tawny wicker basket toward me, unfolded the colorful tissues swathing the final items, and began to consume it all right there, standing up, just by the sink streaked with paints and inks. I scooped up the relish and the runny yellow mass with the crackers and their salt studs, which could hold a coating of yolk and made seasoning unnecessary, and dutifully polished off the egg. However well I may have felt—and I did feel quite well, considering the hangover I'd woken with—I had a kind of proprioceptive intimation that my body was somehow wrong about its needs. My limbs were trailing ever so slightly behind my mind, my will, with the lag of a poorly dubbed foreign film.

Mildly fortified, with the box of crackers tucked under my arm and the last two bottles of Theria, which I'd left in the freezer, in my hands, I returned to the film room and sank onto the couch for the afternoon session. I clicked the second of the links Garrett had sent me and a title card broke up the screen's black: *The Sort.* I'd not heard of it. Soon I was informed it was the work of Bruno Dumont. This was a name I did recognize, and only because of Claire. His *oeuvre*, she'd once explained, vacillated between realistic narrative and something one might have fairly called, several generations back, the avant-garde. What was the word for it now, when the possibility of radical social renewal through art, probably always a fanciful idea, was no longer

seriously upheld by anyone? Many still believed in socially *charged* art, of course. But socially *transformative* art, the kind that might catalyze historical reformation? That was, after all, the *sine qua non* of the avant-garde proper—the Futurists, the Suprematists, the Dadaists, the Situationists. That level of ambition had lost plausibility since at least the mid-seventies and probably earlier. The very meaning of *avant-garde* had shifted; now the term was interchangeable with *unconventional*, though most of the works lumped under this heading were hardly that, as they generally borrowed their techniques from previous eras of genuine invention. So, then, what did *avant-garde* or *experimental* denote now, except for one more ossified form, in this respect on all fours with the great bugaboo, *realism*?

Claire held Dumont's films to be essentially French, and she didn't place scare quotes around the national modifier, which I appreciated. What she meant, I believe, is that Dumont's lexicon derived from a Gallic literary tradition going back at least as far as Sade. It's a tradition preoccupied with form and ritual, unafraid of wandering from the story—from cause and effect, I mean—for the sake of moments of pure visual spectacle; and, in the vein of Burke's Sublime, it's in thrall to calamity, to violence, to bodies and their functions and the purposes to which they can be put, by oneself or another. Claire had expounded on all this as a lead-up to our watching *Camille Claudel 1915*, Dumont's picture about Rodin's spurned mistress, a sculptress who spent the last three decades of her life in an asylum, vainly turning over the master's plots—that's what she believed them to be—to poison her and steal her work. Claudel was Juliette Binoche, and Claire relished her; much of my film-watching tracked Binoche's career.

Claudel, I recall, is shot staidly, even drably, in quiet colors, and, except when indoors becomes outdoors, within a narrow band of contrast. The camera rarely moves, hanging on every wide-angle shot, as if only a steady hand could comprehend such scenes. Claudel, though paranoid and prone to tears, is hardly psychotic, not like the lunatics surrounding her. She is so collected, in fact, that she's often asked by the nuns running the sanctuary to help corral the flock when they stray. Things are different with the others. They've come so unglued it's actually cured them: universally happy, elated by banalities; merely tapping their spoons against the lunch table can fill entire afternoons with satisfaction. What I remember best of this film, though, is how matter-of-factly Dumont enters the realm of the phantasmic. This is plain old realism, there's nothing magical about it. The laws of nature, and of neurology in particular, go tragically unbroken here. Certain subject matter seems to make departures from sober mimicry gratuitous. This is what other asylum films Claire had shown me demonstrated: *Shock Corridor*, *The Ninth Configuration*.

More substantively, what I was left to puzzle over after *Claudel* was the way the sick—not Claudel herself, who seems crippled by her illness, but the properly ill,

who are somehow liberated by it—spent so much of their time testing the capacities of their bodies, especially their voices and faces, twisting both into terrifying shapes: shrieks and hoots, smiles and grimaces. Their bliss in such exploration is for Claudel a great nightmare. The expressive *possibilities* of the body consume them, the manner in which faces and voices are instruments at our disposal, even though they themselves have no particular use for them, having nothing much to communicate as such, given their scattered souls. You might say, as Claire once had said, that the patients are formalists, but of the body itself. For them, every day is an act, a joyful experiment in what they can make this *thing* do. The most discomfiting scene in the film is of the patients' rehearsing for an asylum rendition of *Don Juan*—community theater of a rarefied sort. Naturally the players prove incorrigible, though the nuns go on hopelessly admonishing them until Binoche, who at first finds herself wracked with laughter at the inanity on display, flees the room, screaming for these *creatures* to leave her be.

If there was one central influence on the whole of this film, it had to be Rabelais, the most philosophical and phantasmagoric prose writer of his moment—*not* Cervantes, as Claire held. The relevant tradition was anyway older than Sade, I contended, and Claire, I remember, gleefully conceded the point, pleased she'd drawn me into meditating on feature films and narrative. She knew literature better than I did; it was her first love. In a way, it was also why I knew her at all: it was the bond she shared with Karen, who seemed to be turning further toward text every day.

I swigged profligately from the bottle; the crackers had drawn the water from my mouth. I was curious to see, with *The Sort*, what Dumont had learned in the few years since *Claudel*. The screen remained black for some time as the soundtrack ran and I settled the sketchpad onto my lap. The tune was familiar to me, the way the voice hovered between speech and song, and mingled with plangent piano and strings: Sprechstimme from *Pierrot Lunaire*, the final scene. But the poems, which had been translated into German for Schoenberg's landmark drama, were here returned to their native tongue, the nascent musical vocabulary of the second Viennese School put in service of French letters. *Dumont's first essentialist touch*, I could hear Claire saying while patting my thigh, and this before we could see a thing. Finally, though, the camera rolls; and the first thing that vision makes clear is that the music is diegetic. We're privy to a live performance, at a music hall whose structure the camera steadily lays bare, everything but the stage and the performers, though, so there's still a sort of denial going on. A heterodox collection of tiers confronts us, several of them having been built off to one side, in a tower more precarious than imposing, which manages to blur the aims of its makers, though it does reveal the period of the film to be roughly contemporary. Since today's architecture is so fraught with

realized vaguenesses like this—one balcony almost overhung stage right—my eye isn't detained for long before acquiescing in the geometric confusion.

As the camera pans around the audience, instead of an isolating darkness appropriate to a concert hall we are given twilight, with grays standing in for blacks and visual details easy enough to discern. Which means one of two things must be true here: either the whole of the hall is actually softly illuminated—an odd arrangement for a performance—or the stage and the performers, which Dumont never directly lets us see, are under lights so bracing they cast a penumbral glow throughout the space. The latter possibility quashes the strongest desire I have, which is to look upon the stage and seek out the source of the music, the plaintive voice especially.

The camera makes several passes of the lowest balcony, slow passes. These are first-tier seats, the ones of season-ticket holders, generational wealth. There's a man in a suit jacket a size too large; the pads of his shoulders extend farther than his own, in a manner more appropriate to football than to theater. Beneath the coat is a substantial sweater, cashmere or a very fine wool, by the looks of it, and the only bit of his dark tie that we can see is the simple four-in-hand, the unobtrusive knot which I have always found genuinely confident men prefer to the effrontery of, say, the Windsor.

There is another man three seats away, at the other end of a very short row on the balcony, who by this criterion would appear to have no self-belief at all. He sits with his blazer still buttoned, lapels ballooning, and around his wispy neck hangs a knot so overweening it can only be the Balthus, a comical monstrosity dwarfing the Windsor that was named, yes, after the slight artist who invented it. (Claudel's brother, the effete poet, would have looked just right in one arriving at the sanitarium to visit the sister he'd had committed.) Clustered in the same box are several men more strin- gently attired. Tuxedos. A season-opening gala is the immediate impression I receive, not unlike the ones I'd attended the last few falls with Claire's family at Carnegie. But as the camera pulls back, *this* audience shows itself to be considerably younger, late thirties or early forties, not the sorts that tend to pack openers. Hair color is a part of the story—there isn't much gray in evidence—but mostly it's the way their faces still cling tightly to their skulls, proving that time has had no opportunity to loosen bonds. That's not to say there aren't a few pointy-nosed patricians here and there, heavily jowled and bearing an air of sober rapture, but in aggregate, the group looks homogenous. Unusually so. For the sameness goes beyond age or demographic truisms concerning the sort who goes out to hear Schoenberg. The unity is deeper, phenotypic, and for me, reminiscent of certain Degases, his dancers, for instance, a handful of which are often recycled throughout the pictures. *How* had Dumont managed to cast this crowd of several hundred, I began to wonder. What kind of effort would have been required to find so many who together resembled, well, one large family, or better, a clan? There is something discomfiting in

this, proto-fascist almost, which is also to say *utopian*—no less than the avant-garde orbit in which Schoenberg operated.

Strangely, though, the women, who are, as it happens, nearly all dressed with more care than the men they sit beside, cut against this impression: they don't appear to be part of this clan, nor do they form one of their own. Their stock varies extravagantly; they are each themselves. I note this while mentally marking all those with hair that could plausibly be regarded as red. Six or seven fit the bill, given how low the light is, from a strawberry blonde to two older women in adjoining seats with hair that appears black yet carries enough rogue tints to suggest at least the possibility of red under stronger light. I am seeing things discontinuously, selectively, while the eye of the camera scans the crowd more like a flâneur, refusing to track any one set of figures, casually moving from one to the next without much pattern. This gives the shot the same unstable, decentered character as the music, making it impossible to say which of these seven women might be the one I am hoping to find.

The drive to seek out a center, a thread—I could combat it here and there but never extinguish it, even while knowing Dumont to be content with taking his time establishing motifs, or just basic narrative coherence. At this early moment, a good share of the interest lies in coming to grips with the elementary contours of the film. And the rest? Chiaroscuro, more than anything, form and tone reacting to low light, the tiny gradations of navy and black, the various patterns of wool in the suits, all interrupted by the brighter finery of women's wear, flares of green charmeuse and crimson taffeta. As for what can be heard, the soprano hews decidedly closer to speech than to song, lending the poetry a recitative air; simply returning it to the original French does half the work of softening Schoenberg's German.

The performance begins to wind down, and searching my mind I recovered only Symbolist tropes of urban ennui. They clung to *Pierrot*, and the towering presence of Schoenberg himself, who peeked out from behind everything he wrote. As did the first-generation avant-garde he represented, against which every serious artist like Dumont in some way took the measure of himself, if only to make sense of how far and in what direction he had traveled to get to where he was.

I guzzled from the bottle sweating in my hand until my tongue lost all sense. The drink had sat in the freezer a long time, and anyway the machine was perennially kept too cool, so that among other misdeeds it habitually turned ice cream into granite, forcing you to chisel away at it with an increasingly disfigured spoon. My teeth would ache for an hour at least after crunching these little chips that might as well have been bone for all the flavor they retained. But frigidity wasn't always a problem. It hadn't really ruined the Theria in my hand, for instance, just changed it, as a splash of water will cask-strength whiskey. Once my mouth began to acclimate to its arctic

temperature, the drink seemed to come into proper focus for the first time, and it was immediately clear to me why. The cold had stabilized it, as it does so many things. A few more minutes, a few more measured sips, and I was certain the ambivalent quality that had flummoxed me earlier had more or less vanished. Theria, now, spoke with one voice: acrid, medicinal, still complex but determinately so, its flavor frozen in place. What would you call it? Plantlike? Berrylike? I suppose that's where you'd start, though I still had no certainty as to which berry or which plant. Given Garrett's purposes, this was probably a virtue. If the drink was supposed to have breakthrough effects, why shouldn't its flavor be equally novel? In any case, it was *solidly* good now, in the way, perhaps, of fruited beer.

The more of it I drank, and by this point I'd emptied many bottles, the more I settled into its depths. Though *depths* wasn't quite right, really, as repeated sampling produced in me a distinct feeling of growing transparency, of all mediation collapsing into direct contact with its flavors, which registered more as a surfacing than a submergence. The most remarkable thing was the way it seemed to bring this sense of immediacy, and of fineness of grain, to whatever I looked at, as if there were a whole spectrum of worldly detail that a stimulant like coffee only began to reveal before making one's senses overreactive and less precise. Not so with Theria, not so far at least. The choreographed grotesquerie of the football game had shone through in every particular. And now it was happening with the film: we'd just jumped from the city to the country, to a vast and sturdy house radiating a kind of materiality and firmness alien to the concert hall, which had seemed, through the liquidity of its architecture, to be permanently unsure of what it was or wanted to be, so that every time you looked you saw something different, some new geometric projection that was sure to vanish just as soon as it failed to do its job, its primary one, really, of convincing you of the wisdom of having great numbers of people crowd together in a confined space—space for a thousand, in this case—something human history had generally shown to end in disease and misery and vice.

While city architecture was always contorting itself in apology for the brutishness of mass congregation, the way in which people, rich and poor alike, lived all over each other, *here*, in this forested place, at midday, under a thick and undulating white sky, a family, I assume it's a family, is sitting around the dining table. I strain to find, among this group, anyone from the concert hall, but quickly I see that Dumont isn't offering that kind of continuity. Instead, what binds the first two scenes together is a distinct poverty of dialogue, though it must be said that the family looks to be in good spirits, even if we've only gotten as far as aperitifs.

I count without seeming to count, I seem just to know, though I will go on to verify it by arithmetic deliberately applied—the camera eye lingers long enough for

this—that there are fourteen at this broad blackwood table. I shouldn't be able to visually apprehend more than seven items at once, if I remember the relevant cognitive science correctly, but I've managed to double this total, or Theria has, the drink in my hand I swig again and again until I'm opening the last freezing bottle.

Lunch comes out of the kitchen through double doors held open by thick, worn books: French dictionaries, I can see from their covers, which are so battered they must have spent more time as doorstops than anything else. Prim servants, their hands wrapped in cloth, carry in the meal as the camera orbits the table. Steam trails from the consommé as if from the nozzle of a jet engine as the soup is briskly shepherded to the table in a heavy crystal bowl. The plates of julienned vegetables and long-grained black rice, the partridges roasted until the skin has drawn back from the flesh: each dish gives off a curiously thick updraft of vapor, which, once everything has been laid out on the table, seems to cast the whole scene in a fog.

It must be quite cold there. The profusion of steam is itself evidence of this, but so are the frosted trees outside the bay windows near the table, and the darkened fireplace on the opposite side of the room, beside the kitchen doors. Reappraising the diners through waves of steam, I can see that they are rather heavily dressed, as if they are eating outdoors, with wooly sweaters and long coats. Attire like this wouldn't have been abnormal in earlier times during winter, when indoor heating was spotty, though Dumont's setting appears in most ways contemporary: one frail woman wears a chunky digital watch with a face wider than her wrist, just one modern tension among many in the film.

Four minutes, clock minutes, of genial banalities ensue while the consommé vanishes to the tinkling of silverware on china. The few things that get said are mostly left unrepresented in the subtitles, and knowing a bit of French myself, I concur with the judgment of the producers. What's put forth here—thoughts about the weather, broad praise of the food—matters little as assertion; what's questioned matters little as interrogation. This is human birdsong. Sprechstimme. Tone and rhythm prevail.

Halfway through this sequence, the camera stops gyring and the machine eye settles into a gap between two of the guests, as if taking a place at the table. From here there are no cuts, no movement, just steady observation of the emptying of soup bowls. Before the diners can finish the first course, there's a knock at the front door. Technically it occupies the top left corner of the frame, this mahogany door, though it does so almost invisibly, blending smoothly with the wood of the entryway; which means that it takes me a moment to recognize the door for what it is, a portal to this house that by now seems like all the world. The knock—it comes again—doesn't really undermine the hermeticism, though, as no one rises from the table, no one even appears to hear the knocking, the consommé is too transporting for that, and the steam so very thick. *Is* there any knocking? I begin to wonder. Maybe what I hear are only the thuds of knees

against the table's underside, a game of footsie gone—there's a young woman standing in the open doorway now. I hadn't noticed her enter, she's just *there*, and something in her posture gives the impression that she might well have been there awhile. The belated proof of the contrary comes from the squeak of tires: the faint silhouette of a car is visible through the mesh blinds as the vehicle pulls away sharply. One feels Dumont toying with perception here, although, by this point, I can't help suspecting Theria of manipulating my senses more profoundly than any *auteur*.

This woman, for instance. Her hair is dark, nothing like red, yet it's obvious to me she's the redhead I'm seeking. I stare down into the bottle in my lap and wonder. There is an Americanness to the way she stands, I suppose. A frankness in her hips. Perhaps that's it. She's striking, yes, that head of hair and the leonine frame holding it aloft, but somehow, well, what exactly? She's eminently *everyday*, at least from this distance, from the table, where we've sat with the camera—*as* the camera—for five minutes and counting. This unstable blending of the singular and the common I'd already begun to associate with Garrett; it made sense that he'd have an affinity with this woman, or at least the Dumontian version of her. She's standing there on the threshold in a double-breasted peacoat that's built so softly the jacket accentuates her form rather than obscures it. Unlike her hair, the fabric *is* red, or maroon, which camouflages her against the entryway. Against the long cut of the coat, she wears black leggings, which gives her an adolescent quality, and from her fingertips dangles a pair of translucent blue sunglasses with minuscule lenses. You wonder how strange those glasses would appear framing her face, if she ever wore them properly and not, say, pushed back over her hair as an ornament; they'd never succeed in circumscribing those broad eyes, which along with the rest of her countenance keep shaping up to convey something without quite succeeding at it.

Finally, *finally*, her presence, or just these small failures of expression, begins to register with the others. Perhaps it's only because everyone has by now finished their soup. As the bowls are cleared, a man wearing silvery stubble and long brown hair, combed back, is the first to act as though he can sense her aborted intentions. His mouth stretches into an ugly, irregular smile with not enough bend to it and too much tongue. Yet this doesn't upset the progress of his meal in the slightest; he goes on heaping spoons of green beans around his partridge. He can't seem to stifle this smile on his face, boorish as he seems to know it to be, so the dam bursts and now his teeth are showing, white and blockish, along with his stained gums, and the scene has only gotten uglier. Eventually his gaze pulls away from the plate of beans and lands heavily on the woman, the girl, this princess interrupting his lunch. The man finally takes possession of the smile, it is no longer something happening to his face, no, now it is *he* who is doing the smiling, and he couldn't be less attractive.

A chain reaction runs around the table like a burning fuse: the clatter of cutlery ceases and everyone turns to the girl with an air of respect, or fear, or unwelcome surprise, but without any of the condescension of the first man. A third of them rise from their seats, some only part-way, some standing tall, and the rest grip the table to suggest that they *might* rise. The young woman shrinks from this, increasingly mortified by each new person who stands or half-stands or makes as if they will stand but does not. As for the stubbled man—the rest are notably clean-cut, except for one with a true beard—he never rises or gives any indication that the thought has crossed his mind. He simply returns to piling up beans on his plate. But as he does this, and this is his special contribution, the gesture that none of the others is quite able to make, he greets the woman flatly, in English that seems multiply inflected, so that I can't easily say much about his origins.

Her name is Anne, we learn. She doesn't respond to his words; she doesn't even make a move. You feel she's considering putting those tiny sunglasses on and re-treating. Had she been wearing them when she'd first arrived, or were they already in her hand? I don't bother to run the tape back to find out. The diners are standing around the table, at least half of them. You assume they're a family; there is a unity of appearance to them, as there had been at the concert hall. Most begin to sit down again, as if standing up were enough of a greeting, but two of the older women and one of the younger men give the stubbled man, still seated and no longer smiling, his mouth is stuffed with beans and fowl, something sharper than a smile. You suspect, by the mute censure in their eyes, that Anne's presence at the house is somehow im-proper. She's his young lover, is my first thought—the first thought, I would hazard, of anyone watching. But somehow she *can't* be. Is it merely that I know to expect more misdirection from Dumont? Would any director Claire talked up *not* throw in a wrinkle here? Or is it some onscreen cue I've not identified yet?

An elderly man with a bristly white mustache blanketing his mouth gently mo-tions to Anne from the table, urging her forth. Her lips open and this time you think it will finally happen—speech, it's right there on the tip of her tongue—but only a rictus appears, one I can't decipher, except to say there is no suggestion in it that she's experiencing even a trace of pleasure. The impression is reinforced by the way her visage too quickly returns to neutral, where it always seems to end up. She shoots off into a hallway adjoining the dining room, leading someplace we can't see, as a sense of disquiet falls over the onlookers.

One woman who has until now been firmly in the background of the picture, merely a small piece of the *mise-en-scène*, really, no more distinct than the drapes or the china, this woman wearing a blue taffeta dress and long silver earrings that brush her shoulders like chimes, she turns and addresses the woman beside her rather

gravely, with a weary gaze, in what appears to be the first real bit of dialogue in the film, something uttered that isn't mere placeholder speech:

Súpa verður að koma næst.

Naturally, these are words of a language known to few, and Dumont offers no subtitles, so either you understand it or you don't. Remarkably, I *do*, and I owe this bit of chance knowledge to a summer I spent outside Reykjavík, with John and a couple of his friends from Rapid City. John's grandfather was a Danish emigrant, and John had cousins who'd decided to live in Iceland, the former colony. Visiting them didn't make for an impressive summer, I recall. The destination seemed too self-conscious to me, even accounting for the abject fantasies of college. Drunk on certain myths, as we all were, however much some of us believed ourselves immune, from where I stood now I could see the imperfection of my resistance. John himself came by this journey to a mountain village fairly honestly. Leif Erikson, the Sagas, there was at least a case to be made that they had *some* bearing on his life. Perhaps I should have simply excused myself; my own ancestors came from farther south. But he'd insisted I go with him, just as he'd insisted I drink the Theria with him, and at that time I hadn't yet developed the habit of baldly refusing my friends' beseechments. Now, of course, I could nearly get in a fistfight with John over trivialities. Whatever else it was, my willingness to decline without much justification was, to me, a kind of progress, a marshaling of spiritual resources, a frank acknowledgement that dialectic had its limits. Strange: no one would say there was even a touch of the religious about me, yet to the degree that most creeds placed a premium on silence, on action without explanation, on faith, I suppose I was starting to see its merits.

Back then, though, when I could still be persuaded to do things that didn't agree with my instincts, I went off to Iceland with the others, so that now I have just enough of a handle on the language to know that what this woman in *The Sort* is offering is entirely of a piece with the banalities that have come before in French. She's merely expounding on table manners, etiquette: specifically, about which course ought to be served first—evidently not the soup. The exchange between the women doesn't touch at all on Anne, who's still off-screen, doing something or other in the back of the house, though Dumont's team has carefully cut the film to give the *impression* of import, as though the Icelandic speakers simply must be appraising Anne and her presence at the house. In fact you could easily believe something critical to the plot is being disclosed here, simply by the way the camera lingers over the women, finds them speaking intimately, though this is only because one is mildly criticizing the host and therefore has reasons for discretion. What we have, then, is a peculiar cinematic joke, a red herring meant for an extraordinarily small audience of viewers acquainted with Icelandic.

The others have taken their seats and seem ready to resume their meal, but Anne reappears in the foyer, *sans* coat. She looks less stricken now—quite relaxed, in fact. Finally, without strain, she speaks, and when she does it's in, yes, an American accent. Midwestern, I believe. Certainly it isn't redolent of the coasts. How does this particular way of speaking English strike French audiences, I wonder. What she says, anyway, is that she's very sorry she has to go, but please, please, enjoy the house. Is this a twist? She speaks as if the house is *hers*. And although it will take another hour of film time before she herself comes to know this, it actually *is* hers. The man with silver stubble, we learn a bit sooner than that, his name is Sidney and he's no lover. He's American-born, as are several of the men at the house, though he's the sole expatriate, splitting his time between France and Belgium. All the rest are either European members of the gathered family—the family of Anne's stepfather, Michel—or intimates of the family, on vacation from the States.

Sidney is Michel's right-hand man in Europe, a close business associate and dear friend. Anne and Michel have been estranged for some time, and giving her the run of the house, shortly after she graduates college, is his way of compensating for a past in which he was often absent and occasionally cruel, though the nature of this cruelty is never revealed. In truth, as the stepfather is quite old now, and Anne's mother is dead, the property itself and several others to boot have already been deeded over to her, though she doesn't know it, not at this early stage in the film. When Anne's not in France, Sidney often entertains the patriarch's relatives at the house; he lacks a family of his own—he's an inveterate bachelor, for reasons that emerge—so these gatherings are the closest things to family reunions he knows. This afternoon's meal, and this explains the snow and the fowl, is also an ersatz, that is, a Europeanized Thanksgiving, which Michel, French himself, has made traditional among his continental family. Anne barely knows anyone here, even the Americans among them; since Michel hasn't mingled his two families, old and new, only a few of the guests are in any position to recognize her, much less know of her ownership of the house. But it is just this piece of information, grasped of course by Sidney, that briskly circulates around the table, *sotto voce*, after Anne's declaration from the doorway.

Not knowing what else to say, Anne simply turns and leaves. Sidney rises—finally—and follows her out, but not before a last bite of partridge, which is doing duty for turkey. Dumont and his cinematographer continue to present the two of them under a veil of illicitness, as if they have a sort of deep past they shouldn't, or a silent understanding where, again, none should exist. In truth, Sidney hardly knows the girl any better than the others do, though he's spent time with her on various occasions, particularly when she was very young, when her mother and stepfather were still living together.

Sidney crosses the threshold and we see his silhouette through the blinds. Then we're with him outside, where Anne is sitting in the car with a lithe young man who has all the appearances of a sleazy boyfriend. Adrian, we hear her call him. The three of them drive away as the camera spins back to the window and those hazy blinds. The diners are mere shadows from here, but judging by the dishes being cleared away and the new ones coming in, as well as the faint tinkling of silverware and porcelain, they have already forgotten the episode, or want to.

Anne eventually learns quite a lot about the situation: that she's the deeded owner of the country house, though Sidney is the one who handles operations, of this and a number of European properties belonging to Michel (chalets, hotels, office buildings, museums); and that Michel will not live much longer. (It's suicide, not disease, that finishes him off.) He's only sixty or so, and his death won't be further explained, though there's the suggestion, just at the end, that the girl has an inkling as to why. All the same, two hours after its beginnings in the concert hall, *The Sort* can only be said to end on a note of incompletion. And so the file closes on my laptop, the video-player window minimizes itself, and I'm left beside empty bottles wedged into the cushion cracks, with my eyes shut, just in front of the darkened plasma that continues to hum, and I'm pondering the film's possible meanings, which seem, now that my supply of Theria has filtered entirely into my body and blood, to branch and branch without end.

It strikes me that Dumont almost loses interest in the train of events he's set in motion here. But is that just because Anne's fate is only a subplot and hence unworthy of narrative elaboration? Looked at this way, Sidney becomes the true center of the film, and his ultimate interest, judging by the later scenes of the film, lies not in Anne or her inheritance or her sex, but—curiously—in discharging any obligation to oversee his friend and mentor Michel's businesses on the continent. Still, Sidney has plans for Anne, and though his concern with her doesn't appear to be sexual, he certainly seems keen to dominate her new postgraduate life in Europe. He achieves this by proxy, controlling Adrian, her impoverished quasi-boyfriend, through hinting at the windfall that will be his if he does as Sidney asks and draws close to Anne romantically.

Dumont has studiously removed all natural motives for Sidney's deceit and control, so the man's interest in manipulating the couple comes off as sheer caprice, or else some sort of fetish that Adrian (and I) never come to understand. Naturally enough, in a French film—and, Claire would have added, in a *Dumont* film especially—the female lead must be terrorized in some way by the male principals, just as Binoche was in *Claudel*. Here in *The Sort*, sex has become a further domain of terror. The film's many carnal intimations take on a hallucinatory quality familiar to

me from those asylum patients screaming at Binoche, though hardly any actual sex is depicted. The erotic potential of bodies is curiously de-emphasized: the characters are rarely seen in recognizable sexual poses, the kind that might produce pleasure. Priority is given instead to the precursors and after-effects of sex—its surrounds, as it were. This is where its real meaning lies, Dumont suggests: in veiled conversations about apparently unrelated matters, conducted in cafés and parks, over stale coffee and pastries, steak and eggs and aperitifs.

In fact, most of Anne's appearances, after the initial scene at the house, amount to freighted conversations, predominantly with Sidney and Adrian. It's as if we are watching a kind of sinister, psychosexual *My Dinner With Andre*. Not that Anne *says* all that much in these conversations. What Dumont highlights are the particular ways she *absorbs* what's said or suggested to her, that is, how matters register in her. The simple acts involved. Trivial ones, even. How she stirs her coffee, twists her hair, tilts her chin. Somehow, and this is the remarkable thing, these tics seem to evolve over the course of the film, to develop a grammar and enact a narrative movement of their own, though I couldn't explain just how or explicate their significance, not yet.

These, anyway, are the impressions I had after six bottles of Theria, bottles I discovered all around me, in the cushions but also on the floor at my feet, as soon as I opened my eyes again and was returned to a room ambiently lighted by the afternoon. Strangely, I noticed these remnants first and not my sketchpad, which was still right in my lap. For an instant I was startled, frightened even, as I began to make out an image. Then I recalled the obvious with a jolt: I'd been intermittently working in the pad during the film, although with hardly a conscious thought, I'd been so involved with the film and my Theria-fueled reflections on it. How odd it felt, how alienating, to lose track of that, if only for a moment.

I was tempted then to peruse the sketchbook for any aid it might offer in parsing this film that was so scrambled, not temporally but spatially. Events take place in international locales across Europe, and even a few in North America, when Anne, a bit too predictably, makes a sojourn home. The opening concert hall scene, for instance, occurs not in France but in Germany, in Cologne, which means, for one thing, that *Pierrot Lunaire* is performed in French simply for the benefit of the French film audience. Or did this choice hold some further meaning about the original source of the poems? Why, too, must every scene take place in a different country, with another language functioning in the background of the characters' French?

More to the point, how to understand Anne's changing mien, her *way in the world*, so to say? What details had I set down, what tenor had I transposed, that inevitably failed to register with me while I'd half-consciously assembled these pictures?

Before that, though, it seemed to me worth my while, and Garrett's too, to discover what my Theria-soaked mind could dredge up in the state I was in.

I knew that Anne's kinetic transformation throughout the film wasn't any simple devolution, some fragmentation of the body brought on by the malice of men. That would have been too easy. But, I realized, Anne also doesn't really seize the upper hand. What we get is simply dialectic. There's a fragility to Anne that Adrian's machinations destroy, that much is certain. But her hardening doesn't come across as a diminishment, only a concentration of her essence, a stripping away of the superfluous. Take her early sense of nervy surprise: what she evinces when she enters the country house. This quality wanes in the face of Adrian's increasing demands on her time (he needs her at all hours, seemingly all over the country) and her money (how is he going to get his motorcycle garage off the ground without her help?). But this dawning of reality is gradual, and her naiveté, so endearing and sympathy-winning in the first half of the film, comes to seem less like delicacy or grace or a purity of perception than a kind of feebleness only stress can feed. And so we begin to see her suspicions belatedly take hold, which alters the tone of the film.

As with horror movies, there is something irritating in how long it takes Anne to recognize the real danger Adrian's parasitism presents, though her slowness is partly explained by the gilded life she has led, which is also what brings her to Europe in the first place: an editorial assistantship, too easily acquired, at the *New Statesman* and then, more recently, the same position at *La Liberación*. Meanwhile, Adrian, whose sleaziness, even when it's not much masked, is actually quite compelling—perhaps something in the spirit of a Jean-Pierre Melville character—is suffused by a vague air of sophistication, as if he's spent some time in elevated circles. And he has. That is, after all, how he and Anne meet, at a cocktail party in Paris for the French paper. Certainly he's more difficult to pin down for Anne than the guests at the country house, who are simply her European counterparts; which is to say, Adrian and Anne are instruments of difference for one another, though whether Adrian grasps the situation as such is unclear. His understanding is presented as more instinctive than intellectual, and this can only redouble his appeal for Anne. Sidney, however, *does* understand Adrian's appeal perfectly well to the girl, and by taking him on as a mentee in manipulation, decides to use his knowledge against Anne, who for him can only be the feckless American daughter of his boss. (There must be some resentment here, but it's never developed; perhaps this is a shortcoming of the film.)

Adrian has a lot of women in his life, but it's Sidney who encourages him to court Anne more seriously. Under Sidney's guidance, the young libertine draws her away from her natural orbit among the well-heeled and well-schooled, more so than

he actually wishes to—he's by nature a playboy, not a romantic. And as a man used to following his drives, Adrian can only somewhat clumsily act the role given him by Sidney, which helps Anne catch on not only to his disingenuousness (which she wrongly takes to be harmless), but to the role he's attempting to foist on *her*: the dizzy but earnest American girl redeeming the louche Frenchman. It's not long before she's anticipating Adrian's words. His grand gestures seem less grand all the time, his French cool, his jealousy too, they all appear just a bit dutiful to her. Yet this only forces Adrian, who senses Anne's gamesmanship—or is it Sidney, his quasi-mentor, who senses it?—to an ever-greater wiliness in projecting authenticity: not only do their trysts turn stranger and less predictable, but his entreaties for gifts and money and social access become more oblique. As does his very manner of speech: the less articulate he is, the more believable, apparently, and Anne is seduced, at least inter-mittently, onto this almost animal plane. In the long dialogue between them that at least partly defines *The Sort*, key volleys are often expressed sub-sententially, as if ordinary grammar is too cramped for their designs, their feelings.

Anne's hair, I remember, gets longer in the film; its growth is one way I mark time's progress, the gaps between scenes. It's always pretty, her hair, but it grows ever wilder, which Anne knows Adrian considers a small defiance of his wishes. In one shot more than halfway through, the wind's blowing hard and the sun is at full strength; we are in Marseille, a weekend trip on the water. You can see the ships in the yard, and Anne's abundant hair is whirling about, and *finally* you can see the red of Garrett's forewarning as the wind separates the strands in brilliant light. It was only then that I could be truly certain that Anne, whoever played her, was the one I was looking for. Her hair had—has—*is*—the sort of red that manifests only under uncommon circumstances. Once the wind drops, and we are back in the marina café, her hair draws together again, one long, continuous flow, and it returns to that deeper hue one couldn't *quite* have said was red.

What else changes? Adrian's seductions become subtler, yes, but often enough Anne proves up to the challenge, sussing out the thrust of his vague talk—a plea for yet more money, say, or an excuse indirectly offered for an absence—and beating him to the spot. Her way of dressing, in contradistinction to her hairstyle, simplifies, which he approves of at first, until, as in one of Claire's notebooks, it becomes *too* simple, abstract and invariant, and his pleasure seems to evaporate—to her delight, I feel. She's toying with him, in her way. For every wish of his she grants, whether sexual or material, she collects a tax: for each act of compliance, something is with-held. On the surface, it looks as though he's progressively succeeding in annexing her life—that's what Sidney believes, at first at least—but emotionally, she manages to take back many of these gains. You would have thought Adrian didn't *have* an

emotional life, to judge from where things start, but by the end, owing to Anne's discreet work upon his soul, its frazzled edges are on full display. She's summoned it, or even created it, like a therapist implanting childhood memories: the slights endured but never much contemplated, the mother whose kindnesses were equally jabs, even the dear friends who quietly romanced his girlfriends, including her, she'll suggest, setting off, late in the film, a brutal fistfight between old chums.

There's a genuine cruelty in Anne. You don't feel sorry for her, as time goes by. She's inflicting a psychological torment on Adrian that might exceed his crimes, which are ultimately orthodox in outline, symptoms of the domineering male. She's starting to win the battle of possession between the two, and her actions come to seem like more than mere score-settling against one man alone—which leads me to wonder how strongly she suspects Sidney's far uglier role behind the scenes, pulling the strings for who knows what sort of gain, other than sadism. Whatever the case, a breaking point comes. Sidney coolly persuades a reluctant Adrian to reassert his position in the relationship, physically if need be. Eventually he acquiesces, striking her—not in bed, where any previous violence has occurred, but while she's getting into the car carrying coffee and sandwiches for them. It's nonsensical, this act, a spectacular, unmotivated bit of outrage concocted, one senses, by Sidney. She stews in the coffee in her lap. Adrian's left humiliated by what he has done. It's all of *this*, rather than the plot, that gives *The Sort* its power. Sidney's role in Anne's misery—his senseless role—is ultimately made plain to Anne, though Dumont never clarifies his motives; and although we watch Anne abused by Adrian, Sidney himself witnesses none of it. As he's not cast as a voyeur, it's difficult to read him as a fetishist.

Relations are definitively altered, in the last quarter of the film, by Michel's suicide: it's an event potent enough to free Anne from Adrian's increasingly violent grip, as well as an opportunity for Sidney to pass the reigns of the business on to Anne, thereby freeing himself from the burden of assisting his late friend. Ultimately, Sidney's deeper designs concern a woman his own age, from Cologne, and not Anne, who fades from the last eighth of the film. He has real feelings for the older woman, and their romantic encounters are tender, nothing like what he asks of Adrian in relation to Anne. At the end, she's the woman for whom he leaves France to resettle in Germany. But all this—the aspect of Sidney that has little to do with Anne or Adrian—is never rendered compellingly. Worse, it doesn't shed much light on the rest of his character: his sadism, for instance. Sidney's psychic world is too compartmentalized for that. And so he remains more or less inscrutable—a real problem if, as most signs suggest, Dumont means *The Sort* to be Sidney's film, not Anne's. But could this be precisely why Garrett wanted me to watch it? To observe the gravitational pull Anne exerts, deforming the crafty director's best-laid plans?

I hadn't recognized Anne—the actress playing her, that is. She was clearly young, early twenties, possibly younger, with the sort of dewy complexion suggestive of incipience. I re-ran the credits, anxious to identify her, and there in the first few names gliding down a still frame of the German forest, Sidney's final destination, was Anne—or rather, Daphne Simmel. Instantly I thought of the famous Simmel, Georg, the sociologist and critic. Had I heard of Daphne? Had Claire ever mentioned her, among so many others? A dozen snippets filled my head, of Claire telling me how nimble or transfixing she'd found some little-known actor's performance in a film we'd just watched. It could be someone who'd spent all of ten minutes on screen. *Oh, but those were the most important moments of the film*, this maid cleaning the tub while the murderer picks the lock, or this fry cook lifting up chicken nuggets, grease streaming from them, as the protagonist and his wife have a meltdown at the register. My first feeling was always that Claire was being precious about it all, preciousness being a kind of generational affliction. Yet whenever she skipped the movie back to one of these segments to demonstrate her point, I nearly always found she'd been right. Somehow, the maid really *had* made the scene, and in turn the movie. The strongest evidence of her cinematic judgment was this: half the people she picked out ended up in bigger roles in later films. She should have been a talent scout.

But Daphne Simmel? Claire had never mentioned her. Probably I simply *wanted* to have heard of Daphne before, to make sense of Garrett's thinking she was fit to lead a campaign, namely, that she was already tipped for big things by cognoscenti like Claire, and that *The Sort* was going to be her *Ghost World*. Was *that* his wild hope?

Reflex had me entering the woman's name into my browser's search bar, but I managed to catch myself just before clicking and turned instead to thumbing through my sketchbook, as I'd intended to. Nine pictures—I counted them as I flipped through it—nine had taken form on these pages, executed with the stub of red conté I'd found cradled within a gap in the frame of the television—a manufacturing defect, I think, the way the frame came apart at the bottom. It was still remarkable to me that all the drawing I'd evidently done here was hardly distinct from my experience of simply watching the film, but by now, with the bottles all empty, I was in little doubt as to the cause of this lapse.

I often liked to draw during movies, which probably had some role, too, in my paying this habit hardly any mind today. Or really I should say I *came* to like drawing during movies, because of Claire. Usually it happened late at night, so that the room would be deep in darkness while the film played. I could hardly see the pad,

which was one of the reasons my blind drawings had improved so much in the last twenty months. It was also a way she could entice me into watching more films: they were opportunities to hone my skills, she'd imply, when her own interest lay in our sharing a certain narrative (and physical) closeness, sitting side by side, if not closer than that, our attention being mutually enclosed within a story unfolding on-screen. It was something she seemed always to crave. It could bring me back from spells of aloofness, when even in our happiest days the very idea of narrative, in life or art, could disgust me, and I would tend toward a non-narrative isolation in which nothing was explained and nothing connected. She was right: film was good for us, even if it wasn't enough.

Looking over these drawings confirmed that indeed Daphne's bearing had been subtly shifting beneath manifest alterations like changes of clothing or hairstyle, right down to the bones, it seemed, her posture, the way she tensed her frame. Ordinarily I would have only apprehended these mutations through careful study of the drawings; that's why I spent so much time sketching, to glean information like this. But in this case, remarkably, I'd noticed the differences without needing to make retrospective assessments of the pictures. Simply experiencing the film had been enough, even if I couldn't verbally articulate them; language can do only so much. Here was a new feeling, then: being able to perceive so fully in the moment itself, *before* ever involving my hand. Could Theria really have had this effect on me? A fanciful thought, I suppose, but I was in a fanciful mood, and Garrett *had* spoken of a true breakthrough with Theria, not just an incremental improvement over its rivals in the market. He was a trained chemist, too. *He* ought to know.

My sketches featured not just Anne, of course, but Adrian and Sidney, as the identities of all three of them were woven together. This was true as well of various scenic elements, which functioned as physical extensions of Anne, their forms melding into hers. For instance, at a café in Strasbourg where she meets up with Adrian, she slips into a chair so fully as to appear almost braided into its ironwork, delicately enmeshed in its embroidery, the tendrils fountaining outward, graceful yet unbending.

A couple of the sketches showed Anne in repose, just a few telling squiggles suggesting her torso along with the axis orienting her now elongated form, which no longer curled in on itself, as it so often seemed to when she stood upright. In one picture, her legs were severely foreshortened, as in medieval works, and my gaze was held fast by, of all things, her feet, which poked out over the lip of a lush hotel-suite sofa—Adrian's. (He lived well, for a man without much of a job.)

I doubted that any of these images corresponded very closely to actual frames from the film, as I'd not really fixed any tableau in my mind while composing them,

nor paused the film to prevent entirely different scenes from playing and inflecting the imagery as I drew. But what would be the worth of these sketches if they *failed* to diverge from the stills? Only if my hand and my memory together managed to transmute whatever my eyes received into something else—only then, I thought, was there a chance that the resulting picture, or some version of it, might be worth revisiting, by me or someone else.

The middle three drawings in the pad had the feel of comic-book panels. They were sexual yet inert—pleasure or lust was nowhere in sight, for anyone—and this was really to Dumont's credit, as the film was far from the erotic cool cultivated by European actresses (Garbo and Dietrich) and directors (Malle and Godard)—which was almost a cliché at the time of its introduction in cinema, pointing back even then to a long tradition of retaliatory sexual aggression against remote and unreachable women; and, for the women driven to this remoteness, this alienation from their own feelings, by a world that anyway punished them simply for *having* an emotional life, something impractical in the extreme, the way it led away from the useful and profitable into an untamable inner realm without any obvious yield. These three pictures, anyway, they picked up some of Adrian's impotent aggression toward Anne, toward most everyone in his life, including Sidney, who certainly presented a deeper sort of difficulty for him than did Anne.

Here, then, was her somewhat childlike face, one that retained the expressive powers of an even earlier youth, thrust by Adrian straight into an Art Deco lamp on a nightstand of dark wood. He holds a fistful of that hair, the darkest of reds, I knew, but here on my pad it was just the sanguine of the crayon, though I'd applied it with the heaviest pressure I could muster. He tugs on it, right at the scruff of her neck, and pulls it both upward and forward, throwing her porcelain visage, upturned to a degree the neck doesn't naturally allow, into the lamp, while her naked body hangs limply below. Limply but purposefully, it seems. The more passive she appears, the more it infuriates Adrian, who's not so stupid as to fail to recognize his own barbarism.

That upward lift of the neck. I traced it with my finger, blending the sanguine. If the drawing had an essential gesture, Anne's progress through the lamp—a progress induced by Adrian's force—had to be it. The shade of the lamp itself, actually, is partly displaced by her head striking it, though the base remains stable, unmoved by Anne's plight. Yet because the shade has been violently tilted, an excess of light is pouring out of the bulb within, which finds itself too exposed, viciously brightening the whole scene, flashing light across the low ceiling, even throwing it directly into the viewer's eyes.

As I thought back over the film, I had to acknowledge the inventiveness of Dumont's choreography. So many of the sex scenes had taken place under unnaturally bright light,

whereas much of the rest of the film had been more discreetly lit. These efflorescences were induced organically by various happenings: a fireworks display outside a Toulouse penthouse, a lightning storm in Budapest, and this toppling lamp in the center of Paris. *Enstrangement*, I suppose that was the word for it, even if this was an atypical translation of Shklovsky's notion. Dumont had exploited the camera and setting to disclose the sexlessness of rough sex. Was he a Romantic, then? Claire would have had better judgment on that matter. What I can say is that, for me, the intriguing aspect of the sex in *The Sort* was something altogether different: the delicate evolution of Anne's and Adrian's manner of addressing each other physically, in and around bed, and farther afield, too, in public spaces. These developments formed a second narrative, a sort of maturing cadence between two bodies counterpointing the couple's fraught dialogues.

The most remarkable thing about this film—and the football game as well—was the anonymous star power (not an oxymoron) on display. Here was the mystique of the star *in the making*, the ordinary turning extraordinary, which I couldn't help but associate, yes, with Degas, particularly his portraits of Thérésa, the queen of the Parisian café-concert and possibly the first true pop star, dating back to the mid-nineteenth century. There was the towering figure of Sarah Bernhardt to consider in this regard, of course, for the stage and very early film, and there were the many celebrated touring opera and theater stars of the era. But I mean the truly *popular* star, the *low* star, the kind that would come to dominate a mass culture which was still only finding its footing. My interest in Thérésa was first roused by Degas, the *grand bourgeois* always dipping his toes in the new entertainments of the street. If this woman could capture *his* eye, the eye of an artist who stood both with and against his historical moment, as I often fancied I myself did, well, then, why not mine? It seemed to me now that, like Thérésa and Bernhardt, Daphne and Duke could bend the framing context, transcend the plot or the game, as power centers in paintings and photos exerted a pull on everything around them. Figures, of course, were always the most powerful magnets in any visual field. Evolution had made sure of that. They defied the rules of ordinary composition; almost anywhere you placed human forms, even deep in shadow or far in the distance, the eye would lock onto them, and indeed make you overlook other facets of the scene by fully saturating your attention. Faces, even more than figures, took things further, with a pull that overwhelmed all else except for one: eyes, which exerted the greatest force of all, true black holes.

These were truths that held quite generally. But the specific *presence* (there is no smarter word for it) of *some* bodies, faces, and eyes, along with their particular gestures and movements and leaps—this presence, or substance, if you like, carried its own powers of attraction, drawing the eye to places within the frame that would ordinarily be accessible only with difficulty: events occurring on the margin of the picture

plane, for instance. *This* is how certain apparently secondary figures can overthrow the central subjects of paintings, minor characters can steal shows, fringe players can win games. It occurred to me that Daphne, like Duke, was one of these uncommon substances, evidenced in all aspects of her: her body, her face, her eyes—but especially her face, its striking elongation that didn't bespeak sorrow or petulance, or any of the things it might so easily have, but merely, in the lithe lines that its length allowed to unfurl, the expressions it seemed to make possible, a fine receptivity to feeling *tout court*. It was only an accident of nature that the world as it was—just like Dumont's; in this he was absolutely as much a realist as Rabelais—happened to contain significantly more sorrow than anything else, as the earth's surface was mostly covered by water. This contingent fact was why she'd been so frequently called on to express grief as Anne, although even then, infinite gradations of the feeling had surfaced, and this alone—the ability to make these depths known—cut against the sense of pity one might otherwise have felt more completely for her. She wasn't pitiable, and this distinguished the peculiar force she exerted.

Slowly I flipped backward through the nine pictures and Dumont's drama un-spooled in reverse. I could see that it would never be possible for Daphne to play a truly faceless part; character acting wasn't in her future. She seemed, simply in her person, before it came to the matter of acting, to elide the boundaries of her role, and I knew this without having seen anything else by her. Eventually I came to Duke's picture in the pad, the first one I'd drawn, and felt a fundamental continuity with the previous nine, a certain semiotic density, though visually he couldn't have been more distinct from Daphne, the way he occupied space. These two, Duke and Daphne, might yet fulfill Degas' stated ideal: to die *illustrious and unknown*.

Such, anyway, were my feelings, which I'd learned to trust for straightforwardly empirical reasons: at least in certain domains, like art, my hunches had tended to be borne out. Was there an observer effect in play? Well, so what? I was deluged by hunches now, more of them than I'd thought it possible to experience at one time. They felt slightly irresponsible, but then, in a secular age, that was in the nature of such things. I wouldn't be prepared to defend them to anyone, not full-throatedly, but that didn't negate their power for me, nor others' intimations for them, although most wouldn't admit to this, especially non-artists, who weren't tacitly permitted to allow such shadowy things to play a significant role in their lives.

I tore out the sketches of Daphne one at a time and laid them end to end, as if they were panels not in a comic but in a frieze or an altar ornament. I photographed each quickly and sent the snaps to Garrett attached to a blank email. I did the same with my drawing of Duke, though I left it in the book. Not one of these pictures was anything close to finished; they were only hints at future work,

nothing more, and I was tempted to frame them in those terms for Garrett. Did he really require such disclaimers, though? If he *did*, he'd need to find someone else for his campaign. A brash thought—a foolish one, too, given the terrible state of my finances—but, as I say, that was the mood I found myself in, foolish and fanciful, even if my head had never felt clearer.

It would have been harder to be cavalier had I any actual experience having the lights shut off, the phone go dead, the creditors call—all quotidian affairs for my neighbors, not just that boy screaming *six two* in the street, not just the Beckers below, but the family upstairs as well, still somehow clinging on to their share of the palace. Kiver, our landlord, wasn't quite successful enough to qualify as a slumlord, though he yearned to become one. You could tell by the way he played the role every chance he got: the uncharacteristic efficacy, for instance, of his response to my complaints about the semi-feral dogs and the media (radio, television, anything) blaring into our quarters from below, how swiftly he'd yoked this infraction to the more serious one of the Beckers' being in arrears by a few months in order to have these longtime rent-control neighbors of mine evicted. We even saw the family on their way out, the mother and boyfriend and two little black girls, all collecting their belongings, and neither Claire nor I could look them in the eye—well, except for the dogs, who appeared most aggrieved, and for whom we hadn't the slightest sympathy. Ever since then, I could barely glance at the Beckers' old door on the ground floor as I passed to my entrance above. It raised too many questions: Where exactly had the clan had gone? Had they been funneled into the growing sea of the homeless I saw all around the neighborhood? I felt apprehensive now whenever I looked at one of those people of the street, for fear it would be a Becker. I even avoided the glares of dogs.

Kiver—he insisted on being called *Kiver* even though he had a perfectly serviceable forename (Bob)—he would have delighted in getting rid of the *other* black family, the one above me, under any pretext. He used to call me regularly fishing for complaints, hinting at a complicity between us that didn't exist, or anyway that I would not accept. I never gave him anything to work with, after what had happened with the Beckers. Not because there wasn't a problem. To my chagrin, it was noise again, even if this time it was less of a nuisance to me, for being occasional, than the constant intrusions that had once come from below.

Yet these higher disturbances—of things breaking, fingers tightening, voices choking, and later, slow, unfettered tears falling—chilled me, given what they meant for Tanya, who lived on the top floor with a hard man and three teenage boys, one of whom was his. What could she do about things, exactly? If she left Rod, she would have to take her two boys with her, and she couldn't possibly afford that, not as a

salon receptionist. She needed Rod's blue-collar cash, and as long as that was true, nothing was going to change above. For myself, having never tasted Tanya's kind of hardship nor even seriously contemplated its possibility, it was easy to indulge a devil-may-care attitude, which was, in its essence, a kind of ignorance about how badly things could turn out, and one that had in fact opened many doors for me. I only wished I could share some of my blindness with her.

Having sent the pictures off to Garrett without explanation, I settled down for a nap, right there in the film room, exhausted from the sheer density of a day that had been driven by the drink, but also, I suspected, by the genuine peculiarity of the two characters I was charged with tracking. I doubted that more Theria was likely to pull me out of this torpor, but then I had no more Theria left with which to test the hypothesis.

When I awoke, in the early evening, little had changed. The unyielding curiosity I'd felt hadn't really abated, even if rest or time had lent me greater authority over the progress of my thinking. As Garrett hadn't yet responded to any of my emails—should I have expected him to, given the obliquity of my notes?—I finally gave in to my instincts, modern instincts, for data, for *search*. On my computer out in the library, a sizable generic screen wired up to another old laptop of mine, I opened a pair of tabs. Where to search for what I needed? For Daphne, IMDB. For Duke, ESPN.

Daphne, it turned out, was just nineteen but not unknown. Before *The Sort*, she'd starred in some shorts that had done well in Toronto and Telluride, one even with Guy Maddin behind the camera. Another of them had scored an honorable mention in Budapest; she'd played the role of a theater student, which was, I discovered, exactly what she was in real life. Perhaps this was how she came to the attention of Dumont. *The Sort* had been Daphne's first feature, which I found a bit strange, a US actress making her proper début on foreign soil. In the States, it had been released earlier in the year, screening at Lincoln Center. I couldn't help wondering whether Claire might have seen the film there, given her interest in the director. She might even have thought of me and the "insane" Claudel while she watched.

Duke was three years older than Daphne, and the game I'd watched on tape earlier in the day had to have been played last season at the earliest. I was surprised to find he'd gone undrafted back in April, in what was a relatively soft class. Several teams had worked him out privately since, and apparently he was close to landing with a team. I'd seen enough pre-season football this past month to recognize most of the players who were thriving, even the younger ones whose greatness was wholly ahead of them if it was anywhere at all. But Duke was new to the league. No, he

wasn't even *in* the league yet, though the fact that I'd already heard of this undrafted player signaled he was *something*, or might be.

Beneath the window of my living room I took another long look at the swatches as the fading sun headed off to service other lands to the west. Though these dabs of paint weren't at their most brilliant now, I'd put enough white into them that they still held light. White did that to anything you folded it into. Simple smears of color, that's what they were: not logos as such. Could smears be made distinctive enough—or just the colors themselves—to function as identities for the drinks? Of course, there were brands that had colors associated with them: that Pantone blue of Citibank, say, or Smythson's own blue. Doritos was now playing with the idea that there was a Dorito red, and so they might go logo-less. But I doubt whether any of those color chips would be enough for anyone to know which brand was being advertised without the associated logomarks. Perhaps if one *began* from the colors, though, and refused words and shapes from the very beginning, things might turn out differently.

I leaned on the stool above that stained sheet of paper. Neither Daphne nor Duke had much marked American consciousness; neither was implicated in any public narrative that might overcome Garrett's worries about the privacy of my vision, the narrowness of my profiles.

And those weren't just *his* worries. Naïve though he was of the history of art, there was something right in his thinking. He'd said it all in the funniest tone, as if he were discovering it as he spoke, but I didn't really believe that. It was too considered. Perhaps it was just his Midwesternness, that enforced plainness designed to tamp down the excesses of intellection, the way such speculation could sabotage a person, a town, a nation—a legitimate concern—that concealed just how much thinking he'd actually been doing.

It's hard to find much agreement in contemporary art, but the value of ambiguity, or mystery, seems more or less universally celebrated. It's democratic, letting the viewer fill in the gaps, supply his own meanings and make the work his own. How can this not be a good thing, overcoming the tyranny of intersubjective significance? But I wondered then, along with Garrett, or indeed *because* of Garrett, whether such mystery was partly destructive, severing the work from the public world, blunting its point. There is a pleasure one can take in privacy, in pure form. Degas' ballerinas always come to mind for me. They are creatures with a bodily existence but hardly any interior life, though they do manage to express something deflating about debased middle-class entertainments: the ballet of the period was of course also a place of procurement for well-to-do gentlemen looking for sexual toys. But there are at least two exceptions in the Degas corpus, for two stars of the Paris Opera: Eugenie Fiocre and Rita Sangalli.

Even here, the differentiation is primarily formal, not psychological. You can recognize these flesh-and-blood people in Degas' pictures by comparing them with photos from the time, say, but I don't know how much else you can tell about them as *subjects*. For Degas, they were subsumed by their various roles on stage.

What, though, of his pictures of Thérésa? Perhaps they aren't as interesting, purely poetically, as his dancers. She's somewhat fat, really, not classically seductive. And, from today's vantage, she's nothing more than a picture without narrative content. No story remains permanently intelligible, and some lose their sense quicker than others. Yet even the brightest stars of the era, like Bernhardt, the subject of all those Art Nouveau posters of Toulouse-Lautrec and Mucha and Chéret, are at best *almost* nothing to us now. And who is Joan Crawford or Jayne Mansfield at this point? Can you recognize either? But then our twenty-first-century entertainers will also be nothing for the future, and they will in all likelihood meet narrative oblivion far quicker than Bernhardt.

Still, Fiocre and Thérésa clearly meant something to the society of *their* time, so that even if we no longer occupy the world in which they mattered, we can certainly be drawn into it without too much trouble. Any knowledge of the mass culture of the era can open up their stories, their lives, to us. The cult of celebrity, too, a cult that has by now matured into a religion, also links us to that historical moment. The real shortcoming of the Bernhardt pictures of the era was just that they were conceived functionally by their creators, as mere advertisements for dated performances, like the flyers I'd been knocking up for museums and bands. Such ephemera struggle to speak through time. But what of Degas' Thérésas?

You can properly scoff at Art Nouveau for its mechanistic borrowing of Japanese visual ideas, its ham-handed exoticism. These simply aren't the most *telling* pictures, supposing it's fair to demand that art tell: not that it tell truly, or virtuously, or beautifully, only that it tell *something* all the same. But a popular star, a Thérésa, who was, unlike international opera divas like Fiocre and Sangalli, a genuine omen of the future—that is, of the triumph of low culture, our common possession—becomes something more when put in the hands of a historical talent like Degas, my lodestar, rather than a virtuoso hack like Toulouse-Lautrec.

What resulted went beyond the merely informational or aesthetic. The master's pictures of Belle Époque cafés wreathed in gaslight, of bawdy singers serenading patrons who are at best half-listening, are a portal to a world in embryo: *our* world. Compositionally these images are ingenious, having the rough-and-ready feel of throwaway snapshots, which heightens the sense that we are seeing ourselves being birthed. Here is the long inheritance of the selfie. You don't recognize Thérésa, of course, not today, not by name or face, but it is her absolute social reality that offers you port of entry. She cannot be faked.

We *did* have our own celebrity portraitists. Elizabeth Payton, Kehinde Wiley, Kadir Nelson: their images had spread widely. You could see them on the covers of toilet reading like the *New Yorker*, or in the National Portrait Gallery, which occupied roughly the same plane of taste. Some were made with skill and verve, but hardly with the tellingness, as I would call it, of a Degas. They didn't make a civilization available to you. These artists were Toulouse-Lautrecs and Chérets at best, probably not even that: profoundly limited in vision. So the shortcoming wasn't in the subjects *per se*; it was in the artists. Degas had his own hang-ups, of course: the naturalism he spoke of, his preference for truth over beauty. For myself, I'm not sure I cared for either anymore, nor even for virtue in any ordinary sense. And, no, Daphne wasn't Thérésa or Bernhardt, obviously, not yet and very probably not ever. Nor was Duke going to be Bo Jackson. They were more private than public and might well remain so. What mattered to me, though, was this melding of the two realms, the joining of the private with something public *enough* to offer access to the deeper, murkier, long-tailed narratives beneath the culture.

Future generations would have a far harder time reconstructing these two, Duke and Daphne, compared with Thérésa and Bernhardt, or even Marilyn Monroe and Elvis— people whose lives had become converted almost solely *into* their outward dimension, into form. But this was actually an advantage, I thought. In life as much as in art, too much exhibition tends toward an unbecoming flatness. Mystery *had* its rightful place; it wasn't all alienation and isolation. What is *too* known, what is felt to be understood too clearly, what we too stably receive over time, invariably begins to wash out. That was Hamilton's and Warhol's point so long ago. But that was also why their pictures can be so visually drab, worth one look and no more. Their meanings, as with most advertising, were rapidly exhausted. Pop was an art of exhaustibility, an excess of light; it took publicity too far, at the expense of complexity and depth. While I wanted depth, it had to be knowable depth, not the black-box variety that left you all alone in the shadows with your fantasies. That was just a different kind of impoverishment. Could Duke and Daphne be the right fodder? I wondered. They were known unknowns, I suppose you could say, unknown knowables that had the kind of concrete, obscure, contingent existence we could no longer imagine for figures as overexposed and mythic as Elvis. They might well let me present our world in both its generality and its specificity.

It was good, I thought, that one of the two was an athlete, the kind of figure who wasn't nearly as luminous, or possessed of the necessary generality, back in 1870. (The Olympics wouldn't even be restarted for another quarter-century.) Could there be any national narrative now, any intelligible picture of modern life, that didn't give as important a place to sports as to acting? I couldn't see how. What good did it do Garrett, though, that Daphne and Duke were near unknowns? Did he like the

two-sidedness of the story himself? Was he betting they'd become superstars? Or was there something else going on?

I dozed again on the couch and awoke quite late to the swoosh my phone refused to stop making on receipt of certain emails. I wasn't sure what the pattern was, if it was something that certain senders were doing from their end, and I could only surmount the matter by turning the volume all the way down, which I rarely did. So instead: there was the swoosh. A reply from Garrett had finally come—the entirety of which was a single exclamation point above the photograph of my swatches. No reply had yet come to my sketches.

Rather than wonder about Garrett's curious response, the precise dimensions of his interest and how fleeting it may prove to be; rather than reply to him right now (after all, what is the appropriate response to a mark of punctuation?); rather than speculate any further about meanings embedded in these two characters and these two drinks—the whiskey and the nootropic—the various lines of force between consumption, mystique, perspective, and *Geist*, all of which kept spreading out before me, beneath me, like a thriving system of roots, even after two naps, I thought instead, as evening deepened, to turn to the whiskey I'd enjoyed the night before. Not for comparative purposes—I could undertake that later—but to put a definitive *end* to reflection for the night, which sleep alone apparently could not. It was as if these two drinks had opposite properties, the one promoting clarity and light, and the other, murkiness and confusion. But even these latter states of mind had their uses, I supposed, especially the way they kept their counterparts in check. *Un*knowing, obscurity, even outright error, it was easy to sell them all short. Yet weren't they also the allure of art, and perhaps even art's central aim, if Levinas, or Blanchot, or Artaud, or Nietzsche were to be believed: art as a fantastical consolation for the emptiness of human life? (Flaubert's great question: *why must man's heart be so big, and life so small?*) Didn't art, like alcohol, undermine our sense of having cognitively brought the world to heel, reinstating a sense of the incomprehensible, even the sublime? But to what *end*, exactly? Simply to whet our appetites to understand it better, that is, to overcome our epistemic complacency? Or could it be to help us see that ignorance—mystery—could have some positive, primordial value, not so much as a key to the universe as a brick through the window?

Mystery couldn't simply be written off, I knew, even if it couldn't be wholly embraced or understood in a manner that didn't leave you trapped in a subjective hall of mirrors. It was a matter of holding both together, light and dark, in just the way

I wanted now to volley between the effects of these drinks: whiskey pushing me toward that state of oblivion Blanchot would have approved of, and Garrett's synthetic concoction speeding me in the opposite direction—though I wasn't at all sure I could call this the direction of truth, not without more time.

At that moment, I needed less clarity, not more. For there is a point where sustained cogitation, which generally fills me with pleasure and pride, becomes decidedly inapposite, indeed menacing in its implications. Light brings its own form of terror: isn't that Dumont's point in *The Sort*? Theria, or even just the oddity of the two people I'd been introduced to today, leave alone Garrett's own illegibility—both his motives for such an unusual advertising campaign, the details of which he'd still not revealed to me, and the question of whether he would balk at my images and my swatches and take a different tack, which was perfectly consistent with his noncommittal response so far—had brought a violent searchingness out of me. For most of the day it had been exhilarating. Now, though, as the day finished, and even after a pair of naps in which I'd hoped to sleep off its effects, it continued to linger, but as an affliction, a burden, a threat. To carry on in this direction was self-sabotage.

It was time, then, to slow my terrible progress, and it was my good fortune that whiskey excelled at this, at bringing the mind to a standstill. The repetitive utterings of the drunk are no accident; these are the sounds of the mind spinning its wheels, mired in the animal aspect of experience. And so, for the rest of the night, I called off the search for answers. This is what the first two fingers of whiskey did for me. Soon the bottle was going fast and my insouciance came into full flower. Whatever else happened, whatever Garrett wanted from me, whatever I might have to contribute or not, hadn't I at least gotten this beautiful bottle out of knowing him?

12

Around three in the morning I awoke to the incessant clacking of my bedroom fan, which was hardly able to shift an atmosphere that by this point had become more of a permeable solid, thick and still, than a vapor. I was in a state between consciousness and something else, I can't say exactly what except to say it wasn't wholly unpleasant. I debated for an hour or two, dozing off now and then, about what to do about the smothering conditions, this sense of drowning in air. There was an odd comfort in prolonging my state of indecision, as well as in entertaining the hope, entirely groundless, that things might somehow resolve themselves. When it was finally impossible to persist with such delusions, I got up and opened the two windows in my bedroom and let the Bronx seep in.

I'd arrived on the cusp of dawn, when the voices that leapt in from the street were less threatening, and less compelling, frankly, than in the depths of evening. Together they formed the soft, harmless chorus that often helped me sleep, not unlike the white noise I dialed up whenever someone other than Claire spent the night in my bed; or city workers took something apart in the street; or Tanya, that poor woman, kept up her whimpering.

The neighborhood was most engaging, to me anyway, at its most assertive, whenever it refused co-operation with a local government that had grown intolerant, almost bored, of the depredations associated with poverty—that appeared less keen on leading its residents out of the muck and mire than in helping them reconcile themselves to a life firmly planted in it. The more profound refusal I discovered in my neighbors was the refusal of modernity itself. The workweek and its rhythms, for instance: on a Tuesday, long after midnight, you could still hear people laughing and joking, drinking and screaming, and sometimes, yes, punching and stabbing. Tonight, though, on a Saturday, a time set aside across the world for excess, what surprised me was the gentleness of the thrum, how free it was of the violence and conspiracy I'd come to expect and almost relish. The same clotted air choking me was choking them: their voices, and their feelings along with them, had been pleasingly muzzled.

I fell back into bed with the windows wide open. I'd grown used to sleeping at any time of day as the deadlines had disappeared from my life. Like my neighbors, the rhythms of my days were irregular. And so it was that at six in the morning I settled in for another undefined sleep which, like the last one, would be fitful and

only marginally restorative, given the alcohol still in my blood. Every hour or so my repose was riven by a deep craving to rise, to re-enter the cacophony of waking life, but it wasn't until it was nearly noon that the world, the rapid fire of car horns and tire squeals, became irresistible and drew me out of bed.

My legs buckled as I put weight on them, refusing to hold without conscious coaxing, which only proved how worthless the extra hours of sleep had been. For a while I went around my bedroom in circles, testing my balance and searching for my phone, though what I discovered before all else was that the ache in my legs was perfectly general. Not a muscle of mine had escaped unscathed. It made enough sense, really. For the second night running, things had finished with whiskey, and I could see that the bottle, there on the nightstand without a vessel in sight, was down to its final eighth. I must have taken it to bed with me in a sorry state. In truth, I ought to have been in much rougher shape than I was. Among Theria's other properties, perhaps it was a prophylactic when it came to hangovers. One more feature we could promote.

My phone had ended up underneath the bed. I bent to grab it and felt the blood rush to my head, bringing me down awkwardly onto all fours. I was relieved, however, to find exactly the thing I was looking for. Not the phone *per se*, but the notification on it. Garrett had gotten in touch, left a voicemail. I'd been more anxious, I realized, than I'd been prepared to admit to myself the day before. The point of my extended slumber may well have been, among other things, to vanish the time between my signals being beamed out to Garrett and his responses coming in, which so far amounted to a single ambiguous mark of punctuation.

I closed the windows to soften the horns that bleated now with an almost demonic force. They always got that way by noon. In a recorded voice carrying less of the ambivalence that perturbed me, Garrett quickly put an end to my fears: he'd liked my swatches—very much, actually—or if *like* wasn't quite right for what he felt, he'd at least understood, or believed he did, what I'd meant to achieve by them. He called them *gestures*, which I suppose they were, given how little idea I had of what they might lead to or how they might be built upon. I only knew that the look of the drinks, their precise coloration, was the first compelling thing about them. The tones were so elemental, one not far from ocean water in color, the other closer to the sun.

Garrett's voicemail carried on for an exceptionally long time. I was surprised he hadn't just waited until he could get me on the phone at a decent hour; he'd called at seven a.m., unreasonable by any standard I could abide, though I understood there were many who saw things differently. Eventually he turned to addressing my drawings of Daphne and Duke, which were more substantive, and therefore more risky, than the swatches, even though they were no less provisional. Once again he

judged them correctly to be graphic musings, nothing more. He said, if it wasn't too presumptuous to put it this way, that they had real *intrigue* to them, or rather that the subjects of the drawings held real intrigue for whoever had drawn them, which was just the quality he'd been searching for, and which several other artists he'd tried out for his campaign had signally failed to demonstrate. Now he only wondered what else I would end up seeing in these two over time.

I'd not known there were others before me. Just how many he didn't say. Presumably they too had spent a day watching these videos and... reacting. What had *they* seen in the tapes? As Garrett's voice ran on, the old white woman, this time in a tangerine shawl, shuffled through the propped doors of the bodega across the street. She was a regular presence, hunched over the counter with tubes running from her nose to an aqua tank mounted on wheels like a businesswoman's rolling briefcase. Each time, she would meticulously pick her scratchers from the dozens on offer by some principle I couldn't discern. As I looked on, several hulking Hispanics with strange designs cut into their cropped hair lined up behind her, chips and sandwiches in hand, quietly waiting their turn, indulging her futile pursuit of riches in a way that was almost touching.

Garrett was pleased, I learned, and relieved, frankly, that I was able to get as far as I had with the drawings just by using my eyes, without relying on a brief or bringing any sort of prefabricated concept to it. He liked to see people take *stabs in the dark*, without direction. In all his years in business, nothing told him as much about the people he was working with. And for this job, I'd done the best with it, apparently, though he didn't describe anyone else's take.

The old woman crawled away from the counter, tank in tow and tickets in hand, with an inexplicable pride written into her expression, even as she merged with the beggars accumulating lately in my streets like the falling leaves of autumn—leaves, it must be said, marked by a hue and vibrancy these men and women of color had long ago lost. I don't think it was merely my imagination, this surge in numbers. Just in the time the lady had been in the store, one or two more of the unwashed must have joined this tissue of abjection. I wondered what the city was going to do about it, such rampant destitution, and how suddenly the consequences might be felt.

Garrett rounded out his endless message with two questions, posed in elliptical ways that took some time to unfurl: what did I think of the drinks, really? and can we meet for lunch or dinner with Karen and the chief of marketing at Antral?

I'd leave the details to Karen. Arranging things was something she took pleasure in. Why rob her of that? I forwarded the voicemail to her. She'd be happy, I knew, to see I'd passed whatever vague test Garrett had set for me. There would be more checks from him, for all of us, and, given his manifest wealth, the money was

going to mean something. *Cosquer* the magazine, not just the design firm, would be newly flush with cash. I suppose I should have felt lucky, but I was still too foggy for those sorts of feelings. I proceeded to melt off some of my alcohol ache with a scalding shower. First-degree burns were not out of the question, the water was so hot (though the pressure remained laughable). I only just managed to get out before being overwhelmed. Drying off, I peeked at my phone lying on the bed. As expected, Karen *had* already replied, asking first of all for the drawings and the videos Garrett had mentioned in his voicemail. Remarkably—though exactly how long had I spent in the shower's swelter?—she'd also already contacted Garrett and set up a place to meet: this very day, if it wasn't too soon for me. Garrett was eager to get things going, she said. He liked to work like this, without delay. I also knew this just happened to be the way that Karen liked to work, on a timeline that struck most of the artists around her as abrupt and almost punitive, though it did guarantee that issues of magazine came together swiftly.

Had I gotten on the phone with Garrett myself, there would have been a few days to prepare for this meeting. But what was I going to do in that time, besides polish off the last of his whiskey? I wasn't annoyed with Karen. I admired her ruthlessness toward time itself, the way she controlled it, which was entirely at odds with the outward delicacy of her manner. Even in school, she'd always had a relentlessly methodical dimension to her; yet it never turned her into a careerist, as with so many others who possessed her kind of efficiency. It was simply a personal discipline of hers, an end in itself, not a means to advancement, which she, like me, had a surprising amount of contempt for, at least to the extent permitted by good graces. In college, I recalled, Karen would finish her studio projects weeks before the end of the semester. I had often only begun to draft an idea, mostly in my head, when she was wrapping up some rigorously composed silkscreen or putting the last bit of polish on text art so precise it could have functioned as a billboard. Like Rosenquist she'd learned to paint signs to a professional standard, and even earned money at it in the years following school.

In my first months in the city, when I had nowhere to be except my studio, she'd take me around town showing me her signage, the slant of her serifs, all the ways she could subtly imbue functional placards with other valences. Sometimes I'd even sit on the curb with a bodega sandwich while she worked a job. Our conversations had actually influenced those signs, she insisted, though I don't know if there was anything to it besides the pleasure we took in each other's company. What sort of pleasure? It came down to a difference. The first time I'd noticed it was during second-year sculpture. Most everyone was using a broad definition of the medium, so that nearly anything that wasn't a painting qualified. Karen, though, held herself to a standard I

think proved more fruitful in the end: the *David* standard. She actually paid privately for blue marble. She had those sorts of resources, her father being a secondary figure in a small but influential neoclassical arts movement that had come and gone, but not without making him wealthy, as there was always a market for things that reminded people of Athens. (Naturally this background cemented her bond with Claire, who'd also gone through a productive neoclassical phase.) It looked like a project that would take an eternity to finish, and with little artistic payoff. Myself, I was unimaginatively testing waters that definitively belonged to Frank Stella (a family friend of hers, of course) simply as a way of reinforcing my own sense of discipline, to continue painting even when we were supposed to be sculpting.

Somehow, Karen finished off her very involved piece—a nonplussed man-child a bit larger than Degas' girl of wax—much earlier than the rest of us, so much so that she was able, in the final weeks, to ponder the marble with the same intensity that she'd begun work on it, and make a decisive change to it as well. It was in this final phase of creation, we all knew, from our own work if not from Vasari and Wölfflin, that art often went from creditable, even excellent, to something rarer, something worth putting your name to. At this late stage of the semester, the rest of us were only beginning to discover the troubles latent in our original intentions; it was the eleventh hour, and we were left scrambling to reform things, to change tack by the time of the final show. Meanwhile, Karen was edging her way toward fresh ideas. Her little boy, whom she'd situated upon the bent branches of a sapling that, being as immature as he was, only just managed to support his weight—to all appearances this marble boy and his delicate situation were already fully realized. There was, it seemed, nothing left to do. Yet a week of unfettered meditation upon it yielded a discovery: the work's sense of precariousness *could* be torqued, and Karen did just that in her final pass. The base of the sculpture, the soil in which she'd stood her tree, was a primordial mass that could be pushed one degree further, by turning its irregular folds and ruts into incipient flames, flames that on inspection were actually crawling up the trunk like tendrils, giving the boy uncomfortable intimations. I believe Karen had to work excruciatingly slowly in that final week, individuating each wispy lick of fire without shattering the tree, root and branch, or even the boy himself.

I finished the course with a capable Stella-esque exercise, even adding a wrinkle to his style by bowing the frame so that it bulged from the wall parabolically. It took me half a semester of trial and error to figure this out. Before mounting the canvas, I'd painted a sort of blueprint of a cityscape on it so that as you looked at it hanging on the wall, the planned town, rendered in rigorous linear perspective, seemed to run away from you. The piece stood up well enough amid the student work displayed on the last day of class. Everyone seemed impressed by my jerry-rigged mounting,

particularly the way it warped the carefully gridded buildings. You could feel the structure beneath, of course, imagine what it would have looked like had it been mounted flatly. Or, at least, you thought you could. But Cassie Cortell, our instructor who'd built a reputation on works in molded plastic and advanced polymers, found my cantilevered frame to be the most interesting part of the project. It was actually a sculpture, she said, taking it from the wall and setting it on the floor so that it bulged upward. We circled the work, pleased by the potentialities.

But then there was Karen's little boy burning. Here Cassie's reaction was more muted, more contemplative, and pointedly free of correctives, as Karen's was the only realized *work* in sight, and not a study of some kind. I destroyed my piece just days after class. Karen thought I shouldn't have. Her little boy, I demurred, had driven me to it. Our friendship only took hold after that, when she told me over murky Manhattans in a drab student bar that she agreed with Cassie about what I'd done. *Even if it was a bit of a mess,* I remember her adding.

I'd learned something about the imagination from Karen, I realized later: it had depths you could only reach by continuous exertion. Bursts—at that point, the only way I knew to work—simply wouldn't get you there. Surely my Renaissance heroes, whether Pontormo, Rosso, or Mantegna, knew of this, the slow burn of the imagination. Didn't it stand behind the many series I'd constructed more recently, where the unfurling of time couldn't have been more central? In a world of overabundances of every kind, the sprinter had to give way to the marathoner.

Yet Karen took no undue pride in her systematicity. And I never adopted the attitude wholeheartedly. The late start, the instinct to dash, to push on heedlessly, invariably manifested at key junctures in nearly everything I did. In those moments Karen would try to suppress her displeasure, but I could see it almost constitutively irked her, in the manner of allergies, a condition she might have inherited from her neoclassical father. Not that she thought my tendencies flowed from sloth, preciousness, whimsy, or some retrograde theory of the muse, all of which she had an unveiled dislike for. This is one reason she'd turned toward printmaking and graphic design in school: the lesser prevalence of such vices in those quarters. What displeased her most was the post-war fad for the entropic, still going strong: a craze for the arbitrary and incomplete, or whatever, really, that signaled the defeat of our apprehensive powers, allowing us to bathe in wistful, knowing regret for what we couldn't quite manage. This stance had damaged at least a few generations of artists now, Karen and I agreed on that point. It was risky to traffic in accident and instinct, in whatever was unformalizable, as so few could confront those forces, as Beuys and Cage had, without being toppled by them. I *might* be one who could get away with it, Karen accepted that much. Yet she didn't see this as a threat to her position or approach, given the

particulars of my life. I had, after all, steeped myself in study of all kinds, most of it conducted on my own, with deference only to the primary sources of paintings and copious books. If I now indulged a certain recklessness in my art, in my life, well, I had probably earned the right.

She seemed to accept all of this about me even before I'd *said* much about it myself, which made her a natural companion in college and beyond. Our intolerance for the axioms of the moment, where failures of various sorts were frequently repackaged as strengths, or at least authenticities, manifested our distance from our own times. Of course, she and I didn't reject *all* the same things, not by any means. As much as I recoiled from the epistemic insecurity of my cohort, and all the sloppy pluralisms that followed from it, I had at least as much dislike for the too-convenient pragmatism of the design community, where it was possible these days to make a good living if you'd made your peace with helping multinationals move their merchandise—under the cover, of course, of rejecting the *hermeticism* of a purely artistic practice. If *that* was the only kind of optimism manageable today, I'd have to side with the pessimists. This of course made the prospect of working with Garrett a thorny matter, whatever I told myself about him, or however much I badmouthed the moribund fine arts. Would I too begin to act in bad faith? Was I already compromised, and would I only discover this later? Worst of all, would I suffer the fate of the greater part of mankind, never discovering my own forfeitures and dying in ignorance of my ignobility?

On this point Karen was more magnanimous: at least designers were usually open about their lack of seriousness. It didn't take much questioning to bring out a sheepish look from them. And this in itself made them more bearable, she thought, that they didn't spin their shortcomings as Warholian virtues but acknowledged them for the travesties they were. For the few designers—John, for one—who managed to operate with bona fide negative capability, which was, for her, the *sine qua non* of significant art, whether they did so in magazines, advertising, or "communications," she held them to be entirely equal to any of the fine artists she knew, who were themselves mostly one-note provocateurs, conceptualist pretenders, and political ideologues. Actually, she believed, there were only a handful of people worth paying any mind to in *any* walk of life. Most of *everything* was dross. When it came to real interest, we agreed, the world was a desert, not an ocean. You had to search out the oases in it if you cared about it all. Severity of this sort didn't earn us many friends. But it certainly accelerated *our* friendship, the way isolation can.

Karen had a far less conspicuous way of voicing all of this, so it cost her less socially; her rebuke wasn't there if you weren't looking for it, or if you didn't exercise as much consideration as she did in expressing herself. But it was there all the same; and

it was, if anything, *aiding* her reputation as she made her ascent in the art magazine world. People liked a touch of austerity in their editors and tastemakers, the air of exclusivity it brought.

Personally, I still didn't believe that *any* of the most intriguing artists of our time were working in commercial or communications contexts. Not anyone I knew of, at least. Karen mostly bit her tongue on this point, though, as she continued to assign me work. Only later would I come to understand what she was experiencing in secret then: how full-bloodedly—how *steadily*—she was pushing words to the center of her life, words being a medium dearer to her than I'd known, and expelling all imagery to the consumer sphere, where she sensed more and more it truly belonged.

13

Garrett had gotten us a table for four at Sanguina, a Catalan establishment only recently opened near the southwestern edge of Central Park. Though I'd heard of the place and its rustic seafood dishes, I'd never been, which allowed me the excuse of going preternaturally underdressed: black twill pants and a T-shirt that you could say came with my apartment, with the stack of clothes that had been left on the stripped mattress when I'd moved in. Kiver didn't explain this irregularity, but I knew now they belonged to yet *another* family he'd turned into the street, so quickly that the bewildered evictees hadn't even had time to gather all their possessions. The shirts in the pile were genuine pieces of streetwear, as a decades-long process of degeneration had turned their printed designs abstract and unrecognizable. Luxury designers took pains to simulate this threadbare quality but generally failed, since the magic ingredient was something like despair itself. Claire, knowing the provenance of the clothes, didn't like that I wore them. I certainly didn't do it to pose as a local. It was just that the privation the original wearers had borne made their garments unfathomably comfortable, as if they were about to dissolve into the air.

Whenever I dressed in these items, I couldn't suppress the fear that a beggar might ask me to hand them back then and there in the street. With so many homeless roaming around now, the odds of this nightmare encounter materializing weren't insubstantial. Luck doesn't last forever. But that didn't stop me from slipping into those gossamer shirts and trousers, as well as a pair of Pumas that looked of grey suede, the paint had so thoroughly rubbed off them. Neither the shoes nor the clothes had much of a place at a chic spot off of Central Park, of course, but the thought of picking out something more suitable stood little chance against the feelings of ease pervading me.

I met Karen at the restaurant's bar just before seven that evening, at her request, so that we might have half-an-hour to strategize before Garrett's arrival. The chef was rising fast in the firmament of restaurateurs, she teased me as we ordered our drinks, well knowing that despite my avowals of indifference, I enjoyed—no, I *understood*—good food, and not just because of my half-decade in New York. Really my acquaintance with culinary niceties, the more delicate pleasures they conjured, came mostly through my mother, even if she herself wasn't much of a cook. No, she took a

certain progressive pride, I think, in being no more than passable in that department, more or less refusing to improve when by all rights, given the speed with which she picked up everything else, from curation to administration to academe, she should have been better. So it was left to my father to prepare the more significant meals at home, and though he had a rather limited range, mostly involving meat (as you might expect), he was the person we turned to for going-away dinners and birthday lunches. The everyday meals you hardly remembered—attention to such things was frowned on in my home—were my mother's domain, and the remainder came by way of takeout, the many varieties of regional Chinese cuisine we had a taste for, all of which seemed to be represented in San Francisco in a way I had not discovered anywhere else, not even New York.

My mother's failings in the kitchen had the curious effect of sharpening her appreciation of food whenever she dined out: deprivation, underuse, enhanced her sensibilities instead of dulling them. She was a born appreciator, really, even before she got her first curator's gig in San Diego, her hometown, or after her time in the Curatorial Studies program at Bard. One meal was enough to set a benchmark for her, even if it was three years before she tried another version of the dish, however obscure. My parents' courtship in Los Angeles had actually centered on dining at the finer establishments. This felt like my father's way of apologizing for being involved in something as venal as corporate law. In truth, notwithstanding his culinary skills—he was good at everything he touched; mastery pleased him—my father was something of an anti-connoisseur, content with round steak and domestic beer—if not a cheese sandwich and V8—for dinner. This unfussiness would make those Michelin-starred dinners all the more special to my mother, when she came to understand, after they'd married, that he preferred to eat simply, without forethought. The meals out, then, really were gifts, indulgences of her sense of taste, while for him they were something closer to trials.

Nevertheless, in the name of appreciation, my mother insisted the family make all the main culinary stops in the Bay, starting with the big ones, Chez Panisse, the French Laundry, and ending with pathbreaking places known exclusively to those following *haute cuisine*. I can remember my father's mien during these meals: he was engaged only so long as he was looking at one of us, and always crimped by melancholy as we worked our way deeper into the courses. Whenever his eyes lost ours—and I would learn, as an artist, that this is the only time you saw anything much about someone, when he didn't know you were looking—he seemed to be enveloped by an ordeal, which was often enough that of dining out itself, something he grew increasingly to dislike as he ascended in the legal world and gilded meals like these became *de rigueur*.

Other times, it was a thorny case that perturbed him, although this was in fact the sort of trouble he welcomed, given his skill in constructing arguments and delivering them, too. He had an unmistakable eloquence about him, even if he spoke slowly, taking his time responding to anyone, no matter how many silences this produced. You wouldn't have associated him with the silver-tongued sort who dominate law—and that, some say, was the reason he was so persuasive. In his firm of just six partners he was frequently both the brains and the face of the operation, handling strategic matters behind closed doors and rhetorical ones upon the courthouse stage. Strength in the first domain, though, usually obviated all need for the second. A private discussion between parties would take place, at a restaurant like Sanguina, and the case would be settled without going to trial. Those occasions, marking successful negotiations, were probably the only meals he truly savored, and this while barely touching his food. Nothing nourished him like victory.

In this regard, I was firmly my father's son. I never sought out haute cuisine, abundant as it was in New York, a city in which every nondescript doorway seemed to lead to obscure and exquisite pleasures of the palate. Still, years of fine dining around the Bay under my mother's guidance had well acquainted me with the practice. Karen didn't seem especially keen on it, either; but as she came from a family far wealthier than mine, and of longer standing—her father was prosperous much before sculpture personally advantaged him, so to speak—such meals were, for Karen, entirely quotidian. Impromptu lunches might be taken at Eleven Madison (her family had no need of reservations), throwaway breakfasts at Il Buco or Saint Ambroeus. Having come from such a clan, Karen could only react to occasions like tonight with gentle boredom, even if ancient knowledge had a way of peeking through, say, in her overfamiliarity with obscure varietals (Picpouls, Rotgipflers) and gamebirds (chukars, huns).

I didn't ask her at the bar whether I'd finally get my ortolan, and not because it would have been absurd to ask that at a seafood restaurant. Whenever the two of us ended up at rarefied establishments, which was neither often nor uncommon, I was in the habit of asking her this, *the ortolan question*; and the less funny it was to her—it must have been dead on arrival tonight—the more humor I found in it, in a purely private way, through aggravating this niggling wound of hers, which was also a flattery of sorts, that the world she came from was so well disposed its denizens could quite intelligibly make torturing little birds into a culinary pastime. But I was tiring of this sort of fun these days, so I didn't bother with the line now, and she seemed almost disappointed by its failure to appear.

I did wonder why we needed to meet at such an exclusive spot. The venue was suffused with the spirit of a new world recently come to life within a wider one

exalted by all—the fringes of the park (well, excluding its north side). A restaurant could maintain this atmosphere of familiar novelty for months, provided it held the right delusions about itself firmly enough to engrain them in those who frequented it.

"Coming here was Garrett's idea," Karen declared. "You really thought it was *mine*?" She made a face as if to vomit.

"Well, it's hard to tell with you sometimes. The Tallys and their dining clubs."

She traced the white marble veins with her fingertips and fleered.

"I think he just didn't know what sort of place we'd want."

"And you couldn't steer him to something more our style?"

"Does anyone have any idea what your style is?"

"Yours, then."

"This isn't so bad."

"I thought you'd see it that way."

She turned away from the shimmering bar to survey the tables and patrons behind us. "Know who that is?" She pointed her chin at someone or other in the crowd. But I was more taken with the bartender returning with our drinks. Why I did this I can't say, but I sank my old fashioned in three ugly gulps, almost before he could even set Karen's glass down. He was practiced, though; his grimace lasted but a moment before he offered me replenishments.

Karen shook her head and delicately sipped at the house cava, as if this might nullify the barbarity I'd displayed. "Maybe this is just the sort of place Garrett's used to," she speculated. "*Try* to enjoy it at least?"

We'd come here early not for pleasure but so we could talk things over. This is what she'd claimed, anyway, though so far she'd said nothing about my sketches. Did they displease her somehow? Especially the ones of Daphne? Was there a critique Karen wanted to deliver but couldn't see an opening for? That didn't sound much like her to me. In the early stages of a project, she didn't worry about imagery. And so far there hadn't even been an assignment from Garrett; I'd just drawn without a thought.

It might be that she had something else to tell me. About Claire, even? (Her name rarely came up between us now.) The truth was that I couldn't think of one of these women without thinking of the other, given how close they were, which meant that seeing Karen always gave me the eerie sensation of seeing them both. And in fact every time I met with Karen, I couldn't help but wonder whether the circumstances of our encounter might put me in a light in which I'd rather Claire not see me, given that Karen was surely providing detailed minutes to Claire afterward.

I say this because for a couple of months, after Claire and I parted ways, she'd gone to stay with Karen while looking for her own place. Karen might well have believed I resented her for putting Claire up, facilitating her withdrawal from our

life together. Did she believe that? And did I resent her? How difficult it is to settle such questions. What I spent more time puzzling over was this: What exactly passed between the two of them these days? And what was withheld (and to what purpose)? What, for instance, would Karen report back to Claire of tonight—of me? What might she be scanning for, consciously or not, as we prattled on and took our drinks? Equally, what might she keep to herself? Which is to say, where did their interests come apart, as any two persons' must? These questions were no easier than the others: in listening to Karen, particularly when we were alone, I could never say to what degree the words were hers or Claire's, though I felt certain they belonged to both. No one could have said or suggested all the things Karen did to me without drawing on a cache of knowledge possessed only by Claire. Depending on mood and circumstance, this blending of language and intention was a delicious conundrum I could revel in as we spoke, or a practical bind requiring the greatest discretion if I was to prevent communicating more than I wished to.

Soon we were led out to the patio, to a wrought-iron table that struck me as remarkably informal, although on examination I could see it was hand-forged and marked by countless idiosyncrasies, capricious swoops and swivels of metalwork that somehow managed to harmonize into an elegant whole. Outfitting the patio with furniture like this would have come at extravagant expense, never mind that it still made the guests seated around us, at least at a glance, seem overdressed in their cocktail gowns and dark suits.

The staff brought out another drink for me from the bar and Karen and I finally touched glasses. We hadn't bothered to the first time around, but now without a word we were impelled toward this silent toast by the great park of New York before us, which for the moment stood reduced to a fringe of illuminated green shading into what might have been untrammeled wilderness, for all we could see. The only giveaway of our true locale was the conversation at the next table, where the talk was of the Philharmonic's upcoming season: apparently, Uchida was going to be presenting Liszt concertos.

The drinks were distinguished, that had to be conceded. I'd ordered an old fashioned mostly to test the bartender, just as you found out whether a chef was worth anything by ordering the omelet. Without the obscurity or confusion that complexity risked introducing, you discovered just how sharp his fundamentals were. In this case, very sharp.

"How'd you manage to watch the videos so fast, by the way?" I asked.

"I didn't finish them. How could I have?" Karen held the flute of cava by the stem, without setting it down.

"Well, then why did—"

"He wanted to meet today, I told you."

"So what *did* you have time to see? How's that?"

"A little bit of each. And the sketches, too."

"And so?"

"What?" She took another sip and shrugged.

I pushed my second old fashioned away, nearly tipping it over as it scraped against the ironwork, which had purposefully been left raw in spots. Sometimes bluntness was the only way with Karen. "If you weren't going to tell me anything, or *ask* me anything, why did you want to meet me early?"

She looked at me a long time, as though I were a cross child; she eyed my relocated drink, plucked it with three fingers and set back in front of me, as if reversing time to the last right moment between us. "I just want to drink with you. How about that?"

"I can't really believe that."

"Oh? Well, then, suppose there were something you wanted to tell *me*, before we dealt with these people?"

"There isn't."

"But *suppose*."

I supposed. I thought of Claire as I gazed at Karen and came very close to giving her what she asked for. Instead I settled on silence.

"Then you would have had the chance to tell me, wouldn't you?" Karen raised her glass as she said this, her voice softly sorrowful, her face resigned. She might have wanted me to be the one to mention Claire, to see how I was handling the aftermath. Or perhaps she was hoping I'd talk of something else entirely. But I wasn't going to oblige.

I lifted my glass wearily and tried very hard to smile. I was failing at this when a black Escalade pulled up about twenty yards beyond Karen, and there in the backseat was Garrett. He spied me before he was even out of the car, waving through the tinted window with an irresistible eagerness. I waved my glass at him, as though we were drinking to his arrival, and Karen turned around to see him. I drank alone.

The driver opened both backseat doors and Garrett stepped out. He was followed by another man, slender and wearing a beautifully tailored houndstooth coat, the sort that tapered smartly at the waist—bespoke without any trace of pageantry. The man quickly rose from the sort of crouch one makes when getting out of high vehicles; his full height was startling. Indeed, his fine suitings couldn't hide his excessively long legs and generally awkward proportions, congenital faults not to be pinned on his tailor. Garrett, meanwhile, was again outfitted casually, if crisply. Perhaps he'd just come from the office.

The maître d' quickly put us all together and in moments I was rising to shake hands with my new boss.

"Are we late?" Garrett asked, in a manner I could almost believe was sincere.

"No, we didn't hit any traffic over from Brooklyn, that's all," Karen lied. She still looked shaken from my refusal to engage her hypothetical. I felt a little sorry, I didn't enjoy disappointing her, but then I felt confused, too. What *had* she been hoping for from me, exactly?

Garrett and Karen hugged notionally—their bodies barely met—while I faced up to the houndstooth man. There would be no conventional greeting between us, given the oversize magenta folder he cradled in his arms. Besides, he stood at such a distance that a handshake would have been impossible, were he willing to offer one. Still, he was not so far that I couldn't get a good look at his coat, which was even more refined than I'd thought. I found myself struggling not to stare at the soft lines of his lapels, the gently tapering sleeves, and the intricate patterning of the fabric, all of which put me in mind of my father's best suits, the ones he would wear before his greatest trials. This man's coat was so pleasing, in fact, I was almost ready to forgive him his native misproportions. Eventually I tore my gaze away from the garment and looked steadily into his bespectacled eyes, yet he would only look back at me glancingly, never more than a second at a time, as if he didn't think it right to do so until his boss had formally introduced him.

Bolder than the rest of us, Karen plunged her hand, palm up, into the void separating the three of us from him. He lurched for her hand with a long stride; he even went on to half-embrace her. The two of them, I realized now, might well have spoken earlier in the day, about this meeting.

We found our seats again. The moisture in the air was gone and the night had begun to turn autumn-sharp.

"I never do this right," Garrett simpered after settling into his chair and catching sight of his colleague. It was as if he'd momentarily forgotten he'd come with anyone and was startled to find a man he knew so well by his side. He rose halfway, reached over and grasped that beautiful houndstooth sleeve. "My chief of marketing, Paul." Immediately Garrett's expression registered fresh concern: "Now, is this place *okay* with you two? I've never been before. But Paul tells me it's worth our time. And I trust him." Garrett grasped him once more, this time by the shoulder, and perhaps reconsidering this last bit about trust, which was clearly a little much, made a face as if to laugh. But he caught himself and merely shook the shoulder now in his hand. Paul nodded—happy, it seemed, for the show of respect, which seemed to me perfectly genuine. I sensed no condescension or wryness in Garrett's declaration: it was probably just the truth—he trusted Paul—and he'd been only on the cusp of laughing at *himself* just now, for being too plain about his feelings in a first meeting,

and perhaps also because we might take his words to be a line of some sort, designed to make an impression on us, and he wanted to dispel any notion that he was someone who needed bits.

So far I was finding his Midwesternness no put-on, at least to the degree I grasped the phenomenon, which, to be fair, was a matter for debate, given that my primary source was John, from whom generalizations were made at one's own risk. In any case, it seemed *to me* to have a convenient coyness built into it—the Midwestern identity, I mean. Garrett and John both exploited this, insinuating into conversations sentiments you just couldn't voice, not outright, or else leaving out things you really weren't supposed to but could if you knew it would be chalked up to a certain characteristic discretion or modesty. For all I knew, this was just the way of the Corn Belt. Every regional identity has its subtleties, and though we don't select these identities for ourselves, but have them bestowed upon us by birth, each of us learns to find advantage even in the deficits.

Garrett's bearing, the birthright of Chicagoans, had a gentle religiosity to it, along with a penetrating earnestness that would slash through from time to time. He might look away from you thoughtfully, only to return, for the briefest moment, with a gaze of pure fire and devotion that jarred with his being a man of measurements, not faith. This otherworldliness was also made a tiny bit comical by the manifest influence he commanded these days as a cutting-edge technologist; and his having people like Paul, men in bespoke suits, at his beck and call. His offices alone, whatever rare material they were wrought of, and however much he must have paid to acquire it or synthesize it, radiated the preternatural power that he himself, in his person, was loath to exert in shows of force that would be otiose.

I hadn't much cared where we were meeting when I'd left my apartment, but now that Garrett had forced me to consider the matter, it would have been false, as night fell, to say I was merely tolerating the rarefied atmosphere. It was as bewitching as ever, especially as I didn't spend much time sitting outdoors, except on my balcony, when I was more of a secluded observer occasionally taunted from the street for his impunity.

"And what is it you've got there?" Garrett said, leaning toward me.

"Just an old fashioned. It's very—what would you say?—crisp."

"Oh, well, let's get one of those." Garrett looked over his shoulder at the other man. "And Paul, what would you want? An old fashioned doesn't sound right for you."

An opaque look passed between them, a look free of secrecy but steeped in a long history that couldn't readily be parsed by outsiders. The question Garrett had posed was the first one asked of Paul; I was curious to hear the man open his mouth. He took his time.

"The martinis here... they're already famous." Paul's voice seemed to waver, as if he didn't quite believe what he'd said. There was no bass in it. It reminded me of a child's voice, the kind of child who plays by himself. And in fact he wore a slight scowl upon his lips. A tiny smile arrived belatedly, as if he'd been waiting for reactions to his declaration and found it amusing there were no takers. Yet it didn't really ease the dourness of his visage; the smile just overlaid it with wryness. Indeed, I would come to find that no matter what else Paul's face evinced, even profound joy, a note of displeasure remained. Was this just a kind of expressive defect, or did it accurately represent a forever troubled state of mind? I never found out. In any case, there was this face, this scowl, and now this gaze, which conveyed none of the diffidence of his voice and showed that he'd in fact meant just what he'd said about the martinis, that he felt his grounds were firm and his verdict definitive. My father sometimes gave a look of this sort, though he was the sort of man who didn't really need to. Paul was different, I already knew that much.

The waiter sorted out our drinks, so that I had yet another old fashioned in my hands in the kind of time that suggested here, in this place, any gap between desire and its satisfaction was immediately bridged. These were Michelin ambitions. After Garrett took a deep sip, a single giant cube rattling against his glass, I expected a declaration like Paul's, about the drinks, to come from him. But he moved on to bigger things.

"We've been looking over your drawings," Garrett said.

Paul set down his dirty martini and opened up his folder, which seemed a richer purple in the light of the candles. Inside were high-resolution printouts of my pictures—the ones I'd sent Garrett as photos—with a thick white border on all sides, each brimming with neat strokes of green ink, the product of a firm, even severe hand.

"Paul has notes for you," said Garrett. "*Lots* of them, it looks like. We'll get to those. The thing is, we've known each other a long time now, Paul and I, way before he was doing communications for Antral. And what I know is that even if I don't always agree with him, he's got sense. You'll see. Wonderful *taste*, too. He knows his art—like our friend Rog does. Frankly, I'd be slightly lost in all of this without him. He's my guardrail. Do you know that at one point he was enrolled at the School of Visual Art?"

"A long time ago, James," Paul said.

I knew that SVA had, unusually, an advertising department.

"But it's really something more than taste he's got, said Garrett. "*Sense* is what I call it." Garrett shrugged at this apparently indisputable truth about his colleague.

I examined Paul in the way that one does when a person present is compared to a joint acquaintance—in this case Whent—and one is somehow expected to verify

the similarity simply by looking at him, even though the similarity in question is not a visual one. Paul faced me as I regarded him, knowing he was being inspected in just this futile way; but the gaze he returned was softer than before, less wary, even collegial, perhaps because I was the artist for this nascent campaign. *Their* artist, that's how they would have thought of me. Whatever it was, I was being displayed to Paul as much as the reverse.

He left the folder open, the pictures overlapping yet slightly fanned out, and returned to his martini, which he'd so far hardly touched, except for spearing one of the olives into his mouth.

"You're right, you know," Garrett said to me. "These drinks are something. But what I want to know is, what'd you think of *our* drinks?"

"Right!" Karen blurted out, as if she'd been waiting for this turn in the conversation. Though she'd been engaged enough up to now, it was clear she'd been keen to get on with things—perhaps to distance herself from whatever disappointment she'd felt with me earlier. She'd said nothing so far about my pictures, even now that photos of them lay in plain sight. I'd watched her closely—more closely than I did our clients—when Paul first opened the folder, just to gauge her feelings about the images, but she remained frustratingly neutral in her demeanor. Was it too early in the project for her to care much about drafts like these? Or was she waiting to see how Garrett and Paul received the pictures before entering the fray? She was canny when she needed to be. It's what made her a good steward for Cosquer.

"You've tried them too, Karen?" Garrett asked. "Do you drink whiskey much? I mean, straight?"

She took a quick sip of cava, the last of the glass, inverting it sharply and gulping hard, thinking of what to say. "Sometimes," she began. She shut her eyes tight and let them open slowly. "Sure. Not very much, I guess, but enough to know it was one of a kind, that whiskey of yours."

Without replying, Garrett turned to me expectantly, his easy manner dissolving into a sterner mood of appraisal as he solicited my own view of the matter. Paul's gaze also sharpened, though it remained fixed on Karen, the other creative director at the table. He was sizing up her remark, I thought, wondering how suggestible she might be, what exactly wrangling over the campaign with her was going to look like.

Eventually Paul joined Garrett in regarding me, and under the combined weight of their gazes, I began somewhat reluctantly to expound on the whiskey. I did it circuitously. I know that I used the word *deep* several times in the process. It's such a vague word, not the kind of thing I would ordinarily permit myself. Yet in this case it was actually truest to my feeling, in that it seemed to me the whiskey originally addressed

you only in a whisper. Two drinks had to pass before it spoke to you properly, which meant you could definitely underestimate it if you were too noisy or weren't listening carefully.

Paul seemed to mouth the word *right* at this point. Certainly his bearing suggested a new accord. He had subtly grown more animated, forward, though I noted this from the corner of my eye while I studied his boss. It was the first word of mine—*underestimate*—that induced an appreciable reaction in Garrett, a subtle contraction around the eyes, the ghost of a squint never completed. This was the hallmark of recognition in people who had this response in their repertoire, signaling a pre-verbal, involuntary sort of agreement. Which made it more of a tell than a conscious act of expression. I would have preferred a more definitive indication at that point—after so much silence, I mean—but I assumed Garrett would oblige eventually if I pushed on.

"It's not the sort of drink you would ever want to mix," I declared. "I never tried it that way, anyway. I couldn't see the point."

"It's just so light," Karen said. Her voice had turned dreamier. "Anyone can drink it, I think, even people who don't really *like* whiskey."

"People like you," Paul said with the flourish that was to be characteristic of him whenever he felt at ease, though the feeling never lasted long.

"I would drink it, yes."

He nodded softly and folded his hands, waiting for Garrett.

Speaking would have been the normal thing to do at this point, after Karen and I had offered our assessments. Instead Garrett was *looking*, staring, actually, with that blazing conviction which it would always surprise me to see possessed in such abundance by him. His eyes fixed on the yellow sodium lights along the park's edge, down toward Columbus Circle, from where we all suddenly heard a din. I followed Garrett's eyes and even turned around, not really to see what we were already hearing, but in hopes my apparent interest would encourage him to engage us. He wouldn't be drawn, though. In fact, Garrett hardly noticed me. It was alarming, the force of his curiosity about whatever he was seeing or imagining far down along the sidewalk. It resembled possession. And when I looked at him once more, any recourse to speech he might have made seemed further away, not closer.

Karen joined our collective gaze parkward. There behind us, ambling up Central Park West, talking, or anyway vocalizing, were six men. We couldn't make them out properly at this distance, yet we could hear them as clearly as we did pedestrians strolling much nearer to us, a clear enough sign we were likely dealing with the not-quite-homeless, that is, the merely poor, who were frequently clamorous, having still in their possession a certain élan that years on the street tended to expunge. Two-thirds of what came from their mouths weren't words at all, just yelps and screams

braiding together fits of violent laughter that nothing in this world could justify, at least not if you understood the world in any way I could imagine.

This kind of brash street poetry was obviously a routine sight in the city, so much so that Karen had no reaction to it at all while she waited, I assumed, for us to get back to business. Somehow, though, Garrett was mesmerized by the scene. On his face a small drama played out, one that I stood no chance of parsing. Hadn't he lived here for a couple of decades now? How could *this* still capture his attention? He did, of course, live on Roosevelt Island, which had peculiar demographics, I'd heard, nothing like the rest of the city. It almost *wasn't* the city, just a waystation. And before that, Garrett had been living in the center of the Upper East Side, a place which didn't engender the kind of mixing of life that occurred in showpiece New York, where we were now, where tourists and diplomats and celebrities and criminals and everyone else found themselves in spitting distance of each other. This commingling was only accelerated by the presence of the park, the center of recreation for people from all over the city and the world, even while it sat under the imperial spires of Billionaire's Row that rose right below it, along Fifty-Seventh Street. The Row had been going up for many years now but never seemed any more finished; as soon as one tower approached completion, two or three other buildings in the area became the converted foundations of new towers, towers which would naturally need to shoot hundreds of feet higher than their forebears, going from ten or twenty stories to seventy or eighty by the time they were done, who knew just when. The skyline was permanently marked, quite beautifully, really, by the agents of this permanent revolution: twisting cranes shuttling massive containers and beams over Fifty-Seventh. During the day you could walk right underneath all this dangling matériel and consider the possibility that capitalism might, in a winningly direct way, take your life, then and there on the pavement. I liked the cranes best at night, though, when you could see only the ghost of movement in them, their skeletal upward thrust recapitulating the buildings on top of which they sat.

Garrett, however, couldn't have spent much time strolling the city, here or anywhere else: the kind of success he'd had in life simply precluded it. No, he must have passed nearly all his hours in his lab and his home. He really might *not* have witnessed all that many scenes like the one inching its way toward us.

"I'd keep your whiskey away from ice," I offered rather lamely, hoping to push things back toward our reasons for meeting. "I don't see how you could taste it at all that way." Another punishingly long silence followed. Silence on the patio, anyway. As the gang made its way down the street, we and the rest of the guests outdoors were treated to a parade of epithets and slurs and general ribaldry, chockfull of pronouns missing referents. I suppose it was to Garrett's credit that he could be as consumed as he was. He'd not turned to avert his eyes from the grotesqueries of urban life. For all

I knew, he'd discovered some sort of joy in the profane.

Paul, who'd been looking rather listless until now, interceded in his childish, serious voice: "What about Theria, then?"

Garrett was busy brushing off a waiter who'd sidled up to him asking about our dinner plans, hushing the man with one decisive wave of his hands and a glare as violent as the cackles of the approaching men. I'd never before witnessed someone browbeaten so concisely, but the waiter behaved as if nothing untoward had occurred; as if, in fact, there was and always had been a total accord between him and Garrett. There could be no such thing as indignity in his line of work.

I gave up twisting my neck toward the street and resurrected a manner of observation familiar from my childhood with Ty, gleaning the essentials of the episode from what I saw of it reflected in Garrett's expression. In such moments, I often left language behind, just like our host, a fact of which Karen was aware. So she answered Paul in my stead: "I didn't have very much of it, actually. Theria. But I liked that hint of herbs in it. It made me think of green tea, but then not really. Anyway it's nothing like—and this is the same for the whiskey—nothing like other 'smart' drinks, which taste so..."

"Chemical," Paul said.

"Yes!"

They both turned to me just as I beckoned the same waiter Garrett had dismissed, to get myself another old fashioned. I considered that this might annoy Garrett, to see this man back at the table, but I was rapidly tiring of company, and when this feeling descended upon me I was forced to choose between leaving abruptly or having another drink. So I was doing the polite thing. In any case Garrett appeared entirely invested in the approaching chorus. We'd disappeared for him. Yet Karen forged ahead: "Our partner, though—John—he tried it too and said... well, actually, the most interesting thing he said was that Theria helped him through a hangover."

Paul smiled deeply for the first time—good news for the bottom line, maybe. I could have said I'd had the same experience as John but I was on the lookout for my next cocktail.

"He painted with it, too," she said. "He had a long session..." She trailed off and grabbed my leg, desperate for my co-operation.

The *persona non grata* arrived with my old fashioned and Garrett winked ambiguously at me, amused, I thought, that I'd brought this man back into our orbit and furthermore recommitted us to staying here through my order. He was wrong, of course. I was prepared to finish this drink in one swig, and I nearly did, taking the glass directly from the waiter's tray and leaving only a sip or two in it by the time I set it down on

the table. I didn't care anymore. Garrett was acting so oddly, why couldn't I be a little wayward now? The night again seemed viable to me; I'd been granted an extension.

"I watched the videos, actually, while drinking the stuff," I said finally. "A *lot* of it."

Garrett returned to his senses just then, although it may have only been because the miscreants detoured, crossing the street toward the park. He seemed an inch taller as he sat up and pushed aside his drink, which he'd hardly touched after the first sip. Wouldn't it be strange, and strangely apt, if he didn't even *like* drinking?

"Is that right?" Garrett said. "I was hoping you might do that, without my saying anything. That you'd go ahead and just do that."

"I drank, I think, five or six bottles of it like that."

"That much?" Paul asked.

"Was that not a good idea?"

He almost laughed.

"I guess the FDA hasn't gotten around to this yet."

"No," Paul said. He speared the second olive from his empty glass and admired it for a while.

No, it wasn't a good idea? No, the FDA hasn't looked into it? Or—what I was hoping—No, it's fine? Nothing could be read off his face, and by the way he twirled his fat green olive, I believe he was enjoying my incomprehension.

"It's just interesting, that you liked it so much," he said.

"Well, I almost didn't notice drinking it. Or even notice drawing while I did."

"Really? Well, that could be even better in some ways."

"Do you not care for it?"

"It *is* unusual, right?" said Paul. "It can take a bit of time to 'get,' for some people, is what we've found. Most people. But you, well, you didn't even notice it going down, you're saying."

"After the first bottle or two," I said. "I definitely noticed those two."

"I see." He didn't, but that's what he said, in a tone that put me in mind of lab coats, instruments.

"I don't think I really understood any of what happened."

"But you liked it anyway?"

"I guess so."

"Exactly," Garrett interjected. "Not 'anyway.' *Because.*" He seemed pleased, as if this was the thought he was hoping would emerge from me, the proof, in fact, that I was the right person to pursue this project. "But that's also why the campaign is going to be so important. Not to explain things, really. Not at all. What we need to come across somehow is just, well..."

"That understanding's not really the point?" Karen ventured.

"That's it!" He snatched up his neglected old fashioned as if to celebrate our conceptual progress.

"It's an unusual way to do things," Paul said with more than a trace of skepticism.

"Well, what about that campaign you told me about?" Garrett rejoined. "For cigarettes. Silk—what was it?"

"Silk Cut," Karen answered.

Paul confirmed this truth with a reluctant nod.

"Then you know it, Karen?" Garrett continued. "And it was Saatchi, right Paul? The great marketer, the great collector, he made advertisements leading up to the release of a new cigarette—basically just pictures of cloth. No name, no explanation, just rumpled bolts of purple silk, all over town, on giant billboards and façades, on taxicabs, on TV. Right? And when those cigarettes came out by name—Silk Cut—months and months later, that connected the dots for people. And they just sold and sold, didn't they Paul? Nothing to stop them, people were so happy, so *relieved*, to have solved the problem, to come out of the dark after so long. And that was all the way back in the eighties. We should be able to get away with even stronger things now. More encompassing things. We could make something Saatchi might even want *in* his collection."

"We can try," Paul offered cautiously. "And we should try, I guess. USPs never really helped much."

"Unique selling propositions," Garrett clarified, though in fact I knew this term and much else of the sort from Karen, who by this point was well versed in the history of public imagery of every kind, including advertising. I got her to tell me choice bits now and again; it was part of my compensation package.

"That cloth probably did more for them than 'superior flavor' or whatever," Karen granted.

"Just *purple* itself probably. What people believe, what they think they see, is less important than you'd guess," Garrett said. "That's something I've learned from Paul, really. His research down under, with Professor Conley."

Paul shrugged. What exactly *was* his relationship to Garrett? He didn't have an Australian accent about him, that much I could say.

"Well, if you're looking to throw people off, Theria will do it," I said without a hint of a smile. "It's really not like the competition. Red Bull, say, or Bolt24, or Zoa."

"But is that even competition then?" Paul asked. "We have to think about where the partitions really are in the category, as far as actual buyer behavior goes. What's a truer rival to it?"

"Gatorade?" Karen offered.

Garrett cringed a little. I'd seen him do this once before when Gatorade came up.

"But that's very chemical, too," I said. "Not in the nasty way of Red Bull, but still. What I was saying to myself yesterday was that Theria's more like good beer. Something earthy, marine. In a way sports drinks obviously aren't."

"And what about these 'wellness' sodas coming out?" Karen said. "Moment, Recess, all these silly names. But you see them around a fair amount now."

"Well, that's the other thing," Garrett said. "Did you notice any *gains*?"

"Gains?" I asked.

He smiled at *my* coyness. "Well, I didn't really brew this thing for its taste, not first and foremost, though it's important to me that it's worthy on that level, too. But if you think about beer, why do people really drink that, most of the time? Don't they just *accept* the taste at some point, once they've got the routine down, felt the buzz? We'd drink it if it tasted like piss, I think. And lots of people say that it does taste like piss. Same with these pot drinks, right? They *are* nasty. But that isn't hurting sales. The difference with ours, of course, is that it's not meant to—"

"Derange you," Paul said.

Garrett held his hand out in front of Paul to quiet him. "Theria's the 'good' kind of PED, that's how I see it. So it *is* like Gatorade or Red Bull—like they like to *think* of themselves, anyway. We're still testing the formula, but I believe, and I hope, the effects are a whole lot more tangible than anything you can get from the others. Gatorade's refreshing, sure, but so is lemonade."

I sat back a little and marveled at how long it had taken Garrett to get on form tonight. Until this moment, I'd hardly recognized the man in whose offices I'd been introduced to these concerns.

"It definitely had effects," I said. "It had to have. Usually I can't gape at screens for long, not unless I'm only half there and it's basically wallpaper to me. There are so many movies, good movies, I've never finished. An hour in, sitting there becomes unbearable. But yesterday I was rapt for, what, *five* hours? Either those videos are utterly singular or the drink dialed me in."

Garrett flagged down our long-suffering waiter. The man flew in swiftly, ready to serve once more, this time with dinner menus in hand. Yet Garrett only wanted a couple of bottles of sparkling water for the table. "Well, I'm thinking both of those things are true," Garrett said. "That's why I'm using Daphne and Duke. Aren't they a little bit curious? But I can see why it might be hard for you to tell. Maybe that just means more experiments. We're all for that."

"One thing I *can* say about Theria," I replied, "that has nothing to do with the videos, is I had no appetite left after drinking it." Unlike now, of course.

"Interesting," Paul said. Everything would be 'interesting' to a researcher like him, I thought. Despite his fine attire, he had the manner of a lab scientist down

pat, more so than Garrett himself, who was a scientist. Paul and his "studies" down under, though... Motivational research, I supposed, or whatever they called it these days. Or could he be some polling man like Gallup? I was already beginning to see it in him: the clinician.

"Anyway, with the two of them—are you finding... prospects?" Garrett asked.

I nudged Karen's knee beneath the table with my own. I don't think the others could see this through the delicate metalwork, as it was only an exertion of pressure upon an appendage that was already nearly touching my own.

"What exactly were you hoping for, James?" she asked, understanding me perfectly, my need for deferral, my growing exhaustion. "From them and from us." Her tone was so gentle she probably *did* care what he thought, whereas I was of two minds as usual and growing less sympathetic as the night wore on.

Garrett drew breath deeply, as though long occupied by this issue. He seemed pleased she'd asked about them, angling his chair toward her with a scrape and spreading out the photos of my drawings. "Maybe my question wasn't entirely sincere," he said. Karen pursed her lips and frowned slightly, as if he might have mistook what she'd said. "What I mean is, to have even come up with *these* pictures, you must have found something in these people." Strange, I thought, that Garrett was addressing her and not me. Did he not know I'd composed them unfettered and without any consultation?

"You like the sketches, then?" Karen said with the tentativeness of someone offering words on another's behalf. Oddly, I had no idea of her own answer to this question.

Garrett immediately looked to Paul. I suppose it was only appropriate that a proxy question got an in-kind reply.

Paul straightened himself a little, as though he were about to deliver some vital judgment which until that point was unknown even to Garrett. "This one"—he put his finger firmly on a drawing, the second from him in the fan Garrett had made, pulling it up slightly like the decisive card in a winning hand of poker. Here was a sketch of Daphne in a corkscrew. You see her back, her feet, everything in red chalk, with her face turned toward you. It's got a romantic feel to it, in a certain way, at least in the context of the film. Adrian, I recalled, is just out of frame in that scene, off to the left, fully clothed—or everything but his shoes. He's taunting Anne pitilessly, striking her as well from behind. It's why she's twisted around toward him here. But the blows seem secondary, for some reason. They are cruelly delivered but perhaps can be taken, sans words, as a kind of foreplay. The words, however, were something other than perverse. No sexual prelude in any possible world relied on them. More than that, it was the precise way they were said, as if spoken to a door, or

a stone—that's why her wince here, in my sketch, carried so much *less* than torment, anguish; but there is the tenderness of understanding, too, which is also the tenderness of blankness, neither dark nor light, opaque nor clear. A flat revelation. For us, anyway. It's apparently no affair to her. What I mean is, in one manner of speaking, there is nothing it is like to *be* her.

Paul tapped Daphne's face several times with his stir-straw. "There's a touch of Schiele here, isn't there?" he said.

"It's uglier than that, though," Karen replied. Finally an opinion! But what exactly? A compliment only I could grasp? Or a reservation? Could that be why she'd not managed to say much to me earlier, that she'd planned to bring it up but couldn't when the moment arrived? Or was she just probing to see what misgivings the others might have, where their lines were, before we undertook the project?

"It's more plain in its violence," she expounded. "The scene isn't really framed as a scandal, or even something sexual."

Paul weighed her words, touched his forehead. "I guess not. No." In matters of art, Karen wasn't easily assailed, even if she was working in a commercial vein. Paul, whose bona fides were as yet untested, beyond some time at SVA, treaded lightly.

"There's some Goya to it, too. A certain cruelty in the rendering."

She was right, even if my first thought was Brueghel the Elder. Karen's snap diagnoses generally hit the mark, and this was no exception: there was something here that went beyond the formal and the expressionistic, and cruelty was one way of describing the result. I didn't care to think too much further about this, actually. These sketches were mere beginnings, nearly blind ones. And so far I'd not even had direct contact with Duke or Daphne.

"But have you watched the actual scene, from the film?" Garrett said to Karen. He flicked his eyes in my direction: "I think I know the one you've drawn here."

"I didn't have time," she said, "but I did watch a little from the beginning of the film. The Thanksgiving meal. It's not that it's not true to the film, the sketch, I'm sure it is—"

"Well, I don't think it is, actually," Garrett said. "Do you?" he asked me, nominally anyway, before swinging his head toward Paul in the same perfunctory way. "I really think this goes beyond the film. Or *beneath* it. That's what I like about it." Garrett had so far been one to seek agreement, making his contrariness here stand out.

"That's just it, I guess—" Karen began. Graceful as she was bred to be, she never let manners interfere with saying what she meant, even to clients. She really didn't seem to mind losing one (or all) of them over it, and she didn't think contradiction was any reason for upset—this is where she differed from me, perhaps—but simply the best reason to move on politely to something (or someone) else. She could be

inviting and disagreeable, too, and she was frequently both, and no less inviting for that fact. "—I'm just wondering," she continued, "well..." Unusually, her poise was slightly failing her now.

"How will pictures like this work in a real campaign, though?" I offered. Karen nodded with a certain relief for not having to be the woman at the table to raise this perfectly reasonable concern. It was ludicrous, of course, to think that her less-than-glowing assessment (assuming that's what it was) had anything to do with prudishness, but that is probably how it would have been taken had she gone on to air her doubts explicitly.

"We can do it, of course," she reassured them, "if *this* is really what you're wanting to project." We all stared at the sketches before us.

"Cruelty?" Garrett growled, and in a single word he put all of us on notice, even Paul. He was suddenly all disbelieving, mesmerizing fire—though hadn't he made the suggestion himself?

Karen, as always, was the first to recover. "What I want to know, James, seeing these images, seeing that you like them, is what you're after. With the particular products you're trying to represent. So that we can think about what we can do for you."

"I think I see what she means," Paul interceded. "Look, I didn't quite mean we could use this as-is, anything quite *this* extreme. I just meant I admired the unusual way the girl's mind, her subjectivity, comes out in her body here. It's compelling. Quite unique." He looked me squarely in the eye and nodded sharply, as if this were the way he gave compliments—flatly—and I shouldn't expect effusions in the future.

"Well, I just don't know about that," Garrett bristled. "Why *can't* we use something this intense?"

"But it's also a bit repugnant, right," Paul said. "That's what Karen means."

She limited herself to a half-nod of agreement, I think mostly not to offend me unduly. I wondered what she thought of Daphne from my drawings, and of the idea of getting to know her personally, which would be inevitable. Was she dreading the prospect?

"They like it even before they know they do," Garrett continued, now more calmly. "Anyone knows that." Were they drawn to the intensity, though, or to the repugnance?

Paul's face lost a bit of its self-satisfaction at Garrett's hardening resolve. He probably hadn't counted on it here, on this particular point. But then came his boss' little chuckle, laced with annoyance and resignation. Skirmishing must have been a commonplace between these two, involving longstanding disagreements that would probably never quite go away, not least because of how generative they were.

"And how do you want to link the pictures," Karen pushed on, "or the tone of them, if not these ones exactly, to the products? And to each other?"

"Well," said Garrett, "that's why I have you here, right?"

"But there's only so much we can do until we know what you—"

"I've seen *his* pictures, his gallery work," he said, pointing baldly at me. "That's what started all this. He's got to have told you that much."

"Right, so..."

"Can you *guess*, then?" Garrett asked with palpable edge.

"You want *profiles* of these two," I intervened. "A series."

Garrett leaned back with obvious satisfaction.

"I had an inkling," Karen said, her voice undimmed. "But—well, first, do you have any feelings on what types of media, or format? That would help us think it all through."

"You're only drawing these days, right?" he asked me.

"Pretty much."

"So, mostly drawings then—but they shouldn't *look* like drawings. Not like most drawings, I mean."

"Nothing too scrappy or dashed off," Paul elaborated. "No Pettibon, or Dzama."

"I like Pettibon, actually," Garrett said, correcting any misimpression of his tastes, or perhaps simply showing us he was familiar with such work and wasn't rejecting it out of ignorance. "There was that wonderful exhibit of his at the New Museum not too far back. Remember? But, no, I don't want that for this. Otherwise I'd have gotten *him* on the phone."

"And the tie-in?" Karen said. "With the products? That'll help us find a format and style."

Garrett drained the last of his drink.

"What's the tale here exactly?" she persisted, though I sensed she was losing patience herself. "With these two people?"

"Technology and nature," Paul declared.

Garrett waved him off with a glare. "I want *him* to find out," Garrett said, nodding toward me. "And don't even start from anything Paul's saying, technology or whatever. As far as I'm concerned you've already started—from the tapes, the drinks. Just keep going." He put his palm on the base of the photos where they all overlapped. "That's what I've done for most of my life now. Grope forward. It works. With the right person, anyway. And you're him. I believe that."

Paul appeared chastened by Garrett's heady take; it chafed against his empiricism. He pushed the empty martini glass to one side and folded his hands.

Karen ran her pinky along the contours of Daphne's corkscrewed spine. "So should I just wing it with the copy?" She even winked at Garrett.

He sat back and smiled a bit wearily, as if the occasion, not necessarily anything Karen had said, was tiring him. It was past nine now, and who knows how much work he had managed to cram into the day already.

"Or did you have thoughts about the words?" she said.

Garrett perked up at this—that's what it seemed like, anyway, until we discovered, with some chagrin, that his renewed attentiveness had nothing to do with us. His eyes shifted into the distance as his face began to pulse with color: red and blue, broken by flashes of white. I swung around once more toward the street to find two patrol cars pulling up along the curb, both their strobe bars lit but with their sirens cut, so you could still hear the crowd they'd come for—the same crowd we'd been listening to earlier, the men who'd never quite fallen out of earshot, even though they were now across the street, on the edge of a stand of trees, under a streetlamp's orange penumbra. Though softened somewhat by distance, the tenor of the ruckus had turned guttural, suggestive of descent and decay, and an imminent loss of control. Immediately, it seemed, policemen were closing in.

This kind of scene, with officers bringing the unruly to heel long before anything criminal had occurred, was a quotidian sight these days. No one paid much mind to the surge in proactive policing, as they called it—no one but Garrett, it seemed. It hadn't been the mayor who'd ushered in these measures. He'd actually held out. They flowed instead from the president himself, the law and order mandate he wielded. Naturally crime *had* gone down with it—how could it not?—but the martial approach made the city, through the new ubiquity of officers, feel psychically insecure: *Why should all this be necessary if the criminal element wasn't very strong indeed?*

Karen gave up on holding Garrett's attention and turned to Paul with her questions about the campaign, the written aspect in particular. But he'd fallen into a state of private reverie, which seemed to be his habit at every lull. Karen's imploring gaze startled him, and ultimately spurred him to re-engage: "Well... if we were to use images this strong, the copy would really have to soften them."

I was surprised by her apparent deference toward their wishes. I'd always imagined that the freedom she gave me on assignments had been granted to her from the start by her clients. Clearly not. Even if she was going to end up doing as she pleased with a commission, she didn't get there by insisting on autonomy. You had to have more guile than that to make even a heterodox studio like Cosquer function.

"You'd want headlines, obviously, but anything beyond that?" she asked. "Sometimes we do longer copy, persuasive stuff, personality stuff, if it works for the client. And there's the identity work we should get going on, logos and typefaces and the rest."

Karen's was the good kind of maturity—not merely capitulation by another name. It's tricky to tell the two apart, but I knew she had it by the lucrative jobs

she'd scrapped. Those ones involved clients who couldn't fully embrace what we'd delivered. She could have redone the designs to their expectations, but if *she* was satisfied with the original, she took the kill fee and pointed them in the direction of *a better fit*. Even when the client's taste was abysmal, she unerringly found a match in the design market. Better, instead of identifying a studio that fully comported with the client's crudity, she would suggest an outfit a half-step finer, that produced work the client, with suitable persuasion, had the aesthetic resources to understand as an improvement on their own taste. With Cosquer, of course, no amount of talk would suffice for this demonstration. The gulf was too great, and I knew this pleased her.

"I think we'd want some of those things, Karen," Paul said. "Though James was—"

"Now *what* is going on over there? I mean, *exactly what?*" Garrett rose from the table this time, keeping his gaze fixed on that same spot behind our heads. There was a new contentiousness to the chorus. Others had joined. At least one voice was coming through a megaphone or the speaker of a cop car.

My neck was burning again from having craned so long. I swung around and caught Karen's eye. Did we have to keep on looking *with* him? The swift return of her gaze to the altercation was her answer. And so I twisted once more.

The cops weren't bothering much with official pretense, preferring to get down to the level of their opponents, at least verbally. There was less and less grammar to this shouting match, the language of both parties melding into a sort of obscene tone poem. Nothing much was being said, genuinely; the words had become blunt-force instruments.

My neck and back had had enough. So I faced Garrett again, and Karen followed me in this. We waited silently, willing him to sit back down. His gaze eventually fell to the table, he fell in his seat, and he began to play with the wedding band (still) on his finger.

What was it that had entranced him? Police aggression? Street provocateurs? Thoughts of his estranged wife? Or something less concrete? None of us, not even Paul, could know.

Karen and I nodded at Garrett in a vaguely affirmative way that could mean whatever he needed it to while committing to nothing. It seemed impertinent and probably futile to talk business with the battle developing behind us, with more patrol cars arriving, and more gawkers massing around that troubled cone of light. Garrett, for his part, stared only at his drink now.

"As far as copy, though," Paul said, "what do you think, James, for general parameters? Even if we don't necessarily *need* copy"—here he shot a knowing look at Karen, his advertising counterpart at the table, as if to suggest discretion was essential around the money man.

A new waiter, androgynously bearded with soft downy hair, approached clutching menus. Tiny little cards, really. Most of the dishes must have resided in his head. But before he could distribute the cards and begin his recitation, Garrett drew a squiggle in the air. Dinner was off. Although *I* may have had questions about Garrett's antics tonight, the waiter didn't. With only the tiniest hitch and a small nod, he walked right by us, subtly altering the position of the menus in his hand to suggest, I'm not quite sure how, that they were obviously intended for another table, which he was leaving us presently to find. I expect there was little that could have wrongfooted him or anyone else working at Sanguina. The staff seemed to adapt to any shift in our desires, even the most fleeting of feelings, without a hint of strain. Dispositions so finely honed commanded a premium in the service industry, indeed in any business, or any relationship. No doubt he made far more money than I ever did from my day jobs.

Paul was somewhat less composed than the staff, suppressing a sigh before a smirk crept across his face, one registering both forbearance and delight in our uneasiness. He'd had many years to make sense of Garrett's antics, or at least to make peace with them. We weren't so lucky. Garrett pulled out his wallet and turned it over absentmindedly in his hands, fingering the stitching of the black leather, nondescript except for its thickness, rugged beyond all use. "I think we could use copy sometimes, sure," he said finally, almost matter-of-factly. He turned to Karen. "Headlines, or something more? I looked over the magazine issues you sent me. I thought the text was interesting across the board, not just within the ads, but outside them, too."

I wondered just what he'd seen of her text art, which was equivalent to asking which issues of the magazine he'd seen. In the earliest days, if I wasn't simply romanticizing beginnings, *Cosquer* had been more capricious, as Karen had worked from the premise that formal precision was no obstacle to recondite meanings, which led to an exacting kind of poetic illegibility. Other times she would render the words and letterforms themselves in strenuous ways, with such graphical condensation you could barely tell what you were reading, or in weights so heavy they seemed to positively invade your space as you looked at them. More recently, though, she'd turned toward greater transparency in form and substance. Simple sentences, simply adorned; perhaps it was no coincidence that the magazine itself had become more influential in the design world.

Whatever her motives in making the shift, Karen's art had grown uneven because of it. Some of the newer pieces were among her very worst, I thought, not transparent so much as blunt, mired deep in the intractable silliness of Holzer, Montgomery, and Sherman, all of whom, it was now apparent, represented empty gestures in the history of art. If Karen's works were still typographically more sophisticated than her

slab-serif-obsessed precursors, these days they could be crude in their social critique and generally too sure of themselves, especially about the significance of their own *doubts* about society. A good number of her text pieces didn't justify more than a glance.

The most intriguing strand of Karen's recent work differed. It ran through the last dozen or so issues of the magazine, unassuming pages of Times New Roman, as if pulled from a twenty-first-century version of *Yeah*. They were effectively slice-of-life anecdotes, each no longer than a thousand words, though the life they concerned was not her own, and they weren't staged in a place that was recognizably New York. In fact they seemed to occur in many places and many times. They must have been slices of many lives, and I had no real idea what conclusions to draw from them, particularly given their unframed, centerless quality and the vacillation in point of view, first to third and back again. Nor did she quite know what they amounted to, I suspect. Yet lately the magazine seemed to me most worth following for what it would reveal about these textual snapshots, what sort of life their accumulation might point to. Were they fiction or fact? She would look at me shyly when I asked. *They are what they are*, that's all she would offer. This or some other pedestrian deflection, and always with an enigmatic shrug. Whatever they were, she was allowing herself more leash here than ever before.

Most of Karen's art, however, and the most visually impressive portion of it, concerned *fairness* in a way I found increasingly life-averse. It made me worry Garrett would get the wrong idea about what *I* was game to do for him.

What had taken her down this road? A slip in judgment? I had a hard time believing that. A loss of conviction? It was easier to accept this idea for having had that feeling about my own life, even if things were beginning to turn. Were they turning really, though? Or was that Theria—who knows really what was in it?—putting a glow on things for me? Would this campaign be *her* new avenue, too? Or did she just need to start drinking the stuff to begin to believe that?

Garrett squeezed his wallet and pulled out a credit card (black, of course) just as the check arrived. "I do think," he offered, "the stronger the image, the *less* we need words." He was testing the proposition on Karen, and she nodded in a way suggesting understanding without endorsement. She did this a lot, actually. I provided many occasions to, apparently.

"Exactly," I said. "Especially nothing teacherly. Kruger-y. I don't think anyone feels much of anything now when they see that kind of thing."

"Well, people have been filling commercial adspace that way for a long time, since the eighties at least," Paul said. "Not just proper artists, either. Toscani did this kind of critique for Benetton. Fuji did it. Absolut."

"The liquor of liberation, you mean," I added.

"It bores people. That much is true. The research is there on that."

I couldn't have been more pleased with Paul and his polling. Naturally Karen was less enamored. It sounded like an accusation. "I hadn't been thinking of anything like *that* here," she offered. "I don't think I really *do* anything like that, anyway."

"I know," I said softly, as if we were alone. But no one needed a scolding, or a lesson, built right into public space, whether it was through advertising or art. That would be to treat the world like a giant white cube, or a seminar room, glazing it with the same knowing aridity and showy self-laceration. Worse, in the case of businesses like Benetton, they were seeking to cleanse the banal and pernicious aims of market transactions with the purity of a moral sentiment that found no traction in the actual world, a sentiment detached from all consequence, which was more properly called a lie.

We needed to plant something else in the world. I certainly did, and I was sure Garrett agreed with me. Art had shifted so much on people's tongues over the millennia, in a sort of semantic zigzag, from Greek notions of good craft to medieval ideas of devotion and transubstantiation to Romantic concepts of inner expression down to the reflexive intellection of the present era. I wasn't terribly concerned if what we were about to undertake didn't precisely align with today's usage. Soon enough that usage would give way, too. What would matter, retrospectively, was only whether what we'd done, under whatever banner, was something worth our attention. Or else we would just stretch the concept of art. Wasn't that always the work that rated highest historically, even if it had to start in scorn and incomprehension?

Karen ignored my *sotto voce* and moved things ahead, though with a feigned sprightliness in her voice, as she often did to mask her focus. "And the logos?"

Garrett sighed as though he'd long since tired of this question, even avoided it: the troubles it raised, the philosophy it called for.

As closely acquainted with the problem as he was, he was also used to pushing it into the shadows: "Did you see those swatches of his?" he said in a bright burst, leaning forward and signing the check. Paul hadn't brought printouts of these dabs of color, so Garrett simply spread his fingertips to suggest those smears of paint.

"I did," she said.

"Can a color be a logo?"

"In what form?"

"No form?"

Paul radiated amusement, as though he'd already put this to Garrett and was enjoying Karen's disbelief at the response: a request for a formless logo. But Paul was wrong about that. If she was at all incredulous, it was only because such a possibility might occur to Garrett. She was impressed. We both were. It boded well.

As soon as Garrett's wallet went back into his pocket—he stood slightly to maneuver it in; it was tall, European, with nothing Midwestern about it except for its

sturdiness, so it had to go in his front pocket before he could sit down again—his expression veered back toward the practical. That odd, wide-eyed tentativeness I associated with him had been flushed. Settling up had done it, as if now, with the bill paid and the meeting effectively adjourned, the time for the sort of speculation he found so useful in his life was over for the night.

"I've always tried to make things like nothing else," he said without much inflection. "So of course I want my marketing to be that way, too. That's to be expected. But I want you two, and the rest of you, the people at Cosquer... I mean, the magazine you put out is just phenomenal." He said this as if it irked him to do so, though that feeling must have attached to the fact that he once again was forced down a sidetrack, just when he'd meant to be coming down from loftier heights to the plane of decision. He looked to Paul. Perhaps he could pick things up, wrap up the conversation. Happily for all of us, Paul seconded Garrett with the solemnity he paired with all serious judgment. Having secured Paul's backing, Garrett continued, as if that alone had been enough to push him past the block. "It makes me feel sure about this project. That's why I wanted you two: his paintings, your magazine. Whatever your ideas, copy, no copy, we'll listen. Logos, no logos, odd logos, same thing. And the images themselves—this is what matters most to me—I don't actually want you guessing what I like. Not too much, anyway, beyond what I've said. Let me, let Paul, *see* what you like, just through what you come back with."

The bearded waiter collected the check and we were all quickly standing.

"If we like it, too, that's perfect. I'm betting we will. But if we don't—I *think* we will, but if we don't—I'd like to just leave things there. No second takes. That's just not going to turn out the way I want it." He grabbed me by the arm and squeezed. "But you'll still get your fee." I suppose he knew I needed the money more than anyone else at the table. I let myself laugh when I looked at him. We both chortled, in fact, not something I much did, and we did it full well knowing.

"So we'll play it by ear, I guess," Karen said. "I just want to be sure you're on board with that." Everyone nodded. "Really, it's our favorite way to work—when a client's open to it." I could tell by the little movements of her hands as she spoke, the way her gestures subtly accelerated, that Karen was genuinely excited by Garrett's experimental approach, never mind that Paul seemed to feel somewhat differently.

"Shall we?" Karen said, pointing to the doors leading back into the restaurant. She and I had quickly accepted that drinks were all we had convened over, that there'd never been any thought of eating.

"I'm sorry about dinner," Garrett said as we walked, resuscitating the truth. "There are just things I should take care of tonight. And Paul, I'm thinking it'd be

best if you finished off those projections, for Bobby and Lynn, right now. They'll need them first thing. Does that ruin your evening?" He was beginning to laugh.

"You've ruined so many, though," Paul returned in a startlingly sweet deadpan as he checked his phone. It jarred me, this light-heartedness that had been absent all night. Instantly it gave Paul fresh proportions. For all I knew, this edgy tenderness might comprise the lion's share of his character. Why had I thought I'd understood anything about him so quickly? Yet people like Paul had a way of provoking this sort of absurd response, and in so doing had a valuable role to play in life. Something in their disposition, I'm not sure just what, invites you to rush to judgment about the contours of their person; and then, with some relish, they invariably proceed to reveal the utterly ordinary fact that no one can see anything so quickly as all that, not without the healthiest dose of luck. As we finished up at the table and I looked over Paul through my altered notions of him, I was left to wonder about the many things he and all others of curiously deceptive bearing might gain, if only unconsciously, through misrecognition, and whether I myself was just such a beneficiary.

14

Although it was past ten, the restaurant proper was still raucous with gasconade, so distinctly violent in its dynamics, the loud-soft-loud of it. Most of the jabber crisscrossing in my ears over the tinkling of cutlery amounted only to fulsome rehearsals of particularly good or bad days at offices that looked and ran much the same. There was probably less to this bluster than there was to the harsh percussion of the knives and forks.

Even the waiters offered up more to the mind, the way they hurtled with un-flappable calm through the tiny aisles fanning out within the patio doors, feeding the thin-limbed tables that had been arranged, in line with the architecture of the building, in the pleasingly vague shape of a seashell. Anything too literal would have been gauche, of course. Unaccented evocation was needed—and delivered. The ceilings were unusually low for a restaurant of such obvious ambition, but this was also by design, I felt, to induce a feeling of envelopment, as if a wave were cascading over us, sheltering us within its barrel.

Blue, born of tiny halogens ringing the space, bouncing light off the ceiling: blue was the tint of the place. But not a hue that took much of the heat away. Hot blues existed. This was one, though just at that moment I might have preferred a more typical shade. The distilled intensity of the restaurant, incarnated most fully in the staff, was—just in our little walk through the dining room to the lobby—beginning to harm me. The honeymoon wasn't quite over for Sanguina, that much was clear; only a few months had passed since its opening. At the time, Immo tried to go with me, me and a childhood friend of ours, Gerry Finella, known as Mr. Vanilla in his boyhood. He had roughly equal standing to me with Immo, I'd always felt, though Immo would imply I was a cut above. I couldn't be persuaded, though: Vanilla was a man of worthy complexity. Ugly, boorish, ingenious in all things—there was *nothing* vanilla about him, which is just what made the nickname stick. If I were to tally his rank among my friends, as I once had—if I were somehow to recover those bits of paper, half- and quarter-sheets I first tore from each magazine I read in those days to contemplate an issue's strongest images together, whether it was my father's *Game and Gun* or my brother's *Sports Illustrated*, and then, after finishing with them, piling them up for use as scrap paper, paper I would sometimes fill the marginal space of, often *just* to fill it up, with silly rankings of various kinds, including the depth of my friendships—if I were to find those scraps again, I think there'd be at least one or two that had Gerry Vanilla in my top five.

He had an objectively terrible countenance, something like a wad of newspaper. It lent Gerry a meanness he only gradually resigned himself to, before he began positively to embrace it. What sort of man might he have become if not for that crooked brow and those impacted cheeks? His hair frizzed in tight naps of the darkest brown, giving him a foreboding Semitic appearance, with incisors jutting forward, distending his lips and sometimes abrading them, making them fatter than they already were. Still, this ugly little boy was, to put it simply, the cleverest mischief-maker among us, most adept at picking up on how a specific circumstance of suburban banality we'd jointly found ourselves in—a Fourth of July fireworks display, or a Little League baseball game (I played second base and played it badly, blowing I don't know how many double plays)—might be converted into something as dire and interesting as his face. It was a talent that earned him a place of privilege among us.

Time would reveal his genuine technical talents. He would lead and often concoct all our significant projects of public disturbance: the cooking of gunpowder, for one, stirred over a low flame and left to dry, per an official Army Survival Manual for U.S. soldiers stuck in the field and forced to fabricate their own arms from local supplies; the filling of pipe bombs, for another, which we set off in the large and vaguely bounded park, thick with sequoias, that led right onto a high bluff above rough Northern California waters. We'd strap these devices to empty park benches, light the extra-long fuses we'd braided ourselves, and hide behind trees, waiting for the hikers and picnickers to scatter at the detonations roaring and the benches splintering into nothing.

Vanilla was also very good—legendary, really—when it came to Halloween, the way he could pedal his BMX to extreme speeds, on a course just inches from children, and expertly snatch a bag from a hand, sometimes with a mother or father still holding the other. Even when the parents followed along behind in their cars, and they could readily give chase, Vanilla's agility, together with his preternatural grasp of geographic minutiae—where exactly every lane and alley and speed bump was, or every neighbor's lawn he could cut across without fear of dogs—meant that even longtime residents eventually lost him. Whenever Immo or I, or a tall black boy named Taylor, the most handsome of us and by far the most successful with women, or Lawrence, a nervous, well-read sort who could be emboldened into such antics only by peer pressure—whenever we tried to follow Vanilla's candy-snatching lead, we generally ended up letting go of the bag at the last moment to keep ourselves from crashing, if we didn't actually sideswipe the trick-or-treater and bring both of us down in a tumble, which, once we'd gathered our wits and taken stock of our wounds, we'd play off as a horrible accident (not exactly untrue). The parents never accepted this, of course, but there was no real evidence against

us, and the rider, having fallen at high speed, was nearly always worse off than the grazed victim. Meanwhile, Vanilla could collect half-a-dozen bags in just forty-five minutes and a couple of miles' worth of riding.

Even when our take was nothing at all and we were coming away with bent handlebars and skinned knees for our trouble, we would coast down to Gerry's house, which was in the neighborhood occupying the base of the hills. Though he wasn't poor, he was poorer than us. Yet this had hardly any effect on our dealings with him; it might even have given him cachet. Inside we'd find his mother, a skittish woman with sharp black eyes that shadowed you no matter how many times you'd come around, just before she lost all interest in you and her gaze drifted toward the ceiling or the floor. She'd be standing there in a simple house-dress, and always without her husband. I don't believe we saw him but once or twice. He worked in Fresno or Stockton during the week, so she would be left to man the fort. On Halloween she'd always leave the garage open, knowing that each of us would eventually come coasting down the street looking for our leader. She'd stand by the inner door opening onto the living room of the long, flat, single-story home, waiting to give us the usual inspection as we set our bikes down as gently as we could and strode inside. We'd head down the narrow hall lined with thick shag carpet that absorbed our feet like sand, all the way to the back where Vanilla's room lay. Gerry would be waiting for us, in this tiny space that was mostly bed, sitting on a strip of free carpet, his many brimming bags of candy neatly arranged on the duvet. When all four of us had finally arrived from our separate missions, and we'd each added whatever pittance we could to the lineup—our bags always seemed withered compared to his—only then would he empty all of the bags before us onto the floor, as if we were all equal contributors, and, that done, flash his earnest, horrible smile, the only one he had. He shouldn't have been held responsible for it except on days like that, where its ghoulishness couldn't have been more appropriate. That smile: how we laughed and shuddered and laughed again at it while stuffing ourselves with ill-gotten gains.

When we were older, in high school, and we'd mostly given up Halloween, now that we could drive, I could still only see the child's face in Vanilla, that Halloween face, or, at best, an aged version in which nothing had fundamentally shifted. Reality, of course, had no trouble disobeying my imagination. Gerry had developed a chin—a jaw, too. Like his teeth, the bones of his face had begun all out of place; yet over the years they must have been working themselves around like tectonic plates. Only recently had the point been passed at which one might note this shift with any certainty, and even that took some doing. I could definitely see these differences in Vanilla's countenance, but doing so meant actively fighting against my unconscious urge to replace sensation with memory.

By this time he'd moved farther away from us, somewhere deep in Oakland. I believe his father might have lost his job, or gone through a separation. Gerry was vague about this, and we didn't press him. Whatever the case, some way or another Vanilla managed to graduate from College Preparatory with us, never mind the steep tuition. Throughout our high school years, his facility with devices and programs of all kinds continued to strengthen. That's how, without a word of encouragement—I don't believe he had any coding friends, not in real life—he began to engineer malware. He was a programming savant, and self-taught, which surprised none of us. Destroying terabytes of academic data at College Prep was his first and greatest achievement there. Only after being caught did Vanilla genuinely turn vanilla: he saved himself from expulsion—and landed on a goldmine to boot—by designing *anti*-malware in his computer-science classes, as a condition of his probation. It couldn't have been more than five years before he was rich—richer than any of us today, even, including Immo and Lawrence (now a somewhat middling hotelier), not to mention Taylor (a prodigious pharmacist). By his senior year at UCLA, he was what you would call a man of means: just after graduating he bought his mom (and, in a way, himself) a new house in our neighborhood in Berkeley, the very one his family had aspired to live in during his childhood. Early success spared him not only the indignities of post-collegiate malaise, but having to live with the face nature bestowed on him. His net worth brought the nimblest surgeons within his reach. I'd not known his physiognomy to have bothered him *that* much, but there you have it. He went about harmonizing his face. Nothing drastic, it seemed: just enough fat injected into his brow to uncrumple it, just enough of the same drawn from his lips to make them expressive, and just enough resurfacing to make everything glow.

Immo, who'd kept up with Gerry even after his professional turn to software—I didn't see the point—was sure there must have been more work done than this. Whatever the truth, it was good old Gerry Finella, the man with the new money and the new face, who was going to treat me and Immo to dinner at Sanguina. Taylor was in town, too, but evidently had fallen out with Gerry for obscure reasons, and Lawrence, the last of our crew, was based in Dallas these days.

I actually meant to attend this dinner. I can't remember what exactly prevented me from doing so on the day. Something of no account, I'm sure. Still, I think I was pleased not to have to adapt to Gerry's new face, to have my impression of him, the boy at the bottom of the hill, changed by his riches. It may not have been right of me to have been charmed by his early privation, and by the ingenuity it brought out of him (changing his face, it seemed to me, was the opposite of that: a conservative gesture), but I *was* charmed. We were *all* charmed.

I felt a touch of disappointment, then, as I made my way out with Garrett and the others toward the maître d's desk and the grand foyer—disappointment that I'd not truly experienced Sanguina today either, given that we were leaving without dining. The drinks, so well-articulated, gave me intimations of the pleasures to be had here, pleasures we wouldn't be taking with us. Nor would we be in much of a position, supposing we cared to, to weigh in on the merits of this midtown newcomer, or even just enjoy the food without the apparatus of official taste firmly in place. The chance for that would probably be lost in a few months. Sanguina would no longer be new enough. All the major reviews would be in, the verdict settled, not unlike at the close of an exhibition. I had that same forlorn feeling now, the one I knew from showing my own work.

The four of us stepped out into the night, and just as the broad doors swept closed behind us the pressure seemed to drop. Now I felt not disappointment but relief, the kind one doesn't know one is needing until it arrives. I was glad that we'd had our meeting on the patio, out in the open. It had spared us that singularly acid glamor which concentrated itself in New York's inner spaces. London, Tokyo, Paris— each metropolis produced its own blend. But none had quite the bite of New York glamor, not even Los Angeles. Hollywood's form of enchantment was so shamelessly airbrushed it had lost all mystique, at least among the better-educated, who couldn't be much impressed by comic book characters, romantic comedies, advanced CGI. Doubtless in the Golden Era, the early days of a distinctively American celebrity, there was an authentic sense of magic in Tinseltown, but not now. In New York, how-ever, you could still feel the substructure of our world being fabricated in restaurants like Sanguina, over nice drinks. It wasn't your fault, you didn't choose to feel this way, but it giddied you, the movement of capital, even as it singed you, while it mutilated those with greatest exposure. Everywhere I encountered it, in luxury restaurants and bars, at exhibitions and galas, and especially at dinner parties—there was nothing quite as noxious as a dinner party in this city—whenever I drew in those fumes as deeply as I could, I tapped into that volatile exhilaration, one that soon-to-be regulars at Sanguina felt far more acutely. My thoughts would lose all their shape, deforming into something unrecognizable. Had we convened in the restaurant's cloistered din-ing room tonight, surely just this would have happened to me, and who knows about the others. Sometimes it seemed to me that the very purpose of open-air spaces in prime Manhattan, those exorbitant rooftop hotel bars, say, or Central Park itself, was to take the edge off all that blazing charm.

"This was obviously so last-minute," Garrett said, walking in front of us all, down the shiny blocks of cement. The restaurant was recessed somewhat from the street, so we had a little walk to make. He wheeled around as we reached the curb; I carried on

slightly too far, too quickly, and ended up almost in his face. "Thanks for making the time, both of you. And sorry again—really—to rush off on you."

Perfunctory words like these usually wouldn't even register with me. But Garrett had a way of renewing banalities, drawing up the living thoughts and feelings they'd once given shelter to, before language had hardened and sentiments had petrified. After that happened, it became difficult to recognize the full spirit of those words, the reasons why our precursors had dreamed them up in the first place. I could never get away with some of the things he said, I knew that. Not that I didn't say those things when called upon. Something often simply *had* to be said; the moment demanded at least placeholder language. I just mean I couldn't use these words without sounding glib or hollow. I said these kinds of things—maxims, clichés, pleasantries—all wrong, in that I never managed to freight them with my actual sentiments, which seemed to slip right off, leaving me to find fresh words to do the job, supposing I really cared to convey something, which wasn't a given. For often I would let the matter simply lapse and resign myself to misunderstanding, even when there was plenty to be understood, if only I exercised a little more imagination. Garrett faced no such quandary. He could mean ordinary words differently, make them carry things most of us could not. How we mean things, what we can impart *to* our words, isn't entirely of our choosing, no more than what our hands can impart to a piece of paper is. Garrett had the talent, like most leaders. I didn't. Nevertheless, I felt a sort of competitive urge to keep pace with Garrett's bromides.

"Of course, and good luck." My words were made of wood.

Karen had been texting with ungodly facility since getting halfway down the restaurant's central aisle, which was twice the width of the others and sliced the room into bulging halves. With her eyes locked on her phone, she'd steered around both the waiters and the maître d's desk fronting the wide white marble foyer, so much wider than the seating area that one got the feeling of exiting a maw. She'd managed all this without looking up, not even for an instant, so that the maître d's ruddy little face, which seemed to be imploding as he stonily regarded us passing by in single file—perhaps something had gone wrong that night, or he thought a grave kind of indifference was the right attitude to strike with us—this tableau was something Karen had the pleasure of missing.

Her gaze rose above the screen only when we'd reached the curb, yet still she was texting with touch-type surety. "Actually... this is perfect," she said distractedly to Garrett. "John—one of our partners—wants me to see a show tonight, sort of a show, it's in a basement in Sunnyside. I can tell him yes now." She finished with the phone and spoke with real presence: "Just let me know when you want to plan more concretely, James. And Paul. You both."

We stood there a moment, waiting for what, I didn't know, and I couldn't help thinking, as I examined Garrett's incongruously fine shoes, with two handsome rows of perforations in place of traditional toe caps, that although the man's words felt deeply meaningful, in actual fact he had lied. I was certain he wasn't leaving us tonight for work, and that this aborted dinner hadn't flowed from any business emergency. He'd not checked his phone, so how could he have learned of any such thing? Absentmindedness couldn't plausibly explain his abrupt departure either. Everything I'd seen from him so far told against it. No, instead, things were just as they appeared: it had all turned on that altercation across the street, which we could still see smoldering as we drifted down toward Columbus Circle, two by two, without any explicit decision taken about our destination. Life simply flowed around the bit of sidewalk consumed by the standoff: pedestrians stepped into and out of the street about ten yards above and below it without a word or a look. With things back below the flashpoint, the gawkers, who had briefly been legion, found no reason to remain.

What had this minor civil incident put Garrett in mind of tonight, I began to wonder. Did it press up against his thoughts, the way Sanguina's cockalorum had stifled my own while we passed through its belly? The fray on the street, by contrast, didn't really dampen my spirits. There was something telling in such scenes, I felt, the kinds of inattention they drew forth from people, about where the faultlines lay. Ultimately they defined the tangible contours of the state itself, that borderland of colliding energies that zigzagged its way all through the geographic boundaries of the country. Through these fractious moments, the territory in which the threat of legitimate coercive force *loomed* was actually made palpable, no less palpable than the resistance of bodies to those demands of the state. Even when episodes of defiance had no moral force as such, I thought, they were still *places* where powers crashed against and into each other. How durable were the rifts so adumbrated, though? Could they be tensions essential to a way of life, ineradicable without simultaneously eliminating other features: for instance, the garrulous men of industry at Sanguina, erupting with bombast not just for the sake of their guests, but for the wait-staff, too, and perhaps especially for those at neighboring tables, their rivals in the city for that resource that was even more carefully rationed than money. Status, of course. All the torqued pleasure of the diners there tonight had rattled me; in a strange way, looking at this abject confrontation in the street restored my equilibrium. The arithmetic of wrongs and rights might be simpler than we think.

I wouldn't have minded Garrett's change of plans so much had Karen not, in the depths of the restaurant, while I was hopelessly trying to repel the chatter from my defenseless ears, managed to make arrangements in which I appeared not to figure.

We exchanged a glance I would have liked to extend into something more meaning-ful, but she looked away. After two drinks, she'd flushed lightly, and her eyes, which seemed slightly purplish, had softened. The agitated curiousness I associated with her had given way to a less searching consciousness, which, for that reason, left her more available to the world at large.

Two drinks—I'd known for a long time that this was her limit if she hoped to remain composed. I also knew she could have another two or so without becoming ill. From the moment Garrett signed the check, I'd been imagining the post-mortem she and I would conduct over dinner and those two drinks elsewhere. For my part, after having a couple—and tonight's were admirably stiff—I tended to press on, if I wasn't mindful, toward double digits. Maybe I wanted to take her there with me now. She'd already made plans with John, though, so none of this would happen, which must be why she shook off my gaze so quickly.

That didn't stop me from regarding her. She was remarkably waifish; this was especially apparent as she and I walked side-by-side, behind our clients, her tiny stride needing to turn over rapidly to keep up. More than this, I was drawn, as always, to her lithe hands, and those wisps for wrists, their grave delicacy. I don't know how she could have made so many sturdy things with them over the years without their simply snapping. They seemed unsuited to manual tasks of any kind, more like in-struments of conversation. There was nothing more entrancing about her than seeing them come into play as she began to speak. It was as though she were conducting her own voice; they swayed this way and that, finding angles for her palms that stretched the meanings of her words, and vectors for her fingers, too, which gently carved up the air when she needed to deal with the finer shadings.

There were at least two occasions on which I came close to falling completely un-der the spell of those hands. Only the first involved alcohol. That was late in freshman year, March or April. Had anything happened, she would have been only the fourth girl I'd really touched, and the first in college, though not for lack of opportunity. I'd never been much for casual encounters, and my entry into art school, which opened up possibilities for all of us—that was the promise of college for anyone, of course—actually had the effect of putting me off women for a while. Sanctioned experimentation didn't appeal to me, in the classroom or the bedroom. And school was all about people playing at things within carefully prescribed boundaries.

We'd met only once before, passing in the dorms. Karen and I were on the same quad, and over the months we'd exchanged few words in the common kitchen or lounge. I recall, though, how at that spring party, given by a whole floor of a different dorm (two or three birthdays were involved), she'd studied me much of the night, as if I might have been changed by the new context in a way that made me worthy of

attentions previously withheld. It unnerved me. Every time I took a pint or a shot glass to my lips, I thought of her watching me and my throat closed slightly. I could barely swallow. At first I surmised her gawking to have traced to her own drunkenness, but as the festivities wound down sometime past one o'clock, and she, who had enforced a certain physical distance between us most of the night, never deigning to join a circle of which I was a part, and even exiting one just as I joined, sat very near to me in a hallway, almost in my lap, since the corridor had been narrowed by semi-conscious students laid out in postures suggestive of varying degrees of stupor, I found that in fact she'd had only a couple of drinks—her limit. She didn't care to end up like *this*, she explained, pointing around her at the fallen bodies. I laughed a little weakly, shrugged, and drank alone from the backup flask of Bulleit I'd brought with me.

I don't know how exactly we got on to it, but soon we were speaking of Cady Noland, Agnes Martin, Chris Ofili—every dropout artist we could think of, really; of what it would mean to disappear; and what it would mean, moreover, to disappear before you ever appeared. Eventually she took the flask from me and put it to one side, although it wasn't long before someone's leg came briefly alive and knocked it over. The whiskey ran onto the thin, cheap carpeting as the smell of rye surrounded us. Karen stood up to survey the damage; the whiskey was pooling beneath another drunkard's head like blood. Yet instead of moving to stanch the flow, she dropped down from above and kissed me. All that whiskey in the air, and her tongue indelicately driving into my mouth: I was so startled by the authority of her kiss that I caught the tip of her tongue between my teeth simply to slow its progress. She climbed more fully into my lap then, I released my jaws, and she pressed on. In the end I got a hand up her shirt before she'd had enough. She laughed as I wiped my mouth; we studied each other, as plainly and openly as artists will, until I too started to laugh. We decided the most interesting thing we could do, given all we'd shared, was to disappear right then. Stepping over the bodies, I left by one exit and she by another. In our remaining years in school, we never revisited this scene.

The second occasion was less than a year old. It happened in the offices of *Cosquer*, while I was helping to close an issue and most of the others had gone out on a late dinner run to Dutch Kills. I'd had to help Karen retrieve an old printing of the fourteenth edition of the Chicago Manual of Style, the bright orange one, from her studio next door. She was sure the volume's copyediting glyphs contained certain crucial characters foolishly expunged from the sixteenth. So I got up on top of her office desk and pulled the tome down from an unreasonably high shelf for her. The marks she was looking for never turned up, but the door did creep closed behind me; I must have set it in motion when we'd entered. As I watched her hurriedly flipping the book's pages—the atmosphere was, as on any day of close, hectic and strained and far from sexy—I'm not

sure just what it was I felt, but before she could flip any further, I put my hand on top of hers and gently held it in place. I took the tie out of her hair with my other hand and the shimmering strands fell down her cheeks. Soon I found myself tracing circles on the back of her hand with my finger. She studied me then as she hadn't since that drunken night in the dorms, but now she appeared far more bemused. I was the long-term boyfriend of one of her best friends. What could I mean by this? I didn't know myself, of course, so the look I returned to her was blank and utterly without solutions. This went on for at least a minute, my frank and empty gaze twinned to the soft grazing of her hand with my own. Would she have stopped me if I'd tried to take things further? Did I *want* to, really? I was still with Claire, and things weren't yet in shambles with her.

The building buzzer rang then, and it kept on ringing until I opened the lobby door. It was raining outside, I could hear water tapping on the roof, and the *Cosquer* crew was desperate to get inside. Which meant nothing could be discovered or resolved between Karen and me, not then. She put her hair back up and closed the orange bible, having accepted that there was no standardized mark for the point she wanted to make. She'd only imagined there was.

I let John and the others back in and rushed through an early set of page proofs in something of a daze. Soon after I wandered around outside with the giant green umbrella that we kept in the office like a piece of found art. It had room for four or more beneath it—could it really be patio furniture? Whatever the case, it was profoundly heavy. Yet in my distracted state I took it all the way up to the Queensboro bridge before getting into a taxi with arms and hands burning.

Yellow cabs came into view now as the four of us paused at the top of Columbus Circle, having finished with our meeting at Sanguina. Paul offered me his hand with his wrist pushed forward in a lightly effeminate manner, though in point of fact his handshake was robust, even if it was mostly fingers and little palm. The marketer stepped into a cab at the roundabout and was gone.

Karen skipped the taxi line for an Uber that seemed to appear a beat before she'd actually summoned it with her phone. That's how I remember it, anyway. She'd had a handshake at the ready for our clients but only a distant little nod for me. While I peered through the rear window of the car as she went away, Garrett grabbed my hand. I don't know that I said anything during the long, deliberate shake that followed, an ostensibly joint action driven almost entirely by him. I had other things on my mind. Yet I distinctly recall the strange *feel* of the gesture, how it suggested no ending, even a provisional one, and hence seemed less a farewell than a bafflingly timed greeting.

15

I started off toward Central Park South with Paul's notes, that purple folder, in my hands; even if I wasn't going to read them, it paid to be polite.

"So you're going to just walk?"

I stopped without turning back toward the speaker, the voice. "I have fewer plans than you, I guess." I meant this multiply.

Leather soles echoed across the pavement as Garrett caught up to me. "You know," he said, "there *is* one other thing I'd meant to discuss. It wouldn't take long."

I waited.

"Just about the drawings—or really the *people* you'd be drawing for me."

I held my gaze.

"You're going to need to meet them soon, right?"

I wondered why he hadn't brought this up earlier. Did he, for some odd reason, need me alone to get into this? I let him elaborate as we turned with Columbus Circle and lurched toward the Athletic Club, the Ritz, and the rest of it. At certain times of day or night, I could still enjoy surveying this part of New York, even if whatever it once was—what it was *in life*, so to speak—now felt lost to the past in the way of grand churches. While I indulgently eyed the façades, Garrett, rather than saying whatever it was he had to say, locked onto the altercation that was apparently still in progress in the street. It seemed to have reignited a couple of blocks down Broadway this time: squad cars crept slowly behind the toughs, expelling them from the neighborhood, when the men stopped and began barking madly.

If earlier it seemed gauche to inquire about Garrett's fascination with this standoff of no account, the embers of which, in fairness, didn't appear to want to die, now it felt almost obligatory to press the question.

"Do—"

"*Look.* At him." My client's voice was so sharp he had to throw me an apologetic glance. I imagined this was how he spoke to Antral workers when, at some critical juncture, a discovery was made in the lab that no one could have predicted. "*Look!*"

There the men were, reconstituted as a group a few hundred yards south, but with elements missing: only a Latino and two blacks remained, along with the same three police officers—two blacks and a Latino. Was it this new symmetry that stirred Garrett, and indeed me, inasmuch as I found myself unthinkingly following him down Broadway? I too must have desired closer acquaintance with this shouting

match, a street tableau that was, for me, like a home away from home, the Bronx in miniature delivered to tourist central.

This second encounter, though, had a certain jocularity missing from the first. The two parties seemed to be enjoying laughing at each other, embroiled in the sort of spirited trash-talk of pick-up games between veteran streetballers. One of the blacks—not tall but powerfully built, with square shoulders and fat calves—he pivoted toward us and gave a prolonged, gravelly chuckle while making and unmaking his fists repeatedly. Ugly possibilities invaded my mind, just as they did in the small hours on the trains in my neighborhood or out in the less manicured parts of Brooklyn: nightmarish imagery followed by a keen queasiness. Rarely were any of these morbid scenarios realized, of course, but that didn't neutralize their value. That such scenes were so liberally activated in my mind created a margin for error, engraining broad patterns of alertness that proved their worth precisely when your luck finally gave out, as it had to at some point. It was a feeling, this generalized dread in certain company, you couldn't readily admit to in Manhattan, though in the Bronx it was genuine common sense, a preservation instinct more secure than any principle of fairness. It was, you could say, the principle of life itself, and it operated most effectively when it was most unjust, that is, entirely indifferent to the moral categories of responsibility and blame. To have a problem with it, I knew, was to have a problem with existence itself.

But the thing about this man Garrett singled out for my attention, this well-muscled black man in fiery clothing—yellow chinos, an orange button-down with a collar so narrow it seemed about to burst, and a silvery tie hanging loosely around his neck, the knot near his solar plexus—the thing about this man who shone under the lights of a boutique clothier, lights that set his yellow teeth on fire like the rest of him... well, for a little while, I didn't know how to complete this thought. Its substance seemed to evaporate while my mind kept flipping through a book of pictures, searching for something, I wasn't sure what. Then, all at once, I grasped Garrett's interest: the man appeared, not in the face, but in his general disposition, which was locked up in his posture and trunk, like someone we both knew, or were hoping to.

"Duke."

"Yes!"

"The feel of him."

"Well, yeah, it's not *him*," said Garrett rather defensively. Was he worried I'd think him a racist? "The shape, though. The feeling."

"Yeah."

"Did you notice him? Earlier, I mean, when we were at the table?"

"Not exactly."

"But you were walking down this way afterward. Why?"

I shrugged.

"To get a closer look?"

I shrugged again. He was smiling.

Our ersatz Duke was smiling, too, even offering his hand to the officers when one of those big fists unfurled into a giant claw that gave the impression, even more than the fist, of terrible strength. But the Latino officer, so broad that the movement of his arms was restricted by the navy fabric of his uniform, had no interest in this ambiguous gesture. No, he was snarling at the man in Spanish, while the other two miscreants remained a few steps behind. Duke, though, as if he'd taken on the spokesman's role, kept on laughing in his low, rolling, malignant way, and jutting his hand further forward. Finally one of the black officers—this one had a curious pencil mustache that gave his face (but only his face) the incongruous Prince-like air of a dandy—smacked Duke's hand when it grew too close for his liking. Yet the outsized appendage barely budged: Duke had converted it into a fist just before the strike. Immediately after he unfolded his fingers, recreating that gesture of peace which was also a taunt, coupled to a smile that was also a grimace. The insult in all of this was so pronounced, I knew it couldn't be the first run-in between these two men. Such familiarity may have been why the officers hadn't yet made any arrests for disturbing the peace or the like, although the crowd had also grown since we'd walked down from Columbus Circle, and aggression without more serious provocation might have made for bad optics. The Latino cop spoke with quiet, coded venom to his ethnic counterpart on the other side of the law. Duke wasn't listening; he'd turned around to face the other black in his own crew, the one that wasn't anything like him, tiny and anxious.

Finally, Duke turned back to address the muttering cop: "I don't know *what* you're saying to me. I don't. What about English? Want to try it?"

But the cop kept spewing Latinate invective. Nothing Duke could say would stanch the flow. And all the while, Garrett beamed beside me.

"So, I think we're just going to go," Duke said to his adversaries. "At this point, yes. Thank you. Thank *you* for your beautiful words." He waved both his hands, those giant frightening things, high above his chest, which gave the false impression that the cops had ordered him to surrender. Slowly he retreated this way, walking backward down a nearby alley between a Greek diner and an oversized Irish bar, a smile on his face built from thick pink lips. His cohort quickly mirrored him and the group proceeded in a synchronized dance of mock capitulation.

The Latino cop was unappeased by this routine. The vulgarities began to flow more freely, though the volume sank in a way that signaled greater intensity, not less.

Duke's cadences, I'd noticed, hadn't corresponded to his crass dress: they were precise, carefully modulated, quite close to proper English. If you'd heard him over the phone, you couldn't be sure he wasn't white. Some blacks were like this. It would have granted him access to markets in which a more authentic black might have a harder time selling his wares. For all I knew, it was this business, his trade with whites in prosperous areas, that had drawn police notice, whereas when his deal-making stayed black or Puerto Rican, as in the Bronx, where there was *no human involved*, as some say, the authorities' appetite for upholding the law would have been rather less keen. I should know. I'd seen brazen drug deals in diners where rocks sat right on the table with the food. Nobody cared.

Again images pressed in on me, suffused my mind. I didn't have to try to conjure anything, nor exercise my imagination in the least, to see this man not only as a stand-in for Duke but as one of those mid-level dealers, the kind who, even while knowing better, was congenitally incapable of passing on flash, and had no way of *not* skimming off the top and crossing the big fish.

The Latino officer's mustache—Lopez, his badge said; he'd been so compelling I hadn't bothered to look for a name until now—Lopez's mustache, which curved over his top lip so that it partly obscured the action of his mouth as he spoke, shone from all the spittle of his words. Really it was the only thing preventing foam from forming there. He was being counseled by his partners, entreated in the way one might coax a suicide down off the ledge. The spotlight was on all three of them now, with Duke's arms raised high, his eyes big, all in mock fear, though you had to be quite close to discern the mockery. For much of the crowd it would have read as genuine. Lopez was furious with the ploy, so the spittle kept flying. His two partners were evidently keen on leaving the scene without making any arrests, which would have looked all wrong now, however justified detention may have been, on various grounds.

The three toughs kept backing away, beyond where we could see, into the small alley only the cops could peer down. Lopez's anger, so intense it had become mute— he was now only mouthing the words—slowly made the extraordinary transition into laughter: soft and knowing at first, though quickly building to bilious peals that rang out into the night. Lopez would catch himself now and then to jeer at the urchins in heavily inflected English—he *could* speak it after all: "Get out, okay? Get out. You understand. I can see you understand." The uniformed blacks flanking him, originally intent on calming or even restraining their apoplectic comrade, gazed deeply into the alley and themselves began to chuckle and snort with relief. Lopez had relented. What had Duke and his crew done to change his mind? It was a mystery Garrett and I weren't going to solve, as squad cars on either side had blocked off the area from pedestrians. By the time the officers had gotten into their cars and we were let through, Duke and his cronies were gone.

Garrett pursed his lips and nodded, as though we'd been watching a play with an ambiguous ending and had been left to draw our own conclusions while the audience dispersed. Something like the same look was on the faces of several others we passed while retracing our steps up Broadway, back toward the park and the fountain at the Circle glowing gold in front of us.

"Did you see the size of the crowd, how it just spontaneously formed? People know a good thing when they see one, don't they?" Garrett rubbed his fingers together and sighed, turning it all over in his head, his eyes half-closed in meditation. "And the officers won, in the end, without even resorting to force—just Spanish swears! Did you understand any of those? I wish I had."

We reached the edge of the park and turned eastward onto CPS without speaking, threading our way through the usual mess of tourists, hansom cab hustlers, and the well-to-do, this last in glinting tuxedos and gowns: probably they'd just let out at Lincoln Center and they were on their way back to their hotels.

"You know the thing about the *real* Duke?" asked Garrett after a long silence. "He's a guy from Cal. That's where it all starts for me. You must've been wondering, why *this* guy. Were you?"

I nodded vaguely while tramping along the cobblestone.

"It's funny, I never paid attention to the football team when I was *there*, on campus—not until my senior year, and even then it was only because Martine, my girlfriend, dragged me to a couple of home games. Very smart girl. Very sad one, in the end. We've lost touch. But for whatever reason, she found sitting in the bleachers therapeutic, the simplicity of watching it all unfold on the field, and she was sure I would as well, so far from home, so lost in testing chemical reactions, in *making* things instead of observing them. That's why I was so unhappy, she thought. I forget now what really was bothering me back then. It might've been *her*, actually. It was certainly hard opening myself up like that, to science, I mean. I was brought up straight, Baptist. But why'd I go all the way to Berkeley if I wasn't trying to see what else was out there?

"Martine was right, though. Rooting without a thought in your head, against Stanford and UCLA, and obviously USC. The throng, the thrum of the band. The pure heat of the crowd, even on a cold day. The bond you could feel on game days, with *Berkeley* students, so-called radical individualists—not me, personally, though maybe back then I could talk myself into thinking that was the answer. To me, the stadium just felt deeper to me than any classroom, all those ideas we had of ourselves,

non-conformists and whatnot. And ever since college, well, I've loved the bleachers. There is just *nothing* like observation. I should've known that, as a scientist. But it was Martine, the actress, who showed me.

"We got blown out by Oklahoma in the first game I saw. Absolutely torched. But who cares? Who cared? The QB that year was a *savant*, Polazzio. He played backup for the Texans until a few years ago, but he went fifth in the draft that year. He struggled in the pros. That can happen. But he was a magician at Cal, I can tell you. He's what led us to Aaron Rodgers, you know that? And Goff. He's turned out okay. A QB has partly got to be a thinking man, doesn't he? Why *shouldn't* he go to Berkeley? Anyway, Polazzio threw some lasers in that game with the Sooners, but they ran right over us, huge O-line, classic Oklahoma team. Nothing you can do about it, sometimes. We were meant to lose."

As he talked, the Hampshire, the Ritz, and then the Plaza slipped past us, though we were walking on the park side, tasting the straw and horse droppings in the air until we met that gaudy gold yankee on horseback at Fifth Avenue— Sherman, of course. I hated to look at him, so I didn't. We cut back across CPS and sat on a bench in Grand Army Plaza not far from the single-screen Paris The-ater and its marquee, which presented a young Eurasian woman superimposed onto the Great Steppe. For a little while we listened to the water gurgle behind us in the Pulitzer Fountain.

"The best pure talent from Cal in a decade, at any position, even QB," Garrett carried on. "And I should know: ever since Polazzio, I've followed them as closely as I follow anything. Duke especially, these last years." Apparently our friend could remake a game from the receiver position, but he, like Polazzio, precursor to Rodgers, was a riddle. "Did you get that from the game tape? I hope so." He turned away before I could answer and continued expounding at a more languid pace as the air sharpened. Plays drawn up for Duke were simple: send him on a slant or a go or a post and just toss it up to him. Give him the time he needed to get there—that was pretty much it. He had a habit of getting to the spot in roundabout ways, not clean routes. But in the critical moment, when the ball first became catchable, he was there ahead of anyone else, even off a ricochet, or with someone grabbing his mask or gouging at his eyes. "He made Hail Marys seem like smart play-calling." That was true to what I'd seen, too, not the exaggeration it sounds like. But that unruly energy he flashed on the field followed him right off it. He'd been quite the presence at Berkeley. "He's a kind of cult figure, almost," Garrett nearly whispered. "Hard to read, I guess. He would have gone early in the draft if it weren't for the baggage. Not just girls and substances, though there was that. There was the stuff he wrote, too: the strange essays he'd turn in for class. They're almost rants."

As with all college athletes of promise, there were "irregularities" surrounding Duke's studies. Physics and chem, for instance. Wouldn't everyone avoid that stuff if they could? Garrett shrugged as he said this. But as far as the *social* sciences went—economics, anthro, government—Duke was thought very capable, even if that didn't save his professors from exasperation when he more or less made up his own syllabi. Duke was stubborn. He knew exactly what he *had*. Athletics meant entitlement—so why shouldn't he take advantage? "He missed out on the draft because of all the red flags, but someone was bound to take a chance on him eventually. His talent's too alluring not to. Players have done a hell of a lot worse than him—out-and-out criminal stuff—and gotten signed in the end, when the media moved on to other scandals."

Garrett's expression brightened. He picked up a few pebbles from between the red and gray cobblestones at our feet and, snapping his wrist like someone accustomed to throwing a ball, side-armed the largest of them into the water rippling toward us in circles in the fountain's flow. "*The Bears*. You like the Bears? The Chicago ones—my team. That's who picked up Duke in the off-season. Isn't that just perfect? That man's energy, the one we just saw, I mean"—he turned around and pointed back toward Broadway—"walking away with his hands up like that. Toying with the refs, right? That man's energy, that's Duke's energy—on my team. That's what got me out of my seat at the restaurant. We would've eaten if it wasn't for that." Garret's arms dropped to his sides, leaving one hand dangling off the bench in a loose fist. "But even *he* got sent packing in the end, right? Run off. It's hard to fool the refs for long."

"He didn't actually *look* much like Duke, though," I offered. "Not at all, really."

"But what does that even matter? He was *still* Duke. Duke the Transgressor," he said with a touch of whimsy. "Charmed—even in a losing cause. I mean, didn't it look for sure like those three guys were going to *get it* back there?" He underhanded the rest of the pebbles into the water and they landed like a shotgun blast. "But they all walked away unscathed. Duke turned a gloomy-looking thing around, didn't he? Turned it into nothing."

"A comeback game, I guess."

Garrett frowned playfully and wrapped his arm around my shoulder. "Oh, I think you know just what I mean, even when I don't exactly come out and say it." He grabbed my thigh and put his weight on it. "Now, if we could tie up that guy's *spirit* with these drawings in some way—not a straight way, but *some* way, some way I can't even imagine yet, but you might—wouldn't that be something? To look at? You agree with that?"

He leaned forward, hands on his knees, and cocked his head back toward Apple's flagship store, the formidable glass monument across the street that presented its wares more or less as MOMA did a few blocks away.

"Duke's going to have an interesting few months with my Bears. The whole tradition—they're hard-nosed, there will be no bullshit. Definitely not with the hell they've been through, all these years of mediocrity."

He planted his hands on the wooden slats of the bench and sprung up smoothly, his natural athleticism showing, scientist or not. "I haven't met the man, myself." He gave me his hand and pulled me up easily. "But Paul tells me we can get to him in a hurry."

"Where's Martine now?" I asked as we ambled toward the church of Apple.

"Martine? I wish I could say. She went down to Los Angeles after we graduated. She wanted Hollywood and my chances were out east. I know that she ended up on the arm of a Universal executive, worked the party circuit, tried to launch herself right into the spectacle. Observation wasn't cutting it anymore, I guess. She wanted the stage."

"And did she get it?"

"Not really. A few tiny parts and then nothing much. Though she did marry the exec, which I thought was a mistake. I knew it would snuff out her ambitions, and it did. She got divorced. And, well, bad things can happen after that." He flicked a glance my way. Where, I wondered, was the woman who went with that wedding band he'd been playing with? And was there anyone in his life now?

"Paul—he finds out everything in the end—he found that Martine had moved to New York a few years ago. And now... I'm stuck wondering when I'll run right into her. Like in that park, tonight. It could happen. But my luck's held out."

What about the prospect of seeing her troubled him? I knew better than to ask.

"Paul knows her, then?"

"They met a couple of times in Chicago, when I'd come home from college in the summer—she was the 'art girl' I'd met out in woolly-headed California. I don't think Paul cares for her much. He was skeptical even back then, and, well, he was right to be, wasn't he? I don't think she gave much thought to sticking with me when LA came calling. But I thought if what she really wanted was the stars, then why not take a shot? Obviously things could have played out better for her in movies, television. And Paul, I think... it's not right, but he takes a certain pleasure in how things went for her. It's well-meant, though, he's a good friend."

"A childhood friend?"

Garrett gave me a long look. He was on the cusp of answering me but opted for a question instead: "What did *you* make of Paul? Tell me."

"I've got to read all this first, don't I?" I held out the purple folder Paul had given me.

"Don't take any of that stuff wrong, though, whatever you do. He's got strong views, he always has, but then I bet you do, too."

We found ourselves astride a kebab cart on Fifth that did business most of the night.

"Hotdog?"

I demurred.

"You want to walk down this way a little?" he asked, pointing down Fifty-Ninth Street, beyond Apple. "Just to see if we can feel its aura."

Garrett bought himself a dirty water dog with nothing on it, ripping it away from the swarthy vendor before he could sully it with condiments that were purest sacrilege to a native Chicagoan. He stuffed this bit of carnival food into his gaping mouth as we walked past the glass cube of Apple: neither of us felt anything much. So we got onto Madison and the boutiques flashed by: Celine, Cucinelli, Ford. He pointed at them with quarter of a hotdog; it was going fast.

"These guys present themselves in the *least* intriguing ways, again and again: women with their bones poking every which way, rakes in too-long coats, all sipping Barolo in some crumbling villa at dusk. What a starved dream life." He took the last bite of the dog as if to highlight the finality of his point. "Who can get *absorbed* by any of this, really? That question, when I walk up Madison or Fifth, that's all I can think about. It's not so much that the imagery is out of touch with life, because there *are* interesting fantasies, right? But this stuff is like a lazy impression of a capitalist paradise. They know this. They're just trying to avoid offending anyone with a fantasy that *actually* appeals. The thing is, though, people buy offensive things all the time, if it's got some force to it, even when they can full well see the offense it gives. All you have to do is look at football. Most offensive thing in the world, neurologically, socially, economically. But also terribly compelling, at its core, the power on display. And them?"—Garrett gestured back at Apple, now out of sight. "They sell a lot, yes. But the dreams they deal in are paper-thin. Anodized life-*styles*. No aura at all, right? That's not technology, not to me. I know they make a lot of money doing it, but there's just something missing there. Nobody's home. What I want someone to do is tell me about my insides! Apple doesn't have any insides. We, though, we *have* insides, even if it's inconvenient when it comes to marketing. You can't wish that away. Football, that's *inside*. Alcohol too. *Infinite psychic enhancement*, as Paul likes to put it. Movies, TV? You get the idea. Technology doesn't have to bracket all that, take you away from your own life, put it behind glass, a screen. I mean, just think about the park."

We went west at Sixty-Third, back toward the grand yard's silhouetted trees and shrubs. "Even when I lived just a few blocks down the other way, I never came to the park much. I always preferred those little grassy cul-de-sacs looking out over the river. Some of them have just a single bench, a couple of trees giving shade, and then the water. No one really uses those spots. But I could sit there by myself for hours. It's the way I feel about Roosevelt now. A perfect desert."

Pleased with this formulation, Garrett smiled softly and stuck his hands in his pockets as we abandoned a murderer's row of luxury boutiques for Fifth Avenue and the sculpted verdure of Central Park.

"Doesn't this giant green say something about us? About how we must feel—even if we don't usually say it out loud? The way it boxes up nature, packages it, pins it right in the middle of town for our use, as and when needed. It's saying to us, *there is nothing we cannot arrange.* Because we believe that. The Greeks put their faith in other things, glory, fortune, fate. What we've got is *control*: everything in its place, ready to hand. That's what convenience is, isn't it? *Ease?* What a vantage!" He punched his palm. "See, at the end of the day, I'm a Christian man, as most of us are in this country, whether we grasp that or not. And we've all got a choice to make. It's in our hands, right? What I'm after in the lab—mixing elements, seeking effects—I do the same thing on Sundays. I'm hunting enchantment. The only difference then is I'm not doing the mixing. I'm the element. But we're still talking about *reactions,* emergence of the unforeseen, and so on; so we must be talking about conviction and faith, too. Because a good scientist has got to be faithful."

Soon we came past Seventieth Street, the Frick, and by that point I started to understand why Paul had reserved his stranger faces at Sanguina for moments when Garrett got talking. In fact I knew I was making one of those faces now, going by the devilish way he looked at me, reveling in my consternation. Garrett was a bit of a philosopher, or a theologian; his Berkeley days had affected him. Not that he sounded like the usual Bay Area technologists, holding forth on white space and stoicism, or liberally tossing around words like *delight*, which, in the first days of our acquaintance, I was always expecting to fall from his lips. So it made sense that Paul's response to Garrett's ruminations was never one of listless dismissal—the kind he'd had to Karen's words at least once, though in point of fact he'd misunderstood her. No, the looks he wore while Garrett spoke were more exasperated than that, because his boss' meditations were hard to condescend to, having every appearance of genuine thinking, the way they confidently, even arrogantly, bypassed clichés. But not only clichés. Garrett also managed to skirt ideas that, though still living and breathing, were in line to *become* clichés, ideas that the mass of moderately clever people relied on, that had found a place in the elite niches of society, which is just what made them safe to deploy without fear of censure. Such notions remained just fresh enough to retain some of their imaginative force, which is to say, some of their charm.

For instance: it was today's "thoughtful" position that Central Park represented an urban planning fantasy of *having it all* that was miserably myopic—we were profaning the planet's real wilds while doting on this nugatory patch of green—*and*

that *ipso facto* this delusion was a problem in need of a solution. (Never mind, of course, how many people lived happily with the idea.) Garrett welcomed the first half of the view but not the second. If I had to distill his thoughts for him, perhaps this is what he held: what *we think* we think is less important than what the shape of our lives reveals we *actually* think. Consider the park, then. The city could easily use some of this space to build more housing and shorten commutes, reducing energy consumption and pollution and protecting the broader environment, not to mention making Manhattan more affordable and humane. Yet almost two hundred years later, the park is still here, real estate is ever scarcer, and our commutes are growing. There must be something, then, about the park and merely symbolic nature that has been and still is utterly apt, whatever we might think about this fact (and ourselves).

Garrett had a habit I was growing to admire, of venturing thoughts before they were fully formed, thoughts that lacked the finer definition of more mature ideas, which often came armored in jargon and depended for their persuasive force on appeals to authority or an apparatus of endnotes. Strangely enough, in some of the things he said I felt the *ghosts* of such references; they gave what he said a peculiarly cogent air, for words so casual, as if there was always more learning shoring up what he said than was apparent, and it was simply modesty, along with a respect for the intelligence of his interlocutor, that prevented him from being any more explicit. This was one way to read such omissions, in any case. Another might be—as I'd felt in first talking to him on the phone—that modesty, for him, was not a courtesy or a function of good breeding but an engrained strategy for getting along in the world.

Eventually we found ourselves at Eightieth Street, with the Met looming in the dark. On past that, the Kennedy Reservoir, the giant manmade lake at the heart of the park, came into view. As did the sand on both sides of the walkway. *A perfect desert,* Garrett had said. I suppose I, too, was interested in what was properly elemental. For me it wasn't about what was natural or real, the way it was for philosophers drawn to the metaphor of the desert. I thought first of the great American W.V. Quine, the kind of thinker they never taught at Cal Arts. I'd studied him on my own, and quite eagerly, too, ever since high school, when I'd picked up a worn anthology of modern philosophers, Descartes to Nietzsche, at City Lights. It was Quine, the last of the positivists, or the one who put an end to positivism, depending on how you saw it, who'd talked of his *taste for desert landscapes* in metaphysical matters. So he'd gone in for the simplest of ontologies, or what he thought was the simplest—an austere materialism—building up the rest of the world, all of the good and the just and the beautiful things, from that, and discarding anything that couldn't be constructed from these materials—which is to say, most things.

Elemental for me meant something else: it was that which was beyond taming. It was what was *vital,* you could say, so long as you understood, *pace* Nietzsche or Artaud, that there needn't be anything natural or essential about vitality.

Just then, two stately women crossed over to our side of Fifth and strode beside us. They were long-limbed, African, and, I suppose, *built like gazelles,* if you learned to live with this phrase that emphasized what blacks could never overcome, even after they'd taken the White House—their *closeness to nature,* I mean, another dangerous euphemism. These fine women, only just beyond being girls, had hair out of magazines, good ones like *Cereal* or *Aesthetica*: one had hers teased out into a tender afro that swayed delicately in the breeze, and the other had put hers into tight naps just covering her head.

Not once had they looked our way. Women of this kind, on Manhattan's streets, never seemed to look directly at anyone. Where would they find their match? No, a look exchanged with another was for them almost always a bad trade. They moved just in front of us, effectively cutting us off without noticing; yet they walked with those great authoritative strides, having legs to match their uncommon height, and soon pulled away from us, we who were merely maundering in a way New York only permitted after dark. During the day, the same walk would sooner or later get you into trouble with someone. The ladies' dresses billowed in the wind, and the lights revealed sheer and delicious fabrics in bright, flat colors that gave a vaguely Japanese impression, although, if I were to guess, the designers were probably Europeans operating in the eclectic vein, the one with no critics, because nothing was missing. How could you go wrong? For a moment, the breeze held steady on an eastern slant and made manifest the purity of the girls' frames, wrapped in waves of luscious silk (I could tell by how it fluttered). All of this was no less appealing and alienating than a Bugatti rolling up beside you on the Lower East Side. Garrett simply pursed his lips, as if to say, *Yes, I know.*

It occurred to me then, seeing these ladies, that Garrett had gone on about Duke all night and yet said almost nothing about Daphne.

"Ah, well she's just... ethereal, isn't she. Silly word, granted. I don't *know* Duke, but I can personally vouch for Daphne."

"Have you seen her other films, besides the one?"

"And her theater work, too. I don't think I've told you about that."

"I looked her up."

"I've been to those shows. Little experimental things, black boxes in Brooklyn and even Queens, these days. Not a world I spend a lot of time in—I guess that's obvious. But my reasons for being there have nothing to do with art."

I waited a beat; I sensed he wanted me to.

"Really, she's not far from family to me: the daughter of one of my closest friends. Well, *closest,* I don't know. Maybe not as close as Paul is to me in some ways. I've

known Tony for almost twenty years now, met him right when I got to the city, that first year, when I was really hungry for culture. We both were. *I* think of Tony as a great friend. He's probably right up your alley. A scholar of comparative literature: Scandinavian languages, illuminated manuscripts—that's his thing. Really a special man. He reminds me a bit of my classics prof at Berkeley. He taught for a while at NYU, actually, when they were just handing out cash, subsidizing apartments in the Village, trying to become a serious place of research. It *did* work, in the end."

"Where's he now?"

"Now? Well, *nowhere*, I guess. You'd have to call him an independent scholar. He takes up fellowships from time to time. He was on a Radcliffe a while back, and more recently he was at the Cullman Center. But Tony, he thinks of literature as a complement to solitude. I think he does his best work that way. There's a book he's putting together now, it's about the Norse Sagas, the pre-Columbian discovery of the New World. I can tell you he's much better company than the businessmen I deal with all day. I just can't afford solitude the way he can. Antral would collapse. But I've learned an enormous amount from him, about how to live."

Just past the lake, the two beauties cut through the park at the transverse at Ninety-Seventh. What an odd sight they made, these high-heeled waifs confidently breaching this pastoral construction in the dark, without fear, the city had become so set-like: nature as only the Ford Modeling Agency understood it.

Having nothing to look at anymore, we crossed back over to the east side of Fifth. Neither of us was following or leading; we co-operated implicitly, the way people jointly maneuvered the letters on a Ouija board, with no one and nothing but fate responsible for what was spelled out. It wasn't long before we came across a bus shelter I'd used once, after a party nearby in my first or second year in the city, at a *Frieze* editor's apartment in Spanish Harlem. I was thinking of writing something for the magazine back then, when I believed writing might help me break in—and when I still *desired* to break in. We had fun at her place, I recall, not just during the party but afterward, too. Yet the piece never appeared. I believe I saw the girl twice more. This was at a time, coming from California, in which I'd underestimated the size of the city, and thought I'd see people again who in fact would only turn up in my life many months or years later. It was, I realized, part of why New Yorkers behaved so heedlessly. If you were lucky, you'd not bump into the aggrieved party until your transgressions had been forgotten or overshadowed by someone else's.

Buses, of course, were the most distasteful form of public transport in town, far worse than the trains. *These* strap-hangers had reached a state of abjection unrivalled by their subway counterparts; one cross-town bus trip is all it took to figure this out. There was also the problem of aboveground exposure to riders' faces: good light

meant having to really see past those countenances to the dog-eared souls within. Whereas when you descended into the Earth at a subway station, left the sun behind, these same faces were both harder to make out and anyway better matched to circumstances: a trip to hell and back.

Garrett paused in front of the bus shelter and squinted at the digital poster forming its near wall, glare-stained as it was from passing headlights. When the cars cleared, we found Vince Vaughn gazing back at us: his wilting visage, some illegible bubble typeface arching above it, and very little else. At this point in his career, the movie was merely a vector for his likeness, even if he was aging poorly and by my reckoning had fallen a few rungs below rivals like Rogen and Farrell and at least one of the Wilson brothers.

"There's nothing wrong with a bus stop, you know, as a place to experience something," Garrett said. "It's just, the *things* they put on display. How much do you have to hate someone to make them look at *this*?"

I smiled and rapped my knuckles against Vaughn—I hit him right in the mouth—while Garrett gently fumed, something he did uniquely well. He was genuinely offended, I could see, and not just because of Vaughn; it was also the mindless execution of this virtualized poster whose electronic frame seemed to be meaninglessly pulsating. Most of us overlooked this kind of shortcoming in advertising the second we recognized the wares being hawked: trashy Hollywood comedy, say. Selective attention like this could even have been a sign of a visual maturity; Garrett might simply be childish in the manner only the very wealthy and the extremely poor can afford to be. But then it also could have been an index of how far people not particularly close to either pole had shrunk in imagining the possibilities of public imagery.

My cheek felt damp. Was I tearing up? There *was*, after all, something sad in all of this: in Garrett and his peculiar mission, whatever it amounted to; in the two beauties absconding into that night-blackened idyll; and in Vaughn, his crumbling career. But then I felt wet pinpricks in other places, not just my face but my hands and arms. Nothing unpleasant, no tears at all—it was just the faintest drizzle from above. The two of us anyway needed a rest from the dozens of blocks we'd come, and the hole in my sneaker sole raised its own issues. (I was already imagining my foot soaking through if the water fell faster).

"But see—*this* guy is one thing," Garrett spat at Vaughn, at me. "Daphne is actual magic"—the words came in a voice as ethereal as the sentiment. Immediately he got that look of devotion in his eyes, turning almost angry with passion, though tenderness was threaded through it.

"I'm sure I can work with her," I said a bit too flatly. I was thinking of home by this point, and I'd lost the stamina to incarnate my sentiments in speech anymore.

How out of phase all feeling could grow with my body, the encumbrance, the nuisance, the fading thing.

"Well, of course you can," Garrett said, "but in the flesh, too, you're going to *see*. Tony and I caught her at this performance-art thing a couple of months back. She had hardly any lines, but it was obvious the show was built around her. She could screw up her mouth thirty different ways, you know? I don't know how else to put it." He paused for breath. "That's not just me saying it, either. She was onstage most of time. Others came and went, pivoted right around her. It was almost choreography."

"I'd gotten that feeling from *The Sort*," I said.

"Right?" He grabbed me by the forearm and squeezed. "In that world, the film world... film-festival cinema–you know there's stuff they reject every year for being too outré? Berlin and Venice and Toronto all have their formulas. But not the things Daphne's in, not where *she* takes them. Do you follow that kind of stuff? The really *odd* stuff. Because of Tony, I know a tiny bit."

"I know some of it, sure. People show me things."

"So maybe you've even heard of her?"

"Well, I focus on the kind of pictures that don't move. Paintings—"

"What difference does that make? Those pictures move, too. Think of... well, think of—

I was, not unusually, thinking of Degas and said so.

"The chanteuses!"

"Twirling and twirling, and so totally still."

"Daphne's going to work in drawings. And I know the idea excites her."

It pleased me to hear that he liked the notion, and that Daphne knew something of what was to come. But it pleased me more, frankly, simply to contemplate my dear Degas, that bewitching conservative radical, Manet's great foil. Any excuse to think of him would do, to think especially of an alternate future of art that might have flowed from him rather than from Cézanne and Gauguin. How easily my mind returned to him—to Goya as well, but mostly Degas. His dancers, maybe his horses, too, are what Garrett knew, but Degas' entire career, through its many phases, and not just the famous bits, came to me at any mention of his name, even when that mention was my own: the early realism, pictures of the urbane in the countryside; the opera and café-concert works, which might be more useful than ever to me now; and those late, intensely colored abstractions, the ones no one really talks about, that are no less extreme than anything by Cézanne. They say Degas only painted them because he was going blind at the time, late in life, as he fell into seclusion and shed his friends, one by one, until he endured more solitude as an éminence grise than any man could bear without losing something of himself.

"She knows her art, then, not just her acting?" I asked.

"She's had that kind of childhood—every cultural opportunity you can imagine. Not a bit like mine out in the country, I'll tell you that." He winked at me, playing down his learning or anyway emphasizing how unlikely it was, which carried no water, given how wealthy I understood his father to be. Money converts effortlessly into culture—and right back again.

"I had dinner with her and Tony and the woman he's seeing these days. A stepmother in the making, maybe. After I brought up your name with Daphne, she went on about what her friends were doing and seeing, about the resurgence of drawing. She even told her father off, defending you!"

"Does he not care for my work?"

Garrett smiled a little ruefully.

"At least he knows about it, I guess."

"Well, he knows about everything. But *she* likes it. She'll be so pleased to hear from you, work with you." He held the breath in his lungs a second and released it as a melancholic sigh. "Still," he said, "I should warn you, she's very much her own person. Just like Duke—how I *imagine* Duke is, anyway."

"The two of them haven't met, I guess?"

Garrett nearly laughed but didn't while bringing two fingers up just under his temple and drawing them down hard to his chin. I thought it must have carried a message, and he had to do it twice more before I realized he was merely scratching his face. When he finished with these long strokes, his mouth, those thin lips of his—blotchy like his skin, which had the reddish complexion of very fair people—his lips turned out a slender smile.

"No, I don't know how those two would cross paths without a little help. Although, with Duke, anything's possible. He's a pretty intellectual guy. That's why he chose Cal. Auburn was calling, Florida as well. Powerhouse programs but not big on the books. Anyway, he's *deep* into art and fashion, not just politics. He's a studied man in many ways, even if he doesn't know just what sort of impression he makes in the world, not by a long shot. Certain kinds of people overflow themselves like that, right? Even real savvy ones. I could ask you: did Warhol know the *full* extent of what he *did*? The full effect? Because to me, he was as cringe-worthy as he was clever. Not everyone will see it that way, I know. But that's how it is in business, too. Facebook and Apple *think* they understand themselves. But when they've been swept aside thirty years, fifty years from now, by some thing or circumstance we have no real grasp of today, we're going to have to rethink that... But anyway—*Duke*." Garrett narrowed eyes, searching for words. "He's probably—definitely—a little 'out of hand.' Maybe you could even take the quotes off that. She is too. I shouldn't pretend. But *that* is the meat on this bone.

These two kids are both becoming—they aren't anything yet. They're going somewhere, I don't quite know where; no one does. Nothing about their futures is assured. But they—I just have this sense—they are *American* futures, and there's—"

A thunderous gurgling swallowed up his words: a city bus pulled up with its engine running rough. Through the windows, I could see passengers dotting it, mostly in the disabled section in front, with one woman sleeping in the second-to-last row, her head tucked firmly into her chest as if her will and quite possibly her soul had deserted her. I could have waited for the bus to pull away before responding to Garrett, but the bus driver seemed in no rush to leave the scene. Meanwhile, a man who could have used this information lurched down Fifth Avenue in the developing rain with harried strides—a cripple, I presumed, his gait was so mangled. For me he was mostly a jerky silhouette, a very loud one, actually, yelling unintelligibly through the engine's hysterical idle. Was the driver waiting because he'd somehow seen him, even *heard* him? Could the man loping southward even be a regular rider, so that this bizarre drama played out here more or less every night?

"You want me to chart all that?" I screamed in Garrett's ear. The driver looked at us, and the approaching man had a few garbled words for me; I think he may have been more than physically defective. I had my own problems, apparently: I was taken aback by my voice, the way it broke up under duress. I wasn't one to scream, and in the end I don't think I really needed to for Garrett to hear me. But I was competing with a bus engine and a madman; it may have skewed my judgment.

Garrett, for his part, refused to raise his voice. I wasn't surprised by this, though I like to think, as he sat there rubbing the ear of his I'd assaulted, that he was impressed by my own decision. We watched the limping man finally claw his way up the steps of the bus. It's perfectly possible my screaming had done the cripple some good, confusing the driver just long enough for the guy to make it onboard. I thought I saw him smile at me from within the bus through the raindrops sliding down the windows, though his smile might well have had nothing to do with me.

When the bus had pulled out of earshot, Garrett answered me with a steady intensity: "Right now, those two, the actor and the ballplayer, are in the moment that tells you if there's going to *be* any moment at all. That tells you where it all might go." He smoothed his shirt with his palms and picked his teeth with his thumb, grimacing to expose the front two, between which he must have imagined bits of hotdog wedged, if this wasn't simply a tic. The rest of his hand formed a ball covering his mouth. "You and I know, any adult knows, about, well, the vagaries of it all. Isn't that what you'd call it? That's what I need you to get down here, the vagaries of a life like ours, in this country. And that's what you've been *doing*, isn't it, with your series? Mapping... fortunes? American fortunes. It seems like happenstance, but one level

up the pattern comes out. The direction. The principle. The end. You make all these choices, thinking you know what's best for you, and life shows you otherwise, again and again. What Tony is talking about all the time: *telos*, *logos*, these Greek notions—the way they feed into Christianity and the Norse and Saxon things he studies."

I shrugged, only to give myself some time to consider his many points.

He leaned over, put his head too near to mine. "What you'll do is wait and see, just wait and see. Your eye'll always be on the two of them. And then something happens. Or nothing happens. Or maybe something *terrible* unfolds. You just keep right on drawing, straight through it. That's the way I imagined it all, anyway, when I saw Roger's walls covered in your pictures. Am I wrong? That they were just brimming with chance? *Life*, I mean, alongside make-believe, story, design, everything else. That's how you get to the *logos*, right?" He looked at me with real expectation. He wanted *me* to be possessed, too.

But when he could see I wasn't going to return an answer or even a proper look, only broken glances as I pondered these meanings I knew he prized, he leaned out over his knees.

"I don't think I'm wrong," he said matter-of-factly. "You couldn't have scripted everything, dreamt up all those scenes." He arched his back and pinched his shoulder blades together, easing the strain of our long walk. "I mean, I *met* Claire."

I looked away so he couldn't see the involuntary contortions of my face. Once I'd found a bit of composure, I played off his remark as if it were nothing to me.

"You know Roger's little sister, Maddy? Just a beautiful person. She and I were having dinner a couple of weeks ago. I mentioned you and the drawings of yours I saw at Rog's home, and she said, 'Oh, you already know *that* girl. I introduced you two at an exhibit a few months ago.' And then suddenly I remembered the woman Maddy meant, how delicate she'd seemed that evening, sipping wine, even though we talked for only a minute or two, and how whatever someone said or didn't, or *did* or didn't, how it affected her. That quality of hers, it must have been a guide for you, your pencil. Because who would turn that down—that *invitation*?

"All I mean by this is, try to stay as open with Duke and Daphne as you were with Claire. They might have just as many 'multitudes' for you to trace. And I really don't want Paul and Karen scripting everything. What are you going to see like *that*?"

He drummed on his knees, made to whistle but decided not to. He seemed younger now, less composed. Talking like this had roused the part of him that remained vitally enmeshed with youth, and that had kept him, as it kept artists and beggars, too, from becoming middle managers, a vein of youth that ran on and on, which was generally for the worse—but not always.

Garrett steepled his hands, flexed them momentarily, and folded them in his lap. After a beat he crossed his legs.

"Tonight, you said my two drinks are a little hard to come to grips with."

His tone was measured, like the first words delivered at a corporate meeting. Nothing of what came before, that spontaneity, lingered any longer. All it took was a *faux* prayer and he was a new man. I studied him without saying anything. He wouldn't look at me this time. His gaze shot across the street and penetrated the rainy depths of Central Park. The tree growth before us, black from the night but a sickly yellow-orange where the lamps struck it, receded into the distance, though just above its far edge you could see the buildings abruptly spire on the west side, setting and enforcing, like a guard checking a prisoner, the parameters of the park. Garrett's eyes held to a point in the distance that was pure black. I don't believe he was really looking, only wondering if he'd misjudged me.

"But the drinks have a kind of obscure potency, don't they?" he said at last. "They affected you, showed you something hidden. Even with the whiskey, it was more than just the alcohol."

"I don't know if I'd say that."

"Well, isn't that what you *meant*?" he sneered, his anger flaring more freely now. "That's the impression I got, that you grasped at least that much." He was really wondering now: *was* I wasting his time?

"That they're what?" I said. "*Potions* or something? Is that it?" My words tasted bitter, I'm not entirely sure why. I hit the 'p' of *potions* brutally hard, I suppose to match the acridity of Garrett's voice.

He looked a little stunned at the first real bit of resistance, maybe even distaste, from me—for his plans, for him even. He took his time looking me over, reappraising me, I felt, before he began to smile wider than I'd known possible, his eyes aglow, their blues and greens shifting like a sea at just the point where it meets lava, turbid and churning. This gargantuan smile made fully manifest his pristine teeth, which weren't frighteningly washed-out, as was so common in Manhattan, but a healthy eggshell tone. I don't believe he was expressing anything like happiness: I don't even know if *smile* was the right word for it. It had the same shape as a smile, at least, even while radiating contempt or some close cousin. In the event, I managed to find him pleasant enough: after all, a smile *is* a smile.

"How about an *elixir*, then?" Garrett snapped. "Would that do it for you? That's a good word. It's really not used enough."

Those beautiful natural teeth hardly parted as he spoke. I could see the musculature of his jaw flex in the light of the street.

I looked out into the distance, into the dark across the wet street. I thought I saw afterimages of his teeth there, little white squares flashing over the black trees.

The whine and buzz of car engines accelerating and decelerating, tracing the pattern of shifting traffic lights, enfolded us. There were few vehicles about this late, which brought their warbling into the foreground. This was the bass note of the city, probably every modern city, whether Manila or Oslo or Santiago. If anything had a claim to being *the* sound of cities, it was this indefatigable chorus of engines, rising and falling and rising without end.

"Look, I think I do know what you mean, at least about Theria," I conceded.

"Okay, so just suppose it's true then. That after every test we can think to conduct, after the FDA has had its fun as well, it turns out to be true: Theria *does* something nothing else quite does—as they would have said in the Wild West." His eyebrows shot up comically. He must have been in on the joke, all those quack advertisers of the nineteenth century with their cure-alls. Or could he really be speaking in earnest, that he'd accomplished what they'd only aspired to or lied about achieving? I didn't know him well enough to ask, which pleased him, I'm sure. He seemed to protect the exact dimensions of his knowledge like a trade secret.

"So maybe," he said, kicking up his Midwestern drawl, "think of it as a *parallel* we're intimating."

"A parallel to Daphne and Duke?"

"Of... a power or effect you couldn't quite know, but you couldn't really doubt either."

Did he arrive at this formulation just now, as his cadences suggested? Was the conversation between us tonight as extemporaneous as the squabble we'd witnessed in the street? And was he *truly* back to God?

"The word for that would be *enchantment*," he said. "That's the common element, right? Unbelievable *performance*."

I offered him a smile of my own now, admiring and a touch incredulous. "What about benightedness?"

He put on a face of shock. "Now, now—that's not what you felt, was it? Though I guess it'd be an easy enough mistake to make. Someone will fall into that trap. Not you, though."

Sensing the return of my doubts, Garrett stood up and, quite startlingly, walked right out into the heavy rain beyond the shelter. He turned back sharply to face me as the laces on one of his shoes went flapping about in the water gathered in deep puddles.

"Is this all too grand for you?" he said with acid, his nostrils flaring slightly. "Look, this isn't advertising in the old sense. No one gives a *damn* about that anymore, anyway." He knelt and briskly retied his shoe. "Find some faith, maybe." He laughed as he rose.

"What do you think Paul was—"

"*I* don't care about it, anyway. And I *know* you don't. So don't worry about it. Paul doesn't have as much faith as he should. It's been a problem since elementary school. But I'm always willing to help the ones who don't yet see what *we* see." Again he laughed, but no one would believe he was having any fun. Interrupting me had come off solely as a rebuke: he'd been waiting, I felt, for the mention of his lanky sidekick's doubts and I'd provided it. Garrett's dirty blond hair, deranged by winds giving him a different style every minute, was soaking through. He ran his hand over his head and water sprayed off him. He held his hands close together, clasped them. Mock beseechment?

"There are people now promoting things—culture, music—by *withholding* all promotion," he said with renewed sobriety. "Releasing things for free. Pay what you want. Deliberately letting things spread almost totally by word of mouth. And those are all, well—they're not terribly impressive efforts in the end, but they are stabs at creating *the conditions* for magic. And I just think, with the right gifts behind them, they could really bloom." He dropped his hands, pushed them out toward me, dripping with water, as if he might anoint me. Then he wiped them crudely on his trousers, vigorous strokes on a fine-looking wool that was as beaded with water as his hair.

Garrett went around to Mr. Vaughn, whose foolish mug and mock-neck shirt were still utterly dry as rain poured off his plastic cage, and looked the faded actor in the eye. "I can tell you one thing: we're going to give you *reach*." He pointed vaguely at Museum Mile. "Your stuff won't be beholden to that, all the people solemnly nodding for a moment and then leaving you behind in the gallery. No, you'll be chasing them down the street instead!"

He came back around to me, speaking matter-of-factly. "I *could* have you look at the marketing research: the motivational work, the psychological stuff, the polling data. But would you *want* to? Paul knows all about it, inside out.

Garrett slapped Vaughn across the cheek and water flew like tears. "The fact is, we've used Paul's analytics for certain products—the sportswear, for instance. But I've got to say, I've lost interest in that. Not because it doesn't *work*, but because it doesn't cut nearly deep enough, not in the way I want it to. Paul's never really had a feel for *the spirit*. Too much of an aesthete for that. I've been coaxing him along his whole goddamned life, it feels like. So I've stopped Paul—he's not thrilled about it—from talking you through all the advertising research, his findings and so on. *You* should be leading *it*. Someday it'll show, I know this, that you've intervened directly in people's lives with your pictures. We don't need predictions, we aren't telling fortunes—the future's for the future. Mysterious ways, and all that," he added with a certain edge to his voice.

Karen sometimes talked of such things, with real ambivalence. In design circles it was thought that advertising only followed the lead of consumer behavior, that technology really molded people's habits, not marketers. But then here was Garrett saying that this wasn't so. Maybe he *did* have the right guy in me. We would do some joint molding, on the premise that images mattered, and quite a bit more than words. After all, if he wanted to call it *enchantment*, or an *act of God*, what was the harm? Even if I didn't have much use for these terms, especially when they came from someone with financial interests like his, that didn't mean he didn't have a point. And if I could only grasp these notions weakly at the time, well, that might have just meant I needed to squeeze tighter.

Garrett paced in the rain—he'd stopped caring about it a while ago—as another bus came rolling in, the second or third of them, which drowned out my meditations. This one stopped near enough to my apartment. We hadn't been waiting for it, not intentionally. We'd been taking a rest and, at least for a time, cover from the rain. My thoughts could only turn to Roosevelt Island, how Garrett had walked me to the shuttle and seen me off. The symmetry, I felt, as he went to and fro just in front of me, leaving me now to think things over, was too perfect to pass up. Whenever I sensed the possibility of this sort of recurrence in my life, I tended to help things along in that direction, for no other reason than that I found it comforting that you could engineer your fate, revise it, improve it on the second or third or fourth pass, creating motifs just as easily in one's life as in art.

"Could this be your ride?" he said, even before I could politely suggest that I might just take this bus.

"Uptown, yeah." Apparently he, too, wanted to engineer my life. Was he thinking about that previous encounter on Roosevelt now? Or was some force rippling beneath the surface, creating loops of certain kinds, driving him to it?

"Take it, then." Again he smoothed his shirt, darkened as it was by the water it carried. He slicked his hair back with both hands, though his curls sprung up before he'd finished. "Look—I'm going to put you in touch with Daphne and Duke as soon as I can. And apologize to Karen for me. I just couldn't tonight."

Karen. I'd been craving her tonight, hadn't I? When she'd asked me to come early to the restaurant, I suppose I'd hoped it was a personal matter: to share a moment with me alone, to *tell me something*. Instead, her reticence, her speedy departure afterward, had left me in stinging doubt, so that by the time she stepped into that Uber with only a nod, I felt a little like slapping her, just to negate the swat she'd given me. She would have drunk with John and Rick and who knows who else tonight; probably she was drinking right now. Claire was with them, too, maybe. Why not? It would certainly explain why Karen hadn't invited me along. I felt a trickle run from

behind my ear, down my neck. To Garrett it would have looked like rainwater; only I would know it was sweat. Even in the cool night, I was burning from the neck up, and although I was outdoors, I somehow felt I needed fresh air. "Where will you go?" I asked in a voice so constricted, it seemed to come from someone else.

"Where?" He looked at me strangely, quizzical yet amused. Without knowing its source, I think he sensed my distress. His face straightened as he turned away. "Just the office."

"This late?"

"Don't feel sorry. It's like a playground for me over there. There's always more to do," his tone carrying the wink he didn't bother to deliver.

I grinned vacantly and climbed onto the bus, which even at this hour was a quarter-full with the tattered sort, the ones who were grateful simply to be indoors, shielded by this mobile refuge stinking of cologne and vomit. God knows where they called home. Once I found my seat near the front, in the disabled area, I didn't look back at Garrett from the window, as the madman had looked at me. I didn't wave. I hadn't even shaken Garrett's hand or given him a valedictory nod. Finally, noisily, the bus pulled away and warm air blasted me in the face. Which way Garrett went, I don't know.

16

The tickets arrived the next day: tickets to a Giants game—versus Chicago, naturally; and tickets to the theater, to *The Vegetable Gender*, staged in Fort Greene. Money came, too, wired by Karen, a nice healthy cash infusion. Garrett saw no point in further preliminaries, more sketches. There *was* a point in it for me, though. After parting ways at the bus stop and arriving home, very late, around midnight, I'd started clicking through the two videos again. Our ambulatory discussion that evening had been oddly strained, yet it had finished interestingly, and his final words, about the freedom he was going to grant me in framing scenes for the campaign, including the story surrounding them, had left me nervy.

Now I was arbitrarily freezing the picture, fast forwarding, rewinding, and sketching out postural aspects of whatever bodies I happened to land on. I wasn't *copying* them—I'd left that technique behind years ago—but constructing variants of whatever I saw on Claire's giant screen, composites from multiple images which were occasionally so fragmentary that Duke and Daphne would come out with only slightly more plasticity than stick men. I was using colored pencil for all of this, observing the medium interact with the two principals in their respective entertainments.

I filled a book and a half this way, tracking their intercourse with space and arriving at some sense of how these two carried themselves, via the characteristic angles of their shoulders, the flexion in their forearms, the bends in their elbows, even the shape of their hands when they were empty. More video, though, wasn't going to help me go beyond these notations toward real transformation. For that, I'd need to see Daphne and Duke in the flesh.

Garrett had sent me a pair of e-tickets for both performances, in case I wanted to take Karen along. If I would feel freer, though, going alone, he was fine with that. Everything in the project, after all, was to emanate from my drawings; any text, unless it had an essential place in the picture, would be gratuitous. Paul and Karen weren't going to acquiesce easily to Garrett's decree, naturally. But by now I knew that the boss, nice as he could be, didn't much mind contention. For the first time, then, the latitude I'd come to expect for my design work was going to flow not from Karen or Rick, nor even from a marketing officer like Paul, but straight from the top man. Which meant it was *I* who would be conferring autonomy upon Cosquer now. The concrete limitations on my work wouldn't change much, only because Karen rarely vetoed things I felt strongly about. Yet the shift in power was clear, and it was

going to give matters a fresh complexion. Probably Garrett was making these unusual arrangements so that I, not thinking of myself as being under Karen's thumb, might work without the usual psychic impediments, which therefore might yield unrulier pictures and persuade me that the project was worth my very best effort. You could certainly call this a ploy of Garrett's, but then there are some manipulations of one's circumstances that should be welcomed, and this was one of them.

The struggle between Garrett and Paul I'd found on strangely pleasant display the night before at Sanguina wasn't my proper concern. And, in any case, it wasn't really much of a struggle: Antral was Garrett's company. Still, their relationship felt more balanced than this fact would seem to allow, and should an irreconcilable dispute arise between them, the upshot felt less than inevitable. Was this sense of parity superficial, though, just an illusion Garrett found it convenient to encourage in his subordinates? Or was there more to it in this case, something shared only between childhood friends? Isn't that what Garrett had said they were? It was certainly how Paul looked at him. What could it be, I wondered, that Paul grasped that gave him such standing, such power?

The Giants game was for Sunday—quite short notice, really, as it was already Thursday. But it had to involve the Bears, Duke's team, and this was the only chance for the season. The seats at the Meadowlands that Garrett had gotten me were, no surprise, exceptional: right around the fifty-yard line and in the second tier, which guaranteed enough distance from the field, and height above the action, to make the total structure of an NFL snap intelligible at once. Macro-level events—screens and safety blitzes and Tampa twos, and which linebacker was spying on whom—jumped out at you from there; yet the distance wasn't so great as to diminish the force with which each man on the field made his individual impact, literal and metaphorical, on the whole of play. The *I* and the *we* of football were fully harmonized, and this was only true for a narrow band of seats ringing the stadium. Through all the Raiders games that I'd acted, at my mother's insistence, as Ty's chaperone, I knew that sitting forward or back unbalanced the experience, and left you, for the duration of the game, unconsciously willing yourself into the ideal viewing position, correcting in your imagination what was missing from your vantage, namely, all that might have been seen if, tantalizingly, you had managed to find a seat within that privileged stratum, or indeed in the even more expensive luxury boxes located just behind it.

Garrett kept one of those boxes; Antral shared it with a couple of other techno-logical and industrial firms, Whent's company among them. Apparently it was how Garrett and Whent became close in New York after college, over football. Garrett could have let me use the suite, of course, but, he said, he would rather have me out there in plain air, getting as close as I could to Duke's play, the game itself, and the feel

of the crowd. That's not to say boxes didn't have real benefits: I knew this from the tickets my father's office had once routinely supplied us with, until they realized he had no actual interest in recreation of this sort. For one, an.entirely different stadium staff, with better elocution, even better haircuts, serviced the suites. These spaces were commodious, lined handsomely in hardwood and furnished with elegant tables of beveled glass having the luster of crystal. The food and drink stocked there—dry-aged ribeye and heavy pours of Lagavulin—were of an order that would leave the hoi polloi baffled, they of the foot-long Italian beefs and three-thousand calorie troughs of chemically larded popcorn. (How the stadium must have loathed having to put up those government-ordered calorie counts, until they realized it didn't actually damage sales. The people knew what they were getting themselves involved in. They'd known all along.) Yet the amenities came at a cost much greater than cash. Something of the game's loutish energy, its rough-and-tumble aesthetic, got filtered out by the box. You thought you were *improving* your experience through the suites, getting the deluxe version of the game, sealed off from the masses, but in fact the separation diminished the game's momentousness, as Garrett himself had discovered when he'd sat in the outdoor seats he'd gotten for me, and later in far cheaper seats in the farthest ring of the stadium when he'd gone to games with Tony, who apparently relished the nosebleed sections for the way the game became only as important as the person next to you in the stands.

Sunday was expected to be gorgeous; the light would be full and pure but not overpowering. Garrett wanted that light landing on me. As did I. Being in a luxury box is like wearing sunglasses: comfortable but distancing, which is fine in most circumstances, but not for football. Better simply to squint and be in touch, even if it hurt a little. New York rationed out two months of beautiful weather per year, and we were soon to enter one of them, October; the other occurred in May. That was all you got. I was already anticipating the sun and breeze with a certain glee that would be denied to me at Daphne's show, which was not only indoors but, looking more closely at the ticket—tonight. Never mind the lack of sun; there was just no time for forward-looking pleasures, given that I generally needed a day or two to adjust to the very idea of going out to an event. Anything less, and what *might* have been pleasurable turned simply into an unwelcome surprise.

Garrett had left me an out: if I really couldn't make it to see Daphne perform tonight, he'd send me a ticket for tomorrow or whatever night in the next week I was free. He'd gotten tickets for the whole week-long run of *The Vegetable Gender*, for *all* his employees, and only partly to please Tony by supporting his daughter's work. It was just something the social engineer in Garrett liked to do: staid scientists and technicians, right along with trivial administrator types, would, as part of their conditions of Antral employment,

attend arts events in the city, with the ostensible purpose of developing an appreciation of the cutting edge, wherever it was to be found, so that it might rub off on how they did their jobs, and help them see which elements of the culture were primed for the introduction of technologies long before they'd become mass-cultural phenomena.

At least, that was the official line. Garrett was probably also interested in molding each member of his staff into a particular kind of person, increasing their receptivity to certain types of experience, sensitizing them like photo plates to see what might develop, irrespective of Antral's bottom line. He was a lab scientist by training. You could say he was experimentally creating culture now, introducing art into the lives of Antral's people and studying the results—or getting Paul to do it; Paul who was greedy for data and cared not at all for Tony's Althusserian agenda. And now, through me, I suppose Garrett was enlarging his test group further, to comprise any man in the street capable of noting a billboard or a poster.

For whatever reason, I wasn't disturbed by the suddenness with which Garrett's designs had commandeered my evening. I was glad to be occupied, actually. I was *too* free these days. Claire had brought resistance, friction, to my life, which it's very easy to undervalue. Lately, I'd glided straight through the days, any which way. They put up no fight, which here and there, yes, gave my time a wonderful sense of possibility. But then, as the weeks piled up, I found there was nothing to stop me, really, from simply spinning off into the void.

My looming shortfall of funds had proved a vitalizing force, pushing me into Garrett's arms. Fear is certainly friction, whatever else it is. And there were more forms of it accumulating around me, I knew. Where exactly *was* my artistic work, at this juncture? And in precisely what condition was my heart? These were pains from which I'd instinctively shielded myself. But as they came increasingly to the fore, I lurched toward a second tactic: seeing my troubles more hopefully. After all, I thought, wasn't the organic function of distress essentially corrective, telling you just where succor was needed, or where limits had been exceeded? If you *didn't* routinely feel the strains of being, you would lose touch with where you ended and the world began.

The real question tonight, though, was much simpler: to go alone to the theater, or to go with Karen. Her abrupt departure last night, to see someone else, had bruised me. I didn't particularly want to see her now; and I certainly didn't want my first acquaintance with Daphne contaminated by these blackened feelings. If I said nothing to Karen about the show, though, and Garrett had already mentioned it to her, she was going to take it poorly, whatever my reasons and pleas after the fact. Going without her, I would also likely end up sitting next to others of Garrett's staff engaged in his cultural programming, people who, under the circumstances, I would have to

be pleasant with—contaminating, in a quite different way, my initial experience of Daphne in the flesh. Was it a Romantic vanity out of time that I needed this sort of neutral palette to begin to grasp a subject of mine? It would have certainly drawn Karen's ire. It was just the accusation she would make, openly or not; sometimes she would just flick her eyes onto me in passing, and I knew, somehow, precisely the indictment she was making, from however many rebukes might have been available to her (three or four at least, usually). But at least I knew, through long acquaintance, how to mitigate any intrusion Karen made on my consciousness, which topics to step around, what tones not to take, and the questions never to ask. It would be better, then, to have her with me at the show, to buffer me from Garrett's great unwashed. Karen had played the part many times for me, on both coasts. She was good about this, and she deserved credit for how effortlessly she absorbed interference, though she resented my saying so, which seemed to her to minimize her sacrifice.

All of this ran through my mind—as did the thought, more dimly, that perhaps she might want to make amends for the brush-off she gave me the night before—as I got out on my fire escape barefoot, my arms around my knees, the sun landing hard on me as I peered into the street below from under an old floppy trilby of a bright brown that was, in almost any context, somewhat foppish. It was a prop of an ex's of Claire's who'd spent time washing out of Broadway; she'd stolen it from him, though she'd never *quite* admit that. I worked my eyes over the details of the street, apprehending volumes and weights and angles, the interplay of everything inanimate surrounding any bits of humanity, like the pimp in Nantucket pants not far from the corner who was awkwardly bent over, inspecting his shoes. The man was a fixture around here, roaming these blocks; he liked to bring out a long, rhinestone-encrusted cane at night and jabber and leer at anyone who happened by, twirling his prop acrobatically. It was almost a routine, how he played at being a pimp; if he really were one, he'd have to be the loneliest around: never a girl, not even some lithe young boy, in range of him. He caught me looking at him from my balcony and, still bent over and dusting his lace-ups with a handkerchief, gave me a conman's smile with plenty of gold in it. Whatever his faults, I had to say he was often inviting toward me in a way others on the block were not. I fixed that smile in my mind and ducked inside, just before he started sputtering at me, as he did at most of the regulars in the neighborhood.

Lately I'd been nudging along my living-room mural with greater energy than usual. This was the only exercise in painting I got these days, though I wasn't especially skilled in this form, never mind Connell's monthly drop-ins. Given what I'd be doing for Garrett, all the prints he'd be making of my work that would, if I understood him rightly, end up all throughout New York's public spaces, greater facility might have been useful. Just after college, traveling through the British Isles,

I'd gotten acquainted with some of work of street muralists who had left a mark there. I'd not intended to see these pieces, really, but when it came to public art, you had no choice. That was the chief glory of the form. Of architecture, too. You were its prisoner. I recall coming through Cork, almost by chance—a friend of mine from middle school had been born there and had returned since—and discovering just how much work Harrington and Early had sprinkled about their hometown, on the few high-rise façades in the urban core of the city, on spidery bridges linking the countryside, and, most unusually, on Cork's outskirts, where one doesn't expect to find such massive works. Later, in Australia, I noted the way Fintan Magee splashed giant industrial workers, tall but fat and seemingly melting in the sun, right onto country silos, often in brilliant silvers. I'd not thought all that much of it at the time, and substantively what was on offer wasn't terribly rich. But these artists *had* come to grips with working at a scale to which I'd not until now given serious consideration. There were artistic problems they'd confronted that most painters and draftsmen never had: what, for instance, happens when a figure expands to seventy times its size and gets squeezed onto the brick wall of an old brewery, one where junkies tie off on the other side at night? These were things I'd now have to think through, too, even if I never ended up executing a single one of these murals in the field, and merely oversaw the work of others.

Back in my apartment, with the window shut, I studied the scene beyond the fire escape, checking the brickwork opposite me, the weight it conveyed, and the sharpness of the light at midday as it struck the black tar on the pavement near the corner. They'd had to dig up the road a while ago; something had been wrong with the plumbing lines. Then they'd patched it up in a raw, uneven way. I'd stumbled many times over that gummy surface, which never seemed fully to cure and always reeked of sulfur. Something was wrong with the mix they'd used, though I doubted anyone from the city would be back, not until a passing tractor-trailer sunk straight into the ground on the spot.

I turned to studying the mural on my walls, having just examined the scene from which it derived. I'd left that dug-up area just as unhealed as it was. I'd even preserved something of the vulgarity of light around here, for instance, the glare coming off the chalky sidewalk. I left out the pimp and everything variable from the picture, though he was there regularly enough, I suppose, that it wouldn't have been exactly wrong to have included him. Perhaps later. Or maybe just his shiny cane, hanging from the security bars of the second-floor window of the tenement behind him.

I got up close to my southern window, which had been wide open all morning. Grasping the frame, I tipped my head and shoulders far enough out that from the ground I must have looked like an ambivalent suicide.

The artificial lake was just visible through the trees, on the southwestern corner of the park, with dark furry moss accumulating along its banks in layers like snowdrifts. It was as though a single creature were choking off all other flora. The water's surface was slightly soupy, as if a skin had congealed on it from that superabundance of algae, which suffused that quadrant of the park with the sweet stink of plant matter putrefying into swampy soil, including once-noble eucalyptus trees brought low by some disease: there were sores all over the lower half of the trunks, big barkless patches that grew larger and angrier by the season. It was this soil, of course, that had been dug up to manufacture the lake. Originally there'd been a small pond at the lake's center, but the pond became a lake by gouging at the mossy ground surrounding it and finding some other place for the detritus.

When I spent time in the neighborhood these days, it was often at the lake, finishing off cigarettes left over from whatever social function I'd last shown my face at. It was with these packets of cigarettes, and the regular breaks outdoors for which they supplied a pretext, even if you never actually smoked one then and simply circled the block, or stopped in at a bar across the street and listened to the jukebox—it was with tobacco that I made socializing bearable, when no human shield was at hand. Often it only took four or five cigarettes, smoked in this fashion, to finish off an evening engagement, spending at least half the time outside, alone. If, on a given night, the animus I felt coming from the city's homeless was particularly strong, and I didn't end up simply handing off the rest of the pack to one of their number, I'd smoke the leftover cigarettes around the lake in the days that followed, though often no more than halfway down, there were so many left. I'd just flick them, still burning, as I circled the water in lazy loops. By the time four or eight or a dozen of my cigarettes were all burning on the shore at once, the nauseating ripeness of organic decay had been beaten back by the more decisive odor of fire, like a lighted match in a toilet. Even Claire might have found the lake tolerable then, as she never had when we'd been together, and I'd had no urge, no need, to smoke.

I pulled my head back inside and crushed a bug on my arm. Blood, presumably my own, burst from its belly. The lake must be a health hazard at this point, all that standing water, the thickets of mosquitos and midges flying in unison and patrolling the park. My shirtsleeves—and the smoke—kept them off me, for the most part. Given the perpetual influx of African taxi drivers and Central American and Caribbean laborers to the city, these flying vermin, and the bloodmeals they took in the park, might have been a rather significant vector of disease. By now there must be some vicious tropical diseases buzzing about in the Bronx air, waiting for a native-born host. In the early months after moving to the borough, whenever I fell ill, I'd spend the first several days wondering whether I'd contracted an unremarkable disease or

something with a bit more fire: Chagas disease, sleeping sickness, dengue. Didn't they *all* begin with flu-like symptoms?

My arm itched at the point of the bite as I dabbed the blue and green and brown of the swampish water onto the wall. I could have ducked my head out again to see whether I was overstating the size of the thing, but the only relevant dimensions, in this case, were just the ones the place occupied in my imagination, as well as in the lives of those who lived here, some of them for generations. Perhaps that was the picture I was really rendering onto the walls of my apartment, something pre-perspectival, annihilating the barriers by dressing them as though my vision passed straight through them, unobstructed, but onto a scene of my own devising, with proportions and qualities the world may not exactly have indulged. Or did I dangle out of the window a couple dozen times a week for simpler reasons? Falling to my death would not only settle my problems, it would perfectly suit the neighborhood.

It took me three hours to finish the lake. I worked leisurely, with a thermos of very black coffee, thick like syrup and bracingly bitter; the beans were badly over-roasted. I bought them in three-pound bags from a Starbucks knockoff in my neighborhood. Why I frequented the place was beyond me, with several actual Starbucks within a two-block radius, except that by being devoid of branding—the place, to judge by the sign, was just called *Coffee*—it expertly fended off new customers. There were just the same five of us, week after week, which created a certain air of peace. I can't say how many ordinary cups of coffee the thermos represented, given how excessively I overdosed the portafilter with those beans, beans that never should have been used for espresso. (They suited drip if they suited anything.) But what I had was my old Silvia machine, a graduation gift, actually, before I knew much about making coffee or even drinking it. In any case, it took about half the thermos to wrap up the lake-cum-swamp, begun many days before in vague outline. I'd built it in layers, in quite fine detail, in just the way Connell had, so its surface now possessed the kind of diaphanousness that fully *expressed* its opaquer depths. I stared at the finished surface, so unqualifiedly refulgent, until my feet ached. Then I dumped out what was left in the thermos: I'd still never managed to finish a full one; I'd never needed to. The one thing the beans had going for them was their brutal strength.

Caffeine was distinctly harder on my nerves than was Theria. Maybe I'd switch over permanently—depending on the FDA's report. Yet the thermos had at least prodded me toward one meaningful decision, and it had nothing to do with the mural: I was going alone tonight to see Daphne. I wouldn't even call Karen about it; I didn't want to argue. If she really needed to see the show, she could do it next week, as Garrett said. In her place, I decided to take my sketchpad.

Garrett had told me to expense a car. The "perk," as I'd call it if I were accustomed to that way of thinking, had its appeal, as only rarely, at least outside of summer, did I take a car straight down to Brooklyn from the Bronx. Almost always this was occasioned by some sort of emergency, which meant I experienced hardly anything of the ride. The last time, I recalled, had been when I'd frantically rushed to John's place. I'd been speaking to him earlier that day from my apartment, or anyway he'd been speaking to me, hurling barely intelligible accusations of perfidy my way. How many other calls had he made before dialing my number? And why exactly was this man obsessed with loyalty above all other virtues? In all these years, no answer to that ever materialized. Yet it was still true. At some point the line cut out. Normally this wouldn't have worried me; John did that sort of thing every few months, hanging up on an intimate, knowing he'd be forgiven. But I'd also heard two women, in what I hesitate to call the background, given how loud they were, screaming with real conviction, and pleading with John to *come back inside*. Between his mother, Lenore, and Chelsea, his embittered sister—bitter for having been left behind in Rapid City, while John, the more gifted of the two, apparently lived a sexy New York life—I imagined that two women screaming at him hardly troubled John anymore. Perhaps he even sought it out when he was homesick. How could I say? I'd never once been back with him to the Dakotas.

Something akin to a roar came across the phone, the sum of all three voices. And then, nothing. I called back twice but no one picked up. I considered returning to bed, but the voices kept getting louder in my head. Not his voice, but the girls', though I had no reason to assume they were in the habit of histrionics, as John obviously was. What had it all meant? Why did he just have to come back inside? Then I recalled the precariousness of the roof-railing at his new apartment, up on the fifth floor. Either someone had or someone would eventually fall from there, even before I fell from mine, taking the measure of things. So, on that very early Sunday morning, I took an Uber to Bed-Stuy, a drive I can now hardly remember, given my fears at the time. It was one straight shot with hardly any traffic, the city to ourselves, at least as much as it ever was. In other circumstances, it could have been an instructive trip; it could have been exceedingly pleasant, even. But instead of pleasure there was only dread, and the low flow of James Blake on the radio. That was the fat Filipino's choice of music, as he tried repeatedly, with his Bluetooth earpiece—the driver, that is—to establish a connection to Manila, before finally giving up and turning up the stereo.

I had John's extra key, from helping him move into his brownstone a week before, so when I arrived I went straight in, only to find him passed out on the floor,

face bloodied, amid a half-dozen crates and moving boxes. The two girls were in each other's arms. I recognized neither of them, but that wasn't unusual with John. They described narrow outlines on a foam mattress on the floor, and they were even younger than I'd imagined, and looked enough alike you could have taken them for sisters. On my entry, one of them, the one facing the door, gave me that same scream from the phone. The other, swinging around toward me, obliged as well. I flicked on the lights and recoiled at their swollen faces, though I couldn't find a bruise or cut on them. They were stained not with blood but with tears, lots and lots of tears, though nothing like the deluge of blood recently disgorged by my friend's face. John, apparently, had been putting on a show; he'd been feeling especially betrayed this night. (Was one of them his girlfriend of the moment? Both?) Faithlessness was a feeling he specialized in, he'd once said to me in an extraordinarily lucid moment while showing me some watercolors. The heartland inculcates this contempt for falseness in its people. It must have taught Garrett this, too.

Feeling crossed up that day, John had started calling up friends, apparently, airing grievances, and eventually wobbling out onto the edge of his uneven roof with its rickety barriers in the manner of Morrison. He'd mentioned none of this to me over the phone, telling me instead, for one, that I *never* should have tried to fuck his ex-girlfriend (I hadn't) because it just wasn't something one *did* (lessons on romantic etiquette from a cowboy?). Other claims of the same paranoid order followed, just before he dropped his phone off the roof at precisely the moment the two girls had gathered the courage to stop screaming at him and grab his legs. This was hardly the threesome they'd imagined. He fell face-first onto the stairs leading back down to the fifth floor, blackening his own eye and dislocating his jaw. There was a four-inch gash on his face that an hour later still hadn't stopped pulsing blood.

He gave me the round-trip car fare the next day, right there in the hospital. He couldn't speak, of course, but using hospital stationery he directed the nurse to give me his wallet. He insisted on it—and he was right to, even if it solved nothing. I returned his extra key. Even when he could speak again, weeks later, we never really talked about what had happened, about those girls and what exactly had been going on that night. They'd looked terrified—and awfully young, which couldn't be ignored. I wondered what conclusions he thought I'd drawn, or what he suspected I'd said to others about events, especially Karen. In fact I'd never said a thing, though I don't think he would have believed me if I told him so.

Tonight would be very different: I was going to *appreciate* the ride down to Brooklyn, to the play, invoicing anything that came up afterward to Garrett, as he'd asked me to. It was a business excursion, after all, and if Paul could expense everything on his outings, why not me? Obviously, as an artist, I wasn't in the habit of such things.

Perhaps that's why it could still mean something to me, give me the idea, in fact, of dressing properly. Attire was once important to me, or rather it had mattered greatly to my father, and the three of us, his brood, had inherited the affinity as a matter of course. (For such a successful lawyer, his influence might have been greatest at home.) My sartorial interests peaked in the first years of high school, which I completed at a verdant all-boys boarding school in New Hampshire—my first experience away from home, almost a trial run for college. I'd followed Immo out there. My father thought much of the boy's father, a hand surgeon name Fritz. Did he fancy that sending me east might make a doctor of me, as it would of Immo? Blazers and ties held some charm for a California kid, I should admit, but then hundreds of children cladding themselves in just the same way took the bloom off fairly quickly. Immo didn't think so. He could have done eight years there, and effectively he did, as he segued into Williams for college. When I arrived at boarding school, though, I remember Immo appeared suddenly *unleashed*. I'd not until then had an inkling of just how repressed he must have been, though it made some sense in light of his gravid Nordic father, a man who only properly acknowledged me, a close friend of his son's, after discovering who my father was, his professional distinction.

Immo thrilled to the conceit of young men of privilege being forged deep in the woods into new masters of reality. He delighted, too, in the curiosities and kinks of the pecking order that emerged among the boys. Nothing so straightforward as William Golding's, but that was just because the kids around Immo were older, so the ingenuity they could summon in the name of cruelty and domination was richer. Immo proved himself a maestro among them, and, on discovering this talent, he came to revel more openly in those things to which Gerry Vanilla had first given us access, but that could only be tasted covertly then, in small doses when our parents weren't looking. Unlike our families, our tutors and headmaster stood little chance of keeping up with us, so there was no longer much of a check on our perversions. The honor code was reasonably effective in the classroom, it's true, but in the dorms it was no more than window dressing.

In middle school, Immo and I would have agreed that I was the more transgressive one. But those couple of years in the woods proved otherwise, at least when it came to collective transgression, which even then I found dispiriting. There was no courage I could see in crossing lines your cohort was committed to crossing with you. So, I spent an enormous amount of my time in New Hampshire reading alone by the lake, and it was only Immo, widely loved and indeed feared, who managed to keep my name in good standing, even though we saw each other less as time went on. When I transferred back to College Prep in Berkeley, we'd taken to communicating mainly by email, not even text.

I got out of the shower and draped a rust-colored tie around my neck. I'd picked it up at Ede and Ravenscroft, in London, and the tie had only a slight mottling for a pattern. The last time I'd worn it was to a cousin's funeral. I'd not known him well, but he'd gotten a splitting headache about seven months ago, took a nap, and never woke (an aneurysm with no obvious causes). From there I clothed myself in a manner befitting the tie: an off-white shirt, lighter than cream, with a spread color and French cuffs, silk cufflinks, and the bespoke wool suit that my father, quite curiously, had gotten made for me before my graduation (I think his own father had done the same for him when he'd finished law school). The suit was made with bright navy cloth without undue shine; side-vents; and sleeves with functional mother-of-pearl buttons that should, in the event, never be undone, my father said, as it was gauche to do so, though it must still be *possible* to unbutton them. (Some abilities, he always insisted, are more noble for never being exercised.) To this I added a pair of svelte yet sober cap-toes in a black calf that had long ago molded to my feet. I stared into the floor-length mirror of my bedroom and savored the hard-edged formality before me. Even my face took on a chiseled distance I found appealing, though no one else I knew perceived this quality in me but Rick. He said it was the truest expression I had, actually—and this was no compliment.

I left my place almost certainly overdressed, if *The Vegetable Gender* was to be anything like the performance I was imagining: skewed, idiosyncratic, hardly the place for an ensemble almost hatefully Anglo-Saxon. (Immo would have adored it, of course.) Daphne was likely to find me odd, given how I'd styled myself. There would be no easy trust or intimacy. But I didn't mind. Trust might have been beside the point tonight. More than that, I knew better than to form expectations when it came to women like Daphne; she was sure to revel in dashing them.

17

A Yemeni and I crawled southward through the city, though not at all in the manner of my last ride down, when I'd shot through Fifth Avenue nearly unimpeded with the Filipino, courtesy of a run of green lights and the late hour. Tonight's driver kept apologizing for the traffic and the delay in an accent that put me in mind, foremost, of cholera, the scourge that had eaten its way through his country not long ago, after the Saudis unloaded their American bombs for months onto the tiny country. He was here as a refugee of just that crisis, he told me. But the little bearded man's apologies were misplaced: our inertia gave me time to savor the trip. My phone shivered in my pocket now and then, yet I never even considered taking it out, not while the cityscape mutated through a multitude of forms as we jerkily made our way across Macom's Dam Bridge and down through Washington Heights and Harlem, toward that radical disjunction occurring where Harlem's Spanish sector gives way to the Upper East Side. It was as if we'd crossed continents in passing from 110th Street to Ninety-ninth, at which point we entered into the gilded world of Whent. Next came the commercial glamour of midtown, all those boutiques, and the great park by our side, through to the Flatiron building and its surrounds, down into the narrow, light-starved lanes of the Financial District.

Finally we came to the Manhattan Bridge. I closed my eyes as we crossed over to Brooklyn and tuned into the buzzing of the tiny motor of our Fiesta and the blaring of car horns all around us, horns just as various as each engine's whine. Dominating both, though, was the backbeat of the chirpy dance-pop that evidently kept this Yemeni going, the same stuff, in fact, that kept gym rats going, and that suffused corner bars. Every year, there were half-a-dozen of these songs that flooded the cabs and watering holes of New York, keeping you apprised of pop trends, whatever your interest in them. They were written by musicians who never saw the stage, who had no real identity *per se*; that's just not what was asked of them. A catchy melody, a few non-specific rhymes about lust or heartbreak, that was all. Songs of this sort were really lifestyle advertising jingles, and in fact the same pool of musicians wrote both of them.

Ordinarily I would have experienced tripe like this with some annoyance, and although I was loath to interfere with a driver's carefully maintained ecosystem—one engineered to create maximum comfort for him, not the passenger, for it was *he* who had to be in the car all night—I might well have gone as far as telling him I required silence, that I had to think over something or other. Instead, tonight, I let him enjoy

himself. I also didn't stop him when he tuned into a fiery exchange between pundits on an Arabic radio station. He even translated bits of it for me, numbers about the humanitarian crisis in Yemen, the number of bodies, the numbers infected, the number of functioning clinics, the number of bombs. He framed everything in a maudlin sort of way, though, obviously designed to garner maximum sympathy. It was tragic, really, his presumption that the facts themselves, all those numbers, could never persuade someone like me to think the plight of his people important enough to interrupt his ride.

He dropped me off at the juncture of Downtown Brooklyn and Fort Greene, outside a large hall, and we shook hands like old friends. He was thanking me for my indulgence, but it wasn't necessary. Through all the horror he'd related, I'd simply enjoyed the drive; nothing could have ruined it for me. Before me now was a vast auditorium that gave the impression of having been built solely for freshman survey classes. As I entered through its towering doors, I was startled to find the stage not above the audience but down below it, in a central pit, a bit like the ancient Greeks would have it, but with the seats arranged in a curve that spanned only 180 degrees, not 270 or more. Capacity must have been several hundred at least, and as I surveyed this amphitheater, finally peering at the stage that seemed quite small from here, I couldn't help but rock vertiginously forward. I'd been anticipating black-box neutrality tonight, not architecture that would so strongly color affairs. The hall was also far fuller than I would have expected for a work of experimental theater. The director, Nik Volger, was a larger name in underground drama and film than I could have appreciated at the time, though I certainly knew he was a figure of some import. The last of my faulty surmises was this: although the chilly crispness of my suit did make me stand out from the group, ultimately I had overdressed by a smaller margin than I'd hoped. The crowd was young but not particularly bohemian; everyone looked well put together, sensible. Insouciance was less and less the fashion, it seemed, even on the left.

I began my descent of the *theatron*, with gray-backed seats rising up steeply on either side of me. I felt as though I had to slow myself, as if I were picking up too much speed and on the cusp of tumbling down to a stage that now felt like the bottom of a well. My imprudence, should I indulge it, would be on full show: my body would end up in a heap, to be examined under the stage lights forensically, and dramatically, too. It intrigued me, this thought of small disasters, given John's close call and my own daily tangles with gravity, pushing myself halfway out my window, always vying for a better look at things.

About a quarter of the way down the aisle, a woman with blonde dreads and pearl earrings waved a clutch of playbills. These red leaflets were printed on heavily veined

paper, rough to the touch, but thin and flaky, too. I'd seen the quirkily styled woman from some way off, but (no surprise) she wouldn't look the guests in the eye, which left me to snatch a program as I passed like a marathoner grabbing water. But then, hadn't I deliberately avoided reading up on the play beforehand? So that I might be led by my eyes tonight, not my mind? I set the pretty red papers on an empty seat and continued my descent.

About a third of the way from the stage I turned down a mostly full row and homed in on my seat. While the patrons stood in sequence to accommodate my passage, I could feel them staring at me, or at least at the steely perfection of my suit. In keeping with this, I declined to engage them, leaving my eyes firmly locked on the block of five empty seats toward the end of the row. The seat one from the far edge was mine. I pushed the seat bottom down and settled into the narrow, low-slung space between the armrests, my knees rising up slightly in front of me. Did the four empties surrounding me all belong to Garrett? Each time I would see someone coming down my row, prompting the same people to rise and fall before me, I felt the briefest flicker of dread. Nothing serious, just what you feel when, say, someone dawdles near an open seat beside you on an airplane. There was more guilt involved tonight, of course, inasmuch as theater, unlike transport, had some right to be regarded as an essay in communion.

The guilt didn't last long: I was relieved to find that while newcomers had plugged many of the gaps in front of and behind me, my block of seats—I thought of them as mine—remained an island for one.

The lights fell very gradually—so slowly, in fact, I wondered how long it had taken me even to notice that they were fading. When they were gone, though, they were truly gone: you couldn't see your own hands. The pre-show whispers of the crowd grew into a distressed murmur. Feeling around in my coat pocket, searching for my sketchpad, I came upon a crumpled receipt or wrapper and unthinkingly tossed it to the ground. Who was going to see me do this? I suppose the absence of all light had already begun to affect me.

Into my lap I delivered the long, bound strip of pages I'd recovered, the same sort of pad I sometimes took with me to bars and parks and such. Technically it was designed as a reporters' jotter, though a bit wider than normal, with a creamy stock and—this was truly silly—gilt edges. A vanity notebook is what it was, like those leather diaries one buys and finds too nice to actually use. No journalist could have taken this into the field without earning scorn, but for my purposes it served quite well. The stock took ink beautifully while the format made it easy to stuff in a pocket. The sheets' narrowness did mean I had to rotate it into landscape even when drawing portraits, but this wasn't much of a compromise.

It occurred to me, quite suddenly, that orchestral music was playing, though almost sub-audibly: *pianississississississimo*—as softly as humanly possible—a purely theoretical concept for me until now. The melody, for which you had to listen ferociously to detect, was actually spiky and strident. I couldn't make out the full instrumentation, it was all so utterly soft. Yet the bare fact of this music's presence, however diaphanous, seemed to settle the audience a bit, convince them that things were indeed *underway*.

Soon, however, the dread noise of people rising near me came back. There were muted apologies, too, besides the shuffling of cloth and the seats springing closed and opening again in my row. The narrow beam of a cellphone light knifed through the darkness to my left. As the only empty seats here were on my island, I knew the bluish spotlight would press ahead until it reached me. When it did, the ray froze at my feet before striking me in the face. Apparently I was being assessed. When it finally blinked off, I heard those stretching springs again: whoever it was had sat down in the seat two from mine. I squinted hard, hoping to see something of him, anything, but after he'd blinded me, all I got were afterimages. Strangely, I could actually hear him breathe—*was* it a him?—and these long, steady breaths, suggestive of health and calm, not weakness, would accompany me the rest of the show.

I smelled perfume, or else a floral cologne, with a distinctive leading note of rose. Nothing much could be deduced from this, really. Scents had grown too unisex for that. Whatever it was, the rosiness was pleasant and gentle, perhaps with sandalwood beneath it, and soft like the music. I settled back into my chair, resigned to the obscurity of the presence next to me, and returned my attention to the music. While remaining a whisper, it was now more cleanly articulated, and more than that, distinctly spatialized. I could imagine a violin on the left side of the stage, and a clarinet along with an alto saxophone, I believed, to the right, and in that order.

There were, I knew, sound systems with the vividness of live orchestras. While I might have had a home theater, it was Rick who had a listening room, and an audiophile's rig. Long an obsessive about music, he'd never wandered from painting into sound sculpture or its ilk. Still, as an abstractionist, he appeared to me irremediably Paterian, aspiring always toward music in his paintings, even if he'd admit no interest in pure art and avow that he was as finished with Modernism as anyone else. *His* abstraction was, after all, of the *post-historical* sort: abstraction after the end of Art. It meant you'd never hear him defend Greenberg by name. Yet he knew *I knew* he was only playing with words, seeking cover, and that in truth he was something of a belated crypto-modernist. Rick also had the good fortune to know when he was beat, which between us generally meant when discussion advanced to an extra-painterly plane. He admired me for this, all the various knowledges represented in that library

of mine; but it was also something he despised, which, to me, was merely to despise the complexity of the world, all that wouldn't oblige materialist or formal reduction.

As for music: little by little, Rick had assembled an enviable sound system: a Rega RP6, Sonus Faber floorstanders, and a vintage tube amplifier he'd found at the Brooklyn Flea, an event he thought no less serendipitous than Claire's discovery of a Chagall print in the rummage bins. Rick had turned his one-bedroom in Sunset Park—which he now shared with Lindy, another of Cosquer's artists, and to my mind his soulmate, however damning that was—into a soundstage, with the musicians in holographic touch as you sat on his couch having Fernet or whatever microbrew he fancied that week.

Now here it was once more, I thought, just as the lights came up ever so slightly from absolute dark: an almost frighteningly detailed auditory image. In this extraordinary dimness, sight again became possible—or something sight-like, anyway, given that the picture I was able to form of the stage was so impoverished that I couldn't be sure it wasn't a hallucination, the mind merely *imagining* light, anticipating it, the very ground of sight, owing to some panicked desire to see, which you could only experience when thrust into the pitch dark unexpectedly. I was unsure where exactly things were taking place: solely within my mind, or out in the world as well. A pyramid of light defined itself before us, emanating from a central hive of swiveling fixtures mounted low above the stage. What was there within this volume of light and the triangular base it laid upon the stage? In this zone, one thing seemed to run into another. The very word *thing* felt out of order. My field of vision appeared as a continuous body, amoeba-like and pre-objectual, shifting without fully differentiated parts. Color and texture, position and extension, all this was unknowable. I saw only vaguely bounded apparitions within the light, and the figures I made out (or constructed) first were in dress even more formal than my own: tuxedoed musicians at each point of the tetrahedron's base—the violinist and saxophonist out in front on the edge of the stage, and the clarinetist recessed in the middle—all as quiet to my eyes as their instruments remained to my ears.

This was no audio system; it was the thing itself. But the longer I studied the three players, the less sure I became of what I was seeing. Musicians are, of course, what it *made sense* to see, given how lifelike the sound was. Somehow this tidy fit between sensation and belief only made me dubious of the actuality of what I experienced; it was, in its way, too convenient. Whenever this thought strengthened in me—and my thoughts seemed to pulse through me now—the apparitions at the points turned from players into shimmers. The stage illumination had long ago plateaued, stymying any attempt to see with confidence, stranding me between illusion and reality. In this purgatory, the refined scent of rose seemed to surround me. I turned sharply to

my left, as if needing to catch the rosy source before he had time to hide himself, and there indeed, in the recently occupied seat, was a man, though he was hardly clear to sight. The stage-lights cast only glimmers this deep into the audience. More grizzled than his delicate scent would suggest, I was just able to make out his thick, patchy beard, of what shade I couldn't say, and his jagged nose. Somehow I also caught the distinct whiff of youth, exuded even by those who, through overdoing it, have prematurely aged their bodies. Perhaps he spent his free time out on the ocean, boating under endless sun. I wouldn't have been surprised; he kept his sleeves rolled back very far. Or perhaps it was down to that steady breath of his, the breath of an athlete at rest, which proceeded metronomically while expressing the possibility of sudden and decisive action, should the need arise. I examined his face as best I could. His eyes were only slits, not because he was from the Far East, although I couldn't rule that out yet, but because my eyes—and everyone's in the building, I assumed—were just the same: squinting to make out anything at all. The bearded man never turned toward me, not for an instant. He was too busy peering at the stage, as if, against the odds, he'd managed to cotton on to what was happening there. For a moment it made me wonder whether he *could* see more than I was able to, if he was possessed of twenty-ten vision, say, and the show was aimed at super-seers, the patrons of *a blind theater*, exactly parallel to those diners who ate in pitch black to heighten the sense of taste. Anything was possible. Weren't some books, after all, written solely for the 160 IQ set?

As time went on, my eyes did seem to adjust slightly to the dark. Certainly I kept willing them to see, and my presumption that the rose-scented man was getting more out of the production than I was, well, I found the notion motivating. The players began to come into a *kind* of focus, the violinist drawing his bow at quarter-speed and the saxophonist puffing his cheeks while barely making a sound. Yet soon these two dissolved again into ghostly quivers of light, and it was only the correspondence between the shifting of this light and the rhythms of the music that made me believe I was genuinely in touch with *something*. Substantial tracts of the audience had lost patience with these ambiguities of experience: they'd refused to quiet entirely and, feeling themselves to be toyed with, were growing more defiant by the minute. I myself wasn't much vexed, to tell the truth, not because I had any more comprehension of events than they, but because pleasure wasn't a priority for me tonight. This was work. Sooner or later, I knew, the girl I had come to see would make her appearance onstage, and that would be reward enough, to set eyes on her finally.

I unfocused my gaze. I was free, really, to drift in and out of the production. I wasn't going to be quizzed on it, and if I were, I didn't have to have answers. In the darkness I let my pen slide idly across the pages without properly seeing the shapes

I inscribed on them. I might end up with only a mess of lines for my trouble, I thought, and that was fine. I was happy enough to listen to the bearded man breathe, in then out, in then out.

Eventually a woman, or a really a very young girl, took the stage. That's what I thought I saw, anyway: a playful little girl, judging by her height, with long dark hair and a dark dress fringed with white. How slender, how *frail* she seemed waddling into the pyramid of light still resting upon the stage. The triangular base defined upon the floor grew firmer, its vertices linking the three musicians even if they now seemed worlds apart musically. I was put in mind of Charles Ives and his marching bands passing each other in the town square, playing different tunes, rallying different causes. All three of the musicians I could just about make out, but beyond them, I saw, or rather, believed I saw—or really *heard*—still more musicians, many more, all playing gently with consummate control.

The girl, though—she was real, or anyway realer. She wandered awhile at the fringes of the light, observing the players, who paid her no mind, before darting to the base of that triangle of light, right along the lip of the stage, on the edge of the black. The abruptness of the dash, the ground being covered so quickly, struck a note of terror against the dark hush, heightening her claim to reality, this creature almost skipping across the stage, apparently unfazed by the abyss on all sides. The rose-scented man's breath, previously so steady, grew shallow and tight—proof of her power. I was reminded of my own breathing, already constricted by the waist retention of my coat and my oxford starched like armor, the way my father always preferred to wear his: to give him, he said, the feeling of going into battle.

The girl was as close as stage-light would permit me to see, and she was looking right through all of us in the seats. She swiveled her head, turning away from us back toward the stage, and her body soon followed, first her torso, then her legs and her glossy shoes, shining like varnished instruments. With her back to us, she *became* us, gazing into the same twilight.

She rocked back and forth to a beat we couldn't hear, twisting her hair around her fingers, swinging the hem of her dress. The musicians kept playing, the ones within the light and the ones in shadow, yet they seemed to have further diverged from one another, occupying distinct keys and time signatures. Hadn't they originally been in sync? Now the discrepancies piled up, all the more given the sea of players manifestly cloaked by darkness. There must have been a chamber orchestra back there, outside the illuminated pyramid. Still, just enough unity obtained between the players to suggest that, if they weren't quite playing together, their universes ran parallel to each other.

Were we ten or fifteen minutes in? That's what I would have guessed, though light has a way of affecting time's passage. Fifteen minutes, let's suppose, and by then I had

the distinct impression that although everything so far had the air of a preamble about it, nothing full-throated was on the horizon. For all I could tell, the entirety of the performance might continue under just these conditions of... blindsight. So I opened my pad again in earnest, knowing that I might not just be drawing blind tonight— sketching without observing my mark-making was a practice I was already quite expert at—I might have no choice but to blindly draw things I could hardly see in the first place. Double-blind drawing, if it needed a name. I started with the clarinetist at the triangle's peak. Really, I couldn't see much of him, mostly just his instrument jutting into the pyramid of half-light. Whereas he himself—it must have been a *he*, from the build, the cut of the coat—there was only the vaguest suggestion of his body, aside from occasions when his hands came into view as he fingered the instrument or applied tremolo. Often it seemed as if the instrument were playing itself, bobbing to its own music. That's exactly how I drew it, or tried to, anyway, seeing nothing of my pad.

I finished with the clarinetist, whatever I could intuit of him, and shifted to the saxophonist, who was out in front and on the right. Tall but sitting in profile, the light caught more of him than of the clarinetist, though his instrument, being brass, shone brighter than the player. Provisional strokes were all he got before I moved on to the final figure I could see: a timpanist, who seemed to have replaced the violinist at the front-left, his mallets pattering on the drum's head, which was starkest white and quickly the most defined presence in this shadow world.

By the time I'd made these more or less geometric preparations for sketching the subject—the little girl—she'd actually crept out of the light. I could still hear her shoes clatter as she fidgeted, though now she was too close to be seen, beyond the reach of light. Other presences superseded her: a flutist took form to the clarinetist's right as the light finally evolved, shifting dimensions, the pyramid turning more classical, with a four-sided base. This rhomboid landing on the stage brought out, along with the flutist, an oboist, both of whom I *thought* I'd been hearing, and finally several other musicians to either side of the clarinetist.

While I flipped through the sheets of my pad, getting down something of this scene, the faint rustling of my paper and the scratching of my pen made the bearded man beside me turn my way. I gave him all I could think to, a simple nod. I suppose I looked at him then so I wouldn't have to look at him again—this emissary of Garrett's, I presumed—establishing that special sort of rapport that would let us forget about one another.

My nod said no more than, *Yes, I see you,* and even that was a half-truth, since the light from the stage carried so little. For this same reason, I'm also not sure what he took from my nod, whether the exaggeration I put into it made him think I was mocking him.

He leaned forward in his seat, curious. I'd *like* to say he nodded back at me, though if he did, his nod was far subtler than mine, and, in truth, probably just a response to a twinge he felt in his neck. He had swung around to me, though, the first discernible movement he'd made since settling in, and after shifting forward a bit, I saw him back in profile again, which signaled an end to our exchange. He groped about in his pocket and took out his phone. What for?

An enrobed man, substantially aged, breached the rightmost edge of the pyramidal field projected onto the stage. Or, rather, the edge of light broke over his body— lights were shifting, not the bodies they fell on. He wasn't wearing a robe, either, just loosely draped cloth, giving him a Biblical air, the look of a sage or soothsayer. He stood with a pronounced stoop, bending over without trying to, arthritically, at mid-spine, his head thrust downward and his neck craned back in the extreme merely so that he could face straight-on. Given his L-shaped posture, the man's remarkable size, or rather length, if you were to straighten him out, took some time to deduce. How tall the actor must have been—and what excruciating contortions he was going through for the stage.

My eyes jumped left involuntarily, toward someone fully enclosed by light. The figure, while no less illuminated than the old man, was somehow too universal to make any judgments about. Gender and age were inscrutable. All clothing was tight to the body, so tight that this character couldn't have come from the same era as the girl and man. Rather, he or she, or *it*, came from the future. Thresholds of vision, manipulation of eye pathways—this was Volger's game, I knew. Soon enough, my gaze was dragged off elsewhere, to the front edge of the pyramid. Not by the little girl, it turned out—the only person with real physical charisma, and so the one I'd been waiting for and expecting to return from just that blackened spot—but by two women falling into the light. Instantly I knew, before even properly laying eyes on the pair, that the one I was *supposed* to be looking for tonight was present. She was facing away from me, they both were, but her hair, it had to be her hair, even if it wasn't at all red, it luminesced. It must have been bleached. It was shorter now, too, above shoulder length, and thicker. Standing barefoot, she wore a light dress, thin and reedy: you could mistake it for a slip. But the real giveaway was her forearms and wrists, the way they seemed to twist slightly outward and leave her hands out and open, even at rest, which I recalled well from *The Sort*. It was an odd signature, yet it's these apparently incidental qualities that often take deepest root in memory.

I suppose Daphne's arrival effectively concluded the play's muddled introduction—for me, anyway—even if the little girl had drawn me away with her petulant charms; and the odd formal aspects of the production had distracted me with the pressures they put on perception itself; and the gentleman next to me, though he'd

now dispensed with his phone, kept up his song of breath. I pulled back my focus and took in the whole of the stage, a fresh sheet of paper before me, only to find that the three musicians had vanished, presumably having receded into darkness as the light's borders further evolved. Was the music really loudening, despite this retreat? And was the light brightening, or did it simply *seem* stronger owing to the accretion of human forms fully within its compass? There were exactly four figures, all in white: the old man of the past, the androgynous figure of the future, and the two women from some time in between. The old man was still pretty much where he'd first appeared, except he'd seated himself in a chair newly visible in the shifting light. The chair, for its part, was a sticklike thing built from spindly metal bars, and clearly designed with certain orthopedic peculiarities in mind: he sat very deeply in it, almost *within* it, as if it were his exoskeleton, and it propelled his bent legs high into the air. Comical as he appeared like this, it might have been the only way of getting the old man's torso perpendicular to the ground, like that of any ordinary man. If *I* were to have sat in that chair, for instance, I would have been staring straight into the lights. He, though, could now see just what was coming—no craning back necessary. Some of the agony seemed to have come out of his face, and indeed some of the years. Maybe he wasn't so old after all, just the victim of a congenital deformation.

My gaze shot to the edge of the stage. Every time I refocused on other aspects of the scene, it seemed to occur just this way: by dramatic movements of the eye. There, right alongside Daphne, was the other woman, who'd finally come out properly into the light. She was tiny, perhaps younger than Daphne, and with much longer hair that was nearly Asiatic in its straightness and tone. Yet she was dressed just the same, in wispy cotton garments somewhat out of time, so that the pair of them put one in mind of sisters (although the blonde's bleached hair made things odder, I'm not sure what it signified). Without the common index, the face, to hold the attention, emphasis was thrown onto their bodies, which seemed to have moved further upstage—though of course they'd never taken a step; it was another trick of the light. This was clearly a theme tonight, the relation between frame and subject. If there was one thing that struck me as genuinely ingenious here, it was this living light. Now the women drifted deeper into it, but this was genuine movement: they were closing in on the seated sage. Daphne's partner glided so fluidly forward, with tiny steps beneath her billowy dress, that she moved without seeming to, like an apparition, making Daphne appear ambivalent by comparison. Together they crossed the midline of the stage, and from upstage on the left, someone new passed by the tightly-clad, undifferentiated figure and descended quite far into the light, with small, forceful footsteps: a young man in dark trousers and a well-fitted button-down. He wore boots, though, and if he'd had a hat you might have thought him a cowboy.

But I took him for a musician straight off, owing to the hard-shell case he held that seemed suited to a guitar.

My pen had been working quickly upon the page for some time now. I was doing well with it all, charting the flow of forms, the flow of the frame itself—the light— all to my neighbor's rhythmic respiration, which I was intermittently conscious of, whenever the music lulled. His breaths were neither erratic nor labored, but always deep: each time he was done filling his lungs, I'd already exhaled. It was unnerving at first, sitting abreast of this cold-blooded man. Ever since he'd put away his phone, I had the peculiar sense he was studying my drawings as they came into being. Of course this was impossible, the theater was far too dark; I myself couldn't see the drawings and they were right there in my lap. But impressions only sometimes an- swer to reason, and over the years I'd learned not to force them into conformity with it, only coax them into accession when possible. So I permitted myself this conceit, this departure from reality, to fill my being as I drew. I imagined freely that those thick-framed glasses of his, which I'd caught glinting in the light of his phone earlier, must have given him rare visual powers; and eventually, as my pen and his breath intertwined, I drew as if he *were* actually seeing and evaluating what I put to paper. Rather than generating anxiety, this fancy of mine smoothed my strokes, gave them new assurance. I felt much as an actor does: skittish and fussy in rehearsal, where the stakes are nil, and fully fluent only during the show, when failure comes alive as a possibility. An appraising eye can drive a performer to a steady stream of choices made without hesitation. Missteps are unavoidable, of course, though nearly *any* choice, taken cleanly, without too much niggling, yields more profit than persistent deferral and equivocation, and indeed can elevate what might have amounted only to a painstaking fidelity to something true *enough* into a seamless imagining faithful only to itself. Self-confidence, it seems, can be easiest to find when you're on trial.

On several occasions I thought the man actually might have whispered a few words to me. Whether these were only imaginings I don't know; once you begin to let go of the world, you can't really say what's left of your grip. Although generally steady, there was, I realized, a noisiness to his breath: wheezy harmonic notes in- duced by minute variations, accelerations and decelerations, crescendos and dimin- uendos, in his manner of inhaling and expelling air. Add to this the frequency with which he cleared his throat, the occasional ferocity of it, in fact, and you'd have to say he had a terrible smoking habit. It would explain his grizzled appearance. Amid all these noises, though, sometimes I felt sure I heard words, specifically remarks about what was materializing at the tip of my pen—*complimentary* remarks: *oohs* and *aahs* and *yes, yeses* and *right, I sees.* Paranoid delusions, we know, tend the other way; I was grateful for the aberration. It freed up my hand, and I began to whip the

pen around like a tennis racket, striking winners at will. I'm sure the performance itself played a role in deepening my hallucinations. I wondered who else around me in the seats was also seeing things, and if their visions were anywhere as productive as my own.

Of course, none of this exactly acquitted the man one seat from me, nor did it promote any sort of trust between us. Why, I wondered, should he be encouraging me in this way, given the plain truth that he couldn't have seen anything at all of my drawings? Granted, *I* had some idea of what was there on the pad, but that was through kinesthesia, an unshareable experience of the position of one's own limbs. No, I thought, all this positivity must have been delivered at Garrett's request, to entice me to carry on with a project that was hardly sure to succeed, in part because what exactly I was participating *in* was still so obscure. I looked down into the darkness of my lap. I was trying not to capture too much in any one sketch: in conditions this unusual, you'd arrive, for all your exertions, at a garble of lines that added up to something less than nothing. Maybe the whole page would come back solid black.

Whatever the man may have been whispering to me, the two women, still faceless, were the first to bring language into the play, twenty minutes after it had begun. But they spoke simultaneously, so that, aurally, you were still squinting: *Just what are you bringing?* I was reasonably sure the blonde, Daphne, said this, though her voice startled me, as it didn't mesh with what I'd heard in *The Sort*. Here her tone and cadences were less quizzical and anxious, and more forward; and while her speech remained profound-ly feminine, it was also mildly repellent, perhaps for lacking any hint of the erotic. Eros, of course, was the only sort of desire or force men happily ceded to women, even while scorning them for relying on it; anything else, say, desire *simpliciter*—desire without wiles—seemed somehow sinister, even in an otherwise unremarkable snippet like this: *Just what are you bringing?* What could I carry of this aural aspect into the visual realm? Plenty, it seemed. How many times had I drawn a scene that was intrinsically silent, and then come to rather different results when I imagined the same scenario animated by sound? Though I wasn't especially musical, my ears, I liked to think, could sometimes deliver to me the same vividness as my eyes.

As for the longhaired brunette, what was it *she'd* said? *Is this for me?* That might have been it, I couldn't say. I know that she spoke somewhat indistinctly, her syllables being less precisely shaped than Daphne's, and with the indirection that made her more familiar as a woman. Which is to say, as a child. Hers was recognizably that singsong tone, the one so many women shielded themselves with in adulthood, and then, if they were lucky (and shrewd), turned to great profit, the shield's edge becom-ing a sword. And the brunette's question, if that was in fact her question—*Is this for*

me?—was precisely the question of a young child. She'd not indicated an object while speaking, just a generalized *this*. With an adult, with a man, you might have deduced she was referring to the cowboy's hard-shell case; but with a child you can't assume this. So it was with this girlish woman: her *this* could have meant the entire scene, or the carefully shaped light, or the old man's curious chair. A child has the distinct power, and it is a form of power, of sensibly posing such ambiguous questions. You can't be sure exactly what is intended by them because you can't say to what degree the child's grasp of language, of convention, of *appropriateness*, has solidified yet. This is the great privilege of youth, and many try to extend it right into adulthood. Artists especially. Actors, perhaps, most of all.

Having let them speak, the musician responded—if it was a response—by dropping the case onto the stage. It fell with the bang of a drum, heavy and dull. Yet no heads turned, no one seemed to notice. Did any of these people exist *together*, in the same space or time?

"My life," he declared eventually, this musician, but in a manner that stripped his words of portentousness or pregnancy. It was merely a fact for him. The blonde, who in comparison to the small-made, childlike woman beside her seemed strangely mature for one whose *physical* form still bore the imprint of youth, appeared incredulous at his pronouncement.

"An instrument," Daphne either said or queried. *Some* kind of channel existed between the two of them—and the old man, perhaps him as well, given he was chewing syllables now. In the event, the musician-cum-cowboy didn't respond to Daphne; he didn't seem to hear her at all. A one-directional channel, then, like mirrored glass? He traced his way implacably, imperturbably, downstage along the left edge of the light, unburdened of the case, while Daphne wheeled around, down toward us in the audience, to keep him in her sights. With this, the blonde had given us her face. And yes, never mind the new hair, it was *her*.

Finally, I flipped to a clean sheet and began charting Daphne in the flesh—the lights must have been brighter now, or maybe I'd just made a profound adjustment to the dark—while her sister stared off away from us, toward the androgynous figure, indeterminate in most ways (what race, even?), who said and did nothing, remaining a cipher. "Here?" the longhaired woman said. Again the referent of her question was inscrutable: was her *here* the same *here* as anyone else's? Daphne, without turning back, touched the tips of her fingers to the girlish one's shoulder, a gesture too distant to give succor but sufficient to convey that, yes, she was listening. The girl turned around and now both of them faced the audience.

Meanwhile, the musician—I felt sure he was more than that now, a sort of troubadour, maybe, though he'd offered no lyrics, not yet—the musician reached the

front edge of the light, which was in fact a few yards short of the edge of the stage. Just how many yards, at this point, was unclear; the light had been shifting so much. For a moment the man hesitated on the brink of darkness. Daphne and the brunette peered toward him from center-stage, and you knew by the direction of their gaze, the slow back and forth of their swiveling necks, and, finally, the placement of their hands as they shielded their eyes from the light, absurdly so, as if there were a noon-day sun and a great distance separated them from the man—you knew they were searching for him, or for something *in* him. The man himself, though, was looking only toward us, *through* us, weighing his choices.

Daphne didn't look much older than her sisterlike companion. Their faces both had a girlish aspect, as well as a sharpness of form gifted only to the young. The lines of the human figure inevitably lose a certain crispness over the years, in deference, perhaps, to the inevitable fraying of the spirits; though something about Daphne's posture, perhaps the way she thrust her hands slightly forward, as if at the ready, suggested a kind of preparedness, a maturity, which the other woman seemed to lack as she clasped the long pleats of her dress.

I played with this thought as the chamber orchestra—the one I imagined, any-way, deep in the shadows—returned to its *pianississississississimo*, so that that strange polytonal music was barely present now as the young man stood in contemplation. A *new* music, a sort of delicate drumming, filled the amphitheater: I turned toward the source and there he was, Garrett's man, tapping at his phone again. His broad screen—how much bigger would these devices get before customers balked?—was a brilliant white field with writing at the bottom and fresh text beginning to form along the top as his fingers pattered. Replying to an email right now? At a show *built* around the rationing of light? I looked up at him in the white blaze he'd created and I could see, in the halo cast, muttering patrons turning toward him. And though he must at least have *heard* them, he never once flinched; he just doggedly thumbed the screen. What could be so important to communicate that it was worth being up-braided like this? Certainly this languid production left me ample time to speculate. Perhaps, I considered, he was Garrett's regular assessor, sent to each performance to be attended by Antral staff, to keep tabs on which members did indeed show up and which merely lied about it. Or was he here to assess the merits of the event, whether it was worth including as part of Antral's education program? His presence could even be a one-off, I realized, and he was here simply to take the measure of Daphne, a proto-star of our proto-campaign. But then wasn't that why *I* was here? Could that mean he'd been sent to provide an independent check on the quality of my results?

I thought that his eyes, in the screenlight, might give away something of his intentions, of what he was typing out, but I found it impossible to see them through

the glare thrown by his glasses. Eventually, he finished with the phone, although he left it in his lap this time, ready to report.

"Your life?" both women called after the cowboy-troubadour on the precipice of darkness, but only one of them, I couldn't say who, inflected it as a question and not a declaration. At the same time, and possibly as an effect of these words, although causality in this play was obscure throughout, the musician, apparently having made whatever decision he'd needed to make, carried on sharply downstage, toward us, into the darkness. And as soon as the man crossed into shadow, the old giant stopped muttering, and the women stopped searching. He'd crossed, in fact, just where the little girl, at the opening of the performance, had done so. Was she still there *now*, in that blackness? Had he gone looking for her? Or would any encounter between the two from here on be a matter of chance?

"You're sure?" the blonde said, though I couldn't know to whom she was speaking—perhaps to the musician now absent. The little woman by her side lost interest at that point, almost the instant the man left the field of light, evidently the boundary of her attention; she turned toward the old man, who was rising with difficulty from his skewed chair. Because of his great hunch, and the fact that his legs were actually rather short, he was far less fearsome once he was on his feet. He shuffled ahead, leaning over his feet, concealing without choice his true proportions. His frailty completed a visual contradiction: a crumbling giant.

Daphne also turned around to face up to the old man, who appeared to be tumbling forward in slow motion, and I was struck, as I would be many times over, by the simple rightness of her movements. Even when they were ungainly or awkward, within a role or outside it, as they could and would be sometimes when she would try to make a particular impression on me through some species of ineptitude—there were endless ways of playing dumb, for instance, the kind her companion was playing tonight, through her apparent incomprehension, which was merely one type; but there was bodily dumbness, too, and sometimes this is just what one wants to project, a kind of discomfort in one's own skin, as we say—even then, Daphne's body, clumsy as it was, seemed to move the way you felt it *ought* to. In her you detected the great variability there can be in our expectations of others' movements; whereas for most of us, the bottleneck on this kind of kinetic expressivity manifests in the rudimentary quality of our body language. We certainly don't all speak it with the same fluency, or follow the niceties of its grammar. Some of us are worlds apart, and it takes people like Daphne, true savants, to illuminate our deficiencies.

The woman who would rather be a child turned away from the old man, bored, it seemed, and clearly unattuned to any wisdom to be found in his mutterings—he certainly *looked* the part of the sage—and began to twirl her impossibly long hair,

straight as can be, taking up big fistfuls of it, totally unconcerned by the giant's approach, his tragic shuffling dance. The grimace had returned to his face since he'd rolled himself out of the chair, swinging back and forth until it turned far enough forward for him to slip out. His blousy shirt no longer flowed much, its drape stifled by the same sweat that shone on his forehead. None of this troubled the small woman, who was back to staring off at the spot where the troubadour had disappeared. The giant, limping along like that, wasn't going to reach her for quite a while still. His real concern, for all we knew, might not even be the women. Who could tell from his almost-words, which might have only been the noise of his lungs straining?

"He's ready," the brunette said to Daphne (possibly?), who pulled on her arm but soon gave up, seeing that the little longhaired fool wasn't going to be diverted from her visions of the vanished man. Daphne hastened toward the panting, grumbling sage at three times his pace, in strides sure and quick. I too was scudding along, crowding one sheet after another with impressions of everything, relishing the newness of seeing both nothing of my drawing and hardly anything of my subjects, merely hoping that *something* of use, across all these pages, was being picked up—especially some sense of Daphne's weight in the world.

"What is it you need?" the blonde said as she reached the old man, attending to him with a sternness permitted by familiarity, history. "Sit," she said, "I'll help you," with a patience not yet tried beyond its limits. It was as if she could decode his complaints. It seemed to me doubtful he had much interest in returning to the chair, even if he'd hardly managed to move beyond it. He reared back at her words, briefly straightened his gnarled spine, flashing his true height before being forced back down by the pain that was behind his grimace, so that his face, which was relatively small and mean next to the scale of his body and its presumably epic past, ended up near hers again. Daphne tugged at him as she had at the small woman, but his slow progress couldn't be arrested, nothing could drive him back. He seemed to be limping straight through her, and in the weak light their forms merged into a mess of limbs.

One bit of clarity had been achieved at least: it was the troubadour's black box that interested the old man, not the women. I wondered why it had taken me so long to consider this possibility, since the case was in fact *closer* to him than either woman had been when he first rose from his throne. It must be, I thought, because I understood the giant to be grinding on with a blind animality that had survived the dissolution of his mind, so that he didn't have the capacity to "take an interest" *per se*. And it looked as if Daphne, or rather her character—no one onstage tonight had names, so it was easy to think of the blonde under the actress' name—it looked like Daphne had made the same assumption. Actually, the giant was more alert to circumstance than this. For one, he clearly found her a nuisance, and began

taking more urgent steps, even *strides,* if one was feeling generous, toward the box. Daphne didn't stand in his way. She was looking off-stage, like her brunette sister, in the direction of the vanished troubadour (why, though, wasn't anyone looking for the little girl lost to the dark?), while the old man made more reasonable time now, no matter that his great size still made his strides look comically cramped.

Light abruptly disturbed me then: Garrett's man was back at his phone, and now he was going at it brazenly, typing so sharply his fingernails clacked against the screen. Theatergoers right around us were exasperated, no longer bothering to mask their indignation. As if in response, the bearded man turned to me with a smirk, daring me to do something, say something. But he didn't linger. He was firing off another dispatch on me, or Daphne, or the absentee employees. I nearly walked out there and then, but decided to remain once he'd put his phone away properly, in his pocket. I drew a deep breath to steady myself before returning to the task at hand: sketching the giant towering over Daphne. I left out of frame the object of his obsession—the black case, or whatever it was he saw in his mind's eye. The drama onstage, to the degree that there was one, certainly centered on the case. All lines of dramatic force converged there, yet its contents would never be known to us. When a key was finally put to it by the blonde—by Daphne—only she gets a look inside. At that point, the vanished troubadour, or really a precursor of him, since the actor who came into the light from the darkness was somewhat younger than the original, yet still recognizably *him,* and not merely because of markers like clothing but because of a genuine physical resemblance (the actor's younger brother?)—this younger version of the troubadour was suddenly put under intense light, sitting on a stool and very soon facing away from us, and still dressed in the rough manner of his older self. His only company was the jarringly incongruous instrument he began to play, and play poorly: a bassoon, more befitting the men in tuxedos consumed by the shadows everywhere around this beam of light descending on the troubadour. It was ugly, out of tune, a little absurd, and it was the only music left. The ever-present concert music, so faint, so gently atonal—redolent of early Schoenberg, in fact, as if nodding to Dumas' film—had given way to a silence that this out-of-place man filled so terribly.

The case, I thought, would have nicely fit just the bassoon he played; but wouldn't it have equally fit a sniper's rifle, disassembled into its components? The notion wasn't so odd: it would explain the man's dress, in particular, his heavy boots, which had a military aspect to them. Here was another idea further down the same line, and with strong contemporaneity: an improvised explosive device. Wouldn't *this* explain his hasty flight into shadow earlier, and even his hesitation over which direction to flee after leaving the thing at the center of the stage, with a maximum radius within the light?

Ultimately, there were too many possibilities to sift through. A narrative-conceptual relation with "The Pied Piper" was being forged, I knew, but I never puzzled out exactly what that relation was supposed to be (had Volger?). For this reason, *The Vegetable Gender* registered as something closer to dance than to theater—a sort of prose dance, though, as the performers' movements had a plainness to them, notwithstanding the quasi-allegorical setup. This fact distanced the work from anything like dance of the more self-consciously lyrical sort, and the allegory was only allowed to peak through the formal elements of movement and light here and there, in a rather unsatisfying way. For one thing, the small child, I was sorry to see, never returned. Her one minute at the start was an *excruciating* red herring. Perhaps one of the other women was meant to be her reincarnation; or the vanished man, depositor of the case, might well have discovered her in the dark.

Daphne's dialogue remained sporadic and banal to the very end: everyday phrases, assertions, and questions taken out of their quotidian contexts. It was, finally, the plainness of the language (if not its use) and the ordinariness of the characters, excepting the giant, that kept things from tailing off into the surreal, where dramatic stakes are lowest. This work struck me as embodying a quite robust realism, but with gaps in it; and it was these gaps, in dialogue, in action, rather than anything intrinsically fantastical, that made the production resistant to conventional interpretation. Strange: you attempted the usual sorts of psychological readings appropriate to narrative drama, but then, finding yourself more or less thwarted by the lacunae riddling the thing, you switched over, without even noticing it, to a more sensory-symbolic hermeneutics, the sort of thing one deploys in fathoming, say, kabuki.

I was already aware, from *The Sort*, of Daphne's startling powers over the eye. The shortcomings of *The Vegetable Gender* stood no chance of dimming those intensities: the way she emptied herself, became a body of simple sensation operating mostly outside the bounds of literary sense, within an arena of arational cause and effect. Whenever the action of the play ran through her, you could almost forget that there were any gaps, that *anything* was missing. She became all surface, shunting her entire self into her flesh without remainder, and the effect was so potent that near the finale, when she opened the case—the old giant had secured the key in a screaming match with some sort of Arab nomad whose time onstage was severely crimped and whose relation to the rest no one could have determined—both she and we, the audience, were barely interested in seeing inside. She peeked half-heartedly, shook out her hands as if they were stiff, and, without a word, simply walked toward us, like the musician before her, and the child, too, straight into the black.

The whole show was over in just forty-five minutes, though some of us would have surely headed for the exits if it had gone on any longer. Almost all of it occurred

either in half-light or absolute darkness, save the last five minutes, which occasioned spasms of brilliant light illuminating the whole of the stage. Everything froze at those moments, the orchestra, the actors, except for the incompetent "playing" of the bassoonist. I never got a clean look at so much as the outside of his black case, for even the lights, when they finally arrived, were blinding. Each time they rose and I studied the black box, it seemed to have moved elsewhere, as if handled in the dark. And each time I probed for insight there, hoping my eyes wouldn't give out *this* time in the overwhelming glare, I neglected to explore, in the heavy glow that hung over the seats, the source of my *real* concern—Garrett's man, still stinking of rose (it's surprising what you can come so quickly to hate).

As I realized my oversight, the show headed for its close. Just before everything went white for the final time, we were left with a tableau: the blonde kneeling beside the brunette, who stood there mute and stupid; the bassoon discomposed into its elements near the foot of the stage, with the musician long gone, as were the trans-human and the Arab; and the old giant still enduring, even if he'd collapsed in a heap next to his chair.

We were, actors and audience, buried in darkness for some time before uncertain applause rippled through the seats. We ended up clapping in the pitch dark, long and loud, mostly, I thought, to mark our imminent return to the world and the end of the night's privations.

Yet the light—it wouldn't come back.

18

People can spend only so much time in the dark, even at the theater. With no sign of light yet on the horizon, an authentic disgruntlement broke out in the seats, although the bearded man next to me seemed as calm as ever, casually typing away at his phone. I knew we'd reached the end of the production: the bassoon was now in unplayable pieces. Music having been at the very heart of *The Vegetable Gender*, the dismemberment of the last remaining instrument told me there could be no more melody, even if three of the actors had remained on-stage in gnomic postures, with the play's action unconsummated, and all speech defeated—indeed, all sound. The giant was resigned to his dying.

Lights of a startlingly *ordinary* brightness flickered on and too quickly restored mundanity to proceedings. I'd been right; that *had* been the end. I sat for a while, breathing deeply, rubbing my eyes, shaking out my drawing hand. By the time I'd finished rousing myself this way, and I looked back down the row, the rose-scented man had managed to slip away. I'd been playing with the idea of conspiracy tonight, yes, but not putting serious stock in it. It was all a harmless delusion that would be resolved after the show, I assumed, when I'd find out that this man hadn't actually known the first thing about me or Garrett. But now, in his absence, I was left to consider.

Patrons had risen from their seats, and while a few looked poised and nodded meaningfully, most appeared bewildered. If you'd come tonight expecting theater in the ordinary sense, where narrative intelligibility had primacy, you were going to be confused or irked, because what you got was something more like visually sculpted *form*. In sensory terms, I thought, there was actually a *surfeit* of meaning on offer. But here it couldn't be peeled away from its experiential embodiment, from the story inhering directly in the positions of figures in space and light, the sounds enveloping the audience, rather than in the meanings of the words that fell from characters' mouths. I would be sifting through these sensuous details for the rest of the night, I knew, and for some time after, too. Yet *this* kind of significance didn't lend itself to commentary, which explained the bemusement I saw around me. I don't really think anyone knew quite what to *say* about what they'd just seen, and, for most, post-show discussion was the very point of going to the theater. Plays that left you at a loss for words were bound to be a problem, no matter how sensorially profound they might be. I, of course, was hoping I'd discovered with my pen just this sort of

intelligibility in things and the cascade of event that others were evidently failing to find with words. I could have checked right away to see if I had—my sketchpad was still there in my lap—but I knew that if I'd fallen short, it would only spoil my mood, and I had to preserve my spirits, since my job hadn't yet come to an end. I'd not met Daphne yet, of course. Garrett *had* asked that I try. And anyway, didn't I want to?

The stage below me filled from all sides with a medley of crew and audience. Yet I didn't see anyone from the cast, including Daphne. Just beyond the spot where the front edge of the light had roamed during the show, two refreshments tables sat end-to-end: heirloom tables, thick slabs of dark wood propping up the usual rows of red and white wine, green beer bottles, and clear plastic cups. This setup would have been there the entire time, during the performance, just barely out of sight, waiting for this after-show mingle, which seemed to be picking up speed, as people getting over their dismay or disappointment mixed on-stage with members of the crew, whom I could see were decked out in black tees. Soon enough, it was all clinking plastic and laughter; you wouldn't have suspected the strain we'd all just been put under.

A pair of exits for personnel featured at the back of the stage, and it was just there that I caught sight of that distinctive throb of blonde hair; it was almost white in the light. And then that long, gaunt face, with a nose tiny and crimped, the one feature of perfection I'd noted from Dumont's film. Daphne wasn't speaking with anyone, though, or sipping a drink. She was making for the exits with purpose, and she'd be out of sight in seconds.

I scrambled for the aisle and nearly tripped over a long, mustard-yellow scarf tangled with the seat of the man who'd fled. A bit warm for such an item, I thought, but the wind was beginning to carry a nip in the evenings. Finding it here actually gave me new hope. I peered up at the hall entrances through which I'd come and searched for the patchy beard and those inelegant acetate glasses, which were both unfortunately too common around here: at least four people sported a look like his, up near the doors and in the aisles. When I looked down toward the stage again, Daphne was gone, though I saw one of the exit doors, gray metal with a long bar across it, easing shut. I glanced back up once more, at the four lookalikes—now there were six—and collected the scarf, wrapping it around my hand as if making to punch someone while protecting my knuckles. Let *him* find *me*. And if he never got this pretty swatch of cloth back, well, it would be recompense for viewing my pictures over my shoulder, uninvited.

I cut down the aisle at a gallop, shouldering through the crowd to catch up with Daphne. On my way, I twisted the scarf around my neck as bait for the rose-scented man, who would very likely be looking for it: though it was faded and frayed, it was so fine between the fingers I had the feeling it was something more

luxurious than cashmere. Vicuna, maybe. Its shambolic state might also soften my appearance some, turn it more bohemian, which would help with this crowd, and probably Daphne as well.

When I reached the bottom of the pit, the light had more strength, but then it was also harder to see over the milling people. One man was in fact easier to spot from down here, because if you looked up, above the crowd, there was only one head, one face, located on this plane, and that was the old man's. But he wasn't old anymore. He had no sign of a stoop either, and he might have rinsed off his makeup, as the pallor was gone, too. His age had been an act skillfully realized, and the contradiction I'd felt between the giant's infirmity and his size must have been driven by the ardor of youth radiating from beneath his makeup and modest clothing. That said, just how much virility the actor really had was an open question. This younger version, somewhere in his thirties, was every bit as morose as the old giant he'd played. Really, there was only slightly more cheer in him now than in the dying moments of the show. This subdued quality in actors, once they'd finished playing their parts for the night, didn't strike me as all that uncommon, though. Men and women in this trade were congenitally hyperactive or apathetic. I'd not met many in New York or California who were anywhere near the center of the personality spectrum.

I pushed through all the people onstage, navigating mostly by the young giant's face there above the crowd, although, when his head went out of sight due to the angle, I used the cup of red wine in his hand, which he sipped in a manner that suggested he was perpetually rediscovering it to be unpalatable. For a small moment, a fissure in the crowd, which led all the way to his feet, opened up. It must have lasted half a second. Yet in that transient corridor, I noted, with real relief, that the one making the giant's head bob somberly was none other than Daphne. She spoke *up* to him, wearing a sardonic look that didn't suit her. I squeezed into another shaft of space, oriented almost perpendicularly to the first—these lanes were opening and closing around me all the time—and glimpsed another cast member, one of the two actors playing the troubadour, who I continued to conceptualize as such although not a song was sung, and the bassoon anyway was no instrument for vocal accompaniment. What, in the end, did I owe the truth? The passage closed too quickly for me to be sure whether it was the troubadour's older or younger self who was coming back in through those exits at the rear of the stage, dressed in jeans, with his hair wet along the edges as if he'd just scrubbed his face.

I pushed on toward the giant and his plastic chalice. At least three times he glanced at me as I waded through the crowd. I don't know if he understood that I was steering by him, but he showed no interest in my approach. Eventually I broke through to another clearing and discovered, to the other side of him, at least a head

shorter than he was, the interloper—the Arab wanderer—the one who'd ceded his key to the giant. The play had asked us to see this Middle Eastern man like this, as the foreign body that literally held the key to the territory: a sentry or scout, maybe a roving knight of the Levant. There was also a new man in the vicinity of the giant and the Arab. He was small and unimpressive, I thought, narrow-faced, with little in the way of a jaw. He would have been better served by a beard, no matter how ratty, while his near-black eyes would have benefitted from being set deeper into his skull (there were surgeries that could accomplish this) rather than clinging to the surface of his face, giving him a permanently bedraggled look even when he affected haughtiness and self-satisfaction, as he did now. His lack of physical distinction extended to his attire: the billowy shirtsleeves he was swimming in, giving his body a massless aspect, and blue trousers with very wide cords that had the look of art-school upholstery.

This man was busy *not* shaking hands with the theatergoers who were congratulating him on the production. The throng had overcome their consternation and come around to the play, doubtless aided by the open bar and the chance to connect not only with the cognoscenti of vanguard theater, but with *The Vegetable Gender*'s prime mover: Nikita Volger. This was him. In response to the plaudits directed at him every half-minute by someone new, he would nod or curtly wave, pointedly refusing all handshakes and hugs. He did embrace one thing: a small crimson flask with a stitched leather stopper, which he alternately caressed and furtively swigged from, shifting his eyes this way and that. This discretion was absurd, of course, no one could have missed him, standing there in plain sight. A reflex from years of sneak drinking?

I checked back on the giant and found him warily eyeing me. Perhaps he'd not appreciated my sizing up his boss. Before things could take a paranoic turn, I put on a quick tight smile, walked right up to the oversized man, and asked without guile about Daphne's whereabouts. His pale face hardened. He'd heard this question before. He leaned down low to whisper into the ear of the Arab. They made a motley pair, one the patriot, one the enemy, but now thick as thieves. The Arab smiled conspiratorially and looked me over slowly, even lustily, I felt, before tapping Nik on the shoulder. The director didn't seem to appreciate such handling. He shot the Arab a look that read as a warning and a reminder. Still, once the question had been conveyed to him, he recovered well enough. All three of them began to laugh in a muted sort of way, and the people still trying to get a word in with the director laughed as well, rather too theatrically, I thought, as they couldn't have heard the question and had no inkling what was funny about it.

"Oh, well, she's gone, of course," Nik said, though I wasn't sure to whom he was speaking, as he quickly turned back to the crowd to refuse more praise. This was his

bit, his pleasure, and I was interrupting it. As had our wandering Arab. Nik was done with both of us. I might have been annoyed with the director's dismissive words had they not come wrapped in a mid-Atlantic accent that diminished him even further in my eyes. He had that disheveled Slavic look about him, which lent him a certain gravitas by putting you in mind of the great Russian tradition, not just drama but also fiction. He could have been a Dostoevsky character, and not entirely by accident; he seemed to have attempted to mold himself into literature. Yet his accent betrayed him. He'd clearly grown up in the States. Probably he was second- or third-generation American, at best only the *great-grandson* of one of those titans.

I turned to the Arab, who winked at me before looking up at the giant with a tentative smile, as if waiting for me to leave. But I wasn't finished yet.

"I *just* saw her," I said. "I saw her hair, actually, from over there." I pointed back up to my seat, or where I thought it was, anyway; a sea of them rose up like a wave behind us, disorienting me. "She can't have gone far."

"Oh," said the giant, "but she never, *ever* stays." His cadences were twitchy and clipped and bathed in neurotic insecurity, which struck me as comic, coming from a pituitary case like him. "Why do you need her, anyway? Who *are* you?"

Introductions were made. The Arab and the giant began by telling me what I already knew, namely, that the man with the crowd around him was the director, Nik. They went on to name themselves: Sikah and Hank.

"How exactly do you know Daphne?" Sikah said with put-on poise. He kept looking at me as though he were a pimp and Daphne were one of his girls. If I played my cards right, his tone suggested, he might be able to find work for me, too. I considered, just briefly, tearing the tiny gold chain that hung from this shifty Arab's neck.

"I'd been told," I said, "by a friend of hers, a family friend, to say hello if I could."

"You know her through a *family* friend?" Hank scoffed. He and his colleague looked at me dubiously, clearly suspecting I was just one more overexcited metropolitan looking to get close to a dramatic principal. I sympathized, in a way. Almost everyone who entered the world of the stage, whether as a viewer or a performer, was slightly off. That's why I'd refused to go to the theater with Claire, preferring the movies on our sofa where I could be at a safe remove from people of their ilk.

"Daphne doesn't *have* family friends," Hank whispered coldly and angled toward Sikah, as if that should be the end of it. The giant seemed to tune me out instantly, the way professional actors will as soon as they're off-duty. Yet his Arab friend continued to study me, especially my fitted suit and ragged scarf, as though our intercourse had some distance left to go. Perhaps in a bedroom. Sikah's lasciviousness, I soon realized, had the unwelcome air of the intellectual about it: you couldn't find any raw kink in his mien, the kind that might actually appeal, just self-conscious titillation, which

made you hope, one day or night, he'd be given more than he could handle and left in a pile by a true sexual sadist. Maybe that would make him finally quit all his playacting and accept which side of the line he was on—the effete and not the carnal. He had a peculiarly bony face, and a bony body to boot, with a freakishly defined collarbone. His knowing eyes darted around after long stares, as if to demonstrate that nothing was beyond the ken of a mind so alert.

Taking all this into account, Sikah's hypnotic entrance onto the stage this evening, with that tiny key hanging off the chain that was still around his neck, was probably his bread and butter: he seemed like he could exist very comfortably on the city's circuit of advanced theater and performance art. Hank was different. Despite his perversely elongated body, he seemed somehow more ordinary than Sikah, his patent neuroticism being routine among mainstream actors. He was talking shop quite enthusiastically with the crew and cast, displaying an earnestness that seemed charmingly out of place here: the Broadway character actor amid radical performance artists. Yes, as I meditated on him I began to see that he, not Sikah, was the real interloper in *The Vegetable Gender*. Ever the professional, Hank had no time for chit-chat with a stranger, whereas Sikah could take a fugitive interest in me, at least for a while. And so I felt his gaze pass over my shoes, my watch, my tie of rust. If I were to learn anything more of Daphne, I'd have to settle for speaking with this one making eyes at me. I turned to face him directly.

"Where do you think she might've gone, Sikah?" I asked.

Apparently he'd assumed Hank had stamped out that topic of discussion. Sikah's ethereal smile withered into cosmopolitan hardness. Yet before I could say anything more, I felt a sharp tug from behind. I nearly fell backward as the scarf began to cinch around my neck. The bitter Arab's eyes glinted.

"You really think *this* suits you?" someone snickered from over my shoulder. Finally I slipped out of the noose and spun halfway around, gasping for breath. Those glasses, that beard, the rose in the air: it was him, smiling, the yellow strip of cloth now dangling from his hand like a whip.

"I really did *think* that was yours, Jeff," said Sikah. "Put it back on. You look naked without it. And you just wear it so much better than *this* one." He glared at me showily.

Jeff started tying the scarf around his neck in an elaborate knot, all the while delivering to me the flattest of stares. It *did* suit him better, I had to admit, its frayed edges and fading colors smoothly integrating with his blazer and jeans. Still, it was too hot in here to wear a scarf as anything other than an affectation. When he'd finished primping, his empty eyes returned to life. "How did you all like the lights *tonight*?" he nearly shouted, making Hank and Nik turn to him.

I found it remarkable that Jeff had nothing more to say to me—I who had, as far as he could tell, outright stolen his scarf, even if I'd mostly done it to get him to reveal himself to me. Perhaps he simply assumed that if you leave something lying around, someone's going to take it home with him: on another night, *he* would be the one lifting someone's orphaned scarf. This was the city, after all.

"The lighting was fine," said Sikah, "just like the last night, and the night before that." He rocked forward, held out his long thin arms and lightly embraced Jeff, stroked the back of his neck, ruffled his hair with his fingers. "Hank here just *fucked up*," he said, tapping the giant in the ribs.

Just like that, Nik turned away from his minions to face us. Only a barb about his work, I suspected, could get his attention on nights like these. He looked us over uncertainly and he drew his flask halfway from his pocket. He let it slip back into place, took a breath, and offered us a sardonic scowl, shaking his head with distinct notes of embar- rassment, irony, and just beneath that, rage, as though his Arab wasn't entirely wrong about the flaws. For a half-second, Hank appeared genuinely stung by Sikah's words, and when Nik signaled his general agreement, Hank's dewy face wrinkled up, giving us a glimpse of the old man he really would become. It seemed, then, he had reason to be morose tonight. He'd been off his game. Nevertheless, he quickly took the wince on his face and willed it into a funhouse frown, passing off his woundedness as merely show, although anyone could see his ruse. You'd think he'd not have tried it; it was so obvious and cringeworthy. We all had a little pity in our eyes at the sight of it, but the others less than I. They were performers, and make-believe was their trade. By this point they'd mostly stopped caring about deception, even the bald-faced kind.

It was the same with Jeff, who I gathered was their lighting designer. Did he have nothing to do with Garrett, then? I'd been sent reeling by this question ever since he'd tried to strangle me with his scarf, wondering what exactly his role was. Earlier I'd assumed that if he did come back for the missing accessory, my first task would be to diffuse his anger, proving to him I hadn't really meant to keep it. But he'd shown no anger, and I sensed that, unlike the giant or the Arab, he genuinely *felt* none. It was the most normal thing in the world to him—to steal. What was the point in even bringing up the incident?

Could he have somehow divined, however, my true motive for taking the scarf, namely, to lure him to me? That he might have deduced my eccentric flight from routine behavior toward something unlikely and far better suited to the stage—and that *this* might be why he wasn't angry with me—suggested that, in several ways, he might be much like the actors after all.

"Well," Jeff said, looking up at Hank, as everyone had to, and trying to soften the blow: "What do you think of the lights?"

"They were fine—*tonight*," came the reply in that skittish voice. "But there's a point in the show, when Elias enters, where they've been too low for the whole run. They're meant to brighten, isn't that Nik's idea? And finally, tonight, they did—"

"Perfect," Jeff said, sneaking a look at me.

"No, but it threw me off, that you'd actually fixed it. Try to keep it this way now. Because one thing I can say is that no one can do the whole *fucking* thing in the dark. Well, maybe your role, Sikah. Nobody with a *real* part." The Arab backed up and made his mouth into an O of mock outrage, though the perfect circle—the tongue twirling slightly within the wet hole—probably meant a few things. He grasped Nik around his neck, as if falling into his arms for comfort, and a palpable shudder of disgust ran through the director's body. Nik gathered himself quickly and sharply righted Sikah before turning back to his narcotic: his devotees.

"Why?" a voice whispered from behind me, loud enough for me and no one else to hear. I looked over my shoulder and there was the girlish brunette, belatedly replying, it seemed, to my questions about Daphne with one of her own: "Why do you need Daphne?" She sounded older than during the performance, yet not old enough to catch up with her manifest age, which put her, by my eye, in her mid-thirties.

"I'm supposed to work with her on something," I said. "Maybe." I almost kneeled, as if I were talking to a child; but I caught myself and straightened up, prizing her apart from her character. She was tiny, whatever her age. I stood to her as the giant stood to me, and so I regarded her in the same paternal manner. You almost couldn't help it, when addressing someone so much shorter. Hank's insecurities and inhibitions were all the more curious for this fact.

"Like what?"

How to put it? "It's a project for her... I don't know, a good friend of her father's?" How much secrecy could Garrett expect from me? I was surprised he'd not said something about it. It was bound to trip me up eventually.

"Someone *close* to her father?" Sikah was right there over my shoulder, caressing me around the hips, ostensibly in jest. I shot an elbow into his chest with just as much good humor and he backed away nursing his sternum. "Jeff, what do you say to that?" he croaked.

"Maybe she's got a *step*-father we don't know about," he replied with a trace of glibness.

"No," Sikah said, "I mean the one we know, the *father* father. Tony. You know him better than any of us. Who could get close to him?"

"Hmmm... Daphne *might* be close to him."

"Oh, that's not true."

Jeff adjusted his scarf a little and looked at me. "As close as you can be to someone like that, anyway. A lonely intellectual." Like Sikah and Hank, he was basking in all I didn't know. There was a faint hostility to his actions, his words, but I didn't mind. I *had* taken his scarf. Moral calculi have their complexities, particularly when applied to cases like Jeff's.

Over his shoulder I saw the troubadour-cum-terrorist approach. Gone was that thin linen shirt. The normality of the light was changing my impression of everyone, especially Jeff, along with my sense of the space we were all occupying, which was vast and towering, the ceiling being much higher than I'd imagined—and I'd imagined it quite high. But the troubadour: this was his older incarnation, supposing there really *was* a distinct younger version of him and his aging hadn't been simply an effect of costuming or makeup. A few steps off to his side, standing shyly and without a drink, was the play's inert, androgynous character. I'd almost forgotten it—my preferred pronoun for such persons, in lieu of barbarisms like *they*—this figure so inscrutable and universal, who'd returned to the stage just before the end of the show, almost as an observer, a stand-in for the audience. Even now, there was no way to tell what it was. Taken as a girl, she was good-looking. Rosy-cheeked, full-mouthed, with hair almost like the fur of a rabbit, she smiled blithely at me. Maybe she'd been observing my conversation with the rest of the cast. But when you drew together the weights of those features a little differently, leaving the emphasis on the sturdy shoulders and hard chin, there was also a handsome man to be seen. He too was smiling at me, of course, though my desires evaporated, even while my admiration for the person's form held steady. What wonderful versatility!

All this was knowable because of the clinical lights above us that reminded me of classrooms, this law school auditorium where many an exam would have been sat. Surveying the actors around me in one sweep, I could see plainly that most of their countenances had been simple imaginative fill-in on my part, the spontaneous hypothesizing the eye engages in when the world fails to throw light. Everyone in the audience would have done the same, though whatever they supplemented those near-silhouettes with, only they could say. They and perhaps their psychiatrists. It can feel like a cheat, a disappointment even, that the mind so eagerly draws on memory and habit to fill in missing details. But what would the alternative be? Perception riddled with absences? Tears in the cloth of consciousness, and with it the crippling anxiety of not knowing what lived in these fissures? Better to gloss over the gaps than to be confronted by your ignorance of so much that lies around you, when most of the time there's nothing you can do about it, no way of putting everything under lights like these and taking inventory. How easy we find it to adapt a previously vague portrait of someone or something to the more detailed picture we arrive at

later, and convince ourselves that *this* is what we'd seen all along. Only someone who'd had reasons to set down their vaguer impressions at the time, as I had tonight, in my sketchpad, would have to admit just how much those impressions had been the dreamwork of the eye, waiting to be massaged into shape by a fuller acquaintance with their object.

This was a datum of drawing I'd learned as far back as middle school: the viewer finishes every picture. Form and volume and color—in all these things he has a hand or an eye. This is why it doesn't pay, as an artist, to recapitulate all the finer details of a scene. You can push the viewer right out of the frame that way. A kind of deadness overtakes images of this sort: photographs, for one, which too often present a replete world without any need for the viewer and his creative powers. Lively and dead all the same.

Nevertheless, I believed the troubadour to be pretty close to my original vision of him from the seats, given how distinct an impression he'd made on me. His was a formidably masculine presence, though he wore it more lightly now, with the beat-up jeans he'd changed into and the mussed-up hair still dripping water from washing his face, which darkened the thin bright tie he now wore over his plaid button-down. He stood by Jeff and spoke to me without the usual self-consciousness of actors: "You're not the *artist*, are you?" He seemed genuinely curious. All the actors, even the director, looked more closely at me now. "It's just, the way you're dressed, it's hard to..."

"So then you *do* know her," Sikah said with briefly widening eyes. "I really thought you had to be some scion who'd ended up at the wrong play. Or else your fiancée had dragged you here."

"Oh, one of those wunderkind philanthropists," the childlike, middle-aged woman exclaimed. "Like what's his name. Chris Hills?"

"Hughes," Sikah corrected her.

She didn't seem to mind or to notice—she'd already moved on, evidently transfixed by my shoes. I didn't learn her name, not then. She was too shy to tell me, it seemed, and none of the others apparently thought it worth mentioning.

"We could use one of those types," Hank said.

"Though with actual style," added Jeff. He dusted my chalk-striped shoulders with his hands. "That's a *very* nice jacket." I gave him a hard look in return that he seemed to appreciate. "I don't know why you'd ruin all that with this scarf," he said. "You know, I thought you might have been a critic—for a little magazine from the seventies."

I was relieved, in a way, that they'd heard something about me. I wasn't going to have to tread quite so lightly and keep all things secret.

"Did Daphne know I'd be here tonight?" I asked them. "Was she told?"

The giant offered a frazzled shake of his sweaty head before I'd even finished asking. I think he shook that head a lot. *No* came naturally to him.

"I don't know about tonight," the cowboy troubadour said as he searched the crowd, not so much looking for Daphne as making sure she wasn't around.

"Even if she did know," Sikah opined, "I'm not sure she would have stuck around for you." I waited for him to explain but the wanderer went for a glass of wine instead—not much of a Muslim, it seemed—and brought back another for the troubadour, whose name, I discovered then, was Elias. Apparently Sikah had some regard for his colleague. The man was, I should say, handsome. Maybe they'd fucked at some point, or, if not, Sikah dreamt of making it happen, with enough wine.

"But Daphne did say she was going to sit for an artist, yeah," Elias resumed, while clinking glasses with Sikah and drinking deeply. He looked me over in a friendly sort of way, man to man, as he gulped. "Some sort of project."

Sikah made to drink from his glass, white wine to Elias' red, but paused to say, "I only meant, she's *shot* after these gigs, sick of humankind. Is that what you call a *delicate soul?*"

"I thought she said she had *movie* people to meet tonight," the woman interjected, trying, I think, to be helpful, unlike the others.

Sikah gibed.

"Maybe," said Elias. He seemed only slowly to be coming out of character. There'd been a stoicism to the role Nik had given him that wouldn't come off as easily as the makeup he'd washed from his face. In an hour's time, maybe, he'd be his old self, though I wouldn't be around to see who that was.

"*I* think," the old girl declared, "she could be an *actual* genius. I do." To emphasize the point she screwed her face up rather hideously. I had to assume she wasn't aware of the fright she could give like this, but then what sort of actress would she be, to be unaware of something so monstrous? She must have *meant* to give me that look—an even more disturbing prospect. "Is that why you're painting her?" she asked.

Hyperbole, I knew, was commonplace among the theater set. But Sikah, who consistently stinted on praise, looked on resignedly, without any of his usual quibbles. The woman's use of the g-word might then have had more substance to it than usual.

"*Could,*" Sikah said at last. "Exactly." Which only confirmed my feeling.

"Oh no, she is—she has to be a genius," Nik broke in after a long absence from the conversation, shedding several interlocutors and returning to our circle. "We *need* her to be." I got the feeling he'd been monitoring everything said by his flock, as leaders will. How long until other acolytes and hangers-on swooped in on him? This must have been a perennial matter of distress or pleasure after shows, depending on Nik's mood, or how things had gone that night—or how much of that flask he'd

managed to empty down his throat. As he joined us, he looked firmly, properly, at me for the first time. The alcohol had made him bold. He brightened, as if he'd not really seen me at all until now; perhaps he was wondering if I was some young and ambitious critic, or, given the way I was dressed, a member of a distinguished New York family. I thought he might introduce himself to me, but he didn't go beyond a nod. He was playing hard-to-get, or had changed his mind about my being a man of influence. At least the nod conveyed respect, I thought. Or caution. I'd seen none of either from him until now. "Daphne holds the whole show together," he said finally. "Did you notice that? We *wrote* the thing for her."

I offered no response; nor did I introduce myself. Disregard of this sort came naturally to me, frankly. I'd been told more than once that it was an odd quality of mine, this lack of interest in making myself known to those around me. I simply carried on, at most social functions, as if I were either already well-known to most, or perfectly anonymous and happy to keep it that way. Claire had delighted in this, my relative indifference to power, which, in the world she came of age in, was a treasure hoarded, guarded, stolen, or (grudgingly) ceded. Fortunately, before my lack of deference or concern could sour things with Nik, the giant's words caught our attention.

"The lighting—I've been trying to say, it was really perfect tonight. It has to be like this *all* the time, though." Hank was speaking to Jeff and some crew members several yards away, but he loomed so large above the others, it felt as if he were still with us, however far from us he stood. From where we were, we could see only the back Jeff's head, the first signs of thinning hair, and his ratty blazer, one of those deliberately not-nice jackets that becomes kind of nice through its lack of airs.

"Daphne's very, very good—Alice is right," Elias declared. So *this* was the woman's name.

"Oh, but she's hardly *there* yet," Sikah hissed in his effeminate way. I would have painted his nails if I were his portraitist.

"Why not?" Alice snapped. "Just because *you* aren't?" Elias nearly sprayed a mouthful of wine over me then. He found his composure swiftly enough and half-apologetically regarded Sikah, who was trying to laugh off his fury for the diminutive infidel. Nik was amused by it all, of course, as I was. These rivalries among his adopted family had to bring him joy. It probably sharpened their performances, that hot-bloodedness spilling over from whatever real-life feuds they had going with one another into the play itself. Nik, I was sure, would have had some pet theory about it he trotted out in interviews.

"I don't know, Sikah, she's getting along pretty well these days, that's how I'd put it," said Nik. "She's got plenty of time, too." The director glanced in my direction, and on seeing that I was enjoying the Arab's torment, appeared more comfortable

with the prospect of holding my gaze. I thought to shake his hand, to say *something* about tonight, as all those sycophants were doing. Did he have any real idea of who I might be? Perhaps he'd been kept out of the loop by Sikah and Hank, as siblings will shield their patriarch from certain schemes.

Sikah sucked his teeth. He wasn't going to convince any of them of very much, so what was the point in quarreling?

Elias got right in front of me now, taking advantage of my open posture, which had been intended for Nik, who was suddenly being led away by a woman I thought I vaguely recognized from fashion advertisements. We watched the two of them disappear through the gray doors at the back of the stage, before Elias asked me flatly: "What sort of pictures are you making of her?"

I took a step back. "I'm not really sure yet," I said. It was, of course, the truth, though it came across as an evasion. "I made some sketches tonight, just to get me started."

"Are *we* in any of them?" Elias squinted at me as though he wanted to see them right then. I felt him slipping into character, not the one he'd played and then washed off in the sink, but one he liked to play socially with *certain* people. "*Will* we be in any of them?"

"As if he's going to tell you," Alice said.

Elias paused, taking this in. I thought he might even pat her on the head. "Where were you sitting? Specifically? What did you *see* in us tonight?" His tone turned dreamy, as did his posture, everything softening slightly in a way I found absurd.

I pointed indistinctly at the seats as I pushed on with the matter at hand: Daphne. Time was passing. I couldn't afford to be diverted further. "Did she seem, well, excited about the project?"

Elias, though, stayed in character and kept up his soft, silly smile, pretending not to hear me.

"More than you are, presumably."

My little rebuff took the slack out of his face and made the other two snicker. Elias recomposed himself and faintly smiled in acknowledgement of the power of my barb, and from that I knew he'd like nothing better than to retaliate now, by pressing me, in front of all of them, on the subject of my feelings about the play, on what I'd *seen*, correctly intuiting that my impressions were mixed or at least unformed. How could they not have been, given how oblique this piece was, all the way down to its curious title? This ambivalence had so far led me studiously to avoid all mention of the performance, and it was why, as he well knew, that any questions on the subject were premature and to that degree unfair.

Elias, however, suddenly pulled back. I can't say what crossed his mind then, but I saw the heat lifting in the way he unset his jaw. "Is she excited about working with you?" he repeated rhetorically, as if I'd asked the question half a second ago. "I don't

know, to be honest." He nudged Jeff, still facing away from us, and looped him into our exchange: "He's asking, was Daphne excited about the art?"

Jeff had to be intimately linked with the play, with Daphne, and ultimately with Garrett, I realized, for Elias even to put this question to him. Hadn't he been occupying one of Garrett's seats tonight? Jeff twisted toward us as if he'd been waiting for an excuse to do so for quite a while. I think his exchange with the giant and the crew had run its course some time ago; he was ready to move on, and what better time to re-enter our circle than at a moment where he could cudgel me for the theft of his scarf? I braced myself.

"Well," said Jeff, "I think Daphne's *unsure* about what all this involves. About *you*, I suppose."

"Maybe that's why she disappeared?" Sikah's grin had been made steelier by the shots Alice had taken at him. There was a genuine refinement to him at his core, I could see that much, yet somehow it had spoiled into *this*.

"She's very quick to go most nights, though, isn't she?" said Jeff, appearing more eager to cast doubt on Sikah's hypothesis than to tell me what was likely to be true.

"It really does exhaust her," Alice whispered to me, pained merely by reporting this unhappy fact. How protective this never-was could be about our would-be starlet.

"Have you tried out back? Through there?" I *thought* I heard these words, but it wasn't easy to be sure; the twitchy little voice, Hank's, came from some way off. Apparently he believed his height equipped him to converse over ranges others couldn't, as if his peculiar visibility in a room had the effect of amplifying his voice. If I had trouble making out his words, though, I could see his bratwurst-like fingers pointing at one of the exits behind the stage area.

I shook my head.

"She might still be smoking, out in the parking lot," he yelled. Then he closed the distance between us and spoke at a more sensible volume. "She chain smokes, you know. She could definitely still be there."

"I've seen her smoke a whole pack like that," Jeff said. "Things went really well that night, I remember."

"Opening night, I think," said Elias.

I absorbed the bunch all at once; the eye, like nothing else, can do this. They were a family of sorts, perhaps only for a few months, convened just for this production, though I suspected their connections pre-dated it. You could see an entire glimmering network of psychic forces running through them, and *this* is what made them kin. It was right there, though it would take you months of acquaintance to begin to articulate it, at least in words. My acquaintance with them, though, probably wouldn't outlive the night. I lingered a second, wondering whether Garrett might

allow me to include them in a drawing or two. They *were* a thread in Daphne's life, after all. For tonight, though, I made do with fixing each one of them in my sights: the old girl, the troubadour, the Arab interloper, the giant, the director, and the transsexual, or whatever *it* was. I skipped over Jeff. I didn't even have an allegorical nickname for him. The spy? Too melodramatic. Then I cast my eye about, in the emptying amphitheater, for the *true* child who'd disappeared into the dark, once and for all. No luck. The rest of them nodded back at me, understanding the finality of my gaze, and I made my way through the dissipating crowd toward the exit through which Daphne would have left.

"Did you like our seats?" someone called after me.

Jeff. Apparently he wasn't quite done. I let him catch up to me and we continued together toward the doors.

"James always gets us good ones," he said.

"You did the lights? That's what I heard."

"I did, I did. Hank's been complaining about them, so I got out there in the seats to take some notes. Just like you." He tapped my coat pocket where the pad's outline could be seen. "He's fucking nuts. The lights are fine." He smiled. "Now I remember why I quit doing this full-time. See, I've actually been engineering at *Antral* for a long while. Reflectancy mostly. But before I ever got into analyzing light, I was working with it. In set design, obviously. And now I'm starting to do it more and more again. Because of James, of all people."

We pushed open the doors and found ourselves in a small foyer. The noise of the reception dropped away.

"So—"

"So James asked me for a favor. A while back. Not for the lighting for this show but another one of Nik's, a few months ago." He wrapped his scarf tighter; the air was suddenly colder. "Really Daphne asked him whether I'd do it, and what was I going to tell him, my boss? He's always game to help out Tony's girl," he said with an unhurried wink. "He *needs* a child of his own."

"He's pretty young."

"He needs to get his wife back."

"Maybe he was trying to do you a favor, too."

"Me? Well, I don't know. You think he was *trying* to set me up with Daphne?"

I was about to correct his impression when I realized he'd not misunderstood. He was simply trying to put another thought into my head.

"But that would be sick," he continued. "No, I don't think so. The favors were all for her. Always. I didn't even want to do it, but felt I had to, out of loyalty. And then I maybe made a little mistake with the group—with Daphne. Took things too far.

And now he seems to want me less and less at Antral. Nik's more my boss than James is at this point. Though he's a much worse man."

"I just meant," I said, "that James likes his staff engaging in cultural things. He probably thought it'd be interesting for you to work on your craft with Nik and Daphne. Though I'm guessing he didn't think you'd get *this* deeply involved with the troupe, making art."

"It's why he hired you, though, right?" Apparently I'd said something wrong.

"Well, he hired me *as* an artist, not a technician."

"But you have to know by now, that's all an artist is for him. A technician."

I gave him an awful smile. I didn't have to try either. I just had one when I needed it, and my body always knew before I did that it was time. Jeff and I evidently were at an impasse. I was afraid, more than anything, that he'd want to accompany me in my search for Daphne. He was interested in her, or at least he wanted me to think so. Could he be doing this *also* on Garrett's behalf? Keeping me away from his favorite, whatever that meant?

He tapped again at the pad in my jacket pocket until I pulled away, out of reach. "So," he said, "what *did* you see tonight?" He must have been listening, with his back turned, when Elias asked me this. "I mean, it was *so dark* in there, wasn't it?" He paused a beat before sticking out his hand and pointing through the outer doors. "*There*. She could be *right* there. If she hasn't run off with someone else."

The wind swept in as I pushed through the doors. Before they could close behind me, Jeff thrust his hand through the crack, holding the scarf in his fist. "Maybe you should take this," he said. "She thinks it's sexy."

19

Outside, in the parking lot, clouds shifted in torqued lattices, throwing down rain and shrouding a moon that was only half there to begin with. Cars roamed around the tiny zone of asphalt shut in uncertainly by wilting chain-link, swinging shafts of light in symmetrical pairs like search teams. I followed these beams with my gaze, hoping they'd find the woman for me, and caught a whiff of cheap tobacco for my trouble. Just under the awning next to the door I found a long row of smokers, all of them lost to their own worlds, tending to a compulsion they'd nourished in themselves over the years. I inspected each of them under the orange lights falling from the lamps high above and lighting up the mist, haloing everyone. Really such scrutiny wasn't necessary. If that bright wash of hair were here, *it* would have found *me*. But I studied them all the same—one of them too long, apparently. Her gaze sharpened in a way that obliged me to ask for a cigarette, masking my true interest, which was, sad to say, strictly visual and entirely indifferent to her concrete existence or anything else she might provide me. People as a rule don't like being gazed at this way. It is, frankly, slightly frightening; even I could be unnerved when the eyes of certain artists fell upon me. Curiously, people prefer it, when you take notice of them, that you *do* want something from them: a cigarette, say, even if they have no intention of giving it to you. The reason is simple enough. When you treat them in the usual way—as a means to an end, that is—they have a good idea of how you are going to behave. But when a man stares at you simply for the sake of staring, what is he likely to do next? No one can say.

I offered to pay for the cigarette. That's all you had to do, in certain company; you'd instantly win favor, and they would never take you up on your offer. I claimed my smoke and ambled off toward the far edge of the parking lot, looking about first in the dark, and then near the streetlights, hoping without really believing I'd catch sight of Daphne. Escape was apparently her way.

The rain began to strengthen and my hair soon reached saturation: the first trickle of water ran down my scalp and neck. The weather seemed to be accelerating my thoughts. A decision needed to be made. I almost reflexively called a car, but as I rounded the corner I found myself by chance under another awning, a neighborhood bodega's, with fruits and vegetables still set out, thick columns of avocados and lettuces and asparagus. My feet were aching from the svelte leather soles of my shoes. Every time I wore them this happened; I could feel every pebble beneath me. I was sweating, too, from the heavy fabrics swathing me, particularly my necktie.

But I didn't even consider loosening it. That was a rule my father had given me, and breaking it always struck me as a loss of nerve, a defeat. When you loosened a tie, the garment showed itself to be merely a prop, to be discarded, or worse, left dangling in the sloppiest way, the very instant you didn't *have* to have it on. So I always left it on, knotted, in deference to a script that was, after all, of my own (or strictly my father's) devising, a law unto myself. It would come off only when the rest did, at home.

The show, I realized, had exhausted me. A mere forty-five minutes had left everyone—audience and performers alike—hollowed out, which was, in a way, to Nik's credit. A lot of people's nights would have been ruined; after-theater plans would have to be called off. Some might end up mutely sitting around the bar, unable to muster the usual banter. The director, a secret admirer of the theater of cruelty, I sensed, would have been pleased thinking about that. He had a right to be, I suppose.

As I took one last draw from my damp cigarette, tasting the acrid flavor of the filter, it occurred to me that tonight was the first night in a long time my expenses were not my own. There used to be quite a few of these nights, courtesy of Claire. She was the progeny of two old Boston families who'd made their fortunes in shipping and paper. She had access to money in the best of ways, where there was no need to ask for it; where there was, indeed, an expectation that, within reason, you'd call upon your ancestors' largesse in launching your own life. This was just the style in which Garrett would raise a child, I thought, if he ever had one. It could be how he was already raising Daphne, if Jeff was to be believed. In any case, it certainly wasn't the world I inhabited, not anymore, now that Claire had gone.

Technically, of course, I came from *some* money, but on nothing like the same scale. Since my father and mother were far more self-made than Claire's parents, however, I wasn't going to see any of that wealth for some time. They found it unseemly to handle things otherwise, and I'd already damaged my name with them to some extent, although this was only conveyed to me in subtle ways, like the growing length of their pauses when I'd speak to them about my economic circumstances. Tonight would be, could be, a blissful return to the days of Claire's munificence, when I'd been able to defer all shame. Garrett, a man also of the *haute bourgeoisie*, if only for three generations, rather than Claire's seven or eight—well, he was going to be paying for everything. Why rush home then? Could there be much wrong in seizing the few spoils to be had, a more comfortable living foremost among them, since I'd broken with a purer artistic path, the abandonment of which I had to believe was also, in some way, behind Claire's disappearance from my life?

These days I had many skeptics, even if she was the first of them (did she take some pride in that?). Questions loomed wherever I went, questions I'd first seen rising in her eyes; I could feel them now in the gazes not just of friends and acquaintances but

strangers, too. In the creative sphere, they came from both directions, from the auton-
omous and relational artists, but equally from the commercial folks. Remarkably, *all* of
this—and this was the crux of it, what made me so puzzling to others—all of this had
been entirely avoidable, unlike for the great bulk of designers, those would-be artists
who'd come up short in their original aims, lost their nerve, their self-belief, somewhere
or other, and found themselves condemned to the noisome stalls of the marketplace.

John was a meaningful exception to this rule, as he practiced commercial art with
the ethos of a fine artist. Yet it was just this interrogative spirit I found repellant, in-
volving as it did a general obeisance to critique. He was in essence inverting Warhol.
And there was always a sardonic, seen-everything criticality in Warhol and his heirs:
Koons, Hirst, Murakami. The joke had long ago grown stale, though; it might never
have been particularly fresh.

But what was I doing now with Garrett exactly? If it wasn't critique, then wasn't *I*
capitulating to commerce, to advertising and the movement of product, right along
with the hacks? I had no explanation, and that seemed to be the one thing that wasn't
tolerated, to be without a story of why you were rubbing shoulders with mercenaries.
It was pushing me off the grid *vis-à-vis* fine art of any kind. All I knew was that I
was entering the commercial sphere with the idea that, in this moment, there was no
richer artistic soil to work, even if I had no proper idea of what I was going to plant in
it. And as long as I was tending this patch of land, I thought, and was made to endure
the skepticism that went along with it, there was no reason *not* to enjoy the perks:
like, say, a night with a multi-millionaire's credit card. And, anyway, didn't Garrett
owe me something for putting Jeff and his insinuations right there beside me in the
seats? Surely he could have called him off on this particular night. No: he would have
insisted Jeff go, tonight of all nights. He would have paid him double for it. Those
long, assessing looks Jeff gave me throughout the play certainly didn't put me at ease
(although his words were another matter), and stealing his scarf hadn't helped things.
It seemed only right to restore my spirits on Garrett's dime. I could say I was meeting
with the other cast members, scouting Daphne in some way. Any excuse would do;
he'd never look into it.

The street narrowed and bent around like a question mark; there was even an
island further down to serve as its dot. Wind channeled through the road, tilting the
trees and the fall of the rain. Looking through the windows of the first of three bars
along the curve, I found lots of velvet and leather and dark wood, and few people,
which was all the convincing I needed. I took a small table next to a deeply beveled
mirror with a frame of tarnished silver. The barman came around and handed me
a thick book with page after page of single malts and vintage wines, but I decided
to let him do the choosing. He asked if I had any limits in mind, and I could reply

honestly for once that I didn't. I opened a tab; he chose quickly and well: the Cor-ryvreckan. He went looking for the bottle high up on the wall using a simple squeaky footstool—no sliding ladders for him.

My chest stung from the sharp corners of the sketchpad; if I left the book in my pocket much longer it might well saw through the lining. I fished it out and laid it face-down on the table. Soon after, my scotch arrived, and from the first sip it overpowered me in the best way, pushing me out of my own imagination into a plain confrontation with sensation. I typed out a little note to Garrett on my phone then. Somehow I'd missed Daphne, I explained. She'd escaped. She loved to escape, apparently. Did you know this? (I did find your man Jeff, for what it's worth.) But, I assured him, there was no problem; I'd already gotten what I needed from Daphne for the moment, just from watching her onstage, having again been struck by her capacity to express not herself but the role. Had he seen any of it, Nik's work? He really ought to.

I sent the email and put away the phone, hoping not to need it again until I called for a car home, barely able to stand, and only just coherent enough to call. I returned to the exquisite liquor idling in the glass and left all further selections, like the first, entirely to the bartender. He seemed an old hand, the kind of man you could tell, just by looking at him, knew his whiskey—perhaps even a bit too well. He brought me a second dram, a boutique rye from Oklahoma I'd never heard of, and in short order a third, a dark, syrupy rum that had the qualities of both a fine whiskey and a cabernet. I was imbibing with the abandon one typically reserves for house liquor (if one insists on doing this kind of drinking) and, it's true, I was also relishing the wrinkle I was offering the staff and guests tonight, through my own little performance, which fused a quiet, unassailably courteous manner and an immaculate dress sense to an unrepentant and irrepressible lust for drink. I lifted my eyes to the mirror beside me as I worked on the rum, mostly to observe my own image, the impression I was making. I was also, in that same look, hoping to find the bartender's eye, so that I might appreciate his own developing impression of me, and glimpse his surprise, even mortification, at what I was writing (or drinking) into affairs tonight in his redoubtable establishment.

Yet the only shock I managed to induce was my own. Right on the mirror's surface, with the streetlamps shining into the bar, back-lighting all I could see, I found, added to affairs, that great bundle of blonde hair, sitting atop a girl's head like some Hellenic helmet. I swallowed hard and ducked, as if I might disappear from sight simply by vanishing from the mirror. At the same time, I brought my glass down with the unintended force of a beer mug pounded at a fraternity party, sending reverberations through the wood, my body, the room at large. The thud and

the ringing that ensued also served, though again unintentionally, as a rude and incontrovertible signal to the staff that I would presently be needing another. A second barman, apparently an apprentice, judging by the way he worked under the veteran's eye, appeared underage, with a face so smooth you had trouble imagining him ever needing to shave, although he was so effete in his manner and build, you knew he'd never *desire* a beard—this boy came looping around the counter at speed and with some alarm. My chagrin was palpable when he hovered over my table, examining me, trying to puzzle out my loutish gesture. I averted my eyes when he scooped up my empty glass. I'd not meant to take things *quite* this far, and my nerves only began to settle when I thought of the old British tradition of Lowry, Waugh, and Bacon: boors with the bottle and gentlemen in all other ways. Whatever my intentions, the slamming of the drink comported perfectly with this character I'd been laying the groundwork for tonight, even if that wasn't actually *why* I'd slammed it.

Of far greater concern to me than the help's reaction was whether Daphne had caught sight of all this. Would my apparently vulgar act serve as our unfortunate introduction? And would I now have to make her acquaintance in the fuzzy state of mind I was locked into, seeing as I'd had nothing to eat with my drinks? Each of them was a generous pour, closer to a double than a single, as befitted the manner of the place. Nothing came measured in those little antiseptic steel thimbles you saw at the frou-frou houses of mixology; here it was always down to the bartender's eye, and his heart, too, his distinctive sense for the appetites of the customer at hand. With me, he'd recognized my need for drinks so strong they numbed the palate.

Daphne couldn't have been here long, that much I knew. Otherwise I would have seen her as I passed by the bar on my way in. Maybe, though, she'd been in the bathroom, or on the vintage pay phone I noted in the corridor leading to it, tucked far off to one side, a tunnel lined with spare furniture to be pulled out on big nights.

The mirror's glare, a product of a large chandelier hanging from the vaulted ceiling, along with the yellow-orange streetlights just beyond the windows, was forcing me to squint slightly. A mirror hanging this low, I realized, made seeing whatever it reflected, in this case Daphne's outline, all but unavoidable, when one's eyes eventually chanced upon it. Actually I'd chosen the table for its proximity to the glass—not to observe people at the bar surreptitiously, though it *was* an ideal place for that—but to be close to the mirror's unusually vast face, and the ornate frame surrounding it, which I could see now was genuinely antique.

The boy came scampering back with a fourth drink selected by his mentor. He explained to me with great care, as if managing the slow and inevitable loss of my senses, that it was a young but distinguished Irish whiskey. I nodded at the older man behind the bar and he returned a look of resignation. He'd seen men of my kind

too many times; he might even have *been* one of us. If it weren't for the fact that *we* were the ones who kept the bars open, he would have rather seen my chair empty. I held my face in my hands, as if exhausted or despairing, to obscure my identity while my gaze inexorably crept up the mirror's surface. In this way, looking through my fingers with my head angled toward the mirror, I could see Daphne sitting quite apart from the other patrons, most of whom appeared like older versions of me, my uncommonly dressed-up self, anyway—the Gay Taleses of New York. She was focused on the little plate in front of her, stabbing at it with her fork (tines down, at least) and spearing what I thought was sautéed spinach studded with pine nuts. Every so often, she'd bring the wilted leaves up to her mouth in long dangling strands and push them in with her head cocked to one side. She looked as if she were smiling as she did this, though once she'd completed the maneuver it was clear she was simply famished and not in any frolicking mood. I kept my eyes on her: as long as she was *this* hungry, this preoccupied, I could get away with staring, which was of course the profoundest way to see, even through a mirror.

There was a second plate in front of her, half-gone, with purple potatoes, or egg-plant, or beets on it. On one side of her was an empty glass of water and a margarita she hadn't touched; the salt rim was still perfectly formed, I could see. She'd simply pulled a motorcycle jacket over that feathery cotton dress from the play, not even bothering to change out of her costume. The dress, which continued to give the impression of nightclothes, was yellow, not white or cream, as I'd thought, and the jacket, unusually, seemed actually to fit, as though it was really hers and not a boyfriend's.

I lingered over her reflection in the smudged mirror. She'd turned back to her plate of purple without making any inroads on her drink. I set my gaze plainly on her face now, the jaw in particular, sharply defined and projecting forward in a V, giving her a pronounced, almost excessively leonine aspect, which was by turns comely and chilling. Amber eyes lent her a searching, fearsome quality, even when, I suspected, she wasn't really looking very hard. No, this was simply the natural expression of a face of belligerent intelligence, an almost beastly visage incompatible with classical notions of beauty, female or male, and incapable of the tranquil repose in which women like Claire unthinkingly basked. Still, all told, it was probably a gift. It could hold people at bay. What's more, it set her apart from the city's more routine beauties, the legions you saw on every street, stepping out of a bodega in midtown, a subway station in Bed-Stuy, an urgent care unit in the Bronx, so many that you never got the chance to develop a proper appetite for them. With Daphne, though, and the wounded bitterness she wore so well, there weren't many replicas, precisely because she didn't form an ideal to which others aspired and were determined to realize—if not with makeup, then by way of the scalpel. Nevertheless, from the way she engaged

the barmen, it was clear enough that those claws could be retracted and the meanness in her eyes transmuted into earnest curiosity, all through a simple adjustment of the shape of her mouth, when she would slightly pucker it and cloak herself in a pensive air. The freckled cheeks helped, inscribing a degree of naiveté in her that tempered the wariness of her gaze and would, I was sure, far outlast her youth.

I'd lingered too long, though. Returning my gaze to the narrow bridge of her nose, I discovered her regarding me openly while chewing and licking her teeth in a particular manner I'd always found entrancing, so much so that I'd already paint-ed many pictures in this vein, of men and women masticating in posh restaurants, the food peeking out of their mouths; of professionals sunbathing on hotel roofs or swimming off urbanized coastlines (Rio, Miami); and especially of urbanites gathered under awnings, avoiding heavy rains or unrelieved sunshine like leopards clustered beneath acacias on the savannah. For all I knew so far, Garrett's project might be able to accommodate such urban pastorals, as I liked to think of them.

Technically, I wasn't meeting Daphne's gaze. I was looking *between* her eyes rather than *at* them. But how could *she* tell that, from this distance? I shifted my eyes a bit farther away, to make the distinction clearer, and focused on a spot beside her head. I was careful to keep my face absolutely still, to be as unresponsive to her gaze as possible, so as to suggest that even if my eyes *had* run into hers, I hadn't actually registered her presence. Now, it appeared as though I were observing something just behind her, in the street, and she were merely an obstacle to my view. The intensity of my stare was strong enough to get her to swivel her head and follow my gaze—right onto a nondescript tree. She turned back, unconvinced, I'm sure, that such a thing could deserve such attention, and shifted her face right into my sightline to capture my gaze.

But I was ahead of her. I'd pulled my eyes from the mirror and returned them to the bottom of my glass. I took another long and self-conscious drink, I more or less emptied the tumbler, and I wondered if Daphne could tell from where she was that hereafter only pantomime was possible. All the pleasure of that last nip, too, like the pleasure of seeing her sate herself with spinach and beets, was denied me by my new audience.

I set down the glass decisively and snuck a glance in the mirror. She smiled at me. I felt sick—not from the drinks, not yet at least—but from the dawning prospect of having to reverse course tonight and redirect my hedonic energies toward the practical end of making Daphne's acquaintance. It filled me, could only fill me, with desolation. Because wasn't getting to know her precisely my obligation? Worse, didn't *I* steer right into this by coming to a bar so close to the theater, knowing from the rest of the cast that Daphne tended to disappear after performances to unwind, so that

there were good odds that she'd use one of the nearest watering holes to do it? And then, the final recklessness, even after seeing her here: didn't I dawdle in looking her over so that discovery was inevitable?

My misjudgment would mean, among other things, putting on hold another pleasure I was just getting around to, something else funded by my new benefactor: football. I wanted to go over in my mind the game to come, in the same heedless way I'd been casting my gaze over Daphne. It'd been a long time since I'd seen live football. The Raiders had been playing then, and I'd gone with Ty (of course) but also little Helena, five years my junior. That game was low on points, I recall; it had all turned on a fade route by Michael Crabtree, a receiver I'd last seen play, and who'd spent the early part of his career, with the 49ers. He made that catch and the Raiders went on to win a rather forgettable game—forgettable, though, only if you were a routine spectator, but not for me, and certainly not for Helena, who frequently and wistfully reminded Ty and me about it, this talismanic moment of communion between the three of us, which, naturally, could only serve that function through substantial misremembrance. For one thing, it rained the entire time, though my sister claims not to have noticed.

Beyond my official duties for Garrett, Sunday would involve a modicum of simple *fun*, the sort of thing that art generally eschewed. *The Vegetable Gender* had been stimulating, no doubt, but stimulation can be deeply unpleasant. There is nothing fundamentally affirmative written into the notion. Nik's play existed, I thought, antagonistically: it said no in some fundamental sense. Sports, though, even in its most nakedly brutal forms, like football or ice hockey, says *yes*. It always does. This is why, in boxing, fighters frequently embrace in the ring afterward, the more tightly and lovingly—even kissing each other sometimes—in proportion to how violent and fraught events had become. Therefore, however low your regard for football as a sport, however dubious all the traumatic brain injuries and off-the-field indiscretions of its stars, it possessed the telltale force of all things through which life genuinely flows. Like advertising, there was no questioning it as a vessel of communal significances, no need for tortuous exegesis to unearth it, as in the more esoteric corners of life—art, for instance. Its primary meaning was established by the very fact of its occurrence. You could be sure it had import, in just the manner of the mass festivals of the ancient world, even if you didn't fully understand what it was. In the case of modern sports, not just stadium spectators partook, but, through television, so did millions of households around the world, all crowded into the same moment. Sports was what kept network television alive, I knew. It's why the Superbowl, through its commercial interludes, furnished what was still the most expensive advertising space in the world.

Part of the reason I'd been so relieved *not* to have found Daphne after exiting the theater was that, on this score, art was entirely different: sooner or later—generally sooner—you would be *expected* to discuss what you'd witnessed, what you thought you discovered in the experience, in a way you would never be expected to, not with any articulacy or originality, after a football match. You were certainly *permitted* to talk about the game, but this was purely at your pleasure. And for every fan who followed advanced statistical measures, who had teams in multiple fantasy leagues, who parsed each play with giddy aplomb, there were ten who were content to watch and think nothing of the game afterward other than, perhaps, *we won*, or just *so-and-so beat so-and-so*. Wasn't this the highest response? Silence, or something very near to it? Despite the lip service paid to the idea, silence was almost never acceptable in the aftermath of an artistic production. To appreciate was in some sense to think and talk about the thing experienced, and the better you appreciated, the more elaborately you thought and talked. How else to prove that there really *was* something to it, except through baroque discussion?

"What's *that*?"

Just like that she was upon me, derailing my train of thought. I looked up from my glass to find Daphne's face close to mine, her breath smelling of triple sec and beets. She was pointing at my little gray notebook, its cardboard covers bent, arced, curved in the shape of my chest. Wouldn't it be fun, I thought, to finally flick it open and compare the girl in those pages to the one at the bar with me now?

"I didn't get *any* of these," she said as she scooped up a hazelnut and a green olive from the elegant tray the waiter had brought me when I'd first arrived. I'd not touched these nibbles yet, mainly so that I could enjoy the effects of liquor unmitigated by anything that might retard the process of intoxication. Daphne grabbed some almonds and another olive, and I, with a certain grim resignation, followed suit, reaching out to collect small handfuls of each. "You don't mind, I hope?" she asked.

I shook my head as she fetched a tall mahogany chair, almost a throne, from up against the wall. It didn't match the rest of the bar's furniture, yet its grand proportions seemed to me to suit her sense of moment. The seat she'd picked was too heavy for her to lift cleanly, so she dragged it across the hardwood floor, causing a vicious squeaking to fill the room. The bartender immediately surveyed us both, though for whatever reason—probably his familiarity with Daphne—he stopped short of any admonishment. Daphne set the chair at right angles to me and slid onto the green velvet cushion with her legs gently crossed and her dress flaring, displaying a grace in all opposition to the roughness with which she'd just rearranged the scene. From there, together, we rather indelicately plowed through the olives and nuts and cheese, ensuring that I wouldn't need to speak right away.

"So," she said, with her mouth still full—some see no deterrent—"did you come here looking for me?" With that, she'd pushed things past the threshold. I steadied myself in the face of the inevitable, and although adrenaline, together with the bar snacks, was sobering me up, I was hardly straight yet. "James said I should be *sure* to meet you tonight."

I nodded, my mouth still full of pecans and crumbles of an unknown blue.

"But I had no feeling in me at all by the end of it," she sighed. "I'm sorry."

"It exhausts you"—these absurd words, and the sentiment that accompanied them, no less absurd, were conveniently garbled by the chewing I was happily engaged in. Apparently not quite enough: Daphne raised her eyes from a fresh tray of nibbles just deposited by the barman, this one heaping with all the same things, and smiled firmly at me, as if she wouldn't abide the clichés about actors and their frailties.

"Is *that* what they said? Well, I was prepared for Jimmy to be upset. He's always mad at me in little ways. It's usually my fault, too. So I came here for a drink or two. I was feeling a tiny bit guilty."

The old man behind the counter swooped in with the margarita Daphne had left untouched at the bar; he seemed to know more about our evening than we did.

"I got a very sweet message from Jimmy earlier," she said. "He'd just gone ahead and assumed I wouldn't find you tonight, and it was not at all a problem, he said, there'd be other chances, don't worry. And so I was off the hook, but still feeling sorry. I thought I'd at least look you up on my phone, maybe find your email address online, or your Twitter, and send you a message or something, apologize. But you don't have a website, or social media. A couple of photos did come up, from openings around—you know, I've actually *seen* some of your work up close, in galleries. What do you think of that?"

She wasn't interested in a response, so I offered none.

"And just a second later, right above my phone screen, I don't know why I looked there, in the mirror, but I saw your face in it. The same face I'd just found online. *Second chances!*" Daphne took a sip from her margarita and offered it to me. "Since I stole all your olives?"

I smiled weakly but made no move; the last thing I needed was more booze.

She shrugged and with her next draft fully breached the salt rim. "You're dressed so perfectly tonight, though. I couldn't find anything like *this* online." She patted my lapel. "But then I saw your little sketchbook, sitting right there, so it had to be you." She put her hand over my pages. "It's a sketchbook, right?"

I pulled it closer to me, away from her long, lean fingers, and flattened out the rolled cover with my palm. She was the fifth drink I didn't need.

"And so... I came over." She winked at me, a just-for-laughs sort of wink, it didn't mean much, except that she was going to pass over the fact that we'd actually made

eye contact earlier, in the mirror, and that I'd tried then to pretend we hadn't, was pretending even now. She put her hand, cold and wet from the condensation of her glass, over mine. "So show me."

I regarded her skeptically, and she shrugged again, removed her hand from mine. "The sketches are really just for me," I said as I depleted the tray, which was fast becoming dinner.

"And why is that?"

"I drew them in the dark."

"I was wondering how you'd managed."

"I haven't even seen them myself yet."

"It's hard enough to *act* in the dark, you know."

"That's what the tall guy seemed to think."

"Hank? You talked to him?"

"Not really."

"But he told you I tire easily?"

"One of the others did. The girl, or really, the woman."

"Alice."

"But there wasn't anything malicious about it."

"Little Alice, without malice." She thought about it a second, her proto-limerick, before putting her fingers on the edge of the sketchbook and tugging at it. "So we'll just look at these together then." The book was still in my grip, my unflinching hand making my misgivings known. "They might be yours, but they are *of* me, right?"

"Of everything, really."

"Oh, just let me see *one* of them. Just the first page, how about that?" Daphne brought the glass to her mouth again, looked at me with those watery amber eyes, and pointed to my empty tumbler: "Don't you want another of those?"

I turned away from her slightly and made to open the pad.

"No—the *last* page, I changed my mind," she said. "And you can't look at it first." She came around behind me and stationed herself over my shoulder; her hands landed on me with unexpected force.

"Oh, that's not fair," she said, "don't do that."

I'm not sure what she meant. Maybe I sighed, or maybe something changed in my face. Could I even have cringed at her touch?

"Can we get him another of these?" she said to the older bartender, handing him my glass. I didn't interfere. "Jim would want you to drink with me." She squeezed my shoulder. "He always does."

I still hadn't opened the book, though I'd flipped it over so that the back page would be on top: my only concession to her so far.

"Don't I have to figure out if we should be working together?" she asked.

"Oh, you'll get the wrong idea from these."

"Only a *genius* could understand them, I guess?"

"Alice did say you might be one."

"Someone should slap little Alice." Again she drank. "Have a sip?" She pushed the margarita up to my lips, tilted the glass, and I decided I'd rather open my mouth than have the drink in my lap.

"Good, no?" she teased. "Look, under the circumstances, I won't judge you—*too* harshly."

"I don't really worry about things like that, Daphne"—which was true, mostly.

"Well, let's just look," she insisted, threading her arm under mine from behind and reaching for the sketchbook.

I'd come, of course, expecting a certain amount of wiliness from her, having seen enough of it from other artists. Instead of being rattled by her antics, I simply opened the back cover first, left to right, revealing the reverse side of the final image. The paper was certainly heavy, but my markings, repetitive and circular, had apparently been heavier: shadowy impressions peeked through from the other side. Before we could start to make sense of these faint lines, another drink arrived—a simple corn whiskey, the old man explained, or possibly admonished, I couldn't tell. Daphne made to pick it up but I snatched it away.

"Can't I even taste it? I let you have some of mine."

Actually I'd only been worried she'd try to put this drink to my lips, like the margarita. I handed her the tumbler and she drank without comment. I took it back from her and sampled it, too.

"Well?" she asked.

"I don't like it."

I felt her nodding vigorously, her chin bobbing up and down on my shoulder, exulting in the congruence of our sensibilities. "The rest is yours!" she chirped, thrusting her hand onto the blank sheet in front of us and feeling the ridges in the paper made by the marks on the reverse side, as though reading braille. All *I* could attend to, however, was her heartbeat radiating through my shoulder as she leaned over me.

I relocated her hand and finally flipped the page. I didn't look at the picture, though. I looked at her face, which was right over my shoulder, as her bouncy hair tickled my cheek. I knew that she, too, had yet to really look at the drawing, though I couldn't see her eyes, owing to the blonde curtain between us. Probably her eyes weren't even open. Mine weren't. There were other things to appreciate just then that had nothing to do with sight.

I continually expected Daphne to shatter the silence that prevailed, but she held to it admirably, which let me actually look at the drawings myself, properly, as if I

were alone, rather than pantomiming the act and perceiving only an aggregation of pen strokes, something that could happen when I studied things in company. The scene before us, I recalled, came from very near the end of the performance, just before I'd run out of paper. I'd been dwelling mostly on Jeff at the time, the specter who'd been so near to me in the theater. I'd also been wondering when the show would finish, given how little narrative there was to cling to. The linework in the picture was decisive, as, by this point in the production, I'd adjusted to the dark and could select my strokes more judiciously rather than simply rambling with my pen. In the show, the pyramid of stage-light had been sharply set off from the surrounding dark, so that this black void seemed to have decapitated the giant. It had to be said, the show's lighting was inspired, very precisely choreographed. Jeff deserved credit, however much he'd disturbed me with his breathing and typing and gnomic whisperings.

In my sketch you could see the pyramid's base very clearly inscribed on the stage. I wondered if Daphne was seeing this now, if her eyes had opened like mine and she was peering at a single impression of a scene from her play, *my* impression, extruded onto paper so that you could see, if you cared to, what I'd seen or imagined I had. As your gaze climbed the page, the light fell away, which meant that the uppermost object, Hank's head—he was rearing up again here, like the Loch Ness Monster—was completely lost to vision. The countenance you *did* see immediately was Daphne's; her face was at chest height to him.

I wondered if she was staring at herself right now. Daphne put her finger to her likeness, which was starkly simplified but recognizably hers. There were elementary distortions to it—an imbalance between what was above and below the ears, the chin clearly too narrow—yet without any of the hyperbole of the caricaturist. She began to slide her fingers slowly over the lines, sweeping over the little girl—I'd never learned her name—who appeared here as the most rudimentary of my figures, lying prone at the upper border of the sketch, only her face within the light, and her body receding into darkness. Yet wasn't all that my embroidery? Hadn't I lamented the child's disappearance after the opening scene, her never appearing onstage *with* the other actors? So then what was this girl doing here in this sketch, besides proving that when I drew, there were times, at least since I'd started drinking Theria, that I wasn't aware of my pen strokes, so that phantoms like this might find a place, too. Much the same had happened when I'd drawn from *The Sort*.

Daphne caressed Elias next, starting with his shoes and drifting upward. He was facing away from us and playing the bassoon on a small stool, or rather, in the image before us, he was *preparing* to play, assembling the pieces from the pile that had in fact appeared at the very end of the performance. The phantom girl of my

picture seemed not to like what she was hearing, peevishness being her salient trait. Alice had stared at the child onstage. She'd been counseling the giant as well then, but Hank's head, then and now, was an unseen entity, rising out of the light, so who could say what he was thinking? Only Daphne could be seen taking any pleasure in the musician's preparations.

Daphne turned to fingering the light itself, the faint little lines I'd drawn to suggest its direction, and then the firmer hatching I'd used to define its pyramidal form without resorting to contours. "This light," she said, pushing her face against mine through the blonde curtain. I waited for more, but she left it at that.

"I wouldn't take too much from all this," I said somewhat breathily, though without slurring, just before flipping the sketchbook shut.

Daphne recoiled. Instantly the heat from her cheek was gone.

"Why not?" she asked as she stood behind me.

"Did you see the sketches I sent James? The ones of your film?"

She nodded uncertainly at first, and then somewhat profanely, before reclaiming her throne beside me.

"Obviously I saw them." She took a deep drink from her margarita and made eyes at me. "What an imagination you have."

"The rest of these, though"—I tapped the book—"say a lot less than those."

"Oh, I don't know. What you've got here are improvisations. What they say just isn't very clear yet."

"The film sketches were improvised, too, actually."

"Those were *fantasies*, is what those were." She laughed and drank. "But these ones here, they're..." She had both her hands on the table, palms down, and flung her head forward, low over the surface. She straightened up and looked at me without guile. "They're *untouched*. And I think I like what you see, untouched. Without distortion."

I laughed. I couldn't help it, hearing Claire's words inverted like this. How long would it last, this feeling for another life, one that followed me around, always dying, always being born?

"I guess you think that's a very stupid thing to say."

"No. That's great. It is."

Daphne got up and dropped into her original chair across from me, vacating the throne and leaving its light green plushness shining emptily.

"I mean that," I said. "I wasn't—"

She flashed a cutting little smile for which her eyes seemed designed. Her lips barely rose at their corners, so that she could be said to smile mostly because of her posture: she'd cocked her head slightly, kept her eyes nearly closed, and a dimple had formed on one cheek that conveyed only ridicule. Her hand flew at me—I actually

covered my face—before I saw it descending onto the sketchpad. I recovered quickly, stabbed at her hand with my own, pinning both her palm and the closed sketchbook beneath it to the worn wood of the tabletop.

"I'll send you snaps of every sketch," I said. "I will. But you've got to let me get what I need out of them first." Glaring down at my hand, she pulled harder at the pad, rising slightly from her chair to use her bodyweight for leverage. The pad inched toward her until I used my own weight to stop it, and her. I knew I'd pressed too hard on her hand; it probably hurt. "Later, all right? If you still want to see them. I doubt you will."

"And why not?" She sounded like she was reciting elocution lessons now. "Tell me."

For a moment she stopped pulling her hand, left it dead on the table. I loosened my grip, acknowledging her surrender, and she ripped her hand out from under mine with one angled tug, as sharp as a knife, leaving the sketchbook precisely where it was.

"You know, I don't *have* to do this at all," she whispered, leaning just slightly over the table and finishing off her margarita.

"Then why do it?"

"I don't need to."

"And do you think *I* do? Is that what James told you?" The correct answer to the first question was, for several reasons, yes, absolutely yes. But, when goaded, I had to pretend otherwise. My response was sheerest instinct, not a calculation. Maybe I wasn't even pretending: maybe I *didn't* really need Garrett's project. Telling Daphne as much, then, might have been a declaration of my truest intentions, and the only person I was really needing to deceive was myself. What I mean is that, to carry on at all here, with Garrett and with Daphne, I might have needed the pretense that I *was* willing to compromise, in light of my dire economic position. Easy enough to *say* you need the money. But what would I actually do when confronted with the first real compromise? Only then would I know what I needed and what I didn't.

In any case, she looked... *intrigued* by my rhetoric. (I'd hadn't only surprised myself, apparently.) I also think she believed me, and it was this fact, if it was a fact, that made me want to believe me, too.

"Did Jimmy ask you to call him *James*?" she said. She picked up another olive and rolled it onto her tongue before seizing it between her teeth. She gnawed on the pit for a moment and then spit it *not* onto the little plates they'd provided, nor the empty slots in the tray, nor, as a last resort, her empty margarita glass. No, she spat the pit into *my* tumbler before bothering to see that it wasn't totally empty. She replaced the glass just where it'd been, as if I still might drink from it, indeed, as if the last drops

might be even more enticing to me with her pit steeping in them. "I wonder if you'll graduate all the way to *Jim* someday. Even just Jimmy."

"Paul calls him James."

"Things are complicated with Paul, though, aren't they?" Daphne looked at me knowingly. "But their drinks are good, right? *James'* drinks?" Her tone was suddenly constructive, as if she were moving an interview on to the next question after I'd stumbled over the last one.

"Do you think he'd go for plain old *Garrett*?" I said. "That's what I'd *really* like to call him, the way you would in a fraternity. It's what I already call him with everyone else."

She looked tired of me.

"But yeah," I said, "they're very good. You're right."

"The thing is," she said, leaning down low to the table, "did you happen to know—I don't actually *owe* him anything?" It'd been a feint. She'd modulated right back to that whisper, now fashioned into more of a hiss, an oh-so-quiet one. It was perverse almost, the mutability of her voice, which, when she wasn't whispering or grumbling, tended to break up in the most appealing way, whenever the moment was charged with pleasure, say, or exasperation. I'd already seen both tonight.

"It hadn't crossed my mind," I replied.

"I'm doing it just because, with this project, Jimmy wants to... well, he wants to *improvise*. You know he picked that up from me, right? From my father? That spirit, I mean. Even from Jeff. You must have met him tonight?"

"Your boyfriend?"

"That's *not* who he is."

"He didn't seem to like me looking for you."

"You know he did *all* the lights?" She looked around and then up at the ceiling, turning her head slowly until her gaze came to rest on the chandelier, as if comparing the bar's *mise-en-scène* to the amphitheater's.

"Light was the most interesting thing about the show, for me anyway."

"Yes! Even if you're trying to insult me, it's actually true," she said. And you've *captured* light so well right here." She looked airily toward the sketchbook.

I pushed my lips out in demurral.

"Really, you have. You already see it, don't you? And that's—well, that's the other reason I'm doing this." She reached across the table and put both her hands on my forearm.

"Why?"

"Do you not believe I could know your work?"

I shrugged.

"*I'm* the reason *he* knows about you."

"I thought he found out about me at—"

"At Roger's apartment, yes. *Maddy*. But I took Jimmy the rest of the way. I told him about your reputation."

"But you didn't even know what I looked like. You had to search for me on your phone."

"So? You're not an actor. I don't need to *see* you to know what you've done, and what people are saying about you."

"And what's that?"

"*Don't* be stupid," she snarled, pulling away from me. "The point is, he's smitten with you now. He thinks you're brilliant."

"Aren't I?"

She seemed to prefer arrogance to modesty.

"It's why he's giving you so much freedom. Why he's giving it to me, too. But what does he know about art, right?"

"Well, what's there to know?"

She simpered. "If there's nothing to it, well, I guess you won't mind me just looking through this..." She grabbed at the pad and I snatched the free end of it. "I told you, I need to decide if I really want to work with, what—an ignoramus?"

"From this?"

She regarded me violently, with a predatory glower more death than sex.

"He's paying you to be a part of it, right? Why don't you just do it for that? You can't be making much from shows like this one."

"Do you understand," she seethed, "that there *isn't* any campaign unless *I* do it? There is *nothing* without me. I promise you."

There were feelings beneath these words that had nothing to do with me, though I couldn't say if they were directed toward anyone else in particular. Could she have been deliberately working herself up? Was she acting the part—of the actor? To *what* purpose, though?

Daphne's whole face was burning and streaked with purple; her cheeks were closing in on crimson. Like a chameleon, she was changing color, blending not with the world outside but the one within. How nice it would have been to watch her blush out of modesty or embarrassment; in another world, perhaps she was. *This*, though, this wasn't that. But was it *merely* a performance? Did it matter? Could there be anything *mere* about it, so long as it was *honest*, by which I mean, even if she'd gone elsewhere in her heart to draw these feelings to the surface, if they turned out to apply to me, this person she was only beginning to come to know, or to what I said or implied, wouldn't her nascent impressions, these bitter, torrid feelings, be absolutely authentic in the only sense that counted, so long as she found them there when she

looked at me?

She was actually crying now. Although her mouth was closed, the rest of her was screaming. The skin around her eyes looked bruised and inflamed, as if she'd been struck. The bar staff, holding their distance for now, peered at us in alarm. How much further could she carry this? I'd really not meant for things to unfold this way. I was going to be sober when we met, to prevent just this sort of outcome, which was always on the cards once I or anyone else was four or five drinks in. Whose tongue didn't sharpen then? Whose patience didn't lapse? But she'd blindsided me, in several ways. Showing up in the mirror, for one, after I'd thought everything was over, and then speaking so tartly to me. Had all of this happened a year ago, I might have been kinder, even if I'd been drunk. But I wasn't used to bending much anymore, and such recalcitrance might have been my only consolation these days, for the move I'd made toward the margins, into the Bronx, outside the exhibition system, even outside the relational and public art scenes dripping with laughable emancipatory rhetoric and no less sterile in the end than the white cubes of the world: playing along just wasn't something I practiced much.

Still, I needed to know: could Daphne have been telling the truth? Could the whole project be called off because of my various indiscretions, paramount among them my refusal to show her these blind sketches? Karen was going to be more than a little troubled by what I'd done, needlessly antagonizing the subject. That's how she'd see it: a basic lack of mindfulness about our joint interests. But exactly what sort of pull did Daphne truly have with Garrett? She certainly wanted me to believe she could control him, and therefore those beneath him. What, I thought, did I ultimately know of Garrett's aims, or even his life? Not enough to rule this out. He could speak so vaguely at the critical moment. What questions had I even bothered to ask? I asked less and less of anyone these days.

Daphne stood up sharply. The tears had cut trails down her face, clear paths that stood out against the white paint redolent of mimes. I hadn't realized until then quite how much stage makeup she still had on. Yet the skin revealed by her tears... it was glorious, like a fresh page. She, though, seemed to have hit some sort of limit. She picked up the black clutch the bartender had brought over, sublimely unobtrusive, the ideal complement for a woman who was already too much. Might she actually walk off?

"Just don't ask me anything," I said, relenting. With that, I slid the pad toward her and watched her instantaneously fill with life, interest, greed for the drawings and my concession just as much. This version of Daphne was vastly more appealing than the stoical one, and she knew it. She mouthed to me the words *I won't* while sitting down, in complete silence, to peruse the book I'd offered her, while

my gaze inadvertently landed on the old barman, who'd been staring at her, at us, at our exchange. He held a cocktail shaker in the air, as if he'd been mid-shake when Daphne's histrionics brought him to a standstill. Who knows how long he'd been checking on us, surveying all the minor dramas playing out at his tables, gauging contentedness and the value of intervention, whether with drinks and food, or, in the case of the very drunk, counsel and instruction? He seemed to divide his attention so finely and effortlessly; it would take his beardless charge decades to do it so well.

Fortunately, Daphne was settling down to examine the sketches, leaving him to return to his cocktails. At the same time, all the other eyes—his patrons had taken an interest—left us, too, as the potential energy locked up in that moment, *our* moment, evaporated and the clinks of glasses and chit-chat resumed.

Daphne began examining the sketches far more reverentially than I would have expected, given events. She angled the pad toward her as if she were reading a book rather than looking at pictures, which meant that I couldn't properly see the drawings. I suspect she meant to frustrate me then. Little did she know this was a pastime of mine: seeing obliquely, via the reactions of others. She was keen to keep me curious about her, I knew, so what better way than to place herself between me and my work? Oddly, on this occasion the arrangement grew excruciating for me. She could sense, I was sure, the dark feelings welling up in me, to wit, the gradual transformation of mild amusement into genuine anger. Just what, I wondered, could make her face move like *that* as her eyes staggered over the page. Usually I had some idea, but in her case I couldn't say. It was like observing the operations of an extremely fine seismograph without holding the legend to decipher its readings. I asked her for a cigarette—whiskey made me crave tobacco—but she didn't bother looking up, she was wholly occupied with the sketchbook. I was sure she was relishing my discomfort. I asked again for a smoke, this time more directly, clanking my glass on the table. Neither bartender had been back in some time; they probably thought I'd had plenty to drink. The boy passed by the table and snatched up the glass with the olive pit in it, wisely opting not to offer me another, and (equally wisely) not engaging me at all, except with an apologetic glance. Or a piteous one.

Turning the page of the pad, Daphne finally gave me her cigarettes and shooed me away. I couldn't recognize the brand. All I found was a logo of almost Randian abstraction: a few intersecting lines, like a failed asterisk, set on an unusually delicate paper packet. It was rice paper, I could see, badly bruised from being stuffed into Daphne's purse. Handmade, too, looking more closely at it. Artisanal cigarettes. She belonged in this borough.

I stepped outside and smoked two of them down to their ends—they were exceptional, naturally, and filterless to boot—standing under the same yellow-orange streetlights that had glared at me in the mirror, next to the unremarkable tree in which I'd feigned interest. Across the street, the vast parking lot of the auditorium she'd just performed in opened up before me. Really, it was too big for the building. Even if the lot were full, and everyone drove their own car, a third of the seats would have been empty. The faux-classical building itself, designed with grand hopes that had only been partly met—you could see this in the finely wrought friezes that expired halfway down to the ground—seemed very far off now, from where I was, almost an appendage of the parking lot rather than the reverse.

The nicotine managed to settle me, but when I got back to our table the actress was gone. The pad lay open on its fifth or sixth page. Daphne had gotten no further than that, this page with a picture of her at the edge of the light, performing a soliloquy of which I could hardly recall a thing. Her posture had been more memorable: the stiffness she'd put into her hips as she wheeled around the stage signaled a consternation unreflected in her speech during the play. Her words, in fact, had been benign, half-sensical like so much else, full of rustically inflected Ashberyisms, as if the poet had been writing from the Ozarks rather than Chelsea. Not even her face conveyed the disruption; it was something running up through her legs that hadn't yet made it to her mind.

Evidently this picture had stopped Daphne cold. Or else she'd *already* gotten bored.

"I got a call." She was coming back from the corridor leading to the bathrooms.

"And you took it in the ladies'?"

"I had to use it, too. To clean up." Her face was wet and free of makeup now. She looked more drunk than when I'd left her, but also happier, and certainly more interesting, with the real topography of her face available to me for the first time. I wondered what else she might have done in the bathroom. How briefly I had left her, and already she'd changed.

I set the cigarettes on the drawings, but before I could let go of the pack she grabbed my hand with both of hers, crushing it and her cigarettes with it. "Not there!"

I left the smashed cigarettes with her and she eased up on my hand.

"Don't you have any respect for your pictures? They're so..." She looked up at the ceiling, still toying with my hand—I was enjoying it now—searching for a word she didn't end up finding. She looked right at me again, but this time I had trouble finding her pupils. All I saw was amber. All that wild heightening, achieved with white, had been taken out of her face. Yet enough wildness remained, so much, in

fact, I had to wonder whether other unnatural causes, perhaps involving her trip to the bathroom, were involved.

"I'll get you a car," I said.

She laughed a detached little laugh at my apparent indifference to her critical judgment, or my defensiveness—probably that's how she took it. She was too drunk or stoned to see that it was her new state of mind that voided her opinions.

"You'll like your pictures," she said. "That's all I was going to say." She shook her head ruefully and squeezed my hand. Then she kissed it. I managed to free myself, but not before she could take one of my fingers into her mouth. I think I felt her tongue. I certainly felt the hardness of her teeth. I might have pulled away sooner if not for that.

"Perfect," I said.

She nodded and searched the room disinterestedly. "You'll find us a car?"

"So you like them—the pictures," I said with a hint of triumph.

She was smiling, looking everywhere else but at me. "I never said *that*."

20

Not having to be anywhere at any particular time, I savored the ride home, buzzing through the night from a vantage not much a part of my life—a yellow cab's. Unlike the outbound journey earlier in the night, we took a looping route back. No sane person, in the era of Google, could believe the shortest drive between Fort Greene and my place beyond the Patterson Houses could bring one into Chelsea, but this is just what the driver attempted to convince me of, getting lost here and there, claiming that FDR and the whole east side of Manhattan was clogged when it was simply not possible at this hour. I didn't care. His deception, the manner in which he was making me an instrument of his own financial designs, was just another part of my pleasure by this point. I surveyed my circumstance as if it were someone else's, because, in a way, it was: Garrett's cash would cover all of this. Given how much there was to observe, and even more to entertain, to anticipate, I liked being just where I was, taking the long way home. The longer the better.

I think what caught the attention of this opportunistic Balkan—wherever else they might take you, taxis and Ubers took you around the world right within the cars themselves, with every nation contributing its unwashed to their fleet of drivers—was the source of my sense of anticipation. He figured, correctly enough, that a man's attention would simply *have* to be consumed in its entirety by the woman sitting beside me; there'd be no way to mind the driver as well. Certainly it would have seemed that way to him in the early stages of our trip. Just after Daphne and I dodged the rain and slid into his car, she poured a hand mirror, lipstick, eyeliner, foundation, and rouge into her lap from that deceptively capacious clutch. While the car's creaky suspension had us rocking about, she proceeded with remarkable facility to do herself up again, instinctively altering the angle and placement of each stroke as we drove, anticipating bumps and turns as deftly as the bartender had foreseen trouble.

I asked her not to do this. There really was no point, we weren't going out anywhere else. Yet my protest was somewhat undermined by the intensity with which I watched her primp and preen. She knew to disregard my words. I, like any man, was taken with the ritualized face-painting of womankind. Couldn't I see that masks were her passion? By the way I was staring at her, she said, it seemed to be mine, too—other people's masks, at least. From there, she expounded eloquently on the subject, even if she broke no ground. Actors are prone to giving this particular speech, about the truth in masks: namely, we cannot be seen properly until we don one or another

of them, and without a frame for our face we are, all of us, amorphous, unformed, undercooked: in brief, sloppy. And she *despised* sloppiness—she avowed as much while looking sternly in my direction. She turned away from me then, swiping her cheeks with a delicate rouge that seemed to bond with her translucent skin.

Apparently she wasn't merely an actor, but the thinking kind of actor, one who, even at this young age, had already weighed her craft carefully, was indeed, as she should be, still weighing it, sorting out her thoughts. Granted, she said, when she was onstage she might shift her appearance to emphasize one or another feature. And she'd looked decidedly different in the bar, with her stage makeup still on. Yet all of this was only a matter of emphasis, tilt, balance. There wasn't a grain of outright fabrication to any of it. The face she was fixing *now* for me, though, had a special virtue, she said. It was a face *without* tilt, her natural or neutral face brought into focus, nothing more. No amount of dialectic was ever going to prove more convincing than what she'd just produced in front of my eyes: she'd transformed her face into something I could plainly see was exactly what she'd said it was, a face lacking deception or skew. The eyeliner and foundation and rouge, the light touches to her eyelashes, all communicated what lay beneath, which I was in the ideal position to verify, as she'd only just been free of makeup. Somehow her shaded, toned face was more lifelike than the untouched one, and anyone could have seen this for themselves.

Daphne turned to me and softly frowned. One might have thought she was acting the model in doing so, mimicking those glum runway looks. But I recalled her face from the bar, when no one was looking her way and she'd been merely thinking and eating. She'd been offering then something like the same piercing glare. I realized now she'd probably been wearing this look since she was a little girl. It was a function of amber eyes, partly; it might have gotten her into a certain kind of trouble, or earned her a certain reputation before she knew it herself. So even now, as she stared into me, I thought I sensed a quiet, natural sweetness to her. If she were really trying to make an impression on me, she might have gone with a different expression, something coy or seductive, if that's what this was about, as we headed to my place, ostensibly to examine more of my work. No, at this moment she was only making herself manifest.

Our driver kept mumbling excuses, excuses of scarcity and inefficiency, they seemed like particularly *Balkan* excuses, the kind that corresponded to breadlines running around the block. Once Daphne had put her makeup away, collecting it all from her lap and slipping it into her purse without ceremony, I realized how far west we'd drifted: the High Line was there just in front of us. So I brought us back on course, and rather quickly, curtly. As I stared the grubby driver down in the rearview mirror, conveying to him the finitude of my indulgences, this man, twice my size, a man who would have broken me in two for that look had I come across him on a lonely street—his poor

sense of direction vanished. I instructed him to carry on up Ninth Avenue all the way through Hell's Kitchen, then take a right on Fifty-Seventh, all the way back to Second. He seemed a little puzzled—it would have been faster to take Broadway north—which only confirmed for me that he knew exactly where we were. But I had my reasons for seeking out Second Avenue: to retrace the route I'd taken earlier, but in the opposite direction, so that I might witness the most storied homes of New York—nothing compared with Europe or Asia and their ancient traditions, but still—give way to indigence and abjection at the top of the park, beyond Ninety-Sixth.

Daphne gestured vaguely at Carnegie Hall as we crossed town but said nothing. My eyes had grown bleary from drink and the simple fatigue of seeing, of drawing, of coping with the cast, especially the woman next to me. Yet I couldn't help catching a glimpse of all the newly built spires, all that reified foreign capital, in condominiums gone dark from disuse.

There was hardly anyone about as we turned up Second. It was comfortably past midnight, and just as in movies, we hit green lights all the way, each one set just beneath the last from our point of view; but my fatigue, coupled with my tendency to see double at night in situations of high contrast, made these little circles of light run together into a column of green. And this column carried us quite a way unimpeded. Daphne wagered we'd glide all the way to Harlem like this. I took that bet, knowing that our crafty driver would dither, just to run up the fare. I won. He had a knack, I had to admit, for coaxing greens into red without its seeming intentional.

So what had I won? I wasn't afraid to ask, although Daphne dismissed the question with a pat on my knee. The cosmetics she'd applied had altered her manner, calming her in the way my suit had calmed me this evening, even if, of course, she was still no more beautiful. I was falling for her flaws, the too-long jaw, the bony knees, the absent breasts. I felt like reaching for her tiny legs but didn't.

From Ninetieth Street onward, we watched the world descend from the heights of elegance into something moribund and harsh, the obverse face of sublimity: Spanish Harlem. The numbers kept rising, One-hundred-twentieth, One-hundred-thirtieth, One-hundred-fortieth, and the people in the street fell ever lower in stature, along with everything else around them: the buildings, the foliage, even the air, which turned acrid by One-hundred-fiftieth as it scoured my face and flapped the Balkan's cheap, shiny leather jacket about like plastic tarp in a hurricane. Still, a little while back, I'd been glad enough when the driver dropped the front windows; it had the happy consequence of mitigating his exuberant application of pine scent in the vehicle, which had made it smell as if we were traveling through some synthetic wood. I didn't blame him for this, really. A masking agent, even a nauseous one, must have been nicer than the unpredictable bouquet a car traversing the five boroughs picked up as a matter of course.

I could have driven up and down that route all night with him, crossing worlds. But it wasn't long before he was dropping me and Daphne off into the oxygen-starved air endemic to my block, air that smelled vaguely and permanently of motor oil, though there was no repair shop in the vicinity, only dying cars silently bleeding out over the streets. I was beginning to sober up, though, which meant I was tiring. Daphne too, had gone from a state of reverie around Carnegie Hall to something just shy of sleep by the time we pulled up alongside the curb. This woman, fully made up, as if she were just about to go *out* on the town—here she was, asleep, bleary, drooling. I paid the stubbled Balkan. I even tipped him heavily. He gave me a crooked grin full of small teeth, inadvisably bleached; they looked unhealthily white, as if they'd been eroded by chemical cleansing, shrunken to three-fourths scale. Maybe the tip would get him started on fixing that up. I wobbled Daphne up the inclined walkway leading to my door. It felt like fifty or sixty steps to me, as I struggled to keep her frail and limber person centered on the path. By the time we'd reached the threshold, she was mostly awake, reclaiming control of that exquisite mask she'd built in the car, which moments ago had seemed to have taken control of her.

"The *artist's* home," she said hoarsely as I, panting from the trip up the stairs, kicked the door open and guided her in. She'd not spoken for some time, which made her words sound especially stupid; and although she seemed to realize this at once, there was nothing to be done about it.

We didn't come back to them—words, that is—until I'd systematically turned on every lamp in the house. I'd gestured for her to sit on the sofa, comfortable mostly to one's sense of sight, presiding in the living room beside my large kitchen—too large, really, given the slightness of my recent culinary exertions. But she refused to unlock her arm from mine. So we went around clumsily together, without pattern, switching on halogens, desk lamps, Japanese lanterns, simple hallway lights with twenty-year LEDs, nightstand lamps, and one or two naked bulbs on the ends of orange extension cords, hanging in my bedroom. There were more lights here than I'd ever bothered to think about, and in each case, as we approached the unlit lamp, the darker the immediate surrounds grew. On several of these sorties, because Daphne wouldn't walk unassisted, one or the other of us ended up stepping onto artworks I'd left lying on the floor, the path being too narrow for us to take side-by-side. When we'd reach the epicenters of darkness and turn the switches, the many drawings we'd passed on the way there would appear all around us all at once. At these moments, she'd free herself from my grip. She *could* manage on her own, I realized. She just needed the right incentives. She'd then stoop down close to each piece, hovering just inches above. Her balance wasn't bad for a drunk, but either she had odd thoughts about ideal viewing distances or she was so spent that only at point blank range could she appreciate what she was seeing.

I did wonder at the portrait Daphne was forming of me, or indeed, the mask she was forming *for* me to wear for her benefit, at least when she was around. Maybe that's why I'd agreed to bring her here, to accelerate this process. Theater folk, even when their performances were purely personal, enjoyed and insisted on casting characters around them wherever they went, much more deliberately than did the rest of us. So here, in my apartment, was her chance, and she was leaping at it: the only thing I could tell from regarding her as she knelt or stood on her toes beside each of the pieces, depending on their location, was that she was working quickly and with terrible joy. She lived for this, as I knew she would.

I'd met plenty of people like this in college, mostly performance and dance students who worked with their bodies, not pigment or language. I liked the idea that Daphne would probably spend a lot of time coming up short; she'd have to recast this character, this mask of mine she was making, many times, as and when she realized she'd erred, suturing the wrong things together or mislaying the foundation. But that would be later on. Tonight, as we passed through the various clusters of drawings scattered around each of the lamps we lit, I felt it was *her* grip on *me* that was tightening. And when finally we came to those bare bulbs in my room, and we took in the ink-wash landscapes lying on my bedsheets—sketches of the fetid park outside—the two of us each gazed at these pictures, self-segregated by searing streaks of undiluted gouache, with the same degree of distance. That's how much ground she'd managed to cover, coming toward me, and equally how far away I was from much of my own work. What it meant was that this time, when I looked upon her, there was no delay, as there'd been at the bar: her eyes were already waiting for me.

She kissed me roughly in the morning with that wide mouth of hers. She fell on top of me when she did, and I felt her nipples press into me through the sheet between us. That much I could remember through the hangover—the slight unkindness and unpleasantness of it. Perhaps the hour made her crabby: it was barely past dawn. Something about needing to be home before her father woke. The last picture I had of her in my mind, she was standing in my bedroom doorway, her makeup slightly smeared, which lent her an uncanny blurriness. She gave me a smile. She hadn't meant to be unkind, I gathered. It's just the way she'd felt then.

I tried to go back to sleep once she'd left, but I couldn't. Consequences loomed, and, although I didn't think them over explicitly, they weren't going to let me rest. After a forty-minute battle, I surrendered to wakefulness of a kind and brought last night's sketchbook into bed with me. It's what had started everything between the two of us,

right? Hadn't she softened once she'd paged through it? Wanted to go home with me to see more? Or did the change in her stem instead from her trip to the bathroom in the bar, when she'd sent me off with her cigarettes and done who knows what besides wash her face?

By the light still gathering outside my window, I went through the drawings myself. The pictures were a mess, probably the price of the double-blind setup. Still, for what they were, entirely experimental, entirely unfinished, they were far from barren. Daphne had behaved as if she'd understood this, but how could that be? Only another draftsman could see what was sensitive, telling, even expert in these night-visions of mine. Which meant that either Daphne had been insincere, or she had a deeper grasp of the medium than I knew.

Within the swirl of lines from my ultrafine rollerball, her movements and poses had a plasticity I'd not managed to give to anyone else. Her lithe and lengthy body—she was as tall as I was, possibly a half-inch taller, if that wasn't just her springy hair—seemed to impress itself more strongly on the sense of sight than all those slightly more rounded and stocky sorts. It had been too dark in the theater to fully make out any of the actors, but even by gross measures Daphne had managed to intrigue and defy: the slump in the shoulders, the kink in the neck, the rise in the thighs. There are those who are photogenic, and others, like her, who were grapho- genic, naturally suited *not* for the simulated eye of the lens but for the biological organ and the hand with which it has co-evolved.

Coupled to the gravitational pull her person exerted in ink, there was an inscrutability of spirit, I thought, as I looked back and forth through this little book of scratchings. You felt the pull easily without quite understanding what it meant; and you continually doubted that you saw what you thought you did in her, as these were sorts of things you wouldn't *begin* to think you saw in others. You could draw a hundred pictures of her—doubtless I did in the end—and still there'd be something left to work upon, some as-yet-unarticulated matter. So many of the people I committed to paper were wasted away by my pen, used up. Four or five drawings later, there was nothing left of them. That's how it had been with handsome Elias. It made good sense that all you could find at the close of *The Vegetable Gender* were the disassembled pieces of the bassoon: the musician had already disintegrated, and I would hardly have been able to draw him again *had* he reappeared on stage. I'd consumed him by that point with my various sketches, like a photographer stealing Native souls with his camera firing away.

But Daphne, I knew now, couldn't be voided like this. I had the proof in my hands, and it filled me with lusty, whole-souled hopes.

21

I didn't draw that morning, though I sharpened up certain pictures to bring out what I'd seen the night before. I fell asleep doing this, and in the afternoon, when I woke feeling relatively refreshed, I got a note from someone I'd not thought I'd hear from directly for a while, if ever. Paul. There wasn't much of a greeting to this email; he launched right into the details. One of the reasons, he began, for keeping the campaign so open-ended, was that nearly anything Antral rolled out over the next year could be folded into it without trouble. Well, one of these fold-ins was now on deck. The optical division Garrett had walked me through at headquarters had apparently made great progress. (That walkthrough might have been less off the cuff than it seemed.) The first prototype frames and lenses—*Obscura* was the brand's working name—had been shipped by the fabricators, and some were already *en route* to me. More were going to Karen. *See what you can do*, he signed off.

Within an hour, a perspiring Central American (I was guessing here) showed up with two hulking boxes, both of which he stacked right inside my door. Just how many pairs of glasses had they sent me?

I'd actually been expecting to hear from Garrett that day, not Paul. Before letting myself drift off in the morning, I'd made sure to tell him that, as luck would have it, I'd managed to find Daphne the night before. Something in the way Daphne had talked about Garrett suggested to me I should do this. If she really *was* like a niece to him, I couldn't say what he would think about what I'd done last night. I'd not pushed matters; *she* had. I couldn't believe just how little talking had occurred. She'd stripped and stood in my bedroom, just beyond the light. I merely followed suit.

Each time I took her that night—and that's the way it seemed to me; in the last instant she would make you the aggressor—each time, images from *The Sort* filled my head. I felt myself press her body into distinctive postures reminiscent of those pictures, or anyway my pictures (the film was more discreet). I'd suggest a shape with my hands and she would invariably finish the job, so that I was surprised by just *how* I was taking her. These were ways she seemed to intend more than I, yet each put her in a pose classically associated with weakness, submission. Most memorably, she'd even gotten me somehow to full-nelson her, as if I were an arresting officer, holding her at bay. It—*I*—forced her head down unnaturally, making her witness her own penetration. Silently, though. It made me quiet, too. All you could hear were the springs in the bed and our skin slapping together.

I hadn't touched anyone properly since Claire, who was a quite different animal to Daphne, more tender but somehow also more sordid in bed, with a surprisingly foul mouth. I'd made out with a few girls here and there since she'd left, at parties of Immo's and John's, frequently with girls new to the city who seemed to crave authentic New York experiences via strange men like me. More lately I'd realized I'd mostly been intimate with them to prevent their fantasies from deflating. I was doing it for New York, you could say, defending its sex and myth, and it felt every bit the chore it sounds like.

Daphne was less beautiful than some of those girls, if beauty creates a sense of completion, balance, and harmony, if it can't be fundamentally uncertain, which is precisely the feeling her angularity, her four percent body fat, her assured gait produced. The woman's flesh seemed hitched to her mind so tightly that negligible changes of affect or conviction, the kind that are usually imperceptible to others and only known to us by the most careful introspection, when we choose to engage in it—all these minor modulations that don't matter enough for us to bother expressing them, they readily surfaced in her. Her body said *too* much, I suppose, so that psychically she blurred in front of you. Not like a Richter painting; those blurs were harmonious, very much intelligible. You didn't actually feel, in their presence, like trying to squint through them to something on the far side, to treat them as frosted windows rather than as objects of attention in their own right. With Daphne, though, when you focused on her, you couldn't help but peer straight through her. Her body *was* a window, and inevitably you felt, judging by everything you could see through her, that you were missing something about her nature. Many things, in fact, so that you wished you could grasp it all. Then, after this phase passed, you simply wished for her to disappear, to unburden your senses. And so I was happy to see her leave in the morning. I made no protest and doubted that she would hold that against me. She must have been familiar with this response, people's desire being drained by her—temporarily, anyway. Perhaps that's why she accepted my enervation so readily: she knew it couldn't last. And wasn't I already beginning to miss her? Not very much at just this moment, but I could feel that changing by the hour.

Garrett eventually called. I didn't pick up, though. I'd done nothing wrong, this wasn't statutory, yet still I could hear the blood pulse in my ears. I can't say she didn't seem to be *charmed*, as they say in certain parts of Africa, after she'd come back from the bathroom with a scrubbed face. Perhaps the night's climax would be described as my fault. She was nineteen and high, a business partner in the campaign, and a very fond friend of Garrett's to boot. *How could you not know better?*

Hoping to snuff out the gentle hangover beginning to engulf me, I slogged my way through a paper bowl of microwaved oatmeal. Whenever I ran out of perishables around breakfast, whatever time I might be having it, I always ended up back at oatmeal, a foodstuff with uranium's half-life, unlike, say, eggs (never mind that I treated them, at great risk to myself, much the same). The mere sight of oatmeal now, at home or in diners, invariably put me in mind of grocery stores, where I ought to be refilling my fridge, so that I might avoid this watered dust, made only slightly more palatable by a nugget of crystalized honey—another comestible I was sure could last forever, even though, when you kept it around as long as I did, it barely melted in the heat of the mush. Finishing up the bowl, I let possibilities of a conversation with Garrett roll through me, all the branching contingencies, how each might look five moves in. At some point, I knew they'd all converge here: *Couldn't I tell something was off with her? How could you contaminate the project this way? Did I not tell you she was almost a relative of mine?* The checkmate would follow soon after. I'd put myself far out of position last night, and restoring the defenses now, should the attack come, was probably impossible. Certainly not to my opponent's satisfaction. That's what made conversation different from chess: the rules, the outcomes which were to count as decisive or terminal, were not agreed upon in advance, so that what you regarded as an impregnable defense might be full of holes as far as the man on the other side was concerned, and no ultimate authority was anywhere to be found to settle matters. It was as though two overlapping but distinct games were in play; and despite my best efforts, even my great skill, I might lose simply for not knowing where the line was with Garrett, what would count as a conclusive defeat for *him.*

Which is all to say that, after the call, the whole project could well end up in the garbage. There was nothing to prevent that.

So I dialed.

He answered in one ring and I braced myself.

"Well?"

I hesitated.

"What do you think?"

"About her?"

He laughed a little distantly. "I have a feeling what you think of her. She called me."

"She did."

"She's looking forward to your first sketches for the project, I can tell you that. So am I. I mean the glasses, though. *Obscura.* You like that name for the line?"

"I haven't opened the boxes, actually."

"You can open them now, can't you?"

The boxes were still by the door, sealed in a curious metallic blue tape honeycombed with some sort of fiber—overkill, it seemed to me. Likely proprietary, too. I put the phone on speaker and went for a kitchen knife.

"We brought on people from some of the best places. Eyevan, you know them? Dita, Matsuda, even the son of the founder of Oliver Peoples. Just to seed things. Paul's idea."

I started working on the tape with a butter knife, my only clean blade left.

"But you know how I think by now. Every chance you get, you have to expand the gene pool, keep the mutations coming. Which is why I called."

The knife's almost notional serrations made no headway with the tape binding the top box, which, like everything else relating to Antral, must have been high-tech—created, I would not have been surprised to learn, to yield only to a razor blade and nothing else, and liberally used in all their packaging, whether consumer or industrial. Stupidly, hopelessly, I kept sawing away at it, as though the firm's R&D wing hadn't accounted for the powers of the humble butter knife. Prying at the tape, my last resort, disfigured my knife, bending it in two—nothing would make the seal give.

"You got them open yet? I think in one of them... well, Paul had everything packed. Have a look at the glasses and, you know, if you could play around, incorporate them into some of your drawings..."

"I can try." I was trying now.

"Paul tells me lots of people come into optical design this way—the way you are. Although you're more prepared than most, I have to think. Your home turf is the face! You won't have to *build* anything; all the technical stuff, fabrication, I'll leave you out of. I just want your DNA in this project, too. These frames are still just prototypes."

My DNA. I thought of last night and everything I'd done with it. That nothing about Daphne had come up yet, that he was in such good spirits, apparently—I didn't want anything I said now to inflect that. Who could say what she'd told him, or exactly how grave my misjudgment was?

"Sounds very good."

"Then I'll ask you one other thing, too, if you don't mind." Garrett sounded less appreciative than I'd hoped, the *if you don't mind* being patently rhetorical. Perhaps he did know about my indiscretion, and it was this that negated any thanks he might have otherwise felt. "Would you do some drawing *through* the frames?"

"They've got the actual lenses in them?"

"Have you *not* gotten the box opened yet? Still hung over, I guess."

He was peeved. And there they were again, those dreadful intimations I couldn't seem to escape. Nor would they come out fully into the light. My tormentor seemed to want to keep them where they were.

"Not really," I said, a new edge flashing in my voice. It surprised me, the velocity at which my fear had turned to anger. "I just don't have the right tools at the moment."

He chuckled, sensing my resistance. "Did you get something out of last night, the show?"

"Jeff was wonderful."

"Oh, you met him?" He was off-balance now, searching for words. "Wait, that's right. He does good work, don't you think?"

"What's he do for you, exactly?"

"*Exactly's* asking a lot."

"Beyond working with light," I added, "which is all I got out of him. *I* work with light. That says nothing."

"Or that you and he are more alike than it seems, right? It *could* say that. I never considered it, actually. *She*, though, she can be feisty. Did you find that? After the show, wherever you two went? I'll tell you something, she's basically a good girl. I hope you saw that."

"I don't really know what I saw."

"Well, I can't wait to see what you come up with. And to answer your question: yes, they've got Antral polymers in those lenses. My first love was plastics. How sad is that? I think you'll be surprised by them, though, what they can do. Someone as discriminating as you. Just try them out, once you get them out of the box. And enjoy the Bears. Take Karen with you this time, maybe. Everything's better with a girl, isn't it."

He clicked off. I wasn't relieved, exactly. Still, even after whatever he'd heard from Daphne, and perhaps Jeff, too, come to think of it, Garrett wasn't going to derail the project over it. I *should* have been relieved, that is, if he'd definitely gotten the news about last night. But why should he have? When a man meets alone with a woman like Daphne, you could form the very suspicions Garrett appeared to harbor about me without any evidence at all beyond the laws of nature.

The blue tape, though. I still hadn't breached it. So I opened the dishwasher, which had been off-duty for something like three weeks: I just kept sink-washing the same fork and plate and glass. Digging through the cutlery basket, I plucked out a steak knife thoroughly encrusted with fat—an instrument that had last been used, I believe, to dismember a gristly kebab from the street cart a few blocks over—and this time, it took only a flick of the wrist to slash open the top box, the tape gave so easily. I pushed aside the mountains of yellow tissue—how fragile could these glasses be?—and discovered a clutch of dark blue cases nestled in the center, like eggs in a nest. The smell of vinyl, or something synthetic, came to me at once.

Within the first case, I found frames with squared lenses, the temples tapering down to svelte ends. The whole thing was black acetate or some more exotic

composite material, given that it was nearly weightless—disconcertingly so. When I held the glasses at an angle to the light, the lenses gave off the mild rainbow shine of gasoline, and there was a bit of tinting to them, too, a purplish-gray hue. I put them on, expecting something like the visual effect demonstrated in those low-budget commercials for driving glasses with orange lenses that cost almost nothing, if not for the remarkable shipping and handling rates. *Good in the car and on the golf range, too*: the ads would start with a long over-the-shoulder shot, for instance, of a young buck of the fraternity system in a budget-friendly roadster. He'd be wearing the sunglasses, navigating a treacherous mountain lane with frightening ease, totally carefree, singing along to the radio, although he's just inches from plummeting off the cliff. Next we see a sunglassed man in his fifties, graying at the temples—could it even be the *same* man, later in life?—wielding a three wood on the range with familiar nonchalance. This time around, it's his lower back that's the hazard, but that's not stopping him from swinging free and easy, with a reckless confidence—the confidence he's always known, and which the glasses allow him, even as he ages, to retain.

What did I see through the squarish glasses I'd put on? Discriminating as I could be, I was at a loss to make out the spectacle's effects. They were nothing like those advertised driving glasses, as far as I could tell: no aggressive coloration, and no great cleavage of foreground from background, just a mild violet shading projected serially onto the other sealed box—it would turn out to house an entire *case* of Theria, which I'd not been informed of—the mural on my walls, the cutlery piled in the sink, and then onto the light itself as it came through my bedroom windows. I had to wonder whether these frames might be placebos of a kind, and Garrett, or Paul, more likely, was operating on some hypothesis they tested out on all their trial subjects: namely, whether I might see more in that violet shade than there actually was to see. I wouldn't have minded being fooled, though. If you could generate a psychic difference without a physical one, so much the better (and cheaper).

If there *was* anything to notice, I realized, it was going to take time to emerge. I'd have to watch for signs as I went about my business, just as I'd be doing with Theria, which Antral, it looked like, intended to supply me with going forward. *Ballast* was the in-house code name by which the nootropic sometimes went in the all-staff memos Paul and Garrett occasionally forwarded me. Perhaps for its stabilizing influence? Or was it rather for its closeness to *Blast*, which was pretty much the opposite of stabilizing? Did the word betray itself, and was this their point in using it? More practically, were they going to change the name from *Theria* to *Ballast* when the drink was released, or was the latter only for private consumption?

These matters never strayed far from my mind as I cracked open the rest of the eye-glass cases, spread them out around me, and tried the frames on in sequence. One had

rims so thin you wondered why they'd bothered with them. *Architect glasses* was what Karen and Claire called this kind, and not incorrectly. Unlike with the first pair, the lenses were uncolored. Were they different in other ways, too? Next was a sports frame, much meatier in build, yet molded out of a crystalline resin that made the entire body seem fleet and liquid. I hooked the tiny red elastic cord in the case around my temples and put them on. *The artist, headed to a pickup basketball game.* A suitable caption.

I kept those frames on while pencil sketching another, a bug-eyed pair with giant lenses and a gold metal outline embedded within translucent pink plastic, like something from Dior. My mother owned a pair like these, wearing them sometimes when she was in a playful mood, or if she *wanted* to be in such a mood. I could never take her entirely seriously when she had them on, which was a strange feeling, since generally it was impossible *not* to receive her in earnest, given the calm, somewhat severe tones she spoke in, underlaid by a hint of brittleness, all developed in the foyers of art galleries. I think that's why my father had bought the sunglasses for her, and much else besides—to take some of the edge off her.

All afternoon, I worked on the new optical drawings, scaling them up to twice actual size, wearing one pair while limning the next, until I'd gone through all the glasses and I'd achieved some dimension and polish with the pictures: the soft, chunky graphite sticks I used with overlapping strokes and light blending produced a reflective silver-gray tone that appeared to make each frame float above the white paper.

All afternoon, though, I was also wondering not about graphite but a different sort of medium: the very one I was looking through. Remarkably, the lenses made seeing itself pleasurable. I reveled in studying the various frames through them, ogling them almost, while pondering the manner in which each related to the absent human face to which they might be ideally appended. When I felt I couldn't proceed without some semblance of an actual face, however, I used the hand mirror lying on the ground next to me. I would gaze at myself bedecked with these advanced optical instruments but only put to paper the frame, so that my face remained a ghost, knowable only by inference. Large white sheets were my ground, cut from a long roll of paper with little tooth, not much good for charcoal or pastel but serviceable for graphite. I left much free space on the sheets, and later, in the early evening, over dim sum from a neighborhood hole-in-the-wall—those pillow-like roast pork buns—I conjured alternative versions of each pair, small variations, probably life-size but handled somewhat roughly. By the end, with the drawings all pinned up on the three walls of my apartment mural, I had a fresco of disembodied spectacles studying *me*. One even had eyes scratched in—the first drawing I'd done—just to orient me to the task of representing not just objects of sight, but *instruments* of it, too.

My hand burned from the careful work once I'd finished. I sat on the sofa still wearing the second-to-last pair, a rounded set of English glasses cast from silvery metal. My eyes continually darted around the room, often dragging my aching neck and head with them, searching, I think, for things to look at, familiar things, new things, anything.

Relenting to the new needs of my eyes, I got up and wandered my apartment for a bit. The disrepair around me was notable—at least from the vantage of my old partner. Remarkably, it was as if I were, for the moment, looking through Claire's eyes, and it was simple to see she'd have had no truck with the present condition of things. It wasn't that Claire was excessively neat, but that I lacked standards of order that were widely shared. Had she been here now, there wouldn't have been carpets made strictly of dust lying atop the floorboards, or caked dishes overstuffed into a washer that had idled so long it was really more of a filthy cupboard at this point. I'd run out of cleaning pods some time ago and only did the dishes—the absolutely necessary ones—by hand now, when I did them at all and didn't advert to paper or Styrofoam.

Most of all, my work, the detritus from it, at least, lingered everywhere, more than it had to or should. I had no good excuse for the state of things, certainly none that Claire would have accepted. What pushed matters beyond the pale, however, what made them unforgivable, was my paying for the entire floor below me—Kiver wouldn't consider letting me out of the lease, I knew, as he wanted me, my kind, here—without having the courage to sort through the Becker's orphaned chattel and make the space usable. Shame would overcome me on the ground-floor threshold every time I gazed through the spiderwebbed glass. Still, even without use of the extra floor, Claire wouldn't have thrown out the stuff I'd left scattered about, just organize or tuck it away in reasonable stacks for later perusal. Violet, it seemed, didn't work much like rose when it came to the tint of glasses.

Oddly, none of this troubled me too much. It all felt apt enough, given the man I was at this particular time in my life. It was, perhaps, not a life that I, the one looking through the glasses, might choose. It violated good taste, order, harmony. It had its incongruities. There was an obvious wastefulness and indulgence to it. Nevertheless, it was a life with life, and irrefutable evidence of feeling: for all the garbage, I was choking *mostly* on pictures, some of which, despite the wretched context, really did shine. I could see, then, and without much effort or insistence, this particular apartment's *point*, unlike so many nicer, cleaner ones; I could see, most of all, how the compost surrounding me might make worthy things possible, and conversely how a "gorgeous home" might abolish all fecundity in the name— of all things—of beauty.

I paused in front of the floor mirror next, which was beside the film room and positioned at right angles to the window at the end of the hall. It was an odd spot for a glass, so far from the front door, but then it had been there from those first weeks when I'd slept on the inherited couch in the screening room, which had no mirrors of its own. And though I'd long since moved to the bedroom, I would, even now, if the moment felt important enough, make my way down the hall to check myself before leaving the apartment.

I crouched in front of the mirror now, the last rays of daylight sitting on my shoulders and cheeks. I hadn't yet seen this pair of glasses in a mirror—this English, Lennon-styled pair. When I drew the frames earlier, I'd been thinking, without actually seeing them on my face, that they were the kind of frames that wouldn't agree with my countenance, indeed that it would look ludicrous on me. Now I could see this wasn't really so. I stayed crouched, examined myself this way and that, seeing what *sense* might be found in my own likeness. Something about these particular frames must have compelled me to keep searching. This was, in fact, frequently how I discovered an adequate subject: my interest would fail to wane in the natural way, and I'd find myself detained, paralyzed even, by sight. Is that what these lenses *did*?

I went searching for some paper, something with greater tooth. Beside my drawing board I found some toned sheets, a faint orange, just right for a portrait in autumn light. Lately I'd gone away from dry media like pastels toward the simplest of tools: charcoal and graphite and, occasionally, black conté. Now, though, seemed like a moment for color. From my bedroom I collected a set of soft pastels, secreted away in the closet—a recent and unexpected gift from Sarah, the one who'd taught me introductory drawing in college; the same Sarah, in fact, I'd stolen nibs from (out of love, I believe). These dense sticks were from an old private stock of hers I'd first admired in her studio, where she used to hold "office" hours sometimes. John and I battled for her attention all through that drawing course. As I remember it, I won, though he might have seen things differently. Sarah was legitimately beautiful, so attractive and beguiling you wondered why she ever bothered with something as cerebral as drawing. Why not painting? Or acting, for that matter? While she was also a teacher of real ingenuity, it had to be said that many of her pieces were more impressive for the canniness of her selection of materials—medium, support—than for the imaginative or compositional depths she achieved. She had a talent for integrating exotic specimens of both, a gift, unfortunately, that didn't always extend to execution. Yet my affection and respect for her remained undimmed; having a deep talent for *anything* was already rare enough. Sarah's pastels, apparently made in New Zealand and now discontinued, were the closest I'd ever seen to pure pigment, undiluted with binder. I'd remarked offhandedly on the luster of a sketch she'd executed with them,

and I remember her seeming distinctly pleased I'd noticed. (Had others not?) We'd kept in touch through the years; she followed my career with some admiration. Her own had risen only so high: nice notices, comfy academic posts, but lacking the racier undertones that were lusted after, sometimes not so secretly. About a year ago, I told her that I'd turned toward pastel and drawing, to the things I'd studied with her; a few months later, a box of her treasured pastels arrived.

Paper in hand, I sat before the mirror so that my reflection occupied only the lower third of the glass: proportions I decided to recapitulate in the composition of my sketch. I swiped a stick the color of setting suns along a test sheet and realized how much I missed the simple tactility of the medium, the feeling of the stick crumbling onto the support, the slightly bumpy, uneven resistance it generated, which decent graphite and most charcoals wouldn't give you. With my eyes red and slowly closing behind those effeminate frames, I began to dab my bespectacled face onto the paper and soon enough found myself estranged from the results. I'd never worn glasses; my eyes were better than twenty-twenty. More curiously, I'd never worn sunglasses, as I couldn't overcome the sense, no matter how subtle the tint, that the lenses stood between my gaze and reality. At the periphery of vision, the margins of the frame, I was continually reminded, by every sideways glance, of a brighter, more various world, one I could always get closer to by ditching the glasses.

Annoyed by my complaints about the heavy sun one day—often, I opted to keep indoors in canonically idyllic weather—Rick once pointed out to me that for creatures who evolved with just slightly different eyes, the world would organically look just as it did to me through sunglasses. What's more, he said, some sorts of spectacles might *enhance* one's vision, as ordinary glasses did for those who wore them, not corrupt it. It made no difference to me, though. I'd rather squint through a blazing sun than sit behind filters.

And so it was an unfamiliar sight—myself in glasses of any kind—that greeted me in the mirror today. It was almost like drawing someone else. Perhaps that's why *I* had so held my own attention. The first notable property of these circle glasses was that the violet tint, stronger here than in the other pairs, somehow *didn't* give me that queasy feeling of separation from the world. I felt no need to shed this perspective, I mean, even when I peeked out beyond the edge of the frame and saw the bright blur of life. I *wanted* mediation now, and preferred to keep my eyes straight ahead, away from the margins, in just the way the short-sighted do.

I worked on the picture slowly and deliberately. Lately I'd abstained from self-portraiture, which meant it'd been some time since I'd peered this closely into a mirror, a device that always put me in mind of the Renaissance, of perspective artificialis, of

Brunelleschi's original experiments, to wit, his mirror image of the courtyard fronting the church. I didn't adhere closely to the rules of this visual regime anymore. I'd stopped gridding out underdrawings. Brunelleschi's was one more point-of-view I wasn't much interested in occupying, whether or not it was an enhancement of vision, as it seemed to me you couldn't transpose a geometrical theory of optics onto rough and ready experience without losing something. Which meant I tended to deploy perspective selectively, to wit, whenever I ran into an intractable problem using more experiential methods. The impressionists had gone too far, but in their overcorrection was insight. The proper starting point, it had always seemed to me—the central datum to be accounted for—was the simple thisness of experience. It wasn't some immutable category. No, experience changed as our ideas about the processes of the world did. Yet whatever it was perception delivered to us had to be accommodated within our understanding, even if, occasionally, it was only by massaging theory into sensation that we could arrive at a coherent result.

About halfway through, my face began to emerge on the page, my long jaw, my narrow cheeks, the prickly stubble I frequently wore, my eyes of brown. I was myself no picture of serene beauty. I didn't look betrayed or forlorn, the way Daphne did, nor did I look wicked, as someone with similar features might. If I had the building blocks of menace, they came together benignly in me. But there was usually a rawness to my gaze, something undiluted in it, even when cut with a gentle smile, that preemptively cautioned those around me. I'd attempted at various times to suppress this brutishness with my accompanying manner: genteel elocution, gorgeous posture, all the things my mother had emphasized from the earliest days. (She had, in fact, helped civilize my father in some ways, who was exceptionally clever but also somewhat unregenerate, though *certain* matters of comportment relating to integrity or decency—like the manner in which one dressed—were ones he took deadly seriously.) Suppression, though, only seemed to shunt the unruliness in my heart right into my eyes, giving anyone around me advance warning of the volatility of my spirit.

The second I'd seen the round frames on my face, I'd been struck by the way they offset that rawness so effectively in the mirror, I suppose because they were the first line of defense against the offending objects that exceeded my control: my eyes. Yet now, as I saw my half-rendered face on *paper*, and I compared it to what I saw directly in the mirror, I was less sure of the lenses' efficacy. They seemed not to soften or shape my portrait, but to unsuccessfully perpetrate an outright deception, casting me in the role of the intellectual who relished distance and academic brinkmanship, cleverness and bookishness, all things that my natural face, for its part—and I was quite proud about this—exposed as a sham, or at most a half-truth.

Although these glasses remained, in themselves, perfectly respectable, and there was nothing *a priori* unreasonable about their shape or materials, when coupled with my face, I—the man behind the face—appeared, through the contrast they set up, *more* brutal than usual, not less, with cheeks so jagged you could follow them through heavy stubble. Was it just that the frames didn't suit my face, as we say? Were they an overlay that garbled my visage? Did they somehow manage to *lie* about me? Or instead, was it that they made my face confess its true darkness, revealing a physiognomic fact about me I might not even be conceptually equipped to describe?

I altered the self-portrait with a variation of the circular frame I'd dreamed up earlier in the margins: the lenses were slightly ovoid, neutralizing the monocle effect, the sense of affectation and dress-up. But as I began transforming the portrait to interpolate the new glasses, I could see that strictly speaking the picture was straying further from the physical properties of my face, even if I did appear less of a fraud. I decided to backtrack and further pursue the thing in the mirror—my face in the perfectly round frames—and the eventual effect felt to me like revelation, not distortion. Was the visual relief the lenses set the world in helping me to cleave more closely to underlying structure now, the structure that undergirds not only the skin you see, but the deeper tissue that can strangely lead you *away* from ultimate form? Yet as I kept on drawing and filling in detail, and the picture came to fruition, a less severe structure emerged, a kind of composite between the deepest forms that this enhanced attention revealed, coupled to a more finished rendering of the most superficial tissue, what the light did to my topmost skin cells, in the many shades of pastel I covered the surface with to capture it. My hand was in flames by the time I'd finished, but the drawing, as darkness grew outside, seemed to have taken on an undeniable force, even if it wasn't exactly pleasant.

That was with the glasses on. I took them off. Besides subtracting the violet tint, what else had changed? I took the drawing to my bedroom, where on the panel above my closet I'd hung four other self-portraits from the last few years. Though it lacked the polish of its predecessors—it was only a sketch—somehow it seemed to hold its own, assert its authority, which was grounded in its superiority in one respect at least, the one I'd discovered with the glasses on: surface and structure, tone and contour, clarified each other rather than simply dissolving into a unity. My skin complemented the musculature of my face and the lay of my bones without being entirely faithful to them, the cutaneous curves slightly varying from the fleshly and skeletal depths below. None of the layers asserted final priority, though together they suggested a convincing sense of articulated mass. What's more, this picture seemed to find a place for the frames within the broader structure of my body, welcoming them to my face, as it were. The element of caricature and guile I'd previously noted,

the kind that goes along with a fake nose and glasses, had also dissipated; there was nothing laughable about me now, not just physically but psychically. The final work disclosed the composite, fungible quality of personality, and demonstrated that there need be nothing untoward in this variability.

I hadn't emerged as markedly more handsome than before, I should say, but the circle glasses now resonated with something *in* me, something perhaps that was a less-than-beautiful thing, but the affinity, the congruence, couldn't be denied. I can't pretend to have grasped the optical properties of the glasses then, and their extraordinary capacity to affect my vision even *after* I'd taken them off. I snapped a few photos of the day's drawings and sent them on to Paul—as always, without commentary. Let him take the first chance.

22

I slept well that night, being truly fatigued in the best way. But I woke with a start around six. Kickoff was only hours away and I'd forgotten to invite Karen or so much as properly consider whether I ought to. One thing I knew: if I didn't text her right now, it would seem to her, from whatever time she woke today until the time I *did* belatedly invite her (supposing I would), that it'd been a fraught decision for me, and that she'd only made the cut in the eleventh hour. She would also have spent her morning feeling that, once again, I'd chosen to leave her to one side of the project's principals. Those kinds of hurt feelings, even when shown later to be unfounded, always leave a mark, simply from one's having had to go down a thorny psychic path: the pentimenti of the heart. *Other things to do*, a text came back almost instantly, dismissing my invitation. Why was Karen up so early on a Sunday? Maybe she meant her words in earnest, and not as retaliation for my having gone to see Daphne's show alone. No, she'd risen early to attend to these *other things*. Whatever she meant exactly, this was, for my purposes, the best possible outcome: I'd extended the invitation, insincerely enough, and she'd declined, leaving me free to indulge my solitude.

It didn't last. A few hours later, as I was getting ready to go, she wrote again to say that she *might* meet me at the game if she could. Here was the worst possible result, worse even than her definitely coming, as it introduced the kind of looming uncertainty that unnerved me most.

All the same, by eleven-thirty I was on a train to East Rutherford, the New Jersey home of New York football. I'd left early for the stadium to savor gameday properly, something I'd not experienced in five years, and never on this coast. I pushed through the turnstiles of MetLife, the hulking stadium housing two teams, the Jets and the Giants, though secretly everyone knew it was Giants stadium; the snake-bitten Jets would need a lasting renaissance before that would change. In catching a first glimpse of the field, I had to shoulder my way through the crowd that was already developing within the stadium concourse. The grass I discovered was almost shaggy, nothing like what you got out in California at the Coliseum, home of the Trojans and at one time the Rams and Chargers—that paler green trimmed low and flecked with bits of brown from perennial sunlight. Today's green was hard, overrich. I assumed it was rolled-in sod, bought from somewhere more hospitable and then scored with stark white lines. Lush and green, the grass somehow gave the impression of artificial turf,

probably because it couldn't really belong here, in East Rutherford, any more than that hemmed-in, electric green patch at Whent's place belonged *there*.

I knew my seat to be exceptional even before I'd reached the stadium, but it was only in making my way through the congested aisles, past fans carrying pre-game pretzels the size of faces, cubic feet of popcorn in candy-cane troughs, and skinny daiquiris a yard long, that the margin by which this seat exceeded any I'd had before became fully apparent. The players, the red-and-blue Giants and the blue-and-orange Bears, were already on the field, running drills, taking handoffs, stretching in poses that smacked of yoga. I spotted Manning, the second Manning, as it were, throwing fades to Beckham Jr., who was still in sweats and wearing headphones that dwarfed his head. By this point, with game time approaching, most of the players were deep into their warm-ups. But Beckham was operating in his own time, playfully one-handing passes in the corner of the end zone, which would have been pointless showboating if not for the fact that he caught a quarter of his in-game passes this way, stretching out for balls you couldn't get to with two hands.

I took my seat and scanned the field not for Duke Briar but Victor Skovsky, the new Bears quarterback and would-be savior of the club. The few others in my row were too deep in conversation to pay attention to me just now, so we got by with ghost nods and air-clinks, notable given that I had no drink in hand. Skovsky, I'd learned, had come straight out of the draft, a top-five pick. The front office was anxious to show off what he could do, and hence where the team's future lay. For eight years the Bears had staked their fortunes on Cutler, the petulant, permanent boy with the prodigious arm, a type-one diabetic with first-rate toughness. He flashed greatness, tantalized coaches with it his whole career, but in the end could never sustain it for more than a drive or a quarter or a game or two at best. The quality of his on-field decision-making plateaued prematurely, refusing to keep pace with his physical development. *He wasn't a winner*—it was pointless complicating that phrase. It said everything that needed saying.

I looked back into the luxury boxes and the darkened glass rebuffed my gaze. Were some of Garrett's people here, too? Could the ones beside me be on his payroll? If only I could have wished away these thoughts recycled from the theater; but they were inevitable, given Jeff's odd appearance in my life on Friday night. Unlike prior occasions, when my seat had been much closer to an end zone, and lofted in the sky, two or three decks up, the people right around me—I hesitate to call them fans—didn't seem like diehards, or even people who had much room for spectatorship in their lives. They were busy, I thought, making the money that could cover seats like these, or they were aligned with others who did. The man nearest, for instance, wore purple cufflinks with a shirt that, despite the French cuffs, was making a play at casual, a pinstriped

linen shirt that could equally well grace a boardroom, based solely on the fineness of the cloth. Immo's purple, those cufflinks, those socks. *Williams* purple: Steinbrenner country, as far as New York sports went. No, these people didn't seem much like fans at all—to my great relief. I would come off as an aficionado by comparison.

The seat next to mine was nearly covered up by the Williams man's stuff: a leather briefcase, an umbrella, a three-quarter coat and hat. I staked my claim to the remainder with the aid of my windbreaker; he took no notice. Only then did I begin to wonder, rather unpleasantly, about Karen and when she might show. I tried to keep my focus on the field, even if the game wasn't due to start for another twenty minutes, and I was helped along when my gaze landed on Skovsky. The quarterback had originally played hockey before his family, of Lithuanian extraction, moved to Bay Ridge and he morphed into a serious football man: American life could do that to anyone. Probably six-eight, taller even than Hank, the giant (this was the new way with quarterbacks), Skovsky was firing rocket after rocket in foreboding Cutleresque fashion, the ball traveling twenty yards without a hint of arc even though he was throwing flatfooted and, to his coaches' dismay, sidearming the ball. I certainly hoped he could bring more joy to this team, Duke's team, than his predecessor.

From my marathon sessions of sports television, which filled my apartment with a sham conviviality I depended on while working and living alone, I'd rapidly come to know more about the state of professional football at this particular moment than I'd ever known before. The Bears were off to a reasonable start this season: 2-1 and looking promising for the first time in a while. They'd not wanted to describe Skovsky as a franchise savior right after the draft, fearing they might jinx him and the city itself, only recently recovered from the Cubs' curse. The storied Bears were now thirty-five years removed from a championship, then won under a dyspeptic coach and an uber-cool if diminutive quarterback, Jim McMahon. Skovksy, who'd played college ball for Arkansas, had better mechanics, crisper footwork, than McMahon, and his size ensured that he'd almost certainly be more durable.

But a quarterback, as they say, can only be as good as his receivers. The Bears had traded away their veteran pass catchers to shore up a shaky offensive line, and they'd used most of their picks to trade up and nab their quarterback near the top of the draft board, though they'd spent a second-rounder acquiring a wideout from Ole Miss, Johnny Farrell. Which meant the man who was really making this season look, for the Bears, like something more than just the final year in a rebuilding effort, the man with top-three talent if not composure, was a mercurial undrafted rookie they'd just picked up for hardly anything: Duke. The win over the Chiefs last week, in Kansas City, had depended on him. Nine catches, one hundred and forty yards, including the grab that had brought them into range, in the waning seconds, for the

winning kick. None of this was surprising as such. The question was, could he deliver with any consistency? Today, say.

Where *was* Duke right now, I wondered, given that he wasn't the one on the other end of Skovsky's tosses? My mistake had been to limit my search for him to the field. There on the near sideline, dressed in Bears' colors, being earnestly counseled by three coaches—being talked into catching some warm-up throws, presumably—was number nineteen. He'd had to switch numbers for the pro game; no more thirty-two. He didn't nod or otherwise react to the staff's words, leaving me no way to know whether he shared their views or even understood them. It wasn't indifference in his eyes, though, so much as a kind of focus tangential to sports. Whatever it was, he radiated tranquility, just as he had in that Cal game.

After receiving the lecture with due grace, Duke took up his helmet, which had been laying at his feet, threaded his fingers through the mask, and trotted onto the field. This was my first live glimpse of that trot, the one that had mesmerized me on tape. And to judge by the rustle of boos (his signing had been controversial), together with the attention of both teams' fans, including my tony neighbors who so far had seemed oblivious to all goings-on, it might have been *their* first look, too. Everyone in the stands collectively regarded this uncertain prospect, just as tens of thousands of others must have been doing throughout the city, at home and in bars and right in the street, taking the game in through one screen or another.

Duke went on jogging right past Skovksy. No look, no words. The vaunted college quarterback followed Duke with his eyes, assessing his new teammate with the languid gait that didn't suggest speed so much as power—prodigious, latent—and with it control: all things Duke wasn't going to summon yet, I knew, not until the clock had started. Ten yards, twenty yards, thirty yards ticked by before his glove went up, a faint little wave for Skovsky and his retinue with only the back of his hand—he didn't bother turning around. The coaches were motioning Duke to come back some. I think they'd wanted him to run a proper route, but he had other ideas. Skovsky didn't quibble, flicking the ball off his back foot with only a touch of bend, flaunting his own ease and conveying to Duke, or at the least to the team in general, that his own powers were every bit the match for the rogue receiver's. Both were rookies, after all, and most had expected Duke, before his college troubles became news, to fare better in the draft, and Skovsky worse, than the two of them actually had. Duke might well have gone *higher* overall than Skovsky, had it not been for the baggage. Which meant there were things to prove.

The pass was long. I couldn't tell if this was deliberate on the quarterback's part, to suggest Duke's sloth. In any case it didn't matter: nineteen leaned back, crouched a touch, and lofted himself into the air, a near-vertical leap with a graceful backward

slant to it and not much kick, right before two-handing a ball that looked borderline uncatchable. Not only that, he landed with the kind of poise that suggested, in-game, there'd be many yards after the catch, a Cal specialty of his. Instead of tossing the ball to practice personnel, Duke bent down and set it on the field decisively, like a heavy and fragile package, and went straight to stretching his hamstrings, as though warm-ups were over. Was one catch all it took when you were *this* good? They had Skovksy load up another one and send it sailing toward a receiver positioned deeper than Duke. This was more of a lob than a pass, though the sheer height of its arc evidenced the force this QB could muster, a power he would have to harness if he were going to throw effectively in the NFL. Remarkably, the ball got there so fast the receiver couldn't close his hands around it, which sent it bouncing off his chest. From a profile I'd read in the *Post* on the train to the stadium, I knew Skovsky's ball was considered hard to handle, but there was Duke, toward the end of the article, with a choice quote: "Put it on me, I'll be fine." If you could judge such things from a single pass—and Duke had caught the ball in a manner so impressive you probably could—well, he was right.

Nineteen was coaxed out of his stretches into taking a second pass, and this one, which came in just beside him, was a laser, the sort of pass only three or four quarterbacks in the league could manage. Without moving his body an inch, Duke picked it cleanly out of the air. Immediately he was back up on his tiptoes, reaching for the sky, stretching. An older man wanted to pass my seat. I stood up and he offered me a ruddy dewlapped acknowledgement as he brushed by and sat on the far side of the Williams man. His cable-knit sweater was too heavy for this time of year, but he appeared the sort who would've worn it in one-hundred-degree heat. A season-ticket holder type, he probably spent a lot of time on the golf course these days; but, once upon a time, at West Point or Dartmouth, he would have played good football, lining up perhaps at tight end. This, I thought, was the kind of man whose grandfather had probably lamented the mass dissemination of the game outward from the Ivy League. He was old enough, I could see, to have had some contact with that attitude himself, even if it was fast dying, or going underground, which is what actually happens. That sort of thing just doesn't die.

By the time I'd sat down again, Duke was sprinting hard on a diagonal, coming back toward his QB. After a fractional hesitation, Skovksy, showing real touch, floated a ball out to Duke, who—only then did I notice—was heading straight through a running back platoon lost in pre-snap rituals, making first cuts, hurdling imaginary tacklers, turning the corner. It was going to end badly, clearly. Yet Duke accelerated, looped right around the players, cut across in front of the ball just as it cleared their heads and picked it up off his shoelaces. He left the ball where it was and almost

skipped to the sideline. Where, after all, could you go from there? Even the running backs, once they'd figured out what had happened, were giddied by the improbability of it all. You started to understand how someone could begin to see himself as untouchable; you could also see how, the day the feat didn't quite come off, things might suddenly grow cold.

Three passes were enough for Duke to know his game was in shape. The team still thought otherwise, particularly a rotund, nearly hairless man with a headset, who I knew to be the Bears' head coach. Ed Cotter. I'd seen his martial baldness on SportsCenter only days ago, berating reporters. He'd been the last to counsel Duke before he'd caught a single ball today; this time around he was more animated. Advice turned to admonishment. Duke took it just the same as before, attending to his superior in a manner that gave little away. An encore from the receiver followed, a short post route—but now for a backup quarterback, as Skovsky was down on his knees, loosening up an apparently fickle back. The pass was more or less perfect, a better pass than anything the starter had thrown, finding Duke right between the numbers. Yet the receiver barely raised his arms, leaving the ball to recoil off his pads and skid in tiny circles on the grass. Duke looked over at Cotter and innocently held up his hands.

The recalcitrance was impressive—career-killing, perhaps, but impressive, given the struggle he'd just had finding a team. Clearly the ordeal hadn't cowed him. The shame was that it had surely further embittered him, which would only make him more of a nuisance to teams, for instance, through deliberate pass-drops like this one. Decisively contributing to last week's win would have also given him leverage to exploit. You ought to enjoy whatever power you have while it lasts, I suppose. What would ultimately matter to Duke's career was whether he caught the same pass in a game. Nothing that happened outside those sixty minutes of clock—even terrible, criminal things—counted for anything. That's what his raised hands said to me.

I wasn't the only one drawn in by Duke. The audible reactions around me to these inconsequential pre-game catches and drops confirmed as much. Whatever else he was, he was an All-American with freakish gifts, a player whose NFL life would have been off to a charmed start if not for the indiscretions that were so vaguely described by reporters, one was positively invited, by the shallowness of explanation, to assume the familiar script: girls, drugs, doping, bribes. But if that's what it was, why didn't they just give us the details? It's as if the specifics might reveal circumstances around Duke to be troublingly distinct from the misdeeds we'd by now accustomed ourselves to from athletes. ESPN took the central question about Duke to be how high he could climb in the NFL, if he stayed true to the game, at least on Sundays. Comparisons to Beckham were rampant, but he'd been parrying them for reasons he didn't seem eager

to describe. Some pundits thought Duke had better hands, better legs, and that he could really block, too, relished it. Could he turn out to be *that* good? Going by the number of fans in Giants jerseys tracking him on the turf rather than their own star, Beckham, you'd have to say it wasn't out of the question.

Many great college athletes, of course, failed to develop their nascent mythology in the pros. At the next level, they stopped seeming *possessed*. In my teens, it was Reggie Bush, the demiurgic USC halfback who even my father knew something about, following as he did, from some distance, all things Los Angeles, even after we'd moved away—including the Trojans. Simply put, Bush appeared, while in red and gold, to be of a different species when he was out on the field. Every game of his was touched by the supernatural, and everybody in California, not just Los Angeles, seemed to follow along, even if you weren't really a sports fan. It's why I knew of him even then. He was the second coming of Barry Sanders, the way Ty presented him to me. And, watching him, you couldn't much disagree. When Bush went pro, in New Orleans, there were flashes of that sublime instinct for gaps. Those flashes ran through his entire career—with five teams. He never succeeded in turning them into lasting light. As early as his second season, it was obvious he wasn't going to be the same man he'd been in Pasadena. As high as he could still leap, he wasn't going to make *this* leap, to feature-back stud. Sanders' legacy couldn't have been safer. Eventually Bush would end up generating far more interest for a sex tape with a Kardashian (at least she was the really famous one of the sisters, Ty liked to joke) than for anything he achieved on the field.

So what would Duke's path look like, given that Bush bore nearly every mark of superstardom yet showed himself to be utterly mortal, a creditable player but hardly a dominant one? For Duke's part, he bore only one mark, and it lived in the loose-limbed jog he was showing off now before kickoff: what he was able to do in that split-second at the apex of his jump, in a crowd of arms and bodies, with the ball raining down. Today, what people wanted to know was whether last week, his demolition of the Chief's secondary, was to be the exception rather than the rule; whether he would end up, like Bush, an athlete of glimmers alone, built for Hollywood, the C-list. The Giants' defensive staff, its analytics department—every club had one now—would have been game-planning for him all week, studying film just as I had, but with data-crunching tools to isolate his weaknesses, how he might be exploited or taken out of the equation. That, of course, wouldn't be a win *only* for the Giants. No, it would ratify the collective wisdom of the league and its scouts, in passing over Duke in the draft, a wisdom that extended to the Bears themselves during the offseason, before desperation set in and they'd been forced to make a late gamble on him.

I'd first noticed how Duke's reputation hovered over him while watching the USC-Cal game Garrett had sent me. The innuendo of the commentary addressed both a sordid history and his custom of dabbling outside the lines of fair play and good taste: the way, for instance, he'd brutally blocked that USC safety right out of the game, as if his primary line of business were concussing opponents rather than catching balls. You could see he enjoyed riling his coaches and quarterbacks, whereas Bush, as far as I understood it, was never thought a bad teammate, one who couldn't, for all his arrogance, keep the club's interests out in front. How much differently, then, would Duke's failure be understood, if indeed that's what lay in wait for him, as it had for Bush? I got the sense there were plenty of people rooting for Duke to fail, for reasons of poetic justice alone. Was it *this* that excited Garrett? The prospect of betting on a villain, and on the fates not specially punishing evil, as the Greeks believed?

The two captains gathered at midfield, over the Giants logo. The home team won the toss but decided to kick. Soon nineteen was back near the Bears' goal line, waiting for the ball. I'd not known whether Duke would return kicks at the pro level; he hadn't the week before, against the Chiefs, but then his broad success in that game must have tempted Cotter to expand the receiver's role and see what else he could bring to the team.

The kick came in low and flat, the ball wobbling in an ugly way, but still it had good depth. Not so much depth that Duke wasn't going to try to run it back, though. From five yards deep in the near corner of the end zone—the kick wasn't only ungainly but crooked—Duke cut back to the center and headed right up the middle, his lack of straight-line speed, or any appearance of even *trying* to run hard, fully on display. Who knows if he could have made better time if he cared to? What I'd witnessed before the game, his catch behind the running backs, certainly suggested he could, when it was strictly necessary, as in matters of pride.

This would have turned away some true aficionados of the game, never mind most coaches. It was almost a moral flaw in Duke's style. Rather than appearing a half-step quicker than the rest, as Bush did, he appeared markedly slower; yet he was almost Jedi-like in working his way calmly through the chaos. The first defender arriving downfield supermanned Duke and missed, flying harmlessly by, a perplexed wrinkle running through the length of his body before he skidded to a stop behind the action, useless for the rest of the play. From there, one after another, Giants ended up on their faces in pursuit, frequently overshooting him, incorrectly anticipating his course. Duke seemed a master at finding an unorthodox line up the field,

looping back, sometimes shuffling his feet on the spot before gently sidestepping another player. It had to be conceded, his nonchalance was effective. *This* was the way he searched out the right cut, explored the incoming line of defenders not just for *a* seam, but the richest one. There was the example of Le'Veon Bell, who'd once indulged in a similar running style, I knew, until his game deserted him on being traded to the Jets (not an uncommon happening, for that particular team). Yet Duke alone simultaneously gave the paradoxical impression of heedlessness and indifference. Doubtless he displayed elite elusiveness on this runback. But success couldn't last forever: around midfield, a fourth or fifth man tried his luck, but this one approached rather gently, mirroring Duke, Jedi against Jedi, before shooting for Duke's thighs and taking him down cleanly. The Giant had dug his crown right into the ball, expertly attempting to dislodge it, but somehow Duke hung on as he crashed to the ground at the forty-seven-yard line.

A screaming filled my ears, a hoarse, furious voice. Even amid the chaos of a football game it made me actually duck for cover. The Williams man looked alarmed, even reached toward me to give succor, I thought. But after taking a glance just behind me, from where the scream had come, he half-suppressed a derisive laugh, took a sip from his drink, and gave a mischievous, patrician yell of his own in opposition, being a man of New York. The scream recurred, and this time I made out a long, distorted cry of *Bears* in it. Turning sharply, I discovered a boyish man in a navy and orange jersey where I wasn't expecting to find one. Not one who yelled like that, in seats like these. Though I hadn't appreciated being deafened, I was glad that someone able to afford such a seat could also be so free with himself, with all of us. With crude joy on his face, the boy—he couldn't have been more than twenty, and maybe not even eighteen—went so far as to squeeze my shoulder; and instead of shrinking away, I watched myself patting his hand in return. Our ensuing exchange, however, which took place during the television timeout—football was structured around these two-minute intermissions—disappointed in at least one respect. The laws of economics, it turned out, had *not* been challenged by his presence. This was really the seat of his moneyed grandfather, a season ticket-holder of long standing going back to the days of Phil Sims and Lawrence Taylor. Usually, when the old man wasn't free to take in the game, he gave his seat away to business associates (just what sort of business I never learned). Today, at any rate, the ticket had fallen to the grandson, who'd only recently graduated from high school and was in from out of town with his father, the businessman's son. The boy had come alone to the game, though. His father had things to tell *his* father, who wasn't in the best of health.

But this young man—Oliff was his surname—was the third to take the name Henry, and he was here to cheer on *his* Bears, never mind his granddad's eastern

alliances. And it was clear enough to me, simply by the strength of his accent, which was much stronger than Garrett's, that Henry was no child of privilege, nothing like the Williams man or his associate with the dewlaps. He was here, he told me, because he might take a clerical job at his grandfather's firm. Which meant this might be a taste of his new hometown, though not his new team, of course. You couldn't just switch allegiances as you pleased, and he, in his Bears regalia, was good enough to know that.

Henry was large but athletically built, something of a rarity as I looked around at all the indulgences in the stands, the nachos and tall boys and foot-long brats. There were plenty of hulking men and women here, but few whose size suggested strength, which stood in contrast to the players on the field, even the fattest of whom were in fact frighteningly powerful; those men would die of heart failure, yes, their brains would clot with tau proteins, but for now they were strong. Not so for the fans. Even the Williams man, though not fat, had withered and wilted, losing all the vim of humankind. But young Henry (the Third, technically), he was ruddy and alive. You imagined he could actually engage in a backyard game of football without collapsing in exhaustion after two or three plays. He had the forward, squared shoulders of a lineman who hadn't, unfortunately, been able to bring himself to overeat enough to hold his place on the team. Henry was going to live a long time.

Though he seemed genial, I did notice him sizing me up. Truth be told, I don't think he was much impressed. Why should he be, really? I looked a lot like the Williams man. Even if I was more casual than he was, my T-shirt today was too finely finished, effete by Henry's standards. *Most* of the people in the vicinity looked like corporate types existing at several removes from the game, and I must have appeared like the moody child of one of them, no less than Henry appeared the dunderheaded progeny of another. Beneath the skepticism, I thought I detected a certain warmth in him that was the upshot of this kinship: brothers who'd taken different tacks yet came from the same stock. At first I pushed away from his familiarity. But when I had to explain how *my* ticket had come to me, the look of recognition he gave me, of like meeting like, compelled me to admit he was basically correct, even if my benefactor wasn't my grandfather but my client, Garrett.

I told him I was here to see the Bears, *his* Bears, and that I'd heard interesting things about their new receiver, Duke Briar. That's just when he waved me off, froze. As the ball was being snapped he pointed to the field: the first play from scrimmage. Apparently he had a sense of reverence and ceremony when it came to the game. One had to bear witness in the right way; talking over the inaugural snap would be wrong. What his team delivered then was perhaps *the* platonic NFL play: a simple draw up the middle, good for four yards. The crowd, appropriately enough, had no discernible

response. Henry let his arms back down and went for his beer. I wondered how many he'd had before I'd arrived, and how many were to come before we were through.

It wasn't long before he was regularly clapping me on the shoulder, and I had to admit to myself that we were incontrovertibly watching the game *together*. Ordinarily this would have put me off, but I felt an odd, almost silly sense of camaraderie with him, this devout fan who'd come all the way from Chicago. Probably it was a grave flight over, given what he'd had to discuss with his own dad about the grandfather's failing health, the settling of affairs; but here the youngest Henry was at MetLife, oblivious to all of that, perhaps by the designs of the Oliff clan.

Henry got even friendlier as time went on, leaning right over my seat, plastic beer cup in hand, nudging me meaningfully at every turn in the game. He saw the pad I'd brought along, too, and even boldly reached down for it before I was able to push it out of sight with my foot. I told him what I'd be doing later on with it, though not to what purpose. He seemed pleased enough his team had an artist's eye trained on it.

He started explaining things to me, just to help me along in digesting the on-field action, while the Williams man checked in on us quizzically from time to time, taking the measure of this new friendship that had sprouted in a part of the stands, the rich part, where few bonds ever formed. The Bears were short on good receivers, Henry noted. They'd taken one early in the second round: Johnny Farrell out of Ole Miss. *You know about anything of this?* his look seemed to say. I did. Farrell's ceiling was a lot lower than Duke's, but his game was more polished, which meant he'd be immediately productive on the field, not a project the coaching staff would have to work on before seeing consistent dividends. With just three games in the books, this piece of conventional wisdom was already looking dubious. Dropping dead-on passes, being manhandled off the line, getting into his breaks late, Farrell's follies had contributed to several picks. The occasional double-coverages thrown at Farrell—opposing coaches always did this to rookies, to test their nerve—had led to a clutch of offensive pass interference calls against him. He'd fumbled three times already, too, defenders jacking the ball right out of his hands.

Duke, though—Duke was actually making things happen, Henry declared cool-ly. This was really just his third game, since he'd only played a few downs in the season opener. He'd only been *signed* a week before that, so even now he was probably shaky with the playbook. Yet already he was seeming like the surer bet than Farrell, whatev-er the baggage he brought with him. Baggage hadn't stopped Dez Bryant, right? And what about Beckham, making game-breaking plays through all the drama? I could see Henry enjoyed blitzing me like this as we watched. I think he'd assumed this level of detail would be too much for me, that it would prove his fanatic bona fides,

not just to me but to all the bankers and lawyers in our midst, showing them that when it came down to it, he belonged here more than they did. I didn't flinch. He was right about them, but not about me, not at this moment in my life, after sports television had entirely suffused my being. He had no idea just how much football I'd been watching the past months—exhibitions, pre-season games, even the Canadian Football League—far in excess of most sports fans, and maybe even more than him. Only a sick man could do it.

The next two plays of this ultimately futile three-and-out drive found Duke, not Farrell, drawing the double coverage. How quickly assessments in the league could change: Farrell had a couple of bad games and already he'd become an afterthought for the opposition. It must have made him furious, and fearful. The Giants were effectively daring Skovksy to throw to Farrell. So he did. On second down, Farrell caught the ball on a little curl route near the far sideline, yielding three or four yards. The Bears went to him again immediately, on a play-action bootleg. He was open coming across the middle but dropped the ball, flinching at the safety who'd set up to level him. Cotter yanked down his headset and whipped around to him in full glower. Coach had to be genuinely crazy, Henry said, to be this upset a few plays into the game, particularly since the doubts about Farrell were already starting to get old. He might just lack the nerve for the pro game, the rap went, and this sort of cowardly drop only reaffirmed the suspicion. In fact, Cotter was famous for his aggression, recalling Ditka, the menacing leader of those eighties Bears squads. That's how Cotter had won the job, actually, on a mandate of putting fire back into a franchise that had fizzled decades ago. It's why they'd let him sign Duke, a wild card but a winner, too, and winning—whatever the cost—was all the Bears calculated for these days. Yet so far, on this opening drive, Duke was a non-factor.

He never seriously got set along the line when the ball was snapped, and he didn't push himself, accepting somewhat too readily that the double team took him out of play, that Farrell would have to carry the load. Not the *ideal* attitude in a decoy receiver; you couldn't fool anyone so half-heartedly.

As the Giants took over after the punt, which was fair-caught, I turned to my sketchbook, a full-sized pad, and began to lay out Duke's kick return on paper— mostly to have a reason to disengage, at least temporarily, from Henry, who was yelling a series of qualified *shit*s and *fuck*s in Manning's direction as he got under center for the snap. I'd have to dump this sketch as soon as I was home. It had no authority at all, and authority flowed from the right beginnings. You couldn't build up to it or add it in later; it could only be preserved. So I kept retracing the first faulty lines, reinforcing errors, suggesting wrong volumes and misapprehensions of the field's geometry from my unfamiliar vantage. Still, it was an effective shield from

Henry, which is all I needed it to be. For a moment he was looking over my shoulder, impressed by what was actually abysmal, before I threw him a stern glance and put my hand on top of the drawing. He leaned back and chuckled, and soon after went off in search of the bathroom and another beer. Really I was passing time until the Bears had the ball back, but the opportunity wouldn't come for a while: the Giants, a perennial hit-or-miss team, were looking strong so far, steadily moving the chains with a recently revived running game. And the Bears, Henry admitted once he'd returned, quite collegially, with two beers, had a leaky defense. He sat next to me, in fact, in Karen's vacant seat. Luckily he was quite comfortable talking to me without my having to look at him, easing things substantially. It pained him to speak ill of the franchise, long famed for its defensive prowess, but it was the kind of thing you couldn't shade without losing credibility among football fans. And so he was dismayed but not surprised that the Giants were effortlessly finding first downs. But the Bears would tighten up, he assured me, or himself.

Perhaps, but not now. The Giants marched seventy-five yards down the field, Beckham caught a couple of short passes along the way, and the drive was capped by an improbable fourth-down Manning touchdown scramble from seven yards out—apparently the old man could still find a way. Henry groaned theatrically, and the Williams man hooted mockingly. There were many gentle *heys* and *yeahs* and *all rights* from right around us. This was as loose as these professionals could get in public. You couldn't say who said what exactly, and I'm sure they preferred it that way: close to the vest, even on their day off.

In the event, the scramble was reviewed and the score waved off: Manning had, as fate (and Henry) would have it, stepped out of bounds at the decisive moment. Yet the Bears didn't do much with the ball after getting it back. In fact, what I remember most vividly of the game, and this is a sure sign of a moribund contest, is the punting. The Giants had one of the two or three best legs in the NFL, and their man Mahoney artfully pinned the Bears back deep time and again. His counterpart took a more primitive approach, evidently kicking the ball as far as he could each time, without much thought to strategy, which led to a series of touchbacks. Most disappointing, from my point of view, was Skovksy's only throwing to Duke a couple of times. Tight coverage was part of the explanation; the Giants seemed intent on not letting Duke get going. Henry also mentioned the receiver's *lackadaisical* route-running (when else did he use this peculiar word?). The Bears might have felt they had to throw to Farrell, Henry said over his third cup of beer, the one he'd brought back for me but reclaimed for himself, sensing my indifference toward it. They had a lot more cash committed to him than to Duke, after all. The problem was, Farrell appeared to specialize in dropping balls, the easy balls you couldn't drop and stay on the field for long.

The stadium Jumbotron replayed these botched catches in slow motion—red meat for the home fans. If the Giants themselves couldn't do anything special on the field, the video staff could at least humiliate the other team. For the Bears, Farrell was the biggest embarrassment of all so far, the sore point to be worried by anyone interested in heckling Chicago. Henry wasn't going to sweat it, though. What was happening with Farrell happened all the time with rookie wideouts. Either nerves threw off their timing, or communication with their quarterback hadn't emerged yet. Getting a passer in sync with his catchers was the hardest thing an offense had to do. So what if it hadn't happened yet? The season was young.

Chemistry—and Farrell must have been worried about this—chemistry *didn't* seem to be an issue for Duke. Early in the second quarter, Skovsky finally sent the ball his way on a broken play. Only shreds of the pocket remained. The quarterback scurried toward the sideline with his torso twisted back, ball half-cocked, looking downfield. Duke waved vaguely in the middle of the field. Skovsky was going to have to throw across his body, with his feet and weight going the wrong way. But the arm he'd shown off in practice, that backfoot bullet I'd watched him fire, gave me and Henry a good feeling.

Skovsky threw. Three defensive backs were closing in on this ball that, under the circumstances, didn't have much on it. All signs pointed to an interception or an incompletion; no one would have blamed Duke for such outcomes. But somehow, in the grand collapse of those three Giants around the Bear, we watched him come away with the ball. I couldn't quite see how; I don't think Henry could either. Nineteen had a defender hanging off his mask, yet he stayed on his feet. Like an ox he dragged the man three or four more yards. Now, it seemed, Duke was anything but aimless. A twenty-yard gain. Dear Henry nearly spilled his beer. This, I knew, was just the sort of catch Duke had made a living at in college. Everything had to break down before he could get to work.

In the end, the Bears' drive stalled. They got a long field goal for their trouble, and that was all the scoring there was by halftime: 3-0, Chicago. Henry, pleased we were leading—he adopted me as a Bears fan, and I felt like one in his company—escorted me to the concession stands, where we got platters of top-heavy nachos whose glinting orange cheese-sauce overflowed onto the ground in gobs, and would dribble off with any sharp movement we made walking them back through the concourses. Bits of jalapenos and ground beef would leave our plates this way, too. Henry bought himself another beer, of course, and smiled and pointed out the bar, all its liquor bottles, in case beer wouldn't do for me.

Something about Henry made me want to stay sober, though. He was right to sense condemnation in my abstention, though the problem wasn't beer as such. I

just couldn't possibly eat *these* nachos *and* get drunk here with him. There had to be limits. But the nachos—now that they were in my hands, I was happy to have them. There was no comparable foodstuff outside the ecology of the ballpark. You had supermarket and pub versions of nachos, but the cheese was never tangy enough, or the chips tasted too much of actual corn or grain, whereas the proper flavor was more like salted crackers than anything else. I picked at the platter as we walked back to our seats, making my way up a steep staircase that threw me, suddenly, into the open, with all that blue sky and green grass in front. By the time I'd taken my seat, the paper boat of chips was sagging ominously. I'd asked for extra cheese sauce, yes, but the man had gone too far. The soggy edges of the boat were beginning to give way; some cheese had already made it over the edge. I looked down and found a drizzle of orange on my pants.

Henry was laughing, holding his own nachos clear of him. A practiced hand, clearly. He could have warned me—this would have happened to *him* many times before—but he just kept giggling and chewing those filthy things. Even the Williams man seemed to be getting in on the fun, giving me a wry wink. So, with real disgust for the both of them, and a savage pleasure in I don't know what exactly, I took the leaky mess and tossed it like a pie, chip-first, into the aisle, splattering cheese in a wide sweep. The Williams man and the dewlapped gentleman beside him were aghast—and not only them. They wouldn't look at me. Good. At least there wouldn't be any more wryness. Henry's laughter finally subsided. He even stopped chewing for a moment as his eyes bulged incredulously. He'd pushed me to it, though. I wasn't about to feel bad. He closed his eyes momentarily, gathering himself, I presumed. Then he squinted at me, his face went funny, and finally, without warning, he slapped me on the back harder than he had all day, offering me his heartiest congratulations, being duly impressed, I suppose, by my utter disrespect for our luxury section, for the Williams man and his ilk. And just like that, I made the grade with Henry. It pleased me more than I would have guessed, which was the best kind of pleasure, the kind you never expected to find.

I was still licking encrusted cheese from my cuticles, even sipping once or twice from Henry's beer, when Karen showed up.

"Don't look so surprised," she said, inspecting the nacho sculpture I'd created in the aisle; it had taken about half an hour for the cheese to set like concrete, fastening the whole thing in place. I didn't know that I looked surprised. I probably wouldn't have, had I not made a friend I wasn't quite sure she'd like. I pointed rather lamely

to Henry, who was occupying her seat. He and Karen looked at each other and she introduced herself to him. She pushed her hand out to shake his, but he looked away. Despite his masculine bluster, maybe he wasn't so good with women. She was certainly pretty enough to make you nervous, particularly when coupled with her gentle assertiveness. Eventually I told Karen his name, because he wouldn't do it himself; he was busy chewing his soggy chips. He'd been fine to speak to me with his mouth full. I'd been listening to his mushy words, feeling the tortilla flecks ricochet off my face as he spoke. But, apparently, he couldn't open his mouth with a pretty girl around. He was stuffing in more chips without chewing, to stall for time and readjust his approach now that the girl I'd mentioned had actually turned up. I felt sorry for what was being lost: I knew it was the end of the Henry I'd been getting to know. From here on out, I would get Henry-in-front-of-a-pretty-girl, who was liable to be far less interesting.

The Chicagoan stood and gathered his victuals and moved down one seat. Already he was showing some semblance of manners, which didn't gibe with anything I liked about him. Why had I bothered hurling the nachos? Not for this! Now, if I were to do anything of the sort again, I knew he would feign surprise, even reproach, like the Williams man he was sitting directly beside, who looked alarmed once more but needn't have been. Henry would be a good boy from now on, I could tell already. Karen smiled softly at my former friend, squeezed his forearm to avoid any nachos debris further down. She appreciated manners in whomever she found them, even a heavyset teenaged boy in a stained Cutler replica jersey. I thought her kindness might encourage him to strike up a conversation with her, if only small talk. But it seemed just to intimidate him further. He doubled down on the chips, and when he ran out of them he got up almost immediately, saying he needed the restroom. On his way past me, though, he smirked at me admiringly. I think he thought she was my girlfriend. I'd *really* made the grade with him now.

"So, how was Friday?" Karen asked me.

Friday? Indirection wasn't her way, of course, but I'd not expected her to cut to the quick quite so sharply. The Bears kicked off just then to start the second half, so I paused in apparent deference to the game, as Henry had, and then, instead of answering her, I went straight for the pad at my feet. How could she interrupt me now, given how conscientious I was being about a Cosquer project?

"I thought you would have let me know something by now," she pressed.

This time I was saved by helmets cracking like gunfire. The returner's arms spiked forward and the ball fell to the ground. This was called the fencing response, the venerable diagnostic index of a loss of consciousness owing to blunt trauma. The Giants recovered the fumble, but players on both sides—is this half of what they did these

days?—gestured quickly to the sidelines for the gurneys. I'd been looking at Karen at the moment of impact, watched her head recoil at the shot. Even if you'd seen your share of football on television, I couldn't imagine a more bracing introduction to the live game. It would have confirmed for her every critical thought that had been swirling furiously around the game now for a decade: the CTE, the progressive loss of executive function, the violence it had induced in Aaron Hernandez, Junior Seau, Ray Rice, Richie Incognito, Kareem Hunt.

Karen murmured a few words while an unknown Giant got stretchered off the field. The downed man gave the ritual thumbs-up as he approached the tunnel, although the gesture was spare and meek. It looked like it cost him a lot, and indeed the Jumbotron showed his thumb twitching. But the crowd depended on this gesture: *everything's good.* On cue, a roar went up. Karen, not yet acclimated to NFL expiation, groaned in disgust, and I understood her, though I *felt* with the crowd. What sort of project had she and I signed on to? This must have worried her privately, the use of an NFL athlete for Cosquer business. Was it wrong to profit from this grotesquerie?

The second half was short on scoring like the first. I was sorry there wasn't some bit of magic for her, to offset the genuine fright the game continuously delivered even to its partisans. Not just that massive hit that greeted her at the start, but routine hits and blocks, often far off the ball. If that original demolition had left her speechless, prevented her, thankfully, from inquiring too closely about Daphne—*what happened? what did you make of her? why didn't you invite me along?*—the smaller, routine traumas of the game were enough to keep her silent, inducing in her only minuscule flinches. I could see Karen's neck tense each time, the skin going taut, and that tremor of her head as it retracted, cued precisely to whichever of the hundreds of on-field collisions happened to fall along her line of sight: reflexive responses to the unfolding game before us, from choice seats that made the experience as vivid, as gut-punching, as could be. Perhaps *too* vivid for all but the Henrys of the world—he who, when he returned to his seat behind me much later (I don't know where all he'd gone), would offer muffled cheers, no more voluntary than Karen's flinches, to the very same happenings on field.

Television screens cleaned up the game, distanced you from the worst of it. Tragedy in general depends on the gap; otherwise staged traumas become too painful to witness in tranquility. The pleasure is lost. I think this is what happened to Karen. She could find no peace.

Had she verbalized her troubled response to the game, I might have rolled my eyes. Henry surely would have, at least privately. But these physiological responses of Karen's were more convincing than any sermonizing. They displayed, in real time, how a football game, even a low-scoring one, amounted to a long procession of shocks.

The live game was nothing like the televised version, where commentary drowned out most of the field noise, which was anyway pulled down low in the audio mix. In person, from the moment the ball was snapped, there was a crunching to be heard as opponents of all positions collided all over the field. This crunch accompanied every snap, with infinite variations, depending on the particular nature and sequence of the collisions involved in a given play. No matter what happened, no matter which team benefitted from it, no matter if anyone scored or not, you kept hearing it right up to the whistle, this syncopated banging of bodies. And the fans ultimately came for *this*, not the scoring as such. Yes, they desperately wanted to win the game, but so long as they had *some* point advantage, as the Bears currently did, they were only too pleased, like Henry, to lose themselves in this percussive symphony.

As the game wore on, the music did change subtly. The athletes picked themselves up off the field a bit more slowly, and their movements, even their impacts, began to lose their original crispness, their bodies bruising like ripe fruit. By the fourth quarter, everyone would have been playing through a fog from their heads having slammed into the turf, and each other, dozens of times throughout the afternoon. In the end, four or five of them would be helped off the field by trainers. Two would end up leaving by cart. Yet I can't say I was genuinely worried for anyone's safety. No one was, it felt like.

Duke, anyway, seemed never to get caught by blind hits. He had a peculiar and profound awareness of space, and he used this gift to send player after player to the ground. In his dreams, Henry said to us, nineteen must have been a bulldozing defender, not a pass catcher. I was doodling by this point, mostly because tight coverage was keeping Duke on the margins of the game. We could see him trying to overcome this, wearing down the secondary with full-speed blocks and shoving his way through press coverage to create more space for himself. The result was two offensive pass interference penalties and a personal foul for unnecessary roughness, which brought back a touchdown run early in the fourth quarter that would have given Chicago some cushion.

By the fourth quarter, Karen's cowering was subtler but there all the same. She didn't ask me or Henry for any explanation of what we were seeing, as she knew I'd come to observe, not to teach, and any tediousness of that sort would only provide me a ready excuse for why I hadn't brought her along to meet Daphne. So we found ourselves sitting in our familiar, sturdy silence, with Henry hollering as quietly as he could and the Williams man and his friend slowly losing patience with the game of attrition before us.

New York had been threatening to score all day, and finally they managed it, tying things up at three with a chip shot from the left hashmark. With two-and-a-half minutes remaining, Duke returned a punt from his thirty, weaving back toward

midfield from the sideline, stepping around incoming defenders in his methodical way, creating rhythms none of them could dance to, four or five of them stumbling to the ground, some of the best athletes in the world made to look foolish. When the Giants finally brought him down, he'd made it all the way to their twenty. An incredible run, really, the second significant piece of work from Duke today, and once again a potentially game-changing one.

Skovsky went to him immediately, never mind the double coverage. The pass was slightly high but no one was going to be talking about the throw—Duke should have had it. Instead the nose of the ball struck his fingertips at the top of his jump and the pigskin went spraying dangerously downfield. On second down, the Bears picked up four yards on an option pass; on third, Farrell cleverly batted down an errant pass that was likely to be picked off. The Bears took the field goal. Three more points, traceable to Duke.

The Giants did nothing with their final drive. A quick three and out, a punt, and the Bears bled the clock down to nothing. Duke didn't even come onto the field for the possession. Henry was elated by the final line, 6-3 Bears, and in his exuberance spoke to Karen again, told her how she'd lucked into a *real* game today, even if it didn't seem like it to her.

I would have preferred a slightly less real game, so that she, my partner in this business, would have something more positive to leave with. She took it well, though. And I'd managed to get in four or five loose charcoals, including a quite developed one of Duke stretching on the sidelines, which I thought might be of real use to us.

Henry said his goodbyes speedily. His grandfather was anxious to see him; he had to hurry back. He came around into the aisle and leaned past me to shake hands with Karen; perhaps his team's winning had given him confidence. He offered me a fist-bump and pointed to the fallen nachos, now petrified at the bottom of the stairs—a surprise for the staff, he said with a chuckle. I laughed, too, though Karen was occupied feeling around in her purse. Henry took the first step up the aisle and again gave me the look: admiration for the prize next to me. There was something small I saw in his eyes. All his sports knowledge, his passion, was for a sport that knew nothing of him, except in those few moments during the game, when there was a brief lull in the stadium, and he would scream his loudest from the stands. Someone on the Bears' sideline, player or coach, had to have made out whatever bit of rude advice he'd offered the team. Wasn't that a *kind* of acquaintance? Yet that look in his eyes, just as he was leaving, told me how glad he would have been to trade all those moments he'd collected over the years for what I had with Karen. What he *thought* I had.

"Do you want me to go?" Karen wasn't looking at me as she said this.

"Why?"

"Well, you met Daphne on your own, so—"

"You can't be upset over that. It was convenient, that's all."

"Oh, no." She said it so plainly I almost believed her. "I just meant, if you and Duke will be more comfortable... It's the same reason I didn't show up at the beginning of the game. To give you time."

"You're Mr. Garrett's guests?"—a question in form alone. MetLife staff, from the jacket badge. I immediately thought of my nachos just below us. The speaker was short and Puerto Rican, that's the way she looked anyway, with tightly braided hair of black. She was chewing a giant wad of gum that looked like silly putty, and with each chew I could see the fillings in her teeth. She kept slapping the rubberized antenna of her radio while static intermittently came through its speaker, voices that were indecipherable without, I supposed, long experience with such devices. "Gotcha," she replied to the noise. Without a word to us she started moving quickly up the aisle toward the exits.

"Oh, you have to come meet Duke," I said to Karen, who seemed already energized by the briskness of our escort as we snaked through the concourses. We nearly lost sight of her more than once. The woman expertly shouted people out of her way, but strangely didn't bother with smoothing our way. I was left to watch for any glimpse of her silvery hoop earrings as they jangled. She would pause periodically, just when she was about to slip off our horizon. She had an unerring sense for exactly when this was, even though she only turned back once to scan for us. On that occasion, she actually stopped and waited for us to catch up, snapping the gum and speaking into her radio, which seemed almost to be her companion, her friend. When we got within a few yards of her, she gave us the briefest of reproving looks and speeded onward.

Eventually we entered a parallel arrangement of walkways meant only for staff and VIPs. It seemed to cut the place right at the joints, linking areas of the stadium you thought couldn't be so close together: the concession stands and the clubhouse, say. Everything was quiet in this alternate circulatory system: through the heavy concrete walls you could only barely hear the drunken yells of fans filing out. Without the crowds now, it was easy to keep pace with the woman, and in the new hush I could hear long spiels coming from her radio in BEV—maybe she wasn't Puerto Rican—though I still had trouble making out the meanings. We twisted in all directions, occasionally rising up stairs, before finally descending to the locker-rooms.

She walked us into an adjacent room. "You mind waiting here?" She asked us this almost charmingly. "He'll be out soon."

I thanked her and she was off.

"What'd you think, anyway?" I asked Karen as we both sat down.

"I've never been to a game."

"Not football necessarily."

"Anything. Any game."

"You looked... yeah."

"The players are so much tinier than on television. But they feel *way* larger."

"Too large."

"Sometimes. Yes. Sometimes..."

"What?"

"I wonder if—"

"What, whether we should be doing this?" I squeezed her hand and she threw me off just as fast.

"Not exactly."

"The game's voluntary enough, isn't it?"

"Wow."

"I can't cry for millionaires knocking a ball around. That's your turf."

"I'm *not* crying. I'm, I don't know."

"Maybe you shouldn't have come."

Through the open door we could see Bears trickling out of the locker room. Many had giant balloons of ice taped just under their knees or over their shoulders. One, a lineman who was bloated even without his pads on, came out limping in just a neoprene tank top and jockey shorts, with two assistants spotting him. After a win, spirits ran high. Even the lame, as much as they squirmed in pain with every step, wore the halo of victory, and that's all you saw in their eyes, even when their faces winced from the beating they'd taken.

Journalists crowded around, dashing in and out. There were suited men as well, one of whom swept the place with an aggressive gaze until it fell on me. He strutted forward at a good clip, smiling, his longish hair bouncing slightly and his brown lace wingtips clacking. The gray pinstriped suit he wore was cut a size too small, in a manner that was slowly but inexorably going out of style. The man flared into view under the strong light of the little annex we'd been kept in, some sort of media waystation that none of the reporters were actually using. Apparently they'd rather get their story in the locker room from half-naked men—and the players would rather give it there, too, saving them time.

"Here for Duke, correct? Arête?" he asked as stood in front of us. I didn't answer to the company's, or really the brand's, name. It still sounded alien to me, like someone else's possession, but Karen was quick to pop up and say yes to this man.

"Fred," he said, pumping her hand while studying me.

Duke's agent, Fred Hartley. His name had been cropping up lately on Fox Sports owing to his controversial roster of clients. He was talked about like some infamous attorney who loved nothing more than to defend evil itself, for its own sake. Not that it didn't pay well. He'd once represented the most untouchable of them all, Michael Vick. Now even Vick had been forgiven. There was nothing you couldn't come back from; I'm sure that's how Hartley saw it.

Karen gave her name to him but I didn't offer mine. I barely looked at him, aside from his predictably impeccable shoes. He retreated to the doorway, almost pulling Karen along with him.

"Duke's keyed up about this," he said. "Just let me get him."

Hartley scraped sideways into the Bears' locker room, his spotted blue tie ending up parallel to the floor as several reporters shot out trailing a tight end, a man of real magnitude who was dressed beautifully to boot. Suits rarely looked right on men of ordinary physique, but he was archetypal, so his garments' lines merged with his own. Two reporters carrying phones as though they were mikes came out next, and then, after a small pause, there was Duke, clad in a black stretch top, icing himself just under the arm, his ribcage. He was no taller than I was, six feet at most. Yet unlike me, he was constructed unimpeachably. Some of the Bears I could see around him, however, looked like cartoons. Whenever I perused those sepia-toned photos of leatherheads from football's early days, not one of them cut *that* figure. Syringes and creams must have been involved in turning men into such creatures, and in truth every year players were knocked out of the game on PED charges. But Duke was different: smoothly muscled, sinuous, with canonical dimensions; he was manifestly strong but also discreet.

"And *here* they are," I heard Hartley say as Duke stepped gingerly into the room. Duke pinned the ice under his right arm and offered his claw of a left hand. Karen took it in both of hers. I stood up, finally.

"So," he said softly as he looked us both over with big, cool eyes, "you'll be drawing me." He was the game breaker today—his halo was bright.

"*I* will," I said.

"And what are *you* going to do?" He touched Karen's shoulder and dropped his eyes while taking his hand back.

"She'll be writing about you," I answered.

Duke looked at her again. "Is he right?"

"Sort of," she said.

He laughed knowingly. He'd been a pro with the media since he was a red-shirted freshman; he conducted himself now with the composure such experience confers.

"Any headlines on the pictures," Karen added, "that sort of thing. But what a game you had!"

"He did, he really did," Hartley said.

I shook Duke's hand, realizing that, like a pianist's, his hands were his prized possession, the two things responsible for my being here today at all. He applied no pressure to my hand, simply extended his own to be fondled. Maybe he hated wasting them on anything but catching passes. This at least would explain why someone who'd been the center of attention for some time at Berkeley, a star, had the handshake of a forgotten man, the kind who'd have to go postal for anyone to notice him. Just as I was thinking of pulling my hand away from his, he squeezed it a little, to show a hint of respect, I thought, or else the opposite: to suggest the force he could generate if he needed to. Then, holding my eyes, he simply opened up his hand, this cavernous thing, so that our limbs were no longer in contact. The shake was over without my having moved an inch.

"That your sketchbook?" Duke asked.

"There's nothing really worth seeing in it yet."

"Well, let me know when there is," Hartley said. "I'm clearing everything." He thrust his card forward—it had nothing but his name on it in microscopic letters—clasped my arm, and patted Duke on his good shoulder with the authority of an age-old friend. From Duke's patronizing nod I was sure that wasn't true. He probably didn't appreciate his white handler pressing his client's rights just now, when he was here to do it himself, if the need arose.

"You really like football?" Duke said. "You follow it?" Karen and I hesitated. "I mean, you understand the game, right? The basics, anyway." He was on the cusp of disappointment or anger, it seemed, though all you could see in him now was post-game beatitude. You knew it couldn't last.

"He probably knows more than that," Karen said.

"Oh yeah?"

"A little. But I'd actually hate to know too much before we started."

Duke gave me a cocksure smile, as if offering me the look that should have accompanied my words but didn't. I think he was impressed, early resistance being so alien to him.

"We'll see, I guess," he said. He lifted his arm and let the ice crash to the ground. "Don't take me too seriously, though." He stepped on the ice, packed it down. Larger pieces broke into smaller ones. "You know when this happened?" He was massaging his ribs and squinting from the pain while leaning onto the ice and crumbling it with his weight.

"On the interception?" I guessed. "That tackle?"

"Nah. That's what they all thought, too. I didn't feel anything on that play. No, this happened on a nothing play. You'd never pick it out on tape. Middle linebacker

caught me with a little bit of his helmet, first quarter. I was feeling it the rest of the game, just barking louder and louder. I don't even know if he knew he hit me."

Hartley twisted around and segued into a new role—an agent played so many—that of bodyguard. He had the build, actually, of a former player, someone who was very good in high school but only average in college. At that point he would have washed out of the game, kept up his business and communications double major, and turned it into this, servicing (or fleecing) the players that actually did make it through to the pros. His resentment would have justified all this once upon a time; now agenting was just a lifestyle with endless rewards, like those shoes, that jacket. As if revisiting his playing days, he seemed to take an athletic pleasure now in sealing off the room from press stragglers. They'd had their chance with Duke already, in the locker room, and anyway they would have put to him the four or five questions they put to every athlete, every time, whether they were in the winners' or losers' locker room: *How were you feeling out there today? What makes this team so tough to beat? What was the game plan going in? What can you take from this game into the next one? Any niggles you're dealing with?* Beneath all this was the real question they had for Duke, one that had been asked so many times now it was pointless stating it again, though in fairness it was the only one of real interest at this point: *Do you really believe you're going to last in the NFL?*

Duke's voice dropped down low as he spoke with us, while the stragglers hurled questions that Hartley neatly swatted away. The receiver's tone wavered uncannily between the brusqueness of athletes and something more formal, reflective, almost academic. All this *interest* in him from the reporters seemed to drive him inward, so that I had to move closer to hear him, even cock my ear.

"You see me lay out those guys today?" he asked Karen conspiratorially. He turned to me, the arrogance returning to his countenance: "Did you draw *that?*"

I shook my head ruefully. "I can, though."

"But do you think it would make a good picture?"

"Depends on how it's done," Karen said.

Duke rubbed his chin teasingly, as though his imagination had been set alight.

"You know, though," I said, "I'm not sure how many straight football pictures we're going to want."

"I'm playing. I'm glad you're not doing too many of those. My friend Fred here tells me we're going more high-concept. Like the stuff you're selling, right?" He pulled on his elastic vest at the neck and it stretched a great distance, probably two feet from his torso. He let it back down and only then did I notice, in black on black, the word ARÊTE stitched right over his chest, with the diacritic transformed into a pictogram suggesting a severe and craggy peak. "This is beautiful stuff."

Karen leaned in to examine the fabric.

"It's got so much flex, it feels almost loose. You barely know it's on when you're running in it, but when it's back in neutral, when you're not pushing through it, there's real shape, support. Never felt anything like it." He tugged it one last time and it returned to form, holding his ribs in place like a soft cast. "And, I have to say, Theria isn't so bad either." A grin came over him. "Cotter doesn't know a thing about it, so don't worry. But that's what's in *my* Gatorade bottle."

The reporters' chatter faded as Hartley sent one beat writer after another packing with a glib comment or non-answer, and often a knowing compliment that couldn't have been sincere yet nevertheless satisfied them that a modicum of respect had been paid.

"But right now, I'm just saying hi to you, like, *Yes, I know you're here.* Obviously I'm not ready to go. Let me catch you in an hour? Two hours? The team's letting me stay the night here. My hometown. So I can nurse these ribs."

"Where should we meet?" I asked.

"I'll text you." He bent at the knees, keeping his back straight and lowering himself to the floor to scrape up the newly compacted ice bag. I gave my number to Hartley, who was done clearing the room, and he showed Karen and me out to the concourse.

I stood there in the wind that had kicked up, now that the sun was falling. Karen's long dark hair was slapping me in the face; she made no effort to prevent this. I took a step back to get out of range and she bunched her locks in her hands and winked at me.

"You want to handle this on your own tonight?"

"Why do you keep trying to—"

"All we know for sure is that there'll be drawings—that's why," she said. "They didn't necessarily want copy at all, remember? James especially."

"There will be, Karen. Just—"

"Oh, I guess I know that. At *some* point, there'll be something for me." She grabbed my hand, squeezed it, then put herself very close to me. I think she was accepting the apology she knew I'd offer about not inviting her to the theater, had I been a more straightforward man. "But why don't you get us started? He might speak to you more freely anyway, don't you think?"

I frowned as if I didn't quite understand. Really, I just wanted to hang on to her hand. Henry Oliff might have been right.

"I mean, to another man." She laughed and looked at me and grabbed me by both hands; her hair went back to lashing me as she leaned into me, or I into her. I felt the blood in her cheek.

23

At around six-thirty I arrived at a bar on the Lower East Side that Duke had picked out. I could have gone back to the city with Karen, talked with her, but instead I'd wasted half an hour in an East Rutherford bodega thinking he'd want to meet me in Jersey. So I rode the train alone again. Duke's choice of venue was certainly odd for a man who'd just signed with an NFL team: a basement sports bar festooned with the faded paraphernalia of the Green Bay Packers—the Bears' chief rivals. The place was shriveled, stricken by time, neglect, and changing fortunes. There seemed to have been a glorious past, but perhaps it was only nostalgia to imagine that these dirty and wilted things had once reverberated with life. All these placards, photos, illustrations, and replica trophies might have appeared even worse at that point, for lacking any history, even one of degradation; there might, then, never have been a time when this bar induced meaningful feelings in its patrons, not until they were several drinks deep, at least, and pretty much any place would do.

As I entered, a bouquet of skin, charcoal, and the froth of bad beer greeted me. Duke waved me over as I came down the few steps below ground into the dark and dirt of the place, next to a window that might have brought some relief when it was fully light out, but now only gave one a sense that the day was at its natural end. He eyed me steadily as I sat down on a thick chair made from unmatched boards of pine slathered in a layer of clouded lacquer, so that they looked as if bacon fat had dripped and dried on them.

Duke wore a white hoodie and sweats, and still had a bag of ice under his arm.

"Like it?"

"Never been before."

He let out a rumbling, croaky laugh, my first taste of his merriment, even if pain contaminated it. He clutched at his ribs, looked down at them as if they weren't his problem but someone else's, and he was simply inspecting them out of politeness. "You don't like the place," he declared. "That's okay. It's not great."

I admitted my feelings with a shrug.

"It's simple, really. I used to live right *there*." He pointed up, out of the grated, water-stained window, into the night. I turned and saw the lights from the tenement building at the end of his finger. "My mom and dad moved back to Chicago only a few years ago. So the Bears are a *dream* for them. They want to keep an eye on me, after everything they've heard. But tonight I'm going to be in the old building with my man Bryan. Just because of the ribs... well, and the leg."

"What happened to the leg?"

"It started cramping hard after I got dressed. Now it's real sore. I didn't notice until the car ride was over. I'm going to need *all* of this." He took a shot of something or other and then downed a third of his pint. "I told Cotter my mom was here visiting, I think that's why he went for it. He's not as bad as they say. Freddie made the case, came up with the idea. He's been working with them ever since I signed. I don't know what he said exactly, but I guess you can tell, he says good things. He's worked with a lot worse than me. Heard of Maurice Clarett?"

I vaguely had.

"Bad example maybe, what happened to him."

I went up to the bar and got myself an IPA, and when I returned, without my asking, he began to tell me things. Perhaps this was to control just how much he divulged, and what. For such a young man, he was an old hand at dealing with doubts and questions. He'd also probably recounted the narrative of What Went Wrong so many times, the story that made sense of his peculiarities, now polished over dozens of tellings, that he didn't, for his own sake, want to have to go at it piecemeal. I hadn't really intended to talk extensively with him on a first meeting, but if *he* wanted to speak, I could certainly listen.

"We were doing pretty well here, in the city." He pointed up again at his old building. "Chicago was harder, but it was never that hard on *us*, my family. Not next to people I knew." His mother, it turned out, was the bookish one (there had to be one somewhere to explain Duke's makeup), a pleasure reader of novels and monographs. That meant no television for the kids, no internet after five, nothing of the kind. He had an enterprising dad, in household supplies and hardware, who took the first opportunity, a decade in the planning, to move his family to New York and open a storefront with a white colleague of his from Chicago. There were siblings, too, two brothers and a sister.

"I was ten when we got here—the second child." Duke sipped his pint and looked at me squarely. Now that he'd set the stage, made his opening move, I felt him waiting for the familiar pressure of an interlocutor picking a line of attack that he'd then counter, run around. But I asked him nothing. I wasn't a journalist. I was there to look more than talk; I don't think he understood this. So I simply got us a couple of beers when we'd finished what we had. I didn't need him to do anything in particular for me, *be* anyone in particular. It would have been rare in his life to meet someone who took this attitude toward him. Perhaps it's rare in anyone's. Now that he was talking, my only aim was to steep myself in his stories, the truths, the falsehoods, so that he'd rub off on me, on the drawings. *What* rubbed off exactly didn't matter. But he couldn't have known this, that I wasn't a truth-teller attempting to limn his

person. He might not have even agreed to the project if he knew how cavalier I was about it. For this reason, I adopted the studied silence of the psychiatrist, yet without the physician's purposes and principles, the Hippocratic oath. Intervention, dialogue, I knew, drew out not half the gems a well-timed series of nods could. Girls had taught me that, actually.

"What *is* that rotting in here?" he asked. "You smell that? I've never figured it out. But when I was sixteen, coming in here with a fake ID, it all smelled like roses to me. They knew it was fake, too. Didn't care. My dad's store was a few blocks from here, down near the river. It was there for a decade. Whenever I'd walk to it, I'd come by this place, look in this window, looking for friends of mine, the older ones, when I was too young. The store's gone now. They've got something better going on back in Chicago."

He studied me. Again I felt he was trying to induce me to probe, to search. And again I declined, focusing instead, and quite happily, on my drink, which negated the rank odor, or anyway reduced it to just one, of bad pale ale infused with the taste of ash. I was feeling intrepid enough to order food, maybe some loaded potato skins, but Duke grabbed me by the forearm, pleaded with me not to give in to a temptation I'd regret indulging.

"Want to come up?" he said. "There'll be something or other in Bryan's fridge we can hit. He's not home yet. Probably the best time to see the place."

I didn't understand.

"Wouldn't it help you, with all this? He was my next-door neighbor."

I squinted at him slightly.

"Look, I don't know *what* kind of shit you want out of me. Freddie didn't really explain. But Bryan's place is a lot like mine was. Not as nice, but a lot like it." He swung his stiff leg out from the bench seat it'd been resting on, a posture that had kept his body rotated slightly away from me since my arrival. "Anyway," he added while probing his thigh, "I want to put some heat on this."

Bryan's apartment was a two-bedroom affair with ceilings of reasonable height and fresh white paint everywhere. Nothing fancy about it, yet it was sharp-edged and clean, not at all like the bar below, or, for that matter, my own home, miles north.

"Our place was down the hall, just over there."

The lights dotting the hallway ceiling barely glowed, so I couldn't see the door Duke pointed at on the way into Bryan's apartment. I wouldn't have asked to come here, not so soon, as I had no very developed thoughts on how I was going to proceed with Garrett's project as it related to Duke. I was prepared, actually, to dream up most

of him, including his history. None of Garrett's or Paul's instructions contradicted that. Duke was, of course, feeling me out tonight, getting some sense of my angle and aims. It was making him slightly wary of me, clearly, but this was no game on my part. Although I knew I needed to spend some time in his presence—and Daphne's, too—that's about all I knew. Nothing could be ruled out. He was right, then: maybe coming upstairs *would* help. With nothing else occurring to me, I took out my phone and held it up as a camera, out in front of me, and waited for Duke to load a plastic bag with ice from the freezer and come back and see what I intended to do. No surprises, not so soon.

"Yeah, yeah, fire away. That's why we're here."

I started snapping without much consideration, my usual way, when I bothered with a camera at all. I took pictures of the light fixtures, the moldings, the views out of all the windows (mostly unexceptional). Then I went out down the hallway, toward Duke's old apartment, shooting the faint lights above as I walked.

"I've been sitting on this couch of Bryan's," he called from inside, "for over a decade. And it's still stiff as hell."

I came back across the threshold and shot the L-shaped sectional, long and red, that marked off the living room from the dining room: first the bit with Duke on it, then the segment without him, or all but his iced leg, which ran right down it.

"These are just guides," I said. "Nothing serious." But he wasn't listening, he was closing his eyes and sighing deeply, thinking of his pained body, of the flight back to Chicago tomorrow, of the game next week. Of everything but me and my pictures. While he meditated, I roamed farther afield, taking snapshots of each of the bedrooms, giving myself the largest range of materials to work with. I had a strong memory, but it'd softened a bit from disuse, the outsourcing of psychic duties to phones and pads and all other screens. I never leaned heavily on photos while composing. I'd tried doing that back in school and never cared for the results. The Rockwell effect, I called it. The function of these pictures, if I ever looked at them again—and there was no guarantee, just like the study notes one takes but never refers to, because writing them down sufficed to engrain them in the mind—if I looked at these pictures again, it would be merely as triggers to memory, which might lead me back to the living pictures of the imagination. This is why I took many of them, and so heedlessly: so that they might possess the unframedness of ordinary experience.

I was at the threshold of what looked like Bryan's parents' bedroom when Duke spoke again: "What exactly are you thinking of drawing? Because I sort of don't give a fuck." He laughed hard but briefly as a whine came from his lungs, his mirth punishing his inflamed post-game body. "I get the feeling that's why you're coming to me in particular. Not you. Arête, though. Why else? I didn't even make the draft.

It's not like basketball. We've got seven rounds in football. And I still missed it. Only other thing is, maybe this guy James has got some serious Cal nostalgia."

I returned to the living room and slipped the phone away, I hoped for good.

"I thought my shoulder, my ribs, was the worst of it, but now I can't tell." He had ice on his neck and his leg now.

"So... why Berkeley?" I asked bluntly. Why not? It was what came to mind.

Duke's brow furrowed a moment. "Why *Cal?*" he corrected me. "Well, why me? How about you tell me that first?"

"You should ask my boss. I didn't pick. Freddie probably knows more about it than I do."

"They wanted me, for one."

"Cal?"

He smiled.

"I have this feeling," I said, "this wasn't just about an athletic scholarship for you."

"So you looked me up, I see. Well, I like football. I like smoking dope with Bryan and my crew. And I like selling it—*liked* selling it, I mean. But not really: just fucking-around selling it, small-time shit. *Oh, the people you meet!*"

"I believe that."

"What you're really asking is, do I like books. Yes. *Hence* Cal." He was toying with voices, though I wasn't sure whom he was mimicking. Someone with a sort of pan-European accent, certainly a non-native Anglophone. Someone *not him*, maybe that's all that mattered. He pushed the ice bag off his thigh and started gingerly flexing his knee. "You been reading about me?"

"Believe it or not, James told me not to."

"Well, I don't really believe it."

"If I knew more about what we're doing exactly, or how we're doing it, I wouldn't be taking random photos and saying a prayer."

"So you're meeting me for what? "Inspiration"? We've got room to fuck with then. That's what *that* sounds like."

"And why you, you wanted to know?"

"I do."

"I guess you've got other things going on besides football."

"*Other things?*" He pushed up violently with his arms and stood on his bad leg, keeping his knee locked.

"That's got to be part of why."

"There's plenty of *other things* to pick from, yeah. A lot of these players, let's be serious, they're dumb as dogs. You and me aren't like that, though, right?"

He was standing over me, biting his thick upper lip, exposing the brilliant pink innards of his lower one. He bent awkwardly at the waist, keeping the leg taut, and dug under the couch, into the lining, one section at a time, starting with the one farthest from me. As he moved along the couch, he pulled off the cushions and let them tumble to the floor. Eventually he got to the segment I was sitting on, closest to the window. I popped up and he flipped the last cushion and stuck his hand deep down into the crease near the arm until a smile emerged on his face.

"The final part of my post-game treatment is this right here." Duke pulled his hand out and brandished a roughly hewn pipe and a plastic bag, one inch square, with oily brown sludge in it. He pinched off a bit of this sludge, whose pungency, as soon as he unsealed the bag, revealed it to be hash, and with a dexterity that was remarkable for hands of such magnitude, he nimbly loaded the tiny pipe, which looked like a scrap of wood whittled by a child, or a trinket from an Andean bazaar.

"So why'd the girl leave?" Duke raised his eyes as he tamped down the hash in the pipe with his pinky.

"You'll be seeing her."

"Did I say I wanted to?"

"I mean, if you don't mind."

"The fuck do I care."

"She's my boss—one of them, anyway."

"You understand that, though, right?" he spat, ignoring what I'd said.

Perhaps it was this sort of thing that worried the team.

"You know I'm just *joshing* you, right?" He enjoyed putting italics on words, even when he didn't slant his accent. He was suddenly mischievous, and it seemed to arrive from nowhere. I suppose the mere prospect of getting high raised his spirits; his body instantly seemed less imposing, lithe rather than stout, reposed rather than explosive, though he couldn't have done more than shift his hips and shoulders a touch. "But yeah," he resumed, flicking the baggie onto the cushionless sofa, which now appeared a repository of cellophane wrappers, coins, and crumbs: "I did wonder why she left. She didn't say a whole lot. She wasn't *scared*, was she?" He lighted the pipe and pulled long and slow on it, eyeing me in a way that made me feel as though he'd never stopped smiling.

"She said she wanted me to break the ice," I replied. "Because I know a little about football." I started replacing the cushions he'd thrown up in his search, just to soften the DEA-raid aesthetic prevailing in the living room.

"And anything about *manhood*?" he asked as he exhaled, no less deeply than he'd inhaled.

"She might know more than me about that."

"I see," he said, grabbing my neck and massaging it as if it were *I* who'd taken the big hits tonight. He started waving at the smoke with his other hand, big swings of the forearm, not so much to dissipate as to indicate that it was *this* he wanted me to draw into my own lungs.

"Shoot this," the order came, just before he took another quick pull that made the pipe rustle like faint television static. He lowered his eyes to his lips and watched the smoke depart his mouth at its own pace. "I'm going to want to talk to her, eventually."

It was a strong picture, the way Duke's eyes were active but low. I let it settle in my mind.

He stuck the pipe close to my face.

"Shoot this goddamned shit." The words were suddenly harsh and frightening. There was that torque running through his body again, the sense of coiled energy. You'd have to be outside a certain radius to feel he couldn't pounce on you whenever he liked, and I was not outside it; the apartment wouldn't allow me any distance from him. What was it that had changed in him?

I came out with the phone again, snapping blurry little jpegs of Duke.

"*Not* with this fucking thing in my hands," he said with a blistering glare as he held the toylike pipe aloft. "Just the smoke is okay, I think. I can say it's whatever, even when these end up online."

"Oh, don't worry about that."

"But I do, see. People are paying for these now."

"My boss pays me more to keep them private."

Duke shook his head. I didn't know what it meant, exactly, the way he did it.

"I'm going to need to do a few drawings of you from life, at some point," I said. "That's one thing I did want to say tonight."

He stared hard at me and tightened his grip on the pipe, which was sheltered now within his capacious palm.

"Okay?"

He opened his palm, gently cradling the device as though it were a baby bird.

"You can come out to Chicago. We'll find some niggers in the wild for you," he offered quite sweetly, as if cooing to the roasting bird.

"And here too, maybe," I said. "Drawing you, I mean."

The pipe disappeared in his fist and he smiled. "If I'm around again—if James pays me enough to be." He pinched the instrument between his fingers. "Now *hit this.* And don't tell me you don't smoke, or that you only eat it in candy bars or some shit." He said this as though my hash use weren't a surmise on his part, but something he knew for a fact. He was right, actually: I'd had dalliances with it, though I'd quickly gravitated toward stronger things, when I was still interested in drugs. Most

of the artists I knew these days were reliable workers, abstemious in the extreme. They'd never ended up in hospital beds on drip IVs for alcohol poisoning. They were academicians at heart almost. Excellent students, budding studio professors, no less than the Paris Salon painters of the fin-de-siècle. Somehow Duke seemed also to know I shared his contempt for the cannabis industry. Legalization really just meant pot-laced Snickers bars and CBD smart drinks, nothing more. I found the whole thing sillier than vaping.

Duke condescended to me with a smile then, watched me come to grips with *his* powers of observation. I took the pipe and the lighter from him without a hitch and smoked it like the natural I was or had been, in the days when I was every bit John's match. There were entire years when I'd smoked it too freely, when I'd spent most of my time divided between the studio, the library, and the balcony, with hardly any left over for humanity. John hated that I'd moved on from that stage, actually. That was the first wedge between us.

I closed my eyes as I inhaled to better focus on the smoke in my lungs and the acrid relationship between the two that laced my experience with pain. At the same time, there was engagement; one managed to absorb the other, in the end. As I opened my eyes with my lungs burning and I spouted smoke from my mouth, there were Duke's eyes to meet mine. Something like the first glimmers of trust crossed his face, trust in his own intuitions about me.

"It could be your leg, it could be something else—your soul even—but you have to say this shit's pretty all-purpose, right?"

24

It was beautiful hash. I also wouldn't put it past Duke, or Bryan, the rightful owner, to have chemically enhanced it in some way. All sorts of agents might have been involved, but I liked to think it was angel dust. I didn't smoke much of it, just a couple of hits to please Duke, and perhaps to satisfy some slight nostalgia his words and mien stirred in me, for the days when Rick and John and I would gather to discuss our latest paintings—the stuff we didn't bring to class, our private work—only to descend into an oblivion induced by the hash-soaked cigarettes John would pass around, whenever sobriety no longer suited the lot of us, not just him.

Even if I wasn't going to smoke seriously, Duke expected some sort of camaraderie in his rituals of self-medication. Afterward, he started rummaging through Bryan's kitchen. From among the household cleaners, below the sink—I had no idea why it would be there—he pulled a bottle of Bombay and held it aloft. That would certainly do.

It did far too well, in fact. It was the last sturdy memory I had of the night: Duke grinning triumphantly, pleased with himself for having sniffed out, for the second time, one of Bryan's stashes. Everything after that moment was streaky and smudged. There were a few items here and there—I do believe I met Bryan, for instance—but my mind only returned to me with any solidity on Monday, around noon, back in my bed in the Bronx, with my lungs only capable of three-quarter breaths.

My phone, however, teemed with traces of the night just past. It was on occasions like this, where biological endowments stood no chance, and memory capitulated, that photography earned its keep. Most of these pictures I couldn't actually recall taking, which only reinforced the point. Some of them I hadn't shot at all, as I was in the frame, from far beyond selfie-range. Duke would have taken those, after I'd crossed a certain threshold of incoherence. Some of the snaps were of me with Bryan, and some with me and his friends, who, I recalled now, did eventually turn up, although what I retained of them had the contradictory funhouse quality so often propagated by drugs: big hugs, and also, I'm sure, a punch to the face. My face. I ran a hand over my mouth and discovered only an eminence of flesh, mostly numb, hence not so painful. Not yet. It was only by opening my mouth, or trying to—as I discovered, I couldn't open it much without a violent pain shooting through my jaw—that my lips could be individuated with my fingers. Using the phone's camera as a mirror, I could see they were almost the size of Bryan's. They could have become like this in a number

of ways, of course, drunkenly stumbling through the city: crashing into a fence post, say. I hoped for a photo that would settle the matter.

My thoughts came together in a pleasantly sluggish way. Everything took an extra moment to register, leaving a trailing interval, a sort of wake in consciousness, where the strangest apprehensions, the unlikeliest possibilities, would enter and dissipate before I had any chance of examining them, much less putting language to them.

I'm not sure, given the way my head felt, just how it was I'd managed to get home. If Duke had been feeling generous since signing his new NFL contract, or if he had basic compassion, he might have put me in a car. But he might have simply wanted me out at some point. I could be that kind of guest. And if so, I might well have taken the train back home, tripping my way down the stairs and onto the platform. Is that what happened to my face, a fall down the stairs?

My comportment in subway stations was well-known and abhorred by nearly all my cohort, but it might have been my saving grace with John, the only reason he continued to believe in our brotherhood. For one, I smoked freely down there, waiting for trains while drunk or stoned on pills, dragging deeply and slightly enjoying the looks I got. Once in a while, someone would get brave, ask for a smoke and stand there with me, both of us puffing in triumphant silence. I might have smoked more cigarettes down there than anywhere besides the park.

I'd also been ticketed once: three hundred dollars for emptying my bladder in Grand Central. This was always the great temptation I felt, relieving myself down below the Earth's surface, among the indigent dwellers, whether I was alone or in company. It all depended on the amount I'd drunk and the fullness I was feeling. It might have been why I looked so kindly on Helena, the homeless one in my station, who always stank of just this public feat, weakly executed, to wit, directly in those military fatigues that clung to her. My favorite memory on this score was the time, being frustrated with Helena's failures, that I demonstrated the proper technique. I did it that night, right near the tunnel arch, the proscenium through which the train crushed the fourth wall. (Sometimes Claire had served as an unwilling lookout, and sometimes I hadn't cared. I just went about my business, even with the platform half-full.) I sent up a heavy arcing stream in the corner there, right in front of the stage, as Helena looked on from track level. She was laid out flat on her stomach, with her head turned toward me and her eyes widening periodically as they always did. I thought I saw her smile, or else nod. Naturally she'd have to vary the technique for her own sex, though you could just as well crouch where she was, pissing onto the very edge of the tracks. I trusted her to make the necessary adjustments. But she never smelled any better.

I assumed Duke couldn't have lost his mind quite the way I had last night, where I'd gone well beyond my usual limits. He probably got up to this regularly

enough to have some tolerance for it. It was also, I knew, an NFL rite to smoke marijuana not for the purposes of recreation, not primarily anyway, but simply to ease the inflammation engulfing players like a holocaust the night and day after the game. In this they were no different than late-stage cancer patients, smoking to relieve their suffering.

It also came down to bodies. Though we were about equal in height and frame, Duke's person was denser than mine. Just looking at his forearm, the taut skin, the muscling, the prominent veining that reminded me of ancient sculpture, I knew he must have had twice as many cells packed within him as I did, or else the ones he had were twice as alive. It wasn't a matter of virility or dash. In fact he gave off a vaguely repellant air. Instead there was a kind of completeness to him, which meant his vitality had a fundamentally aloof aspect, sealing him off from weakening forces of all kinds, whether competitive or pathogenic, environmental or cellular. You expected joyful aggression to define every part of him. His blood you imagined thick and syrupy with macrophages confronting any and all invaders; and his organs, his kidneys and liver, you knew were vitiating all impurities. On the level of medium-sized dry goods, you sensed the recalcitrance in his arms, his neck, and then in his entire body, which was shot through, even at a standstill, and even lamed by injury, with movement—with, you might say, a basic resistance to fixed position and place.

I, of course, partook of none of this. A profound immobility dwelled in me, so that resistance of any sort didn't, for me, transcend the psychological, where it was indeed strong, as it was strong, I could see already, in Duke. Physically, however, I was easily undone. Small amounts of toxins made my body succumb. Surrender came naturally to it. I looked to some people *wiry strong*, but in fact I was probably just wiry.

In bed I scrolled through last night's photos on my phone, blowing them up at random with two fingers in the haze that found its way around my blinds. I could see that Duke had spent much of the night without a shirt, or even that Arête vest. The only thing his upper body had as shelter was black pressure tape laced around one shoulder. At some point, Bryan's ceiling fan, which I remembered to be hanging by a thread when we arrived, came crashing down. There was a deep soreness in my right hand. My fingers were stiff, as if I'd punched something. Looking at the wire-laden wreckage of the fan, flash-lit and photographed right on the floor, which was covered in the short green carpeting you find in office buildings rather than homes, alongside Bryan—yes, it was him, and I *had* met him—who held up one of the broken vanes that looked almost like a boomerang now with a disconcerted, unresolved look on his face, I had to wonder whether my hand had somehow ended up in the path of the blades. Yet the fan had swirled so lopsidedly, it might have simply ripped itself out of place with its own momentum. Could it have been slowly but irrevocably on the way

to becoming this pile on the floor from the day it'd been installed, working its way out of joint over the decades? A bad bruise is what it would have dealt a roving hand. It wouldn't have taken anything off cleanly; it rotated too lazily for that. And *wasn't* I standing up on the couch at one point last night, putting my hand within the fan's ambit? In any case, I was surprised Bryan wasn't angrier in the photo. Hadn't I myself been doom-struck in the moment recorded by this picture, on seeing the fan in pieces while assuming the consequences were going to be steep for this mishap, whoever might have been at fault? Perhaps fault was hard to parse in this case. We could have *all* been responsible for the destruction, if it was the result of some collective inanity we'd engaged in beyond the drugging. You could see Duke in the upper-left corner of this photo, in the deep background, laughing gleefully, with a look that signaled at least complicity, that is, that he lay *somewhere* in the causal sequence leading to the fan's tragic end.

It's possible Bryan didn't appear truly incensed in the picture because he'd only just arrived home and found Duke in his apartment. Wasn't there a touch of enthusiasm and warmth lingering on his face here, from seeing his old friend, now a pro starter, back in the old place? And wasn't this feeling, this expression of his, being supplanted by a rage prompted by what we'd managed jointly to do to his place in his absence?

I scrolled on, hostage to these photos of my own making. They were all that definitively remained of my mind, as far as yesterday went. There were shots of the hallway; I vaguely recalled taking some of these. But there was one of the door at the end of it, the door I'd not been able to snap the first time around when Duke had called me back from the blood-red sofa. There were photos of people I didn't recognize, probably some of Bryan's friends or neighbors, who'd come around for only a very short time. Maybe one of them softened up my right hand(my off hand, as it happened).

As Monday wore on, my head swiftly cleared—too quickly for a hangover. In fact, I realized, I was still sobering up, and the crash had yet to come. When *had* we wrapped up last night, then? It could easily have been five or six in the morning for me to still feel this way. Which meant that the struggles I had in recalling the evening need not have been down purely to a faulty memory brought on by blackout drinking and drugging. My present intoxication might be contributing something. The afternoon went by happily enough, while I anticipated the revelations that would come into my possession when my dream state abated. I avoided all my messages—I was working, in a way, wasn't I?—and simply observed, as my liver went to work for the rest of the day, great stretches of past experience come forth, talking with Duke, with Bryan, with his friends. It was like *seeing*, as though for the first time, what was already plainly *there*, fixed and determined: my perceptual memories of the evening

past. And with every hour, the mental "tape," originally just snippets of footage here and there, mutated into something resembling a continuous whole.

By Monday evening, I'd fully sobered up, and was in fact starting to have an inkling of the profound hangover to come. Though much of the previous night had returned to me by then, not everything had. Certain events remained garbled or simply missing. In other spots, the sequence of happenings blurred, though reasonable guesses could be made, especially in light of the email and text exchanges I would go on to have with Duke and Garrett throughout the week, clarifying this or that matter, or indeed, extending the discussion of certain points, filling in holes as best I could. The tale I came away with by Friday, a composite of *all* our knowledge, seemed, if not comprehensive or cogent in every detail, as strong as *I* needed it to be. The first bowl of hash Duke loaded yesterday, I had a very clear picture of. He'd smoked it standing up, in the kitchen. Frequently his bearing struck me as that of a caricature of an MC from another era—maybe Nas right near the beginning—the way Duke hunched slightly, with his arms curling out to his sides, as if he were ready to throw signs. I wasn't sure what, if anything, he was trying to tell me by this. Was he playing to my own illusions of blackness, what he imagined them to be, anyway? I decided to proceed, at least for now, on the assumption that he was mostly stretching out his sore limbs.

I'd been alternating between sitting on a stool at the counter and standing next to him in the kitchen, hitting the pipe once or twice, but mostly topping up my glass, depleting the Bombay he'd found two-thirds full. After he finished the bowl, he was done hunching. His body had become elastic, he moved more freely, and he began to pace, a step or two in each direction, within the kitchen. That's all there was room for.

"California," he boomed, his voice tilting black here. Again I was finding there were always two things to assess in speaking with Duke, more so than with most people: what he was actually saying to me, and what impression he was trying to leave me with. I think in this instance he was saying the full name of his college team, though without any lead-in: a *non sequitur* that had enough meaning. Or maybe he was naming my home state, the stomping grounds of my family. Could he have known that? What had Duke been told by Hartley and Garrett? What had he found out for himself?

He stopped pacing but kept adjusting his weight from one leg to the other, testing the state of his limbs, I thought, or dancing to some music playing only in his head. While doing so he gathered up, through great reach alone, ice, a bottle of club soda

from the fridge just behind him, and another glass from the cupboard near the window. (The absolute compression of space in Manhattan meant you could frequently do everything from a single pivot. You didn't need to be an athlete to pull it off.)

Duke had been recruited out of high school as a tailback, not a receiver. "The best in Illinois," he said. "One of, anyway." This he told me on the phone, actually, a couple of days after our big night. He'd come up three yards short in the state championship. *That* was what he recalled most vividly of his high-school career: his broken hand (he'd played half the game that way) resting on the three-yard hashmark as a cameraman rushed onto the field, right past him, toward the opposing team celebrating wildly behind him. This is where Duke still drew his motivation, Bryan told me. Division I was calling: UCLA, Cal, and Stanford, and that was just in California. He, like anyone else, had all sorts of ideas about the state, long before he'd ever been. He also had family out there, in Oakland, his mom's brother especially, Uncle Irv, who'd played ball at Fresno State. Duke had stayed with Irv some summers during high school, when his parents were trying to get him away from friends like Bryan. The boys had too much time on their hands over the summer holiday for anything good to happen. Irv planted the seeds of playing ball in California. Not for Fresno, of course; Duke was better than he was, everyone knew that. No, he should play for one of the big schools.

While Duke's father, Dante, was rather business-minded, and therefore not as interested in old grievances as in fresh successes, Sheila, his mother, had schooled her son in the long history of civil rights, so that Oakland and the Bay Area, the Panthers and the like, always mattered for him, even if now the region had been totally remade by the 0s and 1s of the digital revolution. She was, Duke forgot to mention—he was grinning now, he was happy to have forgotten, to have to remind me this way, after emerging from the kitchen, a gin and soda with lime in hand—she was a professor of sociology, *African-American* sociology, though higher education hadn't managed to pull the family out of poverty. It didn't always work as advertised. Actually it had pushed them *into* poverty, and then helped keep them under: she'd fallen into adjunct labor, beautifully schooled (a doctorate from none other than Chicago) but dirt poor, which was hard for her parents, being merely poor, to see as advancement.

Duke went out on a recruitment trip to California. It ended up being the only one he took. In his mind, it's where he needed to be. He'd believed this for years, actually, before he'd even become a standout player. He'd schemed about living with Irv to get in-state residency status, so he could attend Berkeley at local tuition rates. Of course, all this became irrelevant for an athlete like him. He wasn't going to be any kind of walk-on. They'd take you on and pay for you entirely, whichever state you

were from. Given the money that college football created, it made perfect sense: this wasn't affirmative action, just sound investment.

"Cal, though, Cal was the place." Where did he say this to me? In the kitchen? The couch? Outside the building, where we roamed I don't know quite when? What accompanied this snatch of aural memory were Duke's bulging eyes, his normally taciturn calm shattered through recounting his school of choice. (Or by PCP.)

Cal was the place, he'd thought. There, they'd been most receptive to his "extra-athletic prowess." Duke brought with him commitments, *ideas*, which had baffled some schools during interviews. But they didn't bat an eyelid, the football staff at Berkeley, when he rattled off texts and figures approved of and administered in the first instance by Sheila: Gordon, Hall, Fanon. It wasn't just this, though. Chicago had done it to him, too, the rising murders all through his youth there, the growing sense of black doom, which was twice that of New York's, if such things could be measured. Oakland, though, *it* could compete for desperation, and it had worn politics on its sleeve for at least half a century. It made sense to him, to push deeper into the cauldron. To Irv, too.

I remembered Duke sitting next to me in Bryan's apartment, with his feet up on the couch while he told me much of this. His body had limbered up, though he seemed, in speaking, to turn almost grave. He was eloquent and succinct, not much meandering. I could see by the look he flicked my way now and again that he was quietly resolved to show me just these qualities, dialectical ones, civilized ones, as early as possible. This was the burden he lived under, I knew. It was incumbent upon him to dispel preconceptions everywhere he went, not because there weren't preconceptions affecting everyone, but because the ones pertaining to "men like him" were what they were.

I couldn't really relate to him—that would have been the standard thing to say. But I wasn't so sure. Relating wasn't such a high bar. All you needed was an analogy to hold two things together, nothing more. *Being* is the tough thing; I certainly couldn't *be* him. Nor the reverse, though. That was metaphysics.

But the analogies between our lives weren't so hard to see. Having artistic ambitions made you immediately suspect. Not professional or financial ambitions, those were different and in no need of explanation. I mean simply the aim of creating artistic objects, even if they didn't bring you money or fame; indeed, especially if they pushed you further away from either, and left you, at best, illustrious and unknown. *These* aims were doubted, ulterior motives were sought. No one could be that pure.

By no means was my predicament equivalent to Duke's trials—and vice versa—but the common factor was also more than nothing, this visceral skepticism I encountered wherever I went, particularly now that I was no longer playing much for the usual gatekeepers who could verify my merit and intentions, approve them

like the FDA approves a drug. Just what was I up to, they wondered, in getting off the career track? What sort of stunt was this? David Hammons had been mentioned.

Duke topped up our drinks, mine being straight gin. He seemed amused by my refusal of soda. He must have thought *I* was trying to prove a point to him with this, for instance, that I was bold or raw in some way, when in fact it was more practical than that. Whenever I was driven to drink with the purpose of getting drunk, which by this point I was—it was also a *fait accompli*: there'd be no avoiding intoxication tonight, so why hold back?—whenever I drank like this, I was going to take the shortest route, and mixing drinks wasn't it.

He was standing at the window, rattling the ice in his glass, looking down onto the competing bodegas buffering churches, when he started speaking as if the window were open and he had an audience outside. He returned to the matter of Berkeley. In the series of moments making up the night in question, I'm not sure just where this one goes. Other things certainly may have happened between my drinking gin on the couch and Duke speaking down into the street like the Pope. Bryan may even have come back. What he said, though, and elaborated on later in emails, was that Cal wasn't merely unfazed by the oddities manifest in his interviews, where he would venture all sorts of academic and political hypotheses with both the coaches and the deans. At least outside the locker room, they were actually going to flaunt his intellectualism. He'd be proof of their liberalism in a moment of crisis for multicultural capitalism, a volley fired against the ruthless, mercenary approach to college athletics that ruled Division I, where athletes routinely cheated on tests or didn't bother going to class and everyone involved just pretended it wasn't happening. Duke, though, was going to fulfill the true ideal of the student-athlete, rather than end up another teenage boy exploited for his black brawn, playing in a sport that mostly made whites rich, whether they were associated with the university or the professional sporting leagues that beckoned.

There was the question of whether Cal was merely using Duke as a red herring, as the Democrats had Obama, to lead people away from the fact that, at bottom, there was nothing to challenge the *status quo* here, no change, no difference, just business as usual.

"I'm not so sure it's as heinous as that, though," he said. The university's intentions may well have been basically sound, or anyway not straightforwardly bad. They were probably fighting in good faith against the darker elements emerging in American and European politics and culture—even if they weren't exactly in a rush to reform the NCAA, top to bottom, as they sometimes pretended, rather than simply check its worst excesses. Maybe Duke would count as a precedent, or at least an example of what was possible, for other recruits, other schools.

He also had purely personal reasons to sign with Cal: he'd get a longer leash, given their avowals, to do much more on campus than chase a ball around.

"Politics doesn't *really* mean books to me, knowledge"—another thing he'd said at some point in the night. It had struck me, particularly given my dawning realization of just how much he'd read. "And a lot of it," he'd said—or had I misinterpreted him in my stupor?—"isn't really under my control." What did "it" refer to? His behavior? His politics? Duke did make it plain to me that he wasn't conscientious like his siblings. None was quite as exceptional as him, either, his two brothers or his sister, and this wasn't a boast, just a fact. So far they'd not established a domain in which they consistently excelled others. But, he admitted, none was quite as ornery as he could be; his mother used to say this with a sharp little laugh that actually tickled him. Sheila was a tiny bit proud of this mean streak in Duke, an untamed forcefulness, a less-than-civil disobedience. A degree of barbarity was tantamount to being truly *involved* in something: Sheila would never quite say that out loud, as it went against her education. It was probably an attitude that would be hard to argue for, yet this didn't make it an attitude you shouldn't hold. Wasn't she herself a bit nasty? But then what about Duke's father? Dante had been ambitious in his way, commercially, even if he'd not quite made out as well as he'd wanted to for the family. But there wasn't much edge to him.

The problem with Duke, and it was unique to him within his family, was that under the heading of social awareness and resistance of the oppressor he placed more or less wanton criminality, the release of improvisatory impulses. Naturally, given the amount he *had* read, he had to justify, in his own mind, not just others', this proneness to the unrestrained discharge of energy, the kind of electric experience that can only properly exist outside the realm of sanctioned behavior.

He knew this, of course. "That's what makes nigger culture so potent," he'd said to me. He didn't hit the word *nigger* especially hard, he simply used it, in this case with an academic detachment, as if it were a bit of passé jargon. Probably one of his mother's areas of expertise: uses of the word *nigger* in the Americas. There was no one who didn't at least implicitly know this about black culture: the source of its fecundity, its pervasiveness in mainstream American and now European life—whether in matters of music, fashion, television, film—was its original illicitness, its origins in humiliation. You could accuse Duke of rationalizing his conduct, but so long as it wasn't *pure* rationalization, as long as some bit of it was genuinely a matter of disintegrating the known order of things, he wasn't going to lose sleep over it.

"I like to ball this way," he said, plopping down next to me on the couch, renewed by the hash and gin. "I like to fill with rage." He liked to steal, too. To destroy things, though never people, he said with a wink of his watery eyes. It was his personal

version of "disruption," he said with a laugh. Weren't we all supposed to be disrupting things these days, especially in California?

Duke started digging up more bottles of booze, methodically sifting through Bryan's things and taking real pleasure in these discoveries while reacquainting himself with an old friend (he'd not seen Bryan in months). There was nothing malicious in it. He wasn't snooping. Well, maybe a little, checking that Bryan hadn't crossed any lines. But this wasn't at all like the searching they'd both witnessed as kids, all those raids. At least that had never happened to either of *their* families, two of the more upstanding ones around here. There would be none of the officers' thievery and seizure he recalled. Not that he was above such things, by any means; only that at the moment, unlike me, he had no financial troubles, and he wasn't going to add to his old friend's. Bryan was still selling phones at a Verizon franchise, second in line to the title of store manager, and still living with his mom, who was staying right now with a sick auntie of his in Delaware, which had made this little reunion possible.

Duke poured himself some Jameson he'd found in Bryan's bedroom. "The short of it is," he said—and the short of it was all he was going to give me, it appeared—Duke had gotten himself arrested, along with his younger brother, Zeke, and Bryan as well. More than once, in fact, back in high school. More than twice, too, Bryan would tell me later that night, beaming. An image remained with me of Bryan's making this little correction, and of the friendly daggers Duke sent his way, to stab out the joy in those eyes.

The arrival of Bryan and his friends changed the atmosphere of the apartment decisively. With the crew present, Duke filled out the rest of the picture of himself somewhat reluctantly, although he did do it in a more nigger-friendly tone, as he called it later. He was right to be careful, because now the group would interject whenever they felt his tale went astray. Unusually, it appeared Duke was mostly *downplaying* his exploits, which was odd, given that his reputation was hardly a secret. Still, you had to be absolutely sure you had nothing to prove to take this line.

I couldn't tell whether their versions of events were likely to be truer than Duke's, of course, and frequently someone in the group took issue with someone else's proffered amendment to the story. At the very least, Duke knew he couldn't pass off any real howlers on me, which, in one sense, was a shame. If lies were part of his fantasy life, part of the man he wanted me, the artist, to see in him, well, that was real enough for me. Anyway, there'd be other chances to get him alone and give him a free hand to embroider.

The first thing that became clear was that he'd spent "his share" (was there a share, really?) of nights in jail. Never prison, just jail, with those chilly concrete walls and the steel toilet right in the middle of the cell, separating the two beds—if you can

call slabs of concrete *beds.* The only pretense of comfort offered, with vicious humor, were the bleached white sheets mere microns thick. This bedding, a guard releasing him one morning explained, was only there to preserve the cleanliness of the cell, like a paper tablecloth at a chain restaurant. And always across from you on the other slab, Duke said, while Bryan and the others heartily agreed, there was a *real* criminal, muttering, barking, threatening absent people before threatening you, while you tried to lay low, given the smallness of your crime—when it *was* small. Vandalism with a spray can. Reckless driving. *Wet* reckless driving. Disorderly conduct. Public intoxication. Marijuana possession, before it ever got legalized in NYC.

Duke never carried cocaine or anything stronger. The guys he knew who'd been caught with that were, several years later, still serving time. Bryan, though—and this was the most valuable service he provided for me that night, an unintentional one—his face started shining, not just his eyes but everything, this face many times lighter and less menacing than Duke's, yet with the heaviest of lips, this face turned to pure light whenever Duke's indiscretions surfaced. Bryan was almost prouder of his old neighbor that he'd managed to make it all the way to the pros *with* all this history weighing him down, that he'd dragged it all past the finish line, into the end zone. Bryan himself was never a student like Duke. Nor an athlete. So there was never much chance of him hurdling Verizon. Duke though, however unruly, was the one who could, and simply knowing that it was possible for *some* was solace enough for Bryan.

Throughout the night Bryan's visage, which seemed naturally to convey a certain thoughtfulness—he *looked* smart, even if he wasn't—acquired a teasing edge, referring back, I felt, to a shared history of indiscretion, only a fraction of which he and Duke had ever been caught for. Some of it might have been quite a bit darker than anything I was being told, and *this,* perhaps, explained exactly why Bryan was so proud of Duke. But old comrades weren't going to incriminate each other, not seriously, anyway.

Eric or Derek, I can't be sure of his name, only of the brand new puffy red vest that looked out of place on him—he was one of their friends, and everything he wore besides the vest was mean, which made the garment look desperate on him, a poor cover-up, whereas a sweat-stained Hanes T-shirt would have lent him the greater power of authentic poverty. This man Eric intimated, as we sat around Bryan's living room, that there might have been a somewhat longer stint in jail for the second DUI Duke had picked up, even that someone might have gotten hurt or threatened a lawsuit. I think he thought only *I* heard him; he was sitting next to me and fondly relating the possible injury to the other party: Duke *took him out good.* Immediately after, Duke stiffly passed him the pipe, shoving it into his chest with a thump as if

it were a football. Derek didn't speak much again, or anyway he didn't resurface in my memories. From then on he would have been too muted, too cowed, to have made the cut. Some of these people, I must have met five or six of them that night, including several who hadn't seen Duke in over a year, were probably auditioning for his payroll, should his contract, presumably heavy on incentives and light on promises, yield enough cash to put together some sort of an entourage, as professional sportsmen will. Duke's remonstrance might have been his way of training up Derek, or Eric, for the role, seeing if he was fit for it.

Sometime in the very early morning, everyone left and Bryan crashed out, having to work the next day at eight. Duke, seeming remarkably sober as he sat in the living room with me, both of us whispering so as not to wake up his friend, came back, at great length, to the subject of Cal. He was obsessed with it, just like Garrett, and he'd go on to tell me a lot. The university's recruiters had known about some of his trouble, apparently, the deeds that had made him untouchable for many other schools, once their full extent surfaced. But at Cal there was policy-based wiggle room for students with difficult pasts, and not just athletes. Partly this was down to Berkeley's committing to a renewed, radicalized progressivism as the distance and enmity grew between left and right in the country. In the end, when all of Duke's records had been fully released to colleges, the only ones not hemming and hawing were Cal and UCLA, which answered to the same Board of Governors.

In truth, he explained, he'd always quietly counted on a blind eye being turned on his transgressions. He considered the wide berth he was given in the more civilized portions of the culture the true reparations every black man got. It was compensation not just for past grievances, but for current ones occurring at the lower end of the culture, on the street and at the "correctional" level. What, really, was the *point* of being black if you didn't collect your allotment of leeway, Duke said that night. Sometimes you collected it on your own behalf, for every time you were followed around a department store or a pharmacy by staff, and sometimes you did it for all the other blacks who continued to be macerated by society, the ones who didn't have enough brawn or hustle to lend their services to white diversion. On the gridiron, say.

For all his errant behavior—errant from the point of view of the university, anyway—he'd actually enjoyed college. "It was beautiful," Duke said, and the way he said this word, the governing word not of art but at least of aesthetics—the philosophy of the beautiful—caught my notice. His college years couldn't have been beautiful

in any ordinary sense. The experience had been full of turmoil, chaotic; there was nothing balanced or harmonious about it. What, then, did he mean?

Well, he'd been able to be an athlete, an intellectual, and an aesthete all at once. He'd not had to sacrifice the spirit of moral dereliction that felt like his birthright. I'd noticed after the game, with Karen and Hartley, something subtly wayward about Duke in the company of whites, a quality that lightened considerably in the presence of his own race. It was easy to enjoy this about blacks, of course, their waywardness. The entire entertainment and sports industries were built around this possibility. You could enjoy them, their doings, their productions, in just the way you enjoyed the strife and suffering of fictional characters. So when you saw blacks in person, if you could overcome your initial fear of meeting such things, these creatures of low tragedy—and there was no guarantee that you could—you might even enjoy it in person. For a while, anyway, until those dramatic things, inevitable things, really, given who you were dealing with—humans pressed into the quasi-human role of entertainer—until they started happening right around you, in real life, when you very much stopped liking them. No more than you would like the serial killer who steps out of the crime procedural right into your living room.

Duke, I thought, had smiled at me that night in a way he didn't smile at his brethren; and there was a warning in that smile, although I didn't strictly require it. I understood the fantastical element of his appeal, to me, to Garrett. But there was something nefarious about him, even once you accounted for his racial and economic background: an air of perfidy, I'd felt it already, even if I had no real idea how this might manifest. It was hard to say whether this quality was rooted in his thinking, or whether, as he liked to suggest, it was lodged somewhere deeper, a place unreachable by knowledge or etiquette. Whatever it was, it radiated from him, right along with an indwelling power.

Duke had actually finished his college degree, a rarity among gifted college players, who typically entered the NFL after no more than three years of school. He could have done that, given his talent. Yet while he *did* see himself as an athlete, that didn't mean he wasn't also, in his mind, a budding intellectual. Or even a sort of performance artist. A college acquaintance of Duke's had once described him that way, and he'd held on to the term, long after he'd forgotten the person who first applied it to him. I myself began to see the man as a belligerent provocateur, whose medium, for the moment, happened to be football, but whose vision easily exceeded it.

There were other facts about those four years, he explained, that even a star professional would find it nearly impossible to replicate. No city can be dominated by a single personality the way a sportsman can dominate a college campus. Granted, the effect was probably stronger elsewhere, particularly in the Midwest and the

South, with so little else competing for attention, than in Berkeley, an intellectual and activist haven with all the entertainment and energy of the broader Bay, of San Francisco. Yet even there, if the team were really winning that year, beating SC and Stanford, vying for the PAC-12 title and a bowl-game berth, a football player could hold the place in his thrall. True, in staying for graduation, Duke proved he needed to understand something more than a playbook. But he also wanted all four years of the paradise promised him.

His on-campus persona had been, almost from the start, and I suspected by design, indissolubly complex. At least he took some retrospective pride in his own inscrutability. On the field, there were the improbable catches. But there were also the often unnecessary blocks off the ball—outlawed, in the pros, by the so-called Hines Ward rule—that had left half-a-dozen players unconscious, to be carried off the field on gurneys, some with cracked vertebrae. There were a few suspiciously low tackles on interceptions: he would chase down the cornerback and play games of chance with their knees. Several thought it a matter of time until he paralyzed someone with this approach, or sundered someone's ACL, and about all of this Duke wasn't exactly unrepentant, simply vague, dipping into player-speak so that nothing of substance actually had to be said about it. People sensed this in him, that something was slightly off—which he liked, he claimed. It was important that they know. What would be the point if they didn't?

Away from the field, he reveled in building as much as in destroying. There'd been the campus protests against the right, the notorious visiting speakers of Breitbart whom Berkeley, as a state university, had been forced to host. He'd spearheaded those protests in his junior year, to much praise, even by university staff, who tacitly agreed with him. With his bullhorn, he'd also apparently let them descend into riots: rampaging students destroying property, private and public, some even looting in ways that made Californians think back to the riots of the nineties down south, in Los Angeles. The consequences had been serious. One student ended up blind in one eye because of a rubber bullet; another required skin grafts for burns sustained in the midst of automobiles set ablaze by the more violent elements of Duke's faction.

He wrote an ongoing column for the *Daily Californian*, unheard of for an athlete, given that his pieces were almost never about sports. In the paper he would critique Cal's sometimes malignant relationship with the city of Berkeley. He was even able to save certain neighborhoods from university designs, by preventing sale of their land. At least that's how campus lore had it. At the same time, Duke used the column for personal vendettas, subtly attacking the credibility of certain professors—he considered this to be political intervention, and maybe it was—professors who'd not taken to his classroom grandstanding and refused to show him the privileges he was

accustomed to on campus. Frequently his targets were women, and the incidents with them went beyond mere words. No rape allegations, he was very firm about that, even standing up for emphasis when he told me. They were, he said with a laugh I found chilling, allegations of *unnecessary roughness*. Everyone was a consenting player, in his mind. You understood the risks. He pointed to his forearm: an opponent tackled him by it and broke it in three or four; he lost most of his sophomore year. But he wasn't mad, he'd left himself vulnerable to it. "Protect yourself at all times, right?" He had a boxer's mentality. No complaints.

Later, I would learn online that his sexual encounters with women, several of them underage, had led to as many people being brought to unconsciousness by him in his bedroom as on the field. How much, I wondered, did Garrett know about all this? Both sorts of incidents, the two halves of Duke's life, had cost him a lot of playing time. Apparently he'd needed all four years just to get the minutes he wanted on the field to refine his game.

Duke told me that night he'd been one of the four or five "problem" players in his class, perhaps the worst offender among them. So he wasn't exactly shocked when nobody called on draft day. He'd laid the groundwork for it, hadn't he? "I sacrificed," he said unequivocally, and absurdly. "It's just the price of being something more than a player." Of being *what more* exactly? Something good?

As he stretched out those long arms that finished in monstrous hands, the stuff of stereotypes—but then, he was a receiver, this was no random sample—I couldn't help but marvel at his lack of loyalty to his own talents; to something, football, he took probably more pleasure in than anything else (didn't he?); something, too, in which his singular skill, his exceptionalness, might be made plain. It was precisely this that made him a threat to the NFL, and what put his future in doubt.

So what was it Duke held above pleasure or worldly success, both of which he was already experiencing through football? When the game became something concrete, not an abstract contest of wills, it was clear from the way he spoke that he had a sort of gentle contempt for his colleagues, whom he didn't view as equals, just instruments, nothing to be taken too seriously. It was, he warned, this same spirit, of existing beyond the plane of his fellow players, of more than anything *tempting fate*, that had allowed him to sign on to this project for the Arête brand without much sense of where it was going. If you were desperate to succeed in the NFL, you probably wouldn't be open to such improvisations.

But he didn't seem to mind doubt, confusion, havoc. Wasn't that night at Bryan's itself its own kind of chaos, one he had more or less manufactured? Didn't it have the feel of an initiation into some obscure cult whose rules were unknown to me? And where had we left things at the end, exactly? My memories gave out at that picture

of him somberly uttering the word *sacrifice*. Nothing that happened afterward was going to be able to compete with that.

It was sometime in the small hours of Tuesday that the hangover seized total control of me, and I was almost glad for its arrival, signaling as it did the beginning of recovery. Typically I dreaded the time lost, the concentration destroyed, not just the day after, but in the days after *that*. If you paid enough attention, you could sense a slight diminishment in acuity—a new and unwelcome graininess to consciousness. Indeed, whenever I went to blackout levels, as I had with Duke, and most of the night was a blank, it could take me as long as five days to regain absolute clarity and expunge the mental lag. For that time, I'd have to deal with a persistent clamminess to my eyelids and forehead, and the subtlest tremor of my tongue when I placed its tip on my palate. It was a test I used to conduct on myself, actually, to know when I was truly fit again to work, to think, to imagine. Yet as I lay there, in full knowledge of the disagreeable week I'd set myself up for, my thoughts were pervaded by an easy and unfamiliar optimism. In a single weekend, I'd gathered proof of the adequacy of my materials: Daphne and Duke. Which meant that when this bleariness abated, there'd be *real* work to be done, not mere trial runs, or just final pieces to previous puzzles, like those morose portraits of Claire that had come to dominate my life. It had been a year at least since I'd last worked with this excitement of possibility, of opening rather than closing vistas. Along with this would be the first serious money in a while, quite possibly more of it than I'd yet experienced or had any right to expect had I carried on with Sandy and his vaunted gallery. With philanthropists like Garrett, you really couldn't know just how lucky you were going to be.

25

Over the next days, while waiting for the texture, the finer shadings, of my consciousness to return, I assembled a first portrait of Duke as best I could. To speed my recovery, and my portrait, too, I decided to start in on the case of Theria that Paul had sent me. For quite a while after, though, I was unsure exactly what effect it was having on me, foremost because of the baffling collection of photos I received piecemeal, one every few hours, texted to me from a number I didn't recognize. The pictures made me worry about just what *other* drugs we'd all taken that night at Bryan's, given the number of them that showed men looking rather seductively into the lens. Dating-app images, I thought, although some of the men were posed so provocatively, in bedrooms and on couches, that their likenesses could realistically only serve the purposes of procurement.

I recognized no one in the images, even if there was something familiar about the locales. I'd seen most of these places before, *been* to them even. One picture, for instance, was of the Dia building in Beacon; another, of Bard's library. I soon realized they traced a line going north from the city, right along the rails, up through the Hudson Valley. The times of day captured in them appeared to match those outside my door at the moments I received them—morning pictures came when the sun was ascendant, and evening pictures arrived in darkness—suggesting they'd been taken right before being sent. I recognized one photo as downtown Kingston; it'd come to me before the picture at Bard. But it was the fifth or sixth image that finally betrayed the identity of the sender, just as I was wearying of their banality. Although he seemed younger and fresher, and he was without scarf—the air must have been doing him good—it was undoubtedly Jeff. He was also *sans* trousers here and down to a very fine undershirt, a sea island wifebeater. He was making bedroom eyes like the other men.

Might this be an intimate gesture intended for Daphne that she was forwarding on to me, to incite my jealousy, or merely to mock Jeff? Were the four men she'd sent various pictures of her lovers corresponding to those days, those towns?

An adequate response didn't occur to me for a while. I settled on a simple one, straight out of Garrett's playbook: the single exclamation point, which really could mean anything you wanted it to. Without context, and that's precisely what I refused to supply, all one could really conclude from it was: *I am getting your messages.*

I didn't bother offering even this much vis-à-vis the *other* notes I started getting—the ones from Paul. These were emails sent only to me, with no CC for

Garrett, and they were blank: no text, no subject line, just attachments. Even though I was on far less intimate terms with Paul than with Daphne, I got much more out of his correspondence. Mostly it amounted to research studies, polling data summaries, along with more theoretical papers in consumer and social psychology, management theory, and advertising. I understood now why he'd not CC'd Garrett, who'd specifically told Paul not to guide me with data and analytics. But here they were: papers on so-called motivational research, some involving PET scans, fMRIs and other imaging technologies. *Reds and blues in the psychic economy: colors and politics* read one title; *Cell-phone carrier preference hierarchies among Leicester adolescents* read another. The phrase *Adverts and Amygdalas* headed up an issue of *Adage* featuring the latest lab findings—dumbed-down stuff, in case I couldn't quite handle the peer-reviewed material.

Paul was credited in some capacity on most of them, sometimes as first author. Plainly he wasn't just a marketing guru, an advertising executive, or a graphic designer turned advertiser, the kinds of people whose educations often didn't span beyond Dumbo or Madison Avenue. No, he was evidently a trained, indeed distinguished psychologist and he wanted me to know it. He seemed to have a special interest in patterns of consumption, and in one paper, from a decade back, he was listed as a senior researcher at the Ehrenberg-Bass Institute in Australia, a place Karen once described as a contrarian center of contemporary marketing theory that had railed against the targeted-ad fashion ushered in by Facebook. The group preferred a strenuously mass-market approach, on the dreary but plausible principle that buyers cared far less about your consumer products, or indeed your art objects, than you did; they didn't, in general, acquire things nearly so thoughtfully or discriminatingly or loyally as most advertisers had been taught to believe. Hence the key wasn't the sophisticated, numbers-driven isolation of the most profitable customers, or the creation of an emotional bond with consumers—relationship-building, as they called it—or any of the other soft terms of the modern advertising business. What mattered was crude ubiquity, pure and simple. That was all the lizard brain reacted to, blunt force. *Consumers aren't the marrying type*—that was Karen's phrase. The key was to work *with* their promiscuity, to be available night and day.

Although Paul had his primary appointment at Ehrenberg-Bass' London branch—I'd detected faint overlays of Australian and English accents upon his Midwestern one—he'd gone to Sewanee for college. One of the papers he sent me, the first he'd ever published, grew out of his senior thesis in sociology (he thanked his professors in a footnote). Later he attended the School of Visual Arts, and then, after an interval of some years, he took a doctorate in psychology and management theory from Columbia. Strange that Garrett hadn't bothered to explain the gravity

of Paul's credentials. The man was foremost a professor, though Paul never mentioned this fact about himself either. Was that behind his coyness at our meeting at Sanguina? He also didn't bother saying anything else in the body of the emails, leaving it to these attached PDFs to make plain his purpose, which of course they didn't, couldn't. Paul was the hyper-calculated sort; the meticulousness of his dress alone told me that. There must have been a reason for his vagueness. I decided not to reply to any of these messages.

I did read the articles, though, or at least the parts of them I could grasp, since most were thick with statistics, integrals, delta functions. He wanted me doing just what I was doing, I knew: reading the papers, guessing about him, and eventually, searching around online, always our first recourse now, often our only one in a case like this, where asking him or Garrett directly might compromise my position in any debate over how the campaign was to proceed. I had, and always would have, my suspicions about patronage; just as Paul and everyone else did about the existence of art *as such*, and not art as career, art as hobby, and so on.

Luckily, there was a lot to find. The internet told a long and varied tale about Paul, the renowned psychology professor, the advertising executive. There were even some pages about his time at SVA, where he'd enrolled not in the advertising school, as I'd imagined—he was never so crass—but in mixed media. Immediately before joining Garrett at Antral, around four years ago, Paul was leading a private research firm he'd given his surname to. It was called Siglin, and it provided raw marketing data together with deep proprietary analyses of it based on his academic work, teasing out implications that could be of use to his clients, whether they were marketers themselves or the advertising agencies that served them. Some of this research was commissioned. A business would retain Siglin's services, as it might those of a management consultancy or investment bank; but, just as in those lines of work, a good deal of the group's research was initiated by Paul and then dangled in front of potential clients with promises of greater revenues, or at least greater insight into the mechanics of their market sectors.

Siglin drew partly on traditional polling data, which was only semi-reliable, given that people often lie about themselves, when they aren't simply deceived about who they are. It was the sort of information, Karen had been helping me understand me, that George Gallup gathered in the early days of market research, the 1920s, when he was the first to empirically demonstrate just *how well* sex sells (we always knew that it did). It was only in the wake of his work that mass-market advertising turned steamy, lascivious. The admen intended no special harm. This was just sound economics, good science. If propriety and decorum had turned out to sell best, they would have happily opted for stuffiness. What's more, they held, there was nothing immoral in

these advertisements that wasn't already immoral in the consumer. What advertisers helped to do was acquaint people with their own desires, not to humiliate or chastise them, as was the norm till then, but to celebrate and liberate those drives, while liberating, too, the money from their wallets. The polls proved that it wasn't just *you* who was mean and boorish; everyone was just as crude. There was no reason to be ashamed, or to expect anything either.

Instead of simply touting the virtues of the products, usually in big blocks of print offering reasons why you ought to buy, it was finally grasped, with the establishment of the psychological subfield of motivational research, Paul's specialty, that consumption was often an irrational process, that atmospheric, *creative* ads pitched at our deeper instincts could be more effective than logical, persuasion-based, better-mouse-trap types. This was, effectively, applied psychology, tracing the parameters, conscious and not, rational and not, of the consumer mind of the period, which had been continuously updated since then by men like Paul. For just as the delusions of schizophrenics varied in systematic ways through the ages, depending on the shape of the culture around them—today, it was mainly chip implantation or cellphone signals burrowing into their brains; in the eighteenth century, it was the Devil directly addressing them—the guise of desire was always evolving. Toward *what* exactly, though? Is this what Garrett wanted to know, the *logos* underpinning our longings?

Up until then, for at least a couple of hundred years, but really much longer than that, I knew that advertisers had been relying on hunches and home truths about what tended to move people to buy. In truth, every marketer, huckster, or hustler, from the beginning of time and trade, long before capitalism as such, when barter was the practice of choice, had to have *some* psychological acumen, no matter how little formal study he'd done, or how little he could explain what it was that he knew. Yet it was the great behaviorist Watson, not some disciple or proselytizer of the unconscious, who was at the forefront of this formalization of the huckster's intuition, turning advertising from a set of hunches into a science. Before he would settle permanently in the halls of academe, make himself one of the leading thinkers of man at the turn of the twentieth century, he led a research firm himself. This couldn't have been lost on Garrett's man. It explained the technocratic smugness Paul evinced, the sense of scientific pedigree that hovered about him. It was what peeked through from behind those Swiss architect's glasses of his—a frame that wasn't yet represented in the Obscura line, though it could only be a matter of time. Paul would have fancied himself a branch of that Watsonian tree, which must have lent his work, in his mind, a sort of dignity that mere polling data or rough-and-ready marketing tricks couldn't. No, he was a man of real intellectual range and creative power, perhaps more so, or anyway more openly, than his rich boss.

Certainly he thought this scholarly expertise was the edge he held over Garrett. What else could he cling to? The breadth of papers he'd sent, some of which had hardly any bearing on Garrett's project, was meant, I think, as proof of the respect he was owed even by artists. Respect I hadn't shown, I'm sure.

At all events, the papers *were* fascinating. One study, *Dirty-hands ads and consumer loyalty*, conducted with the help of college students over a period of twelve months, appeared to show that companies relying on messaging involving self-mockery, the kind that directly acknowledged consumer ennui, were, though very much in fashion, less effective, in the long run, in retaining buyers, and could in fact cause the tenuous bonds between consumer and company to fray. Owning up to manipulative behavior, then, didn't cleanse you of the sin of manipulation. On the contrary, companies that employed campaigns which either ignored the question entirely or chose a path of simple earnestness, even if they were derided at the time by their own buyers, ended up outperforming the irony mongers. Nevertheless, the very next day, another article Paul had a hand in arrived, claiming to establish some version of the old saw that any publicity was good publicity, visibility was all.

Several papers compared, along various dimensions of measurement—total dollar expenditure, brand loyalty—outdoor versus indoor elements of ad campaigns. And one of them, a careful piece of applied semiotics authored solely by Paul, questioned the importance of an influential truism concerning the color scheme of McDonald's Golden Arches—namely, that they stimulated hunger—and instead prioritized its shape properties, the fact that the logo *resembled* several French fries sculpturally balanced against one another, that the design was in fact a kind of homage to the fry, and that *this* was the primary trigger, the feature that cinched things in the mind of the driver passing by on the freeway, since the fry was, without doubt, the hamburger chain's most compulsively consumable product. In this it rivaled the mighty cigarette. The paper was positively Barthesian in its nuance and wit. I had to credit Paul, even if he seemed more evil to me because of it.

Some articles that Paul didn't send to me, but that were cited prominently within those that were, turned up in my search, and their implications were more troubling than the rest. Presumably he'd expected me to look them up? They tended toward the theoretical and appeared in the more esoteric social-psychological journals, with titles like *Authority and the Crowd, Disarming Subjects*—I kept reading it as *suspects*—and *Persuasion and Coercion: Defining the Difference.*

Links between Paul, Siglin, and Garrett emerged, too, spilling into the business sections of newspapers without Antral's ever being cited by name. Apparently there was a precursor company Garrett had been involved with—JG Chemical—which was quietly dissolved shortly before the founding of Antral. It had, controversially,

helped supply American police departments in several states, though not New York, with advanced materials used in the construction of riot-control gear: foam slicks that made walking impossible; mists that induced fifteen minutes of paralyzing pain on contact, far worse than any produced by stun gun or pepper spray, although no permanent traces were left; electrified truncheons that weighed hardly anything; a chemical powder that burned so brightly in flares that unless you were masked with specialized lenses (also produced by the firm) your eyes would *fry*. And this was just the beginning.

JG had retained the services of Siglin right around the time they started producing these items. And the articles on crowds and authority seemed to have been published in just those years, which would have made Paul the right man to make the case with local governments and police departments for the legitimacy of JG's technologies as instruments of law enforcement. (In the end, I couldn't conclusively verify this hypothesis, although I did see Paul described in one advertising trade magazine as a *crowd control guru*.)

It wasn't clear if JG undertook the fabrication of these products, or if it mainly supplied the materials. I also couldn't quite tell whether its successor, Antral, had carried on any of this business and was simply doing it more discreetly. Still, neither JG nor Antral had been found to have done anything strictly *illegal*, just ugly and brutal. The besmirchment had been bad enough for Garrett to wind down the company— *his* namesake firm—and reform under a new moniker. I wondered what else might have been going wrong at that time to force his hand. And in any case what *kind* of man was Garrett, as a self-professed man of religion, to have led a firm involved in such commerce? Was *this* his idea of spirituality? Surely Paul would have known that in sending me these articles, I was going to go down this trail. Was he really trying to undermine his boss, then? Did Garrett possibly *know* that, too?

A thousand questions gathered on the tip of my tongue, and I knew I wouldn't put even one of them to Paul or Garrett. How could doing so help? In fact, I was inclined, for the moment, anyway, to pretend I'd never gotten Paul's emails. What proof was there that they hadn't gone into spam? If Paul was above explicitly asking me to read his papers, to discuss his purposes and his past with Garrett, by rights I could be above reading them. To answer him now, but only with questions, would effectively put him in control of me, the neophyte puzzling out the professor's meanings. I wasn't going to tell Karen anything either. I didn't know what this sort of knowledge might do to her, to Cosquer, to my plans and livelihood. I needed time to think.

Soon after, when I had Garrett on the phone about deadlines for a set of polished drafts—a progress report, in essence—I couldn't resist asking him what account he

wanted me to take of the known research on matters of image psychology. I was giving him an opening to mention Paul's emails, if he indeed knew about them and was willing to talk about them.

"Oh, not too much," he replied. "I wouldn't have gone with you guys, you know, if I were looking for a Big Data campaign." There were lots of tried and tested options, he explained, if that's what he was looking for. No, the only data he wanted me collecting was whatever I could pick up with my own two eyes. It wasn't that different from the way he liked to do science, actually, without too much forethought. There was such a thing as an excess of expertise. Sometimes he thought his "comrade" Paul suffered from it. There was nothing more valuable, in Garrett's mind, nothing had taught him more, than reinventing the wheel over and over again. Because what you ended up inventing, most of the time, wasn't quite the wheel at all. It might carry out the same function, but it had a different structure. Like evolution, nothing would turn out quite as it has if you ran the whole thing over again.

Daphne—I knew her name would have to come up, I was just wondering how and when—she'd told him similar things about acting, the value of amateurism, of flying blind sometimes, so that you didn't become mechanical, a slave to technique. Did you know she was being educated in just such a program? he said. She'd abandoned NYU in the summer for a program upstate that was going to let her branch out. In fact she was there now—have you heard?

In some small way I felt better after talking with Garrett, knowing I wasn't being recruited simply as an illustrator of Paul's pet theories. He did mention, just before we hung up, almost under his breath, that I ought to keep my ears open, too, not just my eyes, that Paul was a "special guy." What exactly this meant I decided not to ask. I had the feeling, though, from this caveat, that Garrett might well have been aware of the research Paul was sending my way, vaguely seeding my mind with contradictory ideas. Paul, I now knew, had a way of playing both sides in his academic life, to prove himself non-doctrinaire, pragmatic, quintessentially American, no matter that he'd spent much of his career abroad. Might Paul's sending me those studies be Garrett's way of telling me something about himself, and about what I was involving myself with, without having to take responsibility?

Neither could I ignore the possibility that Paul was using the fruits of his long years studying psychology, desire, motive, and intention, *on me*. And who could blame him, really? If you knew such things about the human mind, would you really put all that aside in your personal dealings, just because the people in your life happened not to be objects of your professional designs?

26

A few days later, taking a break from my work on the first batch of drawings, I met Karen and John for lunch, at her request. We decided on a place not far from Cosquer's headquarters, one of those forlorn Hispanic bodegas, a Brazilian one, which doubled as a makeshift bistro for the direly hungry or the intrepid, with a few plastic tables and chairs settled right next to the counter and its covered aluminum bins of prepared food. Even at midday, the place was drenched in fluorescence, which always troubled me in a way it didn't at night, where such intensely shallow light could be warranted by the absolute depletion of all better sources of it. But when you could see sunlight through the front door, being awash in a blue-white glare wasn't easy to stomach.

Just as we were sitting down to our steel plates and the shared platters of meat and fish, rice and plantains, Karen wrongfooted me: to get a jump on the copywriting for the campaign, she'd gone ahead and met up with Daphne. *Just to suss her out a little*, she added to break the ensuing silence at the table. The point of our Brazilian lunch was obvious now. Having pounced on Daphne, Karen had to explain herself before I could find out about it another way. Given how quickly she'd abandoned Duke and me after the game, the idea that this was about efficiency or speed, or getting the jump on anything, rang hollow. And since she'd not seen any sketches from me yet, and so had nothing from which to work, what could have been the point of meeting Daphne, unless it was something personal?

While Karen and I were squaring off, John gorged on a foil pan of charcoal-fired beef, along with plates of beans and blue cassava. It was all going into his mouth at an extraordinary rate, as Karen and I sat there twirling our forks over empty plates, trying to figure out how to destroy each other with a witness. You didn't have to eat it to see that the food was, as promised, quite beautifully done, something one got used to in New York: tragic surroundings, this neon blue plastic table with chairs so low your knees bent at a forty-five-degree angle and pushed your feet beneath you (they must have been children's seats, or else expressly designed for South American statures), combined with sublimely precise food, born not of fastidiousness but long, ancient experience. The staff would have turned this out effortlessly, I knew. The entire neighborhood was Brazilian, in fact, so the customers, bronze men and women with tiny bronze children running around their legs, were Brazilian as well, which created enough of a local market to make the place viable, even without people like us frequenting it.

Karen and I watched John with a contempt meant only for each other. He relished eating like a beast and generally flaunting a certain vulgarity in New York. It was almost an act of Midwestern preservation, his rural, strip mall childhood in Rapid City scarfing hotdish. He was the only one of our friends who'd gone on for an MFA, from RISD, right after returning from China—a black mark in my eyes, he knew this. He met us back in the city afterward and leveraged his rural tastes; they were nearly an extra credential, his very first degree, the one that made his MFA less damning. Today, though, with just Karen and me for an audience, there wasn't much leveraging going on. He really did just crave platefuls of cheap grilled meat, and this dingy shop was one of the best around. He would know. *Deals* were something John pursued unabashedly. He was the poorest among us, which cleared him of any wrongdoing in being price-obsessed, or in jumping full-time into graphic design so early.

I noticed a vicious edge in the glances Karen sent my way. What did she know, or think she did, anyway? Had she somehow already heard about JG Chemical? I couldn't say exactly what Paul had communicated to her. But I did know what she thought of cads, even the ones she liked, for instance, the man eating for all three of us now. She held me above John in that regard; I'd always prized that. But now I was getting looks she usually reserved for him, after she'd become aware of one of his exploits. It wasn't an unfriendly gaze, exactly, although a degree of disgust evidently pervaded it. Was that because she'd grasped that Daphne and I had spent the night together? What knowledge could Daphne have dangled in front of Karen? Girls could always smell competition.

None of these matters could be hashed out properly with the boor feeding next to us, although I had my doubts he would have noticed anything. John kept the small plates coming: not just yellow rice, fried plantains, and green beans, but a sort of tomato casserole, a South American antipasto thick with red onions and Serrano peppers, and something that looked suspiciously like seafood gumbo. Pan-American cuisine, all for next to nothing. John barely spoke, and so Karen and I turned to coldly exchanging logistical information. It's all we could talk of without insulting each other: about, say, when I'd have some fully-rendered drafts for her (I didn't know, but soon), or whether she'd actually gotten any useful ideas for copy from her visit with Daphne (she didn't know, it all depended on the drafts, really—an answer that infuriated me, of course, though I refused to stop smiling).

When we'd finally finished, the staff, bemused by our order of eleven dishes between three people, removed many of the trays still three-quarters full. The leftovers might end up with the dogs I could see out back through an open door, if the cook and the two children dangerously wandering around the kitchen, just in front of the animals, weren't too hungry.

Our plan was to catch a screening at PS1 after lunch. This was a social call, technically, though I think the silent face-off we'd begun fulfilled Karen's real aim. (John, true to form, was mostly here for the food.) Films were going to be projected, she said discouragingly, right onto the walls of the exhibition halls: real films, narrative ones with sync sound, not just doctored art films of the Frampton and Brakhage varieties. These days, *Artforum* dedicated as much space to feature-length cinema as to anything else. Why not.

There were going to be drinks, too. The whole gallery would be made up quite comfortably for viewing, giant beanbags and some folding chairs, that sort of thing. Apparently you were encouraged to treat it as a social occasion, to talk over or through the films; all the art being fired onto the walls was incidental to your experience.

Did we *need* PS1 for this, though? I asked through gritted teeth. I was in a nasty mood, Karen had drawn me into it. They both wore a look of slight exhaustion, John even while he ate, in anticipation of what was to come. So I delivered. Surely, I continued, there were more natural spaces where talking over the entertainment already occurred, totally of its own accord. Wasn't our time better spent simply bringing that existing practice, as it was realized in jazz clubs and hip-hop shows, the homes of friends and films shown in amid greenery, which New Yorkers were already familiar with, whether it was Bryant or Brooklyn Park—wasn't our time better spent bringing *this* to greater self-consciousness? At least, anyway, if we believed some sort of Bulloughian notion of out-of-gear appreciation was a good, I said, or even the *sine qua non* of art—both of which I strenuously doubted. What did PS1 bring to all this, besides a certain kind of legitimation that hardly served anymore? Couldn't we just accept that only a very few sorts of art were genuinely *portable*? That you could slap them up on a wall in a giant hall full of other pictures and get the most of what they had to give? That most work withered, like a joke with a strong punchline and an unintelligible conceit? Why, after all the decades of institutional critique, did we still feel the temptation to shoehorn in aesthetic experiences that naturally and most profoundly occurred elsewhere, except for the economic might of those institutions? If there was no money to be found there, would we care at all?

Before I could slice any deeper, John stuffed a couple of yams into his mouth and rose, wiping his hands on his jeans and looking resigned to the fact that I was, through my obnoxiousness, putting an end to his meal. Karen collected some sort of milk drink from the counter before they both walked out of the place into clear, bright sunlight, leaving their trays for the South Americans to scavenge. John separated a pack of cigarettes from its cellophane and continued feeding his appetites. After I'd caught up to them, I was just about to resume my harangue when he spoke properly for the first time.

"You know," he drawled, "Lindy is showing something of hers here." He turned to Karen: "What is it again? I know it's longish, with amateur actors."

I stopped in the street and then they did, too.

Karen nodded broodingly in the face of my glower.

"If we mentioned anything earlier," John said, "you wouldn't have come at all. Lindy *really* wants you to see it, though. You don't have to speak with her. She might not even be onsite right now. Just let's go by, see what you think."

"Rick would appreciate it, too," she said. "He just *loves* her now, thanks to you."

As usual, John and Karen were acting in concert. I could see I'd be expected to keep my thoughts to myself on the hopelessness of Lindy's art, most recently championed in the back pages of *Art in America*. They would have made an attractive couple, these two, and in fact John had been wooing Karen a long time. As far as I knew, she'd always held out. She didn't like the openly promiscuous types; she probably would have been with John if it wasn't going to be taken, at least by him, as a form of conquest. In my gut, I'd always thought John really wanted something deeper with her, only her, the way he hung around at headquarters long after he strictly could have gone home. I don't know that he'd admit anything of it, of course. He seemed to prefer playing the wild pig.

What really made me want to bolt wasn't the prospect of meeting Lindy and confronting her art, or all the lies I would have to tell if I ran into her, but what Karen might try to wield over me the rest of the afternoon, tormenting me in subtle ways (she had the gift) with whatever she'd gleaned from Daphne. All the same, I needed to know what she knew. And even Karen's implicit censure, my own rage at her presumptuousness, couldn't help me from appreciating, beneath those bangs of dark hair, the shine of her skin, the pleasure of her company in other circumstances.

Though she'd eaten little, being embroiled in battle with me, she'd bought some kind of ethnic milkshake on the way out. We used to like drinking horchata back in LA, on the hottest days under what was in truth a Mexican sun, even if America had won that particular war, and she'd never given up the habit. The lid was off and by now she'd lost at least a quarter of the foamy pink contents to the pavement as we walked.

"Daphne was a little disappointed I didn't have any text for her already. That was the main thing I got from her," Karen said to me softly.

Daphne had hounded me prematurely, too, about drawings that I'd not yet created.

"She had thoughts about the project," I said.

"I'm sure."

"Meaningful ones. As if she'd been thinking about this sort of thing for a while."

"Yeah?"

"Didn't you know? You must have."

John took possession of the milkshake and Karen wiped foam from her mouth with her sleeve. She seemed to regress whenever she consumed anything of this sort: a shake, ice cream, a Dutch waffle from one of the trucks in Manhattan. Probably she was happy to return to childhood now. It was strange to me, the way John, even now that he was done eating—he was contentedly pulling on a cigarette between sips of the shake, all his biological needs addressed—*still* had nothing to say about our project with Garrett. He seemed to know there wasn't much room in it for him. At some point Karen would have explained to him Garrett's obsession with my work in particular. By these means, John had become a kind of neutral observer, who seemed, if I grasped the import of the occasional glint in his eye aright, to be finding some pleasure in the simmering conflict between Karen and me.

Really, he had no reason to be upset about not looming larger in the project. He already had a heavy schedule. He always did. There were student loans he was still paying down that the rest of us hadn't worried about in years, if we ever had. It's why we tolerated his outbursts and excused his malice. He'd had an objectively harder ride than the rest of us, though the gap between me and him had closed lately more than he knew.

John certainly had enough to be bitter about. His family had neither supported his career choices—in the context of the Dakotas, they could only appear less than masculine—nor offered him any sort of filial stability. How many times, when he was drunk, had he told me and anyone else in earshot, Oh this is nothing, Lenore is the *real* drinker in the family; *he* was an angel by comparison. It was only a matter of time, once John had started down this path, that he'd arrive in the same terrible place. You did everything in your power to disrupt it, but he would find a way back: she'd murdered Chelsea, he'd whisper. That's how faithful a drinker she was; she wouldn't rest until his sister was dead. Why? he asked in a slurred hush. Because *finally* Lenore had a reason to never stop drinking. She really was magnificent; her self-pity knew no bounds. Harried, smart, spotted skin, frazzled hair, and a *murderer*.

Lucas, his father (he actually called him Dad now and again), was still in the picture. John had no idea how the man had held on through all of this, how he could bear the murderer of his child. Sometimes this was a cause for admiration, other times contempt, depending on the day. Lucas was a gentle man, if not quite a gentleman, who'd only ended up in South Dakota because that's where Lenore was from. He was a junior high school teacher—American history—whose primary charge was his wife, keeping her on track, taking her to dialysis treatment though she

was only halfway through her fifties. They'd met in college, in Columbus, but Lenore just couldn't stand to be far from her family, generations of them who, since Chelsea's death, mostly kept their distance.

John was also the only one of our group to have entered into a marriage, and therefore the only one to have annulled one, too. He'd gotten married in that first year at RISD, proposing to another student almost on a dare, you sensed. His parents married in their early twenties and they'd barely known each other then. It was in his blood to do the same, he'd said at the time with a laugh. The truth was that, once upon a time, in school in California with us, he was a terribly lonely man, a depressive in the first instance, not an alcoholic. After the quick fizzle of his marriage, he put all that away. He'd annulled the inner world and spent his time now looking outward.

"Is it any good?" I asked him, pointing at the foamy puddle at the bottom of the clear plastic cup shining in the light. John stuck it out toward me and tilted it. A thin pink crescent formed at the bottom, its color fading as it melted. He inverted the cup above his head, tapped the last dribbles into his mouth, and tossed the cup ostentatiously in front of Karen, who had another of those mildly disgusted looks ready for him.

"One thing Daphne was thinking of was those ads from the 1920s," she said to me, "where the copy totally dominates the picture. Pictures where you'd barely be able to see her, they're so small."

"She must have been trying to make you happy, I guess."

"And not you?" she rejoined. "Anyway, the idea made enough sense to me—coming from her."

"'Coming from her'? What is it you know about her, exactly?"

We turned a corner and movies commandeered our minds. This one was playing on a PS1 façade, like a drive-in. It took us half a block to grasp that this was a film of films, spliced into narrative semi-cohesion from classic noir: *The Hitchhiker*, *The Stranger*, *In a Lonely Way*, *The Big Sleep*. We paused before the "screen," where there were several dozen spectators already viewing the one- and two-minute clips that had been braided together. Karen sat down Indian-style on a patch of free grass; John went to one knee and chain-smoked his Pall Malls.

"Is this Lindy's?" she asked.

"She usually shoots her own footage," John said.

"I'll go in and find where her film is showing."

"*Inside?*" he said.

Karen snickered and patted John's knee.

The two of them, I knew, thought they were sparing me something by pausing outside, giving me time to acclimate to the idea of being in a gallery before actually

entering one. And so we listened to the staccato noir voices flowing through the speakers parked near us, Bogart and Bacall and Welles, all hailing from different films, convened for a roundtable discussion.

You could say I was trying to excise the noir from my life just then; I'd even tolerate Lindy's work if it meant getting away from *this*. Generally it seemed a congenial scene: people were talking organically, smoking and drinking something or other, but if I'd genuinely sought such a setting earlier, the feeling had passed, I'd rather be gone. What *was* the problem, really, if Karen knew Daphne had stayed the night at my place? It might be an issue for Garrett, given his apparent closeness with the girl, but what was it to Karen, unless, of course, there was more to our own relationship than she cared to admit.

She and John were transfixed with the collage film, though I'd heard enough of Bogart's gravelly, tough-guy seductions for today and maybe for all time. Which is to say, Bogart left me positively *wanting* to enter an exhibition space. My last visit to one had been to the new Whitney, for the Biennial, which failed to inspire even a twitch of interest in me. It was the smart pose, of course, to scoff at these sorts of shows now, this or Venice or (especially) Documenta. The art reviews filled up their issues with columns that, while disagreeing on the details, excoriated the work and its conceptual basis, *regardless* of what or who was exhibited. On all sides it was a play for absolution, I thought, for participating in a socio-economic system whose flaws were too well-known to be worth rehashing. Merely a passing acquaintance with Bourdieu showed you this. But contemporary art amounted to a way of life that no one could—or rather, would—surrender willingly. The life*style* it held out was too charming, however iniquitous. So the same display was always made, it was no different in Washington or on Wall Street, that rueful frown at the flute of champagne you were drinking, as if this somehow exculpated you. It was just the same in the pews, really, for the billions who held that merely acknowledging the fallenness of mankind, and pleading forgiveness, was all that redemption required. Along with this frown—this *was* perhaps specific to the art scene—would come various kinds of reforming critique: a *plan* for a better world, rife with the sorts of cosmetic changes (donating portions of gallery proceeds, say, which Sandy liked to do) that made participants feel a bit better. Whereas the only decision that truly counted for anything, that made any sort of fundamental improvement to your own life, if not the world, was whether you stayed or went. But then, to genuinely be in a position to choose, and not simply self-flagellate, you'd need a kind of courage in facing cultural oblivion that hardly anyone could summon.

Today, I was keen on finding a quieter space in which to confront Karen about Daphne, to get a proper sense for the actress' state of mind, post-rendezvous, what she

might have said or kept to herself. The funereal quality of art centers and exhibition spaces, so often with their long-faced attendants standing about, hands folded behind their backs, as if in cuffs, could be absolutely depended on—even, I suspected, in ones that asked you to be part of some belated happening.

Right in the lobby another film played, another collage, in fact, although there wasn't much of an audience for this one. I'd always looked ambivalently upon such works, which were assemblages from other works, for the fact that their makers seemed so often only to be fishing for significance. You were dared to suppose that the artists, often carrying mighty university credentials, *didn't* have some ingenious or profound conceit in play. This was a dare I usually made. After all, I'd known these same sorts back in art school, when they were taking their first tentative steps toward their professional identities and attitudes. One in ten, perhaps, had any real sense of direction. The rest were searching out an angle, a hook on which to hang a career.

The most interesting thing about this film was its raw materials: psychotronic films from Japan dating back as far as the seventies, mostly of the Yakuza variety, it looked like, given the bright red paint that stood in for blood, common also to Italian cult films of the same era, De Sica and the like, and linked there with the same archetype of organized crime. Somehow you read the precise shade of this blood back into earlier black-and-white films, imagining the blood in that unbelievable, almost pink tone. It had a touch of orange to it, too, and seemed alive, organismic, as it pooled all over the floor. But the image that had always stuck in my mind, and that I kept seeking out in the collage, was that of Joe Shishido, the legendary Japanese thespian with surgically enhanced cheeks. He'd made himself into a chipmunk, apparently, so he wouldn't be forgotten in a sea of generically handsome Yakuza actors. It worked—at the price of disfigurement, of course.

I asked someone strolling past the three of us, either she'd lost interest in the film or she was an unmarked PS1 employee, perhaps even an artist, what did it matter—I asked her something simple: where might I find the films *not* made from other films? She gave a throaty, unpleasant chortle that made my quip seem poorer than it was; I resented her for this. Then someone slapped a hand on my shoulder—John—and Karen quickly flanked me on the other side. He clamped down, impressing upon me, by this gesture, the need to at least try not to attack anyone else today, while impressing upon *her*, whoever she was, that I meant her no harm, and that he, John, would anyway shield her from the worst of it.

The woman had just watched part of an original film, she told us, two rooms down. It must still be going. It looks ancient in a very modern way—she tittered and finished with this line.

Karen and I followed the woman's finger, while John—of course he would—stayed

behind with the woman. On another occasion I would have rolled my eyes, but this time, as soon as I'd felt his hand on my shoulder, I perked up knowing there was a reasonable chance she'd detain him. She had a foolishness to her, and in a looker, foolishness of a certain sort could be profoundly appealing.

It was the right call, for all of us. I would be alone, finally, with Karen, and John could resume reveling in his senses. And the other woman? Well, when she found out John was an artist, a formidable one, rising in a manner more interesting than most, she'd be all right with things.

27

There were at least fifty people in Lindy's space, although they weren't keeping to the social premise of the show, which the wall text somewhat crudely informed you of as you entered the exhibition. Instead, they were silently watching this film, shot on Super 16, in all likelihood with the old Arriflex that had come down to Lindy from her grandfather, a middling if well-connected documentarian who'd cataloged the rise of Television and other post-punk outfits so many decades ago now. Lindy's film unspooled in one continuous shot, the camera panning to and fro on some unshakeable dolly. She'd played fast and loose with the light meter, so everything was washed out, this barbeque in a cramped Brooklyn backyard that seemed vaguely charged with nefarious meanings, though I'd not been watching long enough to parse them. Something about the grass that was matted down in patches; the patties on the grill that convulsed in the flames; and the more or less unintelligible chit-chat that resolved itself here and there in instants of clarity, almost all of them portentous, the men leering at the women and the women just slightly recoiling, whenever they weren't positively basking in the attention.

Whatever they thought of the film itself, the crowd looked distinctly uncomfortable with the viewing conditions, standing around, leaning on walls, sitting cross-legged on the bare concrete floor. And for the very few who were actually talking—the films were meant, after all, to be ambient accompaniments to social life—they did so rather dutifully, fulfilling the instructions of the artists with a theatrical, empty sort of jabbering and simply listening to themselves *speak*. They carried the expression that audiences invariably did at installations, a happily scandalized sort of face that was at the same time self-regarding, conveying pleasure with their own openness to such provocations. I always associated that face with the lone Venice Biennial I'd attended (I'd never go again), and the prize-winning installation, which consisted of runway-jaded models lolling around a room, just beneath a glass floor, like a fashion show run only slightly amok. (You could expect something just like it in Milan and London and New York very soon.)

If anyone were to draw conclusions from *this* exhibit—and I'm sure they would, as *de rigueur* panels were scheduled for later in the week—they'd be doing it from a needlessly deformed version of a quotidian phenomenon: the way it is possible to converse engagingly in the midst of watching a powerfully charged film, neither practice coming at the expense of the other. You were *really* watching and *really* talking;

one shouldn't speak of a state of distraction here. The same is true, paradigmatically, when ambient music bleeds into our conscious activities—reading, say—and we attain a curious kind of intimacy-at-a-distance with it. The background can be the most vital thing there is, like oxygen in a room.

What my counterparts didn't fully appreciate was that heightened consciousness wasn't always to the good; it could destroy or disfigure precisely what one yearned to be closer to. Some features of life were simply too delicate for the spotlight, which is merely to say, there are things in this world that exist most fully and truly in shadow. Indiscriminately throwing light everywhere you went only revealed something about your obsession with light-throwing. I'd learned these lessons from my own profiles. Some of the most probing pictures came together from a kind of *in*attention, from not peering so deeply into someone that you lost sight of their face.

If this insight-free chatter surrounding me now, about such things as, oh, how strange it felt to talk like this in public, or to watch like this together, or just how *interesting* the film was—if this was really the best they could muster, then I had to side with the ones who'd gone silent, who might never have even tried their hand (or voice), who might as well have been watching the film all alone, as most of us do now anyway. In fact, I realized, there was an opportunity here for me and Karen here, given all we had to say to each other, now that we'd dispatched John. I was sure we could do better.

"Did you mean, then, Daphne likes working with text?" I announced.

The room acoustics put my voice on the same plane as the film's soundtrack. I'd noticed this as others talked, too, the way their voices merged with the ones at the barbeque, particularly those three middle-aged men in trunks, no shirts, their bellies distended, kneeling beside an above-ground pool that was sky blue, while the sky itself was more faded than that. Yet it was altogether different to find one's *own* voice disappearing into a space that was uninhabitable. I gave myself pause, talking. The loudspeakers must have been arranged just so to achieve this. There was impressive craft on display here, and Rick would have been the one to execute it, being expert in audio matters, even if it was Lindy's idea.

Karen seemed perplexed, wondering, perhaps, what was making my voice swell so unnaturally, as if I were speaking from someplace other than *here*. The acoustics swept signals around the room, making it hard to localize sounds and impossible to know if one's voice was being electronically processed somehow through planted microphones. She had other reasons to be confused as well, given the many minutes that had passed since we'd last spoken of Daphne. The actress had been on my mind ever since, though, and I'd been patiently waiting for the chance to discuss her further. My tone, the distinctness of my elocution, made others in the room

break off their stilted exchanges, sensing that an actual dialogue, driven by actual need, was about to ensue, unlike their own or even the film's.

"She likes what?" Karen replied.

I cocked my head incredulously, there being no need for words, and felt the audience sway as I sent gentle ripples through that field of attention, and through Lindy's imagined world, too, which seemed suffused with a strange sort of brooding nostalgia. On the one hand, I'd been impressed by the aural techniques deployed in the exhibit. I didn't mind admitting that, and I would tell them both, Rick and Lindy. On the other, the imagery and the narrative were somewhat less inspired, in ways familiar to me from Lindy's *oeuvre*.

"Well, I don't know what Daphne likes," I declared. "I was *asking* you. But what about... Egyptian, condensed, in white, stamped right across the drawings? That kind of thing."

"She's not some sort of Kruger hack, no." Each syllable of Karen's careened off the walls; and both of our meanings, hers and mine, were amplified by the attentive forces surrounding us that stretched and shaped our words and gestures. You couldn't *not* be aware of that power here, one I wasn't much used to feeling lately, having been away from the podiums and openings and panels for a while. When was the last time I'd formally spoken? Or even had something I'd wanted to say to these sorts?

"Then who *is* she?" I said. "What about her ideas 'makes sense' to you? That's what you said, before." I looked around with only my eyes to see if I might find Lindy or Rick along the perimeter, somewhere in the crowd.

"I only mean..." Karen had lowered her voice, not because she was self-conscious, but because hearing your own voice at twice the volume you expected can make it hard to think. You became louder than your own thoughts. In this space, you felt, and this was clever of Lindy, that when you spoke, you were on stage, so that each word *should* count. There was no such thing as private talk here, really.

I presumed this acoustical anomaly, this effect on voices, had originally been an architectural accident. But Lindy must have noticed it at some point, perhaps while seeing an exhibition here months or years before, and claimed it for her own piece. The room had odd curves to it, I could see, and wedged right into the upper corners there *were* in fact what looked like the black bulbs of microphones: we were, then, being electronically amplified, our voices actively mixed with the soundtrack, though subtly enough that you couldn't help but wonder whether you were losing control of your own voice or simply suffering a bout of technological paranoia.

Karen's hushed cadences did absolutely no good. If anything, the hint of a whisper falsely freighted it with significances that didn't exist, making it even harder to really think *through* this voice, knowing you were being misunderstood. And yet

Karen, who was always ready, when challenged, to display a freedom from the yoke of politesse that Claire was loathe to, admirably decided to hold forth without further reservation.

"What I meant," she said, "was this—she's obsessed with scenography, that's what she told me. With Meyerhold. Copeau. The way language could be a part of the *mise-en-scène*, when you blended it with sight, movement."

The room was rapt and packed now. We'd drawn them all away from the film, its ambient ominousness, the waters of the swimming pool rocking across the screen like a Hockney come to life in a bad part of town. The imagery enriched our dispute, which the crowd would have been trying to unravel and interpret, particularly, or even only, because such a bold and unreserved discussion must have seemed a *part* of the installation itself. They would have been trying to figure out exactly who we were—perhaps, they might hazard, the artists themselves, Lindy and Rick. I swung my gaze around the room and noted the passing acquaintanceship I had with several of the flock. That would have gone triple for Karen, as *Cosquer*'s fortunes had risen. She was, I noticed, studiously avoiding the mention of Daphne's name—perhaps she'd not entirely lost her graces—and I decided to follow her in this.

"Language onstage, you mean?" I asked.

"Maybe. But why not at home, too, right?" Karen's voice seemed to break up over these words, but in a way that was no longer appealing. No, it was anger working its way through her mouth, anger nourished by the moment, the fact that this exchange was taking place far more publicly than we'd wanted it to. The word *home* had been specially marred by this new inflection.

"*My* home, you mean?"

"Well, what exactly did she say to you?"

"She wasn't that keen on talking after coming off stage."

"I'd heard that."

"She'd also had a few drinks by the time I found her."

"Go on."

"How do you mean?"

"Well, I just remember you saying how drained she was after performing." A hitch came next, which only the odd context gave drama to. "That's about *all* you said, really."

"She was fresher when she met you, I guess."

"But I don't know if that's what it was, actually. Are you *surprised* she might not have felt hugely talkative around you? Can you think of someone who does? A woman, I mean." She was taking us into dangerous territory; naturally, our audience tightened around us. By this point the film was running a distant second to our back-and-forth.

"You seem to do pretty well around me."

She curtsied here. "Besides me, though."

"Maybe she just finds it hard to talk to men."

"I really do think it's *you.*"

"So this is why you just had to meet her?"

"You gave me *nothing* in that note."

"I didn't *get* much from her."

"Verbally, at least."

"What are you saying?"

"I'm saying that's why I went."

"To find out."

"To find out."

"About me."

"The *project.* I know too much about you as it is."

"Well, if that's all you were looking for, it was only a matter of time till you found out about it from me."

"And how much time do you think we have? Cosquer, I mean."

"Plenty of it."

"Garrett doesn't see it like that."

I took half a step back, a reflexive expression of affront. Karen shrugged that practical shrug of hers, as if to say that behind all his inspiring words, Garrett was still just a client, that I shouldn't confuse his aims with my own. But I wasn't sure who was confused here, me or her. I could find it so ugly and beneath her at times, this off-handed matter-of-factness. It was then that I longed for the manners of Claire. I knew Karen didn't *really* hold such vulgar attitudes, though she could be pushed toward them, like John, in a different way, with his hillbilly routine.

"So, exactly what time are you meeting Duke tomorrow?" I couldn't suppress a smile.

"I could do that," she said, smiling as well. "Or you could just tell me about him, so I don't have to."

"It would spoil your fun. I think you'd hit it off, you two."

I considered bringing up her absence from my post-game meeting with him on the Lower East Side, when she'd had every chance to find out more, if she and Garrett were so concerned about time, progress. In truth, she would never agree to meet with Duke for any significant period without me, I knew that already. Despite her sound politics, there was such a thing as animal fear. And, yes, Duke took a certain pride in inspiring it, especially in Karen and her ilk, who were really only *conceptually* interested in the Dukes of the world, once such people had secured the right perch in society.

Did she, beyond the jealousy I sensed and savored in her—there was something unconsummated between us, for many years now, since that party with all the fallen bodies everywhere, and we the only survivors—did she also have business reasons to worry about me? Did she think, for instance, I might be unfair to Daphne, that the actress needed some protection from my imagination, a check on it only Karen could provide, through early, prophylactic contact with the girl, so that the images wouldn't get out of hand? Was she concerned I might lose the project for her and bring ignominy to Cosquer through my encounters with Daphne, though not with Duke? What exactly did she think of me vis-à-vis womankind, I wondered. What had Claire *said* to her? Probably she'd painted a grotesque portrait of me, in her anger, that had put this fear into Karen. Were there other women, too, though? Which ones? And could Karen's jealousy merely have been a phantasm of my mind, and in truth she was simply disgusted by what she'd heard I was capable of with women, things which might have been almost as bad, in certain psychic respects, anyway, as the things that were held against Duke?

"Did Garrett say something?" I asked. "About Daphne. That she needed…"

No answer, only a what's-it-matter shrug from her. The room was silent. The crowd pushed ever closer to us as more gallery-goers trickled in, and all you could hear was the onscreen banter (about girls, of all things) between the three curly-haired men, who had by now moved to the patio and were looking out over the pool and the other guests. A dull rage began to sharpen in me; I thought it best to end the back-and-forth between us before I said something in poor taste. Perhaps Karen was even hoping to goad me into it. Her disgust was peaking. It'd be better simply to make her finish her performance and explain Daphne to me, all the things I was bound to miss about her, *as a man*. I took a full step back and turned up my palms. The floor was hers.

She observed my hands, touched a finger to her nose, as if weighing things up, and then, again rather impressively, began to expound on just what she'd meant by the phrase *coming from her*. She suppressed just enough information to mask Daphne's identity, but was otherwise expansive, corkscrewing outward with the voices of these swarthy men coming through the loudspeakers, their chests bared. Some had donned what looked like Wayfarers; others, barely tinted driving glasses. There was a nod to the yakuza montage from the lobby, something gangsterish to the shape of their mouths when they laughed, jaws clenched so that you saw their teeth, even in profile, the lips peeling back as they bit down on cigarette filters. The sound editing, the contrapuntal orchestration of the dialogue, put it definitively beyond any mere rehashing of mobster tropes. But the Queens-y backyard, that inflatable pool, the dirty lawn chairs gathered in a circle, all had the feel of (barely)

organized crime. That *barely* might have been the novelty: men on the cusp of that world but still only dreaming of it. It was this familiarity, bordering on cliché, that left so many spectators free to be drawn in by Karen's monologue, which had something far fresher to it.

It was from this speech, now in full flight, that I gleaned certain truths about Daphne that the woman hadn't bothered to share with me herself—though, of course, she'd had no problem spending the night. For one thing, she was no less steeped in poetry and prose than in theater and film, which explained why she'd be so curious about the copy going with the images. Daphne was an actor, yes, but she was less taken with Stanislavski than with Meyerhold when it came to *mise-en-scène*. Apparently words and their exact instantiation were a fundamental concern: their sounds, but also their typographic presentation, on a stage or a page. Indeed, a reasonable portion of her theater work involved projected text.

I nodded nonchalantly at Karen, as if this were all so obvious, it could be inferred by anyone who had so much as said hello to Daphne. Of course, this wasn't true. Nor had the actress, on the night we met, shown any interest in telling me this or anything else. Maybe she wasn't ready to get personal with a man, merely physical. Or maybe Karen, and this is what I think she was now implying, was just better at earning people's confidence. But then what reason would Daphne have had for telling me about matters relating to literature and theater? I was a painter cum draftsman, not a wordsmith. Whereas Karen, as a text artist, was the one turning toward literature. Which meant these details about Daphne might have all come up quite naturally, and innocently, between them.

"She's like you, then," I said. "There's bound to be a book of poems. A novel, even."

"She's studied painting," Karen said. "She even knows your work. She was comparing your sketches that night to what she knew of you."

This much Daphne had told me, though I behaved as if it were something of a surprise. The scrutiny I felt all around me grew: who was this man? More than one person had recognized me as I'd entered, although I acknowledged their acknowledgement with the briefest of reciprocal glances. Withdrawal, the past year had taught me, tends to create a certain demand. Meanwhile the shot playing out on the great white wall in front of us showed the men, who pulled on tees and polos without drying themselves, going indoors, into the kitchen first and then through to the breakfast nook, which overlooked the yard, the smoking barbeque, and the pool in which water wiggled from children splashing about, and one almost-teenaged girl languidly shifting in it, sunbathing and imagining, I suspected, that she was older than she was.

What other details fell from Karen's lips? Everything was bubbling up like a barely controlled taunt, so that I wasn't sure if she was performing anymore or simply lashing out at me.

"She was a student in Paris for a time," she said. "That's when she met the French director and was cast in his film. Did you guess that, too?"

Karen's question hung in the room while the men daydreamed of an afternoon at the beach with their families that was still to come. "It'll put all *this* to shame," the bulkiest of them joked with a sweep of his hand toward the windows. Yeah, they were going to fire up one of those beach pits and *throw something thick on it*, let it cook while they swam in the Atlantic, not this what-the-fuck pool. The host, Charlie—his ease around the house, and the casually authoritative manner in which he led the other two men around, made this clear—the host chuckled quietly. But the jibes kept coming, as the other two pointed out each thing in his backyard—the fence, the patio tiling, the grill, the parasol—and cheerfully dissected its second-ratedness through increasingly violent bouts of laughter. Charlie, the handsome one among them, with a strong-jawed face not yet despoiled by age or the sun, and a solider torso than his chums, sat straighter and straighter in his chair while his chuckling grew more strained. After the other two had had their fun, they were quick to dial things back: the burgers had been spectacular, the sun was nice and heavy, and the grass *was* green, wasn't it? I don't think Charlie, who remained steely-eyed, believed any of this.

I nodded irefully at Karen then, as if I'd learned hardly anything from what she'd been saying, and that she really ought to just tell me the story in one go, not in little phrases and fun facts, so that I could see if she'd really learned anything *new* about Daphne, something that might matter.

One of the girls from out near the pool, probably in her late teens, came into the kitchen. She smiled uncertainly in the direction of the men while fixing a glass of lemonade. (Strange how effortlessly I followed both dramas at once; my admiration for this work was growing all the time.) Again we were treated to rolling waves, now in the carafe, the cloudy yellow water that put me in mind of piss in a pool. One of the men, small, stocky, and fat-faced, a bona fide guido, pointed her out from the nook: "And her, just look, isn't she gorgeous?" Her appeal lay in her slender frame, as well as in the long straight chestnut hair that dripped down over her eyebrows and slightly hid her expression. But the two guests who'd been ribbing the host now offered him secretive smiles. At this, his handsome face blotched over with anger and only permitted him a smirk. Sitting between the other two, he grabbed them each by a shoulder and kept squeezing and grimacing until alarm and evident pain began to show in both of them. They'd pushed Charlie too far, it seemed. The tall girl

was taking in the scene from the kitchen. She took a sip of lemonade, gathered her glass, and poured one more, presumably for someone out back, when the two men flanking the host, still rubbing out the pain in their arms, passed through the kitchen and ambled back outside. Now, her uncertain smile was nowhere to be found; she was losing all doubt that menace was afoot. But, just as she made to go back out into the yard, Charlie called to her. "Florence," he said, in a way that somehow expunged the natural euphony of her name. He patted the empty chair next to him, and in a moment she was sitting on its edge.

I had to smile, considering our parallel play. Given how openly Karen and I had started to speak here, how our voices now dominated the room, it was nearly impossible for the audience to believe that we *weren't* plants of just the kind I'd suspected would be around here somewhere, recapitulating or counterpointing the film's conflicts. This smile wouldn't have helped my case. Yet I refused to acknowledge the crowd with my eyes, and in this way managed to stay in character.

Charlie snatched the Ray Bans propped up on his head and hung them from the collar of his waterlogged shirt; then he stood up and began to quiz the girl. You saw that sky-blue pool through the window, pondered its immobile waters, now that it had emptied, while the girl wilted under the host's calmly posed questions.

How'd you meet my boy exactly?

How well do you really know Chris, you think?

And how well does he know you?

And then much worse: *Do you think you could be "the one for him"?* His face turned as ugly as his friends' as he asked this.

Florence was ashen by this point. You thought she might drop the two glasses of lemonade, or simply piss herself.

Meanwhile, Karen hadn't missed a beat. She hadn't even thought of the screen in a while, caught up as she was in her monologue, enunciating her words with increasing bite. Unlike Charlie, she had answers, not questions. But it was hardly the well-told tale I'd requested, just an even longer string of unexplained assertions about Daphne, doled out, it seemed, in no particular order. Could she be believed in all this, or was this playacting now, rampant falsification?

She did theater and film at Tisch—only for a little while, though.

There were classes at SVA, just like Paul.

She dropped out of everything for this radical theater school upstate.

The string of photos came to my mind—the trip upstate, all the way to Kingston and beyond. (Did Karen know anything of this?) Yet I maintained—I was determined to maintain—a neutral façade, my own theatrical riposte to her rationed divulgences. So she ratcheted things up, just as the handsome man on the wall did, and I, cast by

circumstances as the teenaged girl, Florence, continued, like her, to listen and burn. More crumbs from Karen, they came faster and faster now, like bullet points in a case file. She was possessed by the facts, and the quicker she served them up, the more deeply I resolved to remain impassive.

She hates American indie.

Mumblecore was recycled Rohmer; everything else—Haynes, Maddin—was lazy Lynch.

She loves Kenneth Anger, for his color. His stories are painted not filmed.

She loves Haneke for his precision, and Costa for his patience.

But she adores the grotesquery of Dumont.

I smiled.

She hates alcohol and drinks all the time.

She loves cigarettes, even in rehearsal.

She's known she was bisexual since at least eleven.

There was a boyfriend in New York, in college, who tormented her for two years without even once touching her.

There are still the most vicious fights with her mother, Anna, whenever she shows up.

She lives with her father but likes him no better than Anna.

She has a "complicated" opinion of her father's dear friend, Garrett.

German philosophy—her father taught her how to love it, and she does.

What to make of this? I no more trusted Karen, in this state, than I trusted the Italian or Greek father on screen and the things he was saying to Florence, who by all appearances was profoundly unsuitable for his son. Evidently she was a parasite of some sort, and later a rat. Certainly, by implication, she was a slut.

Karen exulted in telling me all the things I'd failed to uncover about Daphne, demonstrating just how abject my ignorance was, and how glorious her knowledge. She gave me the impression there were another fifty facts for every one she mentioned. Yet she overestimated how much I cared to know the real Daphne. And if I did, it would anyway take a less charged occasion to separate truth and fiction, a moment *not* unfolding in front of what was now a crowd of a hundred or more. Our tête-à-tête had pulled in visitors from neighboring rooms, including, I now saw, just beyond Daphne, the artist herself: Lindy. She was smiling at me curiously, pleased with herself, perhaps, for having orchestrated this chamber piece.

In a darkened corridor, away from the window, Charlie, the father, has just laid an extraordinarily paranoid accusation: that Florence was informing on the group, that this was her real interest in his son, not love, nothing of the kind. The cinematography and the narrative, which up until now have been both pointedly low-key, finally show themselves to be as visceral as Rick's soundwork.

When the first blow, close-fisted, landed on the girl's solar plexus, a shot right between her pert breasts, I could see Lindy beaming at the screened images in a complicated sort of way, just before Rick swooped in behind her. Karen and I had stolen the crowd's attention away from the film through our conversation; yet it took just seconds for us to be definitively upstaged by this train of projected images, by celluloid, and especially by the increasingly shapeless face of this teenage girl being sprayed across not only the walls of the gallery but, by the man's fists and boots, the virtual walls of that darkened corridor in the house.

As in a Mike Leigh film, dread long summoned but seemingly bounded suddenly burst its dam. Soon we were leaving Leigh territory, lower-class domestic realism, for something approaching the brutality of those psychotronic films showing not fifty yards from here, with their flippant dismemberment of the female body and those oddly casual thunderclaps that landed so surprisingly on the faces of women. The blows proved cathartic for the Japanese men depicted in those films, men who were somehow more sane, more balanced, after delivering these shots out of the blue. Slapping, then, was how they cured their *own* hysteria, and not that of the women, who often enough weren't especially unhinged at the moment of impact.

Florence's dismantling, however, really occurred *psychically* in Lindy's film, as each strike was accompanied by a chilling rhetorical question, voiced through the host's clenched teeth, that when taken together with all the other questions, came down to this: *Who exactly do you think you are?* An answer at this point was no longer sought, so the permutations of that single non-question perpetually expanded while the girl's visage disappeared under the mark-making of his hands. The heavy glass door to the patio was shut, trapping her whimpers inside the house, so that in the yard, all were oblivious to her fate: the inflatable pool that had briefly been empty filled again with life; guests frolicked within its perimeter or else kneeled just outside it, in the grass, canned beer and brats in hand.

Evidently nothing Karen and I could say was going to compete with this. Indeed, even the two of us could only stare dumbly at the moving pictures. We'd been put in our place, Karen's litany had been stymied. Like others around us, she was vexed by cinematic goings-on; I, though, was experiencing a sort of bliss, no longer having to listen to her. There was something tawdry about it all, what Lindy had set up here, but even I had to admit its power, and more than that its convenience.

Like a boxer laid low in the championship rounds of a dogfight, Florence was twitching in a pile on the floor. I hooked Karen's arm a bit too sharply with my own—the kinetic force of the film was contagious—but before she could pull away I gave her shoulder a friendly little squeeze. Without another thought, we shaped our mouths into Os, exhaled like spent athletes, and briskly walked off, arm in arm,

leaving the others behind, including Lindy and Rick, the only ones who showed signs of consternation.

On my way out of the exhibition hall, I'd given Lindy, this gifted, cloying character, a single glance of recognition, just over my shoulder, before sharply turning away. I did it for Rick's sake, really. Lindy's mercenary interest in me naturally had persisted even once she started dating Rick. Though he understood her eminently better—they shared more of a world—I carried more cachet, probably because of my lesser availability. I was no longer appearing in reviews; even the critics could hardly reach me. Between Karen and me, it was something of a running joke how I appeared to be perpetually trying, politely enough, to evade Lindy, this quite beautiful and fast-ascending artist-manqué with the spotless pedigree, a woman whom most men, for one reason or another, would having been rushing toward. That I preferred Karen's mostly platonic company to something more corporeal with Lindy, that the gulf in my feelings for the two was wide enough for this to be possible, gave Karen real pleasure—one I was happy for her to have.

In many ways, Lindy embodied the archetypal contemporary artist, with her Yale BA/MFA and artistically "accomplished" New York father who'd greased the wheels of her career. She had a habit, in her work, of foregrounding either climaxes or the just-befores that gave you no real sense of the denouement to follow, and hence of the full shape of things. You were often left trying on potential endings to the action, and, because of your uncertainty, you lost all sense of the significance of what had happened or was just about to. Doubtless her rise in art-film and installation circles depended on this peculiar dramatic structure undergirding her work. It made everything she did seem senseless in a certain way, incapable of being narrated convincingly. She'd become a specialist purveyor of this breed of insufficiency. In her PS1 film, say, near the end of the work, you couldn't quite make out Charlie's questions for Florence over the fireworks going off in his backyard; nor could you apprehend what answers, if any, were coming back through the girl's screams and yelps. It made the violence unbearably transfixing.

Another work of hers: a series of photographs of industrial accidents, purportedly non-fictional ones, the way she'd written each of them up in convincing journalese for the accompanying wall text. You couldn't quite get your head around the results, though. The pictures foregrounded a moment, or *possible* moment, of terrible consequence while withholding the knowledge you craved most—what sort of end the depicted persons came to. A man, for instance, with his shirt caught in a

woodchipper, photographed looking rather confidently at the garment, as if it were sure to simply tear away, while those standing to his side looked terrified, far less certain of this outcome. The text that went with the photo simply referred to the initial conditions: so-and-so with his shirt caught in the jaws of an industrial woodchipper, Oregon, 2014.

In another work, Lindy presented you with a tsunami-like wave bearing down on a city (which?) and left you again to imagine whether this was just one more near miss, the kind that happened every day, or one of those that quite suddenly *counted*. The same with various mass shootings. There was something irredeemably cheap in all this, of course, and if it wasn't the totality of what she had to offer, it was ever-present in her output. What were we likely to learn about the spectacular from *this*, though, at this point in history? And even if there *was* something there, how could it not be overwhelmed by the crudely sensational in her *oeuvre*? It was no saving grace, for me, that she would emphasize one of the quieter theoretical strands in discussing her work, about dramatic or narrative structure in relation to the aesthetic field, rather than the luridness that was actually responsible for her growing visibility in the arts.

Lindy certainly fancied herself, like all those enmeshed or dependent on university patronage, as a researcher and an activist: a philosopher (when she leaned toward the conceptual) or a social scientist (when the inclination turned political) who just happened to use a camera, and not a word processor, as her primary compositional instrument. Sometimes, as in the untitled quasi-gangster film I'd just seen, she seemed to be involved in critique, perhaps of cultural tropes, their horrendous car-wreck-like capacity to entrance us, as well as the degree to which we'd become inured to assaults of several kinds, going on in parallel, on women and even young girls. One sensed the aim was to bring this to consciousness and thereby free visitors of PS1 from the problem. At moments like this, John's Midwestern skepticism toward the coastal establishment seemed thoroughly right-minded to me. It put him miles ahead of her, that attitude. There was also a tinge of nihilism to her work, although in truth it was a simple hedge. She played both sides, sometimes depicting art as a force of revelation, and other times as inescapably bogged down in the very things of which it was supposed to cleanse us. She could never be accused of naiveté, nor of being apolitical or jaded. She had it all, really.

The fellowship- and residency-hopping that would define Lindy's life had already begun. She'd spent six months in Kiev on a Fulbright, researching Putin's totalitarianism by studying one of its prime targets. The visiting teaching posts would come. Wasn't she already doing quarters at Pratt? Perhaps one day, if all went well, she'd settle into a faculty position back at Yale and complete the circuit.

She'd found herself the perfect boyfriend in Rick; I may well have intuited this in introducing them. Rick was a man still consumed with abstraction, though free of expressionism (this was *conceptual* abstraction); with formal features of contemporary life transposed into the medium of sculptural paintings; with naming and the paradoxes of representation. It was only a matter of time before he discovered, or fell prey to, some signature gesture he'd be reproducing to the end of his days.

He struck me as the third kind of artist domesticated by the art-center ecosystem: the conceptualist or post-conceptualist, though here the *post-,* just as when it was a suffix to *modernism,* was otiose, and should probably have been replaced simply by *late,* or in Rick's case even *post-historical,* for those who thought Warhol's Brillo Boxes had signaled the end of the history of art. Given his participation in Cosquer, which meant his working side-by-side with far less institutional artists like John and Karen, it was difficult to say how Rick's next years would play out. I had no idea how to feel about him, really, now that promise alone was no longer enough for any one of our group, and our choices were beginning to accumulate, to matter. Maybe he'd even head in some art-rock direction, or become a sound sculptor. It was probably a good thing, though, the lack of clarity here—better than certainty about staying on his *current* path. It meant he might do something interesting after all, who knows when. Perhaps only after parting ways with Lindy, if he ever managed it.

Lindy's future wasn't hazy at all. It was much nearer, too. Already begun, almost. You could see it would be spent much as it already had been, traveling the world's museums and universities, showing films like this one, alongside dozens, sometimes hundreds of others, depending on the particular exhibition or conference, and serving on achingly long panel discussions in seminar rooms and reception halls, where on other days businessmen sat in the same chairs talking of money. I could see her at the end of one of those long *faux*-wood tables, pulling a long-necked microphone toward her and wetting her lips with Poland Spring before reporting her "findings" in that abstemious voice humanists must have held under copyright. These findings, cavalierly culled from the language of Guattari and Agamben, Sloterdijk and Vattimo, she would of course have to quilt in patterns that strained not merely credulity but intelligibility.

Mostly what you got from Lindy was a botched rehashing of theoretical reflections one or two decades old that had already been quietly superseded among the philosophers and theoreticians themselves. What she could offer was just what had had time to trickle down, second- or third-hand, to the laity. Lindy and her ilk were effectively illustrators of decaying ideas, working in the past light of old stars. The results of her artistic "experiments" were already validated before she ever came to test them in the studio. At best, her work amounted to replications of earlier trials;

at worst, to just-so stories of the Kipling variety. Naturally, as a viewer, you'd have no notion of what in particular had been demonstrated by any of her pieces without the assistance of the wall text, or the artist's statement, or the ultimate legend and repository of the show's import, which one could usually consume more profitably and pleasurably than the show itself: the catalog. You could replace any of these textual mashups with a thousand others and hardly anything would have been disturbed. The fit would be just as snug, because there was never any fit to begin with.

One curious feature of artists like Lindy—the very sort that most of those I'd gone to Cal Arts with were hoping to become—was the dutiful interest they took in what eluded institutional matrices, what had not or could not be accommodated. That it was necessary, in seeking absolution, to avow such concern—that every artist understood, however tacitly, the rank shame of being taken to the bosom of bureaucracy—suggested how different the field was to, say, physics or anthropology, where there was no need for forgiveness or apology. It was a measure of the artist's talent, seriousness, and nobility, however, to evince disdain and resentment for his cage, to signal to all others that he, too, craved the outside—as if somehow it were difficult to *get* outside, when everyone knew the cage only locked from the inside. All that was really needed was a modicum of conviction in *life outside*. And *this* turned out to be remarkably hard to find.

Lindy was in love with me: my own exit from established grounds acted on her like an aphrodisiac. Being close to *my* escape, being married to it, would excuse her from having to make her own. She could enjoy the comforts of the cage while siphoning credibility from the chances I was taking with my career. That was my value to her. But I knew there was more to it. There was genuine longing. Every artist of her sort would leave the confines of the museums and universities if someone could guarantee that they'd remain visible and secure. Being beyond the aegis of the organs of consecration, without losing their blessing—it was the most coveted position of all, *if* you could manage it. That I was taking just this risk, turning down the perch and playing for it all, in the manner of Agnes Martin or Hammons or even Trisha Donnelly, was something Lindy would have wished she had the courage for. The top tier of institutionally sanctioned artists always had this wish, to see themselves as one step up even from the institutions that sheltered them.

So far, so good, she would have thought, with my name still buzzing around town. Scarcity had deepened the import of my endorsement. She'd been desperate for over a year to become some sort of intimate to me, I wasn't sure exactly what. Given Lindy's own choices, however, the feeling could hardly have been mutual. She was adored in certain quarters for her work and her legs, that much was true, I'd explained to Claire more than once. But I really didn't see it—*any* of it. Yes, I admired the prices her

works were fetching, and the spot on the payroll of the academy she held. But that was the extent of it. I *think* Claire had believed in my loyalty in the end, though I couldn't be sure how much damage Lindy might have done. I'd never seen such spite in Claire until crafty little Lindy appeared on the scene, relentlessly searching out opportunities to bump into me: house parties of the underground, *Cosquer* functions (she eventually became a semi-regular of the magazine), even the obscure whiskey bars in upper Manhattan I was known to frequent, ones she had no business being at. It went so far, this craving for my stamp, that over the years she'd effectively offered herself to me a few times. Eventually I made a pact with Claire not to see Lindy anymore, one I was more than happy to keep, even now.

Admittedly, the way I'd managed to get her off my trail was perhaps not the most honorable. I'd put her onto Rick, talked up his burgeoning stature and iconoclasm. My maneuver had never been revealed to Rick for what it was, and I don't think she ever made it clear to him how intensely she'd pursued me, as fiercely as any other career goal: a fellowship, a reference, a solo show. Rick had thought she was simply someone I thought he would like. Ever since, I could only think of him as someone who'd unwittingly taken a bullet intended for me. I was fonder of him, it had strengthened my sense of duty to him, that he'd been my shield. Lindy, then, might well have saved what was left of our friendship.

Rick had taken to her, though. That shouldn't have surprised me. She had her virtues, for the right man, even if I felt guilty that it was he I'd thought of first as her ideal match, which had to say something about my esteem for Rick. I wouldn't have introduced her in the same way, for instance, to John, who unquestionably would have enjoyed sleeping with her. Most men would have. But she wasn't likely to be girlfriend material for him—not that he was looking, not openly—and he would have been insulted had I suggested the possibility. Without exactly saying so, John had conveyed to me what he thought of the pair of them, still plying their trade on the exhibition circuit. Unlike the rest of us, Rick found the hand-maiden-to-the-philosopher role agreeable enough, as if Hegel and Duchamp were right and it was really only philosophy, pure thought, that could reconcile us to the world, which meant that either art had to play some *other* role in our lives, or it had to turn into a branch of philosophy—a rather poor relation, notwithstanding the contortions both artists *and* philosophers were willing to make to show that artworks were dialectically useful and could earn their keep, at least while post-historical artists like Rick and Lindy, in shoring up their own importance and seriousness, kept increasing scholars' cultural influence and visibility (which is what academicians lacked most) by publicly parroting their clunking verbiage of nominalized Latinisms. Nothing could have been more drab and *in*artistic than

this language colonizing their essays, artist statements, and wall text; the professo-riate, for its part, would turn a blind eye to all the artists' misunderstandings. They needed each other. Just as Lindy and Rick needed each other.

So, once again, I was tickled to be absconding without having to speak to either of them, especially together, when I felt most on the spot about the whole matter of their relationship and their art, those doubly dim futures. Lindy was never going to reach us before we could escape—not through such a thick crowd born of the very success of the work. I threw one last glance over my shoulder, I couldn't help it, and there she was, amid that sea of people who were dumbstruck at her vicious art. She was pursuing me, she had let go of Rick's arm to do it, shouldering her way through her own audience. Meanwhile I hurried Karen toward the doors. She was too tired to fight me, it seemed, and her own opinion of Lindy's work may not have been much higher than my own, even if she was always going to be more diplomatic about it, given her loyalty to Rick, her right hand at Cosquer. Just before making it to safety, we glimpsed John, facing away from us, deeply engaged with the woman from earlier. She seemed terribly impressed with him now, as I knew she would be. He never saw us, though she did; she even waved, but John was implacable. Nothing could take him off course. And that's how we left him.

As soon as Karen and I were outside, heading for the subway station, arm in arm, I began to bask in the uncertainty of her tale of Daphne. Among other things, we spoke of logistical matters, timing for the initial roughs and so forth, but I didn't ask Karen to confirm or deny anything about her story, whether the more improbable elements belonged only to her imagination. Nor did she volun-teer to clarify anything. She only laughed softly, spontaneously, as we arrived at the station, patting my chest and embracing me sharply. Our exceptionally public exchange seemed to have defused the tension between us without solving a thing. I kissed her hair, taking strands between my lips. I'm not sure she could feel it; she wasn't going to show it just now if she did. She wasn't prepared, I knew, to absolve me of sins either suspected or confirmed, only suggest, with this tight little squeeze of a hug, that she'd not given up on me. But there was also something of a warning in it, I thought, a personal one. It made me mournful. I clamped down on her arms and gave her a firmer kiss on the top of her head, a kiss unequivocal and unconcealed. She looked up at me—I thought she might even touch my cheek for a moment—before she walked off, back to headquarters. There was *nothing*, it seemed, she was prepared to confirm or deny today.

I wasn't pleased, of course, about Karen's get-together with Daphne. Yet I was hoping some of the closeness she'd developed with her, supposing any of it was genuine, might accrue to me; that it might help me overcome the discomfort I

felt with the actress after what had happened that night. It might take me beyond that inscrutable exclamation point, borrowed from Garrett's lexicon, I repeatedly adverted to in answering to her texts, almost nonsensically at this point; and it might let her feel that I wasn't an aloof, Lucian Freud sort, wanting her merely as a subject for painting and then as a sexual object (or vice versa, as the case may be). *That* would have been what she expected of me, given her experience with photographers and filmmakers; it could even be what she wanted in some way, to bed another rising talent, to *make* each other. Of course, she might also just like someone to talk to.

I'd resolved that night to reply to Daphne properly and ask her, among other things, about the cryptic photos that continued to come to me by text. Was that the drama school—those little sheds or studios, the long flat buildings out along the plains—that Karen had told me about? And what exactly was Nik Volger's approach to theater, if he had one? I was putting together my thoughts when another picture arrived, this one of the marble angel that hovered over Columbus Circle's central island. Daphne's return trip to the city was apparently complete. Immediately following the photo were her first written words to me: *I like Karen.*

For the smallest fraction of a second, I considered unleashing one final mark of exclamation. I settled instead on silence. I'd held out this long without a substantive reply; a tiny bit longer and she might finally surrender. *She likes you* was what came next from her, no period, and with that, I felt silence wouldn't do anymore: I needed to cut off this avenue of conversation. I began to type out the matter about drama school, if that's where she'd gone on her trip upstate. *But I had a question.* I typed faster, hoping to fire off my inquiry before anything further came back, but she struck first. *Adored what you showed me at the apartment.*

I stopped writing and let her finish. When she was through, I discovered it all to be rather benign. Why she was writing now, and she was only *asking*, was for art from me. For the same theater troupe I'd seen her with, though not the same show. She'd told the others about my paintings and drawings over the weekend, at an improv retreat upstate. *Maybe like a poster that's not exactly a poster? For no particular show. Long run. The troupe.* She offered not a word of explanation about all those provocative photos. Were these meant to inspire the poster?

Sure was all I could muster in reply. *Soon* would be my follow-up response, whenever she ended up asking, as I knew she would, just when she'd be sitting for me. My apartment or hers?

It didn't take a heart-to-heart with Karen for Duke to get back in touch with me. Ever since we'd met, in fact, he'd been sending me texts, real-time fragments of his doings and his life, thinking, correctly, that I was looking for inspiration. Unlike Daphne's, the pictures had some concrete utility to the campaign; they weren't, not in the first instance, coded messages. I suppose it wasn't unusual to update one's acquaintances like this these days, to no purpose at all, without solicitation (though *had* Garrett or Paul said anything to him?). Duke might have sent similar notes to his friends. For all I knew, he was sending these very ones with blind carbon copies to others. Parts of them were quotes in black dialect which he'd punched up for my benefit; but there were, as with Daphne, plenty of photos, too. (As my trade was pictures, I tended to prefer English for communiqués. I don't think I ever once sent a photo message to either of them.)

One early snap that had struck me powerfully, especially for a phone selfie, one I felt sure would form the basis for a drawing as nothing Daphne sent me could, was of Duke wearing one of Arête's new sunglasses while a thick coil of smoke rose from his mouth, like a snake wrapping itself around his face. I recognized the pair from the box I'd been sent; they had a truly brilliant mirror coating and small lenses shaped like eggs laid on their sides—a bit like eyes. Not only that, the lenses sat abnormally deep, so they seemed to inhabit the same plane as the eyes, replacing the organs rather than covering them. On me, I recalled, the glasses were simply nice. My face lacked the kind of angularity and tonal contrast that could generate traction against the frame's rounded forms. Duke's physiognomy, however, his jagged face, together with the blackness of his skin, seemed to transform the pair. The sunglasses performed a kind of voodoo on him, as his forefathers in the Congo might have. His eyes had been scooped right out of his skull and turned into reflective absences—that was one way of seeing him. The other was less voodoo than twenty-second century. You could experience him as an android under repair, with eyes popped out to work on the inner circuitry.

While walking away from the station, Karen had shouted one thing back at me, a deadline: *one week.* In seven days, she explained to me later, she and I would meet with Antral's representatives with a portfolio of roughs that would be developed into the initial pieces of the campaign. Oddly, Karen never mentioned needing to see any preliminary drafts from me. But then, I thought, how could she work up any draft text to present at the meeting, if everything was meant, as Garrett had told us, to be inspired by my sketches? Could it mean she and Paul were having second thoughts

about the relationship between images and text in the project? Might there no longer be any need for Karen to wait on my work—had she privately been given authority to operate independently of me? It had to be said, however many happy accidents owed their life to Garrett's low-information model of teamwork—an approach that bore, especially of late, unfortunate associations with demagoguery—it necessarily produced suspicion between colleagues.

28

Lately Paul was putting together the media-planning operation for the launch of the two drinks and the lenses. In one respect it was going to be simple: a purely outdoor campaign of billboards, posters, and such, with no internet, television, or periodical advertising whatsoever. But the limitation created complexities. He and the team at Siglin—joining Antral hadn't meant leaving his firm—were busy identifying spaces throughout the city in which to lodge the first of my images, before expanding outward to a second set of sites, and later a third. Everything would unfurl in waves that eventually washed over the entire country: Chicago, Los Angeles, and San Francisco, together with the major national highways linking them all, beginning with what was once Route 66.

We would be operating at every conceivable scale. Daphne and Duke would sometimes appear only a couple of inches high, stuck in phonebooths on guerilla stickers of the *Andre the Giant Has a Posse* variety, or else nearly a foot tall, pasted up *en masse* all over construction sites on letter-sized flyers—in-the-wild postings, as Paul called them. But our principals would also stand hundreds of feet tall on the broad faces of major city buildings and infrastructure. At John's suggestion, we were going to go with a billboard-style approach to production, blowing up my drawings and printing them, at extreme resolutions, at twenty-five and fifty times the size of life.

Siglin was negotiating for vast numbers of façades: blind ones, windowed ones, recessed ones, any and all. The same went for billboard spaces along the major and minor arteries leading into, out of, and through New York: the BQE, the FDR, Fifth Avenue and Broadway. The MTA and the broader public transport system, including the ferries, wouldn't be spared. Buses and subways and taxis, they'd all be tapped in strategic ways that would be, at least at first, more up to Paul than to me. He and Garrett had been quick to tell me my input would be sought in all of this, but frankly, I might have had more to learn from a mercenary like Paul than the reverse in matters like this. I had *that* sort of humility at least.

Wearing his advertising hat, Paul had spent the bulk of his time persuading legions of building owners throughout the city, including the Bronx, to let us use their vacant façades for portraits, simply for purposes of residential and urban beautification. After all, our first batch of pieces would be entirely untouched by any sort of branding: no logos or names, nothing at all, these were Garrett's orders. Though

he might have chafed at the notion at first, Paul was proving skilled at turning constraints to his advantage.

No one had even spoken publicly of there being corresponding products for these images, and no one *should* have. Paul was pitching the drawings, and presenting me, in a way I'd been sure he couldn't: as works of art by one of the burgeoning young painters the city had begun to bet on, and whom Garrett was underwriting as a matter of patronage and philanthropy, like Arnault or Saatchi. Yet public space mattered, too, Paul would contend; it might have been what mattered most to Garrett's idea of the project. In this way, Paul and his lieutenants had begun to convince the city council of my value; he'd even succeeded, miraculously, in recruiting Sandy to the cause. I'd been avoiding my dealer for some time now. But, at Paul's request, Sandy was now speaking on my behalf. He probably thought this would get him back in my good books. I knew he must be incensed by all the money and clout he thought I'd cost him, if only I'd not careened off the path he'd put me on. Yet like Paul, he had guile. Technically, Sandy *was* still my dealer. We were separated, not divorced, and so he maintained a right to represent me unless and until I revoked it. Now he was exercising that right, by way of a stellar reference, to coax me back into his orbit.

His endorsement was working on the city, if not on me. We were beginning to get the OK to renovate various public spaces—parks, roadways, municipal complexes, including the police station—provided, of course, that the council, in each case, could satisfy itself that our proposal would incontrovertibly improve what already held sway there. Our competition, luckily, was merely peeling paint, an index of renewal programs long ago defunded. The country had moved on from the idea that maintaining public space qualified as essential business of the state, had instead doubled down on security and contract enforcement. Which left the commons mostly in private hands these days, subject to the whims of the ultra-rich. This is what made Paul's pitch viable in the first place: the city's appetite for cost-free beautification. The MTA was a paradigm case, a circulatory system the city had nickel and dimed into infirmity, whose trains no longer had the capacity to get their riders to work on time. Whatever money the Transit Authority could get now, they invested in new infrastructure. Beauty would have to wait on men like Garrett.

On a call that Monday, after checking that I'd received the case of Theria he'd sent along with the eyeglasses, Garrett emphasized to me the importance of the simple *power* of the first batch of pictures—without, however, giving me any specific instruction in subject matter or execution. *I depend on your judgment*, he said. He wasn't wrong to trust me on this. Unlike Lindy, I didn't think the first volley in any project needed to bring fire and brimstone. There'd be time for that.

Karen was in touch a couple of times during the week, though always by the

rather chilly means of email. Each time I opened her notes, I expected some hint about the overriding need for restraint in the initial imagery, given the delicate circumstances under which we'd won placement for them: the lie, more or less, we were passing off on the private and public organizations that would carry our pictures. The *interpersonal* restraint I'd failed to show with Daphne would have been plenty of justification for such a warning. But Karen, too, offered nothing of the sort. Was she trusting my judgment? Or merely giving me as much rope as I needed to hang myself? I suppose that would depend on just what sort of chat she'd had about me with Daphne—and perhaps even with Claire, later on.

On Monday, at my apartment, I inaugurated the afternoon, as I did most days now, by opening a bottle of Theria—I'd begun to revel in its protean profile—and charging my eyes, which amounted simply to looking, though without too much care, at the work of others. So many artists I knew seemed studiously to avoid this so as to circumvent the urge to copy, to steal. I never felt such an impulse; I let the art wash over me inchoately, the way the drink washed over my palate, before I began my own work for the day. I went into my library and targeted the wall of prints, taking down, with the help of a footstool, a whole block of volumes. I went no further in imposing order on the shelf than ensuring only picture books sat on it, so that every time I swiped down a rack like this, it was like taking a core sample whose constitution I couldn't predict. On this occasion, the book on one end of the block brimmed with illustrations of disease from the nineteenth century, horrific pictures of consumption and hysteria. Deeper inside, I discovered the classical scientific illustrations of Romer and Haeckel. Not just the infamous embryos, but the whole range of work, starbursts of color conjoined to the kind of sober modeling that furnished a veneer of objectivity and no more. It would all be of use to me now, this approach to physiognomy and verisimilitude that didn't go by way of *sensory* fidelity but rather the analytic credibility of science, or pseudo-science, which, in truth, is simply another part of science. We don't consider it *pseudo* until the evidence against it has crossed some threshold, as with mesmerism, say, or phrenology. There must be things we practice today in earnest that will one day take the moniker *pseudo-*. The science of consciousness? Or else the science of matter as we now conceive it?

Other books in this particular lot were more classical: one had prints from Ingres, Delacroix, and Daumier; another carried a dedication to the great Italian draftsmen Pontormo and Mantegna; and a third gave most of Rubens' sketches. In each book I focused on the works in chalk and conté, pastel and charcoal. As for more recent material, along with an Agnes Martin book I found myself lingering longest over a collection of prints of Mazzoni's drawings. He was hardly the most profound of the artists I looked at, yet he managed to extract an uncommon lushness from a staid and

neglected medium, colored pencil, that traded the clarity of graphite for the variety of color. Somehow, in his choice of shades (often pinks and purples) and layering of strokes, he managed to generate saturated hues without ceding the precision that remained the specialty of graphite. The combination could be captivating. And you felt the power of this even if you thought, not wrongly, that there was something insubstantial in Mazzoni's baroque, quasi-mystical intertwining of flora and fauna, nature and man. Some pieces could remind you of high school doodles taken too far, or bad Bosch, particularly since many of them were executed on Moleskine paper. I would never be able to quite endorse him or his works. It all made me queasy. Yet there was undeniably a sensory world he put you in touch with, and it felt, despite itself, genuinely salutary.

One thing seemed certain: the city could hardly take offense to this kind of quasi-decorative work. So that week, I worked up imagery of Daphne and Duke that seemed to me unified in style, if nothing else, although they only faintly bore Mazzoni's hallmarks. No colored pencil, for one. Instead, I opted for oil pastels highlighted with acrylic gouache, the only paint I had much use for anymore, and even then I tended to use it somewhat oddly, in its opaque and undiluted form, for the sake of intensity. Similarly, I'd shed Mazzoni's preference for notebook paper and the necessarily off-handed quality such a ground imparted to anything drawn on it. It's why Pettibon and Dzama and Davies were all too casual to help me now. Intentionally so, of course, but that didn't change much, glorifying the slapdash, the note, the fragment. I had no longing, in any department of life, for the merely provisional. I might *accept* the provisional, from time to time, but only if I had to. Mazzoni, trivial though he was, at least brought his pictures off with a degree of polish.

For a support, I returned to lightly marbled, untreated goatskin vellum, for its sense of moment and concentration. It was expensive, and I'd always had to ration my use. No longer. The freedom of patronage on the scale I now enjoyed (for who knows how long, though?) could be measured through my new profligacy with animal skin. Dozens of rolls of the stuff arrived. My tiny supply in the coat closet never even got touched, I had such an abundance now, in all varieties, including a slightly pink one that appeared to have retained a mist of blood from the animal to which it once belonged. All sorts of strange hybrid supplies that art stores seemed only to sell on a lark, acrylic inks in one hundred and twenty colors, also descended on and deluged my apartment, filling up shelves intended for dishes and dry goods.

Remarkably, the budget Paul outlined was effectively uncapped, at least for me. So I acquired many other materials on a waywardly experimental basis, which Garrett didn't discourage in the least. On matters of limits and boundaries I tended to consult with him first. Paul was a boxed-in sort; his life showed it in so many ways. Except for

his role at his research firm, he'd grown used to a lifetime of seconds-in-command. It made sense he'd be tighter with money. Garrett, though, had spent his life building his own worlds, taking all the risks and setting all the rules.

Patronage, even just a few days of it, starting with my trip to Daphne's show and, less than a week later, these indulgent acquisitions, was an intoxicating thing. Would anything I were doing somehow be any purer if the backing had come from the NEA or the Guggenheim Foundation, everything filled out in triplicate or what passed for it in the digital realm? There was something wonderfully Medician in producing work under Garrett's conditions of extravagance. I'd anyway been looking back to Florence and Venice and Rome in my recent work, the oracular significance of *historia* and so on. Why not explore that world's conditions of production? The beauty, of course, was that as with Dia or LUMA, there was no board of directors in charge; you needed only to convince a single person of the worth of your aims.

Most of that picture of Duke in the mirror shades with the trail of smoke, the very first I worked up in earnest, had a matte finish. But the eyes, or rather those eye-shaped frames, demanded oil, my estranged friend, for its singular shine. In the photo I'd based my rendering on, Duke's body was entirely absent. I could see a bit of a Nehru collar, and that turned out to be enough. I was including the body in my version, as it seemed to me, in his trade, the body should never be forgotten. He, more than most, really *was* his body; it's what allowed him to be who he was in the world. The collar of his shirt had led my hand more than my mind as I built up the picture in provisional strokes, maybe-shapes and forms that turned increasingly definite until reaching a threshold of commitment, which was different in every drawing but always clear enough for me to know when it had been crossed.

In this case, the *tunic* Duke ended up in formed the dividing line, with all the draping it permitted, the gentle play of modeled forms over his battering ram of a body. In his hand, a cellphone materialized, not a smartphone but an old flip, with its v-like structure clamped between the pads of his fingers: one of those burner phones, bought in bulk and ready to be disposed of when the job was done, whether the sale of drugs (the smoke put you in mind of this) or the detonation of IEDs (here the tunic helped). The picture might have served as the cover to an album by a Wahhabi MC. I took pains to capture Duke's face with an almost overpowering verisimilitude, the kind that turns a visage into a vortex, inexorably dragging your attention down into it, particularly those two shielded eyes. Summoning my recollections of Duke from our night at Bryan's, which came to surface after long reveries—now a controlled habit of mine when augmented and eased by Theria, I didn't quite understand how—I would mentally rehearse each detail in the half-light. Duke's face, after however many bowls of hash he'd smoked, manifested to me as vacated, holy, possessed.

In tandem with this picture, I worked on a charcoal piece of the football player. For now I held off on Daphne: Karen's interference with her was retarding my thinking, my imagination, though the Theria might well help, just as it had that day watching Daphne on tape in *The Sort*. I drew this piece on toned paper, a pale green rice paper with smallish dimensions: fourteen by twelve. And I put Duke in a pose it took many drafts to discover: facing the door of his old childhood apartment at the end of that dark corridor, his hand gripping the knob of whoever's home it was now, in a manner that conjured in some small degree the charming ambivalence reified most indelibly in the *Mona Lisa*.

In the two photos I had of this tableau, Duke was dressed purely in undergarments, black stretch material with red pinstripes and a fierce, almost blinding shine. Prototype Arête gear. I'm not quite sure what had happened immediately before that had led to this odd situation, a man effectively in his underwear out in a common space. Had I coaxed him into it that night? The look on his face did have something of that *happy-now?* quality. There was certainly a touch of humor to the whole thing. What I went on to draw represented the incident in somewhat less humorous terms. I left Duke in his tights, of course, and I left some wrapping on his knee that was partly coming undone, the spongy material trailing ludicrously down his calf and onto the floor like a wedding dress. Yet the perspective I adopted was low, the horizon and vanishing point much higher in the frame than in the photo, as if I were seeing the scene while keeled over from drink (had I been?). The focal point, the place every element seemed to funnel you toward, wasn't, as in the bespectacled drawing, Duke's face, which was cocked back toward the viewer, no sunglasses this time, just a curiously undetermined look, the look just before fixity comes to it. Nor was the focal point, as in the photos, the elaborate fresco tattooed on his back that could be seen beneath the narrowly defined tank top stretching across his back. The camera's flash had made the ink more visible than it otherwise would have been, given how black his skin was. And the doorknob was barely visible, a glint of gold between his dark fingers.

As the drawing firmed up, the interest concentrated around that knob in his hand, and the odd kinetic charge of his body, which seemed not to project forward, in the direction of the apartment door, but back toward the viewer, the direction from which he'd come. Was the door locked and resisting the torsion running from his shoulder through his forearm to his hand? Or could he have been repelled by whatever he was hearing from the other side of the door? His eyes did seem to say, *You hear that?* as if physically he was proceeding, but psychically he was repelled, thinking that where the viewer stood, back behind him, might be the best place to be right now.

As I continued modeling the figure in charcoal, laying in a loose graphite wash with turpentine and wrapping space around Duke, all the hard geometry of the corridor aggressively pulling away from you, what materialized was a man, certainly some sort of athlete, turning the knob with the familiarity of one who knows this place and the estrangement of one who knows he doesn't belong there anymore. This is how I remembered the scene, yet it surfaced fully as the drawing progressed and I got three or four bottles in with Garrett's curious drink.

It was then, with a start, that I recalled someone coming out of the apartment that night: a girl of fourteen or fifteen, with braids and braces and something stronger than a mean streak. Before Duke could get into it with her, which in itself was slightly comical, but then not, given how belligerent she turned out to be, telling us all her brothers would be home and take care of us good, Bryan rushed out from his own apartment to calm things down. By the time one of the girl's brothers came to the door—he'd actually been inside the entire time with his girlfriend, who gave us a violent and frightened stare—everything had been defused. We'd actually woken Bryan this way. He'd not been happy about it, obviously, and it was from there that they both showed me the door. Duke did spring for a car for me. I recalled now the three twenties he'd given me, crushed-up bills poked through the crack in the window as I fell back in the seat. I could see, even then, that he'd been genuinely hurt by the teen's anger, by how the past had expelled him.

It was late Wednesday when my thoughts resolved or simply calmed sufficiently, having not had to communicate with either Karen or Daphne for a couple of days, that I felt capable of working on the Daphne drawings properly. What role my steady consumption of Theria had played, I don't know. But suddenly I had *ideas*. The first picture was going to double as the poster she'd wanted for her troupe, and not just for my convenience. The campaign, I thought, ought to subsume every facet of her life, however tangential it might have been to the product at hand, which meant that the pictures could serve the purposes of other promotions, in this case, the theater company's. The unusual priorities of my patron gave me license. Antral's fortunes were predicated on a certain randomness, as was the history of chemistry itself, the unpredictable reactions that occurred in testing, or simply by accident; and the particular properties any compound might end up having, about which you could only make smart guesses beforehand. Applied chemists were on good terms with the fluke; in many ways it was the engine of the enterprise.

Paul didn't care for serendipity, I knew. But the laws of psychology were so much *weaker* than chemistry: if anything, he should be *more* comfortable with

unpredictability, the failure of reason and the intellect. Yet when it comes to the human mind, the most complex compound we know, our ambitions to tame it, to believe we already *have* in some measure, get away from us. For me, as an artist who didn't see himself as an investigator of nature, whether utopian, nihilistic, or participatory, one involved in a common project with the philosopher or the scientist or the activist, I couldn't have been more cheered by the latitude Garrett granted all of us to operate in a commercial and artistic dark.

Several drawings for Daphne's troupe came together before the end of the week. Perhaps they would amount to a set of variations, all executed on heavy cream stock, or better, yellow, a dull saffron shade. In the first of these pictures, a pastel offering, I positioned the girl in an untouched rhomboid area of the paper, climbing the giant and teetering out of the light, her head lost to the black. Even though I was going to vanish it soon, I drew her face carefully before using my fingers to scrub her away, just as I had the men of Joy Division. This time, however, I achieved the effect not through erasure but by blending the contour lines and stretching the gray-black that filled the upper third of the picture. This was not a taking back so much as a bleeding through, from one into the next. And, in the same way that Rauschenberg's Gorky pictures held a trace of the original forms, so too did my Daphne, in that uneven dark that shimmered with so many grades of black. It took me a number of tries, using the chamois occasionally but mostly the stump, to get her to raise her head, almost triumphantly, into the dark, which was here something like a realm of purity and ignorance. It was in the light, by contrast, including that saffron of the paper and the white highlights that brought an even greater luminosity, where disfigurement lived. The giant onto whom she clings and his grotesque proportions shine brightly with that grimace upon his face as he stares toward the floor, leaning down into the light, while she's held aloft, thrust into the black heavens. The dark, as for Garrett, is the promise.

A second image, in colored pencil, starker, less romantic than any Mazzoni I'd seen, although no less rich, would turn out to be critical. I had no sketch or photographic base to work off, but my memory of the moment was so strong there really was no need. (I seemed to remember everything more intensely these last weeks.) I could picture, almost *see*, Daphne's face hovering over her margarita glass, with a ghostly lamp bouncing light onto our table, a brittle stripe of yellow down the mirror, raking her face like the gaslight falling on one of Degas' danseuses, a face which, as I had it before me now, in my memory of that evening, had not yet glowered in anger. Daphne had a ghoulish cast for only slightly deeper reasons: she'd left the performance in such a hurry, as was her habit, that she hadn't yet shed her stage makeup.

In the picture, as in my memory, the margarita held the lamplight on its surface just beneath Daphne's face, which was covered over by a danseuse's mask of white

paint. She carried an air of the mime, mute as ever, though strangely also lacking all expression, as I'd found her for portions of the night. Or else she was *between* expressions. She seemed to me very clearly to represent some untrammeled lake of feeling, meaning, expression, far larger than the little pond of liquor on which she floated.

Where *was* Daphne now? Was she going to wait until she sat for me to offer any hint of affection, or even simple interest? Was it already finished, used up? The pictures, the drink too, made me ask all this. It was the worst part of making these roughs, not the pain my hand ended up in, or my stiff neck, but the ache in my mind.

A third Daphne emerged only on Friday morning. The entire week blurred into one long day and night, which made me wonder what Theria was doing to me besides giving me "energy," as if energy were some undifferentiated source of power. This draft was based on a photo that had come from my employer. I found it strange that Garrett should have it: Daphne's yearbook picture from Spence, before she'd been expelled, or simply left, her financial latitude having disappeared with her mother when her parents split. Presumably that capital had been channeled into the mother's new family, the step-siblings Daphne didn't much care for.

In this rendering, Daphne looked remarkably... normal, I suppose. If we wanted to introduce her to her hometown with a certain nonchalance, this was it. Not only that, you couldn't connect this girl of eleven or twelve with the young woman she was now. She had one of those faces, like Gerry Vanilla's but with a much happier outcome, in which it seemed almost every bone had migrated some distance and formed new continents, just as there are those whose bones never stop shifting, so that you can't even see the identity between the thirty-year-old and the sixty-year-old.

I went with red acrylic ink, the kind sometimes used for the jaunty, impressionistic contour drawings that had found their way into a good deal of advertising and identity work. But I opted for a more meticulous and sober approach: laborious marking with what might have been the most perfect nibbed pen I'd ever known, naturally from Japan. You could barely see the line it drew, it was so fine. Geometrically speaking, the drawing was correct; I'd gridded it out in graphite first to be sure. Yet I'd managed to extrude the usual illusionism from it, as the blistering ink on toned laid paper, red-brown and bark-like, didn't lend itself to verisimilitude, which I'd no special desire for or against when I'd started the piece. I rarely had any such intentions of effect. The resulting image was almost holographic, the little girl's face hovering over the paper, her spirit come to life.

When I finished these pictures in a state of sleepless fatigue, I did what I was under no obligation to do: I sent them over to Karen, but hedged in a manner I was borrowing now from Paul and Daphne, too: no explanations, no text anywhere, just the attachments. If she wanted to add anything to these, or comment on them, or

use them to spur her own ideas, she was free to try. It was a show of goodwill, my sending these along without waiting for my arm to be twisted; it was also a push toward rapprochement after our spat over Daphne. It would show confidence, too, in myself, my pictures, and the project itself. In the end, if Karen added nothing to these pictures, indeed, even if she ended up thinking poorly of them, at least she wouldn't be blindsided at the meeting with Antral. One more small kindness.

29

I laid out the drawings end-to-end at Cosquer's offices, two pictures deep, facing either side of a long, light aluminum table that looked as though it had been lifted from Antral's headquarters. You could survey the work simply by circumnavigating the table. Karen, who'd returned my favor of silence—she'd not said a word to me about the pictures over the weekend—had a dark green notebook sitting on her personal desk, about five yards nearer the windows. She had reams of these books: a tony French or Japanese brand, I don't remember which, that she'd started using so long ago the mere sight of them in a stationary or art store immediately got me thinking of her, wondering for a split second what was in their pages, as if any and all of them, even the brand new ones, had to contain something of the inner life of my dear friend. She'd even started off Claire on them.

Several Antral underlings were present at this meeting, helping to set up the drawings and photograph them. They were tweaking lights they'd apparently brought with them, an eccentricity of Paul's. He liked to see what he was buying in a light he understood. So, he always took his own lights to the design contractor's office, bright white sodium lights that eased comparison with the mock-ups and drafts he'd already seen. Garrett and Paul stood back now, leaning gently against the entirely empty and unmarked desk I used just often enough to be considered mine. Unusually, not just Paul but Garrett was dressed in a suit. Probably there was a luncheon with investors afterward.

Karen talked with them both while I finished setting up with the underlings. Once I was satisfied with the position of the lights—they'd exposed nothing really problematic—I waved them all over. Garrett approached with a furrowed brow and a certain caution, as if he were worried about what he'd find. Karen, for her part, looked slightly withdrawn. She'd eyed my drawings blankly as I'd pulled them from my portfolio, without opining in any way. She had plenty to worry about, I suppose, that had nothing to do with the pictures, like her own contribution to the project, which I still knew nothing of. She would have been doubly anxious with clients inspecting Cosquer work today. She'd told me of this feeling in her gut, whenever patrons assessed commissioned pieces, no matter how many times she'd gone through it before. It was odd to see her palpably concerned to *please*, which wasn't the norm for her. Nor was it her forte. Notoriously, within the upper echelon of the art-design world, when there was a dispute over something she'd offered, and she felt the client's

criticism sprung from one or another kind of stupidity (*there are just so many kinds*, she liked to say), she'd quickly transform into the headstrong artist I knew, balking at such qualms. All the same, she genuinely liked the idea of pleasing: it's what her upbringing demanded of her, no matter her recalcitrance. I had something of the same feeling with Sandy sometimes, when he'd sold works I'd not yet produced and I had to show him my efforts and gauge the buyer's reaction from that. But those days were gone; I had no interest in returning to them. Cosquer's success had proven that middlemen like Sandy weren't really necessary, not today.

I *say* I had no apprehension, but when Paul, who dawdled with his phone for a little, finally came toward us, a palpable constriction seized my stomach and chest. He embodied a more direct challenge to me than did Garrett, skeptical as he was of the whole project, which was ultimately centered on my work. This veteran of advertising imagery, of consumer psychology, of even more esoteric semiotic matters surrounding management and authority—until the moment he entered the penumbra of his proprietary lights, he was the most matter-of-fact of any of us in the room, presumably having reviewed images in this way hundreds of times throughout his life. He didn't bother acknowledging me as he stepped forward into his domain with a convincing air of objectivity about him. He merely flicked on that Schopenhauerian look of aesthetic contemplation; it was effortless, as though such appreciation, far from being some transcendent meditative experience, was utterly mundane. He'd spent more of his life in this state than in any other, perhaps even more than he cared to, but there was no way around it, the job demanded it of him. What could such a workaday approach to seeing really yield, I wondered. Yet was it any different, in the end, from the ways of most art historians, professors of art, and professional collectors? They did a better job of masking the perfunctory element, perhaps, but so what? Wasn't it just *this* kind of man I'd been trying to escape from, in pulling away from the galleries and art shows? And here he was to give his appraisal.

"May I touch them?" Garrett asked.

This was the privilege of the patron. To fondle the work. If he destroyed it, well, he'd created it, in a way. But Garrett was in fact terribly careful in his touching. Rather than draw his fingers along the surface, through the charcoal lines I'd left without fixative—I'd always thought it flattened out the variations in texture and color one found in the best charcoals—he dabbed at it, as if blotting a stain. Most of the time, his fingers hovered over the surface in closest possible proximity; I could barely make out the space between his fingers and the paper, but it was there. It was this hover, he explained, that was essential to his manner of assessment. He'd done the same at Whent's apartment, though his handling then had been a little rougher: he'd been drunk, he said apologetically, though he'd not mentioned the indiscretion to Whent.

No wonder Garrett was no ally of the museums. He required a kind of kinesthetic access to art that couldn't be had in such settings, not without ultimately destroying the objects when practiced *en masse*, like a vinyl record played ten thousand times or a public statue worn away at precisely those points at which contact was chronically made with it, like the fat bronze man's penis presiding in Time Warner Center.

One of the great pleasures of my new patronage was the sense it gave me that I had nowhere better to be than my apartment, that being housebound was, remarkably, the most fiscally responsible use of my time. I'd holed up in the apartment the entire week, guilt-free, leaving only to restock on plain bagels and peanut butter and, a few times, around three in the morning, to tear apart fatty kebabs, while drawing at any and all times of day, without regard to the rhythms of ordinary life going on around me. Unexpected dividends arrived over the weekend: I'd managed to conjure up, indeed, felt *compelled* to conjure up, a few extra pieces.

The first of these late arriving items, set up now on an easel rather than lying flat on the table, was a landscape: a wheat field pulled from my imagination, and nourished by the memory of the only cross-country drive I'd ever made, when I'd traveled with Immo, as his chaperone, at a time when he was moving to New York and I was already settled there. The light was only twilight here, and the stalks of wheat looked engorged, as if they might burst. The piece was expansive: sixty by forty on black paper, now mounted with gum on a slice of plywood, all in white chalk sharpened to a very fine point, so that the detail was close, precise. It had taken twenty-five hours to compose, working until dawn this morning.

A day and an hour, fueled by Theria, which Garrett had quietly agreed to supply me with in bulk now, as I'd already gone through the first case. Apparently Antral was still waiting on FDA approval. The delays, however, seemed endless, which gave me something to worry about. What exactly *was* it, chemically? What had that look on Paul's face meant at our first meeting? I know I'd felt, while I'd worked all week, as though Theria were bringing a certain skew to my vision, a greater intensity to the periphery of consciousness, where many of its neglected curiosities lie. There were no hallucinations as such, none that I could verify, anyway. Yet the drink provided much more than mere energy or clarity, the sorts of things caffeine or Adderall could deliver. No, it had a way of recalibrating the senses, exploding assumptions and enhancing the imagination, apparently without even a touch of the psychosis or deceleration of thought produced by marijuana or LCD. With Theria, your epiphanies *remained* profound, even after you'd sobered up or told your friends about what you'd discovered. And I'd been having them for days now, various kinds of cognitive breakthroughs, in exact proportion to my consumption of the drink.

There'd been less exotic things in my diet, too, and they might have been just as important in their way. Bowls and bowls of steel-cut oats with chestnut honey; loaves of stale brioche and challah microwaved and eaten squishy and smoldering. There was shot after shot of watery espresso, the grind's being all wrong. I was dropping cheap bodega coffee powder in the basket that wasn't close to fine enough, so that the water would rush through the spouts. I had the impression hardly any of the actual coffee ended up extracted into the cup; it was just a lukewarm brown runoff. What was carrying me forward, really, was *interest*, more interest than I'd shown in anything in at least a year and a half. I had Garrett to thank for this, almost as much as for his money.

Pondering this wheat field shoulder to shoulder with the others, I felt there was something pleasingly generic about it, at least superficially. It looked a bit like a negative print, except for the life I'd put directly into the stalks, which shimmered as though everything weren't quite black and white. I'd made them young and thrusting with growth, infused them with a heroic stoutness, so that they offered more or less successful resistance to the gusts that swept along a few leaves and bent the saplings among the surrounding trees. These shoots, compacted together and propping each other up, hardly yielded to the wind.

Paul and Garrett and their Antral lackeys might well have missed the quiet vitality of the scene; it would be easy enough to do. I wasn't worried, though, since I'd planned on the campaign's making this image ubiquitous, which Paul assured me it would be, so that on your fifteenth time crossing paths with it, down in the trains, on the side of a bus, or up above on a billboard or a building, its apparent triviality would give way, in your mind, to an underlying vigor. Certainly I hoped you'd be surprised to learn, weeks or months later (we hadn't settled on a timetable) that this was a first glimpse in the rollout of a whiskey, the name of which was still being picked out by Garrett, who'd made it known that he wouldn't be soliciting answers to this question.

Karen clasped my arm from behind. By the time I'd turned around to face her, after slipping out of my private thoughts while Antral people pored over my pictures, photographing them for later analysis, her head was almost upon my shoulder.

"I like it all," she said flatly. "Even the wheat."

I'd missed her voice—it had been a week since we'd spoken—though I'm not sure I believed what she was saying with it. Yet there was none of the repression her manner could subtly accommodate.

"I was thinking of lab equipment, too. For the Theria."

"The origins of energy."

"Basically."

From where I stood, it was easy to see that the pages in the notebook on her desk didn't sit perfectly flush. Except for the last quarter of it, there would have been a good deal of work in that volume, one of her project notebooks, of which there were many stacked on the office shelves, each one distinguished by a single word on the spine. Here, it was *Arête*. She would have been trying out text and layout for Theria in it, *sans* imagery; it was effectively a sort of sketchbook, which she used for purposes far from art or design or copywriting. Through Claire, I'd originally learned of the metamorphosis Karen tried not to talk about. More and more, she was shifting toward fiction, training herself, Claire had thought, to be the sort of novelist they *both* loved, the ones doing "advanced writing" today for tiny presses. Anyway, that was the direction Karen was headed in. She'd studied writing at CalArts within the Critical Studies department, as it was called. To me, writing always seemed a silly thing to take up in college, a bit of a waste, given how much we all naturally used it, practiced it in life, just as a matter of course. Better to find one's way from there through self-study. But Karen had done it more as a signal of intent to herself, that she was something *other* than one more visual artist.

At the time she'd mostly composed poetry, prose poems, good ones, too, I recalled, redolent of Hejinian and Carson. Now her writings had grown longer. I could tell merely from the outsides of her notebooks, particularly a series she'd started a couple of years ago, marked N1, N2, all the way, so far, through N7. There were eighty sheets to those books: one hundred and sixty pages. She had a rather loose script, and there must have been various portions consumed by notes or research. But, at a minimum, she had something like a draft of a book-length work. Claire had told me it was a novel or pseudo-novel of sorts, and by the sounds Karen had been making lately, I had to think she wasn't all that far from completion. Early on I'd asked to see those notebooks and was simply denied, something that hadn't happened with the poetry, and didn't happen with the non-fiction prose, on which she actively sought my opinion. I merely observed the accumulation of these notebooks, and around N4 she'd confirmed what I already knew from Claire, that it was indeed a work of extended prose fiction, though she reminded me that the Greeks wrote such things long before anyone used the word *novel*. Had I read those Greek proto-novels? I hadn't, though I'd read enough Bakhtin to admire them in concept.

I was staring at the Arête notebook, yet Karen refused to acknowledge my interest, so the book stayed closed, its dark green covers closing off white depths within. Meanwhile Garrett and Paul kept circling the table. You couldn't help but think of a very slow game of musical chairs, I pointed out to one of the Antral assistants, a fresh-faced man, probably a recent Columbia grad. And while there were indeed chairs slung to all sides, there was no music except for what we heard wafting in

from Brady, our impeccably dressed neighbor and could-be conceptual artist. Shosta-kovich's symphony cycle appeared to be his present obsession. The Second was just closing, and once it did, Paul and Garrett, who seemed to have been following its final notes, drew near.

"Paul?" Garrett said in an exploratory way. But his marketing director and chief strategist, never mind his close childhood friend, retained the same quasi-contemplative look he'd surveyed my drawings with while circling the table. Here was a man who reveled in judgment, oppressing us with its prospect until deciding to release us from the threat and issue his verdict. But without ado his boss simply moved on with his own thoughts, which were actually for Karen: "Don't you think this is such a nice start?"

"The imagery is quite strong," Paul broke in, not wanting his opinion left aside. "I'd expected that." He glanced dutifully my way, above his spectacles. "But as far as the messaging, don't we, well, I know we want to be subtle—"

"Totally unbranded, Paul, I told you. We've promised the Public Art Fund and the rest as much. *You* did the promising."

"I don't mean branding *per se*. Obviously. But what about the smoke rising up out of Duke's mouth, and the missing eyes?"

"And the *robe*, yes?" Garrett said quite confidently, as if unperturbed.

"And then, this one—*this* is what we've based off the girl's yearbook pic? Can you see there might be people who've got problems with a pre-pubescent girl drawn like this?" He refused to look at me.

"Like what?" said Garrett. He was acting as my proxy, which gave the exchange a peculiar tenor I did nothing to disrupt. Garrett put his hands on his hips for a moment before setting them both down on the table and leaning forward slightly, bemusement overcoming his entire body, just as it was my mind. He rubbed his face with both hands.

"You don't see *anything* off about it?" Paul pointed to the little girl with hair in pigtails, finely modeled in crosshatched lines, which gave her an intense plasticity. "These are going to be everywhere in Manhattan. That's how we are positioning this first batch. So we should be sure that, well..."

Without any further talk or instruction, each of us independently began to look upon her *as if* she *were* a sexual object. We ogled little Daphne. I knew this by the way we all, even Karen, rotated through different squints, different postures, hunched shoulders, bent knees, hands on heads, each of us seeking to put ourselves in the most lascivious frame of mind. Once I'd managed this—I should say it was a frame I certainly hadn't occupied in *rendering* her—I had to concede Paul's point. Daphne's breasts were fuller than any eleven-year-old's had a right to be. They were fuller than they were *now*, possibly. I'd exceeded the

source material, that yearbook picture. But hadn't the photo attenuated the torso, so I was left having to make it up for myself? And the bangs, the face under it, the cheeky little hint of a smile I'd given her, perhaps it all suggested a pubescent world she was already hankering for.

The uniform of the schoolgirl naturally played into all sorts of sexual fantasies, and seeing it here, I wondered why exactly these dreams were tolerated, as they were across all of society. You could see references to them, the tartan skirt, the stiff white blouse, in even the most benign situation comedy. Yet were these not, at the end of it, the fantasies of a pedophile? I surveyed the growing alarm on Karen's and Garrett's countenances as they came to a similar realization. Meanwhile, Paul exuded a sense of triumph over what he'd been able to make us see: the drawing's iniquity. Yet hadn't I only concretized the lurid side of a quotidian fantasy? The volumetric richness I'd given young Daphne had played its role not in generating verisimilitude but in showing something about sexual essences, how they lived right in the child and could manifest long before it was appropriate to acknowledge them, or even welcome them. Didn't our fantasies count for something?

"What do *you* think?" I asked Karen. This wasn't a rhetorical gambit, though Paul's bearing, ever skeptical, searching for guardedness in me and probably all the artists he worked with, suggested it might be. Garrett turned to her expectantly. He appeared shaken in some way, uncertain about his judgment perhaps, which was rare. So then, what *did* she think? Whatever she said in this moment was going to count, and count for a lot. She could scuttle the entire project with an inapt response, or re-inflect it in ways that weren't necessarily recoverable later.

"Well... there doesn't *have to* be a problem here," Karen answered. "But I see what Paul means, in a practical sense."

Before I could probe her meaning, Garrett intervened. "Well, it certainly has power, I know that much. And that's exactly what I asked you for. It's just too rare a quality, Paul, for us to police it out of existence." He favored me with an assured nod.

Paul expected this response from his employer, it seemed. It was *always* his response. The marketer interlocked his hands in front of him like a tennis linesman and said, "I think if we were to add some text—no clear branding, James, just copy, words of any kind, poetry for that matter, whatever—that could steer us away from meanings we don't want."

"And it could bring other qualities to the pictures, expand them," Karen added. "It wouldn't have to be a dodge. It wouldn't have to read like that."

Garrett pondered this while holding my gaze. "I don't know what meanings we *don't* want, Paul. Do you? I want as many meanings as there are. That's what puts this all beyond persuasion, rhetoric. I know that's your specialty and all."

His voice immediately softened: "But look, Karen, are you saying you've got stuff? Right now?"

She pointed to the notebook. "Maybe some lines for the Daphne pieces. But not much for Duke yet." She eyed me as though it were my fault she had nothing on Duke. I could have told her more about him during the week, sure. But after what had happened with Daphne I didn't see the sense in it.

"I've got nothing against text here," Garrett said, "as long as these don't end up looking like ads in any way, except for their locations. Otherwise, what the hell *are* we doing?"

Paul's lips went taut and flat as agitation skittered across his face.

"So you want to try anything out on us then?" Garrett said.

"Oh, she's been trying things on me," Paul said. "That's partly why I brought it up."

A wave of fear coursed through Karen's features. She'd told me nothing of this collusion with Paul. I looked away.

"Not *really*, though," she said. "I haven't had enough time with the drawings themselves, just little snaps."

I turned back to her with a certain sharpness but she refused to regard me. Yet her next words seemed bent on addressing my glare: "We could even skip the copy in the end, though. We should consider that."

"But let's just see, first," Paul said. "I think it could be very smart. I really do, James. We want this to fly a long ways. If this is supposed to be just the start, we have to think about what gives us the best chance at it."

"I need something up *now*," Garrett snapped. "There's no end to thinking, once it starts."

"How about we make a call on it at the end of the week?" Karen offered in a spirit of conciliation. "I'll have some things for you by then. We can decide if they do anything you want them to, or if we should just go ahead with imagery for now."

We all agreed—Garrett and I somewhat reluctantly, sensing this as a hindrance rather than help, and the other two, the practical ones, with visible relief. In certain company, I'd always thought Karen became too sensible for her own good, and Paul was that kind of company. It made me wonder what sort of novelist she would end up being, if the wrong influences were to work upon her. If indeed writing fiction was where her future lay, if she left behind *Cosquer* eventually. She was already halfway out, I thought, more of an editor than a creator now as she handed off various editorial duties to Rick, making sure her knowledge became his, as her possible successor. What she did produce for the magazine increasingly was writing. Short, elliptical, critical things. Yet as she moved forward, would she feel the most viable path was a

more transparent one, even a realist one? Would matters of scale begin to impinge on and indeed infect her reasoning, as they clearly had Paul's? If Karen's effect on the campaign was going to be a matter of temperance, as Paul had suggested, well, I wanted no part of it.

I didn't really want to see Daphne after Garrett and Paul concluded our meeting, both looking generally pleased as they left our offices. I should have been happy enough, given how things had gone, but instead I felt as though I were very close to turning vicious. I had a reputation for it. People who'd only met me briefly couldn't quite believe it, as I reserved it for those I had some feeling for. But it was an excellent reason, among others, not to know me. It was part of why Claire had gone. As an act of mutual generosity, then, I left without explanation. I didn't even collect the drawings; the assistants could convey those to headquarters when they wanted to. On my way out, I saw Karen's notebook for the campaign and felt the urge to take it with me, not so much to read it but to toss it in the East River.

30

Eventually, Karen and I had to reckon with the contents of that notebook, and she wanted me to meet her at an art event to do it. As much as she claimed to be some kind of outsider, the sheer number of events she attended, and even more, the far greater number she declined to, was a prime index of her member status. Interest in *Cosquer* seemed to double every six months, with no sign of an upper limit. Demand was growing on the circuit, not so much for her artwork, which, perhaps it's cruel to say, hadn't attracted enormous interest (unfairly, I thought... sometimes), but for her celebrated editorial project. Many peers, and even a slightly older generation of artists, were turning to her, seeking reviews of their shows: however gnomic the magazine's write-ups were, you could count on their being written by *someone* worth puzzling over. And if it wasn't reviews they were after, it was small portfolios—Karen liked running micro-spreads—that they'd try to place in this smallest of magazines. The truth was, as far as *Cosquer* went, I owed Karen a lot. The magazine was, almost by itself, keeping me in demand, ever since I'd left the power brokers at Hinton. My visibility, it seemed, couldn't sink while being lashed to the magazine. It's part of what Lindy wanted in associating with us, this glow of untouchable cool, even if her cast of mind ill-suited her for our operation (though I suppose the same could be said of Rick). Karen shielded me from most of what came along with being a tastemaker positioned between the underground proper and the more vulgarized world of *Frieze* and *Art in America*, never mind *ARTnews*. It was some feat she managed, not winding up in a conflict with me these days, where so many others had failed. Fellow-feeling played its part, but at bottom, a great curator or editor knows that her real resource is talent—the talent of the artists and writers she goes on to present, to package. And I knew from Claire that Karen thought I had a good deal of it, and that she was in fact secretly possessive of my work in the magazine, to the annoyance of others of the group.

I was reminded of my place in Karen's stable whenever I had to meet her somewhere other than the Long Island City offices, as well why I always tried to keep our meetings limited to those offices, namely, so that we might avoid the eyes of the art set. She did occasionally make the trek to my apartment, if far more frequently when I was living with Claire. Nowadays our meetings were usually proximal to some art event in Brooklyn or the city, either immediately before or after one. The scene would unfold similarly each time: an assembling or dispersing crowd, and my having to hunt for her figure among the flux before moving on to whatever venue we'd selected, a dive bar, a park bench, a Chinese spot.

This time, we were meeting just after an *e-flux* book launch and panel discussion, downtown at the Ace, in one of the event rooms. I waited for Karen in the lobby, on an early evening when traffic wasn't especially thick but the squawk of car horns nevertheless pervaded your soul. The usual mess of creatives gazed into their laptops, cocktails sweating by their sides as they rustled the keys. I found a deep sofa facing the stairs, next to a clutch of tech workers prattling on about their jobs, when a crush of people filtered out of the bowels of the hotel through the lobby, some of whom I recognized and no longer spoke with much anymore. Every third one was carrying a thin red-and-black hardcover. I searched for Karen amid the crowd with a fugitive gaze, making sure not to keep my eyes fixed for too long in any one place. Doing so would have invited contact, connection, things I didn't need, not with these particular people, anyway. I was practiced at this now, so that with consummate skill my eyes flitted about, catching several waving hands and mouthed greetings in the swift arc they carved around the room, too rapidly to commit me to anyone. Which of them might still refuse to keep their distance? There were always a few.

Karen was suddenly upon me. She didn't bother waving or shouting, she knew there was no point. She simply sat very close to me and wasted no time, opening that red-and-black book over our knees. She walked me through a sheaf of prismatic photos that had been distressed to appear more analog in origin than they were. These were mostly old family photos, and some party pictures, too, black tie. I thought I recognized a few of the mutated visages, Frank Sinatra, Bette Davis, leaking down the frame, or burnt out entirely, missing arms and legs, mutilated as if in a war. Karen thumbed through the pages without pause or comment. We were both used to this icebreaker between us. She'd show me whatever there was to see on the day or night and wait till I'd finished looking to comment.

A different photographer's work filled the latter half of the book. These images were fully abstract, involving, as the little italicized descriptions informed me, unusual treatments of the emulsion: buried film developed after decomposing in the soil for months, as if nature herself had coughed them up. It was fine work. Which is to say, I couldn't see why anyone had bothered, given the certainty they'd be swallowed up by tomorrow's event at the Frick, Thursday's on Bogart Street, and Friday's, some literary-art soirée at Albertine's. These photos' fates would hinge almost entirely on the charisma of their creators. That's why a launch like this was crucial; it was an opportunity for the artists to interest the audience in *them*, never mind the picture book.

Apparently the authors had been only mildly charismatic. Not enough to push themselves to the front of the crowd, but not so deficient as to preclude them from releasing another book in a few years' time. I suppose there was nothing wrong with this arrangement. Academics, too, operated in parallel, putting out creditable

contributions to the literature. That was the word for marginally significant work. *Creditable*. Karen and I both laughed quite harshly then. She counted on me to bring out this cold-bloodedness in her from time to time. That's why she invited me, to serve as an inoculant against complacency as she made the rounds, taking in art book releases and gallery openings three or four times a week. What was merely creditable was of no account to either of us, really. That was our common ground, even if she enunciated it less now that Cosquer had grown. These photos would *never* feature in her magazine, though of course she'd been invited today on just such a hope.

The crowd itself, which had by now filled the lobby to bursting, had the talent in it, here and there, that the book lacked, Karen said. For her, it had been worth coming just to have had a word with a few of the guests, which she'd done during the mingle after the launch. And it would do something *for me*, she teased, simply for them to find me here in the lobby talking with her.

"Open that thing," I said.

"Oh, that?" She followed my eyes to her navy leather bag. The green notebook from earlier today was poking out of it.

"It's got to be better than the one we just looked at."

"I don't know. You're tough. And the more I think about it, the more I think we might want to just save our breath, skip the copy."

"Just images, then."

"Or maybe run some text separately, in parallel."

"Like what?" I put my hand on the book, expecting her to brush me off, but when she didn't, I pulled it to me slowly and, still more slowly, opened the cover. I had no way of telling, of course, which pictures of mine might have induced which lines I found inside.

The room that doesn't, and isn't.

Had this one come from the eyeless Duke trailing smoke—*the room* being, then, the theater of his mind? There was a less oblique possibility: Duke twisting the doorknob of his old apartment. I looked up at Karen and read the phrase aloud, quietly. She looked back at me blankly, unwilling to guide me. Another possibility for this headline, the more because it wasn't Duke but *Daphne* she'd had contact with: the actress' painted face hanging over the margarita glass—although we would ultimately be selling whiskey, nothing fit for the glass I'd drawn.

Wouldn't it be hard to tell?

This came at the top of the next page, along with several crossed-out lines. Blacked out, really. A lot of ink had been applied to the paper, which was plain in design but patently archival. Forty euros per notebook, I knew. They were one of her childhood luxuries, when her parents had paid for everything, that she'd never been able to

give up. But the ink had been so profuse that even this stalwart paper, meant to last centuries, had started to wilt into an infinitely black patch. The first of these black boxes would have obscured a long paragraph, extending for two inches at least. "You must have used half a cartridge here," I said, touching it with my finger. It was inked as if for fingerprints, still wet. The redactions had to have been conducted earlier that day. "I would have liked to see some extended text."

Karen wasn't going to engage. We had our template for such, from our days in college, in the library, where we'd dig up books and sit next to each other, flicking through, looking and looking at the pictures. It was then, in fact, we'd hit upon the value of reserving serious comment until the book was closed.

I flipped the page and studied the obverse of this first bit of censorship. It'd nearly come through the other side, which had a remarkably even, frosted gray tone, with little sign of pen strokes. Had she *brushed out* these passages? I touched the back and held the page upright in the book; I thought my finger might shatter the black pane. She might have thought so, too, because she turned the page in the book for me, saying only, and incredibly, "It was empty."

Hardly. But what had called for such total erasure, rather than a simple strike-through? Her words in these books often segued into metacommentary, the diaristic function of notebooks being irrepressible, whatever official use you gave them. Under the circumstances, I had plenty of reason to wonder whether the volume might be fraught with matters pertaining to Daphne and me. But then, she'd chosen to show me what remained in the book, or anyway allowed me to look when I'd reached for it, when she needn't have. I stroked her hand instinctively, to settle her; she withdrew it sharply, uncomfortably.

She turned the page, but three pages went together, bound by a paperclip.

"Too on the nose, this next one," she warned me.

I followed her eyes to the page: *There is no crisis.*

"What about 'Against the grain'?" I offered.

"For the wheat field? That is *so* bad."

I knew that. But she looked a little more comfortable; some color came back into her face. I could smell the Sauvignon Blanc on her breath from the reception.

Study for a theatre of the unknown.

"Yes, good. And 'R-E' instead of 'E-R'—better that way," I said.

"There's no drawing for that one, though."

"There *could* be, right?" I held my hand over the page. "You could maybe title some of my drawings for me."

She looked truly surprised. As a rule I never worked together on art that mattered to me, not even with Claire, which had sometimes been a sore point between us.

"You could try, I mean. We could see."

"You mean... *collaborate*?" she squealed. "I thought I was going to fuck up your work."

"Is that a disgrace? Collaboration?"

She kissed me on the cheek almost violently, rocking my head with a thrust of her face. She grabbed the hand she'd rejected moments ago, spontaneously, fraternally. It warmed me.

"Did you know, in my head, I title *all* your pictures, the ones that go in the magazine? I've had lots of practice with this, figuring out where to put them in the issue."

"So if I dug around in your notebooks, I'd find all these titles?"

She nodded briskly, beaming.

"Which you've never bothered to share with me?"

She grabbed my knee and put her weight on it, as if rising. I think she would have accepted the kiss I just about gave her then, something that was to be less than fraternal, a visitation or an intimation. But the friendly face of a video artist I knew destroyed all my feeling for her, the second I saw it looming just behind her as I leaned toward her mouth. I smiled at him, wishing I could strike his kind from the world altogether. Nothing would be lost.

"Or would they all be blacked out, too?" I whispered to her without backing up much.

Her face reddened slightly. She'd been on the cusp of accepting my offering, I'd drawn the feeling to the surface in her, and now it would submerge again. She gathered herself and I leaned back, still looking at the video artist, this man whose name I couldn't even remember, who'd taken something from me now. "I think we could run some of these titles without the pictures," she said. "Even before the pictures rolled out. Like, now."

"And how about after, too?"

She was all yeses.

"Maybe some longer things—like Daphne had wanted, you said. *Black-box sized.*" I touched one of the rectangular redactions in the book.

She blushed profanely. I had trouble looking at her now without reaching for her, too. "Honestly, the thing is, I couldn't think of anything to fill them. Or I only thought of *shit*."

"And what about the typefaces? Are you going to get sansy?"

"Are you going to get blacklettery?"

"You remember."

"Well, you even tried it with Joy Division."

"It would have worked."

"I could do this all in Caxon if you want."

"I could do it all by hand."

"Until your spacing goes. I wish I could kern all your lettering, it would be perfect."

"What do you think Paul and Garrett will think about all this?"

"I don't know how you feel about Paul, but he's actually not so bad, I think. I've dealt with morons and hacks over the last couple of years, and he's not one of them."

I believed her. It's what made him a problem, his formidability. Karen returned to the book. I scanned its obscure pages, trying to parse the textual fragments that existed between garden-variety strikethroughs, slightly more vigorous erasures, and those ominous boxes of black that must have contained things that just couldn't be revealed to me or anyone else, though they might represent the most essential commentary of all in her mind. She could recall them so vividly, she could afford to black them out. Nothing was lost.

"So I guess this would be your first collaboration," she said with pronounced pride.

"I did some things with Claire."

"Not enough." She looked sorry as soon as she'd said it.

"They didn't see the light of day, I guess. Maybe they don't count."

"Our thing is going to be seen in the *craziest* way, though, isn't it?" She grabbed my hands and squeezed. "James is sort of psychotic. I wish I had more clients who'd go this far."

I continued with the book, reading aloud now:

The not-quite-parallel.

Grab and smash.

"I don't know about a lot of these," she said pre-emptively.

"Just the unconscious speaking in these ones, I guess. Duke would love it. *Grab and Smash*, right along the bottom."

"We can't use some of these, obviously."

"It'd read like an APB almost. For suspected statutory, maybe?"

"Oh Jesus, no. I don't know. What the fuck did he *do* exactly?"

"What *does* he do, you mean. *Will* he do. I can't say yet. But what about Daphne? You know her well enough by now."

She rolled her eyes and commandeered the book, flipped a few pages and set it back on my knee.

Clearly.

"This is for the glasses? You know the line is going to be called Obscura, right?"

"These are just *notes*. God."

"*Selected* notes—otherwise what are all the cross-outs about?"

She flipped to another page, near the end.

The one who didn't get away.

"Do you mean Daphne? As a victim or something? Seriously?"

She studied my face before her own turned from perplexity to disgust. "You know, you read everything in the *worst* possible way."

"That's the way everyone reads. Aren't you the one who said she's had her problems with men? And you saw *The Sort*."

"No, men—sick men—have had their problems with her. Even *Lindy* understands that much."

"It doesn't seem like Daphne's had a lot of success separating herself from them."

"Well, we can't use that line, not *that* way."

"You wrote it down."

"My unconscious, though."

"You believe in all that?"

"You don't, I know."

"I believe in self-deception. Excuses. But that's something else, isn't it. Anyway, why not use it?"

"Garrett does have an *actual* business to protect, you know."

"He's psychotic, you said."

"Not like you."

"Neither are you these days, I guess."

"What do you mean?"

"I mean, I guess you have your own business to protect."

She snatched the book from me and snapped it shut. "That's *really* not what this is about."

"Actually, I bet he's more reckless than you, in some ways, because he can afford to be, so it's not really reckless at all. If all of this tanks, do you think the shale industry is going to care about it, when they need Antral's containers for runoff from all the fracking? Or Lockheed Martin when they need carbon fiber polymers? That's the real engine of this business. It's like Bloomberg's terminals. Everything else is illusion."

"Rick's been nagging me about Antral, you know." She spoke more quietly then: "Something about riot control?"

"Oh, I think that was a different company. Antral is all about receptacles, trapping everything noxious for us, everything we do to ourselves. But I bet Rick doesn't even like waste storage, does he?"

"Do you?" she shot back.

I was still, shall we say, sorting through my feelings on the matter.

"Has Rick brought down his energy use to whatever they say we'd all need to use to keep this planet going? What is it, two thousand watts a day?" I asked. "How

would he listen to his music like that, through that beautiful sound system of his? How would he and Lindy put on that film and sound show we saw? When he gives up all that, I'll call Garrett and tell him his services are no longer needed, mankind has ascended. Until then, though, he probably has his uses, you know?

"Anyway, look, I know you need to fill up this notebook. It's mostly redactions at this point. Let *Paul* censor us if he wants. I don't see why you should do it for him. Maybe don't even show them this. They'll think you're full of doubts."

My voice was like a knife now. What had changed exactly, even I couldn't say.

"Excuse me?" Someone said to me from behind our couch, where the video artist had briefly been. That man had been replaced by two others who, as far as I knew, were strangers to me.

"Your fans," Karen jabbed. She stuffed the book back in her bag and rose to her feet with an acid wink. It was the most peculiar thing, this wink she could give, really letting you know, in the nicest way, how much she hated you just then. After quick shakes of the hand with the two of them she was gone, out into the street. They came around the couch and introduced themselves somewhat sheepishly. In days past I would have stood up, showed reasonable manners. But now I didn't even bother with a shake, a nod was as far as I went, and even that was desultory, easily mistaken for accidental movement, perhaps some sort of stretching of the neck.

Karen *had* stood, of course. I liked to lean on her for grace these days. But in this case she'd gotten up only because she was leaving—naturally, to their disappointment. The two of them were fans of hers, too. In their nervousness, the men had still not actually *said* who they were, only that they knew who we were. Karen had seemed vaguely to recognize them, or was anyway kind enough to pretend to. I wasn't going to ask. Probably, judging by their youth, they were newer elements of the very crowd I'd been escaping from over the last year, a choice that had brought me both pleasure and pain, though the ratio refused to settle.

One of the men sat down in Karen's place. They were both wrapped in black cotton, and in prime New York shape. The effect was flattering, even intimidating for a certain sort of person (sadly, I wasn't one of them); there was an exhibitionistic coarseness to it all that cut against their beauty. I thought they might be models. They knew of me from her magazine, apparently, and seemed, impressively, to have some sense of what was distinctive about my work, the way my line flitted between severity and self-effacement, one said, while the other mentioned my *ineffable way with space*. Sycophantic, certainly, but at least they were listening to the right people. They moved on, as I knew

they would—I was just an instrument here—from praising me to praising Kar-en. Arts people spent a lot of time these days currying favor with anyone close to her, in the hopes of being able to sneak something into *Cosquer*'s punishingly slender profile. I smoothed my coat at this point, patted my legs, made the noises of a man soon to take his leave when they got around to business that, surprisingly enough, did concern me. They were hoping *I* might be able to help them, specifically, by making a poster for their exhibition. They were artists, not designers—finally that was clear.

Could they know Daphne in some way? That I'd agreed to do something for her theater troupe? In fact, they were young cohorts of an artist who'd told them all about me: Terry Ohly. He was a feature player in this planned show, they said, and though he wasn't here now, he too was hoping I would agree to this.

Terry. I knew him well enough. He'd not mentioned any show to me, but then there'd been little opportunity of late. Perhaps this was his way of telling me of his latest work, sending his emissaries, as royalty would. I had to smile a little; Terry relished ellipses. But knowing what I knew of him, those oversexed rampages he tore through New York, other possibilities suggested themselves. I invited the men to sit. They were exceptionally handsome, really, a truth that shone forth more brightly as they sipped at their clear fizzy drinks. And they were *very* young; they belonged in *Interview*, if it hadn't have gone broke, anyway. I wouldn't have been shocked if they'd turned out to be sixteen, frankly, and Terry was up to his statutory games again, which were, everyone knew, his preferred form of art-making, as he'd joked with me once before flashing a ruthless grin. Might these two be his latest toys, deluded about their real value to him, very far as it was from ink or paint or paper or canvas? No, it was their mucus membranes in which Terry needed to smother parts of himself. I almost laughed in front of them at Terry's deviousness. He was very good, I'd always thought, at getting what he needed. Frankly he was weak with a brush, but apparently quite good down below. He was involved in art more for the sex than anything else. It could win you time with lambs as few things could.

I was suddenly giddy with Terry's ploy. Encouraged by the change that came over me, my newfound elation, the two of them told me more. There were ac-tually four of them showing together, so it was Terry and *three* boys. There was grant money to pay for the poster; that wasn't an issue. And, as long as Garrett was in the picture, I didn't really need any help anyway. I thrilled to the charade and told them to let Terry know he could count on me to handle the job. They bought me a drink, a shot of whiskey, and we toasted. I knew, of course, there'd be no show. But Terry's act itself was its own benevolence, a gift and a warning of

sorts to these neophytes, about the tricks of the city. Terry only performed these days, and wrote. What he didn't do was show. Perhaps he'd incorporate this ruse into his latest project, the series of lascivious diary entries he'd been publishing on a semi-regular basis, a few of them, naturally, showing up in the pages of *Cosquer* itself.

.

31

I first became aware of its reality while looking for a taxi, and the first thought I had then was how much had Karen known when I'd met her at the Ace, and why wasn't I told about it. I was on my way home from an early dinner with Immo; hearing of Terry again had put me in mind of him, the other devil I knew, who was also the one non-art-related friend who remained in my life, now that Vanilla and company were out of the picture. Every couple of months, Immo and I sought joint reprieve from the desolation of our respective social circles. My choices, of course, were always curious to him. That was obvious from the long, patient stare he would give me once we'd taken our seats in his very nice apartment downtown, or at a restaurant or bar, and my story finally came out. But what about *him*, since we'd graduated high school? That tale was a lot stranger, he'd once agreed with a stifled chuckle: his staying the course to becoming a physician, briefly a shared goal of ours, long ago, before I was capable of formulating my own and merely parroted my father's hopes for me. In truth Immo was no less of a seeker than I or any other artist I knew, but he'd decided his profession wasn't going to reflect this. There were certain standards of acceptable conduct coming down from his father that imposed limits on his future, limits I never felt for my own. (I did feel limits, of course, just not those ones.) So, as he was expected to, he'd gone into a respected and well-remunerated profession, and practiced it at an august place (Langone). He'd also recently gotten engaged to a woman he'd met in his boarding-school years, Vera, the kind of woman Claire and Karen might have become had they not pulled against the natural flow of their lives. I'd met Vera but once, and Immo didn't seem keen on our getting too close. I knew he was right about this; we would have loathed each other.

Immo had hardly left behind the transgressive leanings inspired by the antics of a young Gerry Finella, a man whom he continued to call a friend and inspiration, though I find it difficult to tell when a Scandinavian is joking. That he still kept company with me, a denizen of the filthy Bronx, swarming with homeless, was just further proof of his refusal to be the son his father would have liked him to be.

Yet he went much further than this, much further than he should have. He introduced disrepute and some amount of joy into his otherwise above-board career by, well, fornicating with his patients. Nothing that wasn't consensual, of course. There was, he said, no special intimacy between a patient and an ear, nose, and throat specialist. It wasn't like being someone's gynecologist or psychiatrist. The closest contact

he had with them, in the examination room, would be while taking a throat swab, when he would sometimes thrust his fingers into the patient's mouth and collect cells from hidden places. He enjoyed this feeling of filling their mouths. If the patient was attractive enough, it had a sexual aspect; if she wasn't, it was more contemptuous, and he thought of asphyxiation, punishment for her plainness. He liked, in either case, to roam around in there until she gagged.

I knew, of course, that *whatever* field he went into, his impulse to color outside the lines would have found expression: corruption and kickbacks, had he been a businessman; ambulance-chasing and tax evasion, had he been a lawyer; and improper relations with students, had he been a professor. The thought brought me a certain peace, and walking with Immo, this marauding Viking, after eating on Hudson Street that day, looking for a cab home, I'd felt even more revivified than by Garrett's concoction.

It was then that it happened, standing in the street, holding out my arm, searching the taxis as they shot by, establishing imaginary eye contact with drivers through the windows' opaque glare, hoping something in my gaze might compel them to pull over, even though their lights were off. This was false hope, perpetually renewed by each wave of darkened yellow cabs that came through with the changing of the signals. Chilly and storming, middlingly so, the air was just on the point of putting a mild, not unpleasant sting into the skin, in the way of bedroom slaps, the kind that warms you. The clouds had grown all day into big silver puffs, low and pressing down upon us. Beads of rain collected on the nap of Immo's plush camel coat; he swiped at it at one point with a gloved hand, inducing a watery cascade.

A fresh cluster of taxis streamed by, and then, suddenly, there it was: *The one who didn't get away*, right on the rooftop billboard of the taxi passing nearest us. It didn't register with me immediately, though. As Immo briefed me on his latest fling, this one with a fellow doctor, not a patient, my gaze slid onto the side of a bus bedecked with a geriatric Schwarzenegger, who featured in an ad for, I gathered, some sort of a reality show. Only then did it occur to me what I'd seen a moment ago, or thought I had. More taxis approached in the distance, yet I found myself dropping my hand and retreating onto the curb. Immo, who was looking to put me in a car, stepped back out of the street, too. He stood beside me, perplexed, as six or seven more cabs rolled by. This time, two of them had their lights on. My ride was here. Yet I stayed planted on the curb, my arm frozen by my side. I wasn't looking for a ride anymore, nor the wares these particular cabs hawked. Not Shia LaBeouf's return as a grizzled, middle-aged veteran of the interminable machine wars in the latest *Transformers* iteration; not the unsung divas of an apparently indestructible show, *The Voice*; not a new Netflix series that seemed to be chattered about all over network television, *Vicarious*;

and not a dated, paint-by-numbers comedy for which I couldn't make out the title, only Kevin James' squirrel-toothed countenance. My skin goose-bumped from the cold when, a moment later, a lone cab drifted by with no images, just another flash from memory: *FALLING SPIRITS*. Hadn't I seen this one, too, in Karen's book of proverbs, epigrams, and koans, one I hadn't thought worth speaking aloud or lingering over? Evidently *someone* must have thought well of it.

I felt a flush of heat pass through me despite the damp. They'd made decisions without me. The argument, I could already see Paul making it to Garrett, was that these lines weren't going to be placed near my pictures, so what misgivings could I really have? But, I knew, these were just the first few drops of a storm of advertising no one in the city knew was coming. Eventually, people wouldn't be able to ignore the links between my images and these texts, when they'd both grown ubiquitous.

I knew I needed to find Garrett as soon as I could. Yet if he put his foot down, what were my options, really? Beseeching Karen not to supply any more stupidities like this one for Paul to use against me? That could have its own costs. Simply refusing to illustrate any of these taglines *ex post facto*? Wasn't that my deepest worry, being forced into that? That this independent textual campaign wouldn't truly *remain* independent, that there might be a want, say, for something as crass as a drawing of a whiskey pour because of this line, *FALLING SPIRITS*? That *wasn't* the kind of collaboration I'd had in mind when I'd proposed the idea to Karen. But would I be able to fight off such constellations and loop-closing without being ejected from the project and having my images taken down? I'd been given no real guarantees except that the art remained under my copyright.

Quickly I realized I'd have to make my peace with *some* associations between image and text as the campaign swept through the city; in which case, I'd rather have a say in which phrases Antral would be letting loose in town. I'd have to demand as much. But for now: *FALLING SPIRITS*, crawling by. At least it was presented acceptably. Slate gray background, a deep black typeface—something transitional—and all capitals, without the contamination of that entirely different alphabet they kept in the lower case. Offsetting the nugatory semantic component of the sign, there were pleasing visual rhythms here. And one thing we *had* discussed as a group, an idea suggested by Karen, of not using a unified typeface across the text, was being respected, at least in the two instances I'd seen today. Branding was a spent force, she'd said. Companies weren't people, products weren't people, *people* weren't even people. None of them had or needed a calling card. So we'd agreed on a song without a refrain.

I said some hurried goodbyes to Immo. He grabbed me by the back of the neck, leaned in and pressed his cheek against mine in the way he'd been doing since he

was a boy just arrived in the States from Oslo, though now with added gravitas. I sensed he knew something was wrong but that now wasn't the time to talk about it. He had problems of just the same kind. I got in the next cab I found, and, as we speeded along, we passed one of what I would come to think of as *our* cabs; this would soon extend to *our* bus shelters, *our* buildings, *our* subway stops, *our* trains (the E and C lines). *Hurt yourself, but only if you want to.* Here was one I hadn't noticed in the book. It might have been a redacted entry, one that Paul had gotten Karen to cough up in the meeting they would have had without me. Although it incensed me, it also intrigued me, the business relationship between the two of them to which I was not wholly privy. I was impressed, frankly, they'd gotten a taxi to carry this one. That's where we were, societally. Even this headline seemed like a possible enticement, perhaps to some submarket of cutters. So long as it was, it was advertising.

My eyes kept searching on the drive home, through a blurred windshield that turned crystal every two seconds, with each slash of the wipers, before blurring again in the waters that fell heavily now. I hoped Immo had gotten himself out of the rain; I could picture his jacket and hair sopping wet, and him detained on his phone in the street, making excuses to Vera. Everything I saw or imagined only served to stir my anger and fear about the nature of this campaign. I sent off a *fuck you* to Karen by text, exactly what she deserved. Back came the disingenuous *???*, and then, when I'd not responded, the call, which I didn't answer. *Can you talk?* she wrote. Well, I could. But she shouldn't sleep well tonight, and only silence from me could ensure that. Garrett was the one I actually needed on the line. Why put things off? I wouldn't be able to finish those drawings otherwise.

As soon as I stepped in my apartment door, I was pouring Lagavulin, a birthday gift from Ty I'd not touched. I splashed it down, felt the smoke in my throat, and poured another to drink more thoughtfully. I'd more or less given up spirits until being drawn back to them by the wheat whiskey. Sometimes, I had to admit, drinking fine liquor seemed no worthier a placation than television, which I'd reduced almost entirely to football coverage by expensing a cable NFL Pass, so that I could see any and every game. All the same, the scotch had settled me, and with that I made my call. Garrett—I should have known this—was ready and waiting.

"I don't get it," I began. A long pause ensued.

"We just had to get something up quick, and Paul—"

"Paul what?"

"Well, he thought it might be best not to distract you from the job at hand, finishing those pictures. We need them real soon. And the reason—"

"As if there wasn't time for me to weigh in on *which* lines." My tone was sharper than I'd ever allowed it to become with him. I'd not planned on it, but it felt utterly right, coming from my burning throat.

"You can weigh in on the rest of them, how about that?"

"How many are there, already floating around?"

"Five, six, nothing much. The reason—"

"What else are you going to do like this?"

"Like what?

"Behind my back."

"Oh, I wouldn't put it that way. The reason I okayed this, just this time, is simple. And I think you know what it is. These ones don't venture anywhere *near* your pictures. They're Karen's babies. And speed, total speed, was the point. I couldn't get into a debate with you, because if I'd asked, I would have had to listen to you, because I respect you. It was more practical this way. You should realize that."

"Did you tell her not to tell me about this?"

"It had *nothing* to do with deception."

"*Did* you?"

"Our contract is with Cosquer, you understand that, right? If what we were doing was so untoward—and I resent that, there's nothing to it. I don't practice deception. There are *principles* in this world."

"But *which* principles? If *this* is what they are, what they allow, what's the point?"

"Karen could have told you, if there was really something wrong here. She didn't see a problem either."

"But did you discourage her in some way?"

"Unless she had some strong objection, we thought you shouldn't be troubled right now. But like I said, for the next round, and all the ones after, you'll be in the loop, whether your drawings are involved or not, if that's what you want. Okay? They're *the key* to this thing—you know that's how I feel. I'm the one who has to ram these things down Paul's throat for you. No one'll touch your pictures, I can promise you that."

The next morning my phone held a string of texts and voicemails from Karen. I felt a dreamy pleasure at this, knowing my idea of sleeping on it, leaving things alone, had been sound. I'd stoked her night with worry. The messages had come in every few

hours, from someone who normally slept quite regimented hours: proof that even the healthy dose of Klonopin she'd grown accustomed to couldn't quash her fears. Every vibration of the phone on my bedsheets during the night had been a confirmation of victory, no matter that I only felt it in my dreams. I could see now I'd even extracted an apology: *They wanted to go ahead with a handful and they insisted I not 'disturb' you,* 2:15 am. *I didn't want to lose the account over it,* 3:05 am. And then this morning, just beyond 5:00 am: *I am sorry.*

Looking at this little odyssey of grief and guilt that had played out while I'd slept, I lost some of my enthusiasm for a real fight with Karen. Even if she hadn't spent the night wrestling with her conscience—a tussle so much more poignant than any simple apology could have been, because here on my phone I held a record of the tenuous steps she'd had to take to get there—I still might have let her off lightly. There *were* extenuating circumstances. I'd not exactly been a good citizen of Cosquer in bedding Daphne, and I'd known, even during the act, that it could make for irreparable difficulties with Garrett. The account might well be lost. How angry could I be, then, especially now that I had Garrett's assurance that I'd be included in all future decisions? Frankly I was surprised Karen had even gone this far in apologizing.

Still, she shouldn't have done what she had. Her fear had gotten the better of her, her anger, too, and I wouldn't forget it. I settled on a punishment: three or four days of solid silence. That felt like enough, considering what I was withholding from her about JG Chemical. Who knew if those activities still went on, but under better cover this time, arming police forces with military gear to shock and awe the citizenry? Rick hadn't been wrong: Paul and Garrett's hands weren't exactly clean.

The two cabs I'd spotted earlier seemed to have mated wildly in the night; by week's end they'd spread all over the city, though the phrases they each carried were distinct. Garrett was genuinely working fast; that hadn't been just a pretext to operate without my approval. Perhaps his principles were better and stronger than I'd thought, and the God-fearing routine no put-on. After our exchange on the phone, he sent out to a group list the taglines of Karen's he liked, giving me the say I'd demanded. But in fact I didn't find any phrases I wanted to veto. Most I'd already glimpsed in the margins of that notebook of hers. And even if I'd wanted to object... well, there was another reason I grew less angry with her, stemming from an idea first put into my head by Duke: control, choice, having things just your own way, wasn't everything. Worthy things, even the worthiest, could emerge through coercion, deception, vengeance. Any such happenings might end up in my drawings, if it felt right to me.

Sometimes only a few days would pass after we'd approved an idea—a phrase or a couplet—when I'd be confronted with that same bit of language in the street. Instead of our simply saying these things to *others*, they were also being said back to us. You would never see the same line twice, though, so it wasn't possible to speak of slogans as such, only shared tones or shadings between distinct expressions. That was enough continuity for us, and frequently we jettisoned this, too, when it felt necessary. Over the next weeks, Karen's phrasemaking began to colonize the city, moving from the taxis to the bus shelters to any open wall space, covering friezes, mostly with giant prints, but occasionally with stenciled murals executed under my and John's supervision. The real work was left to Cosquer's sign painters, Pete and Shannon, and the hired crews working under them. We weren't, after all, just a design group but a production company, one of unusually small scale, so that for now, as long as we kept within the city limits, the project was something Karen could manage well enough, assembling crews of freelancers and subcontractors as needed. Our primary source material remained the jottings in Karen's notebooks, even if what we extracted from them was not quite what she would have liked. We'd send around a scan of a few pages from time to time—Paul's idea, a good one. I noticed more and more of those blocks of black, covering portions of text that had been exposed when I'd seen the book at the Ace, but that I couldn't now recall. From what little remained visible in the book, we'd choose the bits we liked best, sometimes taking only a constituent phrase from something longer: *Thirteen studies*.

The campaign had me wandering the city far more than I was inclined to (I was no flâneur), just to see all our words—her words—unfurl in a fast-growing gyre. The financial outlay must have been enormous. Garrett was even richer than I'd thought. He didn't carry himself with pretension, of course. He was a modern businessman, an entrepreneur who had no need of a suit. I was never briefed on the exact figures. I thought to ask once or twice but never did. What would they help me understand? This was going to be one of the largest stealth campaigns a metropolis had ever seen. That Silk Cut operation in London, perhaps even the more notable oblique rollouts of recent decades, say, for Radiohead and Beyoncé, might end up seeming quaint when a man like Garrett was willing to invest so heavily and eccentrically. We were literally changing the face of the city, changing its expression, and hence its import, you could say, and none of this change had been thus far directed, even nominally, toward commercial ends. It was like Holzer or Montgomery, but without all the shouting; which is to say, Karen's first book—it

should have been called *The Writing on the Wall*—was being published not by FSG or Dorothy but by New York itself.

It would keep urban studies professors busy for years afterward, Paul said the next time I saw him, apparently without irony.

To appraise our early work, the four of us decided to gather in Chelsea and walk up to Times Square. The others were all together when I got there, bunched on the corner, right beneath the High Line. I hadn't seen them since we'd looked over those initial drafts at the studio; nor had I spoken to any of them in several days now. They all eyed me, each with a slightly different brand of concern, I thought, corresponding to the differences in our relationships. They turned apologetic once I informed them, without being asked, what they were waiting to learn: that in fact the first set of drawings was virtually done. I exchanged a brusque hug with Karen, nothing more. She tried to hang on as I pulled back, but what she got instead from me was a nod so deep it was almost a bow—acknowledgement of the revenge she'd exacted, in keeping the campaign plan from me, for my dalliance with Daphne. I was smiling gently, though. I was, truly, not very angry anymore: not because I'd forgiven her, but because I'd begun to long, in the last few days, for Daphne again. It meant I had a harder time sustaining *any* of my feelings, including anger, for Karen. Let her take me any way she wanted to.

Today, I was here, we all were, to see the first stage in the project launch. After a few attempts at engaging me, as if what had happened recently *hadn't* happened, they mostly kept to themselves, with hopeful chit-chat here and there about the campaign. But my quiet eventually quieted them; the march up Seventh Avenue, which was supposed to be an early victory lap of sorts, and an icebreaker between me and them after this betrayal, turned pensive, almost funereal. Karen *was* everywhere, though, it was true, scattered across so many surfaces, you could read her in a million ways, on façades and street signs and right in the flow of traffic, too, on buses and the taxis littered with those familiar words from her fraying notebook. The team had done a brilliant job, even if they'd begun it without telling me. We even went down into the subway at one point, where I didn't much go these days, preferring the Lyfts Garrett was paying for, to see more of Karen's book splashed about Penn Station, as one might in a venerable and well-trafficked gallery. She should have been thrilled. Maybe she would be, looking back on the occasion. But, for the moment, walking off to one side of me, she seemed stricken, no matter the encouragements and compliments Garrett and Paul sent her way. I'd not yet offered absolution to any of them. Nor would I.

We, of course, were all actively searching for her works, so we were bound to find them. The truer proof of omnipresence came on the taxi home from Times Square, where I took my leave of the group. Karen had lingered near the car door but I'd

shooed her away. On the ride home, just beyond noon, my driver spontaneously spoke of these phantom phrases, wondering aloud who was behind it, and what it might mean. I told him I had no idea, and luxuriated, the rest of the way, in the certainty that we were changing things, tying the city together with words and soon with pictures, however estranged we may have been from each other.

32

The morning Daphne was to come to my apartment and sit for me, I left some of the still unnamed whiskey out for us. With her, it was never too early. Since I'd seen her last, two weeks ago, we'd mostly exchanged pictures (hers) and exclamation points (mine). She'd offered no explanation of where exactly those photos had been taken, or the meaning of the half-dressed men in them, although through Karen I'd at least figured out that Nik's troupe was based upstate. They must have convened there recently.

"The Bronx!" she yelped as I opened the door.

Daphne was very precisely on time, eleven o'clock. I had expected her to be in sunglasses, I don't know why, given that it was intermittently drizzling. I found both relief and disappointment in her having had better sense than to shade her eyes, at least on the day. Her hair was still a slightly grotesque blond, too bright for good taste, reassuringly so, with less body to it today than on the night of the show, and more wave. Wet, too.

"What is going *on* downstairs? It looks like a murder scene."

"They're on vacation."

"Where?"

"We're not that close."

"I really don't think they're coming back."

I left her at the couch and headed to the kitchen to get us drinks. It was good to have her here again, to wonder where we were.

"I saw me today."

"In what way?"

"The with-my-eyes way. In Noho. I must be a hundred feet up, looking down over traffic."

I had to set the bottle down. It was shameless and brutal, how Garrett had dared, even after our agreement, to change things up *again* without telling me. Did he want to suggest what a pawn I was? Why, though? Which principle of his did *that* serve? I opened a drawer as though I were searching for something, just to give myself a moment to regain my composure, the only thing I needed now with Daphne already in my apartment. She didn't notice. She was almost laughing to herself with joy, imagining that billboard, her own image.

"What was it like?" I finally managed to say.

"Have you *not* seen it? Here." She scrolled through her photo roll and handed her phone to me.

"You took this from the car?"

She smiled without answering, substituting, as the attractive often do, a rictus for yes. She made her way past me into the kitchen, having spotted the bottle of whiskey; the smile, then, might have had nothing to do with this photo, which was shot from an extreme angle relative to the surface of the billboard, not so far from parallel with it, when it would have appeared merely a black line in the sky. As it was, the face of the board was severely foreshortened, occupying only a narrow sliver of the picture plane. Daphne would have almost passed the sign before taking the shot. But there she was, the little-known actress, perhaps never to be grasped much beyond these drawings of mine, looking like those nineteenth century, gaslit danseuses of Paris I'd studied so carefully, with her morose and frightened visage, pale white yet heavily shadowed in my rendering, out in bright sun on the billboard, this countenance floating atop a pond of tequila, triple sec, and whatever else.

"No text though, right?" I could see none in the picture, but I needed to know how far Garrett and the others were willing to cross me.

"You don't know about that?" She was holding the whiskey bottle in one hand.

"I *thought* I did. There shouldn't be a single word."

"No text," she said in a whisper, right into my ear. So, he wasn't yet willing to go all the way. "But there *are* all those possibilities, aren't there, all over town? *Karen's* work." She said the name as if it were a dirty word.

I took the bottle from her and directed her back to the sofa. I followed with two stubby glasses, two fingers full, pinched together in one hand, her phone in the other, and a feeling of some small joy that Garrett hadn't gone completely rogue. "Have you seen the color boards we've been putting up, too? The stripes?" I pointed to the photo still displayed on the phone, to a small awning in the background, upon which ran a raw stripe of straw, running into nothing, like a loaded brush discharging. It was the *other* thing, I'd only recently learned, Garrett had gone ahead and done without my approval, although at least the hues were quite faithful representations of the samples I'd provided at the meeting we'd had at Cosquer.

"That's part of it?" She touched my hand and took one of the glasses. "I think I've seen a few of those, actually. Isn't there one in Grand Central?"

"I assume." I had no idea, but why not.

"It's sort of... a signature. Is that what you'd call it? A hallmark? What would be the word?"

"Looks like neither of us really knows the plan here."

"That's Jimmy."

"Oh is it."

"*Especially* with the ones he likes. Haven't you found him that way? He doesn't mean any harm, I think. He just feels he and his friends ought to trust one another."

I couldn't have trusted "Jimmy" less now, and doubted I ever would again. Was it worth it to him, earning my contempt like this?

"It's one of the first things I did, those swatches of color. There's a giant blue one just up in Union Square. It's easy to miss, in a way, because it's so big and neutral and watery. But if you look closely, it's got all sorts of variation in it, like a Rothko, except not at all a Rothko. Other ones are like streaks of straw—the one in the photo, for instance."

"It's like a patch of light."

"It's like light being lighted."

She turned to me with a sharpness couched in the clenching of her jaw. This was the tautness of desire I hadn't seen from her since that first night—what I'd been waiting to see from her since. This time was even better, as she wasn't drunk or stoned, not as far as I knew. Perhaps that's why it retreated so quickly from her body. She returned to practical things: "But is there an *actual* logo for any of this? Jimmy isn't being clear with me."

"I think we're all wondering about that. That doesn't have to be a bad thing, really. A lack of a logo." I was eyeing her hips.

She looked at me curiously, sensing that I was wondering about other things now, entertaining possibilities triggered by that lapse in her mien. Her eyes narrowed. "You're like him, you know."

Was I?

She snatched her phone back. "I sent this shot to my friends. I've been getting emails about it already."

"Do you like it?" I ventured, not yet sure if I cared whether she did. It depended on who she turned out to be, really, how deep her aloofness ran. I knew too many "difficult" girls to want to add another to the roster.

"Can I have some coke?" she asked.

My eyes widened.

"Diet Coke."

She got the can herself from the fridge and the rebuke I knew was coming came. "It's like a cliché, this fridge." She poured half the can into our pure and delicate whiskey, of which there was very much a finite supply. It would take another generation to get more of it.

"Can you taste it that way?" I gestured at her glass with mine.

"Do you think Jimmy cares if I can?"

"I thought you might care. You're the one drinking it."

"I *look* the part. That's what he said when he came to me with this."

"I agree."

She took a few steps and was up against the wall, drawing her hands over the mural, her fingertips mostly hovering above it, just as Garrett's had.

"It doesn't really matter if you hate the drink, we're doing things so obliquely," I said. "He's right, I guess."

"Is that what you think? That I hate it?"

"What matters is that there's a relationship."

She drank a bit of it. "What kind?"

"It doesn't even have to be an affinity or a parallel."

"So hate is okay?"

"Right angles, anyway."

She turned just her head toward me and smiled, dismissing my cleverness by acknowledging it. A few more steps, efficient yet gilded with grace, extension, sweep. It was no metaphor to invoke dance with her; she moved with the kind of casual articulacy I'd never seen off a stage. She fell into a crouch over a stack of drawings I'd piled arbitrarily in the corner, behind a stool. The frill of her pale orange cotton dress, exceptionally sheer while remaining opaque, picked up pencil shavings as she shifted around the piles, adjusting to the orientation of the pictures. There were many piles, and there was rarely any meaning to their exact composition. I'd set the pieces that way simply to keep from trampling them in the dark. She pulled her hand back at the last moment and turned to me, as if for approval to peruse, though I doubted anything was going to stop her.

I looked away, out through the window beyond her, the one with the grease lattice still upon it. I wondered if it could even be wiped off at this point, or if it had eaten its way into the glass, much as bleach had annihilated her hair, whatever its true color. She used a smile the way I used absence, omission: by turning away from her I signaled not exactly yes, perhaps, but at least that I had no objection. She understood. By the fourth or fifth drawing, she came out of the crouch onto her knees, shuffling about more like a child as her attention seized each image. She proceeded meticulously, sometimes seeming almost to read the picture, left to right, top to bottom. Perhaps she thought this brought objectivity to her gaze. Then she'd let herself observe less calculatedly, her eyes shooting here and there in accordance with the logic, when there was one, of the sketch itself. She made no attempt to compliment me, nor did she turn to verbal critique. You could only tell what she thought of something by the time she spent with it. She would throw over some drawings in a matter of seconds, long before you could have come to grips with their nuances: she'd lost interest already. In other cases she lingered a very long time, only

gradually rolling the page over while her eyes clung to the marked surface, refusing to give up the picture to the action of her hands.

"I wish *we* could do something like this." She was looking at one of my large format drawings, done with delicate closed contours with an uncommonly dark graphite. I'd had to re-sharpen the stick almost every stroke to keep the line fine and clean.

On all fours she moved to another stack a few yards away, against the west wall, with a facility that would have come from years of exercises dreamed up by St. Denis and Grotowski. It could have been a come-on, the animality she was enacting before me, if it weren't so fully rendered; there was nothing being portrayed, which is where the eroticism normally came from—pretense, role-play. This was simple incarnation, wondrous from a technical standpoint, the appearance of *this* creature in her place, bound to a form of life that, not participating in the feelings of man, could only be remote.

What sort of creature, though? Her strides were accompanied by a slight rolling of the hips, the place in which kinetic energy was concentrated and idling for the moment. She was genuinely lost in the drawings themselves. The idea was bound to please me. But then her line of work *was* acting. It made picking up sincerity in her more difficult than it already was. What I felt, deception or not, was that her movements weren't addressed to me, but to herself. They stemmed from some inner need to take up certain postures, to be low to the ground, to travel quadrupedally, and so on. My stacks merely provided the occasion for this, in the way of scratching posts.

She sat back a little, transferring her weight to her legs, and without a word began nodding vigorously. If some relied on body language, Daphne seemed to live within it, without residue. This wasn't a matter of using gestures and actions to express assertions, the kind one might also verbalize, so much as generating a distinctive sort of extra-linguistic significance, which the drama teacher Delsarte, I knew, had quixotically attempted to map for all time in his system of expression. There would be no mapping this space, as later generations would learn. But that was precisely what made masters like Daphne so enchanting. What was it they knew, or simply were, that no one could seem to re-present? She'd probably carried on entire conversations like this with Nik's group, among others who could articulate themselves as she could. I wasn't a fitting partner, of course. I could only watch.

She sprung up, returned to her old form at my desk, to examine the final pile of drawings in eyeshot.

"I saw a show of Pettibon at the New Museum a couple of years ago."

I shrugged. Garrett had mentioned him, too, the same exhibition in fact. Maybe they'd gone on a date.

"Not that you make me think of him."

I complicated the shrug with words: "Garrett thought he was too rough, improvisational."

"You wouldn't like improv, I guess."

"Not outside the theater."

"Do you *go* to the theater? Never mind what you like."

"Only with women." I looked at her crooked. "Just like ballet."

She could sense the purposeful ignorance I was tossing her way.

"I imagine you seeing, I don't know, Corneille. Racine."

"I haven't."

"And Brecht?"

"Definitely not."

"That's what I think, too. I despise him in some ways. So what about Wilson? I can go on like this forever, you know. You should probably—"

"*You* must like him. Your play seemed like—"

"Well, no, not really. Nik is doing such *different* things with light than him."

"What about Foreman?"

"So you know a little. But we aren't re-creating the sixties. Hysteria's sort of passé. But tell me someone *you* do like now."

I leaned back and thought a long time.

"This is fun."

I kept thinking; she kept waiting.

"Well," I said, "what about Marlowe?"

"Better than the Bard!" she provoked. "I've done a few of his plays, more than *Faust*, though there obviously aren't many to choose from. How did he die again?"

Once more her person seemed to speak with an eloquence I would never achieve. There was something terrifying in it, the way she mounted my vinyl chair, whipping around and balling up in it, with her feet resting on the seat and her knees sticking up and her arms wrapped lightly around them.

"Do you consider yourself—" I began but broke off. She leaned forward in the chair. I tried again. "Have you heard the expression *athlete of the heart?*"

Daphne convulsed with laughter and lust. "Oh, I don't know about all that. Is Artaud your man? Do you *want* me to be an athlete of the heart? For your pictures? For you? What if I were just an athlete?" She walked over to me gently and formally, as though she were as far from untrammeled desire as one could be, showing me she could be anything.

"Just looking at you, I thought..."

"I hate improv, too. Did you guess that? Artaud doesn't *have* to be that, maybe, but the ones who've come along since have seen it that way. Grotowski, Brook. They

want to shatter something in you, right? Through ritual. And I don't destroy things. All that Freudian stuff about an untamed core of ours that everything else papers over. You don't believe that either, do you?"

She walked to the window, stared out through the grease bars. "What you've put up on the billboard downtown, I think I remember the moment. From that night." She turned back to me sharply. "I've been thinking about it ever since I saw the picture. There's a depth to it, but no... well, what? No revelation. That's it." She walked back toward me. "I don't remember you taking a single photo, either. But there's total control to that drawing. Memory! Not improv."

"Fantasy can be as controlled as anything."

She reached me as I reached for the bottle. "It's not a very nice fantasy, you know. It *is* a strong one. That face you gave me..." She looked sullen, and then just as suddenly recovered. "I guess that's why it's strong, though." She sat on the couch and kissed me lightly on the cheek. I nearly touched her but allowed her to pull away unencumbered, snatch the bottle from my hand.

"You're aware of the source of this?" I asked.

"Hm?"

"The limits on supply?"

She kept pouring until there were four fingers in the glass and settled herself back on the sofa. "Do you know how long I've been drinking this? Ever since Jim first started sharing the stock with my dad. After they discovered it out there in Illinois, near the farm. Two years ago, I think. I know *exactly* how much there is." She drank half the glass to make her point. However smooth it may have been, in that quantity, any spirit was going to exact a toll. She gulped hard through an alcohol-stung throat and dangled the glass by the rim with her fingertips, loosely swinging her wrist.

"Have you ever tried it with the other one?" I asked. "Theria, they're calling it."

"Should we?" Her words came out strangled, her throat still in spasms.

I lingered at the fridge to let her find her voice. She must have regretted her bravado now.

"I used to get into the liquor cabinet," she said, coughing slightly between words, squeezing them out, "our big, wide, white cabinet. When I'd just started college, I would still come around a lot—home, I mean. And one day I saw this whiskey bottle with a handwritten label, just a date, no name. My dad isn't a whiskey guy, mostly wine. It stuck out. My dearest drug buddy, Jackie, she and I watered that bottle down to nothing over a month or two. I think it's still sitting in there, just water with a touch of color. It's the most transparent gold in the world."

"That good."

"It was just so exotic to us, not bourbon or scotch or Irish whiskey. I doubt he ever noticed what we'd done. He'd taken the bottle just for Jimmy's sake."

She met me at the kitchen counter with her glass, there were still two fingers in it; she replenished mine to the same level.

"But did you *give* me that face, or is that just what was there? I'm just not sure, looking at it."

This hardly seemed to exhaust the options. I took the bottlecap off the Theria.

"There is so much *command* in that picture. That's a word Nik loves. Alonso also. I don't... I don't think I look like that anywhere else, though. Like in *The Sort*. That's what all my friends are saying, too. Just how odd it is."

Her phone seemed to vibrate every ten seconds with a new text. Who was Alonso?

"But not that it's untrue to me," she said. "They're saying, well, like this one: *How is that you? It is you, but* how?"

"You can't compare drawing to film, I guess."

"Why not?"

"Drawing is different. It's not like painting either."

"The drawings you and Paul and Daphne run by me, I look at them all the time. I don't even think it's about vanity. How could it be? I look *awful* in them."

"That's not really true."

"I keep wanting to disown them, but the longer I look, the less I can. I only adore you more, the one who *did* this to me." She gave me a brief, whiskeyed kiss, the first proper kiss of the day, standing in the kitchen.

"Well, pour it in," she said. We watched the marine tones of Theria crash into a sea of gold. "I mean, I look so full of fear in that picture, right, but then I'm brimming with confidence, too. And not in two different ways. I was telling a friend of mine, it's like an Escher, but psychologically. An impossible person."

"Maybe you're just..."—I tasted the mixed drink before continuing; we both did, and were surprised by their harmony—"...frighteningly confident," I finished what I'd started.

Daphne winced and drank another finger's worth. The pressure dropped and an intimacy enclosed us that, for the first time since that night, didn't dissipate at once. I'd need to keep things this way, actually, if I were to get any useful work in with her today.

"This is so *good!* It works better than water with it."

"Now will you go sit in the light for me? There isn't much of it today."

"And what about everything I'm telling you?"

"Keep telling me."

She shook her head and followed my finger to the rusting corner stool that really was too tall for most women. But then, that's how I liked them to be, precariously sitting on the peak.

"I was paying you a compliment just now," Daphne said. She didn't appreciate my parries, which were all part of shepherding her, as every portraitist learned to do, if they ever got anything done.

"Was that what it was? You said my picture, what was it, *bothered* you?"

"I didn't say *bother*. But yeah. That was the compliment."

"I'm just glad we see it the same way."

She climbed up onto the stool with none of the trouble of other sitters. Even when she was half-drunk, her kinesthetic authority shone. She swiveled around to face into the corner, away from me. I dusted the hem of her skirt, freeing it of all those fluttering pencil shavings. She paid me no mind, kicked her feet at the walls, my mural.

"And the poster you made, the headless me!" She caught my arm for a moment. I was bent over her knees, swatting at the hem, when she leaned down and kissed me gently on the lips. I adjusted the dress on her, smoothed it along her waist and belly.

"It is so *right*. Nik's going to put it up soon—not just for the show you saw, which is pretty much over anyway—but for the future."

"Is it because you're headless that Nik likes it?"

"But I'm not, really. You can see something in the shadows, and everyone, Alonso, they can all tell right away it's me. Not by the body, either. By the face."

"Can you?"

She laughed a little and drank again. The glass was nearly done and she had to have been objectively drunk now; it just hadn't hit her yet.

"Alonso wasn't in the performance I saw, was he?"

"Well, he was the last to join the troupe. I'm sure he'll be in the next things—he's a *star*. Nik is in love with him."

"And what about you?"

She snickered and finished the glass. Her thoughts, or at least her words, shifted: "What's it taste like by itself, though? This mixer."

"Haven't you had any?"

"Does it work like a speedball or something, when you blend it?"

"I don't know. Anyway, I'm glad Garrett doesn't mind reusing the poster for your troupe in his campaign."

"Oh, don't worry about him, he loves it." She looked at me while I was still at her feet. Her eyes were reeling. "Will you propose while you're down there?"

I got up from my knees and swept my hand toward the illuminated corner, among the trees of the park painted on one wall, the crumbling sidewalk across the street on the other.

"I think, actually, if we get rid of the stool, and just have you right here..." I picked up a charcoal stick lying on a bit of unstretched canvas from an abandoned painting, got up, and pulled her off the stool. I pinched the glass from her, too. "Just for now, over here..."

"Nik really likes me without my head. He said you two met."

"Was he the short one?"

"He's the one who made me quit NYU. I'm learning so much upstate, at his school."

"That's where the photos you sent came from?"

"Just keeping you in the know. Did you appreciate that? I didn't want you to worry."

"And all the men, then? Was that supposed to put me at ease?"

"Everyone works together. The writers, the set designers, the actors. Jeff, Alonso."

"Wait—you mean the olive-skinned stud in speedos?"

"Those weren't speedos."

"But what was the point of—"

"It all comes down from Meyerhold—"

"Orgies?"

"Not to have a fixed script you're just handed, or even a set. It all comes together at once. And Nik, he is just so *interesting*. Anti-expressive without being pro-artifice. Do you know what I mean by that? There's no one like him."

"Anti-expressive."

"Anti-holistic, anti-organic. But anti-formalist, too."

"Anti- a lot of things."

Apparently she wasn't going to explain the only thing that really needed explaining: that the men were frequently only half-dressed.

"He just thinks the mind and the body should *never* be mixed up. And isn't that exactly what your billboard avoids? That's what we thought when we all talked..."

"Who all? The people in the photographs? I didn't recognize most of them from the show."

"The school's got more people than that."

"Good-looking ones, too."

"You think so?"

Finally I detected a shade of knowingness in her bearing, something in the bend of her mouth. But then she yawned, and it was back to blankness.

"But mind and body—I keep them nice and separate, Nik thinks?"

"They're together, but apart. Look at where the light strikes me?" She fumbled with her phone, dropped it.

"Just leave it."

"Where you made it strike me. Right at the neck."

"It's like a decapitation."

"You're laughing at me."

"I think you've been laughing at me, actually. But Nik's a dualist, I guess."

"He hates Strasberg as much as Artaud is what I know. Those two gods. You would like Nik. Not everyone does, or can. And I am not laughing, just *keeping you apprised*. What I said from the start. You must have missed me, I guess."

"Just stand right here and let me get going with this?"

Once I'd pulled the stool away, and she got herself into the corner where I wanted her, I brought out an irregularly cut sheet of brushed vellum, one that preserved the look of animal hide: mottled, supple, you could have just as easily used it as a drumhead.

"You're going to put me on that?"

I pinned it down on the easel and looked her over with care for a couple of minutes while she basked in my attention, which had now freed itself from all the usual barriers—basic social graces—erected in ordinary life. We were operating under the banner of art now, which meant I was free to gawk with impunity. It was one of the finest parts of the job, to leer fearlessly, without needing to be prepared to shift your eyes away lest you give a false signal, induce some unintended consequence.

I wandered around before Daphne, slowly closing the distance, studying each limb from very close range, each joint, observing how she was linked into a whole. Only a few minutes later, though, she was wilting from boredom. The pleasures of *being seen* evaporate before those of *seeing* do, that's an ironclad law confirmed for me by every portrait I've ever made. And once someone loses interest in being seen, she really does become someone else.

"Is this dress right?" she asked, slapping the orange fabric in annoyance. "I have tights on underneath, and a tank top in my bag, if you want something that shows me more."

"Let's do the dress first. Can you turn, though, slightly to your right?"

She torqued her body without moving her feet, and something, I could feel it, locked into place. So many postures only disorganize our form, scatter us. Now she seemed of a piece.

I sketched her in like this, concentrating on the ways her weight was distributed in space, how each element fell against the others. Once I'd put down enough for

my imagination to work upon later—once she was struggling to hold her posture, really, the twist I'd put into her—I got another sheet and dragged the stool back to its original place for her to sit upon. It reorganized her. Her slender limbs, elegant while she stood, were in some way disguised atop the stool, like grace at rest. I rendered the vectors along which her limbs ran, and as she could naturally sit longer than stand, I put more finish on this one. Instead of only adumbrating the force and direction of the light, its precise play on her, now I let myself revel in the details, particularly the way the dress resisted a purer delineation of her form, or brought her a second form, in fact.

Daphne sat quietly now. I hadn't been sure she was capable of that, but then I recalled the drive home with her from Brooklyn, when she'd been silent most of the ride, and probably less drunk. There was also probably a touch of self-interest involved today, the best kind: she wanted to let me concentrate, so these pictures would come out right.

We took a short break, smoked cigarettes on the front steps, but she remained turned inward and I made no attempt to change this. It was all coming out wonderfully, from my point of view. Perhaps *I* was as anti-expressive as Nik. I didn't think the mind always had to be ramified through the body, that one should always seek the greatest possible transparency. Actually, it was one of the most interesting features of being—that it could hide in the shadows, that you could miss it, and that *that* could be just right. Afterward I had her change into clothing more easily dominated by her form: a tight silk tank top in burgundy, black tights, no shoes (she had slender feet). I put her on the long table this time, not far from the southern wall of the apartment. She ignored the folding chair I'd positioned to help her up, leaping instead with a feline fluidity that shouldn't have been possible in one so drunk. Immediately she became, through proximity, absorbed with the finer points of the mural beside her. She traced the picture with her eyes as I traced her body, with Sumi ink, onto watercolor paper.

She was lying on the table, that's the way she ended up on it, and I didn't alter the position she found for herself, only told her to hold it. There was nothing seductive about the pose; it had the pragmatic quality of someone avoiding a flood. Without the dress, there was no interlacing of forms. Her hips were hurting, she soon complained. She'd arranged her body for herself this time, but inhabited it less surely than the postures I'd found for her. She needed more whiskey, she told me, to carry on like this. I was too far into the piece to refuse her now, even if it was only the excuse of a lush. She wanted the cocktail again, whiskey and Theria. And so we both drank it, periodically breaking for gulps from the glass, while I continued rendering her in a foreshortened position, on her belly and side, looking hard at the wall.

"I am *sick* of being silent and frozen."

"You *can* talk. Who said you couldn't?"

"But what about holding my face perfectly still?"

"I can work on it later. Just keep your body where it is."

She craned her neck both ways, testing the bounds of her freedom, before tucking her chin against her chest. I worked on her legs, her feet, and those few shavings that still clung to her soles despite my dusting. Eventually her eyes closed—her opinion of silence must have changed—until at last she began to speak, carefully but naturally, without excessive music, though in a language centuries-old.

"In thee, thou valiant man of Persia, I see the folly of thy emperor... I hold the fates bound fast in iron chains... draw forth thy sword, thou mighty man-at-arms... And when my name and honor shall spread, as far as Boreas claps his Brazen wings, or fair Bootes sends his cheerful delight, then shall thou be competitor with me, and sit with Tamburlaine in all his majesty."

I stopped drawing a quarter of the way through this speech to appreciate its irony. Yet by the time she came to the end of it, somehow I felt genuinely moved, the way she'd managed, even while sauced, to convert a high-toned bit of Marlowe into something so right-seeming on the modern tongue. It would have taken years to achieve this tone, perched between artifice and organicity. Physically, she drew the necessary variation from her face and neck alone; it seemed as though nothing at all was missing, that there was *nothing* frozen about her. It was a marvel, this dexterity.

"See," she said, "I *can* work from a set text! I just like working with the group. Sometimes Nik has us wear masks—the noble mask, it's called, or was called, before it was corrupted by the guy's disciples into 'neutral' mask, which is all wrong, since there's nothing neutral about it. What's the name of the guy? I don't know. It doesn't matter."

The control she'd just exhibited during her recitation was apparently on the wane. I tried to speak but she cut me off, not even on purpose, which was the shame of it.

"Though it *does* neutralize the face. Your entire body takes its place, your personality ends up squeezed into your feet, your hands. But I always liked the other exercise better, the reverse one, where everything ends up in your face."

The shape of her words was beginning to unravel: it wasn't understatement anymore, as I might have taken it earlier, but the first trace of slurring. I could see the same in her body, the wilting of the casual posture, on her side, she'd maintained up to now. Her limbs sagged, seeking positions requiring the least effort, which our sense of grace normally prevents us from assuming.

Grace was sometimes a burden, though. I began to subtly reshape the forms of the drawing, putting this droop into her, and the piece took on an expressionistic aspect.

She could hardly say her inner state, her disappearing mind, was *not* expressing itself, making itself known, through her body—not an effect I was necessarily looking for here, but now that it *was* here, I was happy enough to let it manifest in the picture. If it contradicted *her* aesthetic aims, or her director's, perhaps that's what would make it most interesting: the way her mind, less inhibited, refused to mask itself. She'd argue with the result, as I'm sure she didn't know how positively ugly she was growing before me. Who would have, in her state?

"And sometimes"—she lurched back to life, shrill and less composed, as if this were a vital afterthought she couldn't suppress—"we'll read from behind a screen, each of us behind our own veils, just our voices flying through the text. Learning how *not* to inflect, to affect, to overcompensate like fucking fools. Letting the meanings we find pick the phrase, the phrasing, not the other way. But there's no technique we're all taught. We do what we respond to. Biomechanics. Sense memories. Even fucking improv, for the *lesser* ones!"

"And you like what you're taught?"

"The teacher doesn't *teach*, I just fucking said."

"But I bet he teaches you what he doesn't know."

"Don't you *laugh*."

She scowled violently, in a way I recognized from the bar; it was a version of the look I'd made into my first drawing of her for the project. I had a way of bringing it out of her, and it seemed to me, immediately after taking such offense, she was more pliant, more mine. It was a hard lesson we all learned at some point: the things cruelty can do for us, with or without theater.

"I'm not laughing," I said.

"I didn't fuck them. That's what you've been dying to know, isn't it."

"Nik helps you teach yourself." She wouldn't look at me. "You know, I made sure *I* got taught the same way, in art school, even if that's not what my teachers were hoping for."

The final thing I did, once she fell silent, was put a pair of the company's glasses on her. I expected resistance, now that she'd grown drunk and antagonistic. I didn't bother asking her to choose a frame; choice only aggravates a drunk's condition. Instead, I got the box of frames and approached her quietly. I pulled out the first of them, the perfectly round, English ones, held them up near her nose, preparing to place them on her. With her eyes groggily opening and closing—I couldn't help but think of dear Helena and her piss-stained fatigues—she found them to be a fresh source of interest rather than a disruption to her reverie. I slid them on her and she looked back at me cross-eyed.

"What do I look like?"

"Do you need a mirror?"

"It would ruin my pose, I think." Indeed, she was still managing to hold some semblance of it, though in a fallen state, which filled me with pity and admiration. "You have to tell me what you see."

"Let me do some comparing first." I took another pair from the cardboard box, this one was more Bushwick, chunky acrylic frames, and although she made a face when I opened its arms—well aware they were no longer especially fashionable—she didn't resist when I settled them on her nose and ears.

Most faces will accommodate only certain frames, certain geometries. Half the pairs in the box had seemed odd on me, after all. But as I cycled through the same glasses on her, putting them on her myself while she stared ahead impassively, her eyes open but apparently seeing very little, or only intermittently, when the mind behind them snapped to, I couldn't find even one that lacked all interest. Each one seemed to stretch or narrow her face in an intriguing way, and none looked plainly wrong.

"Well?" she kept saying, almost like a mantra, after I removed each from her face and studied her. But I simply moved on to the next in silence. Even drunk, she respected my need to inspect without comment, to operate in a certain quiet. In the end, I settled on the fourth pair I'd put on her, trapezoidal lenses in brushed titanium that had an academic air, meant for the shrinking sort, really. Yet her natural forwardness offset them nicely, like the whiskey and Theria that had me seeing so quickly and clearly.

By the time I'd chosen a pair, she'd lost even more starch. Her body, that tiny thing, was failing, and she'd gone mute under the pretext of aggrievement. All of this was induced by liquor, too much of it, taken too quickly, for someone likely weighing in the double digits. Looking at the bottle, the low oval defining the whiskey's surface, I realized I'd not been supervising her closely enough. I asked her several times if she might stand up—we could find something else for her to do—but she just lay there on her stomach, in a posture that was no longer merely restful. In the arch of her back and the twist of her waist you could find an element of seductive resistance, accentuated by the librarianesque restraint implied by the glasses: another collective fantasy.

I could have taken her. But, I wondered, had she really not been with those men in the photos? With doubts circulating in my mind, I focused on draftsmanship. My discretion eventually led her to whine, and then to simmer, yet I continued to work on my final life drawing of her, in sanguine. It came out as the gentlest of the lot, only mildly rippled with tension, even if, psychologically, this must have been the moment of greatest torment for her. Daphne was right: I didn't think the body always, or even ideally, expressed the mind.

I took my time, the alcohol cutting against the Theria, so that when I finished she was actually asleep, resistance having mutated into unwilled unconsciousness. I studied her as I had at the start of the session, yet with even greater freedom, almost an obscene degree of it, knowing that she could see nothing of me now. I must have looked her over not for five minutes, as before, but for half an hour, poring over her body, making small notations on a half-dozen sheets in a notebook as a tailor might, filling out that notecard of measurements you found in the breast pocket of a bespoke jacket, all about her angles, twelve versions of her knee and its graceless jut. I manipulated her, too, rolling her over on her side for eight takes of her scaphoid and the soft slant of her foreshortened spine. All the charm she'd held while conscious was gone, leaving only a pile of matter behind, doubtless with its own points of interest, whether or not they had anything to do with beauty.

None of these observations could be directly transposed to the campaign pictures, which had to be charged, vital, as far as I'd understood Garrett. Now, though, Daphne was in a dis-enchanted state, her spirit made absent and in full retreat, her body lying awkwardly, semi-conscious at best, not unlike underground Helena and all the dispossessed of the subway and my sidewalks, who seemed always to be growing, like a tide or a fungus.

Remarkably, the next day, when I sent Garrett these little unconscious animal glimpses of Daphne to test his feelings, he took to them immediately, not finding them soulless in the least. They were even a little erotic, it surprised me to hear him say. Erotic because, for him, they conveyed the quintessence of that part of her spirit it was easiest to neglect. It was the same way with Claire, he thought, when he'd seen my drawings at Whent's. This, in fact, was what he loved most about the way I drew. What I could see, it wasn't merely beauty in abasement—aestheticized suffering was old hat. What was the *Iliad* if not that? Or the Greek tragedies that would follow? No, he thought, I could see something like the rightness or worthiness in what was repugnant. It didn't make it beautiful, it remained repugnant, which was the key. The phrase he used, which I'd found odd but seemed to me absolutely correct, was this: I could see the *victory* in it.

This was beauty absconding. It was probably the very quality Daphne meant, concerning the billboard in Noho: a frankly unpleasant image, in many respects, and an untrue one, too, but one she and her friends still recognized as *apt*. In that picture, she seemed to be succeeding, flowing smoothly forward, wind at her back, despite, and unbeknownst to, herself. What did knowledge have to do with the good, the right, even the ideal? Here was a question that cropped up more and more for me. Only within my image, it seemed, could she recognize the worthiness of a terror she'd not chosen.

There was the possibility, of course, that for all Garrett said, he didn't quite know *why* he liked my work so much; or else that he knew exactly why, he just couldn't tell me, for fear of disrupting its steady flow. I tried not to think about this too carefully. It could make the job more complicated than it already was. I thought to put this collapsed heap that was Daphne, now totally desexualized—indeed, frankly, somewhat nauseating—onto the couch, into a posture that was a bit more pretty, that was less likely to lead to a stiff neck and an aching back the next morning, or whenever she woke. But, as I reached out to do so, it felt to me no different from moving Helena to a sleeping bag, or carrying her out of the station and laying her on the grass of the community center, or giving her five dollars instead of my admiring gaze. I was going to let Daphne have what life had prepared for her, even if it had nothing to do with her happiness, or pleasure, or desire, or beauty. You could ruin everything, saving people.

It turned out I wasn't quite as pure as I'd wished, not yet: I couldn't help putting a pillow under her head eventually, to straighten out her neck. Other than that, I left her to sleep as night came on, along with the lights around the neighborhood, repelling it.

Later on, after I'd been settled in bed for quite some time, blasting my white noise machine to silence the screams and thuds coming down to me from above, and flicking through *Towards a Poor Theatre,* which I'd not thought of since high school, I looked up to find Daphne standing in the doorway, wide awake and continually making as if to speak but unable to decide on what to say. I turned off the machine—perhaps she didn't want to yell over it—and put down my book, and when I did she crawled in next to me. I turned out the lights and we listened to voices from the street suffuse the apartment, along with stronger voices from within. We heard Tanya being punched in the throat; it was the only way I could explain the odd ejaculation she made, as if air were being forced out of her body. I'd heard this sound at various times over the months, seen her wearing turtlenecks in the blazing heat of summer, and I'd thought, naturally, to call the police. Once, I even made the trip upstairs to confront Rodney after hearing noises of this sort earlier in the evening. He told me with a wink that this was just what Tanya sounded like in bed. What was the crying about, then? I knew, anyway, what my interventions had done to the Beckers below. Suppose Tanya, and even the boys, too, were being thrashed overhead. Was the street liable to be any kinder? As long as she remained well-stocked with turtlenecks, I guess things were working.

So, in that spirit, I let her serenade Daphne and me with hoarse yelps and cattish squeals. You really *could* ruin everything, saving people, and Daphne seemed to understand this: she positioned pillows over her ears to muffle the sounds, and then,

as more and more things could be heard breaking above, and the kids kept pleading hopelessly for peace, she reached down under the covers and worked my cock until I came. Silence eventually fell until the coda—a gentle, endless wailing, which was all that remained of Tanya by this point. Daphne flipped the white noise machine back on and went to sleep.

33

Before I could schedule anything with Duke, he confronted me in the street. He was forty feet tall now, and though he was wearing an Arête frame with a flowing white shawl that I knew even better than he did, his growth still astonished me. Whatever it is you project in your mind, the future rarely obliges. Either what you had imagined would scale up grandly turns out mean and paltry, somehow *smaller* than before. Or else, as in this case, the new proportions radically alter the thing's meaning. What had read as removed or distant, when I'd drawn it in my apartment, now appeared apocalyptically void. Duke's simple cool had been replaced by a solipsism so powerful it threatened, through lips just barely parted, and a jaw only beginning to slacken, to evacuate everything around it of all significance, consigning it to a footnote to his own being.

He stood in place of a Pringles can that had struck me, when I'd first caught sight of it, as a watchtower or castle turret. Scale in that case made the thing garish, a sham, laughable in fact, showing only how slight an ordinary can of Pringles was, which was the great trick of Warhol and, after him, Koons: you could steal the gravity from things by magnifying them. The picture of Duke was of another order, though. He was quite grave in real life. At seven times the size, though, plastered on the building façade, he appeared metaphysically transcendent, anything but absurd. Very few, however, could possibly know who they were looking at. People like Duke were almost never turned into pictures like this; the economics didn't make sense.

Whatever the case, the figure's blackness, shrouded in white, felt perverse. Anonymous though Duke was, he seemed to carry some great covert meaning in the billows of his robe, or the mirrors of his eyes. My pastel strokes glowed, gold and white and silver, against that black, black skin. African black. The tunic had, on vellum, seemed only to represent a puzzling fashion sensibility, perhaps in the school of Dennis Rodman. Now, out in the Bronx streets, eccentricity shaded off into implied bloodshed: the garment summoned terror and dread, the Unabomber and ISIS, making the image genuinely harrowing.

I'd been walking down Seventh Avenue when Jihadi Duke, as Duke himself would call the image, first appeared to me, just above my usual bodega. He stood about one hundred feet back, across the street, at the intersection where the Pringles can had just recently covered the top half of the façade. Duke's likeness, though, doubled the size of the can by descending all the way to the foot of the building. We'd

used a kind of translucent print Karen had thought up, so that the brick behind him showed through slightly, particularly at his feet, where several locals were gathered, smoking cigarettes and pointing up at him, his arrival.

Paul and Garrett had actually informed me about this picture's being released to the public. In general, though, after earlier omissions, I was becoming resigned to the fact that our clients were going to be sorting out some of the details of the campaign for themselves, without me or Karen; that there would always be a portion of their designs in which I wouldn't participate, or perhaps even know of, never mind the lip service they paid to keeping me apprised. I'd changed, I suppose, or was shifting at least. I could recall being truly furious at not being told about the first of Karen's taglines going up, and I was even angrier about the billboard with Daphne downtown. But now, I found myself less keen on the entire campaign. After all, Garrett hadn't bothered to tell me about Antral's or JG's relationships with police departments, their provision of tools to intimidate the citizenry, to incapacitate it, and probably sometimes things worse than that. *This*, I realized now, would have driven his obsession with the police standoff we'd seen that night at Sanguina. Paul would have known this then; I could recall his shifty eyes, the way he wanted to move things along.

What, though, was the point in confronting either one of them about any of this, if I did indeed want to (or need to) see the project out? They weren't *really* going to change their ways, so why not just proceed carefully for now and see what still could be achieved through them?

There was something else I gained from this gap between my knowledge and theirs, and since it wasn't going anywhere, I might as well enjoy it: the simple pleasure of jolts like this, being brought to a standstill, quite organically, by the ramifications of your own hand, gawking and shuddering at the picture's terrible grace, just like anyone else in the street. I'd been on the lookout lately for Daphne-related iconography, too. Anywhere I went now, I kept one eye open for the two of them. But I'd not spotted her yet in the Bronx. Perhaps the feeling was that a woman like her would never be comfortable up here. Unlike Duke. Who knows what they were thinking. There was no point in asking.

My neighborhood was certainly changing in character, not via public sculpture, with its usual ostentatiousness, but trivially almost, within its mundane advertising spaces, like leaves turning color. If Jihadi Duke was here, I thought, he must be elsewhere, too, coming into being at all sorts of magnitudes, and always in a slightly different form. We'd decided—it had been Garret's notion, actually, and we'd all liked it—that although we were involved in mass printing, we would also create singularity. There were, strictly speaking, no duplicates. There was always a permutation. It could be the particular support used, the sizing, the saturation or brightness of the

colors, or frequently just the cropping. Family resemblance was what we were looking for, not mechanized repeatability and exchangeability, though frequently the tweaks were made by algorithms. (None of us bore any general hostility to machines, Garrett least of all.)

I began the walk back from the bodega, peeling the plastic wrap off the squishy bagel I was by now so familiar with—the cream cheese was a texture and not a flavor, while the bread was somehow neither—and pushing the soft mass into my mouth. I was on my way back to the apartment, a bag of loose licorice in hand, when Duke texted with a photo of my drawing of him at the door of his old New York apartment, taken from inside a subway car I didn't recognize (it was part of the 'L,' it turned out—the campaign had already spread to Chicago). There was only one sensible thing to reply with, so I spun around, hopped out into the street during a lull in traffic, and took Jihadi Duke's photograph.

34

It wasn't long before the inevitable happened and Garrett sent me off to Chicago to meet Duke. Apparently the Bears didn't want him leaving the team too much at this time, while he was still acclimating to an NFL season. They'd not been pleased with his staying behind in New York after the Giants game and wouldn't tolerate that sort of thing any further, even if they were glad to have him healed. Myself, I was glad to have a reason to be somewhere besides New York. Things were still fraught with Karen; we'd settled into a cold war, and everyone involved had the good sense not to suggest she come with me on this trip. With Daphne things remained distressingly vague. Drinks had colored our second meeting just like the first, making it impossible to say what counted for what. Who knows when I'd hear from her again? And everything with Paul and Garrett stood on a knife's edge.

I rarely left New York these days; it had been over a year since I last boarded a plane. Things had been different once. In college, I'd studied abroad not one or twice but three times, to the consternation of my advisors. Glasgow, London, and Rome. But those trips hadn't felt like the evasion Chicago did. For someone who'd given up travel, New York wasn't the worst place to be. You could get a fair picture of the destiny of humankind, if not necessarily its current state, from walking only the city's streets. You'd have to make all sorts of deductions and projections, of course, to understand how things must stand *elsewhere* for things to be this way *here*, but it could be done reasonably enough. Only London might serve any better. And it was London, actually, where I'd flown last. A year and a half ago, I'd sold some work and, without my mother's knowledge, borrowed a small amount from my father, which freed my trip of the tacit dread of financial repercussions that inflected so much of my experience—until, that is, Garrett came along to take my parents' place.

The occasion abroad was perhaps the last shimmering moment I shared with Claire: her first international solo show, at Gasworks, comprising a warren of conceptual pieces I'd consulted on in the informal way of intimates. Over the last couple of years she'd gotten caught in the net of critical theory and post-critique, too, another permutation of criticism; but these shortcomings were offset, even made moot, by a talent for molding volumes, containers of space, the faces objects show us. It separated her from other artists also languishing under the burden of Nancy or Latour or indeed Simmel himself. (I'd not yet brought up the philosopher's views with his great-great-granddaughter, nor had she mentioned him.) Claire decried the reviewers

of that London show, and most of her shows afterward, for having more interest in her instincts than her intentions. As a woman, she was rightly given pause by the notion that thinking and deliberation can only represent a kind of denaturalization of femininity. Stereotypes aside, however, I had to admit that the most cogent part of her *oeuvre* had little to do with advanced theory, however much she might have wanted it to.

As for Chicago, I packed hardly anything: I was staying just one night. I did try to get Immo to join me. He could bring his latest victim if he liked, or we could locate some innocents for him over there. With all the casual murder going on in Chicago these days, he said, he'd probably be called upon to work *pro bono*, doing triage. He also had a date on Saturday with Vera, and dates with her weren't things he could skip out on; they were all that soothed the wounds inflicted on her by his escapades. The deal we struck, in the end, was just this: if his plans changed in some way, if Vera excused him or had to excuse herself, he'd let me know. Certainly I wasn't counting on it when I left with my gray nylon duffel bag and my old leather portfolio.

The only thing notable about the flight out was the robustness of the TSA presence at both JFK and O'Hare. Bin Laden had created the original bump; now it was our nativist president spiking things again, making us feel we ought to carry not just our driver's licenses wherever we went, but our passports, too.

From O'Hare, I headed straight for the Bears' practice fields in Lake Forest without stopping at my hotel. There wasn't time. When I arrived, I found the facility's entrances sparsely monitored; only after I'd come nearly the whole way was I regarded by someone, a bearded black man in a gargantuan Bears raincoat that looked more like the bulkiest possible robe. Granted, the air was noticeably sharper than New York's. Yet neither could account for the sheer size of his coat. Perhaps worse was on the way.

I explained who I was—he'd been waiting for me, apparently—and he gave me a lanyard much like his own to wear. I dropped my portfolio and bag in the staff lounge and took a medium-sized pad with me as we turned a corner near the locker room and quickly found ourselves in the tunnel and then out on muddy grass. The panels of white stadium lights were just coming on, revealing mist wafting through the air. The rain was finally fading, the man explained as he walked out among the mud-spattered players wrapping up their final practice before Sunday's game. Water had turned the field into sludge that clung to your shoes and slid away as you walked—just as it often did on gamedays. Gales, flurries, downpours, they were all routine in Chicago, which gave the Bears an edge when other teams came to town. By December, Soldier Field achieved the consistency of granite, so that even a routine tackle wracked the body. Teams at that time of year were making their playoff push:

the seriousness of the competition, and the catches receivers were willing to lay out for over the middle, where the hits were hardest, both surged. It was then that the field itself turned into an opponent, not only in Chicago but in all the most famous football towns: Green Bay, Pittsburgh, Buffalo.

Music thundered through the stadium, hip-hop of a variety I didn't recognize, while the coated man and I trudged onward. Most of the players were headed in the opposite direction, back to the locker rooms, helmets in hands. Done for the day, presumably, they were batting around obscenities good-naturedly and clanking those helmets together in solidarity, or slapping those still on people's heads. The more progress we made toward the Bears' iconic wishbone *C* painted onto centerfield in navy and orange, the soupier the ground got. Sod started flying from our shoes, until my escort stopped sharply and stuck his arm out across me. I was about to ask him why when a ball came tumbling through the air, end over end: an unfielded punt, it turned out, launched by someone other than a kicker, as players goofed after practice, exploding in laughter as the ball struck the ground lamely in front of us and splattered us with mud. *Now* I understood the man's coat. He began to walk again, explaining conditions further to me, the sorts of storms they got in the area, the way the mud could ride all the way up your pants, that you could slide right onto your ass if you weren't careful.

The air thumped. A ball flew over the field in an inhumanly tight spiral while a helmeted man moved for it at an extreme angle, launching into the soggy air. The ball caressed his fingertips and hurtled onto the ground beyond him, splashing water as it skidded on the grass, the spiral annihilated by his touch as he himself went careening to the ground, hydroplaning along the slick.

"Goddamn you, Briar," someone bellowed from far off, in the direction from which the ball had come. "You got to get at it faster than that."

"Keep shooting them at me," a voice came back, cool as ever. Duke's.

The Jugs ball machine made its curious thumping sound, as if it were firing something larger and lethal, and so another ball came in, this one a little higher and deeper. Through the mist swirling under the lights, Duke laid out for it, tucking an apparently uncatchable ball against his chest as he fell onto his back.

"You are *never* going to come down with it with a break like that. Not ever. On Sunday someone'll be right in your chest. Goddamn. Not once." The voice was different, a coach's voice, though it was just as angry. Anger was what they were steeped in around here, getting people ready for war.

As if in reply, Duke threw the ball back at them in the highest of arcs while still lying on the ground. He rose, his white jersey now a fecund green and brown, just as another football screamed in low, so low he didn't even go for it. The sadist operating

the machine was firing impossible shots now, skipping balls likes stones on a lake. Skovksy had nothing like this in his repertoire. No one did.

I was nearly upon Duke, who was wiping cakes of mud from his uniform with a certain satisfaction as the music turned old school, Rakim. The assistant was no longer beside me; I looked back and saw him filing away with the others, halfway toward the tunnel from which we'd both come. I lurched forward through the sodden field, heading for nineteen, trying to heed the bearded man's words of warning about the field and slow down a little, steady myself, until finally, after Duke had finished clearing away most of the mud, he saw me. He took his helmet off and while still on his knees caught a human-issued pass that buzzed my head. I whipped around to see who'd thrown it, but I could hear only laughter as the music faded. The rain, though still mild, was swirling wildly in a strengthening wind.

Duke pushed in on the ends of the ball with his palms, plumping it like a kicker. In fact he was gearing up to rifle it at my chest: in the event, the pass ended up offline. He side-armed the ball, though had it been perfectly true, the wind would still have corrupted it. I reached for the errant pass with one hand, pointlessly, perfunctorily, the way one slow-jogs when jaywalking, more a signal of good faith than anything else. I was more concerned with my sketchpad, which was caught in the currents; I nearly lost a hold of it before pinning it against my side and traversing the final yards.

Another ball flew above me, this time from behind—it might have been the same one Duke had just launched the other way. I turned back but couldn't pick out who'd thrown it, as nearly everyone was facing the other way, if they hadn't already vanished into the tunnel, their departures all speeded by the wind. Duke, however, still had a few more routes to run for the couple of staff members remaining on the field: a post, a dig, a pair of wheel routes. I took out my phone and snapped all of this until the coaches disappeared, leaving just the man running the Jugs machine, who would probably have rolled the training device away had Duke not yelled at me: "You got to take a few of these!"

The first ball I barely saw—until it was feet from my head. Something about having to be on the other end of a pass made the ball far harder to track, knowing you'd have to *do* something with it, deflect it, catch it, whatever, not just smile and sip your beer. This one nearly caught me flush in the face. I darted to one side, just managing to evade it after seeing it eclipse the stadium lights in the distance—my only warning, those disappearing lights. Duke clapped and hollered with something like joy; the minute you become a spectator, everything looks better. The next ball I got one hand to. That's it. The third and fourth I nearly caught, though in both cases I'd waited for the ball to strike me in the chest rather than use my hands to pick the ball out of the air, even if all the games I'd watched had taught me that

doing so only led to dropped passes and a bruised sternum. And that's precisely the way it unfurled, on that fourth ball: it took the wind out of me on contact, leaving me dazed. Yet I went to the ground slowly, onto my knees, which sunk into the mud as I began to gasp and cough. How utterly transformed the game was for me, out on the field. What seemed, on television, or even from the bleachers, merely exciting was now almost *too* alive, and pregnant with consequence. Harm concretized—I'd just experienced that. And if circumstances turned, and the ball fell differently, I might mete out the same to others. What was it players learned *not* to feel, in the midst of the game, to be able to do their jobs? Is this the font of all that athletic blather one heard after games, the trance state they cultivated that made their work not only bearable but pleasant, even joyous? Was it, at root, a kind of glossolalia?

After helping me to my feet, separating me from the mud, though plenty of it came up right along with me, Duke went back to catching passes, talking to me all the while, instructing me on proper technique. The balls arrived with every kind of arc. The man behind the machine was getting loose, with no coaches watching him, pulling out every stop. Duke took runs at these engineered passes from a clutch of angles. How he managed to get such solid footing on a field this swampy was a marvel; how he managed not to tire visibly was even more baffling. The wind got worse but the mist finally lifted, which cheered me. The gesture drawings I'd intended to get out of this on-field visit were again in the cards. I grabbed one of the folding chairs lying flat on the sideline and dragged it out to the right hashmark of the forty-five-yard line. I watched Duke tear tracks as I pinned the paper down with one hand and began to sketch crudely with the other.

After a while, noticing the rain had vanished for good, a few players emerged from the tunnel, including a decorated cornerback Duke called over: Brooks, whom I knew to be an All-Pro, one of the bright spots on defense. A few of the others jeered, dubious of Duke's capacity to outplay or even keep up with the veteran, the star. They did seem in some way impressed, however, by Duke's arrogance in even challenging Brooks. From the sideline, nineteen got himself a new helmet, white and unmarked and fitted with a tinted visor, before trotting back toward his counterpart.

As choreographer of the event, the Jugs machine, which the man operated now via remote interface—the device had clearly been customized—swiveled to and fro unpredictably, launching rockets; and as it did, a sort of improvised dialogue took shape between Brooks and Duke that lent my lines, as I drew them, new verve. Here was the first sign of a proper *performance*, even if it was technically a rehearsal for Sunday. Here were my danseuses, no coarser than those debauched marionettes,

who'd worked in a form no less debased than football. The French opera had found its low point then, after all, becoming as much a place of procurement for the well-to-do as a form of entertainment or, at the limit, artistic contemplation. Some of Degas' pictures show exactly this transformation, the old patricians gaining introductions to the girls backstage.

Football, too, however much the modern game gleamed, however much revenue it continued to turn out, was, as a game, also at a nadir. It mostly served as a place where young, disenfranchised men were separated from their senses, pushed toward Parkinson's syndrome for the benefit of the middle classes.

There was a difference, of course. Degas, a *grand bourgeoisie* of Montmartre, really did *know* dance. He'd always maintained his box at the opera, whatever his finances. He obsessed over it, loved it deeply. Despite my narcotic, round-the-clock sports television sessions, my obsession was of a different kind, far removed from connoisseurship. I didn't grasp its niceties in anything like the way he grasped those of the opera, and that's because my feeling for the game, or love, if you could call it that, had been unconscious, so it could never be actively honed. (The comparison with Ty was instructive.) It was raw and rough—something, I hoped, that would ultimately distinguish my approach, and the results, from the master's.

One thing was certain as I watched the two of them go after ball after ball with a peanut gallery of teammates looking on: the play of forces on display was more savage than any form of dance my mother, or the various women in my life later, would ever expose me to. *Petrushka* couldn't possibly compete. And this barbarity, its pathos, too, was directly connected to the *stakes* that dance lacked. Beyond formal eloquence, here there were two defined aims that couldn't be jointly fulfilled, with each man having a preferred finale—a catch for Duke, a deflection for Brooks. In each leap for the ball these two drives clashed, occasionally so violently that one or the other player was left semi-concussed in the mud, unsure of how exactly he'd ended up there. Decisions were being made at a speed faster than the conscious mind could work. Yet what emerged could hardly be called uncontrolled or random. A lifetime—two lifetimes—of know-how selectively surfaced before me: memories, engrained reflexes, and tacit projections into the future, of the precise place the ball would be at the split-second it came into the range of their hands. And this was only *practice*, though even here, the stakes—respect in the locker room—were clear.

I was rooting for Duke, mostly because he seemed easily volatile enough to call off the rest of our meeting if things went badly now. Triumph for him would spell greater co-operation for me. All of this drove me into a state of muted exhilaration, which I was happy for the moment to bring within the penumbra of art.

Between passes, Duke would check in with me, casting a look in my direction while bent forward, hands on knees and sucking air. Evidently he *could* tire. He'd been out here a while now, whereas Brooks, an uncommonly rangy defensive back who, I knew from television, carried authority with the team, had only recently emerged from the tunnel, had probably been recounting war stories for rookies like Duke in the air-conditioned lounge just ten minutes ago.

My first few sketches were worthless. Long before they solidified, I turned the page. None of the gestural energies I could plainly see, every time the machine lobbed another ball in their vicinity, would transfer to the page. Each of the run-ups Brooks and Duke took to the ball added structure to the field: a geometry defined by strategic rather than visual interest. The player better attuned to these pathways, pathways that came into existence during the ball's flight, was more often than not the one who came up with the ball.

By the eighth or ninth play, Duke seemed to be making inroads in overcoming Brooks' defense. As time passed, the veteran cornerback's craftiness, born of experience, grew less effective in offsetting Duke's raw skill. Nineteen's takeoff seemed a little bit sharper, and his grip that much surer. They were almost magnetic, his hands, latching onto the ball with an audible snap that was all but impossible to dislodge. And when Brooks managed to find the ball first, which happened just two or three times, I believe, Duke dispossessed him midair. His hand talent was outrageous: you'd see Brooks catching the ball at the apex of their airborne scrum, and Duke coming down to the ground with it.

Their teammates' allegiance palpably shifted toward the rookie, and in proportion to this shift, a vengeful confidence, one I'd not observed in Duke before, seized him. Maybe it was inevitable, the way he was beginning to embarrass the elder statesman, his mien turning fiery, unmooring itself from matters of football. On the final ball, Duke had to come back a good way for it. He slowed down on his approach, and Brooks, jumping the path Duke was taking to the ball, imagined he had a clean pick. He'd guessed, and he'd guessed right. Yet somehow, I'm still not sure about it, Duke, with that furious Harvinesque burst I'd never get used to, seemed to pass straight *through* Brooks, sending him reeling helplessly to the ground, while losing no momentum in the process and easily pulling in the ball. *That was legal right there!* two in the crowd yelled, while others howled purposely like monkeys and eyed me with a mix of joy and hatred.

Duke jogged toward me, energized by conquest, flipping the ball from hand to hand, laughing, before finally going to the ground in a heap, where his teammates giddily mobbed him. Brooks, naturally, didn't take the brazen revelry in his fate very well. After recovering his senses, he sent the others scrambling some distance with a few waves of his hands and then loomed directly over Duke, who kept

rolling around on the ground like a child, back and forth, without even the ball in his hands anymore, and now without a helmet, which left his head vulnerable to the rage mounting in the man above him—particularly those *cleats*. Duke spun away a couple of yards from Brooks, and then, undeterred, right back toward him at speed, bringing his face within range of Brooks' spikes, as if daring the defender to do what he had in mind. It might well have happened, I think, if the others hadn't rushed in and gotten between the two. All of them tried to laugh the scene off while perfectly well understanding what had happened. The rookie had shown up the star. All these unfurling events I recorded on page after page of my pad. The dimensions of the two receivers' movement had eventually opened up to me, so that even when I set down very little, I could see the vectors were right, the intersections convincing.

I thought they were done, everyone did, but one staffer evidently wanted to see a little more from Duke, this receiver who now looked entirely spent, lying there on his back. But this was no ordinary staffer, I saw. No, it was Cotter, the head coach himself, making his first appearance on the field since I'd arrived. Maybe he'd chosen this moment, late in the day, with a purpose in mind, as a test of mettle. Whatever it was, by the time Duke lumbered to his feet, his demeanor had changed; he was a picture of modesty, and not far from apologetic for his deeds. Brooks couldn't really have been appeased by this, not so quickly, but under the circumstances, in front of their master, they sealed their truce with an exchange of slaps to the head.

This after-practice session wasn't convened on my behalf; it was just one of many Duke would participate in over the next weeks, until he'd worked through every wrinkle in the playbook. It was also a sort of late pro day for Duke, with all the coaches, and now Cotter himself, figuring out if the book on him was true, that his discipline was iffy, or whether, instead, with the right coaching—Cotter had a history of working with players no one else would—Duke could be worth a long-term contract. Cotter never ruled out anything. He probably saw Duke as a future captain, not because he believed in him so much as he believed in himself, his ability to dissipate the egos of anyone who played for him. And if *Cotter* failed, you really were incorrigible, and your days in the league were almost certainly few.

Cloaked in a cut-off Belichick sweatshirt, hooding his hairless head to stave off a rain that was no longer falling, Cotter quietly asked for a tipped-ball drill from Duke and Brooks. The receiver and defender, both gassed, regarded each other with long faces. Mutual suffering at Cotter's hands was already bringing them closer together, as it had so many others. It was pain's most productive role. The drill itself involved less antagonism than the Jugs machine face-off. It took cooperation to generate the necessary unlikelihoods: pass deflections that sent the ball into the other's hands. It

was the kind of thing you practiced religiously for the one time it might happen to you that season.

Balls started flying again. Now things were closer to ballet, or something more farcical—juggling, perhaps—with Duke deliberately nudging a series of incoming passes with his fingertips, as a receiver might an overthrow, and Brooks trying to intercept these balls as they sputtered toward the ground. It was a drill of *reactions* to incidental events, which made it somewhat difficult to practice. Yet when it came to football, even the arbitrary had to be given a veneer of certitude. The financial stakes of the game demanded this voodoo, not just in football but in professional sports generally. Between the lines, the very idea of chance had to be denied, when in truth it determined more outcomes than anything else. If this weren't so, if sports could genuinely be made predictable, routinized like ballet, it would immediately lose its hold on us. This must have been what Brecht meant when he said the ideal theater would resemble a boxing match, with everything up for grabs to the very end.

Duke and Brooks went through the drill seven or eight times, with Cotter observing stoically and the wind shriveling the loose hood on his head, until both players looked ragged and the lines on my pages turned correspondingly indistinct. Cotter had a merciful plan, though: Brooks had to make good on three of Duke's tips. Real tips, though. No lobbing the ball up in the air, like a volleyballer setting up a kill; it had to come off the receiver's hands more flatly than that, as it would in games. Finally, once Brooks managed the three interceptions—and it was arduous getting there, a couple of dozen tries—Cotter and the peanut gallery walked away without a word. The Jugs machine exited the scene soon after, leaving Duke and Brooks sitting back-to-back on the ground, trying to find their breath. The two of them eventually made it to their feet, and Brooks, panting hard, stumbled off toward the tunnel without even glancing at me.

"So"—Duke gasped and staggered toward me like a drunk—"let me see these," he said, putting his fingers, freshly ungloved, on top of the sketchbook in my lap before I could shut it.

"They're a mess."

His hands went to his hips as he recovered himself. He was in agony, but his mind was clear.

"I took studio... in college."

"James said something about that."

"*Intro to Drawing*... I didn't get far." He was less articulate than usual, his long breaths producing gaps between each utterance as he gathered himself. "No commitment, is what they said. But—I remember the messes I made. And how to read

them. There were good ones, bad ones. I got that much." He studied the sketch I'd just flipped back to, drawn before the tipped-ball drill, though the picture was tantamount to a series of sloping lines, one barely defined form swooping in on a second in the foreground, reaching over it, through it, for the incoming ball, which would have been behind the viewer.

Pivoting on his hand, Duke never lost contact with the drawing as he came around me, over my shoulder, and squinted at my curlicues. "James is nostalgic as hell. You know I've only talked to him twice? Mostly it's been you, and your friend. Karen." As sweat dripped down his wrists and along his fingers, the paper grew moist and the ink began to smear. But it didn't matter. What this was, what I'd been working on through all of these crude drawings today, was a map of *forces*, not forms.

"Maybe I *don't* know what the fuck this is," the receiver said finally. He grabbed the pen lying on the pad and twirled it between his fingers, inspected the fat nib, and handed it back. We made for the tunnel then, his Bears helmet in one hand, and the white one in the other.

35

Duke swapped his uniform for street clothes while I sat in the players' lounge with my things. The team got us a town car to his apartment, which was north of the stadium, farther up the lake, on the opposite end of the city from his childhood home. It was already dark outside, but it got darker still as we drove along the shoreline, until finally every trace of blue and purple withdrew from the sky and nothing but black remained. It was only when the highway cut even closer to the shore, running almost over the lake's edge, that you could rate this a body of water rather than a void adumbrated by hundreds of lights.

When the road swept away from the lake again, toward the interior, the buildings we could make out in the fog seemed uniformly stunted and shrunken, even when they occupied entire blocks. You imagined, for a moment, they must have been yellowed by time, even though the streetlights were responsible for that complexion. Yes, in the morning, the buildings would reveal themselves to be the familiar faded gray of sun-battered concrete. On the opposite side of the highway, however, along the lakeshore, a great variety of architectural styles bloomed, and even in the dark you knew everything here was fifty years newer.

Our driver, a generic American white who gave you little to remember him by, seemed familiar to Duke; he might have shuttled the receiver to work and back regularly, given how much farther Duke lived from the facility than the rest of the team. In deference to the great distance we needed to cover, our rate of travel soon tipped into surreality, the surrounding cars on the highway shooting past us backward as we slalomed ahead. The entire time, I had the feeling, deep in my guts, of hydroplaning, though the asphalt wasn't really wet enough for that.

Silence reigned for almost an hour. Duke had nodded off as soon as he'd gotten in the car, his head pressed against the window. Whenever I would search out our driver's hazel eyes in the mirror, I realized I existed for him only as an obstacle to his line of sight while he switched lanes or searched for highway patrol—which was probably all to the good, he was going so fast. Any small lapse in concentration and there might be nothing left of us or the car.

Really, I didn't mind the quiet, as by now I was feeling quite lightheaded, though it was hard to say why. All I could think was that I'd forgotten to bring any Theria with me. Not forgotten, exactly. I'd just assumed it wouldn't be necessary. Duke was the face of the product *and* a member of its target audience. Surely Garrett would

keep him well-supplied with the drink? Whatever the case, I had to wonder whether the churning of my guts and that sense of the fantastic that increasingly pervaded my experience—not to mention the forlornness that crept in, out of all proportion to prevailing circumstances—traced back to this privation. Could I even be *seeing* less well, too? Hadn't I very badly mistimed those footballs Duke had thrown that went plunging into my chest, leaving bruises that would last for days? And could those moribund buildings along the highway I'd been seeing actually be more variegated than that, and more vital?

Eventually, as our driver took the off-ramp, the car dropped to down to a somewhat more reasonable (not to say legal) speed. A fuller awareness returned to him, so that finally he regarded me in the mirror, if only briefly, as one might a sentient being. Now that the world was no longer blurring past us, I could see we'd arrived in an unusually barren part of town. Yet desolation scanned here as a form of luxury, the way it did in Malibu. Between grand residential edifices—broad, flat-roofed mansions; slashing obelisks; castle-like replicas of other times and places; and everything else—were vast swathes of buffering emptiness and naked shore. It wasn't long before we were pulling into one of these lake-front properties: a shiny black brick rising some dozen stories, with only one floor lighted near the base, so that the building seemed, as it ascended, to lose all light and merge completely with the night. Architecturally, the residence maintained a poker face, embodying a particularly nihilistic strain of the International Style, now *liberated*, if you wanted to use that word, from Radiant City utopianism. Which is to say, no air of reformation or rebirth could be sniffed as Duke and I got out of the town car and stepped into the wide stone plaza. In a voice just acclimating to wakefulness, the receiver explained that there was just one apartment per floor—no families, a few couples—and no shared spaces: gardens, roof decks, balconies, or bike racks. To me, it sounded expressly designed for millionaires who frowned not only on inadvertently seeing anyone down in the street—which was virtually impossible, actually, as there were no sidewalks nearby—but who chafed at any common zones whatever. There would be no cities within a city here, I mean, where the accord and harmony of the property's elements might impel tenants toward the same.

Sheila, Duke's mother, couldn't believe this is what he wanted for himself. Frankly, speaking as a sociologist, she'd said, the place disgusted her. (Duke reported this to me with a smile, of course.) Here, each loft constituted a city of its own, and as we shuttled to the twelfth floor via an elevator with freight dimensions but a silent, commercial glide, I couldn't help but think that in a place like this, even if you didn't quite view your neighbor with suspicion or hostility, you were still happiest when you didn't cross paths. And, in fact, as we'd entered the driveway, there was a woman in plain sight in pastel

blue Chanel, waiting for a hired car, I assumed, who declined even to raise her eyes as we inched past her. Around here, the only place of potential intimacy might have been the elevators, though the developer had accounted for this liability, too: there was an unusually large bank of lifts, all uselessly massive for a building of relatively small scale, further reducing the chances of having to share a ride.

Every communitarian tendency of modernism seemed to have been inverted in Duke's building, a celebration of privacy even when it could still be framed in the dead language of collectivist architecture. Driving in, less than a quarter-mile to the east, I'd noticed several original Brutalist complexes, much vaster than Duke's one; these had hundreds of tiny windows each, and were in much worse shape. Yet there was something about those apartments that signaled honest hope, even if it had been dashed by time and fortune. Duke's home, however, was obviously, painfully, built without any hope at all: if anything, it was a taunt to those earnest architectural disasters just across the way—*the projects*, still waiting to be dynamited. This shiny onyx-esque construction was no second crack at the promised land, but just for the super-premium crowd. This was utopian only if utopia involved thinning out the madding crowd, not in the way Matthew Arnold had envisaged it, dissolving the masses into families living quasi-pastorally in green suburbs, but all the way down to lone souls. Yet, I had to ask myself, did it nevertheless speak to *some* desire in us, not ones we proudly avow, of course, but ones that anyway make us tick? A desire for *peace*, which perhaps might be guaranteed only by absolute seclusion—solitary confinement, so to speak—even in the heart of a metropolis?

The interior of Duke's apartment turned out to be much like the building's exterior. His space was two or three thousand square feet and remarkably free of dividers, so it remained in a disturbingly pure state, a state untroubled by people and very close to the architect's blueprint, where all forms save for the rectangle had been annihilated or never so much as conceived. In itself, of course, this kind of gesture long ago ceased to be radical, ever since the heyday of Gropius and the Bauhaus. What was *actually* radical, though, even now, was what Duke had done with it, by placing the bed almost dead center in the room, configuring this massive penthouse as if it were a tiny city studio akin to the places he'd lived along the way.

"Twenty thousand a month," he said peremptorily as we roamed around that bed—this must have been the extent of the tour. "I think twenty. It hasn't been long." You could almost mistake the place for an unsold unit, or for the room of a wealthy ascetic, it was so underfurnished. But then you'd also have to forget what century you were in.

I had some trouble deciding where to sit, as the floor seemed my only option. So I stood. "How long have you been here?" I asked.

"A week and a half, maybe." He put his arm on my shoulder. "People want to destroy buildings like this now."

"Well, the *old* ones. I don't know what they think of brand-new ones that are *this* grand."

"What do you think?"

I shook my head vaguely. He didn't press me, there was no point.

"My agent thought it was weird. Why'd I want something so dated, right? Designed for millionaire shut-ins, Howard Hughes types—and I'm not even a millionaire. So I'm renting." He seemed about to laugh, as if something funny had just crossed his mind. Then he began to walk toward one of several glass doors facing the lake. "Freddie thought I should be closer to the team, to where we practice. No one else lives this far north. But the places he was finding for me weren't this... *committed*. A lot of them weren't near the water either, or they were meant for guys who can drop fifty, seventy-five grand a month. Not me."

Duke slid the glass to one side and turned off all the lights. Together, we stepped out onto the terrace—one of two—twelve floors up. The shore, the lake, were so devoid of light that the water revealed its presence to us only by sloshing against the sand. "I didn't want any real neighbors, though. I'm not even sure anyone actually lives in this place full-time. It's like those ghost cities you hear about in China. Perfect, empty."

The edge in the winds coming off the water soon drove us back inside. We strolled past the curiously small open kitchen, the bathroom the size of a studio apartment, and a corner where a cream drape had been thrown over various irregularly shaped things. Instead of uncovering them, Duke turned back toward the only real landmark around here, the bed. I'd never seen one this size. No one had, except in music videos. It was probably twice the size of a king, made up starkly in off-white sheets that were stiff and cheap when I rested my fingers on them. Duke had no nightstand and no need of one; the bed's periphery served. On it sat his wallet and keys and phone, even some loosely piled bills and mail, mostly junk.

There was no other bed in the apartment, you could see that at a glance. I suppose this meant the only guests who'd be staying the night would be staying with him; he could accommodate a harem within the borders of his mattress. I wandered toward the kitchen while he unbuttoned his fitted oxford and tossed it next to the mail on his bed. Why he'd needed to leave practice dressed like this, as if he'd just come from a post-game press conference, I didn't know.

"This time," he said, catching my eyes in the long mirror without turning around, "before we get fucked up, we should get something done."

"Front first?"

I wasn't feeling especially well; the nausea had clung to me. But he was right, we should work. My state could worsen, and then I might not even be able to sketch him properly, the *raison d'être* of my trip. Duke turned toward me and I pulled my giant pad from the portfolio, which wasn't much bigger than the paper itself. He turned away and I trailed him to a wall lined with small, intense spotlights meant to illuminate artwork that hadn't been mounted yet—anyone with this much money owned work, of course. Instead, the lights brightened Duke's chest, or really, the woman's visage tattooed over his heart. She had a frilly collar that put me in mind of Magellan; she looked to be some sort of noble, or else was pretending to be. This was all quite rare in a tattoo, I thought. The model for all this fine hatching etched into black flesh would have been an old engraving. If this were paper rather than living tissue, you might have opted for scratchboard instead, just for the contrast of white strokes on black ground. But tattoo ink was generally dark like Duke, so that only under the spotlights did this image, all the fineness of its details, dark on dark, truly become legible. From this range I could smell him, too, the eucalyptus he'd used to wash today's practice away. He declined to look at me as I went about the business of rendering him onto the pad, which I'd laid right on the ground. I don't think he was nervous *per se*, though he was probably more used to women admiring him in this fashion, perhaps a whole roomful of them, right before he did as he liked.

"We've got time, right?" I squatted down, assessing his abdomen.

"Enjoying yourself?" He was laughing with lovely contempt. "When we finish all this bullshit, you *know* we're going out."

This is just what Garrett would have imagined, me trailing Duke around Chicago, though the relish in Duke's voice as he said these words made me wonder what exactly he was envisioning. We looked around the apartment for something short for him to climb up on. There weren't many places to look, mainly just under the large tarp. No stool, though. What we found there instead, among piles and piles of books: three crates full of supplements, all sorts of powders and pills. A personal pharmacy.

"This is *the juice*," he sneered. "All the things in the juice." We unloaded all the bottles and lined them up against the wall. Then we flipped over the crate and set it down near the lights. Once he mounted it, you couldn't help but think of those antebellum stages on which men were set for purposes of inspection. Though I was examining him for different qualities today, his great-great-grandparents would have been similarly scrutinized, for fitness for the fields. I should have checked his teeth, too. He showed me his gums all on his own.

The joke was, of course, that the NFL had long had its own version of the slave auction—the combine—in which half-clothed twenty-year-olds, mostly black,

flaunted their bodies for the procurers, the scouts. Hadn't Duke done *well* at the combine? That's why he'd been able to sneak into the NFL despite the cloud that hung over him. I wondered how he took it.

I'd not drawn a shirtless man in some time, not since my first days in New York, when I'd spent my time in life-drawing classes around the boroughs, particularly the Arts Student League, which was nice in most respects, except for Norman Rockwell's time there being mentioned by someone or other at least once a session. In the end it drove me to abandon the place. Rockwell put me off life drawing; that's the story in a nutshell. The body unadorned rarely appeared in my work again. Instead, it was the intermingling of nature and culture, necessity and choice, that occupied me.

Looking up at Duke now while standing with my toes brushing the crate, an unusually tall one for housing all his supplements in two rows, I found myself, my face, closer to his groin than I might have wished. He smiled down at me radiantly, teasing me with the prospect of a thrust that would take his still-clothed crotch right into my chin. But I was in thrall to the woman on his chest, shining in the light. Only the musk of his testes, cutting through the soap, alerted me to the precarious relationship of our bodies. My angle on the woman was perfect, though. I held my ground.

"Want me to tell you who? Or you want to guess. You're going to guess."

"I'll guess."

"It won't happen."

"Let's see."

I took a step back and bent down over the pad, which was now resting on the other two crates to facilitate my work. I was drawing *and* talking, something I used to eschew, finding it unthinkable, a kind of sacrilege. The very idea of a subject's being *put at ease* struck me as vulgar, no matter how illustrious the artists who'd done it. I could only think of hairdressers and fashion photographers and prostitutes whenever the phrase came up. I'd begun more recently to introduce talk into my sessions purely as a creative act. Far from relaxing anyone or instilling confidence, I could jolt my sitter's psyche, apply pressure to his identity, test its strength from this angle and that, feeling for fissures. A cat-and-mouse game took shape, showing itself through changes undergone by the sitter's body, the exact contours of his posture as he twisted around or through this rhetorical force. Once in a while—and that's all you could reasonably expect, *once in a while*—the results were startling, all from the fear I'd pumped into him.

"Margaret of Anjou," I declared, having made him wait a long while, though the name had come to me quickly.

"Not too bad. Marguerite de Navarre. Know her?"

"Not really, no. Not by sight. But what an odd idea for a tattoo." I regarded him somewhat cruelly.

"And the other woman wouldn't have been? Why'd you guess her? Why that name?"

"It came to me."

"Just intuition."

I smiled tightly and carried on transposing her, Navarre, to paper, nearly to scale: the jewels at her neck, rubies and diamonds in alternation; the frilly, billowing dress she wore; and the minuscule book, presumably a book of hours, I discovered in her hands, after leaning very close. In doing all of this I had also to account for the uneven ground of his chest, its rhythmic swells. Everything needed to go over.

"My mother had me read her. *Made* me. My brothers, too. To see what a woman could do way back when even. Only one who got away was my sister. She didn't need a lesson."

Lower on his body, the pictures were easier to recognize. The one on his stomach, for instance, I'd seen at the Louvre, on a visit several years back, the same sojourn that took me to Iceland. I recalled how excruciating I'd found this grand museum, Napoleon's museum—the first of its kind in the world, in fact—with so much art thrust into such proximity that each piece ended up seeming small and insufficient. This was, in fact, a problem for every kind of vast collection: streaming services holding decades of songs and films, say, or metropolises packing countless bodies together. Yet I suppose the Louvre and its ilk did represent a certain achieved omnipotence on the part of mankind, the world brought to one's fingertips, not merely at the level of the individual collector, as with the cabinet of curiosities, or the family, as with a royal court's collection, but on a grander scale: a collection to be browsed by an entire country, a people, at their leisure. There was something repellant to me still, but the concept had more substance to it than I'd wanted to admit, articulating as it did the full bloom of a form of life—modern life. There was something profound in that, even if I felt at some distance from it. *I* had to bear some of that responsibility. In the end, there needn't be anything wrong with a broader culture carrying on in parallel with its dissidents.

The name of this painting, though, the one on his stomach—what was it? The piece was definitely a Brueghel, but the figures had been radically reimagined by the tattoo artist. Africanized, you could say. I should have known it straight off, but my thoughts wouldn't settle, jumping from here to there. Things were getting lost.

"Well?" The same quiz from Duke. On another night I may have been game, but now, with my head throbbing, I wasn't in the frame of mind for it.

"This is based on *The Beggars*, right?"

"No one has ever, *ever* got that right. *The Cripples* is what you mean, though."

He was impressed. Maybe that would keep him quiet for a while as I pressed on, interpreting his body, which was taxing me more heavily than any of my recent work. The floodlights were hot and the situation atypical, and so I found myself drenched in sweat, with a parched throat. Meanwhile, Duke looked beatific, standing there. The appearance of nerves in me, or what would have resembled nerves anyway, probably brought it on, I thought. More and more, these past days, I'd found myself turning to Theria, even when I had nothing much to do and I wasn't busy assessing it or anything else. It was joining the bedrock of my life. I wouldn't call my relationship to it an addiction *per se*. It had only been a few weeks since I'd first tasted it, and perhaps the most notable withdrawal symptom so far, after six or eight hours, seemed to be the subtle sense that experience, vision and thought, had lost their natural density. Theria instilled a certain curiosity in you, by now I knew this was no illusion. It created rather than slaked thirst, making the world cry out for devouring, parsing—although unlike marijuana or LSD, it left your brain in a state capable of doing the job.

If it turned out, when the FDA got hold of the final formulation—it was still being tinkered with, as was almost anything in Garrett's purview; every product was perpetually in flux, and each case of the energy or smart drink he sent me struck me as subtly different in color and taste—if Theria happened to have some significant side-effects, it could end up in the category of a drug like Adderall: useful but dangerous. But if it cleared that hurdle, if it was as harmless as water, or close to it, there was nothing to prevent its becoming part of day-to-day Western life in much the manner of coffee, the great constructive drug of the modern period, one that doctors positively applauded for its salutary effects. Might Garrett have synthesized something like caffeine, but more potent, and more richly tied to the imaginative powers? Surely this was his hope.

Almost all the imagery Duke wore on his body had art historical resonances, distant symbolisms. Many pictures had been interestingly simplified or abstracted. These weren't the gods, the mothers, the children most athletes bore. Yet he was so thickly covered with tattoos, and his skin so aggressively black, that they were, even with the aid of spotlights, difficult to pick out.

"Can you?" I gestured at his belly and his jeans with a graphite stick, while my head was buried down in the details of the drawing beneath me.

He did nothing.

Finally I looked at him, as he'd wanted me to. I was only asking for the jeans to come off. I would have had to, at some point, if I was to be his artist, his visual biographer, no less than his doctor would eventually have to see him in ways others

didn't. The only reason I hadn't asked the same of Daphne was the presence of other awkwardnesses between us that afternoon, the drinking that altered the equation.

He pulled his face in lasciviously. Why such contraction ought to signal just that, physiognomically, I'm not sure, but it did. The jut of his lips told the story, too, a beckoning for a kiss. I quickly dabbed that in on the corner of the next sheet. I wanted that lip, somewhere, sometime. I was harvesting details, not building complete images. Real composition would come later. But the details, they're just what couldn't wait.

He glared at me salaciously, and for a long time. His lust could have been phony, meant only to strike one more variety of fear into me. Terrorizing people had caused him all sorts of trouble so far in his life; nothing could be put beyond him on this score. I also had to consider the possibility that he was, in fact, *interested*—that he was as reckless in his sex life as he was on the field, turning to homosexuality not out of *bona fide* desire, but for the still-active sense of deviancy in it, especially among male athletes. I'd found, in my research into his past, that the orgies were wild in many ways; that there had been men in the mix, at least in college. It wasn't clear whether he'd been with them, too, or if this was just the garden-variety homoeroticism that all team sports shared in.

He seemed to cultivate confusion on this point, as on so many others. It had made enemies of certain of his teammates, apparently, his unwillingness to come down strongly as hetero. So now, as our exchange developed, I watched him watch me, wishing I could see my part in it, see what exactly my eyes held out for him that remained a mystery to me, simply because the eye cannot properly see itself, not without mirrors and tricks.

Duke bent in two and tugged his jeans down in a quick motion and straightened up again, all without looking at me. Now we were down to underwear, his genitalia stretching a pair of oxblood briefs to the limit. His thighs were lighter-toned than the rest of him. I tried focusing on this, the imagery that jumped out, by virtue of its location, more starkly than on his torso. It was also more personal, as befit the region, the nearness to his sex. Two countenances dominated his upper legs, curving with his thighs and hamstrings. You had to examine these pictures *around* their cylindrical support, not so different than vellum, only still cleaving to the animal. So I slowly circled him, tracking the faces and expressions of his lower half. The left visage faced backward, the right forward, and neither of them did I recognize. The one looking forward was a grizzled man, old and poor and white, to judge by his matted hair, though without any religious inflection. He was no Jesus: there was, after all, nothing particularly elevated about staring at Duke's testes, as this man was.

Duke nearly laughed, between glints of lust. He was enjoying me studying him as a paleographer might, bringing my face close, of necessity. He'd been examined many times before, one felt, by countless women and some number of men, whether lovers or simply colleagues. He spent a good deal of his life in a place where nudity was prosaic: the locker room. The water boy would have been drawing conclusions about him from the tattoos, just as I was. Duke turned his head around to watch me interpret his buttocks—or rather, *fail* to interpret them, as they were still mostly covered in red fabric. I had the strong feeling, soon confirmed, that they would be immaculate, unmarked. Why exactly, I never figured out.

The second man, on Duke's other thigh, faced backward, just below his ass: the headdress made him a Roman warrior, perhaps a statesman, too, a frequent blend. Strong-nosed and strong-chinned, this man bore none of the infirmity of his counterpart. He was majestically composed, with a feathery touch and delicate modulation of color and line that were readily apparent. Yet the net effect of this picture was no less Rabelaisian than the other: the warrior's head leaned back, so that he was staring upward on a sightline that, I was guessing, intersected Duke's asshole.

Finally I arrived at Duke's feet, lighter in tone than all else I'd seen of him. He'd done something peculiar with them, cramming landscape scenes sideways onto their tops, even though the dimensions of human feet naturally would suit them to portraiture, supposing you intended them to be legible to someone standing directly in front of you, or else yourself, and not someone off to your side. He'd not used just any landscapes. His left foot, I was sure of it, was a Pissarro I'd once been attached to, though I didn't ask him to confirm, and thankfully he didn't test me this time. Perhaps he was taking the lightness of his skin here as an opportunity to deal in nuances lost on the rest of his body. I bent down very low to see just what I was seeing, which immediately sharpened the queasiness I'd been feeling for a while now. Sweat fell from my brow onto his foot. He might have kicked me in the face if he'd been inclined, and he did actually lift his foot quite near my face, my lips in particular. I declined the offering and kept turning the pages of the massive pad, mapping his body like a surveyor, and not just the tattooed parts.

I got back up, unsteady on my feet, and met his gaze, which would have stayed with me the entire time I spent reading his lower half. Then, without warning, he put his thumbs under the waistband of his briefs, hoping to up the stakes. I greeted his lust, feigned or not, with a matter-of-factness that infuriated him, as I was preoccupied at the time with my own sickness. What else was left to him? He pulled the briefs off and tossed them at my feet.

"So... who did all these?" I asked, giving his cock a forensic squint. For altogether different reasons, I assume, I felt like I could vomit.

"The same guy does them all," he said, cupping his balls, massaging them almost. He was going to enjoy himself. "A guy in Alphabet City. He doesn't really own a studio anymore, just works out of his apartment."

"He's good."

"But he has to be, doesn't he? If he's going to use me like canvas. You can just throw that in the garbage," Duke said, pointing to my pad. "The stakes are different—unless you think you can throw *me* in the trash." He winked and bared his teeth, but then, this was also a kind of grin, and I liked to think he meant it both ways.

"I guess you think your drawings are *historical*, though," he resumed. "Not like a tattoo."

I kept studying his cock, which seemed to me only half-flaccid, for any trace of ink. All the while my face ran with sweat and my hands trembled. The organ seemed to be plumping right before me, now that it had been set free and no longer had to be imagined. My eyes, I thought, might even be doing the job, a version of the observer effect. Yet now that his penis was out, it was fair game. For a small moment, its growth struck me as a kind of threat. But that feeling was soon tamed by my years of life drawing. The atelier had been my locker room, even if those models never looked at you quite the way Duke looked at me, or used their nudity to put you in mind of slavery or sodomy. But I couldn't easily be put off the job, even when it came to cocks and balls presented with a little roll of the hips, which happened more than once.

Duke's face wasn't especially attractive, that much was true. And maybe he was too stocky to be beautiful in body either. But he certainly possessed force. His genitalia, it turned out, were entirely uninked. I drew dismembered versions of his cock and balls, floating in the void, and without a trace of flattery, of which there was no need.

We took a breather after I finished his scrotum. I was surprised he'd not pushed for a break sooner, but this might have been a matter of pride. I ended up having to ask for it, as my hand was shaking uncontrollably, and aching, too. I'd gone through I don't know how many sheets, a quilt that together would account for his body, and my mind was a mess.

We didn't talk much then, and he refused to clothe himself, though he did return to his bed, to read his mail, actually, and then to shut his eyes for a moment and rest his body. Modeling was an exertion even a professional athlete might not have been prepared for. No one could believe that standing still could be so exhausting. I spent my time on the balcony going through three Stellas to settle me down, thinking I might vomit over the edge at any minute, right into a Great Lake. *Outside* turned out to be the only place you could find any privacy in Duke's apartment, never mind how large it was.

Soon it was time to do his back—the great fresco I'd glimpsed earlier. Little by little, under the lights, I made out the smaller scenes from which a kind of master image had been woven, and eventually, with some pleasure, recognized them to form a collection of Redons.

"The Noirs," he said softly.

"Another of your mom's favorites."

"She hates the shit. Hates tattoos—obviously. But French painting? She likes Corot, Courbet, the realists."

Frankly Duke's mother sounded quite discerning: Redon and the Symbolists were a regression from Manet and Degas. That was my view. They were too quick to turn mystical where there might be a more telling lucidity. Sadly, history hadn't yet figured this out.

Ever since my own life had begun to seem starved in various ways, I'd been thinking about certain reductions of technique and media. More than once, perusing my collection of prints, Redon had crossed my mind and my eye, for the way he'd managed to unshackle himself from the psychedelic fantasia of *Butterflies* and take his palette down to a monochrome—fifty years before Reinhardt and Ryman—and his media down to chalk and charcoal. It wouldn't have been easy, embracing such poverty of means. I knew this for myself.

The tattoo man had taken those noirs, the floating heads and eyeball-balloons and bearded wild men looking like nothing besides death, and simplified the forms internally. But he *added* complexity, too, by situating them within a single space, Duke's back. The only artist missing from his body, I thought, was Goya. There was still room, though: his buttocks, the backs of one thigh. In time, then, the gap might be filled, the link between Brueghel and Redon restored.

"I should meet this guy," I said.

"Oh, he'd never. Ronnie doesn't see anyone but me now—and the people he deals to."

"I could pick up, sure."

"Just let me know, then."

"Ronnie's your personal tattoo artist."

"I'm his work of art."

Duke, now that he was mostly over his theatrics, became a fine model. His tolerance for pain served him well in freezing himself solid for me, and my hand was steadier now with the alcohol masking whatever it was that was wrong with me. We ran straight past midnight, with ten-minute breaks in which we'd go out on the terrace and I would smoke, which I'd been doing more of since starting on Theria. Finally I was feeling more together, which meant there was some irony, toward the end, when during one break Duke came outside with a bottle of Theria, the thing

for which I'd not even thought to ask him. Karen had been keeping him supplied, apparently, though he was running low himself: this was his last bottle.

We resumed our session and began to talk less guardedly. If he'd had interest in me sexually, if any of that was real, it now seemed somewhat faded, which of course left me hoping it had been phony all along.

"Does that really help you on the field?" I asked, pointing to the bottle.

"Did you *see* me out there with Brooks? The visor didn't hurt either."

"What does it do, you think?"

"What about you?"

"I guess there's the clarity."

"A lot of things do that, though. Ronnie can set you up with everything you need for *that*."

I knew, of course, my answer was unsatisfactory. But I didn't want to start dwelling on Theria, now that I was testing my capacity to go without it. I was more keen on drawing Duke's calves at this point, or transcribing them; they were the only linguistic portions of this all-over tattoo Ronnie had turned him into. Mostly I thought these had the sound of gang handles—Keleyo; Bood-ink; The Chimp—perhaps all the suicide-by-cops he knew. Unlikely, maybe, but it felt telling all the same. I was only summoning our common dream life through him, our archetypes, not to parody or critique them, nor even to represent them precisely, pinning them to the dissection board. Rather, I was massaging their allure, their glamor even, into recognizable forms that might suggest an outside, without suggesting that the outside was where we ought to make our escape, that it was in any way more habitable; that there were other dreamscapes we might inhabit, other fantasies we might swap them out for, in particular, that there were more neutral or universal ways of imagining people and things—wasn't this the perennial desire of every rationalist, in which post-Enlightenment was just a phase of the Enlightenment, as post-modernism was of modernism?

To what *point*, though? To whom did we owe this search for neutrality? The longer I worked with Antral, the less interest I had in any sort of *dis*interest. More and more, Garrett and I both suspected that, deep in our hearts, most of us didn't either, even when we knew in some way that impartiality might be more *pleasant*, more *fair*, for some people, that a greater number of their choices might be realized through it. Was fairness the prime good toward which all other aims must be bent? Was the fairest world the worthiest? Did getting what you want *ipso facto* better your life? Were our desires and our wills at all the best guides to our wellbeing? Surely it was the *limits* on our desires, our agency, that created interest, value. It was why, for instance, the art produced in stable democratic regimes often seemed sterile and pointless: the artists didn't meet with enough resistance to generate any heat. They were *too* free.

Ultimately, it seemed to me that the exact depth of our interest in justice, as well as the value of happiness itself, was thrown into doubt by so much of how we comported ourselves. The world was as unjust and unhappy as it was precisely because we *didn't* think such values trumped all else. No, they were just a couple of the many competing aims that guided a meaningful life. I wanted to share with Duke the thoughts to which I'd been led by drawing his person, but I didn't. My mind might have been scrambled by withdrawal. Yet this was what made *looking* so agreeable to me, its relationship to thinking, the way it could help you *transcend* the realm of sight, but honestly.

"Did you see me read that play out on the field? Take my boy Brooks apart? He's a vet, but I was seeing more than he was."

"You must have always had an instinct for that, though."

He twisted his head around and regarded me sharply. "How would *you* know? You're not sounding like a believer in the *products*, man. How are we going to sell them with you acting like this?" He untwisted and continued: "What really surprised me out there, though, especially on that last catch, before the tip-ball work, was how I was just able to *know* where that ball was heading. I was so sure, I had time to fuck with Brooks. A six-inch window, that's what I saw, and I could sense just how much he was off-line. I'm good—really good—but that was something else, something new. It could have just been the drink, but the visor might have taken me over the top. I don't know yet. But these things the Cal man gets me, they just *help*."

"I thought Brooks was going to get to you with his cleats, afterward."

"Well, Arête can't do anything about *that*. But Brooks isn't a fool. He knows I don't just play here—I'm *from* Chicago." His tone brightened: "You know, tonight, we're going to meet some of the people Brooks would have ended up meeting if anything happened out there. I still shouldn't have shown him up, though. I wasn't trying to, actually. I was just sort of shocked by what I could do."

"Superhero stuff."

"Testing my powers. X-Men shit. I really don't know *what's* in this drink. How it can be legal. You?"

He might have been probing my relationship with Garrett here, seeing how much more I knew than he did. The truth was, if his ignorance was to be believed, not much more.

"I'm going to go by his lab again," I said.

"I almost don't want to know. And I don't want anyone I play against using it either."

"I bet it'll turn out placebo. It always does."

"Isn't it helping *you*? I mean, there's nothing real clear about all this." He turned around and pointed at one of my sketches of his nose that I'd torn out. I'd made it

deeply Negroid, more so than his actually was. But there was also a tiny bit of almost Edwardian sharpness to its end. "It seems to be doing something to you—not that I can say what."

"I haven't been drinking it today."

"Do you wear the lenses ever?"

"Not really, not yet."

"So this is just how you are? A lot of people might see this sketch as, I don't know, *off*. How about that?"

I reached to take the sheet back but he hopped down from the crate and caught my hand, which appeared like a baby's next to his.

"In a sort of inspired way, though," he said, marveling at the nose while feeling his own. "Do you want any now?" He pointed to the sealike substance sitting in the bottle, on the floor next to the crate he'd stood on. I was tempted. He could see that. "It's not easy without the stuff, is it?" He picked up the bottle and sipped. "Really, I try everything Arête sends down the pike. All of Fred's clients do. We're working out the details with the lenses, finding what would suit me best. But right now I think you need to have some more of the *blue drank*." He insisted, and we were mostly done now, and I was definitely tiring. Why not? I would have gone for something as quaint as Red Bull at this point. Theria, though, you didn't have to gulp it down. You wanted to savor it, however chemical its origins may turn out to be; its ethereal, algae-like tone was almost as entrancing as the beverage itself.

Duke got a glass and poured nearly half the bottle. "This is some of my last shit I'm giving you, you realize that? Because it's no fun being out of it, I know. Freddie's saying I should have more by tomorrow. But I'm a man of mercy. I can see you're in need. So I'm splitting it with you."

I finished up the session with Theria's aid, although exhaustion itself offered a certain sort of clarity: who could say what was responsible for what? I think the drink steadied me, though. My time was mostly spent on those impressionist landscapes on the tops of his feet. When I'd finished with Duke, he quickly pulled on sweats and disappeared downstairs without explanation. Strange to say, but I hardly noticed; I went on till two in the morning, riffing off everything in the pad, and everything I felt then. Time accelerated but I lost no control. I felt entirely *within* the drawings lacing his body, the gallery that was his person. In the midst of the work, it was as if I were drawing him into life, though all I possessed were fragments. Yet these were no less real to me than Duke was. Once I'd inscribed the last sheet of the sketchbook—that's the only reason I stopped, the paper was gone—I paged slowly through it and, it seemed to me, apprehended the whole of Duke in these pieces, so that I didn't miss the absent man at all.

36

We were both wired, well after midnight. Half a bottle could do *that?*

"I told you, right, we'd be going out whenever." Duke had come back from a late-night errand he never divulged and lay on the bed, awake but with his eyes closed. I was sprawled on the floor with my pad, still tinkering.

"You couldn't have meant this late."

"Why would you think you ever know what I mean?" He stood above me. "And maybe I didn't, but whatever, we're going. It's a home-game weekend—you have to enjoy those. Your boss would want you to come along, anyway. This is a business trip, right? Then let's do some business. I *did* split that shit with you."

He wasn't wrong. I owed him something for sharing his supplies with me, given how desolate I'd felt before the intervention. So, somewhat reluctantly, I traveled south a long way with Duke—too long, I realized halfway through—down the I-41, on the lake's edge. The compromise we'd struck was that I'd bring along my things, so I didn't have to come back to his place afterward: I could go straight to my hotel, which was closer to the airport, and therefore to my home. When we reached the vicinity of Soldier Field, I had some hope that *this* might be our destination, yet our driver never slowed at the exits. I looked over at Duke, still in the headphones he'd put on in the elevator of his apartment. It didn't seem like he wanted to be disturbed. We needed some time apart, I suppose; so the drive was as quiet as the last one.

Descending ever further down the lakeshore, I began to grow agitated, not knowing what this trip was really about, until it occurred to me, quite suddenly, just where we must be going: Duke's South Side stomping grounds, the place that had eaten his teen years. My agitation dissolved into dread as our journey began to resemble my northbound trip from the Upper East Side through to Mott Haven and the Patterson Houses, only much starker. I knew Chicago to be, at this point, an order of magnitude unrulier than New York; despair had fermented into bitterness, which I'd already noticed hung very thickly here, more so than anywhere else I'd been. Its worst neighborhoods were just more dire than ours, and once we'd traded the 41 for the surface streets, the difference became palpable: in the casualness, for instance, with which young men in dirty pants and excellent shoes had their heads tucked into the windows of old American cars—Pontiacs and Buicks more than Cadillacs—arms clasping the frame of the door, scoring without a thought of concealment; and in the melancholic charm of emaciated single mothers in tank tops and tights, prancing

through empty blocks, holding hands with their children or girlfriends, entirely un-afraid when fear was the only thing called for. The Bronx, even at three a.m., wasn't quite *this* ghoulish. The degree of our driver's discomfiture was another novelty. More than once, he pulled away through solid red lights to avoid bands of young men cloaked in solid colors taking a terrific interest in our uninteresting sedan. The driver continually wiped his brow, presumably rethinking the value of taking on this ride, though Duke managed to coax him along with a flash of rubber-banded bills.

More than anything, the slums' architecture set this place off from New York. The chunky buildings seemed to me only three-quarters there, as if partly evaporated, having never being tended to since the ribbon was cut at some municipal ceremony praising this latest venture in affordable housing. However long these apartments might have stood there, they seemed only a good strong Chicago gust away from coming down.

Duke *had* told me his roots were dirty, but I'd suspected he was selling me something, mythmaking to legitimate his drift into waywardness, as so many of the disenchanted and poor do in the company of those they perceive as "haves." Now, it seemed, if anything, he might have underplayed it.

"Where exactly are we going?" I asked while shaking Duke's shoulder, beyond the point at which there could be any doubt our destination was a long-lost hell only his kind could be nostalgic for.

He slid his headphones off his ears and around his neck. I don't know whether he'd heard me, but he seemed to understand well enough. "I was wondering when you'd flinch. I'll give you some credit, though, coming this far without bitching out."

"Your parents' place?"

He clapped his hands and looked out his window. "You won't find them around here anymore. They're on the north side."

"Up where you are?"

"I'm a lot further up. I really don't know how things would go with them if I were any closer. They're more central."

"So who exactly are we meeting?"

He turned back and smiled and reached into his coat pocket.

"Seriously."

"The Cal man—you think he's going to be satisfied if we don't get down to *this*? He's hoping Arête will be a little different, right? Dangerous?"

He opened the case and put his sunglasses on, Oliver Peoples with pure black lenses. He dropped his window—also tinted—and stuck his arm down the side of the door as wind came through the car. I wondered what he could possibly see with lenses so dark.

"These are my oldest, oldest friends," he said once we were slowing down near buildings genuinely teetering on the edge of non-existence, they looked so frail. In many countries, you'd call this place what it was: a shanty town. "It wasn't *this* bad then. That's not how I think of it, anyway. They're almost not friends anymore, that's how old. We lost track when I moved. We all had our crises—there's no friends in the middle of that. But being back now, being with the Bears, it's been good to get these ones back. I don't really know how many friends I'm going to make on the team." Duke nodded, as if reconsidering his own words and coming again to the same conclusion, which set off a slow, controlled, almost meditative chuckle in him.

"Are they different? From then?"

"The ones I'm taking you to? No. There are others who are lawyers, you know. Pediatricians, math teachers, all of that. But not these guys. And because they're older now, they're a lot further along. Not different, I wouldn't say—just a little *harder* than when I was with them, living here, shoplifting, stealing cigars for blunts, selling weed. That's bitch shit to them now. Which is a shame. It's a lot of fun, selling weed, stealing worthless things. Being a bitch, I guess."

Grubby walk-ups, small bunches of them like weeds, interrupted looming tenements that appeared ashen in the chilly beams of our headlights, which provided the only reliable illumination on these flickering streets. The same beams would abruptly land on a face in the black, right in the middle of the road, forcing our driver to veer dangerously to one side, or break hard enough to send my head into his seatback, until some kid wearing an open button-down draping to his knees, with his face stubbled here and there, he was so young, could amble across the way. These boys and men had no appreciable reaction to our lights, they just kept trudging along, their pace unchanged, if they weren't simply frozen in place, who knows for how long, in a narcotic haze. We turned several corners, entered a maze of buildings bearing the stamp of collective design, buildings that had yet to be *un*built, which costs money, too. The inner lanes of this housing complex were fenced in by the apartment towers themselves, so you might have thought they would offer some sense of security; in fact they were only more menacing for being isolated from the street. Our driver, who in New York I would have presumed to be Puerto Rican, though here I was unsure, as I didn't know if they'd colonized Chicago, too—the mestizo driver was cursing every time he came across so much as the shadow of a human form, for the possibility of trouble it brought. He decelerated in the orange glow encircling the entrance stairs of one of what seemed like dozens of near-identical block towers, and with a whip of his head encouraged us to get out, though he'd not even quite stopped. Duke urged him onward anyway: we weren't quite there yet, it had to be just up ahead.

When we finally parked across from the door, which we'd missed in the dark and had to reverse the car to reach, Duke bestowed on the driver the heavy tip he couldn't have deserved more. Without dawdling a moment—and not because of the cold—Duke and I went straight for the half-dozen steps leading into the tower. Just before we passed through the entryway, I noticed the building's blackened face: soot-covered red brick, as if the place had been swept by fire, or else the years themselves had been their own kind of conflagration. We had seven floors to climb; the elevator was jammed with an ornately upholstered chair stained by condiments or bodily fluids, I couldn't tell which. The doors of the lift were propped wide open, the elevator car was screaming (we covered our ears), and no one was coming. Duke took my stuff right out of my hands, as if it would be too much for me to carry. Quickly I lost ground on him—he was probably right. These were long, steep flights, and the challenge seemed to goose him. Steps had been a training ground for him for many years, so many different staircases, depending on where he was, running sprints, up and down. Even more than that, this new proximity to old friends, to the neighborhood itself and this shabby building that smelled of rotting plums, pulled on him harder and harder, the closer he got to the top; he was taking two or three steps at a time by the time I'd made the third flight, springing himself upward into the sky, never mind the baggage of mine he carried.

I didn't bother accelerating. I wasn't going to catch Duke, and anyway I felt a wobble growing in my legs. A few gulps of Theria wasn't going to cover that up. In any case, I didn't really *want* to catch him. I listened for his footsteps, hoping he would clear away any trouble ahead in the stairwell, as though he were my security detail. On approaching each landing, I braced for conflict of any and all kinds. When I clamored up to the fourth floor, I think I heard Duke make his first taps on a door. By the sixth floor I heard men roughly hugging, the thump of quick comings-together, the firm clasp of arms, and all of it slightly muted, in deference to the hour.

I heard no words pass between any of them. Was Duke whispering about my presence now? He might not even have told them he'd be bringing me along, not until this moment.

I stopped mid-flight and considered reversing course. All my exertions in the stairwell so far might be rewarded only with decisive violence. After a moment, I continued my trek upward, though much more gingerly. Maybe, I reasoned, they would have an easier time coming to grips with my arrival if I retarded the speed at which it occurred. That would also leave Duke time to negotiate my entrance, and for his friends to rearrange whatever they might need to before I saw it in the apartment. Finally, I emerged out of the stairwell and into the corridor of the seventh floor, breathing aggressively, slowly examining the walls—stalling. The hallways were canary

yellow, impressively bright under the industrial light fixture running the length of the corridor, so bright they seemed to steer your eyes away from direct confrontation with them. But I was motivated. Squinting mildly, I found what I'd thought I would on them: irretrievable filth, the same brown film that covers laminated diner menus. By the same process, the apartment doors had gone from white to cream. Along the edges of the hall lay the crushed bodies of insects, likely representing several distinct infestations. The final door I came across, just before turning down the central hall, wore what looked like French's mustard, long zigzags of it, and beneath the door, right on the tile, a clear pinkish fluid had trickled out. I didn't bother hypothesizing. There'd be no way of puzzling out the mysteries contained in these projects; here, the most unlikely things were simply the norm. Nothing could be ruled out.

I walked quietly up to the corner and paused when I heard faint clicking and scratching, and the sounds of furniture sliding, too—but still no talking. I poked my head into the hall and found the doorway on the end wide open, yet the threshold absolutely black, owing to the deep shadows made by the harsh lighting. The noises carried on, but hearing no voices, I crept slowly and silently forward until the threshold was just in front of me, hoping the sounds would settle. Duke and his friends could have as much time as they liked, really, if it was going to save me some distress tonight. The shuffling tailed off. I was sweating torrentially again, just as hard as when I'd come face-to-crotch with Duke hours ago. I considered saying something before entering, just so I wasn't seen to be trespassing. I wasn't sure, however, if alerting the neighbors to my presence would be taken as more of an affront than my entering unannounced. There were rules to this sort of public space that I, in my townhouse, had little need of knowing or abiding. With great uncertainty, then, I penetrated the black.

Even deep within, I could see the apartment remained intensely dark, save for the paper-thin sheets of light creeping in through the closed blinds. Another sliver of yellow jutted out of the bottom of a door on my right, though I left it alone (knocking seemed unwise). I felt my way around the edge of what must have been the living room, being careful not to kick anything over. The smell here was different, the plums of the hall replaced by rubbing alcohol and menthol.

I found a sofa by thudding straight into it and falling forward onto the cushions. As if in response, I heard a door squeak from the far side of the apartment. I froze there with my knees up on the couch, holding fast to an arm of the chair so as not to spill backward onto the floor. There was a shuffling again, and this time muted footsteps—the sound of bare feet. Seconds later the refrigerator door swung open, revealing, in silhouette, a boy with a lean build: narrow limbs, and big rounded bumps for shoulders. He reached for something in back of the fridge,

and as he crossed into the light, I found him shirtless and in white boxers. He must have been in his late teens, and his body was a chalky sort of black marked by the white islands of vitiligo.

Now I was terribly grateful for the dark that had sent me crashing. I steadied myself on the couch as the boy straightened up and brought out his hand with an RC cola in it. I'd not seen that chintzy blue-and-red logotype in years, thought the drink long dead, but this skinny black boy, I could imagine him in Lagos with an assault rifle over his shoulder, was proving me wrong about the fate of a third-rate soda. Again he reached into the fridge and this time emerged with a bunch of green grapes. He lifted it with his free hand and opened his mouth wide, the lips retracting over his teeth. Lowering the bunch by its stem, he worked his jaws on the bulbs of fruit, pulping them so lustily I could hear the juice splattering the insides of his face. He looked around slowly as he ate, right into the dark—right at me, at one point, though it seemed he couldn't see me. He lingered a moment before nudging the fridge closed with his back. All light was lost, and all I could sense was his shuffling gait taking him back from where he'd come. I looked for any trickle of light in that direction but heard only the crack of a can being opened. He would polish off those grapes in the same dark enveloping me, with the soda fizzing in his hand.

I turned around on the couch and tried to settle myself properly when a vertical streak of light appeared across from me, opposite to where the boy disappeared. The closed door I'd noticed on entering was opened just wide enough for someone's eye to fit in the gap—and someone's eye *was* in the gap, scanning the area but failing to detect me while I sat stone still in the dark. The slice of light gradually widened into a wedge, and there was Duke, sliding out of the room. Without making a sound, I put myself into the far end of this same wedge, which fell upon a portion of the couch, and after a single moment of alarm—Duke's body seemed to seize up—he smiled softly and beckoned me with one hand while holding two fingers vertically across his lips with the other. I tiptoed to him, but before I could reach him, he slipped back inside the room. For a moment, I thought hard about my prospects. And then I followed him inside.

The light was less yellow than pink or rust, which cut the coldness of the men gathered just inside. I stiffened, naturally, as they studied me from various perches: the couch, on which two sat; the end tables (two); and the identical dining chairs pulled up nearby (three). I found my portfolio and duffel inside, near the dark curtains that were everywhere sealed in a way that seemed permanent. I didn't imagine daylight changed anything here, anyway. Although the room was large enough, these men were larger still, so that they gave the impression of being crowded into the room, a bit like sullen refugees, I thought, awaiting the phone call of the trucker who,

for a steep fee, would shuttle them away to some land where they might not have to wear such scowls, not always. The gaze they jointly trained on me left me in little doubt *I* was not this man.

With a decisive click Duke shut the door behind me, a cold dented metal door that appeared retrofitted, the original probably having been kicked in one too many times. One of the men was quick to his feet: short but thick, with a modest Afro, his big basketballer's hands reached out at me like a zombie's. This was Anthony, Duke said, and the one next to him, Marcus.

Anthony stepped in too close to me to have sterling intentions. "You the guy looking for some nigger shit then."

"This little nigger can draw the fuck he wants," Marcus said, "but he *not* getting a phone out." Marcus looked more of a football player than Duke did. He took up two spots on the three-seater sofa, so that he didn't need to rise for me to see his magnitude, the way his legs jutted forth on an upward slant as though he were seated on toy furniture. He talked at a quick clip, with garbled grammar, and dressed not merely poorly, like the rest, but badly: jeans stained by food-desert slop at the thighs, paired with a printed white tee so oversized it reminded me of a poncho. These were standard-issue shrouds, it seemed—I'd just seen them outside in the streets. You saw them in *National Geographic*, too, in those documentaries from Lesotho or Gabon, where everything the Red Cross left the natives turned up, all our faddish eyesores (Hammer pants) and ephemeral sports apparel (*Buffalo Bills: 1993 AFC Champions*) that could no longer be unloaded, even at half-off.

"Duke ain't bringing no one around who don't know they business," Anthony replied, almost in my defense. I would have been touched had it not been for the murderous stare he was giving me, which in fairness might have been the only look in his repertoire, a sort of all-purpose tool.

"Well, this ain't no nigger *I* know. That the only kind that should be coming in here. You telling me—really, you telling me, Anthony—you ever talked to a bitch like this, looking like he do?" Marcus waved his hand at me as if I were an animal incapable of grasping any of this. Which was almost true, they spoke with such heavy inflection, the syllables were barely formed. On its own terms, I'd always found black dialect quite elegant. So many shorthands were built into it; it was only a half-step beyond pidgin English. Formalities, things in their proper place, were anathema. Practice was all. There was something in it even for someone like me, far removed from where this idiom had been birthed, out on the fields, under a sweltering Southern sun. This was the way of language, of signs generally, roaming far from their homes, taking on unfathomable baggage or losing it all in the process. Things survived by being true to nothing, especially themselves.

This hulking, should-have-been football player, Marcus, he refused to address me all night, other than, once or twice, as *faggot*, which, given the way he generally ignored me, I came to take as a kind of compliment of his attention.

"I'm seeing at least *one* bitch here right now," Duke said, staring coldly at Marcus. "Don't fuck this up, boy."

Marcus regarded Duke with an uncertain fury as the others tried—a little, anyway—to suppress their laughter.

"But I'm not taking any photos, no," I said to Marcus, hoping to ease his troubles and mine. "I'm just trying to get a feel for Duke's life, for the pictures we're doing together. And since he *did* live here..."

"Long fucking time ago," another of them cracked, I couldn't tell who. The rest of them whooped.

Duke eyed each of them, tried to settle them down. "Oh, not that long."

"Duke, you was in the *private* blocks," someone else said.

"Across the goddamn street," two others chimed in gleefully.

"I don't know why this nigger go around telling people he lived here," the first one finished.

Anthony swiped the neon green bandana off his own head, as if delivering a fatal blow to it, and then got right up close to Duke with a very serious face, big eyes, as though Duke had better have a good explanation for his deceit. But, after a single beat, he carried on straight into Duke until he was hugging him in jest. Naturally, Duke pushed him off and the others howled.

All this settled Marcus down. Seeing his opinion joined, and Duke ribbed and jeered, he said no more.

A new man poked his head around the corner to my left, in the darkened recess behind everyone else. It must have been a hallway of some kind. I hadn't realized the apartment extended further; the corridor must have been quite narrow. The man, who only I could see, as I was the only one facing into the room, wore a grave look that didn't change, even slightly, on seeing me. Anthony must have noticed some shift in my expression, as he immediately said with mirth, "Eric, show this boy the pieces we picked up." Eric, though, if this was him standing in the corner, didn't move.

"He's straight—I told you," Duke said.

Eric receded into the corridor without showing me his back. I watched the bright whites of his eyes get eaten up by the dark shrouding this chamber. Duke and I, even Marcus—he followed behind me, as though ready to do whatever was necessary when the order came—we tracked Eric down the little hall, past a table without chairs, back to a room that felt more like a closet, with only a wardrobe and a twin bed crammed into it, along with a comically small window that was covered over, this

time, by duct tape rather than fabric. Under clinical, blue-white light, Eric opened up the wardrobe's sliding plywood doors and began digging behind a layer of clothes. One at a time, in absolute tranquility, he placed firearms on the sky-blue quilt of a bed that seemed never to have been unmade, its folds were so definitive. Had it ever supported anything besides lead and steel?

What materialized before me had the feel of the video games I'd indulged in throughout high school, or at Immo's place even now, every once in a while. My friend was something of a first-person shooter aficionado; his time in boarding school had left him permanently adolescent in some ways, this being one. But what I saw in front of me now was almost like those games' display of stock, shown between levels, where you would select a weapon for your next mission. Starting on one end, then: a greasy .22 pistol; a 9mm Beretta with such a crudely molded handle, it must have been a ghost gun; a S&W Model 29; a monstrous .50 caliber pistol; a plastic handgun, evidently 3D printed; a small-bore shotgun, sawed off to keep its dimensions crime-capable; and a hunting rifle that Eric had to lay at an angle on the bed, it was so long. Finally, when there was room for only one more piece, Eric set out, with that almost tragic look in his eyes, the crown jewel: a shiny Kalashnikov, which I recognized by the brilliant swerve of its banana clip.

Marcus was standing directly behind me as I admired the weapons. I heard him wheezing through his girth; I could smell the Ritz crackers on his breath. Finally, he said, "Can't he just *look* at this shit? Why's he got to take anything down?" A moment lapsed before Eric's long face began to bob slowly in agreement. There was an ingrained caution in the man that must have long predated my arrival. The large, unflinching eyes, shiny like glass, though they moved so efficiently you knew his vision was perfect, gave me the feeling that it was Eric, and not Duke, the most prosperous of them for now, who would be the one to make the final call here. Either he would reach into his waistband—I noticed he often kept his right hand perched above his hip, the ideal position from which to do this—or with a single, sorrowful nod to Marcus, my neck would be snapped and I'd be rolled up in the very carpet we stood on.

"Taking something down," Duke said, "was the whole damn point of bringing him here, M."

Marcus wasn't wrong, actually. I didn't really need to jot anything down in the pocket pad I'd dutifully brought along. The primary value to me was to be found simply in letting my eyes, and my senses generally, absorb the place. That pitch dark living room I'd sat in, for instance, the coolness of the sofa's vinyl against my palms as I'd waited for the lean black boy to take his cola and grapes away, would leave more of a mark on my consciousness than so much else here—and I'd not even seen the thing in the ordinary sense of the word.

"That AK is bullshit," said Marcus, newly sullen. "It jams, jams all the goddamn time."

"How would you know, fat man?" Duke spat. "You've never even pulled a gun on someone."

I was looking at Eric gently, hoping this might mitigate his loneliness, or diminish his caution, and in either case save my life. But nothing changed. His hand hung on his hip.

"I have," Marcus went on—somewhat cautiously, I felt. "You been gone is all. Things have changed, Duke."

"That ain't changed, though. Don't lie." Duke kept re-inflecting his voice, searching out the right tone for each moment.

"It jammed on Anthony. Fucking ask him." He turned back into the hall: "Anthony, the AK jammed on you last time, wasn't that it?"

"Can you keep it *down*, you fat fuck?" Anthony called from the other side of the darkness, past the corridor.

"None of these are for sale, I guess?" I asked Eric *sotto voce*.

This changed things.

"Fuck you asking for?" Marcus said. "Why you bring this bitch nigger around, Duke? It's fucking stupid." Marcus, who'd been on the defensive until now, was strengthening like a storm. And my comment *was* suspicious, that much I had to accept.

"I don't really have to draw anything, Duke," I said. In truth, I wouldn't have minded making some general sketches of the place. It always sharpened the final pictures, even those mostly forged in the imagination, to have some reference point in the ordinary world of sense. But such a plan didn't appeal to me under the circumstances.

"See what he's saying? He don't need to. He's an artist, isn't he? This faggot got *imagination*, right?"

Duke's face, though normally plastic, took on a bit of Eric's clinical sobriety. "Draw something," he commanded. Gradually his voice rose in volume: "The room, the big picture at least. The Cal man told Freddie that it helps you. You're not going to tell me now that it doesn't. That this was a waste of my *time*."

"That's exactly what he's saying," Marcus said.

Duke's scowl evinced purest murder for about a second and a half. Was it meant for Marcus or for me, though? *Had* I wasted his time? Duke's head suddenly went Marcus' way, sending the man reeling into the dark. God was on my side. The carpet would stay where it was, no rolling necessary. No one, not even their resident stoic, Eric, was going to object to Duke now, not when he was looking positively demonic.

We gazed back across that darkened alley. More lights had come on there, but after overhearing Duke, everyone seemed to be finding something with which to busy himself, a reason to look the other way. It was unnerving, the authority Duke clearly still carried with his crew, given how much less illicit his life was these days than theirs. How irreproachably evil must his past have been to justify such deference all these years later? Otherwise, I thought, they must already be on his payroll, given that every pro athlete required a retinue. Perhaps, though, Duke held the kind of authority that lived directly in the flesh, that would only be ceded at death, like Hector's, or when it was no longer obvious to all that he could, as he did so often on the field, reduce you to nothing, to a body without a mind, one that would need to be stretchered out. All this was inscribed in his bearing. Even Eric was shaken by it, enough to take a seat on the bed now, right next to the lineup of guns, and fiddle with a cartridge.

"Get your paper and pen out," Duke enjoined without looking at me, while he escorted Eric out of the armory.

"And don't touch nothing," Marcus called from the darkness.

"Look at him, M," Duke said with feigned patience. "Now look at me. Look at you. Do you think he'd even *consider* taking something?"

Duke closed the door on me with that chilling bit of dialectic. He was right, of course—as was Anthony, when he'd said I was looking for *nigger shit*, although on Garrett's behalf, naturally. There was something titillating, peeking into a world as profane and pained as this. The whole country had been doing it for at least a century, through jazz and swing, the blues, rock 'n' roll, R&B, and finally hip-hop—and that was just the music. There were sports, too, and so much of television and film. Hadn't it been whites lining up in droves to see *Black Panther*, cheering their own downfall? Like the time they stuffed the ballot box in 2008. Hadn't hippies and socialists filled out the protests in the civil rights movement and BLM? Whites were always there, reveling in the dramas of others when their own lives, in virtue of their power, could offer none.

I was specifically under instructions from Garrett *not* to exalt black lifeways, though. Beautiful squalor was a hack's notion, it had always been so. No, I was looking rather to *affirm* something in this kind of life. Not merely the *look* of it, which was easy enough to do, and already had been done long ago by all the vultures of the advertising, film, and music industries, but the very substance of it: the crumbling schools, the stray bullets through children's hearts, the malnutrition and rampaging obesity (the grapes notwithstanding), in short, the abject *neglect* that defined it. Only a fantastic image of black existence interested commercial culture. Yet surely there was *more* to these fantasies, our hearts, just as there was more to black reality.

Advertising had rendered that world too simplistically and thereby missed everything most appealing in it.

I knelt before the bed, withdrew the little pad from my pocket, and sketched on one knee, beginning with the baby of the family, the junky .22 with the heft of a toy and duct tape for a grip. I couldn't say how long it would be until one of the men, struck by legitimate fear, decided to throw me out or something worse. So I rendered everything quickly and loosely, using wide strokes like those I'd used on the practice field with Duke, here applied to guns that signaled, even stock-still, their own trajectories of movement, as the Jugs machine had. Couldn't everything, as Daphne had told me, just after stroking me off to the punching and choking above us that night—couldn't it all be grasped as movement?

Ultimately, what Eric had presented me with, this bed full of guns, looked far too staged, like a Knoll lay. The rectangular framing seemed to attenuate the guns' capacity to *mean*. Still, I thought while composing my group portrait, even a forensic assemblage might have its uses. The deliberateness with which each instrument of death had been laid out for inspection by Eric helped to anatomize the driving force of these men's lives.

Harsh murmurs came through the bedroom walls. Consternation was brewing, my fate was up for grabs. I pressed my ear against the wall and picked out Anthony's and Duke's voices—at the exact moment that Eric opened the door, catching me in the act. His face was no more droopy as he entered than before. I gathered he only meant to ask if I'd finished up, or needed anything else. But my suspicions triggered *his*, and a subtle rigidity overtook his body. I pushed off the wall, approached him as though what I'd been doing were entirely banal. He looked away and gazed deeply into his guns on the bed. He was their shepherd; he'd been almost jealous of my time with them, I felt. His eyes tranquilly but steadily went from one to the next, counting his flock. I doubt he thought I would be so foolish as to lift one. Rather, this was simply protocol: you counted them up without exception. Exceptions were how things got lost. Exceptions were how people got hurt. As he came to the end of the line, his brow furrowed slightly. I had profound hopes the tally matched. He dropped his head for moment; his hand retreated to the familiar place near his waist. Had he miscounted? With his head bowed he eyed me sadly but said nothing. I was about to plead for *something*—for all I knew, he might have been waiting on this—but before I could think of *what* to plead for, the furrow lifted and he nodded me softly toward the door.

I tried to swallow but felt only a tightening of my throat. As I jittered my way out of the room, wondering whether I should thank him for his mercy—I certainly *felt* like thanking him—he reached for the .22, wrapped it in a Mickey Mouse T-shirt, and tucked it into the back of the wardrobe. I went out. The immediate vicinity

was empty. The lights were all on now, there was no darkened alley anymore. The square table, almost too tall to eat from, bore items that, unlike the guns, *didn't* seem arranged for my viewing: powder trails and crumbs of weed, half-crushed pills and cotton swabs. The remnants of a deal? *This*, I supposed, was why there were so many people over, crammed into the back rooms of the apartment in the middle of the night. They must have been in the midst of a sale. Nothing terribly large, it looked like, but something all the same. It would have made them antsy about my presence. I listened to some of them shuffling toward the front of the apartment and presumably out of the building.

Eric would d be coming out of the bedroom on his patrol soon enough: it would have been suicidal to try to squeeze in a sketch of what was on the table. The crew's patience with Duke, and certainly with me, was just about gone; that much was already palpable to me, even in an empty space. So I did what I could: I simply fixed all the paraphernalia of a just-done deal in my mind. I was gazing at a stack of miniaturized Ziplocs when the door beside the table cracked open and a black hand waved me in. It was Duke. The space appeared like another small bedroom but functioned, I would learn, as a storehouse: the desk, the single bed, the water cooler, the leather lounger, all held chambers for drugs.

Duke dug into a couch and came out with a plastic-wrapped brick of weed. "Shit's terrible," he said, unwrapping the plastic a few turns and releasing the brick's stale fragrance. "But they lace it up good. *I* wouldn't smoke it, though. I'd be no good for football with bud like this."

Footsteps. Someone was coming. He rolled the brick on a short pine shelf to wrap it up and buried it deep in the couch, down among the springs, which whined to make room. Then he tore a piece of a broad blackout cloth from the lone window and looked down into the street with a touching serenity, as though it'd been too long since he'd last taken in the view. In fact hardly anything could be seen outside. There was an accumulating fog—common here, I would learn—and only some of the streetlights had functional bulbs, leaving long stretches of darkness. The city didn't worry much about light in this neighborhood, it seemed. What was there to see?

Two or three footsteps sounded directly behind us and then the street was piercingly lit, right down the middle. Duke and I retreated from the window on instinct, turned away from the blaze, and there was Anthony standing by the switch, behind a filing cabinet that kept only their drugs sorted.

"That's some kind of shit right there," Duke said. "A South Side bat signal."

"The fuck it is. But hurry up and draw or whatever the fuck you come for. I can't leave it on long without a problem."

"At four-thirty?" I asked without really meaning to.

"When you drove up, what you find? People, right? *Lots* of niggers. It's no different than daytime, see. No different. What do we care about time for around here? Don't nobody do. It's different for my man Duke. You can't go by that shit." He laughed and offered his fist for bumping, but Duke looked suddenly raw again.

Behind us the burning beam turned the night red rather than white, scorching everything in its path. It was eating up the fog, too, transforming the street, whose abasement I'd not yet appreciated, into a glory of flame and shadow. These were shadows, as Anthony said, of people walking around without a grain of fear, not because there were no looming threats—Chicago these days just *was* one big threat—but because they'd gotten over it, made their peace. Why worry about something you could do nothing about?

In this light, I drew the leafless trees throwing their spindly shadows down onto the people, shadow upon shadow. A couple of boys entered the frame, their hands up to block out Anthony's light, which shone like a second sun. These boys spent a lot of time, you felt, with their hands up, with flashlights shining in their eyes—and flash grenades, too, now and again. What was the difference to them?

Down in the street, there was a touch of Stygian joy afoot as neighbors and transients stumbled around, alone or in twos. My environs back home teemed with the indigent, all crowded together. Here, though, the poor and hopeless preferred to walk alone, anonymous in the cloak of night. Really, it had to be said, this was the picture of a joyous hell, one that Duke's old friends nourished through drug dealing and assault and whatever else they doled out, whenever boundaries were crossed. In another way, they helped keep this inferno raging through *mise-en-scène*, with the help of this brilliant light.

Anthony and Duke crowded around me on either side, staring down into the brightened abyss. (Jeff could have learned something from this.) I penciled in the masses of garbage in the street, all those gargantuan trash bags the darkest green, ribboned by time; mattresses stained with dark fluids; planks of furniture—on the drive, I'd seen some boys splintering a chair in the street—piles of loose clothing, as at a refugee camp. Were they for distribution, a common stock? Is this where Eric, their vigilant keeper of arms, found the garments to swaddle his guns in?

The light failed, and all was dark again. Anthony started to curse, until he saw the long-limbed harlequin boy, I could see only his silhouette, standing by the switch now, still shirtless. He'd finished his soda and grapes, it seemed, and was shutting the shop. Could this be *his* house? Was he far more significant than I'd assumed? Certainly Anthony stopped his grumbling on finding the boy there. Who might the child be related to, if he wasn't the one Anthony directly feared? An older brother? A father?

The boy said nothing to us, not even to Duke. He didn't think he had to. He moved languidly, with that shuffling gait I'd observed in the dark. Without seeking anyone's sign-off, he took the blackout cloth from the ground and methodically re-taped it over the window. Duke left the room and we followed him back into the hall. The dealing table was now clean as could be. The place wasn't just quiet but silent. The guests had all gone. Our time had come—although I was sorry the patchy boy hadn't taken just a few more minutes to arrive, so that I could have taken down a bit more from the window. There were real riches out there; the shine in Anthony's and Duke's eyes then had proved it. They'd even pointed out details without explanation, tapping on the glass, directing my attention to whatever enlivened their world, to whatever made hell *hell*—this hell, I suppose. But then, as I walked out the front door with Duke, without a word to Anthony, who lingered uncertainly in the canary hall, I considered how the mystery boy—a drug kingpin, as I imagined him now—had furnished me with the most potent image of the night, just by cobbling together a late-night snack.

37

It was past five when Duke and I drove back through the center of the city. His parents lived somewhere around here, he'd said, but I don't think he wanted to talk about that, or anything else really. Cars seemed to bring out the quiet in him. Myself, I couldn't rest after all I'd seen farther south, so I turned to filling in my drawings, annotating them, too, a long-running practice of mine for early sketches. If ever there were an archive of my work—I wasn't too humble to speculate on such things—it might strike a rather curious note, the way I marked up salient details I'd like to develop, or dubious bits that might have to go in future iterations, treating my own work as I did the proofs of *Cosquer*, effectively. That's how these would read. Proofs.

As we pulled into the porte-cochere of the Westin that I was supposed to have checked into the night before, Duke abruptly awakened and insisted I should stay with him. I wondered where. Wasn't there just the one bed? He might have thought its vast proportions could accommodate platonic arrangements, if he was even thinking platonically anymore. Yet my plan was to leave for New York in the afternoon, mostly for reasons of damage control back home: Rick, I knew, had worries about Antral, and he'd not appreciated my disappearing after the show at PS1, which left him unable to raise them with me. So, to thrash things out, we were going to meet up that evening in Bed-Stuy.

Duke looked remarkably fresh, sitting beside me in the car. I couldn't be sure what substances had gone up his nostrils or into his lungs while I'd sketched firearms in the bedroom. Whatever they were, he didn't offer all that much resistance to my plan, when I got out of the car in front of the vestibule. He simply gave my hand a squeeze and agreed to meet me soon in New York. Incredibly, the desk told me I was booked in for the hotel's penthouse. I'd made no request from Garrett for anything but a comfortable room, nothing ostentatious like this. I had the feeling my boss didn't have much use for these luxuries in his own life. But he did need to get back on my good side, after his faithlessness in our recent dealings. He would have known that for me there was a degree of novelty in such accommodations, whereas for him it had all become old hat long ago. Even before he'd established JG Chemical, his mother would have seen to it that he was lavishly cared for at home in Chicago; and I knew from Daphne that afterward, once Garrett was rich of his own accord, his estranged wife, Elise, had been keen on these same perks. Now, I suspected excess

reminded the man of things he didn't much want to think about: the paradise with Elise that was lost.

After multiple evasions concerning the campaign—how had he deceived *Elise*, I wondered—lately Garrett had grown more demonstrative in his wish to make things up to me. Early on, he'd paid a notable visit to my apartment, to see my works in progress, only to find the place verging on a landfill; at which point he'd idly suggested I consider renting something larger, more suited to proper work, especially if I wasn't planning on finding a separate studio. The natural solution was just to *clean up* the place—but perhaps he didn't imagine a true artist had that kind of control. I didn't think much of his advice at the time, and I didn't tell him about my claims to the floor directly below me. Later on, during the same call in which he asked me to go to Chicago, he returned to the suggestion, this time more insistently. And right now, on an early Saturday morning, his secretary was emailing me listings of two spots on either side of the East River, with one not very far from him, on Roosevelt Island. These buildings were owned by a close associate of his, she explained, and one of the towers had been built by him, too. Garrett's friend could set me up with something vast at a rate well below market. Of course, I knew it would cost a lot more than my place in the shadows of public housing. Who could compete on prices with *that* kind of locale? But Garrett apparently was happy to pay the difference, the secretary wrote.

I'd had trouble, on the telephone with him earlier, coming up with a response to his offer of assistance, and also to the notion of living in a mansion that *wasn't* in the ghetto: an actual mansion, I mean, not merely a weak joke. I was coping at that moment with the idea of having to travel to Chicago, and I was also suspicious about Garrett's transparent attempt to buy back my trust, all the while never mentioning or apologizing for his most recent indiscretion. Offers like this one, he would have thought, made apologies otiose. Seeing his secretary's weekend work, though, I had to think harder about the prospect. I considered the implications while rocketing alone to the penthouse on the Westin's muscular elevators; the bellhop would bring my things up to my room separately. How long did Garrett think our project was going to go on? Or was he, or else Paul, thinking of keeping me on an indefinite retainer, as Antral's "house artist"? The way he'd chuckled on the phone after my flummoxed silence, chuckled but didn't explain, when that was clearly what I needed, an explanation, didn't exactly comfort me. In the context of making a generous proposal, his laugh was almost frosty. But this was what you got with Garrett, a perpetual reticence that I and probably everyone else around him long enough had grown to resent and to fear.

Quickly I found myself in the living room of my suite. The place was off-white in every way possible: here it was bone and eggshell, there cream and champagne.

Through gargantuan plates of glass I took in the city's downtown, so much like New York, yet with a more unified personality, even if this was one of dark impenetrability—the product of so many shimmering black skyscrapers. I was feeling delirious again, wondering whether I ought to have gone back to Duke's with him, if only for the Theria that was going to be there by morning. I kneeled down before the windows and very soon fell into a semi-conscious state, right there on the floor, in the kind of total exhaustion I'd not known since the nootropic had entered my life. At the Westin, though, even the carpet was enticing, offering the give of medium-firm memory foam, probably of a higher grade than the kind in my mattress back home. It was eleven before my phone gave an ugly bray; I'd chosen the tone for my alarm for its ability to disrupt most states of unconsciousness. I had a short shower, preparing for the flight back, and was just about to dress when Garrett messaged me.

Stay another night?

He himself was heading to JFK right now, on his way out to Chicago—not to see Duke but to talk whiskey with his staff at the old distillery. Anyway, he wrote, the two of us needed to talk about my work for the project. Why not do it there, at the source? It might be good for me to see the facility. If it didn't conflict with my plans, of course.

Ever polite. This is what the penthouse was about, wasn't it? The right to make last-minute requests I had no way of turning down, given what he'd done for me. Things would go the same way if I took the new apartment he was offering. *Of course* my plans couldn't clash with his, when he controlled both. Still... I had to admit, I *was* quite comfortable in the penthouse. And so I swiped away at my phone until my flight became a Sunday affair. That done, I lay down on the bed, naked and in repose, basking in the pleasure of suddenly *not* having to be anywhere but where I already was, yet with the subtle nerviness of one who has given away his freedoms for his joys.

I was to meet Garrett at the distillery itself around four in the afternoon, so, for the second time in my life, I rented a car. The vehicle struck me as the penthouse's obverse: a dusty maroon Buick with a weak turning circle and marshmallow suspension that transmitted nothing of the road. I'd tried to nap at the suite after hearing from him, but I got no further in suspending consciousness than closing my eyes and swimming within a sumptuous darkness for a couple of hours. Hardly rested, I wobbled out from the hard black density of the city into the green and gold countryside. The transition felt jarring to me, surely the upshot of a malnourished mind, of which

I well knew the cause. If Garrett hadn't detained me, I would have been enjoying the quarter-case of Theria I had left back in New York. Instead, here I was, driving out into the Illinois countryside, baffled by the giant, geriatric odometer of my rental: it must have been set too low, because when it read *seventy*, everything—I mean the homes and farms and factories; there were hardly any cars—receded at an ungodly clip. Nothing at all lasted. It was like being back with that possessed driver who'd taken us up to Duke's apartment on the lake, though in that case our velocity had been very much palpable. Now, anesthetized by the car's suspension and, I presumed, my own depleted sensorium, I had the eerie sensation of the world zipping past me, and of hardly moving at all, except for those moments at which experience roughened and the car, failing to bend with the road, nearly went off into the grasslands. My arms had lost feeling along the way, so that I seemed to have no say in where I was heading—that is, right up until the car came to the outer edge of the shoulder. Then, somehow, just before plowing into the prairie, my hands would tug at the wheel, although it never felt as if *I* were doing the tugging. It tugged the way it rained: without a subject. And I couldn't have been gladder for it.

Chicago faded fast, I knew that much. Within minutes, the land began undulating in green and yellow-brown squares, and for a moment I imagined the scene from above, the indelible patchwork quilt of flyover country. Things were different on the ground, though, the grand vistas of the open road being stymied by the billboards that ran, I knew, from one coast to the other, insistently pitching Indian trinkets, dollar slots, strip clubs, gun shops, and finally, when there was nothing else to sell, bail bonds. I kept my eye on these signs as I speeded through, searching for Duke and Daphne, until both sides of the road turned to burnt sugar. The stalks were cut short, the new crop only recently planted. Farmhouses eventually appeared, but very far off the highway, so that they looked more like toy houses, mere barn façades in the distance, along tiny dirt paths that reddened as they made their way out to the horizon, which you couldn't escape, no matter which way you looked.

Pelene was where I was headed. Garrett was thinking of naming the whiskey that—*Pelene*—for this town of six-hundred-odd people, about a hundred and twenty miles from Chicago, so small that even the word *town* seemed too grand for it. *Village* maybe. The distillery lay just outside the place, and by late afternoon, the old brown brick tower Garrett had told me to look for came into view, though it was a few miles still before I actually reached it: that's how far you could see, it was so flat and clear. The tower stood at one end of the facility, presiding over endless wheat, and unlike the houses I'd seen thus far, the entire compound lay right along the highway. I slowed without stopping, peered into the plant's windows: no one inside, not that I could see, anyway. I turned the car around, running off into the gravel

and tobacco-colored dirt that showed through in bare spots, and pulled up next to a metallic silver Land Rover on a patch of overgrown grass abutting the distillery walls. The bricks were clearly returning to particulate, the mortar receding like diseased gums, so that the site had the feel of a ruin, not a production plant. During the *fin-de-siecle*, it would have counted as a genuine industrial facility, but, since distilleries today looked more like nuclear plants than anything else, the appeal of the property was irreducibly nostalgic.

I kept my Buick idling, opened the windows, heard nothing but wind and bird-song. After messaging Garrett that I'd arrived, I sat behind the sweaty, vinyl-clad wheel for some time, torquing the oversized radio dial this way and that but picking up little besides a college station playing "oldies" like "Summer Babe" and "King of Carrot Flowers," though even these tunes came in blurry and faraway. I switched off the engine and approached the corroded plant, which had chunky white letters stenciled onto its sides: *White's*. Here was the man from which Garrett's father would have bought the place. Why not just keep the name? Was it a question of copyright, or did Garrett have something better in mind?

The broad doors of White's—why not call it that, until something better came along?—wore a pungent orange paint that had cracked all over, like a crazed glazing, revealing previous coats in yellow and white, particularly near the twin handles that projected like rusting iron nooses. I rapped on the iron tentatively and heard hardly a sound from the contact. I knocked much harder, jarring my knuckles, and although I managed to generate a bit of noise, nothing came of it, not even footfall. I took the asphalt path describing the plant and immediately noted, from behind the building, the strange and uneven weathering: the back portion, hidden from the road, had corroded profoundly, not like the front. White's literally had its best face on for anyone passing through; you'd never have known it was rotting away like this. If nothing was done, eventually the rear was going to collapse, leaving just a roadside façade standing (who knows how much longer). Loose dirt formed something like a snowdrift behind the plant, and next to the pile of dirt—presumably the spot from which it had been extracted—water had pooled in a large, long hole. The rains in the region had lately been heavy, halting whatever renovations Garrett may have been making here. For now, then, the distillery had a pond, with water remarkably free of silt. Beyond the pool, arrow-straight rows of wheat dazzled in the late light of afternoon, while off to my left, the grain darkened sharply: another varietal, exactingly cultivated.

When my phone finally pinged it wasn't Garrett but Rick. I'd meant to tell my old friend, on the drive over, about my change of plans, but so many details were now slipping my mind. I quickly proposed rescheduling for Sunday, but no reply

came to my text, not right away. So I strolled halfway back along the path, studied the top floor's vaulted roof and tall windows, until I reached the two vehicles. Hadn't I seen this very Land Rover sparkling in the open lot near Antral's offices? At the very least, the truck must have belonged to someone who would know where Garrett was, or when he could be expected. Within the distillery's four stories, there must have been *someone*. I ambled to the back again. Instead of one door, like the front, the rear had three. The closest to me, on one edge of the building, was white, wood, and person-sized, no different to the entrance of a suburban house. I would have liked to find Garrett through this one, and take the lemonade he would certainly offer me. But this was no daydream; the knob wouldn't turn, my knocks went unheard. The middle passage comprised a hulking set of wooden double doors, perhaps twenty-feet high and wide, clearly meant for drop-offs and pick-ups. I kicked these ones hard—my fist would have made no impression—and a gong-like shimmer resounded. I'd struck a broad metal panel built into the oak. Yet in the silence afterward, no one came, and I detected no rustling within as I pressed my ear to the fissure between the doors.

The last of the ingresses, at the far edge of the distillery, revealed itself by a single door, not a set. Its proportions resembled the white one's, although it was painted a sickly lime green and bore heavy scuffs from boots or tools. For all that, it was everything I'd been hoping for: open. In fact it was slightly ajar, though you'd only notice this from close range. Inside, a long, steep staircase led to a pair of small landings above. I got the feeling, looking at the top of the steps, that if I tripped on the way up, I could only end up where I stood now. (Of course, I wouldn't be standing anymore, and I'd be left in the sort of shape that would make calling an ambulance pointless.)

To my right lay the heart of the distillery, a row of a half-dozen copper pots, each the shape of a whiskey decanter, except a thousand times larger, with bulbous stoppers and an array of gleaming pipes leading out of them. They summoned that phalanx of tubes sustaining patients in hospices, for while the ducts sparkled antiseptically, the pots appeared profoundly tarnished. You would have thought they sat on open fires all day, like witches' cauldrons.

I'd seen pot stills in Edinburgh that looked like Hershey Kisses, and others that looked like grain silos. Neither was as compelling as these. I wandered among the giant carafe-like vessels, marveling at their curved planes, holding out my phone—I'd forgotten my pad at the hotel—looking through the viewfinder and photographing them from all ranges and angles.

When I rounded the last of them, however, the viewfinder gave me a jolt. I nearly dropped the phone; the flash went off with my fumbling. Why hadn't Garrett answered my knocks? He was facing away from me, and he didn't turn immediately.

With grave intensity he carried on inspecting the pipes of the last pot. It seemed to be coming undone, as if the patient had spat them out.

"That's your Rover, then?" I mustered in a voice I hardly recognized, my mouth had become so dry. He went on tightening nuts with his fingers, paying me no mind. I'd expected a more ingratiating reception; he had a lot to be sorry for. Evidently he didn't see it that way, or he just wasn't going to give me the satisfaction.

"Was it hard to find the place?" Garrett asked, though he didn't wait for an answer. "And what do you think of all this?" He stepped back from the pot and gave it an admiring glance. He was in a state of communion with the place, the one his father had left to him to turn around, to find success where he hadn't. "They're originals, these pots, though they haven't been used in ages. I had them cleaned up and fitted out with all this." He tapped on the steel ducts with his middle finger, a long thin note ringing out, before waving at a shelf running low along the dusty walls—a shelf filled, oddly, with electronics that had the feel of the twenty-first century, if not beyond. Here, what was new looked like the future, and what was old appeared feudal.

I followed him up warily to the first landing, the steps creaking so loudly that if he'd told me they predated the Civil War, I'm not sure I would have doubted him. There were several offices on this floor, all bristling with computers; I might have been the only analog element of his business. Perhaps that's why I was so prized, although it was also why I was wobbling so badly on the first landing. I held onto the doorframe, feeling unable to reply, as Garrett carried on leisurely expounding on the business, the place.

"We're thinking about using all sorts of grains here. I almost think doing new wheat is pointless, it takes so long to come anywhere close to the stock we have. Rye or oats, those could work in five years. Less, even. But it takes twenty, twenty-five, thirty years for wheat to develop deep flavor. Any younger than that, and it doesn't compete very well with corn or rye. That's why the place failed the first time. The Whites—we've known them for generations—ran it right into the ground. Brave idea, but no, it didn't work. He didn't have a plan."

We were in some sort of control room, an immaculate space. I dropped into one of the Herman Millers, trying to compose myself, while he gazed into the faces of computers and carried on talking. "Wheat is strange. It's too soft, too mellow. Too banal. It takes years to find any character. That's why you don't see a lot of it, and what you do find is more of a novelty item than anything. The great accident, though, was finding all these barrels, just abandoned, more or less, and finding something so charming within them. Not perfect, exactly. There's something unsettling about the dram, the way it's always changing shape on the tongue. But it'll be a generation till we can make more."

Garrett looked at me squarely for the first time, almost challenging me to scold him. When I wouldn't do it—I was too nauseated—a grin full of real warmth broke over his face. He reached out and gripped my arm. "Want to see them?"

"Do you keep any Theria around here?"

"Oh"—he stood and gazed through the plexiglass at the pots below. "This is strictly spirits, actually. Why do you ask? Something wrong?"

"I have a few bottles left back home, but I've got nothing with me."

"Well, I'll work on getting you more, when we can."

"I just thought it would help me see, like you've been saying." I pointed down at the pots.

"I don't really know what's happening with production."

"My shipment never came last week, actually."

"I think the team wants to make one tweak to the formula. So, you know what, why don't you just wait for me to send you some more? I think even what you've got at home, it's not as good as we can get it. Just toss it." He looked at me meaningfully at the very end, and afterward he walked right by me, out the door and on toward the uppermost floors. "Now come and have a look at this."

These stairs were even more suspect than the last, and now there was no handrail: I had to inch my way up so as not to fall. "We'll do some wheat, yes," he called out over the newly noisy distillery; a generator seemed to have tripped while we'd been in the control room. "But while we wait, we're going to need things that mature a little faster. No corn, though. Only atypical grains."

I reached the landing and made the mistake of looking back—a very long way down—which sent me stumbling through the doorway. There I promptly dizzied at the tawny barrels before me, dozens and dozens of them, laying on their sides and propped up on colossal stands reaching to the vault of the broken-down, double-height ceiling. I gathered now why straw and splinters and sawdust had strayed into the more scientific portions of the operation: the rickhouse was littered with natural detritus. Sunlight passed effortlessly through this whiskey cathedral's enormous arched windows, brightening each barrel. The disparity with the control room and distillery below made the rickhouse appear like some holographic reconstruction of the past, the kind you went to museums to see.

Garrett put his arm around me and squeezed as we stared up at all that whiskey, and then around at this freakish hybrid building. "So," he segued, walking slowly with me, "how is our man Duke, anyway? You haven't said a word about Chicago either."

"I only saw the practice fields, really."

"Oh?"

"Well, and whatever it was Duke showed me later."

"Didn't care for it, I guess?"

"It was a little bit terrifying, I'd say."

Garrett held his hands behind his back and turned from me. "He's a wild one, isn't he? You know, the first pictures of him and Daphne, back in New York, they are doing *so* well. I meant to tell you that on our walk up to Times Square, but you weren't in the mood, it looked like. I understand. I'm sorry for the... confusion there's been." He faced me again. "I do love to walk around the city these days, though, just to see how we're rewriting it. Or *you* are, really."

He paused and pointed at the racks of barrels: "Do you know that the *slightest* changes up here change the whiskey? The control room regulates the pot stills, but it has no role up here. Really, there *is* no control up here, except sun, dirt, straw, wood. Tradition. *God*, you could say. Well, you wouldn't. But I would." He gave me a wink, swabbed one of the barrels with his hand, and stuck it out to me, layered with dust. "There are *no* improvements to this—to this light. You of all people must know about light: the seasons, the elements. But scientists have to know their limits, too. When we've been outdone by someone greater."

I was never sure how to take these religious intimations of his. Was he teasing me in some way, or did he really did believe what he said, at least now that we were in the heartland? He turned toward the windows and poked his arm straight through: the ones with awnings, meant to keep out the rain, were actually just holes, unglassed. I stroked the barrels just as he had, felt the slight damp in the wood as a gritty paste of wood and whiskey built up on my fingertips.

"Sometimes the best thing you can do is absolutely nothing," he said. "On the other hand, when it comes to distilling"—he turned his eyes toward the doorway, the stairs leading down—"the refining never ends. Although, even then, there are those stained copper pots. Nothing can touch them. Ancient magic."

I shook my head slightly at the sermon, joined him in the sunlight, and forged straight ahead: "What would you say you know about Duke's life?"

"Duke?" he asked. "I know some." A strain of concern entered his voice. "But I want you to figure out the rest. We've talked about this."

"I guess I just don't know how... usable all of this is going to be."

"How do you mean?"

"Well, *some* things will be fine. I sketched out his tattoos. They'll come out well." Garrett clapped his hands together with pleasure.

"But Duke also wanted to take me around a little, afterward, in the middle of the night."

"I was hoping he would! Otherwise, why come all the way out here?"

"But what I saw was... terrible."

He stepped way, toward the barrels, and turned back, his fingers dancing on his chin.

"That's what I meant," I said, "when I asked you what you knew about him. He was showing me his childhood, his old friends. South Chicago."

"Right..." He walked toward me now, little clouds of dust kicking up at his feet as he crossed from shadow to light.

"It was a lot of guns, and drugs, and thugs, is what I'm saying."

He stopped where he was; he stopped pretending, too.

"Well, that *was* his childhood, right?"

"It's pretty clear he wants back in, though. He *is* back in, maybe."

"But isn't he something of an intellectual?"

"In a way."

"His grades at Cal were stellar. Rog would know."

"For the classes he finished."

"Lots of college players take *five* years to finish. He only took four. I don't know if you follow college ball—I assume Cal Arts doesn't have a team."

"No."

He smiled tightly and looked away, out through the arches, surveying the road we'd come by, searching, no doubt, for just the right way of putting things. Instinctively I girded myself. I was used to him by now.

"You know," he began somewhat gravely, "Chicago, my Chicago, has always had these problems. The South Side's just *dark*. But it's a place that means a lot to Chicagoans. Take the Bronx—wasn't rap born there? The Bronx means a whole lot to New York, to the world, even if it's all hellfire. You know that it does. You've told me yourself. And doesn't Jerusalem, and Palestine, too? Did you get to see Cabrini-Green with Duke? And that's not even the South Side. Did you get a chance while..."

I waved my hand.

"Well, it might be the most famous housing project in the world. It certainly has the right pedigree for it: the heirs of the Bauhaus dreamed the place up, when they all fled from the Reich and settled over here. Chicago's taken so many wrong turns, socially, because we convinced ourselves we were going to fix the problems of man *by committee*. When nothing can fix them, except another man, maybe, acting without anyone's approval.

"My point is, Cabrini-Green *means* something monumental, however *wrong* the place is. So whatever's not right with our man Duke... and maybe it's not even just his past that's *unclean*, as my father used to say—did I tell you he was almost *ordained*, before he turned to industrial farming? Anyway, only Paul would think

there's something to worry about here. You don't feel that way, do you? You *can't*. He's a professor, an adman. And I love him. But Paul is a *craven* man. He believes in nothing at all. That makes him very smart about certain things, much smarter than you and I. That's why—I'm sorry about it—but that's why we had to go ahead with some things without quite being able to check in with you first."

He was still looking out over the charcoal road, unwilling, it seemed, to shore up his apology with so much as a glance in my direction. So I joined him at the window.

"I know you're not happy about that," Garrett said. Finally he eyed me, yet without turning his face. "I can see why. But sometimes Paul really does know best. I've learned that the hard way with him. You'll just have to trust me."

I regarded Garrett stoically until he turned toward me.

"He's a fool, too, though," he conceded, "because he's never really *made* anything. He researches and strategizes brilliantly, but there's nothing he can sign his name to in the end. You and I are the makers. And *that's* how *we* know that even negativity is meaningful. Delusion, too. He'll never quite get that, and that's okay. We're smarter than him on that; he'll have to trust *us*."

I smiled at this, slightly and unhappily.

"As far as Duke and Daphne go, we'll just have to see, won't we? But don't they just get us dreaming so easily? Some people do that. Obama, he did that. Trump, too. Totally different fantasies, but what does that matter? Some of that stuff is just prejudice, obviously, it's not real. But it speaks to us, in a way reality might never..."

I was beginning to lose the thread. I think he was, too. This happened periodically with Garrett; sometimes, no one was entirely at the wheel. Yet he kept saying things that led to other things. Now he put his arm around me again and said with finality, "Just do everything *without reservations*. What you find or imagine is what you do. You meet Duke, like you have this weekend, and you dream, on paper."

I made for the staircase.

"Because isn't that what you did for her?"

I looked back at him expectantly.

"Claire?" he said.

"Maybe you think I'm more benevolent than—"

"Oh, I don't think so," he said, coming over to me, halfway to the windows overlooking the other side of the plant, the pool of water out back. "Just think about those pictures of her. They are *savage*. Or the ones I saw in your apartment that day, of the office worker who was an artist, who quit pictures and went to law school instead. And then the ones of your doctor friend?"

Immo. "Those are just sketches."

"Has he never seen them? I guess he shouldn't."

I bowed my head.

"Do you ever wonder *why* you could have lost Claire? Think about those pictures for a minute, really. I think you did the right thing. But do you think those pictures could please anyone?"

"That wasn't commercial work, though."

"Well then don't think of my pictures like that either. You ever heard of the Container Corporation of America? Paul was telling me about it. It was run by a man who didn't think commercial work—advertising—needed to have much to do with commerce. He and CCA sponsored all sorts of artists. Paepcke was his name, back in the thirties, right before the war, and then after, too, straight through the seventies. Real artists: Man Ray, Magritte, de Kooning. Not just sponsored them—he got them to take part in projects he devised. *The Great Ideas of Western Man* was the big one. They could make whatever they wanted, basically, to illustrate words from all our best thinkers. Augustine, Aquinas, Freud, you name it. These things, Paul can show them to you, they have nothing to do with selling containers, which is, by the way, probably the most boring and necessary thing in the world. Boxes. But how different is Antral? We sell containers, too. And they couldn't *be* more necessary to our survival. What's necessary just keeps changing."

"Like nuclear waste."

He startled slightly. "Well, that is one kind of waste. And it *does* need containing, right? Would we be better off without my boxes? What about all the waste water? Refinery runoff?"

"And riot control, too?"

He seized up then, bewildered. For a moment, he couldn't speak. I'd never seen him reel like this, but how else could I respond, hearing him speak with such impunity? He turned back toward the fields of grain, but I know he saw nothing then, his eyes were so vacant.

"Among other things," he eventually got out. "Sure. Was it Paul who told you about JG? He loves the glory, doesn't he? But you can't say things are exactly *peaceful* out there, can you? Remember what we saw at the restaurant? Happens every day now, doesn't—"

"But what did CCA get out of the ads, do you think?"

"Well, they *barely* have the logo of the firm on them. But they do. And that's where I differ from Paepcke—to Paul's chagrin, of course. I don't even want the logos. Let's go all the way."

"To the *logos*."

He turned his gaze toward me uncertainly.

"The Great Ideas."

For a beat, he closed his eyes. "And aren't you clever. The *mythos,* too. The *telos.* I want them *all.* Isn't it just one thing anyway, a loop? Did you know I studied a little Greek before Cal, in prep school in Chicago?"

"That doctor friend of mine, too."

"Well, now, don't tell me that. He's a dark, dark man, the way you draw him. He's even worse than me." Garrett chuckled in the most innocent way, leaned toward me, and slapped my shoulder. Then he spoke with a somber air, a softer voice: "Look, it's always been my feeling, it's my experience, too, again and again, that the things people want, or come to want, are things they themselves find... well... distasteful in some way. You don't have to like something, or think well of it, to want to be close to it, to know it, have it. Now, does Paul accept all that?"

"Right."

"If I put it like that to him, no, probably not. But I never would, not when we bunked as kids in Chicago, and not now. That's the way *you and I* would talk, though, isn't it? And I don't think all his years of research prove anything other than that. But he wouldn't like us putting it that way. I don't know that Karen would either. What do you think?"

I grinned insincerely. Although he might have been right.

"At the end of the day, if either of them is genuinely unhappy with what we've done, maybe we let the two of them beat us back a little. And maybe that's good. But what I am saying is let's not *worry.* That's their job. Not yours. Because you're going to be paid for everything no matter what. And you keep all the rights—you keep everything."

"Karen's respect, too? Will I keep that?"

He stepped back from me slightly, looked me over with apparent concern. "Sure you will. She loves you. I can hear it in her voice. Daphne said the same thing." He sighed earnestly. "This is partly why I wanted to see you out here," he said. "Just us. Because we're the ones who have this feeling of necessity, of momentum, even when it's got nothing to do with harmony, even when it's all just incredibly blind to reality. It's deeper than any *stance* of ours. This feeling of what, exactly? *Home?* But Paul, he's never been at home in his life. My father's cousin kept me at his place in Chicago while I went to high school. And he kept Paul, too. That's how I met him—*my* family put him up. He's had his share of tragedy, let's put it that way. Home is just something he'll never know."

Garrett gazed wistfully into the clear pool below; its shine was fading as light drained from the sky. In no time, it seemed, the mound of dirt on the water's edge caught his eye.

"But look—you're right," he resumed. "We've worked on riot control. Chicago's a *mess.* That's known on all sides. And yeah, we rebranded. JG turned into Antral,

in honor of CCA, actually: an antrum is just a space, a container, a pit, like in your bones, or your stomach."

I didn't care for the unseemly smile he offered me then, but that wasn't going to stop him.

"I'm guessing you've *also* heard about our defense contracts. People think it just has to undermine the purity of my other enterprises: sports, fashion, health. But tell me—how? And who was seeking purity in the first place? Or what *kind*? Maybe that's the question."

We studied each other for a while. I think he'd almost surprised himself with what he'd just admitted, and now he was trying to gauge how put off I was by all of it. In fact, I was trying to answer the same question: how much *did* it bother me? How much *should* it? Nobody at Cosquer had voiced open opposition to Antral—not until recently, anyway. Karen had told me, a week back or so, that Rick was starting to grumble in earnest about Garrett's interest in us—in *me*—stoked, I assume, by Lindy, who was always game for a crusade. Neither of them could have been too pleased I'd found myself a patron without even trying to, a man with Dia or LUMA and one day even Arnault money, who might well support me long after Cosquer sank as deep underwater as the cave itself.

In any case, this was why I was meeting Rick tomorrow: to put him at ease about the project. Karen hadn't mentioned much of Antral's malfeasance directly to me, not knowing what I might think of it. But I knew from John that she'd been defending the Antral account, which was likely to generate more money than any we'd ever known, against increasingly vigorous objections from Rick and Lindy. Even now, they were locked in a debate over the matter; indeed, this had been *Karen's* reason for ditching the couple that day at PS1.

After a blistering silence, I offered only a question: "How many wars do we have going right now?"

"And how else was it going to go?" he said as his eyes shut tight and his tenor grew ugly and brash. "A massive, imaginative, venturesome place like America, and we're not going to muck it up some, too? What makes the muck something we have to disown? Look, it took some *time* to get here. You don't just end up the most prosperous country on Earth. But we're here. It's the same thing in my own life: this didn't all just happen for me. Look at Daphne. Take her. You must have noticed by now."

"What?"

"That there's something *wrong* with her. And the world deals that unpleasantness right back to her, in all sorts of ways. It loves her for her trouble. *I* love her for it."

"Does she love you?"

"I don't know. I don't think so. But what about me? All those wars that use my stuff, right? All those toxins stored deep in the Earth, or down in the oceans, in my boxes? That's on me, sure. So maybe I deserve a lot of things, too. Unpleasant things. I've already lost Elise, more or less. We're all just waiting for the shoe to drop, right? We've got this feeling, you and I, and I can see it even in the pictures of the ones you love, like Claire. I have that same sense for life, of seeing home everywhere I look, even when it's nasty. Your work plagued me *all night*—that night at Roger's. But what does happiness have to do with belonging? See what I mean?"

I think I finally might have.

We went back downstairs. I went all the way down, to mingle with the copper pots, ruminate on my client's words, and daydream about all sorts of things. Garrett stopped at his office on the second floor to give instructions to a few weekend staffers lodged in the backroom. When he finally came down, he noted that I'd drawn nothing, but he didn't harp on it while walking me to my rental.

"I grew up about ten miles from here, just south, he said contemplatively. "And what we have up there"—he pointed at the rickhouse—"is literally these fields, my fields, in those barrels." He stood by my sun-scorched Buick as I got in, started the engine, and rolled the windows down. I was itching to leave, but I let him reminisce. "We're just replanting it, basically, in New York, Los Angeles, London." He slapped some stalks right near his knees and they sprung back sharply, as if retaliating. "Maybe we'll set aside more of these barrels for wheat. The son I have someday can sell it. Or drink it. Whatever he wants."

We laughed a little. Did he really believe Elise was coming back to him? Or would this be a son by a different woman?

"Enjoy the night," he said, bumping the wheel with his palm.

I rolled up the windows and put the radio on, but Garrett wasn't waiting on me. He was jogging back toward a pretty girl who'd just poked her head out of the distillery's front door, an entrance that have previously been sealed. I wondered what she could know about whiskey, but just then Garrett closed the door behind him with a snap. Already he'd forgotten about me.

I flew back to New York the next morning after fitfully napping in that beautiful bed. My dreams were a mess, just shards, impossible to remember whole, but very much *there* and more menacing for it. On the way in to JFK, I had a double bourbon to help me slow down, perhaps even get some sleep. Without Theria, I couldn't think of what else to do but booze. I had fully believed Garrett would veto the less-than-wholesome

things I'd discovered about Duke in Chicago, only to find he didn't care whether the man's troubles extended into the present, whether he was still underwater, choking. This surprise should have improved my mood, since it meant my Chicago trip *had* been very much worthwhile: the material I'd gathered wouldn't be wasted. I should have been impressed—I *was* impressed—that Garrett was willing to go this far to associate his firm of high-tech luxury products with the fallen side of life. That's how he seemed to understand Duke and Daphne. And not just them. Himself, too.

Wasn't that what he was saying to me, when he'd described Antral's sins? That he was no less unsavory than our two subjects, who seemed to interest him far more than anything he was trying to sell with their help? Had they held his fancy from the start—had the products always been something of a pretext? Or had he found the actress's and the athlete's travails, as they came out in my drawings, so compellingly dark that they now formed the root of his fascination with the two of them? Could it be this question that kept me awake now, rather than withdrawal from the drug he'd pointedly told me to throw out rather than finish? I wasn't sure what I was going to do once I got home. Indeed, I wasn't sure what it was that I felt, exactly, other than a new sense of doom.

38

By Sunday night, the news about Duke had gotten worse, and I found myself wondering whether Garrett could possibly take even *this* so coolly. While I was thirty-two thousand feet up, Duke got himself thrown out of that home game against the Dolphins. He'd played so little, made hardly any impact on the game, yet succeeded in disabling two Miami cornerbacks in ways that managed to trouble the fans—very hard to do, actually—making them wonder what exactly *they* were doing, watching this every Sunday instead of going to church.

The first incident was the more frightening of the two. I watched a replay of it on the washed-out flatscreen above the bar as I waited, double scotch in hand, for Rick to show. I was feeling a bit more composed now, after the nap on the plane I'd self-induced with liquor. After getting home, I debated whether to start in on my small stock of remaining Theria. Why exactly did Garrett want me to dispose of it? Reluctantly, though without throwing anything out, I decided for the moment to make do with booze.

The first of Duke's transgressions had begun with a very bad pass from Skovksy. On third and ten, a Dolphin cornerback, last name *Keller*, easily picked off Skovsky's hurried flip across the middle, which was thrown, curiously, from behind the excellent protection of an O-line that had held its own all day. Seemingly enraged by Skovsky's stupidity, Duke speared the thieving cornerback right above the numbers, so forcefully you thought his *own* neck might break. Instead, it was Keller's head snapping back into the turf. Nineteen took a defenseless posture penalty, putting the ball on Chicago's own seven, and a quick Dolphins' touchdown toss followed.

The injury report hadn't been released yet, but to judge by the video, the way Keller's helmet shot off his head on contact with the ground, and his jaw froze open unnaturally wide as he lay face-up, you thought the blood pulsing down from his mouth to his cheek must be the only motion his body was any longer capable of producing. Almost before Keller reached the ground, the players were signaling for the trainers. How many times had I witnessed this perverse communion over the weeks? As if no longer rivals, the players all sank to their knees and prayed together. Five minutes passed like this before the first signs of life emerged, though even then the cornerback never moved his mouth. It remained wide open, as if he were screaming, or permanently and terribly shocked, though you couldn't really imagine what he'd seen to put *this* look on his face. The dislocated jaw would cost

Keller two months at least; his mouth would have to be wired shut; he'd be fed sugar water through a drip.

The second infraction, coming in the third quarter, was both less life-threatening and more egregious. Duke was ejected without hesitation, though from the replay you could see he was already heading for the tunnel when the referee tossed him. This time the ball was in Duke's sights, coming in on a fade route in the end zone. He'd just about secured this one, the ball was already nestled in his hands, when his cover man, the rare white cornerback, Wickes—a poor replacement for the man whose face Duke had shattered—fell down around his legs and dragged on Duke's mask, which brought the ball out. Even though the penalty was going to get the ball placed inside the one-yard line, the destruction of this perfect play—the pass was a gem, the would-be catch as well—seemed to incense Duke. He struggled to his feet with the same bearing he'd had when Marcus told him it wasn't *his* neighborhood anymore. Bad things, I knew, were inevitable from here. It was against the spirit of the game, to save a touchdown the way the Dolphins just had: I was sure Duke was thinking this. Yet nothing could justify what followed. After kicking the ball clear, Duke dropped his knee straight into Wickes' guts. As he rose, he stripped Wickes' head of its helmet. The Dolphin clutched his stomach, writhing, possibly exaggerating his pain, and so Duke bent down toward him, presumably to offer him some advice, but the cameras showed that the receiver's lips never formed a single word. Instead, Duke straightened up and walked off—well, just after planting his foot firmly in the thespian's face. Now Wickes would *really* have something to writhe over. The man began bawling, cradling his face with both hands and rolling over, back and forth, one or two turns in each direction, as though he were utterly inconsolable, had just heard his mother died in a house fire, and he'd been the one to leave on the stove. Wickes' teammates surrounded him instantly, stopped his rolling and pulled the hands from his face. Everything was red—red leaking this time not in one big stream, as with Keller, but five or six little holes spouting rivulets of blood. The men by Wickes' side soon tailed Duke, who was blithely strolling toward the tunnels, on a sort of Sunday constitutional. Coach Cotter and his team intercepted the belligerent Dolphins before they could reach nineteen, who didn't even acknowledge the scuffle breaking out just behind—and *because*—of him. No, he kept right on walking, not a care in the world.

A suspension for Duke was a near-certainty, I thought while sipping my scotch. His status with the team, with the league itself, had always been tenuous, which meant there was every chance he'd lose his spot with the Bears over the incident. Cotter wouldn't—couldn't—stand for this kind of thing, not if he wanted to field a functional squad. It should be said, the Bears did ultimately win the game, as the

Dolphins suffered without their crippled cornerbacks: Chicago's number one receiver, Creighley, profited mightily from their absence, scoring two touchdowns in the final quarter-and-a-half. Might Duke's actions—one had to consider it—might they have actually been *strategic*, even if nineteen had never informed the team? A fringe hypothesis, yes—but just the sort of thing you couldn't put past Duke. It's why he was so morbidly appealing; you were energized even by his awfulness.

Garrett was the first of our group to address the matter, and I should have anticipated how: through that increasingly disturbing exclamation point, sent to me in a personal text. Paul chimed in later, far more troubled than Garrett with where our stealth spokesman's actions were leading him and, in due course, when the connections were revealed, Arête itself. As I sat there, imbibing in preparation for Rick's animadversions, which Duke's deeds made newly urgent—as I tried to sort out where I stood in relation to these two figures—an email from Paul, addressed to all of us, told us the tale of Nike and Derrick Rose, the young NBA MVP who'd seemed destined to be a rival of Lebron's, but whose career was lamed by injury right after he'd won the award. Nike had made lemonade, though; there was no such thing as a losing bet. They'd run campaigns that *pitched* Rose as a man who'd only known struggle his entire life, having been born into it: South Side Chicago, just like Duke. We ought to admire his perseverance, Nike suggested in a series of black and white ads, even if he never regained himself.

Duke of course was a much harder case. He was no MVP, and he'd not grown up facing the same adversity (his mom was a professor, after all). Worse, he'd not suffered any physical misfortune, as Rose had, which might have made him pitiable. Rather, Duke had been *other* players' misfortune. It was going to be a harder story to sell. Had there been campaigns for Mike Vick right after he'd been caught electrocuting dogs? I don't remember any.

Rick showed up half-an-hour late, nicely offsetting my earlier cancellation: no apologies were in order. His tardiness also gave me time to get a couple of drinks in before facing his doubts, which turned out to be wiser than I could have known: he approached me at the bar with several others in tow, all uninvited. I wasn't pleased, naturally—was he baiting me in some way?—but then, I realized, these unwelcomes could provide a buffer, preventing Rick from bringing up whatever he *thought* he knew about JG Chemical and Garrett. Technically, Garrett wasn't even on the board of directors at the time of the controversy; it seemed he'd managed to put some distance between himself and the firm as the waters got murkier. But this wasn't the sort

of fact that would temper Rick's pessimism. Probably the only person who could have helped me then in coming to grips with Garrett and the project was John. He was just the sort you wanted around when ambivalence prevailed, and solutions had to be improvised if they were to be had at all. Naturally he wasn't here. He was back in Rapid City, according to Rick, dealing with the decline of Lenore, his half-Iroquois mother: a fact—his Indian heritage, I mean—he nobly refused to play up in his work. Being one-quarter Native wasn't meaningless, of course, but it did mean something less in John's case, as you couldn't read it clearly in his skin; it simply hadn't much inflected his life. Maybe he *did* have some greater right to his moral crusading, though, since he'd come by it more honestly than most.

It was strange to me how Rick, even now, was the painter I was closest to, despite our sharing little in the way of style, approach, or ethos. This probably just meant I no longer talked to painters. Was it merely his figureless line that held us together, the way he reliably found a current, an electricity, through the sludge of abstraction? It had been the first thing I'd noticed about him, in the crucible in which we'd come of age, back in school, and now it might have been the *only* thing I cared to notice. Ever since he'd started dating Lindy, less and less of what I liked in him seemed to remain. His shallower aspects had metastasized, as he turned his abstractions either to conceptual or ethical purpose, when quite obviously, looking at his work, what was strongest about it had nothing to do with thought or goodness at all.

In days past Antral and its alleged transgressions would have been the least of his concerns. He would have been investigating referenceless *experience*—even the term formalism did him a disservice. At his best he was a phenomenologist of simple sensation, something no less real than anything else, and quite possibly *more* real than the things constructed on its basis. He was, if anything, a sort of hyper-impressionist who left the world and its water lilies entirely behind; certainly he was no expressionist. Truth be told, his work held real interest. Lindy, though, had turned him away from his greatest talent. These days, he'd become addicted to wall text and philosophically loaded titles. Worse, I'd even noticed figures and worldly things creeping into his paintings, generally as ham-fisted social commentary. I felt sorry, really, that I was partly to blame for his destruction.

Rick and five others arrived single file at my seat at the far end of the bar, near the television. Duke's misdeeds were no longer onscreen, though SportsCenter being SportsCenter, it was only a matter of time till the program looped and he was back. I recognized only three of those with Rick, and only one was I *pleased* to recognize: Hasan, who picked up speed at the back of the procession when he saw me, almost pushing past the non-entities in front of him, his eyes glinting (his being always seemed concentrated in their shine). How nice it was to see him, especially now, this

cognitive scientist turned playwright turned philosopher or philosopher manqué, as he preferred to call himself. He was much more than bearable, a real friend in fact, even if we didn't see each other enough, mostly because we didn't work on the same sorts of things. I think his operating in another discipline actually left more room for friendship between us; a purer, less rivalrous curiosity could take shape, something that was impossible with Rick. Indeed, Hasan admired my unwillingness to see myself as part of his project of investigating the mind, and in particular, of establishing the ways in which cognition, contrary to fashion, was truly dis-embodied, which is to say, Cartesian. He was a cognitive scientist with hardly any interest in the body as such, though he knew the ins and outs of the human vessel painfully well. It had led him on to all that evaded materialist capture, especially the arts. Occasionally I would see Hasan's lectures around town, hosted by one or another interdisciplinary body, pitched for a semi-general audience beyond lay but well short of expert—a kind that really only existed in metropolises. He could *justify* a New York life. His plays, for instance, I'd read with pleasure, though they'd never been staged. He thought that wasn't necessary, nor even desirable. The Cartesian theater was all you needed, I'd once quipped. I recall he didn't laugh, but cited Charles Lamb on the glories of unstaged Shakespeare. That was Hasan.

Lately he'd been out of the country, mostly in Asia, lecturing and writing his mind-plays, as he called them. He earned plenty of money through all of this, though naturally a person who got up to what he did didn't actually need to make a penny. He came from one of *those* Indian families, and he was probably the greatest introduction Rick had ever made to my social circles. I think he liked Rick's abstractions, they fit well with his own subjectivist approach—before Lindy had poisoned him.

Hasan shouldered past the rest of the group and gave me a hushed, conspiratorial hug, his long, regal, blue-black blazer rustling against me. The first thing he said was the very thing on my mind: "Shame John couldn't be here, isn't it?" He meant it, too. We three always managed to have our fun. There was something wrong with each of us, in just the right way.

Two of the others corralled chairs as I moved us to a table. Suddenly I realized they were Terry's rent boys, the ones I'd agreed to do a poster for, though they looked entirely different now, less like models and more like tramps. They were probably playing other roles today, switching them up like women. I'd *thought* I'd arranged the poster as a side deal between us, but perhaps now it was a Cosquer affair? Or maybe these two were just newish friends of Rick. I would never have known, given how little he and I talked these days. These two (what were their names?) were looking skittish. The one with short brown hair: unlike the last time, his locks were greasy and unkempt, as though he were playing a schizophrenic. In place of the all-black of

our earlier encounter at the Ace, he wore a striped shirt with hulking bands of yellow and white, so that only three full alternations fit on his torso. The other one—I think his name was Jack or Jared, or else it was the other way around; let's call *him* Jack, anyway—he no longer had any hair at all. He wore a heavy three-quarter length coat that would have made sense in January but now only made him look like a raincoater—which he might well have been, given the odd little winks he distributed randomly. The only other explanation for this was that he'd run low on Depakote. Whatever the case, I knew Terry would give him his medicine.

I assured Jared and Jack that their poster was coming along. They seemed delighted. In fact I'd done no work on it yet, knowing that Terry had no intention of staging anything with them, except perhaps a sex tape destined for TorChan. Hadn't these rent boys given me total latitude, anyway, to get me to agree to their plan at all? They'd be paying for it with endless delays. What did it matter? I'd feigned familiarity with their work, and Karen had since sent me a few links on their behalf. Jack, the would-be pris-on-yard skinhead, was some sort of fabulist (possibly fabulous) nihilist: lots of blow-ups of stills from Kabul, or, more recently, night vision shots from the Levant, photo- and video-heavy, sometimes crudely marked up with sharpie. This was the *technique* he was onto lately. He'd actually volunteered, I understood, for one of the private armies fighting against ISIS in the Middle East, and it was in this manner he'd acquired some of his best photos. Frankly he deserved some credit for his commitment; it's why I thought I'd do something for his never-to-be show. The picture, supposing I still drew it, could go instead on the cover of the sex tape, maybe. Although I would probably have had more admiration for Jack if he would have just dropped the documentary bit of the project. It tainted with mock-seriousness what was, at least potentially, a meaningful aim, whether contesting territory in battle, or just suicide-by-war.

Jack's appearance might have been of a piece with this, his tattoos near his neck perilously close to SS thunderbolts. On inspection they were swans. It wasn't clever. With that heavy coat, which he'd had to loosen around his neck—the bar was kept hot—he seemed to be downplaying his persona, in deference to my skepticism, which he would have been briefed on by Rick or any other of Cosquer's members. I was the very thing he was seeking to associate himself with, to help him pass some sort of test of legitimacy.

The schizophrenic-looking one, Jared, now he might *actually* have been sick. He was petrified and wan and immediately got himself a drink directly from the bar, presumably to counteract some of this, although I wasn't sure what exactly would come out the other side. I'd not really looked at his art yet, which amounted to drawings done mostly in highlighter. Another artist, I thought, pursuing a signature at all costs. Maybe he wasn't sick, just shrewd.

At the tables we made ours, I ended up far from Hasan and beside the women of the group, from whom I'd so far kept my distance. Perhaps it wasn't an accident that they'd ended up next to me. They were subtle enough, not immediately engaging me, chatting instead with Rick about Cosquer's pictures all over town—my pictures. I assumed he'd disown them, hint at his misgivings. Nothing of the sort. Rick was enjoying their attention, through a soft stance that could be read two ways. Modesty was one; but if anything were to come up later, any poor associations with Antral, say, Rick could spin this as neutrality or even silent inner objection. Lindy, notably—thrillingly—was absent today. I wondered whether Rick was starting to see the light about her, and whether one of these women might be her replacement. For a man who was spoken for, he certainly wasn't declining their affections.

"Amazing how all of it's unbranded," said the dirty blonde to me, without introducing herself, as if I'd been a part of whatever conversation they'd all been holding on the way over to the bar. Annette was her name, freshly graduated from SFAI and new to the city—sharing a house with, among others, the Argentine girl next to her, Eva, who'd been in Kraków for some time now after abandoning Buenos Aires and Montevideo.

"And they're totally in your style, too," Annette continued, looking to Eva for support and only partly finding it. I had the feeling she didn't know my work. And what *was* my style? I'd hoped I'd left signatures to second-raters like the schizophrenic with his Day-Glo sticks. But the man, Jared, could really drink, I had to admit. A pitcher of a rather dark beer soon appeared in front of him, sloshing onto the paper tablecloth and running in a single stream toward me before I dropped my napkin in it, stanching the flow. It wasn't clear whether Jared would be sharing the pitcher with us. From the distress on his face, I got the feeling he should keep it to himself, it would do all of us some good.

Hasan was reading a paper copy of the *Financial Times* that he'd brought with him. He seemed indifferent to all else, Jack and Jared especially. As soon as I'd ended up out of range, Hasan had shut things down, waiting, I assumed, for certain parties to depart. Yet each time I considered whether he might have regretted coming out on a night like this (had Rick so much as told him what he'd be caught up in?), he would flash me a smile through pursed lips, so that there wasn't even a glint from his teeth to match his eyes, which told me much, to wit, that even if his interest was cast narrowly, he was in fact happy to be here.

Rick kept checking the television while the women flattered the both of us. The screen, unfortunately, was directly in his line of sight. I should have taken the seat he now occupied, but in the incriminating clip to which SportsCenter inevitably returned, Duke was helmeted and there were no giveaway chyrons—or rather, the

chyron had been overtaken by news of a fire at Bloomingdale's, which filled me with relief. Nothing worth anything was going to be lost. The one occasion they showed Duke's face, he'd been made over for the post-game press conference, with a foppish bowler, a high-cut turtleneck that seemed to be consuming his chin—I could easily imagine him pulling it up over this mouth for a robbery—and, somehow, a bandana covering much of his forehead. Without any help, who could possibly connect this face to the ones up all over town?

"I knew it was you pretty much from the start," Annette said to me, although she turned to Rick and Eva without waiting on my response. What an odd way of holding a conversation, taking no risk of rejection by moving on as soon as you'd spoken. What she'd said, anyway, was evidently meant as flattery: *you have a signature.* Jared certainly would have taken it that way. What did she mean exactly, though? That there was some bundle of formal traits my Arête pieces shared with my earlier, mostly painted works: my strokes, say, the intensity of their attack, their particular weights and arrangements; or else a compositional continuity, the way I relished certain imbalances and dissonances and not others? Or did this woman intend something deeper, to wit, the kind of signature you needed more than a pen to form? Yet wasn't I now far removed from the concrete perceptual groundedness of my early work? Lately I'd given memory and thought, not observation, pride of place in my art—initially, of course, out of a new necessity: Claire was the first of my subjects to become suddenly inaccessible to me, while Immo, who stopped sitting for me after seeing the dark results, followed soon after. To carry on at all, I'd had to transcend the eye's terrain to the higher ground of mind.

Ultimately, I knew Annette's gesture toward signatures amounted to a kind of generic flattery. Unity *of some kind* was the aim of most artists. It let you become known, re-cognized, like a logo or a brand. Therefore to have a style at all, especially of one's own devising and with some claim to depth, was precisely the privilege everyone but Hasan here was seeking for themselves, and why most of them were interested in engaging me. Rick may have been displeased about the ethics of the latest project, but for my past successes, and for my style, he could still show me off.

"Will you keep it that way?" Eva asked in accented English as she gathered her exceptionally long black hair behind her head.

"Who are those two?" Jared was now quite drunk and hence finally able to speak, though his question came out clipped and twisted with fear.

I kept peeking at the screen above us, wondering how many weeks remained until all the dots were connected with Duke.

"Were all the pictures your idea?" Annette asked.

"Mostly," I pounced before she could shift back to the others.

"And is there... any point to them?" Eva said, leaning on the table with her forearms.

"Of course there's a point," Annette said, with a strained giggle.

"What I mean is," Eva continued, "whoever is paying for it—why? Who are the two of them, in the pictures? The black man and the other one."

Rick, who'd so far seemed aloof, intervened to prevent anything being revealed about the workings the project: "What the client wants down the road, and what if anything we'll agree to do, we don't know. It's meant to run long-term, though."

"The pictures are so sharp and clear," Eva said, avoiding the substance of the drawings. "The printing must have cost a great deal."

"I feel like I've *seen* that girl, too," said Annette, touching my arm. Perhaps she was getting bored with logistics and sought my attention in some other way.

At all events, a barrage of questions ensued from the group:

What was Karen doing for the project?

Was that her text around town?

What's coming next?

I left it to Rick to supply answers, which he did, although with a degree of interest that continually diminished. Meanwhile, I turned my chair toward the television, a brazen gesture of detachment I'd been working my way up to. The threshold now crossed, my responsibilities more or less disappeared. They'd all had their chance to sit with me, hadn't they? The girls eventually started talking with Hasan. The rent boys would get their poster—perhaps. I'd have to talk with Terry first, see how he planned to deal with them. Annette would get bragging rights for having chatted with me, the vanished up-and-comer. And Eva got a bit of performance art out of it, watching me categorically sign off from the gathering while remaining in plain sight. All but she understood my detachment, as it dovetailed with what was now known of me in the city. She, not having been long in New York, must have taken it as a personally hostile act, one that, to her credit, she appeared to enjoy, the more with each round of drinks. But before I could properly consider the possibilities between her and me, Rick disbanded the entire group with the excuse that he had Cosquer business to talk with me.

I assured Jack and Jared that I'd be thinking of their work, and of what sort of design might best suit their poster, while I smiled within at the buggery in their future. For their part, they remained flattered to the end that I was willing to work with them.

Hasan, the sophisticate he was, departed with the others, circled the block, and reappeared as if he'd just gotten there. Rick and I didn't speak while this was happening, preferring instead to work on our drinks and get the voices of the other four out of our ears. It had been more taxing than he'd imagined, this meetup. He'd probably

wanted to make my life hell through it, but I'd managed to make it just as painful for him.

Hasan brought over three shots of some sort of liqueur to us, holding the glasses in front of him with joined hands. Before he could even sit, I asked after John.

"I saw him just a weekend ago," Hasan said dryly, "and he seemed entirely occupied with your little project. He was useless—I was only looking to get drunk that night."

"He wants to do a run of silkscreens from your images," Rick said.

"It's bizarre," I said, "that I don't hear from him anymore." I sipped at my drink without asking what it was: like flowers and wine, is all I could think of. Beautiful. Hasan probably fancied it a palate cleanser, in light of the rude company we'd just kept.

"Well, John's got his hands full now back home, doesn't he," Hasan said to me. "Do you know what happened? His mother went on a rampage: tearing up the house, his childhood things."

"Because he wouldn't come home or what?"

"I don't know what it was, exactly. But *you* know them."

"How is his dad now?"

"Well, I think that's what this might be about. She's saying he hit her, but he's telling John the usual thing—she hits him first, and he's only trying to stop her. I believe that. I've met her once. I recall she didn't like the looks of me, though we're both a little Indian, right? Different kinds, of course, but whatever. Apparently John's just putting out the usual fires with her. But she got hurt pretty bad this time, fell down."

Hasan looked on thoughtfully with those pursed lips. He was one who didn't speak for the sake of it. He might not say anything more tonight unless it felt worthwhile. I think we were all sorry for John, contemplating our own highly variable relationships with him.

This seemed to me to pave the way for talking about Duke. What was the point in our delaying further, now that we'd shed the hangers-on? Hasan could be trusted absolutely, traveling as he did in circles that didn't closely follow professional sports and weren't likely to concern themselves with billboards and murals. They had *the mind* to worry over.

"Did you see what happened today?" I asked Rick.

"With what?"

60 Minutes had replaced football on television, otherwise I would have simply pointed back up to the screen. "What Duke did," I answered. "Check your email." I'd forwarded Paul's note. "I'm not sure why you weren't on the list to begin with." Actually I was entirely sure. Rick was a bit player on this project. He'd made it seem that this was so because of his own abstention, but I wondered sometimes whether he

would have simply liked a clearer invitation, delivered at the right time, before Lindy had a chance to spoil him on Antral. Rick looked back at me wearily. Even without knowing exactly what Duke had done, he knew. He set his phone deep in his lap and pulled his head down low to the table, as if something terrible might be disclosed there and he needed a private theater for it.

"So who is he, then?" Hasan asked, fanning himself with the salmon paper.

"He's the guy on posters and billboards they wanted to know about," I said.

"So he *is* real." Hasan's eyes brightened another notch.

Rick started shaking his head with a restrained violence then, before actually standing up in disbelief. "This whole thing..."

"Is fucking strange, yeah," I finished his thought. Why else do you think Garrett is putting this much money into a nobody?"

"I was hoping you'd know, because I have *no* fucking notion."

"*This* is what he has going for him, Rick. Why else?" I presented this as knowledge I'd long possessed, as if I'd known it when I first undertook the project; of course it was an inference I'd only fully drawn yesterday, seeing Garrett's bizarre yet convincing reaction to the things I had to tell him about Duke and his friends in Chicago, the life nineteen was looking to restart there.

"*This?* So Garrett's *looking* for this to be a calling card for his company?"

"I don't totally know," I admitted, "but I know he's not exactly opposed to the downside."

"Paul sounds pissed—and he's the *marketing chief.* His boss is losing it."

"I don't think Garrett's surprised Paul's struggling a little."

"And what's all this shit about *Derrick Rose?* My god, Paul's psycho, too." Rick sat down again, exasperated.

Hasan merely sipped at a new drink, a hot toddy I recognized by the cloves studding its lemon wedge. Rather early in the night for that, it seemed. My friend eventually turned his eyes to the silent screen. "There!" he exclaimed in a voice he used only once or twice a conversation, for real emphasis. Sure enough, the bar had switched the monitor back to ESPN, and the crawl along the bottom identified Duke and his sins on the field.

It wasn't long before Rick, watching the screen, fell back into the very state of disbelief from which I'd just been helping him climb out. Now we'd have to do the whole thing again.

"So what exactly are we supposed to do with this?" Rick slurred slightly. "You're supposed to be tracking this in some way, is how Karen put it to me. So Garrett wants a picture of a fucked-up face now?"

"He doesn't really answer questions like that."

"Oh, I know. I don't hear back to half the notes I send him."

"Maybe you shouldn't send those, then. He's gotten used to Karen and me." What Rick resented most was being excluded from the decision-making at Cosquer, my growing significance to the financial fate of the studio.

"Oh!" said Hasan, his second exclamation, following uncommonly close to his first. Maybe Duke *did* have the powers Antral and I needed him to have.

"Look at *that*," Rick said, "and tell me we're working with the right people." I turned—I'd chosen not to face the screen until then—and found Duke's second victim, the one who stayed conscious through the strike, though he might have wished to have been out cold. Blood pooling in their hands, two teammates cradled the cornerback's head, which was riddled with puncture wounds: one penetrated his right nostril, a second his upper lip, and another sat quite close to the ear. Only a sweeping step could inflict this damage, judging by the direction of the cuts to the man's visage. The look on his face, too, it was as though he weren't on a football field at all, being watched by millions; he was all alone, in a dark alley, there was no need and no way to keep up pretenses. Yet there was the sharp light knifing him in the face; there was the dirt on his jersey. It was all quite perverse of ESPN, but we were used to it by now, or should have been.

"So I guess now you're going to do *that* face right over Times Square?" Rick snarled.

"It's not the worst idea I've heard."

"Oh, *fuck you*. This is just all wrong."

"I'm sure Lindy hates it."

"Don't you goddamn make it about her again. I know the things you think. It's Garrett who's lost here. There's people who've kept tabs on him forever, through some truly sordid shit. And I *know* you know what I mean."

"I know he's got principles, yeah."

"He's a law-and-order freak, is what he is. Hasan, tell me I'm wrong here?" he drunkenly implored, pointing at the television. The scientist shielded his eyes from Rick's with the newspaper and shot me a look of solidarity beneath it. Here comes another of Rick's hissy fits, it said. Hasan wasn't one to be wrong-footed or discombobulated; he took pride in his composure, which we knew he'd not always had. It was hard-won, this taming of his mind, and he wouldn't surrender it easily.

My sympathy with Garrett strangely waxed at moments like this. What did Rick actually know of Antral's CEO, if I, who'd been working most closely with him, hadn't yet managed to puzzle him out? My colleague's discontent was merely reflexive, a function of his class as an artist. How could anyone doubt that Lindy had

had this effect on him after coming into his life? Rick really didn't want anything to do with the Antral account; he'd become terribly concerned about the origins of Garrett's wealth, though Rick himself was hardly off-the-grid or anyplace else where you could at least try to mount the case that your life wasn't implicated by modern trade. No, the money was always going to be dirty; there wasn't any that was clean now. So, unless you knew yours to be a lot dirtier than average, what was the point of making a fuss *now*? Just because it was easy to complain when the usual suspects were involved? The police? The defense department? Rick's objections were so obvious and unhelpful. Would it have changed anything if the DOD were taken off the roster of the thousands of businesses outsourcing Antral labor? In the end, Rick was like so many others I knew: ostensibly unflappable yet easily scandalized.

Garrett's capital was only the first scandal for Rick, though. My less-than-realistic approach to depiction apparently was the second. He chafed at my rendering of the reigning *mythos*, my lack of fear over stereotypes, and my lack of interest in signaling somehow that I knew the score. What did the score matter in all this? The third scandal—yes, there was a third—was down to the very substance of the campaign, to wit, that we'd so much as chosen to work with subjects like Daphne and Duke. Here again, Rick wanted to ignore everything that actually turned the wheels.

Hasan had been drifting down the corridors of his own mind for the last few minutes, ever since talking heads had replaced on-field imagery. He was working out the kinks in one of his latest projects, I imagined, on animal thought, the possibility of which posed some threat, it would seem, to his interiority thesis. But the spat between Rick and me had brought Hasan back to us, hoping to offer us a bit of help, now that he'd sorted out some problem of his own. He wasn't a man who needed much help; this was another thing he staked his identity on.

"Has Garrett said anything to you about what's happened with Duke?" Hasan asked us. "Does he know?"

I hesitated a moment before confessing to the lone exclamation point I'd gotten from him. I wished I'd not had to admit to Garrett's perplexingly glib response in front of Rick, who immediately turned triumphant—bitterly triumphant—so that he rose as if he really were going to walk out on us this time. Yet before he could do or say anything, Hasan cajoled him to sit, which he did, but in a chair much closer to mine than the last.

"Do *you* like where this is going?" Rick asked with breath of gin and Esprit de June—Hasan's mystery liqueur. "How's this supposed to sell whiskey or anything else?" His voice was lower, nearer my ear, and more cutting. Frankly I preferred his yelling.

"I guess you'd rather I fly solo on this one?"

He made no move.

"I mean, I hear his checks are going out to everyone."

"Is that what you're selling?" Hasan asked. "Whiskey?" He leaned in close, with renewed interest, his blazer buttons shining in the light as he steepled his hands. I should have known: as a man on the frontiers of consciousness, this part of our project, the consumer psych portion, fascinated him. It was also a debate that let him—perhaps this was his real aim—settle down his friends.

"I have to say, Rick," Hasan said, slowly leaning back in his chair, "from everything I've seen, the strangest things can sell people."

39

Fourteen-hour days, that's how the next four went. I can't exactly say I enjoyed this kind of concentrated work, but since my insomnia, induced by withdrawal, had come into full flower, it pleased me to find some use for all my surplus hours. And, actually, if anyone were suited to this endeavor, it was me. I was rediscovering this truth after many months of sporadic work, ever since my last exhibition at Sandy's, really. The feeling upon me now recalled those weeks leading up to the show, where I'd quickly bring together things I'd left apart or merely notional. These days, of course, my exhibition space had vastly expanded, and my "show" would be rolled out over many weeks and months, a few images at a time colliding with all else happening in the city—a Nor-easter, a construction accident, a terrorist attack, a holiday parade—and in the lives of our principals, too.

I wondered how Sandy looked on all of this. He as much as anyone would have genuinely recognized the continuities between the old work and the new. He didn't contact me much anymore, he had his pride, and more than that he knew prodding didn't work on me. I would have to come back to him more naturally, when what he had to offer accorded with what I had to give. Still, once in a while, he would leave me voicemails—he never emailed or texted, he found it unseemly and impersonal; the voice was fundamental in all his affairs—and in his messages he would speak of other artists he was working with, even their shortcomings, or about how things were with his daughter and his wife, to which he knew I'd taken a liking. But not once, to his great credit—it's what told me he was a man—did he ever ask me to call him back. He probably didn't want a call, anyway. No, he was just reminding me he was still there, waiting, and that I could come back when I was ready, no questions asked.

The first thing I rendered from my Chicago trip was the guns, how they laid on the bed so showily, just beneath a window—uncovered, in my drawing—exposing the neighborhood's dereliction. I did it with unrefined marks of my pencil, tiny little stabs, and a stark distribution of values, representing, at one pole, the glare of the floodlight out in the street, and the quiet glow within the gun closet, with dis-ease spread evenly throughout. Illumination made no difference in this world.

The Redon fresco on Duke's back was trickier. My sketches didn't really suggest anything transcending the tattooist's remarkable work. What's more, Duke was displeased with the way I'd rendered his body: too graceful, he told me on the phone, more graceful than he was. In fact, my depictions were closer to the photographs I'd

taken of his legs and torso than were any of the napkin sketches he would send me by text. He thought of himself as squat and barrel-chested, though he was actually somewhat rangier in his motions, moving like a bigger, longer man. Perhaps his brutish style of play encouraged this misimpression, that he was the barbarous black, the former bit of chattel that was just as effective as a freeman. That was the shape of Duke's dreamlife, and for all I knew of Coach Cotter's.

You could speculate on the forces that generate a life like Duke's, you could imagine other worlds with different forces. Perhaps you could even conceive of an ideal speech situation. But in none of those cases would you be reckoning with Duke's dreams as they stood. As *he* stood. You would have to dispossess the actual man to do it, and create a man you thought you preferred, that you assumed *Duke* preferred, in his place. And who could assure you of the truth of these preferences, or the desirability of the results?

I decided to shelve the Redons, though Symbolism would continue to appear in the margins of my notes as I worked things out. Within days, a solution to the first of my problems—the plenitude of the original tattoo—took shape. Redon may have had his *Noirs*, but Goya had his *Black* paintings, fourteen of them. Primitive versions of these, almost pictograms, turned up in my journals over those days: pictures, in essence, of men devouring men, which could be woven into a wider phantasmagoria. Subbing out Redon's iconography would not only distinguish my work from the tattooist's; it would give me the chance to *reconstruct* Goya, the grand reconstructor of Spanish history, and to fresco on something besides my walls.

The problem of Duke's form also could be resolved by going back in time. *Can we have something more original?* he'd asked me via FaceTime. And by this he meant *early, archaic, cradle-of-man.* In short, *African.* Originality, after all, could be taken in two ways, and I was no longer sure which I preferred. I passed along Duke's wish for originality to Garrett. True to recent form, he embraced it. *Maybe Duke's on to something*, he told me. What, though? Garrett would never say. So, once again, I turned myself loose on Duke's flesh, and what emerged on the page spoke of another era. Duke had assumed I had it in me to depict him like this, so unflatteringly. *Had* it been just an assumption, or was there something in me he saw? That Claire perhaps had seen, too, over time? Maybe Garrett had known it as well, and that's why he'd chosen me. Looking at the results, it was hard to dispute their intuitions.

All sorts of physiognomic and phrenological texts that had fallen into scientific disrepute long ago, not to mention Von Humboldt's books, and Herder, of course, and most important, I suppose, the developmental drawings of Haeckel: they got me started, surveying the phases of humankind, socially, mentally, and anatomically, whether

we called it evolution or something else—*drive* maybe. Archaic humans, the hominids immediately predating modern man, had a way of creeping into my drawings, whenever I needed to summon the primordial. The tiniest squaring of a jaw, or the elongation of a forehead, could put a charge into the portrait of even the most delicate aristocrat. In this case, although I didn't exactly recapitulate the features of archaic man, I traded on the fact that among the several anatomically modern human forms, certain ones more strongly recall our ancient silhouettes than others, not simply in the brow and jaw and nose—none of which would have anyway been visible in this picture, as it depicted Duke from behind—but in postural markers and a characteristic compactness of structure we have shed or simply lost. Differences, too, in the shoulder and neck, and quite pronouncedly in the hindquarters. At one stage I'd obsessively rendered such forms, precisely for their contrast with classically human anatomy. This practice equipped me to render Duke in almost mythological, transhistorical terms now, pulling heavily from those extinct incarnations, yet updating the features with small twists of modernity, in the length of the neck, say, or the development of the hands.

By Friday morning, my labors had left me bedridden. It might have been merely a story I was telling myself, but I certainly felt more exhausted since I'd abandoned Theria. Work appeared to exact a much greater toll. I had a hard time saying in what way it differed—in what way *I* differed—but whatever it was, I wasn't sure how long I could last, working like this.

I had the two pieces couriered to Cosquer. Karen ought to see these properly; photos might fail to convey the merits of what, in summary, could well seem obscene. Perhaps I'd messenger everything from now on. I spent the next thirty hours convalescing, though real recovery from my exertions seemed out of reach. My insomnia simply wouldn't relent.

The knock at my door came Sunday afternoon.

"You're serious about these?"

Karen. I'd not been expecting her on the other side of the door. I hadn't had her over in a long time now. Why would I, the way she'd shown herself to be in bed with Paul and Garrett in all of this? I donned a mask of indifference, turning back and walking us both to the sofa as though I were expecting her.

"Paul came around to the studios to see them himself," she continued while repeatedly throwing me glances that alternately conveyed worry and anger.

"Paul is a corporatist, a researcher," I declared. I chose mild epithets and as even a tone as my privation allowed me. I must have sounded as grim as she did.

"He's a realist, and he has experience here where we don't."

"That's true."

"Ghettos and guns?"

"*Garden and Gun?*"

"What kind of picture is that?"

"What are you—"

"You look awful, you know that?" She shook her head. "I'm talking about what you sent me. Do you remember, even?"

"It's just what I found in Chicago, really."

"And the other drawing. What is that? An actual *ape?*"

"Don't make something out of it, Karen. Duke likes it. He turned down the other version I sent him. Garrett liked the idea, too." I paused and almost smiled. "Do you want something to drink?"

"I don't really care what Duke wants at this point."

"What about Garrett? You wouldn't want to disappoint *him*, right?"

"Is Duke even going to be on the football team, after what he's done? It's horrible."

"Don't start listening to Rick now. You know he hated all of this from the beginning."

"Anyone can see what's off here. You don't have to be Rick."

"You're right that the team might cut Duke. But Garrett won't."

"He told you that?"

"It's just a feeling. Why don't you ask, if you need to know?"

"I don't know what you two are trying to do here."

"There's no collusion, Karen—or if there is, it isn't between Garrett and me. You, though. Well..."

"Are you actually unhappy with anything that's happened so far? Did I make a single fucking mistake with your work? Actually?"

"Just try and remember you're an artist sometimes."

"I'm also not a racist though, see." She pushed away the drink I'd brought her, splashing it onto the table and some old drawings of mine.

"That's just so *easy*."

"And you aren't one either."

"Did you think Garrett was? Do you just assume that? I mean, he's a business-man, if that's a sin. Why'd you start a design company if you couldn't stomach that?"

Karen paused and surveyed the mural on my walls. I'd been working on it today, having been, as usual, unable to sleep, and having had nothing else to do. I'd added in a bit of cloud, a bit of shade, as well as a shantytown bearing a strong resemblance to the one growing outside my door: this was simple mimesis. At first, the homeless had crept up from the subway, and then in greater numbers they settled along the sidewalks, colonizing the park just as the moss had the lake. Now the beggars were coming out toward the front gates like hardy weeds, the place was growing so full and

vibrant. I moved to the window and looked down on the scene in front of the park, which was like one of those tent cities in Sacramento, without the tents. Some had dispersed, but three youngish ones, runaways maybe, were still lingering, or laying out in the sun, or in need of medical attention.

"What do these two drawings say to you, then?" she said. "There's no sense of..."

"Satire?"

"Or doubt."

"Oh, I don't know. I've stopped asking questions like that. Because what do the answers do for us?"

She sighed, or hissed, it was hard to tell. I was still looking at the boys in the street.

"What people will say about these pictures... don't worry about it so much. *Without reservations* was Garrett's phrase. Haven't you picked that up by now?"

"And what do you think they'll *feel*? Does that matter? What do *you* even feel?"

I didn't turn, I just talked: "What I feel," I said, "when I look at them, is a certain sense of... correspondence. They're not attractive, or glamorous. They don't give much pleasure that way. And they're not the ugly truth either, I'm not saying that. They reveal absolutely nothing. And they don't seem very instructive, I think we can agree."

Karen sighed again—she seemed always to be sighing now. I couldn't believe just how much air she could draw into her lungs, to be such an endless font of exasperation.

"But look, let's show them to Garrett. If he can't stomach them, we can think of something else. Or you can just kick me out of Cosquer. Would that help? Because then I could keep the drawings for myself, pin them up around here."

"He always backs you."

"He's the client, right? Isn't it up to him?"

"Well, then, who is it who's forgotten he's an artist?"

With that, she walked off.

By Monday, I seemed finally to be recovering from all symptoms of withdrawal. Sleep had been easier the night before. The debate with Cosquer and Antral, which I'd expected to carry on for some time, was effectively over, at least as it concerned those two images of Duke. I wasn't sure what opinion of them I held, or that I ultimately even disagreed with Karen—that was the worst of it. But I wanted to keep the door open here and continue. I'd wanted, most of all, to solicit Garrett's reaction. Not, as Karen had suggested, that I was simply seeking clearance from him. Strange as it

612 Mark de Silva

was to say, I was actually growing to *believe in*, to *feel*, the soundness of his instincts. They'd become, without my noticing it, a sort of litmus test of the value of the work. And this was true even without his drink fueling me.

So, the verdict: Garrett rendered it, as usual, with a minimum of

explanation, on a conference call. He'd considered the concerns of Karen and Paul very closely, but, in the end, he believed we were on the right path with these pictures, or at least headed in a direction he wanted to know more about. He'd like to see more pieces from me as soon as possible. Karen was dumbstruck: she might have hung up the phone for all we could tell. Judging by the violence of our argument following that call, I wasn't altogether sure she wouldn't drop Garrett as a client, regardless of the consequences to the studio or the magazine. Paul, too, was clearly roiled—though he became angrily vocal, not silent—as it was now apparent that it really was just Garrett and I, together on an island. Yet their protests came to nothing in the end; Garrett, against all odds, maintained his charm.

Still, it was enough of an issue for Karen—and even more so for her lieutenant, Rick—that she put the matter to the members of Cosquer. I had real fears over the verdict, now that we'd heard Garrett's. Would I have to continue the project alone, without the collective's support? How deep a rift would that create with her and the rest of them? I didn't really *want* answers here, of course, and luckily it never came to that. In a terse note addressed to us all, Karen agreed to provide further services to Arête and its parent company, Antral. I never pressed her on what really transpired at that internal meeting at Cosquer's headquarters, one to which I'd naturally not been invited. I only learned of its existence from John, who could never *not* divulge conflict and chaos. I have always wondered exactly what calculation she made, how she ranked the pros and cons—and how she managed to put down the insurrection Rick almost certainly had called for.

From that point on, production went ahead full-bore, so that my images could go up more or less concurrently with the precipitating events in Duke's and Daphne's lives. Whatever his misgivings, Paul took a certain pride in deftly carrying out instructions, even when he didn't agree with them. And, old hand that he was, he quite efficiently coordinated everything, so that the gap between creation and distribution of the images throughout the city and even the country could be shrunk nearly to zero. Logistics were being sorted out well in advance of my having the works in a finished state. So, in the case of these two drawings of Duke, all that was left to do was print them and put them up. The costs of all this were never disclosed to Cosquer, or to me, but to have things assembled so swiftly meant keeping printing facilities essentially on standby, an impressively expensive feat. Garrett's chemical and materials operations must really have been

as profitable as he maintained. A lot of crowds were being controlled, apparently, and a lot of waste buried.

The original drawings ultimately ended up with Garrett. I'd decided to sell them to him after all. The *real* original, of course, was the city itself, dressed in facsimiles of them. He'd agreed to buy the entire series, for significant sums. Obviously that would come as a disappointment to Sandy, who might have thought that when I finally did come back to him—I'm sure he saw this as an inevitability, it's why he was still kind to me—I'd have these originals for him to place with collectors.

Garrett's notion of taking the whole series from me had come from his friend Whent, whom I'd met with briefly one afternoon in midtown, to thank him for the referral. Whent was thrilled I'd found so much prosperity through his friend, as well as by Garrett's following his lead and living among a multiplicity of renderings, distributed over time, real time, of both subjects. In fact, Garrett was doing Whent one better, since his patronage was also shaping the lives of those subjects, so that the series would end up tracing Garrett's own efficaciousness in the world. The joy the man took in collecting each piece from my apartment, or from Cosquer's offices, if I brought it in, was more palpable than any other pleasure I saw him take. And this was because, little by little, he'd become genuinely transfixed by Duke and Daphne and their parallel worlds.

His interest in actually advertising his wares, however, as well as in Paul's growing consternation, evidently ran second to his concern with origins and directions, with fate and the principles ordering life itself. Living among the original works could only facilitate this obsession. He might have been addicted to these two people, even to the image of them, as I might have been to his sports drink, which was a shame, in my case, because I couldn't seem to get hold of any more now. Garrett promised that it was on the way, but his promises sounded a lot like the ones he routinely made and broke to Paul about the campaign. All I knew for certain was that ever since I'd stopped drinking Theria, I'd felt more agitated, and more easily fatigued. My imagination still seemed to function, though the ideas coming from it grew darker by the day. What exactly *had* it done to me?

Garrett had one other thing over Whent when it came to my pictures. He would tell me so whenever I walked him back down to the subway from my apartment—often right by reproductions in the street of the very works he was carrying off with him. His greatest satisfaction, he told me, came from the growing harmony between the gallery he was making of his home and the one taking form in the world at large: his ultimate cabinet of curiosities was just outside his doors, so much more fecund for being susceptible to every force operating in the city, to chance, to unexpected growth or decay. Nothing could match the exhilaration of the strolls he took around

town, he said, or his recent forays as a straphanger. When he drove to the north end of Roosevelt Island, or held meetings in midtown, or went to the cinema downtown, it was as if the streets *became* the halls of his home. And how much better was it to make a home of the world itself, rather than something insular, hermetic, alienated? There was nothing I could find to disagree with in what he said.

The arrangement of this greater home, the timing and placement of images, changed continuously, in accordance with the designs of Paul and his analytics team at Siglin. Garrett said he didn't truly understand the plan, nor did he want to. He was comfortable letting that domain be his old friend's. Sometimes Garrett and I would both try to puzzle out why a particular picture, at a particular scale, using some particular support, had been chosen by Paul to go in a particular place—why, say, it had been put on this bridge and not that one, or used for this sort of signage and not another. What, in Paul's theories of the construction of consumer consciousness, validated these decisions? I doubt we ever succeeded in laying bare his ways. Whenever we asked the man himself, Paul would only return a superior gaze, as if to say: just enjoy it.

40

News came down soon about Duke, and it was bad: a four-game suspension. Most commentators thought the sentence relatively light, actually, given the sangfroid with which the receiver carried out the second of the assaults, and the fact that a five-game ban had been handed out the last time something similar had happened in the league, all the way back in 2006. In truth, I'd been waiting some time for a moment like this, for something to crack Paul's cool, and finally it came. On our next conference call, in language larded with expletives that I never heard from Paul again, he questioned Duke's viability as a subject for us now, given what had happened. The receiver was becoming an incontrovertible villain, Paul said, and the doubts about his suitability for the pros, the ones that had made him drop off the draft board earlier in the year, were rapidly being confirmed. *How could you see things any other way?* he asked. *How?*

Obviously Paul had come down with a crippling case of buyer's remorse, just as Cotter and the Bears must have. I could tell, though, it greatly vexed Garrett that Paul was allowing his doubts to leak out of their Roosevelt Island headquarters and into our call. I knew that the marketing man had been trying to shift the campaign away from Duke and toward Daphne, and double down on the upcoming film she'd be starring in, her first feature-length American release. Now, on the phone, he was trying to recruit Karen to his cause. But Garrett held firm: *We're changing nothing here, you guys got that? Just let it all play out, everything.* The principals' misdeeds weren't made off-limits to me in any way, then; they could and should be explored and depicted, even magnified, as much as anything else about them. I remember how deep the silence was at the end of that call. And so I continued spending my days toggling between Duke and Daphne, psychically and graphically, my impressions of one infiltrating those of the other, a natural result of alternately rendering the life stories of a nervy white girl and a gnomic black man, between whom there were radical differences in family income yet certain commonalities of heritage, none more defining, it seemed to me, than their each having a professor for a parent: Sheila, hanging on the margins of academia, and Tony, though once celebrated, exiled in the way of intrepid explorers.

All the time I'd been working on the last two pictures—early man with frescoed back, as well as the family of guns lying in bed—my feelings had been colored by Daphne and her extended absence. The drawings, without any special effort on my part, displayed this cross-pollination; the personalities on either side were vivid

enough for that. Here and there in the curvature of a line, the thrust of a shoulder or a knee, or even the tones of the background—the manner in which they dissolved in aerial perspective—it was obvious I'd not been able to escape from such interpolations. I imagined this was all to the good as far as Garrett was concerned: precisely these mixtures and confrontations seemed most to engage him. At every point, whenever I thought he would advise caution or distance, he only suggested I dig deeper, entwine myself further in their fates.

Daphne was spending time upstate again, Garrett mentioned to me. She sent no photos this time, though; nor did she return any of my calls, the invitations to come by the apartment. She was back at the theater school run by that little man, Volger. I recall Daphne telling me, before she fell out of contact, that Nik was famously demanding of her time—of *all* of their time. I myself had not found him especially impressive, although I was assured he was, by Garrett no less, when he called to tell me about Daphne's film. It was, in fact, Nik who was directing the picture, which was to be called *Adiaphora* or *Obsequy*, he hadn't decided yet. The troupe was working together on a new draft of the script and the *mise-en-scène*, too, sequestered there on the ranch they'd commandeered.

I'd tried to make arrangements to meet with her, but she'd been remarkably cool about it all. Whenever she was back with the company, this seemed to happen. All the desire I observed in her, which found a sort of echo in me, suddenly seemed just as well satisfied elsewhere. I had to wonder, too, whether she was angry about our last meeting: she might blame me for her own drunkenness, or think I shouldn't have drawn her in any such state—certainly that I shouldn't have plastered her all over town like that. But I'd sent the drawings to Garrett and the team: I could only assume they'd gotten her approval before proceeding, if such approval was in her contract. Maybe she was embarrassed not by the images themselves, but by her behavior that day, if she remembered anything of it. Could it even have been my lack of interest in the crying coming from above, from Tanya, as we went to sleep?

We did eventually talk on the phone, more than once, sometimes for quite a while, even if Daphne remained introspective, intellectual, which must have been an effect of being among the troupe. She allowed me these calls, I think, mostly to please her Jimmy, who probably conveyed to her my consternation and how that might affect *his* project. So she began to explain to me the state of play around her, out in the countryside. Nik thought she couldn't, at this moment, be disturbed from her training, or from the collective composition of the film, for any significant period; and that if I wanted to see her, it would need to be incidental, at the site of a shoot. Nik, who was named after Khrushchev, she said to me, though I don't know how seriously, was fast becoming prominent beyond advanced theater circles. He'd already

filmed a series of shorter works, a loose collection of narratives, none of more than forty minutes, and most closer to twenty. This string of films, a kind of serial production only projected live onto screens of modest dimensions, and never brought to video or television, had already met with success in Berlin. There were comparisons made to Shirley Clarke's *Connection*, and to David Lean's entire *oeuvre*, as well as less flattering comparisons, in Nik's mind, to Peter Brook, whose shallow eclecticism was diametrically opposed to the group's working methods, which eschewed any fixed technique, even if the biomechanical teachings of Meyerhold, Craig, and Laban loomed large. Each performer—each actor-theoretician, as Nik would have it—was left to develop their own technical facilities, an approach that was beginning to earn Nik comparisons, in the world of cinema, to Egoyan and Cronenberg.

This new production would more fully inhabit the terrain of extended narrative film, and test how far ideas more closely tied to modern dance than to drama could be stretched. No classics was one policy they had. Character, too, was de-emphasized. In fact, Daphne explained, Nik frowned on the expressionism linking Stanislavski to Artaud, instead seeking to signify without needing to convey any inner state of mind.

There was the hope, throughout the school, that the film would announce the group's un-Strasbergian ways to the wider world: Daphne's in particular. For the first time, Nik would have a proper budget—low seven figures—secured from a newish financier hoping to shore up his bona fides by backing the ascending director. There was an old Hollywood stalwart connected as well, Malory Martin, a two-time Oscar nominee and former member of the Living Theater. She was entering her late-forties, a precarious time for a screen actress, which is what made her gettable by a relatively small production. The hope, I think, was that Malory's recruitment would help propel Nik and Daphne, and Alonso, too, across the divide between serious theater and cinema.

All told, Daphne was a quite recent addition to Nik's troupe. She'd been with him only a year, whereas others of the company had followed Nik around the world for twenty. If things went well, though, she offered gleefully, the two might develop one of those director-actor relationships like Godard and Karina, or Antonioni and Vitti, that would buoy them both. If things went less brilliantly, I thought, this production might represent not a precedent but a peak, garnering more attention in the cinema world than anything else they would ever make. In either case, a lot hung on it for both of them.

The first time I tried to arrange a meeting with Daphne, I got nothing back from her except some shots of a rather arid-looking landscape with a brush fire in the distance. I wasn't interested in playing this game twice. Jeff, who'd become firmly ensconced in Nik's group, helped me with some of the details: bizarrely, it turned out

she was very far from the troupe then, in Seville, which was almost unaccountable, given this was a career-making opportunity. Her disappearance enraged Nik, so that when she returned, a couple of days back, he put her on a much shorter leash. A scene they were about to shoot was going to use the New Jersey woods; she'd be returning home to New York for it in a few days. I was to meet her beforehand at her apartment—that is, her father Tony's townhouse.

In the meantime, my latest drawings went up in the city: firearms in shambolic ghettos, and then, always at a significant distance, around a corner, at some other intersection, on a different sightline, the lightning-rod: that primal African, somewhere between archaic and modern, inscribed with a fresco of black paintings, a collection of Goyas. If you relaxed your gaze, you could almost see the paintings as variations in the blackness of the man's skin, or even whipmarks, the way I'd done them.

Lately I'd taken to riding around town by Uber at all hours, simply to observe my work, not to mention get a picture of the city I'd never properly had before, regardless of the ways in which we were shifting it. Eventually, after a two-hundred-dollar trip, I settled on a single driver, Ahmed. He was rated three stars; evidently he was rather stern with customers who misbehaved or abused his time. Yet he was superb on the road: calm, tranquil, unobtrusive when he could see I simply wanted to be taken around. He asked no questions, which I cherished, as over the last days, though I'd overcome the worst of the symptoms of my withdrawal, I had a harder time speaking, remembering words, answering questions. Could this just be the pre-Theria version of me returning? Had I simply been left who I always was? Yet what if the drink's action over the weeks had opened up a gap, and I couldn't recall that other me to *be* me? Wasn't that as bad as actually *not* being me?

The phone calls began to come in almost immediately, first of all from the city council, which had kindly provided us with some of their privileged spaces in public areas. Owing to the secrecy of the campaign, *Cosquer*, the magazine, became the public front for the drawings, which were nominally pieces of unbranded art, not commercial objects. I was pleased enough, of course, to defend my work. Seeing it around town, I'd been overcome by the distinct satisfaction of its effecting a reconciliation of sorts with the larger world. Even Ahmed would comment on these pictures, whose density grew every day, and whose positions were continually reconfigured by Paul's recondite research. (I suppose in that sense the marketer and I *were* collaborators—this was the best and least contentious portion of our relationship.) I even took a

ride to the suburbs to see just how far the tentacles extended. Quite far—I was in Scarsdale before the signs gave out.

This *isn't* how I defended my work with the council; it merely showed me that it was worth defending. The means I selected were the ones most readily intelligible to those trafficking in dead ideas. *Critique*, in this case. I urged the councilors, in an official statement, to look harder: these pictures bravely opine on contemporary culture, when of course they did no such thing, as far as I was concerned. But as other *Cosquer* work did fulfill this critical function, the council was able to swallow the pretext whole. Naturally Karen felt the pinch. I was sorry, in a way, as I knew she would have been alienated by this ploy, precisely at a moment when I could have used some closeness. But I *believed* in these drawings—Garrett had helped me to see that I should. Yes, I believed in them in a way I was unable to credit the commercial work I'd done so far, even if I didn't quite have a grip on what they were exactly.

That such a grip—a theory, I mean—was vital had long seemed to me a kind of crutch, perhaps never more than now. Image-making had no need of subjugating itself to the project of truth and revelation. Perhaps as a text artist, typographer, and type designer, and more than anything a prose writer, Karen couldn't quite accept or be brought to understand that explanations were superfluous. Still, angry as she may have been with me, she'd not abandoned the project: she must have had some sort of trust in the work itself, in *me*, even if I myself barely knew who I was anymore. Perhaps she couldn't quite put words to my approach, which some had called anti-cognitive, others anti-aesthetic, and still others anti-ethical. Did this confusion mean I was finally on to something? Wasn't that how it was with all great constellations: religion, say, or science? What could exhaust the meaning of the wafer and wine, the Hindu relics, the Chinese proverbs, the funeral pyre, and indeed all the age-old obsequies? What was the final import of gravity, force, velocity, time? All these things had the same primitive inscrutability to them: not the artificially induced obscurantism of abstract art, but the irreducible opacity of being itself.

41

Free, I hoped, from the impress of Theria, on the rainy morning of the first day of Daphne's shoot, I found myself back on the Upper East Side, standing on the hulking steps of a staid townhouse on York Avenue, all white and gray. The professor answered my knock with an imposing handshake and nothing else. He'd known I was coming; we skipped introductions.

"She'll be down," Tony declaimed in a bardic tone that would have preordained Daphne's life in theater. If *this* was the voice you heard around the dinner table every day, what else could you have done?

From the vestibule, he walked me through the wooded foyer to the living room, pointing around half-heartedly as we went, giving me the tour in name only. "We've been here a long time," he told me, meaning, quite clearly, not just he and Daphne but the longer Simmel line. The home appeared unfussily antiquated, with felt chairs and faded mahogany tables right beside angular modern pieces, some apparently bought in a pinch: there'd been an overflow of books recently, he explained. An uncle in Lyon had died and left behind some twelve thousand volumes; hence the metal filing cabinets collecting the overflow right in the otherwise regal dining room. I understood Tony's trouble.

The rest of the books were housed in an annex, on what looked suspiciously like flat-packed shelves. These bookcases were something of an insult to the depth and rarity of the library's holdings, he admitted, though I don't think it actually bothered him much. The collection teemed with eighteenth and nineteenth century editions of French classics, as well as a trove of early Norse and Anglo-Saxon volumes—he was a comparatist but also, inevitably, a medievalist and a paleographer, too—a portion of which resided at his former university, NYU, to avoid water damage, a perennial problem of this grand, old, leaky house.

There was something of a cultivated stoicism about Daphne's father, a deep, unspoken masculinity. His cropped hair carried only a sprinkle of gray, and his lavender button-down, which must have been made for him, it fit so precisely, had a subtle herringbone weave. The sleeves had been rolled up loosely, while the collar, quite narrow and traditionally cut, curled without its stays. His trousers, grayish with a touch of nap, were eaten up around the heels, probably from days spent walking barefoot through the house. And his shoes, the classic index of breeding that my eyes had come to last, just as I'd stepped over the molded threshold and followed him

into the humid interior, were badly scuffed, but with soles quite new and sharply formed, suggesting the enduring quality of the uppers. The total effect was one of jaded elegance, without a hint of effeminacy.

Tony looked generally younger than his age. If Daphne was nineteen, and bourgeois mating habits had been abided, he must have been around fifty, though he appeared a decade younger. The tell, though, was the deep crease above his upper lip, and the slight sunkenness of his cheeks, both of which *should* have been obscured by the beard and mustache his visage demanded. Yet there wasn't a trace of hair on his cheeks, and if you didn't know that he had to be older, you could easily imagine it was simply a life of sailing off Cape Cod that had done this to his skin.

Each time he spoke, Tony would briefly regard me, searching me for intentions, daring me to form an opinion. I didn't bother. I knew well the sharp edges of the independent scholar. Even if my mother was now teaching university courses in art history and museum studies, wasn't that what you'd call her? Someone who didn't quite believe in her profession as it stood, and who found only irregular employment within it? Intellectuals like her, like Tony, were always looking to undermine your notions and show you the irregularities just beneath the surface of life itself. Now, of all times, feeling my fluency of thought to have been stolen from me, I simply bounced Tony's glances back at him, as I would do sometimes to her, when her mood turned sour and I felt incapable in some way. Each time, Tony would turn away, a trace of amusement on his lips.

"Tell me, what is the *point* of an undertaking like this—like yours?" he said bluntly after we sat down, apparently sensing my weakness with words today. "Not institutional critique, I assume." He'd known of me and my work long before my current employer had, though he gave no hint of his attitude toward it or anything else besides the books. I acknowledged his knowledge; that was all he seemed to require of me, and it let me skirt the missteps Garrett had warned me were so easy to make with the Simmels, and especially with Tony. This would all go doubly now that I wasn't feeling especially clear of mind.

"I hope it's nothing that dull," I offered.

Tony shook his head softly. "It's not *dull*, what I've seen so far. But is it worth *doing*?"

I searched his eyes, tried to parse his emphases, before simply trying to elude him: "James tells me you're working on the Norse sagas."

Tony didn't like this turn, I could see, didn't like that I knew anything about him. "Not lately, no. I've been spending my days at one of those things you apparently hate so much. The Frick, specifically, examining their Beatus."

He waited for me to show some recognition of the name but this was impossible, except to say I assumed that Beatus must be some figure like Bede.

"It's a Spanish monk's commentary on the Apocalypse," Tony said. "Which seemed back then, by all calculations, to be coming in 800 AD." He rubbed his hands together slowly in place of glancing at me in his usual way. "When Beatus was alive, it was thought Muhammad might signal the arrival of the Antichrist—and it was Charlemagne's job to put him down."

The question of when Daphne would be with us still hadn't surfaced as we sat opposite each other, under the glow of golden paper lanterns hung in the desultory way of aristocrats. Instead, Tony appeared to be embarking on a discussion of illuminated manuscripts. His daughter, meanwhile, was taking her time. I listened hard for her as Tony cast about for other ways to test me, but I couldn't make out much over the heavy breathing of the steam radiators, which were making me uncomfortably warm.

Tony stood and opened the white cabinet Daphne had once told me about. He poured something clear out of a decanter. I didn't want anything myself—the last thing Daphne needed was a suggestion of alcohol—yet it was odd he made no offer.

"What do you plan to write on Beatus?"

Tony stared at me while stoppering the bottle.

"Do you work on your great grandfather's topics at all? Georg?"

His gaze sharpened into a glare. He pointed the rim of his glass at the staircase, as if he didn't grasp why I'd made no move to go and find Daphne. Which was absurd, of course. I hadn't because of his imperious manner, and the thought of my mother's, too. In any case, as I began to trot up the stairs, make my escape, but before I reached the landing, he called after me.

"About your work."

I turned, waiting for something backhanded, a damning quibble. With his eyes he burrowed into the etched glass of the tumbler, just after drinking deeply from it. I thought it might shatter.

"Do you like my work?" I said. What was the point in tiptoeing? Let him dislike it.

"Yes."

This voice, though, was no baritone. It was frail, husky, adolescent-seeming. I half-expected it to belong to a sister I'd not been told about; it seemed airier than Daphne's usually was. But there she was—with new hair. This time it was nearly black and coiffed in a lopsided bun, with a few strands leaking down her forehead.

"Tell him what you thought of my billboard, Dad."

With an earnest frown, as if he were expressing nuanced judgment rather than bare approval, the elder Simmel said only, "It has *some* appeal."

"Oh?" I considered pursuing this with him before Daphne waved me upstairs. She knew this fight couldn't be won. Yet I stayed on the landing, detained by the

former professor's sentiments: I was always fascinated by those who thought poorly of my work.

"And what about the other one, Dad. The one of me on the *table*." She was looking at me, and somewhat curiously. We'd not actually discussed what she thought of the finished version, only the sketches. I could see a tinge of anger in her.

"Talking to the wall, you mean," he said.

"Yes, that one."

"Speaking *with* the mural," he mocked in those rich cadences of his.

"Yes."

"Actually, that's the one I meant before. I liked that one quite a bit." Tony finished his drink and walked decisively toward the kitchen. "In *your* apartment, correct?" He paused, gave me an odd look, pleased or contemptuous or merely matter-of-fact I couldn't tell, and stepped into kitchen, out of sight. Next, water ran; he was rinsing his glass.

The picture at issue was more than a little sexual—Karen had found it vile and wanted it nixed, of course—depicting as it did his splayed daughter from behind. Her legs dangled appetizingly in front of you; yet her slightly turned head, when you finally tore your gaze away from more pressing concerns, bore the hallmarks of incapacitation, whether from alcohol or heartsickness (inscribing this second valence had taken many tries). Daphne's mouth was open: she was speaking, ostensibly to the wall, as her eyes didn't come back to meet yours but turned toward the windows, the light. I wonder what exactly Professor Simmel thought had gone on that day. Nothing more than a hand job, as I remember it.

"That's the new drawing," she said as she hopped down to the landing and led me upstairs by the hand. "The billboard is the one we went to see together, with the margarita glass."

"In Union Square?" he asked.

"Among other places."

"Do you think it could have been too on-the-nose, though? What did your Alonso think of it?" Tony put special relish into the articulation of his name, as though this man in her troupe were already my antagonist.

"He adored it." She smiled knowingly toward the spot she imagined him to be downstairs, with the sporting grace of protracted battles, the kind with no winners. We could hear his footsteps slowly fading on the tiles of the kitchen floor as he crossed.

Daphne led me to her bedroom, made up in a jarringly cold style incongruent with the rest of the apartment, as if she were significantly older than she was. Yet I was discovering that the house, as perhaps was only natural, didn't have much of an overriding

tone. Like the great cities of the world, it was simply too old to be anything other than a hodgepodge. Different rooms and floors had been made and remade in various ways over the years, depending on who laid claim to that space and when. One room, it turned out, currently housed someone who was effectively a younger sister, just as I'd imagined, although she would be a step-sister if the professor ever decided to marry again. An entire wing of the place, Daphne offhandedly mentioned, still "belonged" to her long-absent mother, who would apparently always hold that territory.

She sat me on the green quilted bedspread and collected a stack of well-thumbed pages from a children's desk-set, short and small, elegantly made and clearly vintage. A well-off child, then.

"Should we get going then?"

"The shoot's not till three."

In that case, she'd lied about the time. I must have looked disappointed.

"Oh, I just need some help rehearsing, basically with *anyone* not in the group. It's like a family in all the worst ways, after a while. Worse than my own maybe. I almost miss that man down there, not living with him anymore." Her father, she meant.

"Who exactly is Alonso?" I'd been wanting to know for a while, and Tony just gave me the opening.

"He's a man."

"To you, though."

She put her hands on my knees, put her weight on them, then leaned down and kissed me.

I pushed her back upright.

"Have you even missed me?" she said.

"And you've missed me?"

"I'm saying I need your help right now. You know, we all wrote the script together. I told you that. I'm as much an author of this as Nik. Which means," she said, sweeping the pages through the air, "you'll learn something about me, reading these. I'm sure you'll get art ideas..."

"You're making it worth my while, then."

"Who knows?" she provoked, jumping onto the bed and roughly putting an arm around my neck from behind, settling over my shoulder. She pointed out my lines, about a third of the way down. "It's really a monologue."

She smelled of almonds. I didn't know which fabled apothecary was responsible, but it was definitely almonds, just slightly bitter—not the cloying fragrance that has little to do with the nut, but the scent cyanide is known to have.

"I'm not sure I'm up for this." My inclination to speak had dimmed ever since I'd gone off Theria.

"You don't have to do very much, okay?"

I leaned back to loosen the chokehold Daphne had on me, but she held on for the ride, pulling me all the way down with her weight until I was lying flat. I cocked my head and a second later there she was at the window that brought in dull gray light, just what Nik was hoping for today in the woods of Jersey. Daphne picked up a second sheaf from among many on the floor.

"You start."

I sighed and held up the manuscript for *Adiaphora* (or *Obsequy,* whatever Nik decided) in front of my eyes, without getting up from my stance of repose. I began inspecting the stage directions on the second page, hoping quickly to orient myself.

"You don't need to know who you are. *I* know. Just read it. The words will tell you everything."

She dropped onto the floor so sharply—it appeared an instantaneous freefall—I wondered whether she'd hurt herself. In fact she'd decelerated expertly just at the base of her fall, her hair expanding outward and bouncing just once, as a unit, the black bun nearly coming undone. She shook out her thick mane, so far the most appealing of her styles. The floor, however, didn't suit her for long; she put herself at the opposite end of the room, facing into the corner, right near the large walk-in closet, to concentrate.

"Fifth line down," she called out clinically.

I looked at my script and began to read tonelessly. "I haven't noticed. Nothing of the sort." My voice wasn't my own. This was going to be strange and empty for me, I knew already. I simply couldn't feel the words anymore; the drink had done something to me.

"No?" she said with sudden bite. She spun around and said, gently but precisely, each syllable seemingly an entity unto itself: "Do you remember when I first got here, I told you what Lisbon was like for me?" Her voice was dense and uncommonly present. I missed a beat considering this and she slapped her pages hard.

"You said you'd liked it fine enough," I said.

"Yes, but how? How can you live for almost a year, tucked away from just about everyone you know, not speaking a *word* of the language? Do you understand how savage that can feel?"

"You picked up nothing along the way?"

"I picked up some *Spanish*, from books I was reading, or trying to read. Vila-Matas, Chirbes. My father is not a fan of Pessoa. He thought *Disquiet* wasn't much more than notes, and he would know. For a reporter, he knows Portuguese literature remarkably well. But I was almost never out of the apartment. They delivered our

groceries twice a week. I said one or two things to the maid, but in English; she had no interest in Portuguese around me."

"I think, all in all, you've handled it well."

"I was isolated from everyone I knew."

"I assumed you'd do well enough."

"And so"—Daphne plopped on the bed next to me—"you must know how I coped."

"Your father."

"You understand!"

"Family."

"What I had wasn't a family. I had my father—eleven months of my father—the foreign correspondent, after seventy months of not having one. But even then it was me and Marguerite, the maid, most days. We understood nothing of each other. I thought it was fine enough, until summer came and my father got some leave to work on a long-awaited book about Iberian politics, which I think he'd been dreading himself—the pressure of the book, while having to spend time with me. Now he was home *a lot*. And from then on Marguerite was only ever in and out. Do you know she claims to have grasped nothing even of *him*, from that time, anyway? You didn't even *need* language to understand what was going on. She was different around him, not pleasant but... more servile. With me, she looked at me more frankly—more viciously, too—as if *we* got what was at stake. This was a closeness Marguerite could never have with my father. I don't even know that my mother had it with him."

Daphne rose and went to the window.

"Anyway, I got the feeling the maid blamed me for having disturbed something between her and my father for those six years, even if it was just a bland routine they had, a simple transactional relationship, two people expertly staying out of each other's way, perfected over time. My coming made it all more complicated. It might personalize matters, Marguerite having to see my father be some sort of human around me. So she started finishing up her chores as soon as she could that summer, just to get away from the two of us. Before that, she used to linger most of the day. Now, it was two hours in the morning and then gone; she'd leave stuff undone even, try to come when the house was quiet and no one was up yet. I stayed in my room during those few hours. It got to be filthy because I never let her clean it. I didn't want her to look at me the way she did.

"Sometimes I had to do what she hadn't done. It became our arrangement—she would leave me and my father alone, *if* I would do her work. Really I wouldn't have minded doing everything, *becoming* my father's maid, if it would have meant getting rid of Marguerite altogether, so she couldn't pretend not to see what anyone could see, with that much *time*.

"And now," Daphne said, stepping toward me, "you're becoming the same way."

I flipped several sheets forward and found where we were. "What is it we're missing, or pretending to?"

"You and Marguerite?"

"We seem to be a lot alike, the way you tell it."

Daphne gave me a look so red I felt the script melting away, its relevance lost or overwhelmed in the inferno of her gaze. I wished those hadn't been the lines I was fated to read. For the first time in a while, she actually looked at her script, composed herself some in order to carry on.

"I should never have gone to stay with him, never have been asked to go. I wanted to take a little time out of the country, yes, but it was my mother who insisted I do it this way. I should have been road-tripping with friends. Instead, I'm off in a foreign city with only an estranged father for company. Like I'm the olive branch being handed across the sea to him. That's how it felt. Sometimes I don't even care, really, if it all could have just stayed quiet. No witnesses. I did cope, right? It's all years ago now, and what does it really matter how I got here? But him, he is just such a *fool*. My mother could read him so easily, even over the phone. I've denied the whole thing, too, but she knows. You know what he got in trouble for in the States. Why he reports from Spain and Portugal now?"

"That was a long—"

A knock came from the door, the first sound I'd heard in a while that didn't occur along an axis connecting the two of us. I dropped the script to the floor with enormous gratitude.

"Daphne." The name came through the door—the lower half of it did, which was low indeed. Tony.

"Yes," she said, as if this voice from offstage, along with the knock, was just another feature of our rehearsal, written right into the script.

"You *do* need to be there this time. Early."

She reverted now to her less mature voice: "We're going."

Nothing more came back, not even fading footsteps. The room was beautifully insulated, sonically, for such an old place.

"Fuck"—the word came under her breath.

"Shouldn't we leave for the set now?"

"I bet it was Jimmy behind that, worrying about his precious campaign again."

"Maybe he just wants things to work out well for you today."

She laughed so naturally it was impossible, in that moment, to doubt the preposterousness of the notion of his concern. "For *him*, you mean."

"That would be one effect."

"I don't really know what Jimmy wants for me. For your football player, either: Duke is so *terrible*, the way you've pictured him. Is that really what he's like? What I mean is, does he have that much *power*? He has to. That's something about the way you draw, I know from my own case.

"But there's something in your pictures, they always read as... well, my father, he called them *outgrowths*. No one could believe there was no me, looking at these. And no one could convince me for all the world that there isn't a football player on the other end of your drawings, never mind how strange they are. The terrorist one, and the one with the paintings on his back, too. He might not be much *like* that exactly, but he's still there, waiting. Because I'm not sure the ones of me are like me either."

She threw the papers on the bed and threaded her fingers between mine.

"So let's go, then," she declared, kissing me properly as I rose. "One thing I do have to say—I just *love* my legs, the way you've done them."

42

Daphne drove. Tony had bought the car for her, a mid-series BMW not unlike her mother's, although neither father nor daughter had seen that coupe in some time. We headed for the film set, a pastoral one, although, being in New Jersey, it could only run up against several industrial and chemical plants. Some of these, I imagined, synthesized the materials developed in Garrett's luminous headquarters, a pristine place that stank not one iota of these grasslands running with benzene. As we drove, we passed—just out of frame, as it were—a marsh lined with tall green reeds bowing so deeply over the narrow gray road at its heart that the asphalt seemed from time to time to vanish.

We'd set out slightly late, and so we pressed along this remote little road, faster and faster. There to our left and right, we caught glimpses of humanity, but these men and women in families of three and four, wedged right between the trees as if this were as much their natural habitat as the frogs' and the birds', were all dressed in black, and carried booms, and panels, and cameras, a couple of which were trained upon us as we approached. The first two struck terror into me. Daphne had noticed my fear somehow; I'm not sure what the giveaway was. She grabbed my thigh and patted it as if *I* were the frightened child.

"It's a trademark of Nik's," she said, "it's becoming one anyway. Hiding people on-set. Remember *The Vegetable Gender*? The way the lights always shifted, always revealed more people. Crew, cast, caterers, whatever—everyone waited their turn. And now that Nik's got real money to play with, well, everything's that much bigger."

She kissed me then, and I wasn't too proud to accept it. I was here partly for myself: not just Garrett, not just art, but my soul and my groin, too. I held Daphne's mouth to mine for an inadvisably long moment, so that she had to rip herself away from me, eyes crazed, and draw us sharply back into line when the gravel slid beneath us at the edge of the road. I felt she'd executed this maneuver before. She was quite the driver.

We arrived at a cluster of mud-stained cars and trucks fronting a river only recently emerged from the exceptionally tall grass. The water ran with a swiftness that surprised me, particularly as the flow was very quiet, perhaps because there were so few rocks or trees in its path that could have made it talk. On the riverside, towering over the rest of the crew like some sort of figurehead, was Hank, now in a crisp blazer and tie, a bright orange thing running down his chest. The man's height, I realized,

was really in his legs; at any moment I thought he might tumble from his stilts right into the water. My eyes began to search, and in moments they settled on Nik, even shorter and fatter than I remembered him, and now gesticulating irately at the others, as though *this* were what it took to make an impression, now that the natural world had shrunken his authority.

"Jeff!" Daphne screamed into the breeze as we climbed out of the car.

There he was, *sans* scarf, looking every bit the man of the city displaced in the countryside, and not diminished for it. If anything, Jeff's weathered skin presented less of a puzzle out here than in town. He was facing away from us, perched on a rock and looking out over the river, but Daphne recognized him all the same: the long charcoal waistcoat, the bright blue wool pants, and the pair of remarkably formal black oxfords, which looked entirely out of place buried in the mud, but still somehow flattered Jeff. Hearing the scream, he turned slowly toward us but didn't give me so much as a glance. I thought she might actually start trotting toward him through the fields.

Hank had already spotted us from the horizon. He was a permanent lookout in any situation, given his proportions. He bent down and whispered to a group huddled near him while Nik slashed his hand about and berated everyone in sight. This was the height of apoplexy: Daphne and I didn't so much as register with him, even while the rest of them, who seemed more at ease than they ought to have been, given the blackguarding they were receiving, turned to us as we approached. The bucolic environs lent the scene a comical air: how was it possible to be *this* angry in the idylls? Perhaps the persistent sting of gasoline and sulfur in our nostrils kept Nik firmly in mind of civilization, and film sets.

We were still twenty yards out when Nik settled down. The group of two dozen, surrounded at some distance by trailers bristling with cameras and costumes, made room for us as we joined. Everyone here was attired quite formally, as was Daphne, in fact, who'd changed into a dark, elegant blouse and skirt right before we left her father's house, just after we'd finished our little run-through. I'd found it a little strange then, too, why the woods would call for such clothing, but what did I really know of Nik's ambitions?

Daphne's arrival drew only a mild shower of greetings. The dominant feeling I sensed from the group, among all sorts of contradictory impulses, was relief that the scene *would* get shot today. The star had kept her promise. Yet some of the group, like Elias, the musician of the earlier play, positively withdrew, in his case to take a private audience with Nik, which seemed further to calm the director. There were those in the troupe I'd never seen before: a couple of young girls, for instance, younger than Daphne, who exchanged a conspiratorial glance on seeing me with her; and an old

man of olive complexion—Portuguese, at least as far as the script went. This man was one of the few dressed in appropriate, country clothes, and the only one who seemed perturbed by how brutally Nik had just treated them. He dusted his flannel shirt and stared hard at Nik over the lenses of his glasses.

One of the group, though, and only one, stepped toward Daphne. This one was olive-skinned, too, but indecently handsome. He was young, too, and could only have been Alonso; there was no need for an introduction. I was hoping to avoid one, actually, but Daphne had other ideas. She clutched my wrist briefly, gave it a squeeze, and then, walking a few yards, let Alonso take that same hand of hers as she pointed me out with the other. She dismissed the dubiousness that overcame him with a cool little kiss on his cheek. This only darkened his face, locked his gaze firmly onto me. I was left to nod at him ruefully, dismayed to have corrupted his beauty with scorn.

Daphne went over to greet Nik, but the director kept his distance, as if she were cursed. In the end, he turned away without saying a thing, and so she returned to us with a forlorn shrug. He'd not appreciated her tardiness, apparently. I thought I saw her briefly exchange a look with Elias, but he wasn't keen to talk, not in front of Nik, anyway. It was Alonso's duty to embrace her now—and kiss her, too, evidently.

The scene to be shot here in the woods, the one we'd just rehearsed in Daphne's childhood bedroom, came near the end of the film. This I was told by the only one interested in speaking with me: Jeff. Seeing me sufficed to get him off his stone, not out of friendship—that's *not* how he approached me—but rather out of a warm sort of cruelty. I had the feeling he thought my presence today would create difficulties for me he'd find entertaining. For my part, I was happy to have an interlocutor of any sort; in fact, his schadenfreude was more comforting to me than the steely glances of anonymous troupe members. I wondered what they'd all been told about me.

The scene, Jeff said, ambling down the riverbank with me like a long-lost friend, was Estelle's (Daphne's) homecoming to America, after a stay with her father in Portugal; and the man Estelle embraced just behind us was her boyfriend, Vincent (Alonso). A consolation between actors had segued into something else, I wasn't sure what, between characters. The vast film crew emerging from the surrounds, like natives engaged in ambush, taken together with the troupe's peeling away from the couple, creating a clearing around them, proved as much.

Estelle fanned out, away from Vincent, using the balls of her feet for the first few steps before settling down into the heels of her flats, as though this were ballet. All the while she mouthed words without voicing them, and evinced an aloofness that had

been absent when the two first came together after Nik's snubbing. I couldn't help but be pleased by this, even if it may have just been part of the performance, the role. The two of them, whether Vincent and Estelle or Alonso and Daphne, now stood many yards apart. Whoever he was, he seemed troubled by the gap, staring off toward Nik, who held his place just at the periphery, out of frame, not far from the cinematographer and the men holding up boom microphones on long sticks, just over the actors' heads. It took three takes to get the six-minute scene right. Alonso got the blocking wrong in the first, and then, in a different way, in the second as well, bringing Nik right back to a boil. What had transpired earlier to make the director this edgy? The crew we'd seen on the way in, along the road—what had they shot there?

Jeff and I were too far away, and too close to the river, to catch anything of the actors' words besides their rhythm, a soft flow of phonemes against the rush of that smooth, seething snake beside us. What we *saw* was Daphne's way with the clearing, that flat little space, how it mutated over each take; how she used the occasion of Alonso's errors to develop her own technique, so that what, the first time through, seemed a perfectly good performance became, by the third, something else entirely, although I felt myself slightly fumbling with words when describing it to myself.

I didn't know how much of what I saw would manifest in the film, especially after the celluloid shot on multiple cameras was edited, spliced, and respliced. I did know from Daphne that Aleksei German's *Hard to Be a God* was a totem for Nik's *Adiaphora*. Before the team had turned to putting anything on film, Nik screened the three-hour saga for them several times, mostly for its extreme claustrophobia, its continuous action in close-up through a roaming camera, one segment leading seamlessly to the next, not unlike Clarke's *Connection*. You could imagine the action of the film unfolding on a stage, obeying the ancient unities. Nevertheless, the German's magnum opus, unlike so many other stage-laden films—say, Wallace Shawn's *The Master Builder* or *The Designated Mourner*—was ineluctably cinematic in effect. The quasi-medieval setting helped with that, as did the hero's sheer power, of which the film measured a thousand gradations, ranging from the subtlest intimations of impending violence to the crushing strike of swords and hammers upon not just the guilty but the incompetent and simply annoying. *God* was the rare film *I* introduced Claire to, and she despised it about as much as I enjoyed it. We'd had the same split reaction to Bela Tarr's *Turin Horse*. She'd said they were boys' films: although they were said to be ultra-sophisticated, these pictures really just hated women. At least Daphne liked both of them well enough—or was that just part of pleasing her own god, Nik?

I studied her footwork across the three takes, the little athletic pirouettes she made as she delivered the lines, I presumed, she'd just spoken to me in her bedroom. Estelle's and Vincent's choreography over the course of the scene outlined a shape in

the clearing, a different one in each take. The first pattern resembled a simple loop, the two of them moving together, strolling while intertwined—it was a miracle they didn't trip—until they arrived back where they'd started. The second one developed less peripatetically, with her opening up a distance from him and thereafter maintaining it as he approached or retreated. In the final take, she built significant gaps between them, outlining what seemed to me the petals of a flower—finally he got his blocking right, this is the take they would keep—while also curling back around him in circles and ovals that shrunk, so a sort of orbit was described, though you couldn't tell who was the moon and who the planet.

Off in the distance, a charming little shed made me think of *Walden*. "Vincent's home," Jeff whispered on seeing my curiosity. Estelle must have come by car to see her man, though it seemed Nik had shot that sequence before Daphne and I arrived. (Who here was her double?) Merely in the way she positioned herself before the shed, which dominated the background of the primary camera's shot, Daphne seemed to manifest a powerful intuition of the structure's spatial meanings for the couple. In fact she inhabited the entire area, these wilds, fully and easily, swanning around, delivering her words as if they were merely another part of the scenery, rather than something issuing from the murky depths of the self. Now that the camera was rolling, she carried her lines far past the point where Tony—who knows how long he'd been listening to us, just outside her bedroom door?—had put an end to things. You felt her, in the third take especially, collapsing Alonso around her simply by the way she crouched, bending slightly at the waist and holding her midsection, or at least *indicating* a hold, a place where she ought to be held: perhaps it couldn't be done for oneself.

With the scene over, the company descended on the clearing, or really on Daphne, who'd certainly absolved herself through the quality of her performance. She'd just been in Iberia, after all, soaking things up. Maybe it *had* helped somehow. As much as Jeff unnerved me, the last time we'd met, I found him strangely agreeable now. He had one foot in Nik's troupe and the other in Antral, though by now Garrett may have finished with him entirely. The two of us made our way back to the clearing, and just as we arrived, Daphne blindsided us with Alonso in tow. His eyes were set deep in his skull—they seemed to have shadows all around them—and his thick shiny hair lay scattered about his head, whipped by wind. Putting aside his striking profile, neither Jeff nor I could hold a candle to Alonso's physicality, not when we were standing face-to-face with him. Even in the scene they'd just shot, where his role was clearly designed to amplify Daphne's, you sensed the bull in him, capable of great flights that men like Jeff and I could only imagine. So, when he took my hand in his with such easy power, I didn't just sense his strength, I knew it absolutely. Everything I'd not wanted to believe about him was turning out to be true.

Daphne introduced me to him only as "the illustrator," whether to diminish the threat I posed or simply to insult me. She kissed the man playfully and in return he engulfed her in his arms. Jeff stood at some distance from me, directly behind Alonso. There was a fraught history here between the three of them I didn't care to explore, yet still Jeff held my eye for a second, and in that moment, I believe he felt a touch of pity for me: after all, the disappointment anguishing me now had once belonged to him.

Daphne, naturally, wasn't to be possessed; she sprung free of Alonso's grip. It was as if the cameras were still rolling, the way Estelle and Vincent endured in the two of them. It put the soothing thought in my head that her interest in this beautiful man was merely dramaturgical, even scenographic; that she was using his form to throw her own into relief. Truth be told, she could objectify people better than any man I knew. I thought I read the same thought in Jeff's eyes as he smoothed his coat.

Before I could talk with anyone else, Daphne commandeered my arm and steered me toward her car. I'd had it in mind to speak with Nik, to ask him about the troupe—he might have felt obliged to answer, given how they were using my art to advertise themselves—but I assume she had her reasons for wanting me gone. I managed only to shake a solitary hand on the way out, and it belonged to Alice, that old little girl I'd met at the Brooklyn production. Here she was in blue jeans and a floppy straw hat, drinking from a paper cup of coffee and cheering on those on-camera today. Evidently she wasn't one of them: she was without makeup—a poor choice, in her case, under any circumstances. It was disturbing, the way she winked at me. I knew she wanted to say something to me, too, but at just that point, Alonso came our way clouded in darkness, some excess of feeling left over from the scene, perhaps, but potentially summoned, if this was a man of affective memory—contradicting all of Nik's teachings—by my arriving arm-in-arm with dear Daphne, and ending up the same way with her again. Perhaps it was fortunate I was being dragged away. Yet now I found myself detained by Alice, and worse, Nik had staked a claim to Daphne, making sure she didn't abscond from the set. Alonso smoothly closed in on me, and it was only just before he reached me that Daphne interceded, hugging me briskly, which provided me some protection while also appeasing him, as this particular hug had a perfunctory quality, the quality of a farewell. It stung me.

Ultimately it fell to Jeff to chaperone me back to the city. Daphne had a quick, quiet conversation with him and gave him, along with the keys to the BMW, a version of the hug she'd given me. Why not? Wasn't he also an ersatz romantic interest? Shouldn't he be expected to bear the same humiliations I did? But then, the embrace she'd reserved for Alonso—had it really been of a higher grade? Or had it condemned him to the same dismal plane as Jeff and me?

"She told Alonso you had somewhere you *had to be*," Jeff said once we'd closed the car doors. He turned his head, put his arm around my seat, and reversed from the grass onto what was little more than an organized collection of stones. It felt sardonic, this hugging of my seat after saying those words. The derisory chuckle he finished with, once he'd returned both hands to the wheel, reinforced the impression. He put the car in drive and we twisted through the grasslands, the road disappearing again in the tall leaves lilting on both sides.

"It's true, in a way," I said. I had to be *somewhere away from Daphne*. Jeff had no response to my explanation, other than looking me over as we drove—excessively so, really, on such a curvy road. But he couldn't help it. If he were me, I thought, he would have lied and made up some obligation he had to fulfill, even if anyone could see he was lying. Fundamentally, he was impressed by my honesty, to a degree only a man used to a lifetime of equivocation and indirection could be.

"She's pretty hard on all of us," he said. He took off his sunglasses and set them in his lap and then pinched the bridge of his nose, closing his eyes while zipping along at fifty miles an hour. I would have preferred him to have this emotional moment some other time, either before we'd gotten into the car, or after he'd dropped me off.

"She was mine for a while, you know," he said.

I did know that much; it had to have been so. The question was only of *when*, and he divulged the answer swiftly. A year ago, they'd more or less moved in together. Now she'd drifted into Alonso's hands, the new star of the company, this Spaniard with a sterling pedigree out of Bogart's renowned SITI company. Nik didn't care for Alonso at first, didn't think much of his audition, where he ironized a monologue from Pirandello, a master ironizer already. Others had to convince the director that he was worth it, including, foolishly enough, Jeff, who mostly found Nik insufferable, and not much of a teacher. Nor was he much of a writer—even the title of the film was going to be decided collectively—though he did *engineer* a lot of words for the troupe.

The school used a highly self-directed approach derived from the model of an elder Volger, a director and teacher in St. Petersburg.

Nik's own gift, Jeff felt, was knowing what was most wrong with an actor, even a talented one you'd think had hardly any flaws. He could smell bluff like no one else, which created resentment and antipathy toward him, until his charges managed to turn things around, see things afresh. It's why everyone had been so uncomfortable on set. Did you notice that? Jeff asked. No one ever feels safe around him—Nik loves to say that. If he has a unifying technique, it is fear: the Volger School of Fear. He didn't accept the notion of unencumbered acting, the freeing up of instinct so popular in other quarters. No, he preferred

an atmosphere of anxiety and even mild paranoia, so that his actors ended up discovering their faults before anyone else did.

It was the funny thing about Nik's style, Jeff said. In the beginning he could really only seem a tyrant and a scold, but in the end, if you lasted long enough, he never gave you an order. He hardly even looked at you. It's why he barely spoke to his best students, the ones like Elias. You could have mistaken this for coldness or disgust. It was in fact the highest praise he knew. He might take the same approach if he thought you were about to turn the corner on your own, even if you'd only just joined the company. It's why he'd refrained from saying anything while Alonso destroyed takes one and two with his mistakes. I'd barely noticed him perform, myself, which was a shame if he really was as brilliant as I was hearing. I'd been consumed with Daphne, whose pull on me was so strong, it had compromised my grasp of the scene in the clearing, including her co-star, The Great Talent. Yet I wasn't sorry. The more time I let my eyes roam over Daphne, the more of her I salted away.

We emerged onto smoother city streets. It all would have been quite romantic, this drive, as the sun fell, had it been Daphne at the wheel. Jeff must have been thinking the same thing. He put the top down; he seemed to know this car well. Maybe he'd pretend I was her the rest of the way, with the wind mussing my hair, obscuring my face out of the corner of his eye.

"Nik's banned her from leaving the premises," he said.

So Jeff *wasn't* going to pretend.

"We're all staying out there in a country hotel. I think it belongs to one of Nik's patrons. So we've got the run of the place, while we're filming by the river. And we'll be there as long as it takes: at least a few days, and probably more, with all the funding we have."

We shot through Lincoln Tunnel and bore down on Times Square, where I'd asked to be dropped, so that I might walk to Bryant Park and the Library, seeing what I could see, meditating once more on my own drawings colonizing midtown, and considering, too, what Daphne might be doing tonight, and for the nights that followed back at that New Jersey estate. As we swept past the last several blocks, I considered whether Jeff felt he had any chance at holding on to Daphne, which would mean winning her back from Alonso and fending off my challenge as well. I thought he might comment on the pictures of Daphne popping up here and there on placards and billboards as we approached the center of the city. But I got nothing out of him. It probably just put him in a bad mood, seeing the vast opportunities I had to impress her. I had the city itself at my disposal, after all, where he had nothing much at all.

The more I studied him, the more wilted he appeared. Alonso and I weren't his only problems, it turned out. Nik never slept with his stars, Jeff confessed, but he had a way of warping their lives. He was good at denying them the things that might bring them peace. He was that wicked. Although he did offer reasons: he needed their unhappiness, Nik once said, when he was crowing over Daphne's starting to see less and less of Jeff. Nik was saying to me, *Oh, how she loves you so, but cannot see you.* The director always thought Jeff had been slightly forced on his troupe by Daphne and her link to Garrett, even if Jeff had proven his light-design bona fides during his tenure. There was a grudgingness to Nik's treatment of him; he liked to torment him when he could.

Garrett, whom Jeff had been working with for years, was yet another problem. Apparently Antral's chief hadn't appreciated Jeff's getting mixed up with a young woman who was effectively the boss's niece. Once Garrett understood the depth of it, he reduced Jeff's role at his firm, though he was still involved in testing some of the reflectance properties of Arête's fabrics and tapes. They had an eye-black, for instance, that acted like a singularity, so far as its light-grabbing properties went. Lately Jeff was spending his time with Nick, digging back into the lighting and set-design work that had occupied him in his twenties. Though he was looking more and more like an old man, Jeff had found youth again.

Alonso's joining the company could actually be a blessing, Jeff said while pulling to the curb at Forty-First and Seventh. The actor was taking certain temptations off the table, putting Daphne out of reach, which would let Jeff get back in the good graces of Garrett. After all, without the obstacle of Alonso, who could say how Jeff might act? Maybe then it was all for the best, he said with a sigh and a snicker. I didn't believe him.

Jeff gazed at me too long and abruptly shifted his attention to the passenger door. I got out under the looming Renzo Piano tower of the *New York Times*, tourists taking photos in front of the paper's sign, while Jeff disappeared into traffic, sweeping past the Port Authority teeming with its usual hustlers, so much tamer now than the sort lurking here half a century ago, when the city hadn't yet been washed clean by capital.

43

Extraordinary messages arrived overnight—from that old country manor, I assumed, whatever was going on there exactly. They were tacit apologies, these texts from Daphne, first of all for their not being phone calls. But now, she said, she had to hide all outside communication from Nik, who was growing angrier with each new delay of his production, all of which seemed ultimately to flow, in his mind, from her still-unexplained European sojourn. Her messages to me weren't entirely insincere—I knew that—yet they also felt played for effect. She was *so sorry*, for instance, she didn't say more to me down by the river, that there hadn't been more time. But Nik was *fed up* with her! She'd been *all nerves*, too, about what I made of her performance with Alonso on-set. She'd wanted to know what I thought—*obviously*—but simply wasn't prepared to be confronted there and then. I suppose all of this technically could have been true, but it did seem very much calculated to assuage my fears. I'd only just been chastened by Jeff's terrible tale, after all, of a livelihood lost through entanglement with Daphne, and then of a slow climb back to respectability within the troupe, which justified all the jadedness now radiating from his well-clad frame.

Just like Nik, I was angry. I wasn't prepared to meet Daphne's alleged vulnerabilities with any of my own, or offer any appraisal of her performance, a refusal I knew would torment her in a way nothing else could. Nor was I ready to forgive the pre- and post-shoot attention she'd lavished on Alonso, or her neutrality toward me then, whether it was feigned, as she claimed, or not. (Was anyone *that* good an actor?) She pleaded with me by text: it was nothing terribly serious with the Spaniard; he was new to the troupe, a curiosity; it was only natural she wanted him to be comfortable. None of this corresponded to the impression I got from Jeff, who'd intimated that Alonso was unlocking something significant in her. In fact, this seemed to be Alonso's forte: he was known to have had the same effect on some of the members in his old theater company. How much could I really trust Jeff's version of things, though? He had plenty of reason to put me off the woman he'd already lost.

Everything was made more excruciating for me by the sheer pointedness of Daphne's performance on-set. In truth it had left me mesmerized, or simply confounded. I could think of little else now but the way she'd managed to navigate empty space, calibrating her body to the field of action, that clearing, the primordial stage of first rituals in the forest, and then throw off meanings like sparks with every glide and twist. Meanings she didn't control. It wasn't like watching a master technician match

physical gestures to inner states. No, she simply shaped the flow of these meanings transcending her intentions. They seemed to accumulate and bunch of their own accord, hinting at something patently human without relying on anything recognizable as *character*, free as they were of all the Freudian clichés that made us lose sight of our inner life just as it was: neither incoherent nor unified, neither discordant nor harmonious.

I suppose I'm saying Daphne's movements, and the rhythms of her speech, too, amounted to something more *and* less than character as we've come to understand it. There was no obvious sex in it, though she was patently dealing in feelings. There was no real lust in play, though there was the love between partners. More than anything, there wasn't much sense of an interior state being extruded into the world, never mind the words that had fallen from her mouth, which were familiar to me from earlier in the day, at her father's home. The very idea of *expression* lapsed with her. Most radically, during this performance, just a fragment of the full film, I'm not sure she was even coterminous with her own body. How to put it? She existed more like a field than a stone, neither a pure, uncontaminated surface, an uber-marionette or scenographic instrument to be manipulated by Nik, nor a self that had withdrawn, opaque and mysterious, that only interfaced with the world outside as necessary. *This* was what Nik was unlocking in her. Those meanings, those densities of significance and suggestion... they seemed, in that clearing, even without hearing a word of what she said, to whirl about her feet, her fingertips, her hair. And though she could influence them, bend them in some way, there was no question of mastery, only negotiation. She didn't interpret or portray a character, nor did she embody one, the two options Brecht had made so much of in his defense of epic theater. Here she was doing something beyond showing or telling. I didn't have a word for it. Did anyone? *Diffusing personality over space*, I suppose, with the entire clearing seeming to *absorb* Alonso, without destroying him either, at least not then.

It had all left me flustered and at a loss, so that I'd had trouble following Jeff's thinking on our way back to the city. Afterward, I loitered in Times Square for hours, watching men endlessly hand out flyers in the street for shows no one but tourists could suffer, before finally making it home and falling into a curious stupor, shot through with a longing I couldn't fathom except to say it was firmly directed toward *her* and the rest of the unformed film, two creatures I had only an inkling of, really, drawn from a future devoid of all our notions of identity, however many hundreds of years it would ultimately take us to reach the point they both gestured toward, a moment related to who and what we are *today* only by faint echoes and chasmic leaps of logic.

I could do nothing now but dwell on Daphne, worrying this strange absence—a literal absence, as she'd be inaccessible to me for a while. She didn't know just how long she'd have to spend holed up with the others in that swampy hotel, like one of those German spas buried in the Black Forest. She'd see me as soon as she could, though, she promised, ending her text, for the first time, with *x*s and *o*s. All I offered in return for her dozen messages was *Don't worry*. I would do the worrying. Really it seemed I was capable of little but worry and fantasy since I'd gone off the drink. What *was* it? The question called out to me incessantly now.

I'd asked Garrett more than once when the new formulation of Theria might be ready, but so far he'd managed to deflect my every inquiry into its arrival time and indeed into its nature. He spoke of Theria's *magic*, of the talent of his research team, but not at all about what this magic consisted in. There were copyrights to protect, of course. But I had to wonder whether there was more to it than that. Asking me to dump the stock I had, to wait for a new batch that seemed never to arrive, could only nourish my suspicions. Admittedly, my fears about what the nootropic had done to me, changed in me, had a tinge of absurdity to them. I felt fine enough to be getting on with things, didn't I? Yes, maybe, but I felt *different*, and sufficiently desperate about the matter to request a meeting with Garrett. Just as I had in his distillery, I told him I needed to steep myself in Antral's atmosphere, to sit with him and Paul, discuss our principals and our principles, too, if I was fully to fire my imagination. Nothing less would do. Every change in medium, or distance, changed the effect, I insisted. Garrett consented to the meeting while being vague about its timing: a display of the very reluctance that made returning to Roosevelt Island so crucial. Once again he claimed the new formulation wasn't ready just yet; once again he checked whether I'd stopped drinking the remainder of the last batch. It was all a little fanciful, I knew, showing up at headquarters and... what? Shaking my hosts somehow and snooping around for, well... what? Would these notions ever have occurred to me before I'd started drinking Theria? Had it changed me permanently in this respect, inflaming my fantasies? Or was this simply a protracted phase of withdrawal that I'd ultimately emerge unscathed from, fully in possession of my senses, my *self*? The most difficult possibility to contemplate might have been that my feelings were simply what reality required of me.

All week, another mission weighed on me. Perhaps my thoughts of subterfuge and intrigue in Garrett's labs opened the way to it. Whatever it was, I was now quite urgently feeling the need to test Daphne's regret about her absence, that is, to discover precisely how strict Nik was about exiling me and every other distraction from the set, and how much Daphne was simply avoiding me. *Couldn't* I sneak a trip into those woods? I could lurk and leer from, what, the gas station? Immo would

drive me. Actually, it would be good to have him along. He'd never made it out to Chicago, and this would be more his sort of jaunt, with a girl at the center of it, and plenty of leering.

The day after Duke's suspension was handed down, on a Friday, he'd spoken about it at a press conference organized by the Bears, with Cotter, normally media-shy, by his side, perhaps to deflect some of the pressure. I tuned the plasma to it. The receiver was dressed tastefully, unlike so many of his colleagues outfitted in bright, shiny fabrics and fashion-house shoes. He had a prepared statement before him, presumably drafted by someone in the front office. He read the first couple of sentences, the usual throat-clearing that traditionally came just before the plea for clemency or the acceptance of punishment. An abrupt pause ensued, his mood visibly changed. Though Duke's eyes remained on the page in front of him, you felt he saw nothing there anymore. Cotter was stoic, waiting. Finally Duke began to speak, this time more slowly, with the natural syncopations of spontaneous thought replacing the metronomic pacing of a PR script.

"What I did on Sunday, it was... strange. We all know that much. Coach knows it better than anyone. I need to think about that, what transpired on the field that day. And I'm going to have the chance to do that for the next four games. That's a lot of time. I didn't expect that much to be handed down. But I'm not going to appeal the commissioner's decision. It'd be a disgrace to, I think. It would take time away from coming to grips with the events of last Sunday."

Cotter grasped his receiver's shoulder and nodded, as large a sign of support as he was likely to give.

"Events that seem, honestly, like they're from another world," Duke continued. "*Where* is that world? *What* is it—what's it made of? How can I make sure I never go back unless I know exactly what that place is all about? It'll take four games to figure that out. How to be a Bear."

He smiled inappropriately, pleased with his wordsmithing when he ought to have had other things on his mind, like blood and bodies and simple decency. Instead he gave us an almost mystical speech about the "world" from which this sort of behavior issued, a world he couldn't renounce until he knew just what he was renouncing.

The press corps, so used to tossing out questions they already knew the answers to, was too stunned by Duke's pronouncements to speak. It was all so far from athlete-speak *or* corporate-speak. Even Cotter didn't know what to make of it. Eventually questions began to take shape on reporters' lips, but by then Duke had hopped

off-stage, his side-vents flashing as he walked off, leaving Cotter there staring at him from the podium, shocked like I'd never seen him.

I found out Duke was no longer a Bear through a picture of his empty locker on the *Chicago Tribune*'s website. After gathering myself a little, I called him up, but there was no reaching him. Garrett tried him, too, even through the Bears, but without luck. It was enough to kill off Garrett's exclamation points and send him careening into fear and doubt with the rest of us over where we were all heading, particularly now that we were finally starting to make the link to Duke manifest in my pictures.

For days, I kept trying Duke's phone, leaving him messages in all sorts of tones: facetious, philosophical, funereal. All to no avail. And every day, Garrett was on the phone with me. We never usually talked this much, but now he demanded to know where Duke was (should I know?) and what we ought to do next. Paul and Karen grew increasingly exasperated, as if Garrett and I bore responsibility for what was happening, which was absurd. In no way had we egged Duke on, even if we had given him a vessel in which to pour his dreams and keep them safe, which might well have been too much for *anyone* to manage. It's why public figures came apart so grandly. Having that megaphone in your hands, you had to go mad at some point, screaming your lungs out.

Eventually, I heard something, or saw something: a photo of Duke. I thought it was him, anyway, but I couldn't be sure, since I recognized neither the person in the picture nor the phone number by which the likeness had come to me. There was a syringe buried in a muscled black thigh, flash-lit and falling into seductive shadows on all sides of the frame, so zoomed you could see the follicles, the way the needle itself appeared to plug one of them. It was just a joke, Duke said when he called a bit later. Although it *was* him.

"If Cotter's going to cut me, shouldn't it be for the PEDs?" I laughed for his sake, just to keep him on the phone. *Were* PEDs involved, or was he playing with me? I couldn't get into that right now. I was happy simply to find that he still existed, which meant my contract with Garrett did, too. "I'm giving up the apartment, man." There was that manic laugh again. "You hated it anyway, though, didn't you?" There'd been no signing bonus, he said. No real guaranteed money either in his 460K contract. "Do you know where I'm calling you from?" My own city, New York, it turned out. He was at a hotel downtown, nothing too stylish, yet the little money he had—that he'd not already spent on extracurriculars with his boys—would go fast.

I hurried downtown, overjoyed to have *someone* to trail, now that Daphne would be off-limits to me for a while. The place was near the tip of the island, where the

buildings got prickly and the lanes narrowed uncomfortably until you felt you were on video-game terrain. The hotel—he'd only given me the street address—was actually quite luxurious, abutting Battery Park, not far from the water glistening icily in the pure fall light.

He met me in the foyer in a tight tank top, wool trousers, black Aldens. Though he'd been laughing on the phone, cheerily inviting me down to see him, there was an air of menace about him. He always carried some menace, of course, but usually it was more equivocal, which could frighten you in the best way. This was different. His darkness couldn't have been clearer, and the mad happiness I'd felt on my way over curdled into caution on seeing him sit down at the house bar, which was just a continuation of the front desk and lobby—all roads naturally leading to alcohol in the hospitality business.

Before I'd even caught up to him at the bar, Duke fired off a question: "Does the boss want me out?"

"He wants to know what's next," I said. "But I'm just thanking God you're back in touch."

He got orange juice—*not* a screwdriver, just juice, he emphasized. Karen had once explained to me over brunch, I replied, that orange juice was the purest of marketing inventions, a way to dispose of surplus oranges around the turn of the twentieth century. I thought it relevant—weren't *we* technically trying to sell drinks, even if we didn't know of the surplus we were dealing with?—but Duke wasn't in the mood. He ordered me juice as well and nodded at me as if *I* were the deranged one. But could I be sure he wasn't right, post-Theria? I flagged down the bartender and he tipped Stoli into my juice. It was the only way I knew of quelling my doubts these days.

"I've got to see if there's another team. Freddie's been looking and no one's calling him back." Duke mustered a weary little chuckle and got the bartender to convert his drink into one like mine. It might settle both our nerves. "You have a bad game, right? You speak for real at a presser, okay? And they toss you the fuck out."

A "bad" game? He couldn't really have believed this.

"But whatever—do you know what the Cal man's going to put up next?"

I did know, in fact. I'd been working on various ideas all week. Paul and Karen had just told me of the one they wanted to use, a quite fragile line drawing of a man spitting cloudy blood.

"It's not a picture of you, *per se*."

"Is it one of the guys I hit?"

"Not that either."

"And why the fuck *not* make it me, though? Why can't we do the needle in the thigh at least?" he pleaded. "But you've *got* to put me on display, somehow. Show them. Because, well, how long is it till I disappear, without football?"

"Cotter wouldn't have signed you if you didn't have something serious going for you. It'll trump everything. Freddie will figure it out."

"I went in for this, being Arête's guinea pig, this urban renewal wet dream of your boss'—I mean, we *know* this shit never works. You can't plan, you can't have *projects*, even when they don't look like the old projects. Did he not get the memo?"

"You're not a fan of what I've done with you, I guess."

"Actually, no, I am. I am. As much as people would have me not be, that it's too racist or whatever. But that's not it, not all of it, for me. Garrett's paying me fine, but the way I get my next gig, whatever it is, to get that gig, I need to be *revealed*. You understand that? How're you going to buy something, even a person, you can't recognize? That's how I fix all this. Teach a man to fish, right. So yeah, why *the fuck* not make this next one me, clearly me, Duke Briar Jr. Start the goddamned bidding."

The way he'd said his own name saddened me. There was an uncertainty to it, about the value of the man so named. We parted on that lugubrious note. I ambled along the water.

"What about clearing away enough of the blood, thinning it out a little, so we can ID him?" I asked Garrett over the phone about the upcoming piece, in the car home. Not only, he rejoined, was the needle image not smart, it wasn't even interesting. He might have been right. Yet he had sympathy for the modification I suggested. As soon as I reached the Bronx, then, I began to adjust the picture still sitting on my drawing board, applying turpentine to the encrusted, fire-red paint Duke's face was laden with so that it slowly lost its opacity, its density, and became workable once more. The visage beneath the blood-paint began to dissipate, too, of course, and so I went about retouching the hatching and contours with firm strokes. In the end, even if he was badly savaged, Duke—it was unmistakably him now—appeared calm and graceful in the thick black turtleneck I'd put him in, the kind of thing you might see in, yes, a post-game press conference. The shirt seemed to strangle him, as Cotter had.

When the picture made its appearance on the streets of New York about a week later—this was the sort of dizzying speed we were able to work at now, because of Paul's careful planning and Garrett's bottomless pocketbook—Duke's notoriety, as he'd desired, was more or less instantly established, given the broad discussion over gratuitous violence his suspension ignited in the sports world. Garrett hadn't minded the revelation, because nothing yet was linked with his products, so any mixed message the image might carry couldn't touch his reputation. In fact, no one yet knew whether what we'd been doing to the city through October and November

was an art project or some sort of stealth advertising scheme, which pleased Garrett to no end—the questions he'd made loom over everyone.

The picture quickly did something for Duke, too: his newfound infamy might have more value than any positive appeal. Athletes frequently didn't mind playing the villain: just in basketball, there was Kobe, Lebron, Jordan. But Duke, he was *being* the villain. You could hardly claim, after what he'd done to his opponents' faces, it wasn't really who he was, just a posture or a character. This would be the equivalent of players like Albert Haynesworth or Ray Rice or Greg Hardy positively celebrating their own NFL misdeeds and ill repute, enjoying the scandal. It was genuinely unprecedented.

My picture certainly didn't parse itself. Did the blood on Duke's face imply regret? Was it just narcissism? In their weekly pieces, the sports columnists had begun to dissect my images like art critics, and they treated Duke as if he were still an active player. He was getting more coverage than anyone on the Bears' roster, that was certain. There was, of course, a history of athletes making more of an impression outside the league than in it: basketball had Stephon Marbury, the point guard who became a kind of American deity in China, complete with operas about his well-documented travails. In football, there was Johnny Manziel, aka Johnny Football, the Heisman-winning Texas A&M quarterback who appeared, for a time, to have the most charmed life in America, before the NFL snuffed it out—the charm, if not the life—over a pair of seasons. The press, perhaps, was sensing this sort of story with Duke; they were going to get their fill of his eccentricity, even his malevolence, so long as it lasted, which generally wasn't long, not in professional sports. As Manziel learned, if you couldn't reasonably compete at the highest levels, your relevance faded, interest waned. This was the bracing objectivity of athletics: you couldn't be permanently famous simply for being famous; you had to be *good*, at least in flashes. And for the moment, Duke wasn't even on the field.

44

"Still nothing, no contract," Duke croaked.

How could there be, I thought, given the way we'd—I'd—ambiguously amplified the spilling of his blood in the last picture?

"I don't think there's *going* to be one, man. That's what Freddie's telling me." His voice had lost all its usual poise; the would-be cult icon had been laid low by his own antics. Now he was nonplussed and raw. "But you know the white boy I stepped on, Wickes?" This was his first mention of the cause of his trouble: the act he'd committed. "Do you know the kinds of things he says out there on the field? Do you know the texts I've gotten from other players about it? Black ones, all of them black? They say I'm a *hero*. One of them called me a martyr. And your picture, this one with the pool of blood hanging over my face..."

I braced for what he'd say. He hadn't wanted to see my work ahead of time, which was perhaps a sign of his derangement. He wanted to confront himself in the street.

"It really is... it's... majestic. It is. And did that make things worse? Is that why they're calling me those things in the news? But I can't take any of it back. There are things that are bigger than any game. And *aren't* I getting seen now, coming out into the light, even if nobody understands what the hell it is that's in front of them?"

"Maybe a team will still call, though," I offered. "People go down all the time, blow out a knee, you know that. Principles don't count for much then."

"But I can't be waiting fucking praying, begging forgiveness just for evening things up with those guys."

I wondered how Duke explained the *other* transgression to himself, though, the jaw-breaking block he used to lay out Keller, his fellow African-American, when it seemed his anger should have been directed at the Bears' quarterback, Skovsky. Shouldn't Duke have ruined *his* jaw, not Keller's?

"Freddie's saying he might have found something *else* for me, though. That we should put football on the shelf for now, until, like you're saying, someone tears an Achilles or something."

"What else *is* there?"

"You're not going to believe it."

"Probably not."

"He's a big thinker, Freddie." Duke's confidence was returning, his voice was soaring, but there was something frantic in it now, unsettled. "And I want to keep this goddamned apartment. See, I couldn't give it up. I couldn't. My mom even visited."

"I just assumed you were still around in New York, with Bryan."

"I've got a lot more time for my Chicago boys now, you could say that. Remember Anthony? Eric? Got some of them crashing with me up here, too. *They* won't let me give the place up."

They were dependents, it seemed, children Duke felt a certain responsibility toward. I had to admire his sentiment, even if it was lunatic.

"It's good for all of us," he said, "getting back down to things. But that isn't what I wanted to say. I'm talking about Freddie, my personal genius. The phone hardly rang—we got a couple calls from the commissioner, from the head office, but those were calls we *didn't* want. But then Freddie, God bless him, he reminded me of something: there's more than football in me. Way more. And he didn't mean there's more to life than sports or some horseshit."

Hadn't Duke himself just asserted this same idea, though?

"Remember I told you I used to play a lot of things in college? I was good at a *lot* of things."

"So what? You're going to pull a Bo Jackson?" *Of course* he was, I thought. It felt as though nothing were any longer unimaginable to me. Should I be grateful to Duke, to Theria, whichever it was, maybe both, for this new sensibility?

"I wish. I can't hit a fastball for shit. Hardest thing in sports, right? But one thing I can do, maybe this won't surprise you after what happened on the field. I *can* throw a punch."

"So MMA? That's—"

"I'd never do that."

"Good to know."

"But boxing—"

"*Kimbo fucking Slice?*" What had happened to me, to Duke, to all of us, to bring such convolutions into our lives? I was gloriously reeling.

"I'm *good* at it, though. He was just a fat fuck who should have never stepped into a ring. He didn't know what he was doing."

"Fighting in boat yards on YouTube is one thing, but I saw Kimbo getting his ass handed to him by third-rate pros several—"

"No, no, you're not listening. I'm *technically sound*—not some simple Mr. T-looking nigger with a glandular problem."

"Sound for college athletics, though."

"I'd hardly got started and I was nationally ranked. So *fuck* you—fuck that—straight *sound* is what I am. And damn good on the street, too. That's still something. I knocked bitches out on the Lower East Side, just like Slice. And he collected some pretty heavy checks in the ring, *getting* knocked out. You know that, right? That's what gets slept on."

"Kimbo was a stuntman. And didn't he die of a coronary at like forty-five, anyway?"

"That had nothing to do with fighting. That was cheeseburgers and shit. But you know what? Except for the dying, I wouldn't mind being Slice. A Super-Slice. I could try that on for a minute, yeah."

"Oh?"

"Like I said, I've got skills, not just heavy hands. And I've been trained by a bona fide New York legend. Ever heard of Anton's? The gym? Of course you haven't. Kimbo was a meathead, and I'm a poet. You should ask Bryan. I almost brought out my skills that night on a nigger of his that was giving *you* trouble, but you were too fucked up to notice."

"What does the street matter in the ring? Or fighting with all the padding around your head in the amateurs? And anyway what does Freddie think you're going to get *paid*, boxing in some Mickey Mouse club as a circus act? Look, I know you want to keep that apartment, but until he can sign you for football, maybe you've got to let it go. Or just ask Garrett to float you."

"I *knew* he was your sugar daddy. But you don't get boxing, that's all this means, man." He was calm. Maybe he knew something.

"And just what kind of agent—"

"For half a second, you could shut the fuck up. You really could. You can do it. I am getting—with your help—*known*, right? Like in college, but nationwide now. Boxing is not a regular sport. Maybe it's not even a sport. Fights don't get made because you're so damn good, or ranked so high. It's about how many people you can get to watch you, how many pay-per-view buys. You understanding me? We're talking *spectacle*, with a little bit of sports sprinkled on top. Real Situationist shit here, okay? I know more than you think. How do you think a guy like Don King could have run the thing for so long back in the day? And with my time as an amateur, Freddie, he knows the kind of guys—I love him for this—he knows the kind of guys who could maybe set something up. So it does matter. And your pictures matter. Every one you put up, it matters more and more. *You're* making this all viable, you get that? So excuse me for reaching here. I could just be some contender's tune-up—that's fine. You can still make a quarter mil that way, maybe more."

"How is this not just reality TV, Duke?"

"Or just reality, fuck the television."

"You really have the perfect agent."

"Well, he's looking for a payday. Just like me. You. Whoever. The white bitch actor you fucking, too. We all the same here."

"You haven't thought this through, Duke."

And that's when the line went dead—probably a nicer sound than anything he was going to say next.

Wow was the first word I got from Garrett—the only time he used the word, I believe—when I told him how things stood with Duke. *Wow* was how I felt all the time now, really, though the overlap between the amazing and the despicable was great. Flustered, naturally, Garrett and I met soon after in midtown, at a coffee shop in the dungeons of Rockefeller Center. He'd just had Antral business down on 43rd Street, a cold and sunny plaza-bench meeting in Bryant Park with several leading petroleum suppliers from South America. He'd walked them back to their hotel near the Rock, he said, sorting out the supply details along the way. He put all this to me plainly, to show me, I think, that he wasn't interested in making any secret of his *other* business. The more he appeared to hide, he knew, the more I would try to dig things up. Better to present dirty hands so that I didn't go looking for more. In truth, I hadn't been looking all that hard since finding out about JG Chemical. I don't know why exactly. It didn't capture my imagination, I suppose, not with everything else that was afoot.

I was meeting Garrett because of Duke, of course, but not *only* because of him. There was also the matter of Daniil Trifonov, playing Scriabin and Prokofiev sonatas at Carnegie Hall in the evening. Garrett was lending me his usual seat in the first tier and I needed the ticket, an old-fashioned paper one. It was a night that would deliberately have nothing to do with anything. So *much* was going on now, so much was uncertain, I was badly in need of an uninflected stretch, even just a few hours.

The perks of the job *were* piling up, though. That much I had to admit. The way he ran things, Garett always had enough to be sorry about, and his apologies, however insincere, were always worthwhile. And so the gap between desire and reality had been steadily collapsing for me, with everything seeming to occur with less resistance, so that there was a new ease to my passage through the city and the world. Indeed, as John put it, after I'd wished him well with his mother, I was conducting myself with *the glide of the rich man I was always meant to be.* I'd certainly gone far past a standing Uber—though even on that score, how long had

it been since I'd gone down into the tunnels like a rat? How quickly I came to scorn the trains, and underground Helena, too, pretty much as soon as it became possible to conceive of a life that didn't require them.

I was also buying up endless stocks of luxury art materials: the kind that lesser artists obsessed over, not unlike those writers who buy two-hundred-dollar calfskin notebooks of the purest rag only to fill them with flea-bitten prose. But things were different now. I was buying *everything*, without any preciousness, with any discrimi-nation, really, because it cost me nothing. I hoarded away most of it in my apartment, for leaner times, when I was no longer with Garrett. (I was already imagining the day he'd spring it on me, my termination, as he had with Jeff, if I didn't quit first. That's just who he was.)

There were also plane flights on offer, going anywhere I wanted to, if I thought it might inspire me: up to Albany or New Hampshire to follow Daphne into the countryside, say, or else to the Bay, where I'd not been since my father recovered from what was described as a minor vascular event, two years ago. Or even all the way to Jakarta, Garrett promised, the last known location of Claire, who'd traveled there on a three-month residency, I didn't know with whom.

Rest and recreation were provided for as well, to keep me fresh and prepared to deal with headcases like Duke and Daphne. Concert tickets like tonight; Knicks tick-ets, choice ones, thousands of dollars' worth, though I wasn't the sort of fan interested in seeing a sub .500 team flail just for the sake of saying I'd spent the night at the Garden. It was only a matter of time, I could already tell, before Garrett offered me boxing tickets, to prepare me for Duke, just in case the receiver turned his ludicrous notions into reality. Probably after Garrett finished his coffee, he'd open up his jacket and pull out two tickets to a title fight in Vegas. He had access to so many things he didn't himself partake of, which might have been the signal measure of his power: to sit before a feast and toss everything to the dogs.

Naturally I would take those boxing tickets; I didn't mind being a dog. In fact, if I had true love for any sport—and maybe I didn't—it was actually boxing. That's what Duke didn't understand about *me*. I'd followed it in some way my entire life. Even the undistinguished fighters interested me, since almost any fight contained the possibility of the highest drama: someone might die, or at least end up on artificial respiration. Bringing those same stakes, that same feeling, into a football game, was grounds for suspension or worse. But in boxing, no one would show up if you didn't leave room for death. It's why amateur boxing, like flag football, was more or less unwatchable.

Most grand of all the perks, the most intimate, too, was Garrett's standing offer to scale up my living and studio conditions. He'd said from the beginning it was about

guaranteeing the best work from me, but there was clearly a paternal element to it, which I didn't yet know how to feel about. He was mentioning the offer more and more lately; for all I knew, he might have been trying to make me more dependent on his largesse, like a true procurer, so that my abandoning his campaign would lose all feasibility for me. Still, looking around my apartment, listening to Tanya crying upstairs three times a week, I had to consider it. Sometimes motives don't matter.

My benefactor had been ramping up the spoils in precise proportion, it seemed, to the growing thorniness of the campaign itself, systematically offsetting the distress it was causing me, especially now with my fears over Theria's side-effects, so that my life remained, on balance, no more vexing than before. It was just that the precise place of distress in my life, the corners it forced itself into, was shifting.

I'd thought Garrett had meant to meet me at the bakery on 49th Street. It was quite nice, an airy enough place. In fact he had a hankering for the restaurant underground, within the Rock's bowels, flanked by all those national brands in identical storefronts, laid out in such a manner that, unless you were down there daily amid the perpetual whirl of people, it was almost impossible to orient yourself. I had nearly acquired this quasi-skill, which was closer to an adaptation to adverse conditions, when I'd worked in the neighborhood at the offices of the Carrington. I'd decided not to pursue mastery.

In fairness, the Rock was one of the few economically sturdy community centers. But the price had been high: it was utterly faceless, an illimitable chain of chains appropriate only to the sorts of beings who were absent from their own lives. Fortunately, that's just the sort you got there, either those peculiar midtown workers who managed to be intelligent and well-dressed while also void, or the tourists who crawled around the place thinking, I suppose, it had some meaning to New Yorkers, though I'd never known anyone who didn't work within a thousand feet of the place ever consider going there unless someone else dragged them, as Garrett had dragged me.

At least it was quieter now, later in the day; navigating its frenetic crowds was less treacherous. Yet it remained crushingly dark, so that it took me a while to find Garrett sitting alone at a corner table, looking upbeat, somehow, while things were going so poorly. Perhaps this was the only way through it. Or maybe the South Americans had good news for him, for Antral, the indomitable portion of his business.

Garrett took his coffee black, he told me while I got myself an espresso, the first of four. He was certainly no utopian when it came to health, though. I never saw him order anything organic or gluten-free, and when his coffee arrived, I was surprised to see the drink remain liquid under the conditions he created in his cup, shoveling in sugar—the classic, highly-processed sort, sparkling white—with a teaspoon. No

stirring, either; he said it affected the texture. Periodically, throughout our conversation, which spanned his business meeting in the park, Trifonov (he'd heard great things, but hadn't heard him), and the sad and silly news regarding Duke, he tossed in little half-spoons of sugar and silently mouthed the word *wow*. Nothing could stagger him; he might have been more unflappable than Hasan. Was he almost pleased, I wondered, that Duke's life had been further bent out of shape by events, and his own misjudgments?

Garrett set down the spoon and smiled broadly when I finished telling him about Duke's scheme. "Think Freddie can pull it off?" The admiring look he gave me then felt as though it might really have been intended for Duke's agent, but I was the only one there. "Boxing is a free-for-all, in some ways. I don't follow it closely, but Tony does. It's been hurting for attention for years. So... you just never know what can take off, or how. Aren't you and I trying something pretty strange, too? Someone could find it bizarre. Some do, I'm sure of that. But that doesn't stop *us*. So let Freddie have a crack at it. Why not? I don't think he's doing much else with Duke these days."

How many cups of coffee had he already had, for him to speak this excitably—and this emptily? I know that he never finished the one in front of him then; he didn't even drink enough of it to expose the white mountain below the surface. As we parted, though, he planted the spoon in it like a flag, so that it stood straight up, as if to prove a point.

As I walked up Sixth Avenue, ticket in hand, I realized I forgot to ask Garrett about my deepest worry—the new Theria, and when it would come. Evidently other concerns were dominating my mind. In fact, I couldn't help thinking, with half-an-hour still to go until the concert, how immensely bothered Garrett had been by Duke's disappearance just days ago; he'd become not just angry but desperate, something I'd never seen in him before. Yet now that Duke had surfaced, the player's travails, which were no less real and deep and urgent than they'd been when he was missing, didn't seem nearly as vexing to Garrett as they ought to. Could it be he'd come to believe that somehow everything had to work out for Duke, that he was never in danger? Was Garrett so confident in his own campaign, his *influence*, that he thought he could resuscitate this black man's fortunes whenever he chose—and even through my work? It was the kind of arrogance, a gentle and benevolent one, you couldn't put past Garrett. There was an alternative, and it was differently troubling. Could he have been at peace with Duke's perturbing trajectory, so that the only outcome he couldn't accept, at least not until Duke had dropped off this world, probably in some ghastly way, was losing sight of him?

There could be no question of simple callousness or perversity, though. Garrett had shown too much regard and tact toward too many people to consider

that idea, starting with Paul, who with his constant carping put himself in a position to be undressed almost every day. Yet most times Garrett would just laugh it off like a country gentleman. And then there was me. He tiptoed around anything having to do with the subject of the pieces that had first drawn him to me: Claire, someone whom he'd even met and might conceivably have something to say about. If I knew anything about him, he would have hungered for so many more details about her. He was a man of science, always searching for data, even if he did it in unorthodox ways. From some of the things Karen had let drop over the last couple of months, I knew he'd pursued with her some of his questions about Claire, presumably not to understand my ex better, but to understand *me*, how I might be expected to react to the vicissitudes of Duke and Daphne's lives—and, I assume, his own maneuvers.

I thought as well of the way Garrett pretended, each time he came to the Bronx, not to notice the increasing shabbiness of my apartment, when a man of such discipline and order had to have found my quarters obscene, especially now, given how claustrophobic they'd grown, stuffed as they were with all the materials I'd bought at his expense, most of which had little to do with his project—although I was at pains to demonstrate otherwise. He chose not to trouble me over it. The nausea he must have felt only induced him to remind me how I might set myself up in a larger place, presumably with housekeeping, too, if I'd just give the word.

You know, he'd say as we shook hands on the crumbling curb outside my townhouse, I think we should move you soon, to the island, how's that suit you? I'll keep you away from the tech campus and the bureaucrats, he'd add, as if I must have feared that more than anything. And maybe I did. Maybe Garrett thought that no bad end could really come to me either, so long as I was in his employ, which is to say, under his wing, and it might have been in this spirit that he'd offered to house me.

Trifonov was baleful and listless that night, lacking his usual abandon, and Scriabin demanded heat if nothing else. Was the pianist simply growing older? Was I not much of a listener, now that Garrett had poisoned me with his concoction? It'd been years since I'd seen the Russian; the first time it had been Liszt, and it was marvelous—so good, in fact, painting had seemed pointless to me for days afterward. Today the effect was reversed, so that after arriving home, I turned immediately to what was on my drawing board: Daphne holding the film script in her apartment. It was a point-of-view piece, and the viewer occupied my position on

that afternoon at her father's home, sitting on her bed. Another work-in-progress sat on the desk. This was proving the hardest: Estelle in the clearing, with Vincent nearly lost in the distance, but framed by her hand whipping up dismissively at her shoulder, creating a porthole, like a Georgia O'Keefe pelvis, through which the disconsolate man could be seen. Vincent might as well have been me. Estelle had been taught a certain playbook. It would be difficult for her to become more congenial; men would bring out the worst in her to the end of her days, that's what this casual swing of the hand told you. Of course, that was no less true of Daphne. Maybe it was *more* true.

45

The absurdity of Duke's "plan" wouldn't leave me. At every moment I felt a little like laughing and a little like quitting. What were any of us going to get out of pursuing him at this stage? Paul wasn't a fool, and neither was Karen. Still... if Garrett could convince our team, with a straight face, that this stunt was the right move, and what's more, if Freddie could actually pull it off—I'd known he was powerful, but surely there were limits—then what grounds did *I* have for protest? Not that I necessarily wanted such grounds, not all the time. While the Chicago apartment remained in his hands for now, Duke had come to stay in New York with Bryan, even after his old friend's mother had returned. Here he was sheltered from the sportswriters of Chicago, who'd been hounding him from the start, and from his parents, too, whom Bryan's mother kept bringing up. How long had it been since she'd seen Sheila and Dante? And how were they all doing now in Chicago?

Before any fight was made or even on the horizon, Duke embarked on the brutal training regimen of a boxer in camp, far more vigorous than anything football players endure. Who would train *this* hard on a lark? I wondered. He must have been serious in some way about his fantasy. In any case, I thought, training would keep him in football shape for whenever the tryout eventually came, post-suspension. It could only give him confidence. But what if Freddie, by some miracle, *did* figure something out, and somebody bit because of Duke's 14-1 amateur record, and moreover, because of all my pieces around town, which guaranteed a certain interest, whether it was rooted in sports, spectacle, or would-be celebrity schadenfreude? In that case, staying in New York really *did* feel like Duke's only option. It was here, I knew, where he'd first boxed, at the downtown gym he and his older brother used to frequent, together with friends from families with far less support. And it was here, I would learn, that he met Anton, a fighter-turned-trainer from Belarus who'd had a small amount of success at welterweight, and who in his retirement had developed a stable of successful amateurs, a few of whom had gone pro and surpassed him handily, winning belts at flyweight and bantamweight. Anton frequently trained immigrants from former Soviet states. His first gym had been in Bay Ridge, but success made a Manhattan branch viable, and that's where he started training non-Slavs, and, exceptionally, blacks and mestizos who showed first-class promise. Anton had once declared—and Duke remembered it vividly: "I can train you even still."

One night Duke excitedly called me down to Anton's Chinatown gym, his spirits lifted by the fact that his suspension hadn't cost him his place in Garrett's campaign, or the money that flowed from it. (How much I was never told; enough, I suppose. Garrett was floating everyone around him.) The gym, being wedged between bakeries, had the smell of pork bun hanging over its entryway, and even deep inside, all the way back to the locker rooms, the aroma of roasted meat persisted, though perhaps it had complementary sources within, all the flesh roiled and pummeled there in the rings and on the mats in the broiling heat.

"Most of the great fighters train out west," Duke said when I met him in one of the physio rooms. "Big Bear, or Oxnard, or LA. Some of them go out to Colorado, for the altitude." He was straddling a long bench of a light wood polished to a shine, and having his hands wrapped by an older man: Anton, I presumed. The Slav eyed me briefly, his lids half-closed, while rhythmically weaving the cream line of gauze around Duke's hands, through his fingers, in a pattern he must have mastered decades ago. There was no tentativeness to his movements, even to his redress of small, unavoidable mistakes—an angle that didn't quite work out, say, given the girth of Duke's once-broken ring finger, leaving a lump in the coiled tape. He would unwrap the tape at these junctures as gracefully as he'd wrapped it. Duke appeared mesmerized by the weaving, or else he was rehearsing something in his mind, perhaps old lessons Anton had given him about what to do with these wrapped hands in the ring.

"Not too tight," Duke said.

Anton didn't acknowledge his charge. He probably retained an idea of how tightly to wrap Duke, from all the times he'd worked with him before, years ago now, when Duke had been pursuing football officially but boxing with friends and gym-mates for the fun of it. Anton sat on a stool astride Duke, his mouth hanging open a little, an unruly crowd of teeth poking out, breathing audibly, just below a wheeze, while boxers and personnel came in and out the gym. Not many people were here. It was very late, near closing; I was surprised the place was open at all. But Duke had wanted some private time with his former mentor, the one who'd first engrained in him the frame of mind he now used on the football field.

"How many times have you wrapped me, you think?"

"Not so much, really. My crew handled it, more than me. You *and* your brother, the older one. I worried about the big things, they could handle the wrapping. You should have been using the cotton wrap, doing it yourself, with the Velcro, like he did. But you were special. So we didn't mind taking all the time doing the gauze and tape."

"Tape was for prospects, champions," Duke explained. "Allen just didn't last, he was a wrap man all the way."

Anton stopped for a moment and closed his mouth. "Why don't you sit?" he said, I assumed to me, as I was the only one standing nearby. He hadn't asked my name, and Duke hadn't bothered to introduce me, perhaps knowing his old trainer would have no interest in my kind. The only thing that could entice him to speak to a stranger was the look of a prospect—something I decidedly lacked. He resumed his wrapping, more quickly, though, with the foundation in place. Duke's dark fists had mostly disappeared in white.

"Your brother was not created for sports," Anton said slowly. "That's okay."

"You can say it if you want, Anton. He's a bitch. I'm older now. *That's* okay."

The trainer looked up at his old student as he finished the job. "You don't have to say that. You *shouldn't* say that." He got up and brought a pair of gloves back with him. "And you shouldn't say you aren't great—even *when* you aren't. You see? Or when you're doing the thing you have no business doing." Duke stared at his hands and flexed them, shaking his head. Anton shook his own in response. "Or helping the one you shouldn't," he said with some regret, his gravelly voice here clarifying a bit because it was said so softly, at the only volume that didn't strain it. Duke stuck up each of his hands as if in surrender, and Anton thrust a red leather bulb onto each of them. He laced and taped them at the wrist, while through the window in the door I could see others gathering their stuff in duffel bags and leaving with reddened faces, looking good and beaten.

It was almost midnight when we three reached the floor, and by then the place was nearly empty, with only Anton's staff remaining. If, in the back of the gym, white and green predominated, out here it was black and red. The bags along the northern edge, hanging in darkness, and the ropes of the last illuminated ring, both appeared black, while red was all around, and not just on beaten faces. The gloves, Duke's shorts, and the canvas itself were all strategically crimson. No one could see, then, when fighters took off their headgear, and sometimes even the gloves, going with bare knuckles for the off-the-book matches of the lesser fighters—the ones who for whatever reason, whether time, commitment, or talent, were never going to make it on the circuit, amateur or pro—no one could see just how much blood was being spilled. It gave even the foolish courage, this ignorance. It also probably meant you didn't have to clean it up quite as quickly, even for the routine cuts and bloody noses headgear couldn't protect you from. I bent down to the canvas and thought I detected streaks of red that weren't quite the same as the rest. How many reds, how many bloods, were painted here? Anton's was notorious for these out-of-hours matches, late into the night and early morning. The boxers could make half their money from the

bets Anton's Belarusian friends placed on their fights. As for the other half: factory work, construction, drugs, and theft usually sufficed.

The dead hush around the paraphernalia of boxing, the speed and heavy bags, the mitts scattered about, the stacks of towels, the clean bleached ones and the ones in the other bucket that I could see were, yes, somewhat redder, left me sick. Places like this were meant to throb and thrum, as when I'd first entered, half the people throwing punches and the other half dodging them. Now it was just Duke.

He hopped up on the ring's apron in a heather T-shirt with the sleeves chopped, before ducking under the ropes. I'd thought, when he was on the football field, that at times he moved like a man of combat sports, someone who sought out collisions. I could see why now, as he shadowboxed in his headgear, the way he crouched down low, the sense of energy on the brink of surging forward, upward.

"So, when I put this guy on his ass," he called down to me, ringside, "you're going to remember it all? Where's your pad?"

"Probably not everything."

"Just what matters—is that it?" He shook his head and tapped the top rope with his glove, as if tussling my hair from a distance.

I smiled, but really I was thinking of the dance of gauze I'd just witnessed, the solemnity in Duke's face twinned to his mentor's regret. Or could I draw the fist blown up so big you could only see Anton's hands circling Duke's, and nothing else? Maybe I'd already gotten all I needed tonight, and Duke hadn't even thrown a punch.

From the locker-rooms several men came our way, including a gangly shirtless one gloved in white. When they reached us, Anton nodded to the boxer—Sasha, it turned out—who humbly offered his gloves to the trainer. They went together to the ring and Anton ably pulled down the top rope for the fighter to enter.

I ended up sitting beside Anton in the crooked row of blue folding chairs, but still he seemed to think speaking with me was pointless, or even rude. I admired his ways and kept as quiet as he did, though I felt oddly comfortable next to him. If he'd gotten up to sit somewhere else, I'm quite sure I would have placed myself by his side again without a second thought. Where better to observe the sparring than from a veteran's point-of-view? He would sit only where he could diagnose the most.

Sasha was an inch taller than Duke, with limbs that were obviously longer: the bigger man, as they say, even if he weighed the same. The two men paced around the ring in a circle, stretching their jaws and paying no mind to each other. Seeing them both with mouths gaping—here was another image I would have to file away. Into these maws were thrust mouthpieces by two young men who could have easily been Anton's sons or nephews; they had the angular features I imagined Anton possessing before he'd been softened up by fists and spirits. Sasha began shaking out his limbs perfunctorily,

looking almost bored. He was a sparring partner for contenders; his only use was as a launching pad for others' careers—even Duke's, come to think of it.

Several of the boys running around, mostly young white men, along with a couple of Puerto Ricans, descended upon our makeshift row of seats. Two of them crouched near the ground on one knee, as if ready to sprint at Anton's call. The fighters finished wriggling, the sweat spraying off their bodies gradually diminished to nothing. Finally they faced each other. Anton waved his hands at them, as a conductor might at his orchestra, but with a curious turn of the head, as if he wanted to get this over with. He didn't seem convinced about Duke's idea of re-entering his sport. Maybe he'd even been insulted by it, and he was hoping Sasha could disabuse the other man of his delusions.

There and then, the two cruiserweights metamorphosed into predators. I knew one of the bodies well by now, its compactness and density, with no obvious markers of grace to it, but a basic strength always radiating. The other, shifting into his fighting stance, evidently had such different lines and points of balance. Sasha was a man for the shoulder roll, or the turtle, as it was sometimes called. It looked odd to me to see a white man of such height do it. Slavs typically fought like tanks, using granite jabs and a relatively simple defense: a high guard, fists just to the sides of the eyes. Anton must have picked up a few of these tricks from the blacks he'd trained. They of course were associated not with the robotic quality of Eastern Bloc fighters, but with *elusiveness*, that word used on the football field just as it was in the ring. Duke, on the turf, had this quality in spades, but now on the canvas he was looking less slick, standing squarely and plodding around flat-footed, though admittedly in a more professional posture than I'd expected when he'd first gotten in the ring.

I'd once liked boxing very much as a child, its being the one sport Ty and I could get equally excited about. Seeing two men, especially journeymen, generally with police records the commentators relished excavating, face off on the undercard in a half-empty arena, effectively fighting for their supper, was an irreducibly powerful experience, however unconscionable it may have also been. Though Duke's case was different in vital respects, it had some of the desperation that could make boxing so compelling: not the easy flash of champions, but the grubby chutzpah of unknowns.

Sasha easily rolled the light jabs Duke probed him with, making himself into a small target by refusing to square up. Soon he was countering with his own jab, long and crooked and hard to read. Duke kept looking down at me, right in between his failed salvos, and especially after being caught flush by increasingly heavy shots. Anton didn't appear as displeased as I'd expected him to; rather, he wore a stoical expression of inevitability. I'd learn later that Sasha, remarkably, was just seventeen, an up-and-comer who might someday do damage, but not yet. Duke was the stronger of the two, with more snap on his punches, but his timing had atrophied since his

heyday in the ring. His balance was weak, too; several times, on soft checks by Sasha, his gloves ended up touching the canvas: a scored knockdown in a real match, even if no damage had been done. He'd need to fight on the inside to make any headway: Sasha was simply too long.

"Ten seconds!" yelled a tiny Puerto Rican holding an old circular stopwatch of a style I'd seen only in movies. Duke rifled off a combination that mostly missed and soon after the boy screamed, "Round one," signaling its end. Duke had spent the first frame eating Sasha's fists; nothing huge, mostly jabs, but still.

In the second round, Duke changed things up and started crashing his way forward. When Sasha backed him up with that long jab, Duke would wing wild hooks at him, abandoning all his lessons, perhaps sensing there was no other way to connect. Sasha got his right hand on track, rocking Duke with sharp hooks to the body that made him wince and hunch forward, and then several uppercuts right on his exposed chin. If nothing else, Anton was seeing that Duke could still take a punch. The two whites next to Anton were speaking in his ear at this point and yelling a few words in Russian at their kin.

After a long while, Duke managed to land a telling punch—directly to the Slav's throat. Anton had to stop things briefly so that one of the boys could replace Sasha's mouthpiece; he'd involuntarily spat it out. Yet not long after that came a wonderfully clean liver shot from Sasha that pushed Duke back into the ropes and, after a short delay, utterly disabled him. Sasha got off a combo upstairs while Duke was clutching his side. It dropped Duke to one knee; his eyes shut in terrible pain. Sasha was close to giving him an overhand right you felt would send him straight through the canvas when Anton waved it off, muttering something to the boys. They went to tend to the fighters while clearly favoring Sasha. Anton got up slowly, gingerly. Duke watched him limp off—I hadn't noticed Anton limping before—and then looked at me as his gloves were undone by the boys.

I might have done something with this, the wincing, faraway Duke, sizing up Anton's disgust or disappointment, but still I found more interest in those hands. At the moment, they were being cut free, but I was thinking of the past, the kinetic geometry of the gauze as those fists were dressed for combat, and the grimly paternal face of Anton, such a contrast to Garrett's, preparing a former protégé for a fight he shouldn't really take.

Duke ignored Anton, of course. In the weeks that followed he kept on training—and improving, actually, regaining some of his form and technique. It still wasn't enough to change Anton's mind, after what he'd seen against Sasha. So Yuri, a surrogate from Anton's clan, took over the training. Duke, for various reasons, was now a talented sideshow in New York, regularly on the sports pages of the *Post* and the *Daily*

News, even the front page, and there were calls, meant mostly as provocations, for the floundering Giants to work Duke out. Freddie apparently was burning through his Rolodex, soliciting every contact he had—and he had some of the best—to get his man in as a late substitution for any fight with any champion, near-champion, would-be champion, or former champion in the tri-state area, not to mention Vegas. Waiting for someone to fail, to get hurt, is what opportunity in sports came down to, it didn't matter which sport.

Each time I heard that Freddie had come up short again in his quest, the viability of Garrett's project seemed that much more far-fetched to me. Yet even if Duke's scheme came to nothing, as it probably should, it was still a thought that Duke *had* had, wasn't it? We all knew that the things that never happened for us counted for a lot. In consumer life, it was these other possible selves—they *seemed* possible enough, anyway—the ones we lived only in our minds, for which we acquired so much, anxiously, incessantly, searching out stimulation: it was *this* life, the life, you could say, of delusion, that so often trumped our quotidian existence.

What is it that made such a life inauthentic *per se*? Was there a consumer anywhere who thought, really, that by drinking Bud Light he was any more likely to marry the swimsuit girls from the television spots? Not even Paul's research, and he hardly had a positive view of humankind, showed any such thing. It was only if you thought that people were more oblivious than they were, that they somehow didn't realize they were trafficking in magical thinking and convenient, cathartic conflations; or you thought fantasy couldn't be a legitimate end in itself, *a way of life*, even; or you were in thrall to the absolute value of truth in human life, instead of seeing it as just one instrument among others—only then did Duke's scheming have to be beside the point.

Frankly, even if people weren't aware of their fantasies *as* fantasies, I didn't see why anything necessarily had to be amiss with their fictional lives. That's what *Quixote* was about. Duke's idea of boxing his way out of trouble, as though life were some sort of surreal Lifetime movie, was genuinely quixotic, wasn't it? Was he in on its ludicrousness, though? He was certainly too probing not to have noticed it, at least on occasion (just as one suspects Quixote does). But there were other moments in Duke's life when no space for reflection was open, like when he was training down at Anton's gym, working blisteringly hard on the bags or doing one-armed push-ups to the point of collapse. And, in those times, I don't think it would have been possible for him to continue *without* believing in this scheme—which would be to *not* see it as a scheme at all.

I got the feeling Duke undertook many things in this spirit, probably even football itself, at least in the beginning. He'd said his mother had done the same, in

studying sociology as a poor black woman at Illinois State, a less than elite college; and perhaps she'd paid for it somewhat, too. But she'd done it anyway, because that was *her* fancy. Was it not also how Donald J. Trump became president? On a lark? Larks could lead all sorts of places: to the things Duke was getting up to again back in Chicago, with his friends, the things that had me concerned, and just as much to his tenuous career in football.

46

I'd given up hope by the time Freddie called: Veneto Jorgas, by most accounts a shot fighter, was giving it one more go in the ring at the age of forty-two. The popular American cruiserweight's promoter was frantically searching for a replacement tomato-can; the original they'd booked had just injured himself ahead of the fight, a tune-up for Jorgas' eventual showdown with the current WBA champion, a Romanian slugger named Svevo. Jorgas had taken a long layoff from multiple injuries—a broken hand and a torn quadriceps—which clouded people's sense of what he was still capable of when healthy. Now, after several years, he was fit and hoping to knock the rust off against an overmatched opponent, which was, oddly enough, a venerable tradition in boxing. So Freddie had gone to Jorgas' people and said: why *not* Duke? After all, he was getting known, which would be good for ticket sales: a novelty fight was as good as any as a first step for a boxer on the comeback trail.

Jorgas' side said only that they'd consider it—that was all.

The risks for Duke were obvious: if this former hero of the ring, a four-time world champion in his prime, could, against the odds, still fight well, then not only might Duke lose (a likely outcome in any case), he might lose *dangerously*, depending on how weak his chin turned out to be. If Jorgas was the sort of fighter that didn't gather much rust—even Jorgas couldn't know the answer to that, only the ring would settle it—and if he'd recovered enough from his busted hand and torn-up thigh, he might well maim Duke.

In the end it was all moot. Jorgas went with someone else. Tolero, who had a 15-6 record and was on a three-bout losing streak: nothing but a piece of meat to devour. Freddie couldn't persuade the promoter otherwise, but I was secretly relieved. Duke, of course, was shattered by the news—until, remarkably, Tolero broke his hand, not in training, bizarrely, but a domestic dispute. That made two tomato cans, already busted wide open. And who was there but Freddie with the save, less than a week till fight night. Jorgas had been told about the concept, and strangely, while his entourage and promoter had serious doubts, he positively welcomed the chance to fight a professional football player. Ever since mixed-martial arts had come on the scene, the entire fight game had gotten weird. Anything was possible, and every six months or so a new freak fight no one could have conceived of before occurred, in front of much larger crowds than anyone had a right to hope for. The fans, the country itself, craved the surreal these days, in every aspect of life, from politics to movies down to sports. They'd hardly settle for less.

Naturally, for most viewers, the bout would carry distant echoes of MacGregor vs. Mayweather, though in this case only one of the competitors had ever dominated his sport. Duke *had* dominated as a college player, though, and that would be enough to sell it: the prodigy prospect versus the returning legend. Duke certainly wasn't going to lay down, he told me after he'd heard the good news from Freddie. Even if Freddie probably would have preferred that he *did*, to protect his client's football stock. But Duke liked the notion of trying to slay Goliath; he'd have to rely on the lone blow, the knockout shot, even if having only five days until fight night meant his preparations for Jorgas would be severely abridged.

I knew Garrett had to be exhilarated by the absurdity of it all. What we called the grotesque was merely part of the flow of life for him, an accent on the most banal events; therefore it was to be expected and even welcomed when it turned up. The fight would certainly raise Duke's profile, ostensibly promoting the fortunes of the Arête brand—though I couldn't say just how. Luckily, that was someone else's job, not mine.

Garrett had somehow even heard of Kimbo; he yelped with pleasure when I mentioned the laughing-stock legend. Duke would make for a *new* kind of Kimbo, though: a phenomenal athlete, a bona fide talent, just operating in the wrong sport. Wasn't that more intriguing, like Jordan playing baseball? Even if he lost badly, it wouldn't much hurt his *football* stock. I just hoped he'd take a knee whenever Jorgas started picking him apart, whether in the first round or the last.

I felt almost ashamed to tell Karen about the latest gambit. I'd started to miss her camaraderie, and took her silence over Garrett's decision to carry on down this path as a tacit vote of confidence in me, even if she wasn't willing to verbalize it. But now we'd be going even further. Would it undo whatever truce had formed between us? Surely she'd see their capitalizing on this stunt of Duke's as only that much further beyond the pale, an even more brazen form of exploitation that actually put him in harm's way. Yet having worked with Duke much more intimately than she had, it seemed to me *he* was the prime user of himself here, not us. After all, Duke knew we'd be "working from life" in developing the imagery for the campaign; he had a natural incentive to make his life as spectacular, as billboard-worthy, as possible. We'd all noticed it in both of them, Daphne and Duke, the dirty joy they took in the unfolding story of themselves, wrapping itself around the city. Most campaigns constructed their characters according to their own designs, like Leo Burnett's classic, the Jolly Green Giant, or the Verizon guy, or Progressive's Flo. Otherwise they recruited celebrities

to play the roles they'd written. But in Antral's campaign, the characters themselves were composing the pictures, simply by living. And so, it had to be admitted, our arrangement might deform their lives, even drive them toward unthinkable risks for the sake of the spectacle, rubbernecking at their own car wreck. Would Duke have even seriously considered Freddie's boxing scheme if not for Garrett and me trailing him, knowing that we'd turn whatever he did into iconography, widely dispersed? He knew Garrett would warm to this, thrill to it even; he'd known it in Chicago, too, when he'd promised to find me some niggers, some guns and drugs, every white fantasy of black privation. Indeed, would Duke have been getting so close, so quickly, to his dark old South Side friends, if not for us? Either we, through our campaign, were demonstrably changing his life, or *he* was using *us* to change his own. It was terribly hard to say which, and even I couldn't completely shake the thought that we were crossing into dangerous territory, no matter Garrett's assurances, which in any case I no longer trusted, particularly given the way Paul had faded from sight of late, presumably under Garrett's orders. I could only wonder at the struggle going on between *those* two.

As for Karen, I decided to tell her in person about this latest wrinkle, in a campaign full of them. She accepted my proposal to come by her Sunnyside apartment, then and there, if I liked, though the text was so short it wasn't possible to read her mood. Proceed at your own risk, it seemed to suggest. So

I rode the seven from midtown to her place. What a distance, I thought, she'd established from her New York kin, who'd been living almost exclusively in Tribeca and Chelsea for a few generations now. They would never have even considered Queens, where my train presently emerged above-ground. When I reached Karen's apartment, I found the door cracked; apparently greetings weren't in order today. And although it was cold outside, she'd taken up a spot on the balcony, in a bathrobe worn over some man's oxford shirt, smoking long hot pink cigarettes with shiny gold filters. Beneath the box of Nat Shermans, she had two legal pads—not the usual notebooks—filled with her script, though her hand looked especially untidy, and the maroon of the ink wild.

I knew from Claire that this was Karen's way when writing. Writers in action, real action, not merely posturing in cafés and punching out emails or grocery lists, but genuinely *composing*, were nearly always pathetic-looking things. Karen didn't disappoint. Her skin was raw and uneven—the smoke wasn't doing her any favors—her hair was stringy, and her dainty feet, put up in the rattan chair across from her, were corrupted by their blackened soles and the perfect circles of dirt on the pads of her toes. Smoke poured into her eyes from the cigarette she held in her mouth as she wrote on a third pad. How drab such a good-looking girl could make herself. She

barely looked up as I came out onto the balcony. Was she still simmering about the bigotry she thought she saw in my pictures of Duke, and probably of Daphne, too? Or was it a matter of her present shabbiness, which was reason enough to avoid my gaze, vain as I'd always known her to be?

I sat at right angles to her, and when she kept silent, holding her pen in place on the pad in her lap, digging a hole into it, I imagined, I began to explain my purpose in being there, the foray into pure spectacle Duke himself was aiming for, and not just Garrett. But before I got very deep into it, she gave me a stare that was neither surprised nor angry but faraway. It brought me up short. After a beat or two, I helped myself to a silver cigarette, rolled it between my fingers slowly, held it up in the light. I smiled or anyway smirked. But she looked the same. So I stole the cigarette from her mouth, lit my own with it, and replaced it between her puckered lips, spilling ash onto her pad. She wiped it away, leaving a long gray trail across that yellow ground. I think she nearly smiled.

"We've already opened this box, haven't we?" she said after a time, in a tranquil tone that signaled, to me, that she'd exhausted her emotional energy on this question some time ago. It disturbed me to hear it; I hadn't expected her to be this bad. "And I know you think, somehow, we're all getting somewhere here. And I don't know that I can see it, but I know..." She trailed off, her voice trembling. She stared out over the balcony, just one floor up and looking out over a treed area, which wasn't much wealthier than my neighborhood, but obviously less pathological, anyone could see, just from the greenish lawns and the fineness of the litter.

Without trying to, I began to read from the pad on the table, upside-down. What I found was a story, or perhaps the first chapter of a novel. She noticed eventually but didn't try to stop me.

"It's probably just all this writing that's making me feel this way."

There was more to it than that, of course. She had a wonderful sense for when the lines that mattered were being crossed. I'd thought so ever since I'd met her in school, on our first trip together to Disneyland, which was more or less the parent university of Cal Arts. She was also crossing other lines, from image to sentence, from art to writing, and this too, I felt, was making her mournful, putting her on the verge of tears. It made me horribly sad, sadder than I could ever have guessed. I moved my chair beside hers.

Over the months she'd been losing interest in the art of picture-making, distrusting it ever more, it seemed. My latest work wouldn't have helped the cause. In fact, she probably thought my drawings for Antral were the best argument for ceasing altogether. It's why she spent most of her time curating rather than creating images for *Cosquer*, which was the closest she could get to non-commercial practice without

feeling burned. Now, though, it seemed she was losing trust in poetry, too, even her own, those lines gracing all those posters and placards, volleys of English that couldn't be held to account, they were too uncertain for that. At the same time, she'd been discovering a new conviction in sturdy declarative prose, the kind that might make you see better than pictures and all their ambiguities. The story on the pad was about a relationship of some sort, and in the few paragraphs I read while Karen looked away, waiting, I believe, for me to do just that, I lost all desire to read on. It was written in the first person, from the point of view of a brittle male artist, and it didn't take long for me to know which one. She waited for me to recognize the implications of the page; she gathered herself to explain. I finished and looked up at her neutrally, waiting for the blow.

"You know—"

"Yes?"

She sat up a little at my challenge and continued earnestly. "I guess I just think there's a little more malice in you than most."

I pursed my lips for a moment and then I puffed on my smoke, filling up the dead air.

"Because I don't think you can be on truly intimate terms with the world any other way."

"I can't?"

"Not just you. No one can. Do you think that could be true?"

I uncrossed my legs and shrugged.

"Nice people—straightforwardly nice—have a harder time with art. Everyone agrees on that. But that's just because, I think, they have no genuine idea of what they are talking about. Of the actual world, I mean."

I flipped my cigarette, mostly unsmoked, right off the balcony.

"It's not like that's the *only* thing you have. You have that eye, the real kind, not for composition or color, but for seeing which things are *worth* seeing. Just look at your stuff now. I sort of hate it, yeah, but still."

The hardest thing to admit, Karen explained, was that the longer she looked at my pictures of Duke and Daphne, not to mention the city wearing them, the more they seemed to her to flicker, despite every appearance to the contrary, with some sort of occult generosity. You couldn't say what this resided in, though you could certainly point to everything in my drawings for Garrett that was touched by delusiveness or chaos.

"They're like those pictures of static," she said, "that you stare at until you suddenly see something within the muddle. Most people aren't going to see anything at all. And you can't really explain those pictures to someone, can you? Not to anyone who needs the help."

I'd been looking off the balcony, but the sudden cracking of her voice, just at the end, drew me back to her. There was water in her eyes.

"I tried to explain it to Rick. We had a very big fight just before you got here. He might leave the magazine." She paused while shadowy feelings fluttered through her visage, and she continued only once they'd settled. "But I defended you, can you believe that? After writing this thing"—she swatted the notebook with hopeless disgust—"how could I not?"

I grasped for her then, the back of her neck, and kissed her deeply and unequivocally, out there in the cold where my hands were beginning to go numb and her cheeks were reddened by the nip. For the first time since sophomore year, she kissed me back without ambivalence. And for the first time between us, in all these years, one thing finally led to another.

Neither of us seemed to know just what to do when we woke. What exactly had we established overnight without meaning to? And where did all of this sit with respect to Claire? How could she *not* loom over this moment, even if, in truth, everyone knew the score, or should have. Karen still drew much of her understanding of me through Claire—the bad things especially, which Claire, I expect, would have expounded on with relish. But didn't I, at least here and there, do something of the same in reverse? Claire was our double agent. The day before, after I'd read part of Karen's story and taken her back inside from the balcony, I caught sight of a little sculpture of Claire's, a dodo head worthy of a professional forger of natural history (there were more than you thought), although I knew its provenance at once. It used to live in our apartment, with pride of place on her nightstand, deliciously conjuring both the singular and the absurd. Plainly it had been dear enough for her to have removed it from my apartment, where she'd left so many other things behind, all those stacks of notebooks, and even, cruelly or carelessly, it came to the same thing, some of the paintings and drawings I'd given to her, *made* for her even.

And now to find Claire had simply *given* our dodo away? That the bird was now in Karen's possession, and being used, of all things, as a bedroom doorstop? That's how much *she* valued it? I tore her shirt out of shock, or rage, or both—a button struck the floor with a pop. Karen might, I hoped, take this as raw passion if I continued, and so the rest of the buttons came raining down. Only peals of laughter followed, though: she found it ludicrous. So I slammed her right through the dodo-propped door and onto her bed behind it, to get the bird head out of harm's way, first of all, and to shore up my rouse of sexual volatility through this brutish display. The

laughter stopped. She'd liked it, though I think she struck her head, too, as I pushed her into the psychic space Daphne always seemed so comfortable in; Daphne, the girl I'd been denied seeing by Nik and his film. Now I was taking Karen, somewhat to my shame, as a proxy for her. (How, then, could I blame Daphne for doing the same to me with Jeff and Alonso and who knows who else?)

What of my energies now truly belonged to Karen, not Daphne? And when I'd dismantled Daphne in bed, how much of that had really been meant for Karen?

I knew she couldn't possibly *like* the things that went over with Daphne, but I felt the need to check anyway, even see if I could turn her. Frankly I admired the way she defied me. I slapped her crisply across the face, a gorgeous backhand—I'd shown promise in tennis once—that spun her head around, plunging her face into the pillow. When she dug herself out, she savaged my lip with a menacing kiss I couldn't quite believe her capable of. I came soon afterward, her chin and neck stained with the blood of my mouth.

She turned gentler from there, pressing her face into my shoulder and tenderly rocking beneath me, and the more I bled onto her—it was quite a gash—the more my desire to warp her physical form dissolved. We kept sorting things out from there, so that the night became a long series of adjustments, our roles silently shifting. Karen could enjoy domination but didn't need it, not the way Daphne did. She could also be surprisingly dominant, but she didn't need that either, I discovered. There was hardly a repetition all night, each encounter bringing me off (and occasionally her) by a different route. There seemed to be a limitless variety of states she might put me in, if I cared to keep finding them.

At some point, I simply ran out of imagination; no one's went on forever. I felt her separating from the roles, little by little. This was toward nine, the lime green LED clock of hers told me. By this point she was peering at me coolly—not without kindness, but with some distance. Inevitably, I found myself useless, flaccid. Perhaps I'd satisfied half her desires for the night. I'd assumed the giggling girl, the icy entrepreneur, and the forlorn writer exhausted her being. What a foolish thought. And she, well, she may have overestimated me, which was the worst of feelings.

Last night we'd slept early and then woke early, too. There was such pressure to grasp the world we'd created overnight, the one we'd destroyed as well, but we were both smart (or old) enough to know it was too early to know much of anything. The only imperative was to part quickly. Temporarily, tenderly, but quickly.

Before I went, though, I thought I might demonstrate the regeneration of my creative capacities. I groped her, forced my hand into her; she pulled me out and shooed me with what were very obviously excuses. Before she could say something implausible about what she absolutely needed to do at seven o'clock on a Sunday

morning, after the night we'd just had—something about going to gym, say—she got into furry, girly slippers near her bed, pressed the stack of legal pads into my hands, and pushed me out the door.

I did receive the indulgence of a single kiss, and a playful slap as well that actually hurt a bit, though she was laughing. I think Karen was returning the favor from the night before—her face bore the darkness of it now. She looked sad, folded her arms; I felt certain she was thinking of Claire, then. There were a dozen plausible reasons to be depressed about me at that moment, a sort of embarrassment of tragedies.

I got through most of the first pad on the nearly empty seven train, the material whipping by like the buildings out the window where the train ran overground. The day before it had been impossible to face these words, their knifelike clarity, so unlike the obliquity of her poems plastered all over the city. But now, having made a good start, I was resigned to the story's invariably queasy moments. I could, at least, steel myself with the memories of last night.

Karen had asked me for a favor just before I left her place, through the crack in the door that hid her near-nakedness (a man's undershirt—not mine—no bottoms) both from the hall and from me: to tell her, after I finished the story, whether it belonged in the magazine. I could be her check on self-delusion, she said: *I can't trust the rest to cut me down to size.* What about Claire? I asked. Quickly I wished I hadn't, for the awkwardness it brought. But how could I not? When it came to fiction, Claire was an exquisite reader, everyone knew this. How badly I'd wanted Karen to close the door at that moment, to *not* be seen by her. The feeling was blessedly mutual.

"I'll let you know," I said through the door she'd just shut. She said nothing, although she had to have still been right there. I listened for any sounds through the door, and I had the suspicion she was doing the same. She would only move once she'd heard my steps, or once she'd been able to separate herself from the sticky thought of what she'd done.

Once I'd made it back to the Bronx, I decided to sit for a while in my neighborhood park, smelling the sweet rot of dead plants and homeless souls. From my bench I scanned the grass and the shrubs for the displaced Becker family, but thankfully I couldn't find them. Next I looked for Helena, and again came up with nothing. She was probably still on the platform, waiting for who knows what. So I settled back on the bench, smoked the thin, garish cigarettes I'd stolen from Karen, and finished reading her tale of an artist and the unfathomable shape of his desire. The more

well-defined one's desires, the work suggested, the easier it was to be understood by others. *This* artist, though, his wants and intentions expressed themselves most saliently in the manner of their mutation, that is, not in their formed and stable state, but in the routes by which they got there, in just the way Cézanne brought a certain non-physical spatial structure, an architecture, to the ineffable impressions of his teachers.

Karen had no need of worrying about the story's worth. She wrote sharply, without the sort of aesthetic self-consciousness I assumed would encumber it—less than was in evidence in her art, and there, too, it was already scarce. The text's power was its directness. It traced a spark between the artist and, of course, an actress, one Karen summoned with rare intimacy. From her lone meeting with Daphne, she'd gleaned more than I had in half-a-dozen. But could she have been simply divining things, the way great novelists do? Or was it all much worse than that, and she'd been *continuing* to meet with Daphne all this time, sharing long and intimate conversations? Wouldn't Daphne have told me by now, though? I had no way of knowing. In either case, I had to accept that these three pads were, in *some* respects at least, more potent than anything I'd drawn or painted of Daphne. Karen's shift toward words had truly paid off.

The story took place like a Kiarostami film, in a car, a Dodge with a narrow center console. There was plenty of dialogue; she was handy with it. But unlike the Iranian director, she orchestrated a lot of action, too. Not exactly heist or car-chase material, but action nonetheless. Most remarkably, the point-of-view didn't simply alternate between the two principals; sometimes there appeared a third vantage, emanating roughly from the car's headlights, tracking the alterations in terrain, the slick pavements, pot-holed side streets, and dirt roads. The artist agrees to drop off a woman at an audition of some sort, but he repeatedly takes all the wrong roads, making the routine journey as hairy as possible, though it's unclear how deliberate this is. His mind goes in and out of focus, and the directions of his inner drives become as difficult to track as those headlights, an hour after twilight.

What made this tale so affecting? Perhaps that it was exactly this, a drive with Daphne, that I'd been deprived of, when Jeff ended up chaperoning me home from New Jersey. That's how I'd understood it, anyway, though I would have liked to ask Daphne just why she'd not pushed harder to drive me back herself, if she'd wanted to see me as much as she'd said. Karen's story filled in this gap, though it added a quietly rendered hand job in the car, known to the reader mostly from the rhythmic excitation of the narrator's voice, his proneness, for instance, to inappropriate exclamations and emphases whenever his body asked these of him.

Things end badly: the woman misses her audition by minutes, not long after the artist decides, very generously, that he'd like her to have the role (which is hardly up

to him). Yet he's unable to get her there in time: he's dawdled too long; the world, its traffic, has gotten in the way.

Karen did such a good job of conjuring the actress, her appeal, that I actually felt a dire need to see Daphne after I finished reading. Judging by the texts that were filling my phone, Daphne felt the same way. Silence, as usual, had gotten me somewhere. She was nearly begging me to come see her in New Jersey by this point, though we'd need to be discreet. Nik was growing stormier by the day, with time running out on the shoot. In my mind, it was now only a question of recruiting an accomplice for the journey into the woods.

47

Now that Karen had acknowledged, on my visit to Sunnyside, the obscure worth of "insensate Daphne" and "simian Duke"—*evolutionary Duke*, as she'd called that particular picture, in bed with me; given archaic meanings, the natural counterpart was *stupid Daphne*, I noted by way of reply—she'd also come to accept that she and I were in this together now, irrevocably so. Karen could make these concessions, however, only because of the unrepentant battle she planned to wage with my pictures, through her text pieces. This is how she explained the matter to herself, anyway. It calmed Paul a little to know this, brought him back into the fold after his misgivings had ballooned, like everyone else's, once Duke had been dismissed from the Bears. Still, Karen's shift toward me meant that Paul had lost a true stalwart, even though she never actually spoke directly in favor of my drawings. They were *beyond defense*, she would tell me cagily. For my part, I'd vetoed several of her lines that felt too didactic or witty; wit was a disease, I thought, a tic of a culture that had no room left for anything but gallows humor. It was vital, I'd said several times by now to her, mantra-like, that we not *unmask* anything, disabuse anyone. Pre-emptive suspicion was a mug's game. In any case, why didn't the great editor deserve an editing herself? It was to Karen's credit that she didn't begrudge my qualms, so long as I could make her see their sense.

To inaugurate our rapprochement, I asked Karen for help on the fight poster I was making, the one of Duke's hand being mummified by Anton. It would be our first assay in integrating her text with an image of mine, the ultimate sign of the peace we'd forged, even if her acquiescence in the disrepute of the project was based more on trust (or lust) than insight. After cycling through three dozen taglines, we settled on the simple and clean *Jorgas v Briar* in Caslon, with centered text.

Meanwhile, Daphne assured me I'd eventually be given a screening of *Adiaphora*, which was actually still untitled. Nik planned on wrapping up production by next week, subject to a forbidding proviso: any scene might be reshot or recut if he felt it was no longer consistent with the *Gesamtkunstwerk* the troupe had created and would continuously re-create, down to the final minute before the film's official release in January, when it would lead off a run in cosmopoleis and festivals. In the face of the release date, somehow Nik remained uncowed in his intention to scramble things whenever he liked; eleventh-hour heroics were simply his métier, never mind that our Hollywood "star," Ms. Martin, wasn't much used to such maneuvers. But what did her feelings matter to Nik, who'd only grudgingly taken this has-been on board, when

he'd realized the film's backers would *really* rather have someone like her attached, if only in a bit role? Soon enough, it came back to me that Nik was indeed poring over four or five versions of several key scenes, thinking about recutting and, to everyone's dismay, especially Martin's, reshooting, never mind how short on time we were now. It was part of Nik's mystique, though; you felt as though he might go ahead and reshoot just to *prove* he was mad, and hence capable of genius like his Volger forebear, who had been, it turned out, a minor nemesis of Stanislavski's.

Paul, in any case, made arrangements for me to discuss imagery with the film's producer, and he met up with Alonso to clear some of my drawings—Daphne's preparing with the script in hand, and the scene with Alonso in the clearing—for use in the movie's promotion. Most of the drawings would be oblique: untitled supplements to the official campaign, though still the grandest part of it. The studio sent us the media materials *they* were likely to use for the campaign, mostly photos, mostly ham-handed and oversexed (even without my having read the script, it was clear that Daphne's role had something of Lolita in it). Nik was sure to feel the same, whenever he ended up seeing it. Yet part of getting significant funding for a feature film was giving away some control to the machine. He was going to despise these visual clichés of Iberia, of intrigue, of lust, and I took some pleasure in knowing I'd be elevating matters with my parallel drawings, which fortunately didn't need to bear any strong relation to the film; that was baked into the arrangement. Garrett, after all, was paying for the production and distribution of my images himself; the producers weren't on the hook for any of it. And a little tension between the two sets of pictures, the official and unofficial ones, so to speak, might be to the good.

For *Adiaphora* I decided to go meta-cinematic, and offer drawings based on the film set itself, my charged memories of it all, very obviously bent by desire—as though behind-the-scenes footage might perfectly well suit the default grandeur of the two-hundred-foot façades these pictures would end up mounted upon. There'd be an element of visual journalism to these works, I considered, redolent of Steinberg's coverage of foreign countries, wars, and foreign countries at war. Thumbing through those collections of his—I'd been pulling more of his books down from my shelf lately—I quite despised that thin nervous line of his, even if I found the substance of his drawings impossible to laugh off. I hated him the same way one can hate Kant.

These days, of course, the only place you find painters or draftsmen acting in a journalistic capacity is in the courtroom. In fact, even portrait painting often isn't primarily about truth; portraits are frequently masks for sitters, expressly designed to prevent you from gleaning disagreeable data. With photographs, the easier they become to manipulate and fabricate, the more they lose their overpowering whiff of reality. That process started long ago, with airbrushing and other touch-ups, so

that now we can say that the day on which photographs and CGI become indistinguishable will be the day the former lose their edge in verisimilitude over paintings and drawings. You will look at a realistic image and have no inkling of how it came into existence: whether by purely photographic processes, or, at the other extreme, without the least involvement of a camera lens.

To further accentuate the gap between the film images' off-hand substance and portentous form, we were going to make our first murals of the project, and have them reproduce the muted precision of graphite, which had become my preferred medium, even over charcoal, bringing me all the way around to those Ticonderoga pencils of first grade. Paul's team had found a prominent façade on a nondescript office building on Thirty-Third Street. It stretched sixty feet across, it started one floor up, and it extended another fifteen from there. Despite the little venture in my apartment I'd started with Connell's help, I was no muralist. (Steinberg wasn't either.) But I could supervise one, or learn to, anyway, while being supervised in turn by someone like John, who'd at one point done nothing but murals. Yet he'd have to be in a frame of mind to take part, and given his problems back in the Dakotas, I could hardly count on that.

In the short term, there were other matters to attend to. Duke had only a week left to prepare for his beatdown in the ring, and everything rested in Yuri's hands, now that Anton had bowed out on principle. Yuri had been Anton's understudy back when Duke was in high school and first stumbled into the gym. The young trainer could still remember the impression Duke's raw punching power had made on the crowd. He was pleased to find that the power remained; it wasn't something a boxer usually lost, not until the very end, when he'd lost everything else, his footwork, balance, tactics. In my afternoons down at the gym, where I now routinely watched Duke spar, just for the pleasure of it, I saw him stun more than one partner with heavy, arcing shots that came in at impossible angles. Every time one of those punches connected, it came as a surprise, especially after I'd gotten used to Yuri's men having their way with Duke, forcing him to cover up thirty seconds into every round. Indeed, *avoiding* strikes is what Duke worked on most with Yuri: against a veteran like Jorgas, a weak offense was going to hurt far less than poor defense. So the trainer would have each sparring partner get at Duke in his own way, forcing the receiver to close off another avenue to unconsciousness. If all went well, Yuri thought—or at least hoped—Duke, on fight night, while inevitably losing, might at least keep possession of his senses.

Meanwhile, most evenings, just as I arrived home from the gym, Daphne would phone me. She'd discovered a private spot outside the hotel, deep in the trees, from where she could discreetly call me and still get reception. Mixed messages

were what these calls amounted to. First, about what a tyrant Nik could be, how he'd happily destroy the film itself—what did he care—if she gave him any more trouble, say, in the form of a visitor; how he was also threatening to confiscate her phone, so that if I didn't hear from her for more than a day, I ought to wonder, because he really is being terrible to me. It's just so hard to be pinned here, she said, in this little rustic house and these empty Jersey fields with this troupe that I'm growing to despise, constantly rewriting, reimagining, re-acting the film we thought we'd already shot: we get ready to shoot something again, and then Nik calls off the change and disappears into his rooms.

On other calls, though, all the fear and anger in her receded. She'd suggest such tender things to me, things that seemed true or true enough, about what she saw in me, in my work—very much as Karen's tale did, whoever it might have actually been about. I realized that Karen's little story, quite remarkably, was somehow helping me get a handle on Daphne now, in anticipating her, and sympathizing with her, too, which seemed to me less an argument for the truth's being many-sided, than for truth, the old, classic kind, simply not being as important, not all the time anyway, as we usually assumed it was.

There was a distinctly Hammurabian pleasure, I had to admit, in watching Daphne squirm. She'd neglected me not just that day on-set, but for the past weeks, where my thoughts often drifted toward her and my texts were only sporadically returned. Occasionally, by the syntax and tone, it felt as if someone else had been responding on her behalf—Alonso, or Jeff, or, what did I know, maybe even Nik.

If I didn't go to her now, I knew she'd be resentful, which I wouldn't have minded except for her proximity to Alonso, who'd surely been capitalizing on my absence while sequestered with the troupe. As Jeff would have, too, and all the other suitors I hadn't uncovered yet. What about the giant, Hank? Did *he* consort with her?

To think of Daphne alone, with that mesmerized look on her face, wrought of too much time with oneself, pleased me nearly as much as being with her, indeed, simply being *near* her, in the flesh, inhabiting the same room. Her *relationship* with space—how much richer it was than my own.

Claire had seemed to engage her surroundings as well, an immanent self that warped the world. Daphne's was more of an *exploded* self, intoxicating to me in its inscrutability. I would rehearse the handful of moments I'd shared with her while I worked, or read, or even slept, puzzling over the trick to no avail. All I ended up with was this: she made you think panpsychism was *plausible*, that personality was simply a locus, nothing more than a neighborhood. In that performance in the clearing, she'd charged what was literally an open field. Wasn't that what I craved now? To be in proximity to her, to dissipate into space itself? Yet if Nik was genuinely as unhinged

as she thought, going to her now in the woods could bring irreversible consequences down on her and the film. Should I be discovered, that is.

By contrast, a more benign if fragile fondness had sprung up between Duke and me, built on those daily visits to the gym. I was going there as much for him as for myself. I realized early on that for all the boxing I'd watched growing up, especially the brilliant and murderous Venezuelan Edwin Valero, whose final knockout was of himself—suicide in prison, for the murder of his wife—I had no feeling for what training was like. Yuri had Duke rolling combinations of punches; the receiver's natural gift for evasion flashed here and there, compensating, sometimes, for the mistakes of footwork and glove position. Duke wasn't exactly fleet in the ring; his punches never magically blurred, as with truly quick boxers. But his vision, knowing where to be and not to be, was beginning to save him, so that after a couple of rounds of punishment from one of Yuri's men, he tended to stay clean. Against Jorgas, though, without the padding around the head, those first couple of feel-out rounds could be his last.

Duke had always had a knack for the broken play. So it made sense that in the ring, when strategy and technique came apart or failed to jell, he made the most of the free-for-all, finding a way, over time, to dodge the big shots and at least occasionally land his own. We'd sit together, me and Duke and Yuri—sometimes even Anton was there in the back of the room, looking graver than usual—and we'd study tape of Jorgas' fights, a couple of which I recalled from my teens. The trick was to find a pattern in the ex-champ, to see just where one of those crooked right hooks Duke had learned from Sasha could be discreetly deposited, blindsiding his opponent just as he had the two Dolphins—ideally with like results.

48

Anton went on grousing about it, so much was to be expected, but my billboard featuring trainer and boxer brought plenty of attention to Duke's fight with Jorgas. On the night of the match, Garrett and Paul flanked the pair of me and Karen, all of us occupying nonpareil seats just feet from the ring's apron. I'd had to really plead with Karen to get her to come; apparently she lacked the taste for unvarnished violence. For her, you could hardly call tonight a sporting affair, though that is exactly what tens of thousands of spectators *were* willing to call it, if that's what it took to bring a legend back—as well as a rogue. If she didn't witness the absurdity first-hand, I'd argued, her contributions to the project wouldn't properly marinate in events. So, after skipping the undercard, she'd appeared there next to me, completing our foursome, right beside the commentary team.

Paul looked especially weathered tonight, and muted hatred could be seen in his eyes. Even if he'd slept all day, it wouldn't have helped him appear any fresher, any kinder, not after all the defeats he'd suffered at Garrett's hands—and mine—these last months. I hadn't seen him in a long time, actually; Garrett had been keeping me from him, or him from me. It was pointless asking him about Theria's mysteries now, in front of everyone. He wasn't going to reveal anything Garrett hadn't instructed him to. I can't say I didn't take some pleasure in grinding down this superior lackey, this quasi-aesthete. Even Karen was no longer firmly on his side. What did it matter if her reasons had more to do with desire than truth, as long as Garrett and I had her support, and we could subdue Paul's querulous being with it?

We'd gathered in the theater at Madison Square—not the main room, though it was big enough, and serious fighters worked here: Immo and I had watched Sergei Kovalev turn another man's face into pulp some time back. Certainly the pay-per-view haul was going to be chunky, Freddie insisted, as plenty of people still believed, delusionally or not, that Jorgas wasn't spent. Duke contributed to the take, too, bringing in fans in a way no ordinary tune-up fighter could. With our images suffusing the city for the past couple of months, and then Duke's bizarre and self-inflicted dismissal from the Bears, this fight against an old lion, a resurrected legend, had number nineteen looping on sports radio and cable, infuriating many but fascinating all. On that basis, Freddie had expertly wrangled ten percent of the profits for Duke, a lot for a man in his first professional fight. Stretching back seven years, Jorgas had netted no less than three million per match, and several of them, in the middle of

that stretch, had been superfights, scoring him north of ten million. If the desire for sports-reality television was strong enough on the night, our football player in exile looked set to clear a million. Could you put that past New York?

Attendance, I could see, was good or good enough: the sections in the back, roped off for undersold events, were swelling as the main event approached. The bill comprised seven bouts in total, the earliest of which we'd skipped, featuring as they did anonymous "boxers" fresh from penitentiary fighting only four and six rounds, guaranteeing their meaninglessness. Shortly before ten o'clock that night, at the foot of a monumental digital image of Duke right up next to Jorgas, the Venezuelan-American who'd spent much of his career fighting at the Garden, if it wasn't Mandalay Bay, I'd stood at the top of the Garden's steps and watched Paul and Garrett converge on me from the north, down Seventh Avenue. Since then, Garrett had been scouring the Garden for every fan wearing a #19 Bears jersey, smiling each time he sighted another, while Paul managed a weary nod whenever Garrett turned his way.

The ring walks began, Duke's first. Scabrous hip-hop, entirely unedited—*nigger* occurred every seven or eight words—blared through a sound system that would have had Rick salivating. The MC was a Bay Area legend, famous, I knew, for cerebral wordplay, political invective, and domestic assaults. I'd experienced this sort of vulgar pageantry before, but Karen was clearly struggling with the rawness of the sport. *Actual DJs, like a house party or a rave?* Duke strode toward the ring in white shorts and a long flowing robe—also white—taking a hint, quite clearly, from the tunic I'd put him in for the first picture; while Jorgas, the dark-skinned great, entered to mariachi music and profound cheers in a sparkling silver cape trimmed with fur, the sort of get-up even a high-class pimp would have struggled to pull off with a straight face.

Paul and Garrett were quietly conferring during all of this, I didn't know about what, but at that moment I had other interests. My arm had been flat on the rest for some time now, with my fingertips grazing Karen's stockinged leg, which lay exposed beneath her swooshy azure skirt. Having habituated her to my touch, I maneuvered my hand up her leg until I received a sting: she raked her nails across my forearm, laughing lightly, pretending to listen to our clients. I withdrew.

As always, the fighter introductions, comical in their bombast, ran on too long, yet eventually the men came together and received final instructions from the referee. Joyous boos covered Duke's heart. They made Garrett beam as nineteen sauntered forward and, perhaps in answer to the odd ovation, cheerfully tapped the chest of

Jorgas, who rippled with muscle as though he'd just stepped off Riker's with a *plan*. For all his ease playing the thug, Duke was an intellectual, and his irreducibly meditative gaze into Jorgas' homicidal eyes brought fans to a state of ironic rapture.

The two touched gloves and retreated to their corners, waiting for the bell, which sounded with an ugly clang. Duke came out with gloves held high, searching for position against the taller fighter, while Jorgas' slick, stringy hair, black and white from the years—the man's agedness couldn't be denied—flew around with the weaving of his head. The veteran rifled off a few jabs straight into Duke's guard, testing its strength and finding it wanting, his fist crashing through to Duke's cheek. Twenty seconds in and squaring up to Jorgas already looked to be a suicidal enterprise. Yuri yelled something in unintelligible English or perfect Belarusian and Duke was suddenly in the shoulder roll, another trick he'd pinched from Sasha, a key partner in this experiment. Duke angled toward Jorgas, tucking his chin over his shoulder, bending his knees deeply, making himself small as this dark Goliath raged from distance, trying to end the fight early. Yet the football player's delicate footwork saw him through the ominous opener: while he threw only seven or eight punches, all errant countershots, he never allowed Jorgas to trap him in a corner, never pulled straight back, always sweeping to one side or the other on instinct. In a way, he'd already put a dent in Jorgas' night, simply by surviving the round. I could hear Yuri rasping encouragements as Duke sat on his stool, blank-faced, getting an end-swell pressed under his eye. If the champ were really back in form, how could he let a neophyte, a clown, out of the first?

Jorgas looked to soften up Duke's lead shoulder in the second round, but his opponent's great strength, I knew, had always been his timing. Soon he was making Jorgas miss, thrilling Garrett with every evasion. Even Paul, dejected though he'd looked earlier, seemed impressed and indeed relieved; he'd been told the bout was going to be ugly, one-sided, full of blood, which he manifestly didn't like the sight of. Garrett, though, growing up largely on a ranch, and having gotten what his father preached was an essential American education, for a Protestant like him—slaughtering chickens and pigs, fattening calves for early deaths, hunting jackrabbit and deer on the plains—had different ideas. Blood and death were wholesome things, elements of the good life. And so it was with boxing.

Round three. Duke, who'd begun as prey, had managed to keep his blood in his veins: not a drop could be seen on either man's gloves. Jorgas was looking frustrated. He'd stopped paying mind to Duke's sporadic punches, which were mostly glancing even when they came, and began winging shots at will, upstairs, downstairs, anywhere, hoping to find a way through.

All around them, throughout the theater, the scene was almost surreally *hushed*. It was the most remarkable fact, I'd always thought, about live boxing: the quiet. Even

when the action was peaking inside the ropes, you mostly heard the thumps of gloves, not the roar of the crowd. All the crass pomp, the DJ, the wild outfits, the crazed and obscene hooting you heard breaking out haphazardly existed to establish and re-establish that we were definitely having *fun*, and not witnessing the forcible resolution of a conflict between persons. That dense, edgy silence that gathered at every boxing match was organic to every physical clash, even on the playground, and suggested things so different from pleasurable diversion: vigilance, fear, fate, and balance.

I wondered what Jorgas' strategy was now, if he might even start to tire and the unthinkable might happen. Duke might start firing back. I'd seen his power in the gym; he'd knocked Sasha to the ground more than once with liver shots. He certainly had it, if he could get off first against Jorgas. Could we, incredibly, be headed the distance? Would the prey be granted reprieve? Might he even manage to turn things around and wound Jorgas, after the veteran had exhausted himself or lost his patience? I noticed Karen was hunched forward in her chair now. Garrett and Paul, too. These thoughts were pulsing through all of them, I realized, through everyone in the arena.

In the fourth round, far from losing his patience, Jorgas slowed his pace, his hands, disregarding the boos of the crowd. No longer under fire, Duke felt compelled to throw, but at least half the time he got hit with something heavy on the counter. Jorgas in his prime, I knew, had been a slick counterpuncher, not a crude knockout artist, and he was showing us that he was still the same man. Duke started tasting Jorgas's measured shots and throwing from growing desperation, the sense of an ending; and this was just when things began to turn against him. Although Duke connected on a few flush body-shots, one of which even stood Jorgas up, most of his punches found only air. Jorgas, with arms a half-foot longer that Duke's, peppered the black man with sharp shots, three to every one of his opponent's. Dropping the flash, managing distance, waiting for openings—Jorgas left Duke with an unfavorable rate of exchange. The crowd had savored the freewheeling brawl of the early rounds, but it was this calculated turn that showed Jorgas' class. Sometimes you had to forget about the crowd to find your way.

In round five, Duke's technical form began to fray, partly from Jorgas' crisp, leveraged punching, partly out of disappointment with a battle of attrition that simply didn't favor him. It was time for him to make way for instinct, fate. On a football field, Duke would summon his peak performance at nadirs like this. But—this is something he wouldn't have anticipated—in a sport in which he was woefully overmatched, a reversion to instinct would only *hasten* his demise. And so, as the bout came to resemble an athletic competition less than it did corporal punishment, the crowd re-engaged, bellowing for their old hero. Garrett beamed solemnly.

With Duke fading fast, physically and mentally, Jorgas changed tack, returning to the seek-and-destroy style he'd begun the match with and landing three- and four-punch combinations without trouble: crushing shots to the chest and face. By this point Duke had sold out on defense, hoping, more than quixotically, to land a bomb, but coming nowhere close to it. Every time it seemed the match would be waved off, though, Duke, his mind presumably only fluttering with consciousness, would offer wild counters, preventing the referee from bear-hugging him for the standing TKO.

It was nearly a minute into the next round, the sixth, when a three-punch Jorgas combination—the second shot, a short straight right, seemingly soft but flush on the chin—finally sent Duke out of this world. He bounced off the ropes and avalanched onto the canvas, his knees landing just before his face, in two percussive beats.

The breaking point came so suddenly, it took the crowd some moments to grasp what had happened. They were roaring cathartically at first, of course: silence only lost its grip on a boxing arena when someone landed on his back. By the count of two, though, it was obvious to all just how *out* Duke was, something first apparent only to the people nearest the ring, like me. Jorgas enjoyed a brief moment of triumph before being muscled out of the way by Duke's entourage. Yuri gathered beside Duke, and Anton soon did, too, even if he'd refused to train Duke. This was, I realized, the companion scene to the one I'd rendered in my drawing: the somber, portentous face of Anton preparing Duke for this star-crossed battle. That image, the entombment of Duke like a pharaoh, beginning with the gauzing of his hands, had been all over town in the days before the fight, priming the moment of recognition now being felt throughout the arena and the city.

The oxygen mask, neck brace, and stretcher came out, all things Duke was on intimate terms with from his usual line of work. If only he were conscious to appreciate these ironies, that what he'd done in the ring tonight, novelty or not, was what he'd been doing all his life, on the field and in the streets. All this resided in Anton's gaze upon Duke's limp body. The good-natured novelty fight with the giddy atmosphere had turned instantly morbid; you couldn't *not* feel implicated in the calamity, when an outgunned, underprepared man was thrown to a former champ like a dog. Karen had been right—where exactly was the sport again? Now she was speechless and on the verge of tears. Garrett's face carried no expression, as though he'd been driven by the horrified commotion filling the Garden to some place deep within his skin, a theoretical point akin to the place Duke now lived, somewhere in the territory of non-being. Karen clutched my arm, asked me what was going to happen from here, but there was nothing to explain, really; the medical team poured Duke into a gurney and was shuttling him off to see what could be built out of him at the hospital. I said nothing as the tears came down her face, the confused, angry kind, as if, in

convincing her of the soundness of tonight's enterprise, I'd somehow betrayed her. Paul's misgivings had been vindicated by the outcome, yet still he looked stricken in a way that couldn't be simulated. I'd come to hate his captiousness, his constant interference with what we were doing or inventing here, and I scorned his grasp of art, which was as retrograde as Rick's. But his response to the scene was as noble as any, any besides Anton's, at least, who regarded Duke from the ropes now, consoling Yuri, his protégé, who was shaken and almost in tears. He'd failed Duke, not prepared him the way Anton would have—I could read his thoughts in his wet gray eyes. Beside him, standing right next to the stretcher, was a distraught woman in a short black dress. Hadn't Duke sent me a family photo from years back with this girl in it? Jonda, his sister?

And what was my response to all of this, to finding my close colleague and con-spirator, my accomplice in what we both didn't quite understand, still unconscious? I had no time to contemplate this, for just as I came around to consider it, the quasi-pallbearers of his entourage carried off the stretcher, leaving Bryan and some of the other friends Duke had comped with tickets to trail behind them almost cer-emonially. Duke's leg twitched as he went by me in the aisle, and then one of his still-taped hands did. Anton appeared before me seconds later. He'd never asked my name in all this time; he'd only looked me in the eye on a couple of occasions. Yet now he gestured for me to follow him in the procession, join the obsequies.

I could see that neither Paul nor Garrett wanted another look at Duke's face tonight. Whatever Garrett's ideas about life, the reality of events had jarred him: none of this was going to serve anyone in the long run.

I took Karen by the hand, and angry though she was, she didn't pull away. No, she held on, wouldn't let go as we followed Anton and Yuri through the arena tunnel and into a black car heading to the hospital, joining a motorcade for this casualty of our mutual ambitions.

By the time Daphne and I made it to his bedside, after Anton had been given a chance to speak with him alone, Duke's face, which had been struck hardest not by Jorgas' fists but by the canvas as he collapsed onto it, snapping his neck back gruesomely, had swelled severely. It was no longer possible to say whether he was smiling or grimacing, or if he was even looking at you, his eyes had closed up so thoroughly, both of them edged above with deep, two-inch cuts, like a second set of eyebrows. That we were permitted to speak to him at all suggested his brain wasn't hemorrhaging, or anyway, no more than you'd expect after having sloshed around in his skull for six rounds.

Karen went around to the other side of the bed, emboldened by Duke's infirmity; and though she'd hardly seen him in all the days of the campaign so far, she held his hand.

"Seven rounds," he slurred to her through fattened lips.

"Six, wasn't it?" I said.

"I went half the distance with Jorgas. Not even four weeks of training. Half the distance." Though he had trouble speaking, trouble seeing—his body was failing—he was giddy, perhaps as high as I'd ever seen him, notwithstanding the occasions when he talked about his lakeside apartment, which was what this fight was really about for him, wasn't it? He tried looking over at Karen but was in too much pain to do it; probably the neck brace would have gotten in the way regardless.

"Are they saying you're all right then?" she asked.

"Don't I look all right? What's *Jorgas* look like?"

I laughed, just as he'd hoped, though his face was too fat with fluid to read anything off it. Karen put both her hands on his veined forearm, just beneath the drip.

"Freddie's been apologizing to me so much, like so much, like I didn't know what I was getting into, as if I fell for his pitch. I didn't fall for anything. I got what I paid for. Or I'm about to. He's started texting me numbers. Pay-per-view. Big numbers."

"There were a lot people in there supporting you, not just Jorgas," I said. "You see the number nineteen jerseys?"

"You see the thirty-twos, though? The *Cal* jerseys?" He opened his hand and Karen took it, the spoils of the fallen. "And didn't I hit him with some nice stuff? If I could have held out a little longer, I don't know. You've seen my punch. But what's it matter?"

Duke's phone rattled on the bedside stand. It was Freddie again: *We're going to find you a team, and this season, I promise you. Just get better.*

"You hear that?" Duke asked with a touch of pride. "Freddie is something. He's a total shitball, yeah, but that's what makes him good at what he does. I mean, I'm keeping my home because of this. I'll be on the lake in a week. Forever."

"Did your parents come tonight?" Karen asked.

"I'll see them when I look right. They're back home. My mom isn't talking right now."

He handed me his phone.

"Shoot me with this," he said.

I shot him.

"Way fucking more, man."

I put it on burst, like an AK, and got dozens of shots in under a minute.

"I'm going to pin all this shit up in my locker, the next team I'm on. They'll know what the fuck it is I can *take*. Think I was going down in the first round?"

I'd never seen Duke so free and easy. He was like an ad for ECT, even a lobotomy. "You were wobbling a little."

"I was dying in there. I'm not even sure how I got through. Jorgas starts *fast*. Yuri tried to tell me that."

Anton was still outside in the waiting room when we left Duke. I think he was going in after us for a second look. He cared enough, I knew, for his would-be protégé, that he hoped this fiasco would end Duke's "career" in boxing. And probably it would. The receiver's amateur background wouldn't pay real dividends against contenders, and fights with contenders were where the public interest—and money—was. All the same, unless Freddie found him that roster spot he'd promised to, Duke might have to push the boat out even further from here. Where exactly, I didn't know. He had imagination. It worried me.

Karen slept at my place that night—actually slept, I mean. Even though Duke looked as if he were going to recover, his bodily mortification had consumed her, so that I dreaded her waking in the morning. In the event, first thing, she groped me with a playfulness that soon turned to common lust. I couldn't fully enjoy myself, though, as it was the kind of sex that wouldn't detain us, not even for a moment, after it was over, from all the issues hanging about, which went well past Duke. The question of Claire, for instance, which we'd been avoiding. *Would* she be hurt by this, by us? Did she have any right to be? She would, I thought, probably have more of an issue with Karen than with me, given their longstanding friendship. Claire had also cut me off without much explanation, which gave me license, in my book, to do as I pleased. But not Karen.

In any case, fearing the aftermath, I prolonged the act as much as I could, pulling out of her several times. When I was finally done, I tried to doze off right away. Karen wouldn't let me, but not for the reasons I assumed. Her phone had good news, she said, news that couldn't wait. The *New York Post* had confirmed Duke's health, though apparently he was having trouble with one of his eyes. He'd even been released, and she was hoping, like Anton, that Duke would have the sense to stay out of the ring.

But there was more—much more. She'd decided, just last night, before things turned ugly at the fight, to put together an issue of *Cosquer* dedicated solely to my work. Some of her friends had suggested it, Lindy included, once they'd come to hear that those pictures all over town and country were actually mine. Karen wanted to collect it all in one spot, the entire campaign so far. No text either, it wasn't about

that. It could be just twelve pages even, a short little blast, a special issue. The work—my work—deserved that.

"The pictures," she admitted, "make me feel a lot of unpleasant things, really. But they also feel big."

She kissed me and I gave her all she could handle, as I would Daphne. This time she acceded, however sore she may have already been. I was sore, too.

"At what point," she said, hours later, as we woke in the ghostly pall of a collapsing light, "are we expected to include, like, actual things? Products. For Antral."

So far, neither she in her text pieces nor I in my images had portrayed anything directly about the smart drink or the whiskey. And though I'd depicted, quite loosely, one of the frames from the Obscura collection, even that I'd done in my own way, without drawing any links. How would anyone know who made those glasses and when they'd be available? Did Garrett even care anymore? No doubt such questions were responsible for the air of defeat surrounding Paul at the fight.

"I've asked Garrett so many times by now," I said. He'd been putting off the matter of explicitness in the campaign for many weeks, and Paul, however reluctantly, had been going along with him. Garrett had been cagey at the fight, too, when we mentioned the business end of things, how our work would be tied up or resolved or carried into the future. Karen and I saw so little of him these days, because to see Garrett would reveal the depth of the rift between him and Paul over how best to prosecute the campaign. Garrett had probably brought Paul out last night to the fight, I thought, simply to defuse suspicions of such a rift. But that's not the effect his doing so had on us.

Karen and I had suspected for some time that, just as soon as he could convince Garrett of the desirability of the move, Paul intended to force Cosquer's hand with something bluntly Pavlovian. Eventually, he must have thought, Garrett would see the light, the value of simple *conditioning*, and on that day everything would turn. Paul's research over the years had showed many conflicting things, partly for the lack of replication studies that might have narrowed things down. But one thing he and the others at Ehrenberg-Bass had found repeatedly, though sometimes he seemed loath to accept it—which might have been a sign of his humanity, his sense that life couldn't be quite so brutish or animal, if it wasn't just an index of his vanity, that only an expert like him could see how to proceed properly, because the circumstances of consumption and marketing had to be *deeply* complex—was that the most effective method of advertising was primitive stimulus conditioning.

Which is to say, when the thought entered someone's mind to buy a certain class of product, whether a soda, a computer, a belt sander, or a college education, it had to be *your* brand that came to mind first, or at least among the first cluster.

But here was the startling, humbling conclusion: nobody needed to *think well* of the brand, really. There was no need for positive associations. True, whatever it was that stuck in the mind about the brand shouldn't be express news of its inferiority: cars that won't brake, phones that turn to fire in your hand. But pretty much *any* other sort of memorability, and not favorability tied to specific features, unique selling propositions, consumer likability, relationship building, or brand personality, would do. Making the biggest impression was all. Not loyalty. In fact, most consumers were far less loyal in their buying behavior than they themselves thought they were. They'd look on their office shelves and discover, for all their professed love of Apple, a rack of old PCs that they must have picked up somewhere along the way. It troubled me, how so much of what consumers—and we were all consumers—actually did had nothing to do with what they believed about what they did.

The only property, Paul knew, that most market leaders shared was this: ubiquity. You didn't need to hire the trendiest "ideas merchant," just a very large megaphone. And no one, these days, was more ubiquitous around the city than Duke and Daphne. Which meant that if the goal was just to figure out a way to stick in the mind, who could say that Duke's vulgar theatrics wouldn't do the job, however much people didn't care to be like Duke?

That left a central problem: until Cosquer tied the two things together and closed the psychic circuit, the conditioning would be incomplete and ineffectual, with only one side of its terms revealed. But I think we all believed that soon enough, Paul would push for something coarse, simple, mind-numbingly direct. That's what Siglin always pushed for, in the end: logos. Drawings of the drinks and eyeglasses, say, or better yet, photos, with their lingering sense of verisimilitude, starkly emblazoned with *Arête*, rather than the black-on-black versions I knew Garrett favored.

When the request for conceptual clarity finally came, it was actually put to Karen, not me. Paul couldn't have been pleased about the Garrett-authored proposal, as ultimately it refused the brute force of fixed wordmarks and logotypes. Instead, when the time was right, once *Adiaphora* was released in the new year, Karen was to introduce, into her ongoing text project, the words *Arête* and *Obscura* and *Theria* and—what was the name of the whiskey? Surely we couldn't keep on deferring that question. In any case, from now on, Garrett would effectively be supporting two artists, as Karen and I, beyond our individual works, jointly wove a kind of meta-work between us. He wanted multiple typefaces used for all signage, as though Antral were working from an extensive set of them, when in fact the plan was to forgo *any* recurrence: each iteration would be a one-off. There'd be no repeating taglines either; Karen's words would always evolve, spiraling, perhaps, but never doubling back.

While Karen went about picking initial fonts and drafting text as suggestive of the brands as of my pictures, I worked up the drawing I'd promised Duke when I'd been bedside at the hospital. Garrett, after regaining his composure post-fight, had actually come to see Duke in the hospital the next morning. He walked him out; they'd talked for a while. Yet Garrett never again spoke of the fight to me, or of this visit. And although he approved my plans for the image, he did it in a quick, clipped tone, as if it hurt him to linger on it: Duke's mashed face—ballooning cheeks, deep gashes, bloodied scleras—bruised in Technicolor like an abstract canvas.

The picture had to be a pastel, I thought. I'd do it without the smallest boxing reference, just his pulverized head in white space, so that the injuries could be understood multiply, as the result of a robbery gone wrong, say, or a rough arrest, or any of the other events that made African faces so frequently look like some version of this. I took a technical pleasure in wrapping all this distorted flesh around the selfsame skull I'd rendered so many times now, seeing how many faces it might wear. Even before I'd finished it, I could see that the picture—the second image of brutality toward Duke I'd drawn for Antral—would be *memorable*. It would be *ubiquitous*, too, and it would resonate with the loathsome things Paul had discovered about consumption. You could accuse me, as some would, of salaciousness, fetishizing black death. But then, hadn't we come by this violence honestly, from the course that Duke's life actually took in the time I'd known him?

There was, in fact, another image of trauma I was working on now for his white counterpart, Daphne. We'd begun it based on events Garrett had learned of from Tony, although it was Daphne's mentioning the matter to Karen that made it fair game for me. One part of the story was verified fact: a party gone wrong, two teenage boys, and too much booze. There'd been a Spence newspaper account of the incident, with the names redacted, but it was clear enough it was Daphne. I'd found the boys' likenesses through Garrett, who got me the photos. But, ultimately, I was going to imagine it all for myself, alternate versions of them, thrown together with the Daphne of today. Why not? Fantasy was second-nature to me now. I didn't need Theria anymore; apparently it had done its work.

49

Daphne had been quiet for a while; I did my best not to take notice. Although I couldn't rule out her being in peril out in the woods, as she'd suggested she might be, somehow her silence felt more like an attempt to lure me to her, to surface my drives, which lately had been finding satisfaction in Karen. In any case, I was preoccupied with the film drawings, which wouldn't seem to crystallize, not least because of Paul's incessant calling. He'd become quite the enforcer, monitoring me with a touch no one could call light, and each day, as we moved closer to the film's release, it grew heavier, more flagrant. Now, whenever I sat down to work, I found I couldn't stabilize Daphne's pose on paper. I couldn't even still my imagination enough to transcribe coherently from it, so that all I got for my pains were sheets with twenty and thirty poses lightly overlayed in India ink. I was stalled. So perhaps it was no surprise that on the fourth day of Daphne's silence, I had a change of heart, if you want to call it that. Why *not* go looking for her? The question had anyway been eating at me from the start.

I was waiting on Immo now. There'd be greater insulation from Cosquer with him in the car instead of John, the other thought I'd had for an accomplice. But Immo, it turned out, had a fresh problem with Vera to sort out. She'd not quite called off the marriage when she'd learned of his latest consort, another physician—*this* was the indignity she couldn't stand, not the infidelity *per se*—but she was keeping him very close now. I felt sorry for them. They would never make it to their wedding day, or if they did, they'd have no more than a handful of anniversaries before it was over. Yet I also had the feeling they'd both be fine without the other. They could do without anyone.

If Duke weren't in such bad shape—his right eye was still giving him trouble— who knows, I might have been tempted to enlist him in my reconnaissance. That left just John, whom the troupe certainly wouldn't know; he could investigate freely in my stead. There was no question he'd do it if I asked, even in such rough shape, having lost kin. And he had his father's Chevy truck, sky blue but torn down to steel in so many places: the best and only present he'd gotten growing up, the only one he'd wanted.

By the time Daphne texted, John and I were already across the Lincoln Tunnel, headed into Jersey: *You never came! I could have used you. But but but who cares, I will see you tonight okay? Nik signed off on a cut of the film, the team is showing it tonight. Uptown, 9pm. You'll come? xxx*

I felt like tossing the phone, crushing it under our tires. Needless to say, I couldn't tell John that we weren't going to find Daphne by the riverside. Talking was impossible, anyway: he had the radio way up, classic rock, Zeppelin, Queen, Sabbath. I'd never seen him take quite so much time lazing through turns, though; his foot had never been so light. He offered me little faraway smiles the whole way, which had nothing to do with unfriendliness. No, he was just leaving his world behind for a while, and I was the only one he knew who could truly appreciate this about him. He didn't, for instance, ask me *why* this mission needed to be undertaken. He just came.

Two hours later, when we arrived at the great house in the woods, far grander than my own, I sent him in as my proxy. He returned with the expected finding: *everyone's gone.* Somehow I found it disheartening to hear what I already knew. I suppose I must have not quite believed it could be true. That's the way things went with Daphne—never quite knowing, until everything changed.

We sat down in the hotel's quaintly elegant restaurant and I bought John a very long lunch, something to match the leisureliness of the trip so far. He didn't so much as scan the drinks menu; it was going to be water for him, beginning to end: *I'm driving, right?* I'd seen him drive drunk so many times, and so uncannily well, that I don't think he expected me to believe this was why he was abstaining; he just expected me to leave the question alone. Of course I did.

As we started on the yellow squash soup, though, I could see reality catching up to him, the heaviness of circumstance saturating his face, which was sunburnt after his recent time on the plains. Now that the aim of our trip had been satisfied, or rather had been shown to be unsatisfiable, he was being ineluctably drawn back into the ruts of his own life. His disappointment, his bitterness, was beginning to show; he didn't much want to be here anymore, I could see that. But I was exceptional at silence. And so, without making anything out of anything, I ate and languidly pondered the finished film I'd be viewing in the evening, considering, among much else, the several takes of the scene in the clearing, the various selves Daphne and Alonso had explored merely through changes in footwork, spacing. I even imagined several of these takes being included in the final cut, one after the next, or perhaps with interpolated material. Nik was that kind of director, at least that's what I thought.

When I'd passed an hour or so this way, in my own mind, working through the soup to the stuffed peppers to the heirloom tomato salad, and then on to the cold lamb and asparagus that was our entree—I was eating the way *he* liked to, with total

abandon; we were both losing ourselves in our appetites—John began to mumble and then to speak, unprompted. About Lenore's condition, first. She'd taken a tremendous fall. Lucas, John's father, might have played his part but it was really her, as always, testing people with her intemperance. She'd also cut herself with a knife Lucas swore was intended for him. The combination had nearly finished her; certainly no recovery would ever be complete.

Lucas was terrified by her state. This was the first time John had seen someone genuinely inconsolable, worlds apart, even though this was his father. John had waited with the man, never a very strong or potent man, for two full weeks, bringing him back from whatever place he'd gone to. And then he'd returned to New York, to sit next to me now. It took him a long time to unwind this story, there were many drawn-out pauses, yet I didn't speak again until he finished, sometime after our cherry crumbles. I picked up the check—my only contribution to our exchange, and it was enough. The hotel was a luxury hideaway, the waiter told us somewhat indiscreetly, a place celebrities turned when going incognito. I'd noticed the menu had no prices, and though the setting was rustic, the bill was fully cosmopolitan. At least it was Antral's to pay.

Now that John had been able to say his piece, and our gluttony had rendered us more or less emotionally unreachable, I confessed to him about Daphne's message. He polished off his coffee and spun the cup on its saucer, but gradually his eyes lit up, if that wasn't an artifact of the shifting cloud cover spilling brilliant country light onto his face. Soon he was smiling, which confirmed his feelings: he was pleased for me, I could see, that I wasn't to be wholly disappointed today, given the screening in Manhattan later. With that in mind, we headed back to the city at speed, John once again driving like he was John. I told him about the mural that was planned, about what might need doing. More than picking up the check, my asking for his help buoyed him. The rising odometer told me as much. There was nothing greater I could have given John at that moment than my confidence. By the time we got back, which wasn't long, I thought I heard him whistling over the radio. He was going to go home and think about how to pull this one off. As I was getting out of the truck on Park Avenue, near the theater, he punched me on the shoulder and chuckled. *You aren't nearly as bad as Rick says you are.* I wasn't so sure he was joking.

The doorman pointed me through to the theater, which I realized, as I entered from the lobby, held only fifty seats or so. Apparently Nik had arranged the viewing for next to nothing, courtesy of an old friend whose life had bloomed brightly, and profitably, once he'd left the stage. I'd never sat in such a carefully manicured screening room: the wide eggshell seats were like nothing I'd seen in a movie house, wrapped in buck leather with full back- and head-rests, as on a business class flight or indeed

692 Mark de Silva

a Gulfstream. No concession stands to be found, either. This was cinema divorced from all that: the swampy popcorn, the stale air, the tight rows. Wine—vintage wine—*might* have been served earlier, I was told, remarkable for an impromptu rough-cut screening intended mostly for cast and crew, although I saw some others, dressed too properly to belong to the troupe, loitering as well.

I spotted Daphne standing at the front, very near the screen. In fact, much of the audience had crowded itself into the first few rows, and others sat even closer on the ground, rather than in those luxurious leather seats farther back. I stood peering at the crowd, their odd configuration, when someone came bounding toward me in the dimness: she nearly tackled me, so that to keep upright I had to pick her up off the ground slightly. She tucked her chin in my neck and I felt genuinely exalted in that moment—anyway, until my eyes ran into Nik's. He was staring me down; evidently he was ready to begin the screening. He looked beastly, his beard grayer than before and his face seeming to have emerged from the fat it had been previously been embedded within.

"It has been fucking *awful*," she whispered in my ear. She kissed my neck briefly, secretly, and I set her back down.

"Did he confiscate the phone or something?"

Daphne nodded and took me by the arm down to the seats, explaining the odd arrangement of the audience, so near the screen, by citing Nik's recently developed view that *Obsequy*, as he was now calling the film, couldn't be watched properly except from *within* the image. Since this wasn't yet possible, he thought we should at least do what we could to approach the ideal. I looked back at the director, whose eyes tracked me furiously, and I had to assume a long time had passed since he'd had a full night's sleep. Although Daphne and I managed to put valuable distance between ourselves and Nik, where we ended up, four rows from the front, was no safe haven: I discovered Alonso in the seat next to mine, wearing a thin white oxford with the sleeves pushed back. He was slouched down low; the chunky seat couldn't truly accommodate a man of his length and litheness—a fact I could only smile at. If the world had turned out differently, *I* might have been sleeping with him, too. He wasn't merely a model, though. He was an artist, apparently an extraordinary one, or an extraordinary one in the making, though my knowledge of theater wasn't strong enough for me to judge. He looked at me in the chest rather than the face, as though he were only used to looking at women. I despised Daphne then, for taking away the pleasure of our reunion so suddenly, by bringing me to seats so close to his. Couldn't she have warned me in some way? Was it imperative that we sit just here, with him? We could have even sat on the ground like so many others. I was still adjusting to the disappointment of having Alonso next to us when things got worse: just two rows in front of us, I found Jeff.

The lights came down a notch, as if we were close to starting, when Alonso rose and walked over to Nik, leaning down to speak in his ear. Then they were both walking briskly out of the room. The lights disappeared on cue.

"What was that?" I whispered.

"They're always conspiring now," Daphne said. "They're like the same person. Nik's *absorbed* him, or maybe the other way around, I don't even know now." She gripped my hand. With the lights down, Nik and Alonso gone, and Jeff a ways off in front of us, I'd become her number one man—for the *second* time. Another rehearsal. But as I sunk into the soft seats that left ample room for my legs, unlike Alonso's, to stretch out flat in front of me, as in an exit row seat, and the first frames of the reel flickered soundlessly on screen, and the sweat from her palm joined that of my own, I found myself less at war with the notion of being a backup or a standby.

We stayed like that, Daphne and I, holding hands, for the whole eighty-three minutes, and it felt like the most intimate exchange I could have had with her, that I had *yet* had with her, simply being appended to her body, even, or especially, at rest, watching her onscreen doppelgänger handle the business of motion for both of them. By the end of the film, Daphne had managed to bend the nymph Estelle into a new shape, though I couldn't say just what. The girl moves back in permanently with the father, now in Madrid; the maid, Marguerite—dear Malory Martin, in fact—remains a phantom presence, continuing to write to her, with ambiguous intentions and terrible knowledge; and Vincent, the lover she finds back in America, in the woods, is left to wonder.

Alonso, it turned out, really *was* commanding—this much, and only this much, was now certain. But Daphne's performance was something even more than that. Yes, it was nothing less than a breakthrough, precise and new, taking the Lolita concept, in this case the girl masterminded by her own cold father—who might as well have been a stranger, how poorly they knew each other—and giving the force of choice and authority to the woman, even if the result was chilling, the choice she'd made so repugnant to common sense. For all that, you couldn't assume that this film, with its oddly matched exposures, and its cuts that purposely misled you as to precise spatial relations, slightly jumbling the grammar of ordinary cinema, which made eighty-three minutes seem more like two-and-a-half hours, as did its total lack of diegetic sound—you couldn't assume, given the vagaries of renown, that such a film would find much of an audience outside the festivals, and maybe not even there. Which is to say: for Daphne, there might be no corresponding breakthrough with the public. Nor could you bank on sensitive reviews of her acting; her artistic triumph, the broader film's as well, might not be grasped as such for years or decades, or, perhaps most commonly, ever. The film would simply disappear, and Daphne right along

with it. Didn't I face the same prospect? My drawings, I thought, could just as easily evaporate as congeal into an evolutionary node of late modern art.

I can say that *Obsequy* had this rarefied quality of significance, all while having scant recollection of what the cut actually looked like, the order of the scenes. Which was strange, given that, frame by frame, the film was highly realistic, depicting nothing that couldn't happen, and moreover, nothing that wasn't likely to happen. Yet the film's primary structure wasn't causal or additive. It was... radial. I knew from Daphne that the cut had been rapidly pieced together by Nik in the final days, working out of a makeshift editing room in the hotel with only his cinematographer by his side. This man, an old hand with long ties to AFI, had been looking for a swerve in his career for some time, an opportunity to work with a proper artist. Nik was the chance. Over two years and a few films, mostly shorts, they'd co-evolved a style that put most elements of his classical expertise on the shelf. Conventional filmic technique didn't much interest Nik—nor did he fully understand it, for better or worse, being a dramaturge, really, and not a traditional filmmaker. Plenty of his troupe, apparently, felt he'd gone too far, with this latest cut, in defying his cinematographer's wishes, and they'd said as much to him. Tyrannical as Nik was, he was principled, asking the group to opine on nearly everything, which naturally made the making of this film excruciating for all. No matter: I felt *Obsequy*'s magic, however much I couldn't parse it.

There might have been slightly more to my recollection's being so vague, I should say, and it began from our sweaty palms. Throughout the screening, Daphne would shift from one side of those capacious seats to the other, altering the tension, almost below the level of attention, between our clasped hands that stretched over the armrest. Three or four times, she moved toward me more fully, breaching the border between our seats, to rest her head on my shoulder. The first time, I thought she'd actually fallen asleep, and it was only by the way her hand tightened at moments of screentime densest with sense that I discovered she was conscious.

Two-thirds of the way through, a whisper entered my ear, an often inaudible one, like those of dreamers and sleepwalkers, all while the same voice, at its full pitch, spoke to us from the screen. The whispering girl told me of the father in the film (Henry) and the one in her life (Tony) who was probably not so far, right then, from the theater, at the Frick, perhaps, inspecting their Beatus for marginalia he'd missed on the last trip. She told me of the way she'd felt *too* close to Tony. Did this explain the frostiness I'd observed earlier at her apartment? Her mother's departure, she cryptically avowed, had had something to do with this bond.

She was being sensational, of course. She probably thought it would turn me on. *Didn't guys like that kind of twisted stuff?* I had come to expect this from her, and

so I said and did nothing. I had to allow, though, that her tone was different this time. The more she whispered in my ear, the more I could see that the film, her own image often dancing in front of us, had set her on a sort of reverie transcending any of her machinations. She might have been improvising even, in just the manner she frowned on. Her commentary continued in fits and starts, right to the end of the film. There were times when words seemed simply to well up in her, and others that gave the impression she was trying to control the future, to shape the drawings of her I'd yet to begin. The very fact of showing me the whirl of men about her so pointedly, now in person, but first in that string of photos I'd gotten soon after meeting her, knowing the distress and confusion it would cause me—surely she was performing.

Iberia dominated the last quarter of the film, though most of the footage had been shot in New York, New Jersey, and Maine. Here on the moors, it's bright orange among the boats, terrific glare everywhere, and Estelle growing close to *her* father, a somewhat laconic foreign correspondent for an American newspaper who seems barely interested in her, annoyed at her presence in his European life. He is, I should also say, played by none other than Nik, which I'd not guessed, and I'd not been told about.

The whisper moved on from Tony, who'd anyway been misunderstood by Daphne's mother. *Though, you know, she wasn't all wrong.* I could see that Jeff's silhouette, not far in front of us, had turned into that shadowy profile I recalled so vividly. Was he now looking back at us, over his shoulder? Would his phone come out like the last time? She leaned further onto my shoulder, already halfway out of her seat and still gripping my hand. I felt her other hand sliding down my shirtfront, all the way down to my trousers.

"There *was* something off," the voice purred.

"What?"

I heard the zipper go then, I could feel my eyes closing, and soon the voice became nothing but the mouth from which it came. My attention couldn't have been more divided: it was the loveliest pleasure, illicitly taken, right in sight, I realized, of the old girl, Alice. This must have been calculated; consternation budded in me. Then the whisper was back, huskier now, provoking with every word, in slow little dribs between glorious silence: "She just... got her... men mixed up," she offered in soft tones partly masked by Vincent, who was clearing brush onscreen at a European ranch. Still I felt her breath, heavier than my own, its rhythms carrying intimations, directly through my thigh, as the girl's chest pressed upon it with her face in my lap.

"But what... does that matter... really?"

How hard it was to parse those suggestions in a state like this, where reality, its presentness, was second by second more apparent, and the future more and more inconceivable. Still, I tried. The questions, my suspicions, too, were growing with

equal vigor, and my voice broke down into the same rhythms as hers: "But then... who are you talking..."

Vincent chopped through the last of the grass, arrived at a tiny marsh, a small little dingy tied up in the floating weeds. And that's when the movie and I finished—within seconds of each other. I wouldn't put it past her to have planned for as much, or to have steered matters that way once it had become a possibility, the screen going black to the sounds of rushing water. I could hear people shifting in their seats, their quiet murmurs, presumably about this particular cut, which included, just as I'd daydreamed hours earlier with John, a sequence in which many takes had been artfully piled upon each other.

Daphne was out of my lap now, all the way back in her seat and indifferent to my predicament. I could feel what she'd done: spat me out on my crotch and leg. I buttoned myself quickly and draped my shirt, blissfully white, over my pants, as if I were one of those young fraternity men on the town. With that, I fled for the bathroom, making myself, for very good reason, into a blur. I could feel the squish expand as I searched for the toilet in the quietly lighted lobby of this Park Avenue building. Its design was so symmetrical, linked by many identical halls, distinct only for their terminating on different rooms, that it took me some time to locate the facilities. Down the first corridor, I ended up at some sort of private club or restaurant, where the maître d' smiled secretively as the mess dripped down my thighs; the second hall, as I swerved, took me to a delivery platform; and the third, a champagne bar. By this time the men at the lobby desk, having seen me for the third or fourth time in succession, were rising to help me, just as the drip reached my knee. Only then, down the last possible corridor, with all my luck exhausted, did I find the toilets.

On my way back out, with my clothing a few shades darker from all the water I'd used, rinsing off, I spied Nik through the windows, smoking in the street. No sign of Alonso, though; he must have seen him off. When I returned to the theater, the lights were up and the cast and crew had gathered in small circles.

"I thought you'd just left"—Daphne was coming in from the lobby just as I was smoothing my trousers. "You look fine," she said, laughing somewhat cruelly. She put her hands on my pants: "Wet and fine."

Was she coming just from the lobby? Or had she also gone outside to speak with Nik? Could Alonso have returned?

I made to leave.

"Oh, you can't! There's an afterparty, didn't you know, just over there"—she pointed at the champagne bar, its gleaming marble façade—"and now I don't even have Alonso with me." The crew had insisted on this little get-together, in celebration of what, I couldn't tell, perhaps merely surviving the making of this film. Nik, who

probably fancied himself a new and more radical Herzog, had been indifferent to the notion, but as a concession to the will of his group, the terror he'd put everyone through, he'd agreed to it. His prosperous friend, the one who'd let him use the theater—everywhere, Nik knew people with money, in the swamps of Jersey and the clubs of Park Avenue—was happy enough to cover the expenses.

"I'm not going without a date," Daphne pouted. I turned back toward the room and searched for Jeff, the man who'd probably seen me getting head from his would-be girlfriend. When I raised my hand to point him out, she slapped it down.

"I'm through with him. It hardly ever started. James fucking *hates* him."

"Is it James now?"

"Jimmy—sometimes I don't care."

"And he hates Jeff being with you?"

"Yeah."

"And what about me?"

"Jimmy doesn't know about it."

"He knows."

"You're an artist, though. *His* one. So it doesn't feel like sharing, to him."

"Sharing?"

She laughed at what must have been the terror of realization on my face.

"You shouldn't fuck around about that," I said.

"What would *you* know?" she asked, with plenty of acid. The shift disgusted me.

I went to the gathering with her, partly, I suppose, to shut her up, though more so to get the rest of the story about her family, which she'd begun in the darkness of the theater. One of the reasons I would have liked to avoid Nik's party, besides the mess she'd made of me, the wetness of my hand-scrubbed pants a perennial reminder of what had gone on (she was delighting in this) and what I'd owed Karen but failed to deliver, was that, because of Daphne's seductions, the way she dominated space in the flesh, I'd experienced the film on an almost non-cognitive level. Which meant I wasn't prepared to say a thing about what I'd just seen. I mumbled something to this effect as Daphne and I wandered toward the bar—we were the first to arrive—and she thought it was a perfect response to the film.

"Nik should kill all the sound in the next cut. Not just the music, the dialogue, too. We can just watch people take up space."

This was too clever, I thought. Only the quality of her acting let her get away with throwaways like this.

We clinked crystal as the rest of the troupe, crew members and peripheral staff, and then several screen actors I half-recognized, filtered into the bar, re-creating the circles they'd built in the theater just after the film had finished. Everyone in *The Vegetable Gender* I found here, too. And though they'd been cautious on that occasion, and then quite positively disposed to me the last time they saw me, unexpectedly, by the river, they segued now to a third stance toward me, worse than either of those: coolness. Hank, the giant—he'd had the smallest role in *Obsequy*, playing a vagrant whom Vincent nearly stabs in a fit of pique over Estelle's relationship with her father—I waved at him from afar and he quite pointedly looked away. Elias was a major player here, as the spurned American lover roundly defeated by Vincent in the contest for Estelle—but on seeing me now, he showed no enthusiasm. Indeed, he seemed to keep twenty-five yards clear of me throughout the event, even though I was on the arm of one of the film's stars.

The one who seemed to have an interest in me now, though the wrong kind, as the looks she gave me were violent and hateful, was old Alice, shriveled in so many ways. Had she really been offended by a blowjob? She kept closing in on me, bit by bit, so that she might find a natural way to confront me. To her I did the very thing that Elias, who *I* would have liked to talk to, especially with Daphne, was doing to me: endlessly slip away. Eventually, though, Alice caught Daphne and me as party talk whirled around us. The strangest exchange ensued between them, of tiny gestures alone, as if they'd devised some private language between them on empty afternoons upstate. She didn't even look my way now, not from close range.

I must have earned a bad name over the last couple of weeks, I thought. I don't know what exactly Daphne, or Jeff, may have pinned on me. Perhaps they'd all agreed that *I* was the reason their star had been so distracted from the company's work lately. Jeff, under the rich light of several chandeliers, appeared just as I'd imagined he would: despondent, especially in the presence of Daphne. The more attention she paid me, the more his gaze hardened, until finally he retreated, his look crumbling into sadness. Had he been spurned by her? Disciplined by Garrett? Lost favor with Nik? Seen my cock in Daphne's mouth?

Nik was the only one who came straight for me, bringing along that searing stare of his. He shook my hand stiffly, and then, without prompting or context, commented on my recent work: *Strong figures* was all I understood, though he went on for some time muttering in elaboration. The drinks were affecting him, or his nerves had frayed from his time at the compound in New Jersey. Ignoring Daphne, who stood just behind me now, he pointed at my trousers but could think of nothing to say. That he'd said something favorable about my work, though, made me want to compliment his film. But how could I? If he were to ask me a concrete question

about it afterward—and I judged him to be the sort of man who would do that, as I would, too, calling the bluff of gladhanders and sycophants—I'd be caught out. So, I reluctantly settled on nodding, presenting a guarded coldness I didn't feel but didn't know how to do without just then. At least I *thought* I didn't feel it. Hadn't he chased me off his set in the woods, robbing me of a proper goodbye from Daphne? Perhaps my look had purposes even I couldn't keep in mind.

Nik left us then, returning to the far corner he'd occupied, but not without first arranging for a bottle of Chablis and a single glass to be sent to his high table near the windows. I re-engaged Daphne, whose spirits were rising as the hub of the room's attention, the real star, Alonso notwithstanding. For myself, I began to take a certain pleasure, as I got through my third whiskey, in *not* relating to the crowd, and grumbling to myself just as Nik was. Periodically, Daphne would try to reintegrate me and speak with the others of my work, both my early artistic triumphs at Hinton and the glories of the new project all over town that were yet to come, though without disclosing anything about it Garrett wouldn't want her to. She seemed, frankly, to know more about it than I did—the two of them were that close. Yet her efforts only further estranged me from the crowd, as did the greediness with which I began to drink, the more expensive stuff the better. This was, I quickly learned, the sort of estrangement that could be delicious on the night: to see bisexual Sikah, for instance, lose his jaded distance—this half-man who was so unfriendly on all three occasions I'd met with the cast, though this may well have been his steady state—to see his composure melted by rage at Daphne's effusions over me pleased me very deeply.

Sadly, my exhilaration dispersed at the appearance of a man I'd thought we'd seen the last of tonight—Alonso. He was rushing toward me, but I was feeling vital, and venomous, and nearly untouchable now in my remove from this crowd of actors. Even if Daphne's reasons were her own, I *believed* in her praise, about the grandeur and distinctiveness of my project, a twenty-first-century resurrection of urban renewal, through a developing body of imagery that didn't bear the lukewarm, committee-approved quality of state-sanctioned art. If there were a time to face Alonso's aloofness, even his rage, and if there were also a time to dismiss it mockingly, it was now. If I had to, I might even show him the stains on my trousers.

As Alonso came closer, the unsteadiness of his gait, which gave his movements their headlong quality, became obvious. He wasn't rushing toward me so much as stumbling forward. The olive had gone completely out of his skin; you could have mistaken him for a Scotsman. He looked scared, too, which didn't suit him. It made everything feel wrong. Daphne didn't know what to say or do, so when Alonso finally fell into me, I put my arm around him, escorting him to the bar so he could sit down before he collapsed. All my plans of attack were ruined. What was there to do, then, but buy him

a whiskey and laud the power of his acting in the film? This wasn't actually a lie. He'd been every bit the match for Daphne, while utterly distinct in style. He was bewildered by my warmth, I thought, and kept looking over his shoulder with a crazed expression, searching for Daphne, who was standing in the middle of the room, just where we'd left her, but seeming lost as people continued to congratulate her. I pulled Alonso's head back around to me, had him sip the drink. Had Daphne engineered this meeting, insisting Alonso make a return, never mind how sick he was? What was it she was hoping to extract from me, or my imagination, this way? And had she been horrified by her own sickly intentions? Perhaps she was trying to figure these things out for herself as she stood there, paralyzed. Guests began descending on the bar, looking in on Alonso. Everyone but Nik. I moved off to the side, near the exit, when Daphne finally came to console the golden boy. From his perch near the window, Nik raised his glass to me, his teeth finally entering into his smile, and then nodded toward Alonso and Daphne: we ought not miss the finale, he seemed to say.

The couple was huddled together; a fight was brewing, anyone could see. But the dispute was all quite hushed: Alonso because he was sick, and Daphne for reasons of discretion. She was trying desperately to explain something to him, to find absolution probably. Meanwhile, Nik looked deeply satisfied in his corner, where no one dared approach him. It must have been the first time I'd seen him content, and it had nothing to do with the film, which gave him, it seemed, an entirely different set of feelings, judging by the amount of reshooting and recutting he'd been doing. No, he was reveling now in domestic drama, the push-and-pull of his fifty-strong family, this school or company he curated so carefully, that could well end up his lasting achievement. His eyes darted back to me, and his grin widened slightly, stretching that patchy grizzled beard of his, all to express his pleasure: after all, if Nik was jealous of Daphne and me, Alonso could only have been more so.

Inevitably, Alonso's simmer boiled over. His eyes landed on me once or twice, just as Nik's had; and as I downed the rest of my drink, Daphne escorted him out of the bar without bothering to wish me good evening. I could have been stung by this; I had a right to be, frankly. But tonight, as I gazed at Nik presiding by his window, an uncontaminated delight irrepressibly blossoming within him, and as I felt the wetness of my trousers finally begin to lift, the woman's departure couldn't touch me in the least.

50

I realized now there was no plan. At this point, Garrett was drawing only on instinct in piloting the campaign—if it even made sense to call it that any longer. Ultimately, it seemed, it came down to this: either the project we'd all been engaged in for months had nothing to do with commerce, and he'd never believed Duke and Daphne would help sell his products, or his ends, halfway through, had somehow turned almost entirely extra-financial, settling on the two principals themselves, and perhaps most of all his medium, his oracle, and the world I'd lassoed.

"Well, he does have *that* kind of wealth," Karen said, squeezing my hand tenderly as we speeded through a subway tunnel, trying to assuage the pangs of confusion running through me as I tried to fathom our circumstances. Distressed as I was, I couldn't help but note the irony of her observation, given the resources of her own family, which, if they weren't quite Garrett-sized, were large enough to elide the ordinary concerns of life, all the strictures that kept us compromised, which is to say, human. Still, she raised a profound question, one I suspected even then might never receive an acceptable or anyway complete answer, the sort of answer I'd hoped for: if the project we were all engaged in *wasn't* about money, what *was* it about? What would count as success? And how was it to be measured?

Daphne and I were on our way to Roosevelt Island, to see what we could learn about Theria and its future, and hence our future—especially *my* future. We'd managed, and only with difficulty, to nail down an audience with Garrett and Paul at Antral's offices, to discuss the trajectory of the campaign and the integration of message and image, something Paul was equally keen to understand, given how firmly he, who was normally mild, had backed our request for a meeting once Garrett, perhaps sensing my *other* reasons for wanting to come to headquarters, tried to backtrack on the notion.

The project was patently fraught, but by now Karen had definitively thrown her lot in with me, which, among other consequences, made things difficult for *Cosquer's* co-editor, Rick. He disapproved not only of the campaign, as John had kindly pointed out, but of me, for all sorts of reasons. Yet if Rick was upset with the direction my work had taken, if he saw me as some sort of pawn of market forces, I maintained a certain respect for him, our history, and his rather antiquarian notions of art. What's more, the friction with him had ultimately done me some good: it had driven him to take a stand on Garrett's project, which in turn forced Karen to do the same, even

if she took an exactly opposite stance. And once she'd publicly aligned herself with me on the matter, her resistance to *being* with me more openly softened. She'd slept again at my place the night before, where I'd woken to find her examining my sketch-pads—affectionately, though, and not with an editor's eye. I had her twice then. I didn't know exactly what to say to her about what had happened with Daphne, but I didn't *have* to say anything just now. I was more interested in getting a second chance to visit headquarters, a place from which Garrett had studiously kept me away.

We gathered around an enormous rectangular stone table, in the place that I'd correctly imagined, the first time I was here, would be Garrett's usual office: it was right at the top of the building, made of pure glass, and went by the name of the Greenhouse with staff. I'd not gotten a chance to visit it the last time, since Garrett was working out of a temporary room back then. No longer.

"Not bad, right?" said Garrett, slapping the imposing table proudly. "It's a proto-type." It looked precisely like onyx, with the same crystalline shimmer; in fact it was a synthetic material they'd developed earlier in the year. Although Garrett hadn't been anxious for us to come, he was in a grand mood from the time he walked in the door to greet us. We were already seated, with a member of staff he'd had attend us while we waited for him and Paul to arrive. The VIP treatment, Garrett called it, though it looked more like due diligence to me.

Paul came shooting in the door with a quick, measured step, fully rehearsed, all-business. He wasn't smiling now, but he no longer looked demure. He wanted to move forward, that was obvious. Yet how long had it been since I'd heard him speak at any length? He'd said so little at the boxing match, he'd even been positioned on the other side of Garrett to discourage conversation. At least that's how it had struck me. Nevertheless, that we were having today's meeting at all meant that he had some pull yet. "I think we all just need a little clarity now," Paul said, speaking for himself, too, not just Daphne and me. "Jim and I have been talking this over—well, *talking* might be a euphemism—but we've come to some conclusions about the campaign's course. I know you've both been asking about that, and we haven't had very good answers for you." He gave Garrett a glance laced with sternness, but his boss was looking out the window beatifically, seemingly happy for Paul to do all the talking. "I almost feel we shouldn't call it a campaign anymore, given what we've decided, but..."

"Well, don't put it like *that*, Paul," Garrett chided. "Some of your own research—"

"What I *really* mean to say, though, is that James' instincts, his hunches, have led him to where he is now—where we all are, in this room." I'd never heard such controlled

rage in Paul's voice. Neither had Garrett, apparently. Paul looked around in grudging acknowledgment at what was indeed an exquisitely composed office, never mind that it was the size of a boardroom or even a mezzanine, and all glass but for the table. The Greenhouse surmounted the building, projecting from the roof like a sky-bound atrium. The biggest decisions must have been taken here. It was an extravagance, to be sure, the kind of thing for which I hadn't thought Garrett had the patience.

"And James, you're right," Paul carried on, "there are findings, among the things Siglin has looked at, that *seem* to show, at least in an experimental setting, how apparently non-existent connections between logotypes or text and imagery can be forged by the consumer himself, through sheer ubiquity, and time. Association can work along peculiar paths. We should give those findings their due weight in all this. I especially. So... do you want to tell them, then?"

Satisfied by Paul's acquiescence, Garrett leaned forward and folded his meaty hands on the table. He eyed both of us calmly, going from me to Daphne and back to me. "What we are going to do is this," he declared. "We're going to keep your two projects, the words, the images, as the two things that they are. That's all—as far as *physically*, I mean. I want people in the street to make the mental jump, if they can. If we've done a good job, shouldn't they be able to? And if they don't, well, we'll have to try harder. But I just can't ruin what you both have done. Don't you think that's what it would be? Destruction?"

Although Paul had forced this meeting, the proposition just decreed couldn't have pleased him—which is to say, Garrett, when pressed, had stood firm on his hunches. I had to feel sorry for the marketer. Yet I was also relieved by Garrett's resolve, as the wedding of my work with Karen's was something I'd been hoping would get called off, however much I was enjoying *her*, being with her, which had quickly seemed to suture our pasts together into one continuous fabric. We'd been seeing each other only a short while, but with so much history between us, we were rich beyond our time. I wasn't sure, of course, how she'd feel about what Garrett had just said. For all I knew, she sought the very union of our work he'd just denied, and thought that any future for us, together, depended on it. It was possible, anyway.

"It'll keep this thing singular," Garrett pushed on, standing up and looking across the river toward Whent's. "I'm not just trying to create suspense, you know? A moment of revelation. This isn't a tease. This is, well, look at it all"—he was pointing back behind us, at Manhattan, the island he'd wrapped in my images and Karen's words, along with the particular blue and gold of his drinks. "What we will do, still, is put up simple names of the brands, without a uniform font of any kind, in some of the *places* we've been putting the color panels or Karen's text: Arête, of course, but also Theria, and Accomplice for the frames—good name, right?"

"Not Obscura?" I said.

"Accomplice is better. And, oh—I know we're late on this, very late, and I thought a lot about just sticking with *White's*, but no, we're going to go with *Field* for the whiskey. My grandmother's maiden name. My father would have liked that, I think, though I can't say about my mom. Anyway, we won't put up too many of these—nothing gauche. Paul here will figure out the numbers and locations, as he always does. Brilliantly." The hat tip, however, didn't seem to impress Paul, only because he knew Garrett's fugitive imagination drove the deepest decisions at Antral, not sober research.

"Maybe we can do it as sign painting in places," Karen offered. "We have some phenomenal people for that at Cosquer."

Paul nodded collegially at his only ally, a partial one at that.

"And you won't be doing any pictures of the stuff itself," Garrett added, "or forcing them into the pictures. I want you to know that. That would be just so... I don't even know. And there's research on this, too."

"Speculative stuff," Paul reminded him. "It'll take a lot more work to verify that."

"Well, sure. But it's always like that—you know that."

It was true, what Garrett said. In the papers Paul had sent me, many alternative hypotheses appeared in passing, ones that very often contradicted the central theses. Garrett listened to his lieutenant a lot, I realized; he just didn't listen in the way Paul preferred. But nobody had a right to be heard in just that way.

I recalled seeing in those papers precisely the notion Paul wanted now to discount: consumers were savants when it came to completing semiotic loops, even those built from bewilderingly disparate materials, whether images, copy, colors, bare names, or typefaces. They would unpredictably thread these bits together on strings of ideas pulled from their own *Lebenswelt*—always the most efficient way of convincing someone of anything. This kind of open-ended opacity, Garrett believed, could make the project more compelling to a certain *kind* of consumer, or even citizen. And it was this kind of citizen he was hoping to conjure. Maybe we both were.

Garrett paced beside the table while Paul recounted the relevant research like an insolent child, as the findings cut against the core conclusions of the psychologist's latest research, which emphasized an almost Cro-Magnon, Jolly Green Giant bluntness of association: Burnett over Bernbach. The best advertising, for Paul, was the stuff you couldn't miss for all your life—even a dog couldn't: Apple, Coca-Cola, Geico. What Garrett and I were up to was much subtler, though, in fairness, the operations we were playing with, the psychic forces we were shaping, weren't ones we had a handle on exactly. What precise effect would all of it have on the people living among these images and texts and colors on the street? Paul's earlier views were being

used against him, seeing as he hadn't exactly disproved them, merely backed away from their most speculative dimension. So now, with Garrett looking on, the boss' right hand reluctantly explained to Karen and me what evidence there was for some psychological bonds' being stronger, more persistent, even unbreakable, when you got the viewer-consumer to make them for himself. *However*, he emphasized, with a glare toward Garrett, there was just no way of knowing the exact nature of such bonds, or the conditions of their formation. The data didn't exist, or if it did, it hadn't been revealingly collated.

But—and this is where Garrett and I parted ways with Paul—*we* weren't looking for verification. Over the months, we'd converged on an attitude, even if it remained unspoken, and it was this: we simply didn't need to know the campaign's commercial effects on the appeal of the products to know it was worth carrying out. There was, after all, something we *did* know more about already, and could know more still about as time went on: the effects of the drawings and text on *Duke and Daphne*, which seemed to mean more now to Garrett and perhaps to me, too, than anything having to do with revenues and profits.

Paul's lecture wasn't finishing so much as petering out. We needed no explanation, really. I'm not sure why Garrett even had Paul give this speech, other than to get him to voice the party line—Garrett's line. Whatever it was, with Paul running out of things to say, statistics to cite, I knew that my moment had come.

"So, when do you think," I interrupted, "we'll have the new formulation of Theria you've been telling us about?"

Paul's eyes widened; Garrett's did, too.

"What's changed in it? It might help us dream things up, knowing that."

"Oh, well, the two versions aren't exactly unrelated. Right, Paul?"

"There's no alcohol in it, I guess?" I said.

"It's not a *quack* elixir, no," Garrett shot back. "But some of its key ingredients *are* derived from wheat. The retrofitting you saw me doing at the old distillery, that was about Theria, actually, not whiskey. But the formula's still being tinkered with."

"So when should I expect—"

"You did throw out the old stuff, right?"

Paul seemed very interested in my answer.

"When will there be more?"

"But did you throw it out?" Paul joined Garrett's questioning.

"I did." (I hadn't.) "But—"

"Well, the FDA is taking their time with us, aren't they, Paul. It's just what governments do. Inertia's their specialty. They assume something *must* be amiss. How could this stuff be so good, so productive otherwise?"

"But *is* anything wrong with it?" I pressed. "Why are you changing the formula if there isn't?"

Paul looked grave.

"What's in it, exactly," Karen said more gently, "besides wheat?"

"It's a kind of herbal formulation, I suppose," said Garrett.

"Is it purely natural?"

"In the sense that nothing is *not* natural, yeah."

Paul blanched; Garrett stood up.

I pinched Karen's leg then and she kicked me for my trouble. She didn't continue with her prying, though, which was my aim. Clearly we weren't going to get answers like that.

Garrett began to wander around the periphery of his greenhouse while Paul stared ever deeper into his notes—*through* his notes, really—to something beyond them, something peaceful and assured, all while tapping his pen on the paper at a furious pace. A peroration was coming from his boss. We all sensed it, yet ten excruciating seconds passed before it began. "Paul just hates it when I get philosophical, I know," Garrett said. "But you have to understand, my entire company, my life, is predicated on one question: is it *worthy?* Whatever the thing is you're considering, is it worthy? Now, if you didn't have to do anything to it to *make* it that way, to get it to say *yes*, great. But, if you did, if you had to synthesize or distill it, as long as what comes out *does* something good, it's fine by me. It's the greatest magic anyone's capable of. The only thing I stand against is inertia, in all its forms. If you can't find *movement* in something, however natural or untouched by the human hand, I'm just not interested. I'm not a romantic that way. My dad was always telling us about the country, all the solitude and peace out there. And a lot of artists are like that, too, I know. The Impressionists out in the countryside, and so on. But that's why I chose *you* to help me here—once I'd seen your drawings."

Garrett pivoted toward Karen then and spoke with obvious sincerity. "I just love the way he sees. He may be a lot smarter about it than I am, I'm sure he is, but he sees things like me."

He waited for us to respond, but we didn't.

"You know, the government's done it to me a million times, with each of my materials, telling me to slow down, look out. It's just a different department making the complaint each time. And it always goes the same way: when they begin to understand what we've achieved, they're *glad* we did it. So don't worry. Just as soon as we've got the drink where we want it, you'll have a lifetime supply."

He laughed alone, and Paul, always the gent, even in distress, dabbed his head with a handkerchief of lustrous green.

I was in trouble, too. My temples were beginning to throb, listening to Garrett. My mouth had already dried up. And my thoughts were crashing into each other again. Garrett was smiling like the first time I'd seen him in this building, when I barely knew him and I'd come at his invitation. Paternally, I suppose you'd call it. Though my own father would never have looked at me like *that*.

I can no longer recall how long we sat there. Nor can I recount all the phases my mind passed through, all the half-thoughts that went ricocheting through me—that Garrett *sent* ricocheting through me. What I know for certain is that at that moment I faced a profound yet benighted *fait accompli*, unable as I was to say exactly what had become irreversible. I would have liked a word for that phenomenon, but no matter.

The four of us eventually went down a staircase to a circular floor, and right away I explained that I knew the way back to the lobby, that Karen and I would show ourselves out. But before we could escape our prosperous clients, Garrett asked me once more about my crumbling, squalid palace.

"When exactly are they going to use eminent domain on your building?" he said. "Because it's coming. It's just another thing governments do. You've got to move— right now, if you're smart. I can get you space, you know, if space is the problem."

I nearly darted away, openly fleeing, running off into the depths of Antral with only that sense of looming finality trailing me. But hadn't Garrett more or less disclosed what I was wondering about? That this was all... experimental? That he wasn't exactly a pro-regulation guy? His fear of me had fallen away, I realized. He took us to be firmly with him now, so that he could tell us just about anything and there'd be nothing we'd want to—or could—do about it. There wasn't much more to hunt around for there, no answers to ferret out that Garrett hadn't already intimated.

As Karen and I walked out of that great glass dome, my head swimming, there really was only one thing I knew: I would somehow have to accept, even if I could barely fathom the thought right now, that the stuff I needed to straighten me out again, to bring back the old self I'd lost, the one Rick and Lindy and I don't know how many others seemed to think I was losing, too, including Karen, even though I'd dragged her over to my side, may never make it back into production. We'd never see another drop of it, and I'd never see myself again.

51

No one was looking to work Duke out. Not a single team called Freddie about a tryout. How much damage had Duke's stunt in the ring done to his football stock? He might now have been seen only as a distraction-in-waiting, a Kaepernick without the moral redemption, just as many had warned him—even I had, it was such an obvious concern. The problem, though, could have been less about his taking the fight than about his losing it the way he did, in such a morbid fashion, as morbid, perhaps, as his takedowns of the two Dolphins. After the beating he'd suffered, GMs might have assumed Duke couldn't be in any condition to play, not so soon. And even if he *was* ready to go physically, he might have made himself unhireable for the optics alone, given the black cloud hanging over the NFL about player safety, sham concussion protocols, and such.

In the event, Duke seemed to have healed up quickly enough. His right eye was still puffy but his depth perception had come back, and his skin was beginning to shed the discoloration. Football shape, Duke wasn't wrong about this, meant you could recover from nearly any battering in a week's time. You had to, or you lost your job.

I met him in Washington Square after dark, as we were bearing down on Christmas. A remarkable gap remained between what I saw before me then, as Duke approached me, and the illuminated façade behind him in the square, which carried my portrait of him right after the fight. *Grotesque. Arresting.* These were the words that came to my mind, looking at the building's face. But looking at *him*, in the flesh? There was a gravitas to the man you couldn't deny.

"You got your face back," I said. "Most of it."

He smiled faintly through the vestiges of a split lip. "I've been loading up on Theria—we should fit that in somewhere. You still have any? I got a case delivered the day you left Chicago. And it's better than any PED in existence. Which you know."

"You're not supposed to be drinking the old stock, Duke. It'll end up a PED, from what I'm hearing."

"Oh, fuck all that. I'm keeping it, at least until I get back on another team."

"But haven't you noticed something strange about it?"

"Only when I forget to take it. Look, there's nothing wrong with it, not *at all*, if I get signed again. Believe me here."

"All right."

"But you were worrying about me, I see," he said with a laugh. I knew he'd agreed to meet with me only to find out what else I could offer him, namely, further opportunities with Arête, perhaps a few more pictures. I, for my part, just wanted some sense of what he was planning on doing now.

"For a guy without a job, could I be any more famous in this city?" Duke turned and looked up at his mushed-up visage across the square. "And the actress isn't doing bad either." He eyed the long retaining wall beside us, the site of the mural John and Connell had helped me with. The tableau offered a sort of improvisatory, backstage history-painting of cinema, with camera equipment, boom mics, tape marks scattered all around, linking me and Jeff and Nik and Alonso to Daphne, all of these valences pulsating together. John had added a few reverberations of his own, some of them emanating from as far away as North Dakota.

"I have no idea what you guys are doing," said Duke, looking it over. "But I'm good with that."

We unbundled ourselves at a diner on Mercer for omelets and potatoes. I ordered a shot of whiskey (full bar) and some toast. It was seven at night and very cold.

"We're close, though. Freddie says they keep talking to him, which is a good sign. Teams get desperate this time of year. For a known producer. They even take wife-beaters back this time of year, as long as there's no video."

"The Christmas spirit, I guess."

"Playoffs. Someone'll need me. Fresh legs, sticky hands. Just like Jorgas did."

"Who's he fighting next?"

"I think he's got another tune-up, then a title shot. Maybe even straight to it—Anton would know. He's talking to me again, it's not all Yuri anymore. I told A. that I'd train right next time, and he told me my game's football. It's *safer*, he said. What you think of that? After everything people are saying about it? Anyway," he said through a mouthful of potato, "the second I can't do inhuman things on the field, I'm done. No one's going to come knocking, the way I've been going at it. But I'll *want* to be done, if I'm not dropping jaws, breaking jaws, all of it. What's the point?"

"And then?"

He swallowed and smiled, nodded with his eyes closed for a moment. One of his teeth looked crooked that hadn't been crooked before. He was getting uglier all the time.

"Probably get back to being a momma's boy. Go to grad school. Why not? I'll be the new American Fanon."

"Well, I've seen your grades. I saw those crates of books, too, behind all the pharmaceuticals in your apartment. No furniture but a shit-ton of books. I was thinking we could use that."

He stuck his fork in his eggs and leaned back in the booth, as though disturbed that I'd been noting things about him I'd not mentioned. What did he expect?

We settled up and headed for the car he was borrowing from friends. "I just need to make one stop in Brooklyn, and we can get you back to your shithole in the Bronx. You think you get points or something for living up there?"

"They might take down the whole area, tear the thing to the ground, if some of the old-schoolers get their way on the city council."

"They can never just leave shit alone. Always there's some brilliant new idea."

"You think the residents, the companies, would do any better?"

"What I'm saying is a lot of that stuff should never have been built."

"Where would all the people sleep?"

He wrinkled his brow and kicked the curb; then he smiled at me vaguely and got in the dusty car. I thought of Helena underground, and the park overflowing.

One thing disquieting Paul was troubling me, too: would Duke *really* find a new team this late in the season? Having just gotten paid for the fight, how much would Duke care right now about football? He wouldn't tell me, at the diner, how much he pulled in for the bout. Much less than hoped, though, Yuri revealed. Those were just Freddie's delusions: there was never going to be *that* much interest in a "chicken-shit" match. That said, Duke *had* already collected a quarter-million, and the pay-per-view receipts hadn't been tabulated fully.

What would any of us have, exactly, if Duke *didn't* sign with a team for the playoffs? It'd be like all the footage of Daphne ending up on Nik's cutting-room floor. Yet eighty percent of NFL players washed out after three seasons, disappearing, once they'd burned through the cash, into the underworld from whence they'd come. Realistically, then, maybe Duke wouldn't lose all that much in future earnings. As for Garrett, I knew, even though he would certainly feel sorry for Duke if Christmas slipped by without his making a roster, he wouldn't allow any of this to taint our project, or Arête and his flagship bottling, Field 25. The story we'd sold the city, the Public Art Fund, and various landlords around town, would then just become the truth: the whole endeavor was philanthropic through and through, a matter of city beautification, with no ties to anything as coarse as commerce.

It was then, however, as we began to resign ourselves to the worst having come to pass, that the call finally came—the tryout call Freddie always *knew* would come. Every year, playoff teams signed players to fill holes after a full season of attrition, to make their title push with fresh bodies. If you waited long enough and you had

the talent, someone would get hurt and you'd get your shot. Even if they secretly hated your guts.

And the team? If Duke shined at the workout, the gig wouldn't even take him out of New York. Those demands by desperate Giants fans to give Duke a look, probably more a morbid joke than anything else, were now suddenly answered. He *was* being looked at, but on the sly—on a Connecticut practice field—to keep the press away; losing a number-one receiver in game fourteen of the season will force a team to take chances. I'd known that Beckham had gone down recently with a broken fibula, and that the Giants, once formidable, had lost three straight, dropping to 9-7 to back into the playoffs. Freddie had actually gotten three calls, not one, but the Giants were first, and that's where Duke wanted to go. Not because of New York. Because of *Chicago.* The NFC wild-card game was now set, pitting the Giants against the Bears, who'd managed, without Duke's services, to surge into the playoffs. Lacking a passing attack to open up their run game, the Giants got shut out in the season finale, losing by four touchdowns—their defense had been porous all season—to the New Orleans Saints, who didn't even make the playoffs. So now here they were, without their star receiver, facing a wild-card game at frosty Soldier Field, looking in every way like the underdog to make it through to the divisional round.

Having just three days until the tryout, Duke seemed for the first time to be engulfed by the purest fire. The wryness was gone, this wasn't a lark. He even declined to speak with me until he'd won or lost the position. He had no interest in how the workout would *look* in one of my drawings, just in locking down the job. He'd never confess to it, but perhaps he was grateful now after beginning to doubt that a team would call. He might have finally come to seem mere bluster to himself, and found it intolerable. In a way, I had to believe Duke was capable of this newfound focus. How else to explain how far he'd gotten in life so far, as a player, provocateur, and scholar-to-be?

Still, there were doubts I had about him that would probably never be assuaged, not entirely, given what happened after we'd gotten into his car that day in Washington Square. That one stop in Brooklyn—it had all happened so smoothly, routinely. His pulse didn't seem to rise even a beat or two through any of it. What I recall of my experience is this: drifting through Brooklyn Heights in a nice enough Audi, catching glimpses of that icy skyline filigreed with stars between the blocks at each cross-street, and parking on the promenade, near to an immaculate brownstone. I gazed on the thorniness of downtown Manhattan and heard the click of the trunk popping open. When the lid came back down, two young blacks in puffy athletic wear appeared in the rearview mirror. They calmly got in the back seat, thanked Duke for giving them a ride, and politely nodded to me, though without introducing themselves.

I remember seeing their giant eyes in the mirror as we set off. They watched me, smiling occasionally but stiffly as we drove south listening to *A Love Supreme*.

Eventually we reached the generic apartment blocks of Flatbush, the place where some of Duke's crew had been forced to relocate from the dwindling stock of rent-controlled tenements on the Lower East Side. Duke opened the trunk again. The men in the back got out, and soon they were joined by other men, all of them shrieking with delight as they pulled the goods from the trunk: several laptops, a set of floor-standing speakers, an amplifier, a gorgeous vintage record player, and a pair of jewelry boxes. Only then did I grasp what I'd been a part of.

Duke drove me back to the Bronx somewhat sheepishly, switching to Ornette Coleman, *The Shape of Jazz to Come*, for the long ride. He was less proud, I think, than he might have thought he'd be, after doing this run with me in the car. Maybe he'd seen the matter through my non-black eyes and was embarrassed by the affair.

I took the episode in stride, though. I wasn't especially angry with him. The after-effects of Theria seemed to have made me immune to real surprise, no matter how strange the path turned. I *expected* the bizarre now, depended on it, even, perhaps sought it out. Nothing appeared beyond the pale anymore, particularly as it related to Duke.

Karen was mortified by the story of that night—she *was* still subject to shock, after all. I should have spared her; the tale brought her needless trouble. But I'd had to explain to her my latest drawings of Duke: one shirtless and in jeans, among piles of books in his empty loft, the white tarp thrown off them, with the great lake outside his window; and the other, the scene not of the crime but of the celebration in Flatbush, though I'd made sure not to use any suspicious faces or goods. The person we'd robbed, the *Post* said, was a distinguished orthopedist whose family had lived in the Heights for generations. The police were investigating.

I learned about the days leading up to the Giants tryout from Yuri, who had the details from Anton. The old trainer retook his place in his Duke's corner, now that the former charge had turned his focus back to football where he belonged. Duke had gone out to Prospect Park, Yuri told me, to rehearse the go-up-and-get-it that had made his name, the kind of ball for which he had an almost occult gift. His friends, some of whom doubtless helped executed the robbery, continuously arced balls his way, trading off when their arms tired, sending Duke diving across the frozen grass for them all afternoon, just as he'd need to at Soldier Field—if he could make the cut in Connecticut.

The workout came, among much skepticism from the Giants' top brass: only the receivers' coach had insisted they look at Duke, among a batch of four free agents, given the team's desperation for a pass catcher. Afterward, with the team's decision pending, Duke sent me the tryout tape. I put it on and saw a player transformed. His route running had bite to it now; he could make right angles just as easily as amorphous swoops. He took directions better, too, adjusting his technique as instructed by football personnel; you would have thought he was a diligent plodder all his life. And he ruled the jump ball, the same kind that the man he'd be replacing, Beckham, did, notably in the corner of the end zone, back shoulder, where he repeatedly beat the Giant defenders pitching in for the workout. Fundamentally, Duke looked like a man doing something he believed in, and perhaps he finally did. He could belittle football all he wanted to, but there had to have been genuine desire in him *somewhere* for its rigors, for all it did to you, for you, and here it was, all on tape.

The playoff contract, a tryout for his future, was his. He won. And for the first and last time, Paul and Garrett, Karen and I, all felt a common joy, a distinctive blending of the moral and artistic sentiments that had come down to us from Athens. In the week leading up to the wild-card game, both New York and Chicago were festooned in my imagery, thanks to Paul's planning; and on the day of the game, a Saturday not long after New Year's, Karen and I lounged in the Bronx in front of the plasma—I still considered it Claire's—to watch Duke play. We'd managed not to mention my ex's name more than once or twice since we'd started seeing each other: some matters could be indefinitely tabled, it seemed, at least until the woman in question returned from her fellowship in Indonesia. Karen and I weren't exactly a couple, of course; she still treated me fraternally often enough, in the way of old friends. At those times, times like now, watching the game, I wanted to ask her badly about the woman I'd lost. I'd heard so little over the last nine months, and hadn't found much online about her either. Did that mean Claire had been struggling? Or that she was engrossed in a project so large, she would only surface once she'd triumphed? How could I ask this of Karen, though, while we were together?

Vapor trails poured from our mouths, and the windows were caked with ice. It was as frigid then in New York as it was in Chicago, and Kiver hadn't managed to resuscitate my radiators. So we cloaked ourselves in a half-dozen blankets, as Helena would have done in the subway below, and settled in for the ice-bound game.

During the season, the linchpin of the Giants' success, I well knew, had been rushing, not passing. Their lead back, Kinney, a number three pick out of Auburn,

broke 1,300 yards on the ground for the season, but hadn't done much in his last few games. Ever since Beckham's injury, defenses simply loaded the box, eight men getting after the runner, sealing up the seams Kinney normally worked his way into. If Duke could do enough damage away from the line, or at least threaten to, things would open back up for Kinney.

For two-and-a-half quarters, Duke ran Platonic routes, the kind on the tryout tape, netting him just three little catches on the edge, all during Chicago's first few possessions. Yet two of those receptions involved long, twisty runs after the catch— enough to demonstrate the danger Duke posed. He'd been drawing double coverage ever since, springing Kinney, who cut up the Chicago front line, right up the middle, with six- and seven-yard gallops, while Duke ran his decoys on the outside.

As the third quarter wound down, Karen and I huddled for warmth. We were beginning to find more interest in each other than in this run-heavy game of attrition, which stood tied at ten. No one had scored since the beginning of the second period. With thirty seconds left until the final frame, on fourth and two, in the no-man's-land of midfield, the Giants decided to press the action, break the stalemate. By this point it was clear Kinney would get the ball, but the Bears suddenly showed blitz. At the last second, Manning audibled out of the play call, took the snap, and when the pressure inevitably came crashing toward him, he hurled the ball—entirely inadvisably—down the right sideline, in Duke's general direction.

To judge from the replays, Manning was simply avoiding the sack by throwing the ball away—except that the pass, high and arcing, never made it out of bounds. It had so much air under it—Manning was hit while delivering it—four players had time to converge on the spot: two Giants and two Bears. The ball fluttered in the icy wind, held up in the air, and finally died, freefalling toward the field. It was at that moment, the moment of death, that this clutch of receivers and cornerbacks, all versions of each other, players who would at some point have filled their opposite number's position, whether in middle school or college, prepared for war.

Duke was coming back to the ball from the sideline, on what was supposed to be a straight go-route. He and his coverman abandoned the plan once they saw the pass mangled at the point of release. As the other three looked to cradle it like outfielders squinting up for a flyball they'd lost in the lights, Duke, from a low crouch and at the last instant—late, even—launched himself *through* his own man, knocking him out of the play, and over the top of the Bears' low-held hands. Duke fingertipped the ball to himself and crashed to the granite-hard tundra without having time to brace himself. Even with his body rebounding violently off the frozen turf, he held on. First down, on a tiny four-yard mess of a play. It was the moment of the game, a drive-saving effort in a frigid, see-saw battle, and you knew it right then, or I did.

Karen was *trying* to be impressed, I could see; she wanted to experience the gravity of the occasion, but she couldn't recognize all that this play contained, the consequences carried within it, for Duke. Not yet.

The Giants' tight end scored the actual points, six plays later, on a curl route, before a defensive freeze set in. Duke had actually hurt himself on the critical catch, bruising the same thigh we'd watched him injure playing *against* the Giants earlier. After gamely trying to play on, he settled on the sideline, his leg heavily wrapped. But the Bears couldn't muster anything more—the sides had ground each other down, and now they succumbed to the chill—so the game ended quietly on Duke's former home field: 17-10, Giants. Nineteen walked off with the help of his new teammates, who'd clearly warmed to him, and the camera recorded a soft little smile from Duke. That's all anyone needed, even Karen. She looked so pleased, I didn't know she could be this free, as we lay there under the blankets and did what we wanted.

Duke had done his job on the field, and without incident: the only one he'd hurt was himself. That last catch of his, even with the aid of replay, continued to beggar belief. It was the only thing SportsCenter was interested in for the rest of the evening—that, and how brilliant the Giants were for signing the unknown quantity. In the press conference after the game, Duke offered nothing of substance, having wisely been muzzled by his new coaches, who spoke admiringly of his grit. Duke talked in circles: lots of words and no thoughts, the birthright of athletes. He seemed to revel in it. He was wincing now and then, too, though, and his leg sported an even larger wrap than the one he'd worn on the sideline during the game. Victory, for Duke, always seemed to come like this. Still, the Giants were going to the divisional round, and the team that had forsaken him, however good their reasons, was going nowhere.

52

Winter warmed, yet in all other ways it remained unyielding. The Giants lost in the divisional round, to the Falcons. Badly. All game, Duke hobbled around, having never convalesced from the bruised quadriceps he'd suffered the week before. Without a passing threat, the field narrowed, leading to Kinney's being repeatedly stonewalled at the line of scrimmage. And so the Giants fell. As Duke departed on crutches before the clock expired, a smattering of applause could be heard in the Atlanta stadium: pity for his strange fate, perhaps, and a touch of admiration, too.

Daphne's film, to her chagrin, got recut and retitled once more (*Adiaphora* prevailed). Most of what the troupe had shot in that last week by the river, when a palpable, extra-filmic anxiety had consumed them—one that I myself played a role in occasioning—got abruptly reinserted into the film, after test audiences found the previous version, the one I'd seen in the private theater, too palatable for Nik's taste. Funding always came with strings, of course; it was the distributor that had insisted on these vulgar screenings. And, quite incredibly, the viewers took this heterodox work of cinematic art for some sort of balmy, impressionistic pastoral. Nik actually walked out of one of these screenings, recalling then exactly *why* he'd shot that tortuous material in and around the country inn only once all guests, including me, had been barred. As time was running out and nerves were fraying, he pushed through the recut without the usual troupe consultations, which had lately turned fractious.

And so... the film flopped. Badly. Half-empty theaters, desultory reviews, no burn at all. Who can say if that quieter, dreamier version audiences had liked would have done any better? Early viewers can notoriously lead you astray. But what if their positive reaction, which had induced Nik's negative one—he'd just assumed they must have misunderstood him, to be so pleased—had blinded the director to what was in fact a better film, artistically speaking? Maybe they *had* understood it perfectly well. Certainly the cast, Daphne included, preferred it to the final version, if not by much, just as they'd preferred the title *Obsequy*.

What did *I* think? Daphne inevitably asked. But was I really entitled to an opinion on which was the better cut, given that I'd spent my time watching the first version, in the theater with Daphne, with so many other things on my mind: the woman next to me, the woman I'd lost, and the woman I worked for? But what if, I proposed, for future screenings, or at least for the streaming version, the studio welded the two cuts together, back-to-back, so the world would always know what might have been?

Whatever happened, I thought, Daphne's performance, the quiet terror you could see welling up in her in either version, at least if you were paying attention, seemed to me permanent, something that would have to endure. Even a flop could be an opening, and some critics had noted their fondness for her acting. That is what I told her, though I'm not sure it helped. At least it was true.

To varying degrees—you could arrange us on a spectrum of concern—everyone involved with the project wondered what our work would mean for the products themselves, which were now very near to release. Paul, in airing his gripes with Karen and me, might well have touched on the real reason, if there could be a single reason, for Garrett's blithe indifference to any overt advertising for Arête's wares and the whiskey, too: he'd never *had* to hawk Antral's other concerns, in biohazard and security. Buyers found *him*. So Garrett had fallen into the mistaken belief, Paul thought, that all truly valuable things could sell themselves; all you had to do was make them available.

I can recall a conversation with Garrett in late January in which he wondered unabashedly, despite Paul's skepticism, whether we really *could* lay, or mostly already *had* laid, the groundwork for a new kind of citizen-consumer, one who stood beyond the reach of all traditional advertising, who responded to codes far less barbarous, almost non-codes, images and words that asserted no real control over viewers, that were not even expressly designed to, only presenting the elements of our common twenty-first-century American dreamlife: the thing that would be called our *Weltanschauung* by historians, that had been pulled up in an almost Delphic manner into the space of my mind, and from which, depending on the makeup of *their* minds, they would wring sense and, perhaps, direction. I had no answers for him. I'm not sure he expected me or anyone else to.

In mid-March, all the products came out, and the only tangible advertising was factual text, typically the names of the brands: *Accomplice: spectacles from Arête*. Similar Theria ads followed, after the FDA ended up clearing the original formulation, the one I thought had burnt my mind irremediably. I could hardly believe this. I would go on to try more of it, but what I found is it made no appreciable difference now. Whatever the FDA said, I knew it had subtly changed me. There was a self that was no more, not quite. Field 25 received no direct promotion at all, except by bartenders at the most rarefied speakeasies in the country. I myself got a complimentary bottle, which I left unopened beside my drawing board. Apparently it was retailing for four hundred dollars.

All this happened just before what appeared, quite suddenly, to be the final piece of mine to be put up around the city, in April. With the release of the products, the need for more drawings had lapsed, Garrett told me, probably with the encouragement of Paul, who couldn't have been more pleased to move on from what he clearly regarded as his most ostentatious failure, a profoundly botched campaign he might never live down in marketing circles, *if* anyone came to know a full-blooded campaign had been undertaken. Garrett would have had personal reasons to wind things down. Hadn't we witnessed the annihilation of high drama in Daphne and Duke, the destruction of all enchantment? Hadn't the both of them come up short? Weren't they still entirely at risk of oblivion, the way Garrett himself was not? Antral, after all, remained enormously, invisibly strong, notwithstanding the moral controversies Garrett had courted. Perhaps he'd seen what he'd needed to, about our world, its *logos*. The parable had been framed, the story told. It was enough.

In this last piece, which I'd worked on through January, although back then I'd had no notion of its last-ness, I finally weaved together our principals, the twin poles of Garrett's imagination, in a large-scale drawing: six feet by four. They'd never actually met, Duke and Daphne, though both had suggested as much at different times. I'd enjoyed denying their wishes, and not only because I wanted to be the only one bedding Daphne. My mind, it seemed to me, should be the only clearing in which they met. It was my province. It's a thought I'd been having for weeks, even in December, trying to find the nexus of these two lives. Paul especially had been prodding me about this. He was *always* searching for integration, simplicity, whereas Garrett and I were seeking a realm that probably couldn't be gridded out.

In January I struck upon the simplest of ideas: a pair of black-and-white mugshots in graphite, as if from an endless book of them, with both Duke and Daphne looking just mildly bemused. I worked on these with Karen pleasantly hovering around me, or just beneath me, actually, doing what I hadn't been able to, namely, sort through the world of the Beckers downstairs, the family that had made way for us. The first floor, it seemed, would end up hers rather than Claire's. We were spending our time mutually, that is, *together*: sometimes Karen would stay for days at a stretch. When she wasn't sorting through the debris below, scavenging what she could, she was in bed with her laptop, working to finish the novel, while I was left to the domain of images alone.

It was fine and classical portraiture, this last picture. I remember feeling I finally had the time to do that sort of work. Even though nothing explicit had yet come down to me from Garrett, I must have had some sense that these two people were gradually leaving my orbit. Truly, we plastered the city with this one. No textual complements, either, just the one pencil drawing, *everywhere*. I had no way of reasonably

estimating the cost of this gesture, but what was the need for an estimate when you knew it had to be terrifically large?

And so?

They all sold well enough. The glasses. The smart drink. The whiskey. Not exceptionally well, but not embarrassingly so either. Field 25, as I've said, turned out to be priced at a remarkable point, but then there really wasn't very much of it; I'd actually seen all the barrels of the stuff that existed in the world. The price might well have been fair for something so scarce, and it would remain scarce for at least a few decades, until new barrels could come of age. Theria, though, and possibly the Accomplice line with its custom lenses—here is where one could imagine, in due course, real revenues.

Even in a playoff loss, Duke had played disciplined, gutsy football. Committed football. There'd be a contract for next season if he wanted one, and for now, anyway, it seemed that he did. He also stayed true to us, never explaining to the media the significance of his likeness being all over the city and the country, not even once the mugshots went up. After the loss in Atlanta, he simply made his way back to Chicago for the offseason, trying, apparently, to put things right with Dante and Sheila—at his apartment by the lake. They'd been at the Chicago wild-card game, in fact; seeing him perform with conviction had induced a thaw.

Naturally, my separation from Daphne was always going to be stickier, but perhaps not as sticky as I'd imagined. The boost that *Obsequy* had given to her profile was probably driven by consumer lust. She knew how I handled women in paint, and ink and chalk and pencil: even when there was no hint of sex in the picture, she told me one day late in March after dropping by unannounced, people found some sort of charge in them. I'd not seen her since the screening in December; the turbid forces seeming always to whirl about her, the ones fairly caught by our mural, finally scared me off. Painting the mural with John and Connell, watching it take shape and fill up an entire wall downtown over a week and a half, I felt I could see where I would have to go to really *have* her, or just a piece of her. Maybe that's all you could hope for with Daphne; some people are better—or better for *you*, at least—on paper, or on the stage, than they are in the flesh. Alonso, too, had put me off. Daphne had been appeasing him ever since his illness at the theater bar. They were together now, she said, although she didn't seem as excited about it as she ought to have been. As I was, for instance, with Karen, who luckily wasn't there the day Daphne came by.

I wasn't quite sure why she'd come, or what she wanted from me. Frankly, there was something repellant about her now, unmitigatedly so. Was it only my lack of need, having Karen? Or had I seen something in her I really didn't like? I snatched the bottle of Field from the drawing board, the bottle I'd thought I wouldn't touch, took out two glasses, and poured the tiniest measures, purely symbolic ones. Her agent had gotten a string of calls about her, she relayed with a pride that felt brittle: *interesting* new parts, both film and theater. I toasted her future. I was happy to, really. Yet the more I complimented her, the more forlorn she became. So I broke off my speech and we drank. Finally, she asked me about Garrett, what he had planned for me. I didn't take her meaning.

"You must see, by now, why Jimmy's done all this for me, made me famous? I more or less told you last time, didn't I?"

I hadn't much thought about it since then, not very directly. I couldn't see the point.

"How about this, then? *He* is why you've never seen my mother, Angela." The woman held her husband, Tony, responsible for what had happened, for allowing one of his friends to *do* that to their daughter, to even begin to feel that way about her. It's why Tony was her ex-husband now. Daphne had been of age, of course; there was nothing criminal about it. But the infatuation had begun long before the legality of it. Garrett always felt she was one of the charmed things in the world, her physical being, although it would be years until she turned into anyone's idea of pretty, if she was that even now. Her evasiveness, even as a ten-year-old, when she'd struck Garrett as an obscure portent of enchantment, had won out in the end over every sensible consideration.

"It's why Jimmy doesn't talk to Tony anymore," she concluded, as though she were putting things together for the first time. "Why he talks fondly of *him* but not the other way around." She commandeered the bottle and poured herself a proper measure. I held my hand over my glass, which I nearly lost ahold of, I was sweating so much. "It's why you never hear much about Elise. That's Jimmy's wife. Pretty thing, and all alone. The only hole in his lovely life. She left him after it came out, but she hasn't divorced, for the convenience of it. I wouldn't either.

"So Jim did all this for me, pushed me right into the spotlight, with your help. I don't know how sorry he really is about it all, ruining my family. Sometimes I'm not sure how sorry I am either."

She leaned in and kissed me and I let her swim in my mouth for a moment longer than I needed to. Then I pulled away. I was feeling sick, and it had nothing to do with Theria. She showed herself out; I'm not sure what I did then.

The summer came, which gave me some time to gather myself, to comprehend—
or try to—who it was I'd been working for, as I began remaking my life with
Karen. *Cosquer* released the special issue dedicated to my drawings, revealing, all
at once, the link between these ubiquitous pictures and me. It was tantamount
to a solo show, in Karen's eyes. I hadn't seen the layout yet; Karen had been
keeping it from me until publication. When I finally did see the issue, in late
August, it came in the mail, two days before its general release. I settled back into
bed with the magazine, preparing to take stock of my work, my year, and felt a
prideful anxiety, one I'd not anticipated, swallow me up. But as soon as I began
to study the issue's pages—the cover was actually pure black, bearing no trace of
the innards—I discovered my pictures to be decorated (or defaced) in a small,
erratic script that could only send me scrambling back to the living room for the
envelope. I snatched it up from the floor: the issue had been forwarded to me, I
could see, and the return address only confirmed what I knew—it had been sent
to me by Claire. I stood there for a moment, getting my bearings. Back on the
couch, I slowly opened the issue again, and on closer inspection found all my
images carefully annotated with Claire's thoughts.

Who, I asked myself, had always responded most meaningfully to my work,
and taught me the most about it, if not Claire? *Of course* this would come from
her, my greatest advocate, the one who even now had the firmest grasp on who it
is I am, or was, or will be. Her hand, to see it engulf my work, head to foot, gutter
to gutter, paralyzed me in the most exquisite way, drawing me worlds apart from
Daphne and Duke and Garrett and even Karen, her great friend. Soon it became
clear her marginalia formed a continuous letter keyed to my pictures, describing
the time we'd now spent apart, and expounding on things I wouldn't have been able
to fathom on my own for years. How grateful I felt for the time she was saving me.
I noticed too that the images had been very gently reworked. She'd treated what I'd
done as a kind of underdrawing, and upon that base reshaped the faces, took what
was ugly out of them—and there was plenty to take out. *This*, I realized, would be
our only true collaboration. The pictures were beginning to make a different sort
of sense to me. After several hours of study, when my eyes began to hurt, I set the
magazine down on my terrace table, in the shining tower I resided in, not far from
the East River. I'd known that the city's "spot clearance" effort couldn't be held off for-
ever in the Bronx, especially in a neighborhood that had almost no clout in the wider
borough. Reverting to old habits, New York was demolishing most of the firetraps
around the Patterson Houses and hoping private developers, given favorable pricing

and tax incentives, would rebuild it adequately. But when had this ever happened? Faith was a powerful thing.

As Garrett had predicted, my townhouse, which I'd anyway never managed to seize control of—Rodney and Tanya were going strong, despite it all, and remained there just as long as I did—and with it my immaculate mural of the outdoors, which had in some way already razed the building, bringing down the walls by depicting all that surrounded them, had been claimed by the state through eminent domain. The place would be rubble in ninety days. Kiver didn't mind much: he was going to be bought out at a decent rate, and he had other properties from which to extract income. The residents of those neighborhood tenements, though, and of my grand old house, were being sent scurrying like rats, until a new home for them could be found or made. They—*we*—were being reduced to something like the state of Helena, who I imagined still lay on the platform each day, sniffing those shoes. We were all obstacles to the city's dreams. And dreams were important, I knew that much. I wasn't bitter.

So it was that after briefly entertaining the fantasy of arranging to have my apartment walls trucked and reconstructed in the manner of Goya, or Cosquer 2 and Lascaux 2, I abandoned the house, many weeks before its scheduled annihilation. There was, after all, nothing to touch up or paint over, given the building's fate. I *did* take some photos of the mural, of course; the sort of photos you might never look at again. I could only leave so quickly, as Tanya and company could not, because I had a place to go, had had one for a long time, really, owing to Garrett.

I was on the Upper East Side now, not so far from Whent and Tony, actually, in an elegant duplex. I was among Garrett's people. He had a large stake in the building—he was always building something. For the foreseeable future, he'd be subsidizing my rent and providing me a stipend, with no very clear conditions at all, as Antral's project with Cosquer was finished. I wondered, as I sat outside on the terrace, staring at my collaboration with Claire on the table, what sorts of plans he had for this building, an old stone structure the color of ash with a marvelous rooftop overlooking the pleasant stillness of Seventy-Fourth Street, just as my private terrace did. What I was expected to do for him next, and how temporary the arrangement was, there were simply no answers he or Paul was willing to supply. What was certain was that I had the run of this place. Five bedrooms. Somehow, it seemed, I'd managed to relocate my palace rather than lose it.

Karen was staying with me off and on now, writing mostly, but also editing *Cosquer* with Rick, who'd taken on the day-to-day duties. I genuinely treasured *not* working with him and the others anymore. Karen had even given me her blessing not to proof the magazine, which meant I could stay away from the offices entirely. I

felt it a matter of time before she gave the whole thing up herself. The notion of her and I being together properly, not in shadow, had percolated through our circle; even John had come to accept it, as he'd had to accept the grandeur of the project we'd managed together, as grand as anything the Bauhaus inspired, perhaps, and probably more effective. He was, in fact, the one person still working at *Cosquer* who I kept in touch with. Karen and I both did.

I flicked open the magazine once more under the high, bright sun, and in the autumn air, I thought of Redon and Goya and most of all, as ever, Degas and his washwomen and chanteuses and café-concert singers. My sense of having achieved *something* in these pictures, of braiding worlds, even if the materials were common stock, and even if I couldn't say just what these worlds contained at their limit—perhaps this was only an index of my success—was undercut by the equally strong sense that for just this reason, I may have exhausted the profit to be had from a working method I'd been honing since college. Garrett's project seemed to me the final iteration of it. Where to go *now*?

The question had left me housebound for weeks, though not exactly unhappily, given my new living arrangements with Karen. Eventually, I presumed, I would hear from Garrett, although I hadn't for a month. Perhaps he and Paul were allowing me some off-time until Antral found a new challenge, a new controversy. For my part, having run out of ideas *again*, I might very well take them up on it, whatever exactly it was, however *dark* it was. Even riot-control dark. Who knows? I was feeling free—so free, in fact, that as much as I liked Karen, I often found satisfaction and a strange sort of solace in her leaving for Cosquer's offices, or returning to Sunnyside for a few days (she'd kept her apartment), or just locking herself up beneath me, on the duplex's lower floor, to write all day. Even Immo, who seemed to be in a détente with Vera; and my parents, who were keen to see how I was making out in my new, exalted environs, I put off till later for this re-entry into solitude, not unlike the one I'd known when Claire had left me. This time, though, solitude was a choice, a craving I had, now that Theria, which anyone could buy at the bodega, was no longer doing much for me. While Karen worked alone on her book, I was spending unbounded hours in my viewing room—our private theater—Claire's and mine, I mean—first erected around that giant screen she'd reclaimed. Garrett had a very fine setup in the apartment, naturally; it'd been mostly furnished when I'd moved in. Yet he'd permitted me to bring whatever I wanted of the old place. Besides my art and my books, the only thing I'd saved was Claire's plasma, which I'd set right in front of the state-of-the-art television that was already mounted on the wall like a painting.

I had some films on my hard drive, and there were the streaming services, of course. But all that was overdetermined, hermetic, subject to the terrible reign of my

personal whims. No, instead of all this, the first guest I'd invited after moving in was the cable man, who these days was going the way of the milkman. I got the largest package of channels on offer: eight hundred of them, larger even than what I'd had in the Bronx. I would miss nothing and nobody.

Inevitably, I find myself rotating between the dozen major channels of my childhood, letting each of them tell me all that it needs to. This is as much choice as I allow myself now: a comfortable amount. I switch off my phone most of the day and drink it all in, so much more powerful than both of Garrett's libations. Karen comes and goes—she has a lot to negotiate, *Cosquer* is evolving, and there's a novel to finish—but I am right here, where I need to be.

Over the hours and days and weeks, I return to this room religiously, sometimes sleeping in it, too. I am watching, and waiting, of course, for signs of Duke and Daphne. (Karen understood this before I did.) Now, it's only a matter of time, I feel, until I see them. And it is only when they arrive *here*, on this quaintest of media, television, that I'll know they have wholly saturated the culture, and not before. It might be many years, it could be decades, but I have time. I'll see them eventually, I know, or hope that I do, in some star-making circumstance, these two not-yet figures, still mostly unknown, still very much in danger of being drawn back into oblivion where the rest of us live. And I consider now, after the screen has somehow switched itself off and become nothing more than a humming black box; in this state just after waking, though in complete lucidity, which I now know springs from too many sources to name in my life, and not a simple drink; in this state of total exhaustion, too, which I cannot separate from it in the least, even in name, I consider what it must have been like to *be* Thérésa, the master's dearest, the day before she and her kind became the stuff of all our dreams.

ALSO BY CLASH Books

CL⬛SH

WE PUT THE LIT IN LITERARY

CLASHBOOKS.COM

FOLLOW US

TWITTER

IG

FB

@clashbooks

Printed in the USA
CPSIA information can be obtained
at www.ICGtesting.com
JSHW021959170624
64962JS00004B/15